This publication documents two components of **inSite_05**: **Interventions** and **Scenarios**. **inSite_05** unfolded between 2003 and 2005 in San Diego-Tijuana. Its public phase took place from August 26, 2005, through November 13, 2005.

[Situational] Public is accompanied by two additional publications: *Farsites*, which documents **inSite_05**'s museum exhibition, and *A Dynamic Equilibrium: Liminal Spaces/ Coursing Flows,* a compilation of essays from **inSite_05**'s series of conversations and dialogues.

Esta publicación documenta dos componentes de **inSite_05**: **Intervenciones** y **Escenarios**. **inSite_05** se desarrolló entre 2003 y 2005 en Tijuana San Diego, y tuvo una fase pública desde el 23 de agosto y hasta el 13 de noviembre de 2005.

Público [situacional] acompaña a otras dos publicaciones: *Sitios Distantes*, que documenta una exposición en museo para **inSite_05** y *Un equilibro dinámico: Espacios liminales/ Flujos en curso*, una compilación de ensayos de las series de conversaciones y diálogos para **inSite_05**.

[Situational] **Public> Público** *[situacional]*

Editor> Editor/ Osvaldo Sánchez
Assistant Editor> Editor asistente/ Donna Conwell

Copy Editor, English> Corrección de estilo, inglés/ Julie Dunn
Copy Editor, Spanish> Corrección de estilo, español/ Tania Ragasol

Design> Diseño/ Estudio_ChP+
Adjunct Designer> Diseñador adjunto/ Sirak Peralta

inSite_05's general design guidelines were created by **fdt/design**> La imagen general de diseño para **inSite_05** fue creada por **fdt/design**

Translation> Traducción/ Gabriel Bernal Granados • Clairette Ranc Enríquez • Pilar Villela • www.languagedepartment.net

Photography> Fotografías/ David Maung • Alfredo De Stéfano • Julio Orozco • Yvonne Venegas • Danny Playami • Sally Stein • **inSite_05** staff • and the **Interventions** and **Scenarios** artists

Photo projects> Proyectos fotográficos/ Alfredo De Stéfano (*Ellipsis,* pp. 398–409) • Ken Jacques (Aerial border images, p. 11)

Cover> Portada/ Javier Téllez/ *One Flew Over the Void (Bala perdida)*

Printed by Friesens Book Division, Manitoba, Canada
ISBN-10: 0-9642554-6-4
ISBN-13: 978-0-9642554-6-3
Library of Congress Control Number: 2006933387
Copyright © 2006 Installation Gallery, San Diego

Público

[situacional]

05

Edited by Osvaldo Sánchez & Donna Conwell

Interventions • Scenarios
August 26 – November 13, 2005
San Diego-Tijuana

inSite_05/
Executive Directors/ Michael Krichman & Carmen Cuenca
Artistic Director/ Osvaldo Sánchez

Table of Contents> Índice

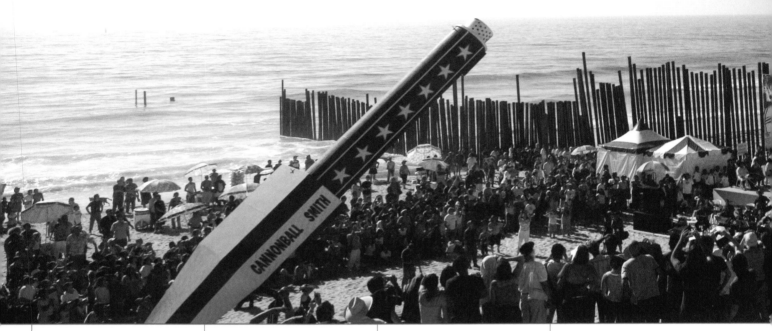

Artists/	Production/	Interlocutors/	Curators/
Allora & Calzadilla	Daniel Martínez	Beverly Adams	Osvaldo Sánchez
Barbosa & Ricalde	Márgara de León	Ruth Auerbach	Tania Ragasol
Mark Bradford	Zlatan Vukosavljevic	Joshua Decter	Donna Conwell
Bulbo	Joy Decena	Kellie Jones	
Teddy Cruz	Esmeralda Ceballos	Francesco Pellizzi	
Christopher Ferreria			
Thomas Glassford			
Maurycy Gomulicki			
Gonzalo Lebrija			
João Louro			
Rubens Mano			
Josep-maria Martín			
Itzel Martínez			
Aernout Mik			
Antoni Muntadas			
Jose Parral			
Paul Ramírez Jonas			
R_Tj-SD Workshop			
SIMPARCH			
Javier Téllez			
Althea Thauberger			
Judi Werthein			
Måns Wrange			

→ Traducciones/ p. 274

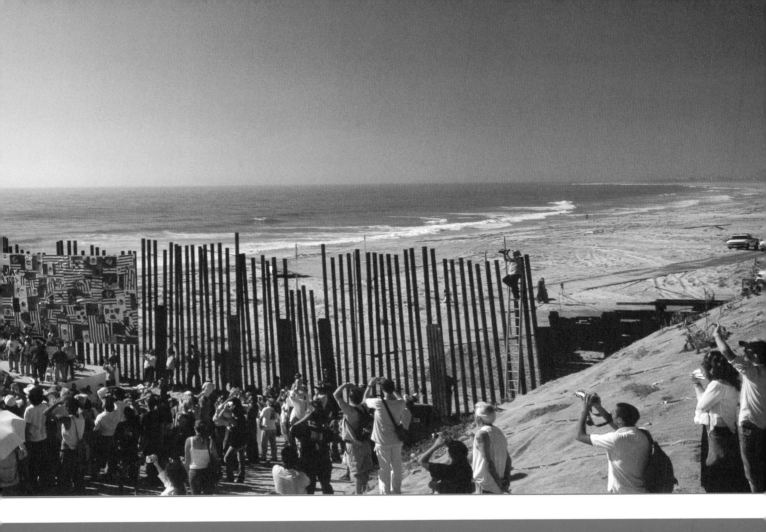

For more than ten years **inSite** has focused on commissioning artistic interventions in the San Diego-Tijuana region that have explored the relationship between the urbanscape, the border, and the public fabric.

inSite's successive versions have documented the historical development of artistic practices of intervention, ranging from urban-scale sculpture to site-specific installations, from performances to non-object based processes and situations.

Twenty-two artists and artist groups were commissioned to produce artistic interventions for **inSite_05**. The projects sought to explore and challenge dynamics of public association and their modes of exchange, and to introduce new political imaginaries into the heart of everyday life. All of the projects employed collaborative processes that developed over a period of time. These processes were utilized to induce public situations rather than to construct aesthetic objects or representational artifacts of the kind that have often been identified as public art.

Interventions unfolded over a two-year period—from an initial research phase through final production. The public phase of the project took place from August 26, 2005, through November 13, 2005. o.s.

Interventions/

BORDER (DIS)ORDER/ ON THE IMAGINATIVE POSSIBILITIES OF THE IN-BETWEEN

Donna Conwell

The notion of motility captures the various stages in between mobility and immobility. Motility . . . means neither immobility nor mobility, neither stability nor instability, neither solidification nor liquefaction. It describes the mobile moments when people and things are physically, virtually or residentially not quite at home and not quite on the move. Jörg Bechmann[1]

Space/spatiality is a dimension of social relations and imaginations; it is not an objective structure but rather a social experience . . . it is a conception constructed by way of people's social practices in their involvement with the world. Kirsten Simonsen and Jørgen Ole Bærenholdt[2]

In the story, the frontier functions as a third element . . . A middle place, composed of interactions and interviews, the frontier is a sort of void, a narrative symbol of exchanges and encounters. Michel de Certeau[3]

Border spaces—be they international border crossings, fortified urban enclaves, or the unstable interstices between oneself and the other—are in constant flux, shifting, reconfiguring, and proliferating in a continuous process of becoming that is embedded in "geometries of power."[4] (Re)produced by socio-economic processes and the everyday social practices of groups and individuals, border spaces are loci in which a complex series of macro and micro relations intersect and where power is performed, secreted, ordered, managed, and resisted. But do these social processes and practices simply construct bounded and discrete territorial units and interfaces or do they also open up a fault line, an in-between transitional zone that straddles the boundaries between binary codes?

Although border spaces may approximate the non-places that anthropologist Marc Augé describes—places like the supermarket, the waiting room, and the mall, spaces where one is temporarily unanchored from a

sense of place and unable to establish relations with others[5]—nevertheless they are also spaces where distinct modalities of mobility and immobility, place and non-place, flux and rest converge. It is precisely the ambiguity of the in-between, the fact that it is indeterminate, which enables actors to transform it into a space of insurgence and transgression, a space in which to imagine new modes of belonging and new ways of operating in the world.

The **Interventions** projects for **inSite_05** involved a conceptual shift—rather than imagining border spaces as physical absolute territories the participating artists approached them as spaces that are constituted by, as well as constitutive of, social relations and practices. They asked the question: If border spaces are conditions and processes that order and produce spatial segregation in what ways can we trace ruptures in that ordering? In what ways can we open up the creative possibilities of the in-between?

→ Otras traducciones/ pp. 334–341

Why [do] modern cultures invest such efforts into structuring and ordering mobilities and why [are] they seemingly so obsessed with marking roads, drawing maps, devising hypertext transmission protocols and stamping passports? Jörg Bechmann[6]

03.21.05/ 4:15PM...

Mark and I walked around the San Ysidro Port of Entry a couple of times today, discussing the project, checking the sites, and talking to the *maleteros* about their equipment needs. We timed it badly and got stuck in a long queue going back to the US. Why is it that the inspection line I choose to wait at always seems to be the slowest? I try to keep my eyes peeled for a sign; some indication that will let me know which line will be the fastest, which one will have the most amenable customs and border control agent, but I never seem to get it right. The frustration builds—there is so much to do at the office, I need to get back. Mark said that he had been pulled aside by border patrol and questioned the day before. They were suspicious because he had been walking around the port of entry all morning. He tried to explain that he was an artist and he was researching an art project, but he didn't think that they believed him. He's worried about getting into serious trouble. I think I may have to ask Carmen if she can get some sort of official letter for him. We are all becoming increasingly suspicious as we spend more and more time down there. Pretty soon we are going to need some kind of identification that explains why we are continually circling around this place.

You've reached the San Ysidro Port of Entry
Today is July 18, 2006
We are operating under at threat level yellow
It is now 3PM
There are 18 vehicle lanes open
Vehicle wait is approximately 60 minutes
The wait in SENTRI is less than 5 minutes
The pedestrian wait is 45 minutes
San Ysidro Port of Entry[7]

International borders manage mobility through diverse ordering processes. Flow is cordoned off and movement is structured and directed. Every threshold presents another point of no return. Movement is always unidirectional and is orchestrated and controlled by "flow managers."[8]

The San Ysidro-Tijuana US-Mexico port of entry is the world's busiest border crossing.[9] An estimated 150,000 California residents and 40,000 transborder Mexican residents make their way across the border everyday for jobs, school, housing, medical care, shopping, cultural enrichment, or to see family and friends.[10] On a weekday the average border wait is fifty minutes, with over an hour and sometimes an hour and a half wait during the rush hour commute.[11]

How is mobility ordered at the US-Mexico border? The diverse mobilities that flow through the San Ysidro Port of Entry are managed through separation and are divided into various sub-mobilities:

Pedestrians/ Is this where the queue starts?

Pedestrians crossing from Tijuana to San Diego are filtered through a narrow corridor to the right of vehicular traffic. Upon entering the US customs building, pedestrians are sectioned off through a series of inspection gates, each headed by a customs and border control agent. SENTRI (Secure Electronic Network for Travelers Rapid Inspection) is a prescreened inspection program that currently enables 50,000 individuals in the San Diego-Baja region to bypass long queues via an express lane.[12] A "bicycle lane" is located on the far left and allows pedestrians with bicycles to circumvent long queues. Pedestrians with large bags are also allowed to make use of this lane.

Pedestrians entering Mexico from the US are channeled through a buffer zone that directs flow towards the taxi rank or towards downtown and Avenida Revolución with its accompanying tourist attractions. The corridor's revolving metal doors at either end function as a valve, precluding the possibility of return once one has passed over the border threshold.

Vehicular traffic/ They just closed my lane. Please let me in. LET ME IN!

Northbound border-crossing traffic is funneled through contracting traffic lanes. There are a maximum of twenty-four primary inspection gates. As drivers jostle to maintain their position in line they are hemmed in on all sides with no possible means of halting their unidirectional flow. A SENTRI express lane for cars is located to the far right.

Vehicles approaching Tijuana from San Diego do so via the I-5 Freeway. During busy commuting times traffic can stretch back as far as downtown San Diego. Nine gates and a secondary inspection area that can accommodate approximately forty vehicles serve traffic entering Mexico.

Photo Project/ Ken Jacques

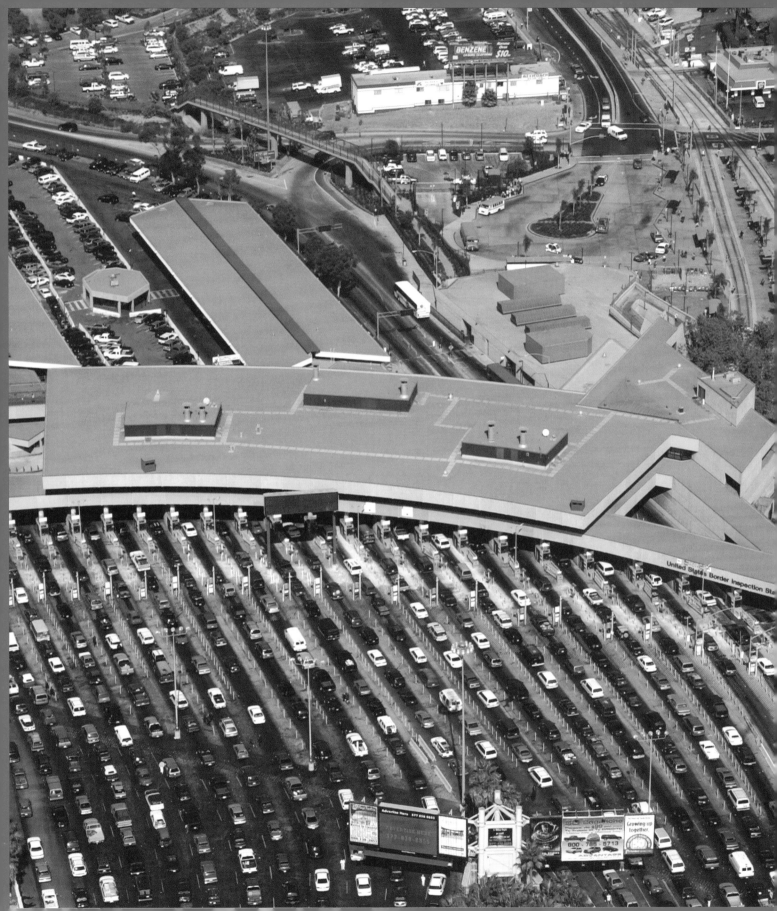

Public Transport/ What time is the last bus back to San Diego?

Mexicoach is the US' largest international border-crossing shuttle service. It is primarily used for tourism and has its own special border-crossing lane, which is not shared by any other buses or cars. A border shuttle also exists along with a number of formal and informal bus services. These services cross from Tijuana to San Diego via a special traffic lane. Passengers must disembark at the border and enter the US customs building through a side door. There they join the shorter "bicycle lane" queue.

Buses entering Tijuana from San Ysidro do so via the I-5, as with other vehicular traffic. The San Diego Trolley's last stop is located just outside the US customs exit and does not cross into Tijuana.

In all instances mobility at the San Ysidro Port of Entry is managed and ordered in terms of unidirectional flow—vertical trajectories from north to south and south to north. But do the everyday itineraries of border crossers really follow such linear pathways? For the majority of its users the US-Mexico border is not a point on a trajectory between a place of departure and a destination, it is the in-between zone on a well-traveled circuit. It is part of the continuum of a loop. Whether the border crosser is a commuter using her laser card to go to work or school,[13] a consumer en route to a San Diego shopping mall,[14] or a tourist visiting Avenida Revolución or Coronado, a multitude of mobilities intersect at the border and, for the majority of them, flow courses through circular not linear routes.

Given the prevalence of these circular flows, what social processes and practices have developed at a micro level to facilitate mobility? What tactics have evolved as a response to, or in dialogue with, the inscription of the border space in a linear trajectory that connects one circumscribed territory and another? A number of informal enterprises have sprung up at the border that disrupt the official discourse of unidirectional traffic. In 2000, as waiting times at the border became increasingly longer,[15] a bicycle-renting business was initiated by a local Tijuana businessman. Bicycles are rented to pedestrians in Tijuana as they wait to cross into the US, enabling them to circumvent long border queues by accessing the express "bicycle lane." The bicycles are then dropped off in San Ysidro and returned to Tijuana. This can result in the curious spectacle of a grown man pushing a child's bicycle through the express "bicycle lane" as if it were his own. The *maleteros* (porters) are another informal enterprise that has evolved in response to the lived reality of border commuters. Not only do *maleteros* facilitate the circular flow of border crossers by carrying consumer goods and/or suitcases and baggage, but they are also able to bypass long queues at US customs because they have direct access to the express "bicycle lane."[16]

Mark Bradford attached himself to the activities of the *maleteros* to draw attention to the circular flows that contradict the unidirectional ordering of mobility at the border zone. His project has tended to be framed in terms of the relationship it established between formal and informal economic spheres; however, *Maleteros* also reveals how mobility at the border is managed and articulated in contradictory ways.[17] By trying, and to some extent failing, to set in motion an unbroken circuit of mobility between the more formalized and less organized *maleteros* groups stationed around the border, Bradford revealed the uneven nature of the intersecting social and economic relations that operate in the in-between. Gaps in the circulatory system opened up and flow became blocked because of deep-seated antagonisms and disputes between the different groups, each of whom sought to maintain and protect the territory they had carved out for themselves.

A number of **inSite_05** projects broke with a unidirectional reading of border mobility, substituting it with a circular trajectory in which diverse economic and social relations intersect. Aernout Mik and João Louro both explored the circuits of commercial exchange and recycling that exist between the cities of San Diego and Tijuana. Judi Werthein explored how San Diego-Tijuana is a hub in a network "constructed out of a particular constellation of social relations [*on a global and local scale*], meeting and weaving together at a particular locus."[18]

Bradford initially intended to merge his interest in mobility with his ideas about "border time"—a complex intersection of diverse timelines warped and experienced as one.[19] In particular, he was interested in exploring the relationship between *chronos* time (chronological time) and *kairos* time (event time)—the relationship between the experience of time spent face to face with a customs officer in secondary inspection or in traffic waiting to cross the border, with the passage of time. In this way his ideas mirror Doreen Massey's argument that the di-

vide between space and time is problematic, the result of a flawed association of change with the temporal, and stasis with the spatial. She posits an alternative view of "space-time" where both are inseparable.[20] Bradford was interested in exploring the interactions between multiple spatialities and temporalities at the border. Although he did not incorporate the theme of "border time" in his final project, his interest involved a re-conceptualization of the border space as an in-between that straddles the gap between—and brings into collision—a series of supposed oppositional categories, including mobility and immobility, and space and time.

Måns Wrange was also interested in the notion of time as it is experienced at the border. Before developing *The Good Rumor Project*, Wrange explored the idea of employing the principal of distributed computing to harness and collectively utilize the time that border crossers "waste" in long waits at the border. By marshalling border crossers' collective experiences of frustration and ambivalence for a utilitarian and dis-alienating purpose, Wrange sought to intervene in the "official" ordering of mobility at the border as unidirectional. He intended to supplant this notion with the idea of a shared collective zone, a hub in the network, an in-between where creativity could potentially occur if border crossers negated their role, and disrupted their established behaviors and responses.

In their engagement with the issue of mobility at the San Ysidro Port of Entry, a number of **inSite_05** artists revealed, and intervened on, the way that socio-economic relations are secreted through border-ordering processes. They posited the question: If border spaces are constructed though socio-economic processes and everyday practices, then isn't it possible to imagine alternative uses and ways of operating that could potentially activate different kinds of spaces?

PERFORMING THE NATION IN THE IN-BETWEEN/ SPACE AS RITUAL—SPACE AS THEATER

Frontiers, in this sense, are part of political beliefs and myths about the unity of the people, and sometimes myths about the natural unity of territory. These "imagined communities" are linked to the most powerful form of ideological bonding in the modern world: nationalism. Malcolm Anderson[21]

There is no stable substance to the state. Our world-society is populated by many sorts of mobile entities, a fact which tends to delegitimize the concept of the nation-state as a container for and exclusive exponent of these entities. Subjects, citizens, inhabitants, goods, capital, and production sites—they all come and go. What remains is nothing but a temporal form of self-constitution, which constantly has to be filled by flows of entities of all kinds in order to remain present. Wolfgang Zierhofer[22]

11.17.03/ 2:56PM…
I always get performance anxiety when I cross the border back into the US. Even if I know that all my papers are in order, that I have my H1 work visa issued from the American Embassy in London in my passport. I secretly dread slipping up, saying the wrong thing, the fear that they'll discover that somehow I'm an imposter, I'm faking it. I'm waiting in line. I'm rehearsing the lines. It is very stressful. It's even worse today, crossing with a busload of artists. There will be so many questions, so many opportunities to get caught out, for them to realize that something is wrong, that we are not supposed to be let in. We are in a state of anxious limbo, waiting, waiting for them to grant us our authenticity. Then we can breathe easy again. As soon as we cross the borderline we are home free, we can relax and laugh and joke again.

The practice of passport control is a ritual, a routine act through which a specific social, political, and territorial order that is dominated by the institutional form of the nation-state is reproduced and articulated.[23] Frontiers and borders define, in a legal sense, the identity of individuals because they structure and limit the conditions for claims to nationality and the exercise of rights of citizenship. The nation-state is collectively understood as a natural, territorial, political community, rather than a contingent historical organization that has been naturalized. The ritual of affirming the nation-state is a performance that border crossers engage in on a daily basis. They perform their authenticity as "national citizens" or "friendly non-threatening visitors" as part of a ceremonial exchange where identities are rendered questionable, suspect, and phony. Everyone is potentially an "imposter."[24]

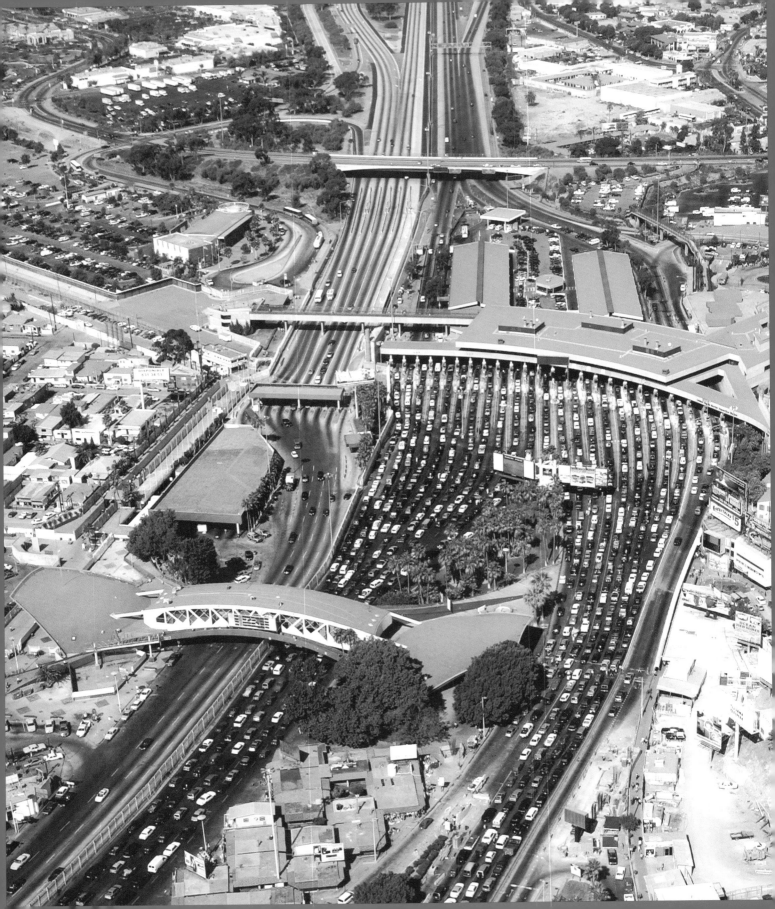

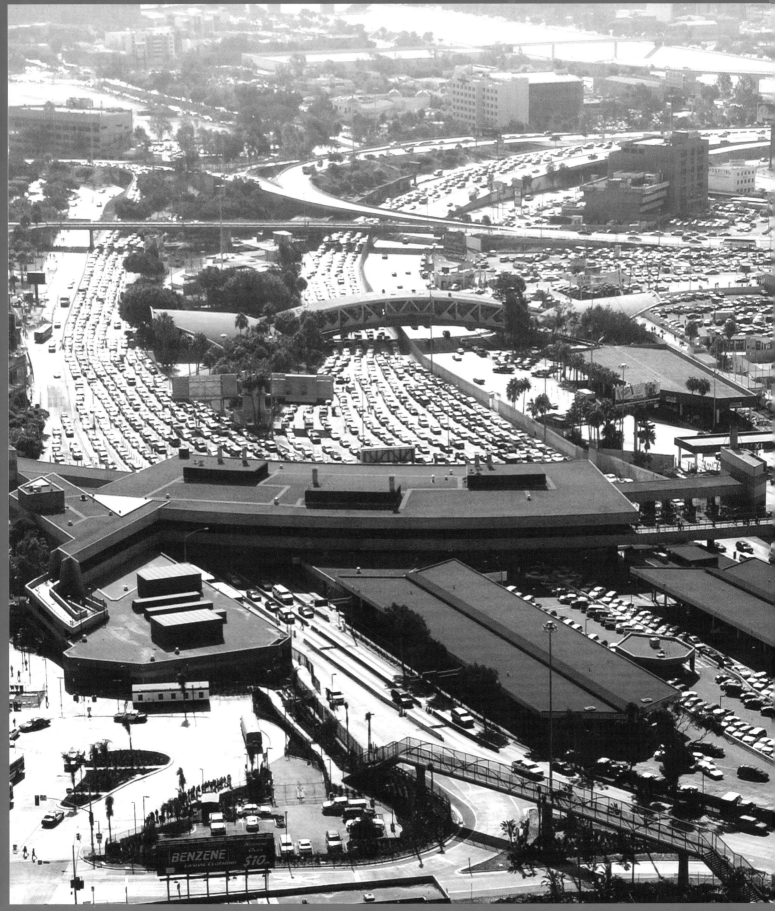

In a similar way to numerous borders around the world, the ritual of passport control at the San Ysidro Port of Entry from Tijuana to San Diego plays itself out thus:

Passport please
What is your nationality? Mexican
Why are you going to San Diego? Shopping
What are you bringing from Tijuana? Nothing
Next

Passport please
What is your nationality? American
What were you doing in Tijuana? Shopping
What are you bringing back from Tijuana? Nothing
Next

Passport please
What is your nationality? American
Where were you born? Slovenia
When did you become a US citizen? 1996
How did you become a US citizen? I was naturalized
What are you bringing back from Tijuana? Nothing
What were you doing in Tijuana? Shopping
Next

This is a fixed script. To reduce ambiguity one must say as little as possible and reply with monosyllabic and codified responses. Deviating from the script generates ambivalence and that can bring the border crosser's legitimacy into question. If, for example, in answer to the question: "Why are you going to San Diego today?" one replies: "To go to work/school" the performance is fractured and the border crosser's authenticity becomes suspect. This is also the case if in answer to the question: "What are you bringing back from Tijuana?" one replies: "Antibiotics and contraceptives" or if in answer to the question: "How did you become a US citizen?" one replies: "I got married." The correct reply—"I was naturalized"—inscribes the speaker within the articulation of a specific order where the nation is assumed to be a natural, territorial, and political community and not a contingent "imagined" one. To answer otherwise will likely elicit a challenge to one's claim to citizenship.

In counterpoint to the carefully crafted script of US passport control, Mexico's absence of any kind of passport checkpoint serves to underline the asymmetrical relationship between the cities of San Diego and Tijuana. In one case entry is carefully controlled and in the other entry is actively encouraged and promoted.

The performance of the nation is a ceremonial rite that border crossers at the San Ysidro Port of Entry engage in everyday, even though the notion of "nation" frequently has no bearing on their lived reality of community, in which familiar ties, work colleagues, friendships, loyalties, and alliances traverse the border line.[25] The rituals of cross-border familial gatherings undermine the social processes that reinforce the territorial order of the nation-state. This performance is also transgressed and bypassed on a daily basis by undocumented migrants who know that they will not pass the ceremonial test and instead choose other less traveled and surveyed routes across to the "other side."

Felipe Barbosa and Rosana Ricalde's project, *Hospitalidad*, subverted and disrupted the practice of passport control by instigating a counter-performance. By inviting pedestrians crossing the Puente México en route to, or from, the US-Mexico border to inscribe their first names on the floor of the bridge, Barbosa and Ricalde suggested an alternate reality of unconditional hospitality and friendship. In their micro-utopia no identity documents, no proof of residence, occupation, class, or even last name was required to cross from one side to the other. Asking someone's name became a question motivated by genuine interest and not a condition of entry. The other is accepted as other with all its concomitant social, cultural, and moral differences. She is not obliged to "perform" her identity, she simply is.[26]

In his project, *Mi Casa, Su Casa*, Paul Ramírez Jonas employed the metaphor of the key to invert the idea of the nation-state as a discrete territorial unit. A door is also an image of a border—it has the same blocking or permitting effect. In counterpoint to passports, which act "as certificates of citizenship, localiz[ing] their 'subjects' [and] providing specific preconditions for their global mobility,"[27] Ramírez Jonas proposed an alternative order, where a network of trust and access was generated through the exchange of keys at designated locations in both Tijuana and San Diego. Even if someone in Tijuana was never able to cross the US-Mexico border he

or she could, in theory, possess the front door key of a person living in San Diego. On a micro scale individuals gave one another access to their personal spaces, breaking with the macro ordering of admittance by creating a parallel and alternative community-space founded on trust.

With *Murphy Canyon Choir* Althea Thauberger constructed a counter-rite to the ritualized performance of the nation. By deciding to work with the armed services community, Thauberger located her project within the context of military ceremony and symbolism. The military embodies and reinforces the prevailing ideology of nationhood—the "imagined community" as a prescribed territory that should be collectively maintained and defended—through its banners, flags, uniforms, service medals, patriotic orations, and choreographed communal ceremonies. Thauberger inverted the "official" performance of nationhood by staging a more intimate and personalized portrait of military life through the voices and experiences of military spouses. The heightened sentimentality of the spouses' lyrics, which often referred to their state of limbo and restlessness as they waited for news, waited for the return of their "hero," subverted the power of officially orchestrated patriotic performances. The performance was a ritualistic affirmation of kinship, family ties, and individuality, recounting the existence of intimate relationships that had been cleaved apart and separated by a distant border thousands of miles away. By stimulating a heightened degree of identification between the audience and performers through the highly sentimentalized and emotionally charged lyrics, Thauberger broke down the binary oppositions of "us" and "them" that have been so perpetuated within the national conscious in the US. At a micro level *Murphy Canyon Choir* undermined the prevailing model for US relations with the other.

While the performance of the nation at border spaces seems to continually shore up its ideological power, the nation-state also appears to be increasingly contested by a network society in which economic interactions in the global economy are increasingly constituted by flows of capital, people, and information between a group of globally dominant cities, rather than between territorial wholes.[28] If the nation-state is weakened, what kinds of documents of identity might potentially replace the passport? What kinds of communities and territories would emerge if the passport were replaced by sets of credit, store, and membership cards?

Judi Werthein's project *Brinco* explored how the spread of global consumer capitalism has led to the branding of identities in terms of trade name affiliations. By revealing the way in which this process secrets the contradictions inherent in the "liberal paradox,"[29] she intervened on the way in which global consumer behavior has constructed new performative rites of belonging, which center around consumer artifacts. In the same way that racial or ethnic profiling is employed at border spaces as a way of identifying and locating suspicious identities through key features and traits that are codified as "foreign," global capitalism's conceptualization of identities as "buyer profiles"—identifiable in terms of their demographics, behavior, etc.—is equally simplistic.

As Judith Butler argues in her theory of performativity, performative acts involve the constant reiteration of norms, which precede, constrain, and exceed the performer. They are the way in which the subject is called into being.[30] By interrupting the performance of the nation, the **Interventions** artists suggested the possibility of alternative "imagined communities." On the day that Maurycy Gomulicki brought together a group of Mexican and American model airplane pilots in the wasteland of the Tijuana riverbed and said: "I believe that the future belongs to the tribes," he affirmed that the in-between is a fault line in which we can imagine new modes of belonging. His poetic counter-performance demonstrated that we can conceive of other communities that are not prescribed by ideas of "nationhood" or by shared consumption patterns, but by common goals, shared interests, and a genuine interest in the other.

ORDERING IMMOBILITIES/ SPACE AS A WALL—SPACE AS OTHER

The border becomes the symptomatic embodiment of expulsion of this other or of this otherness from the same. The external border is the illusion created by the denial of internal difference, of the integral entre, the interstice. The frontier of the state is erected as the symbolic mark of rejection, or at the very least of control and surveillance of the other, and the symptomatic displacement of a radical antagonism within. Patrick French[31]

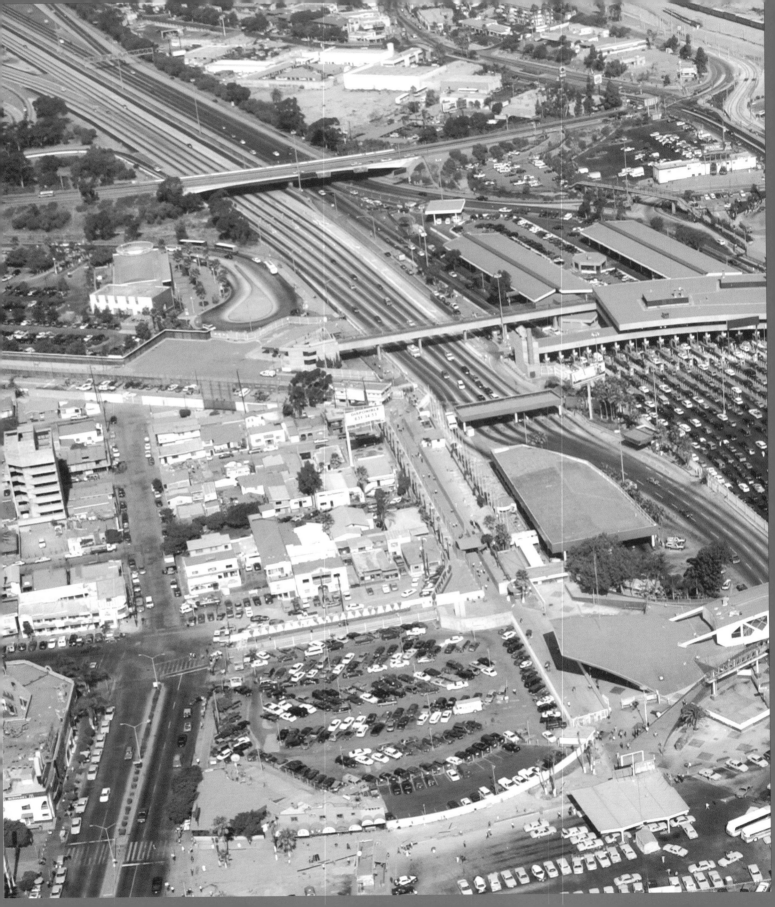

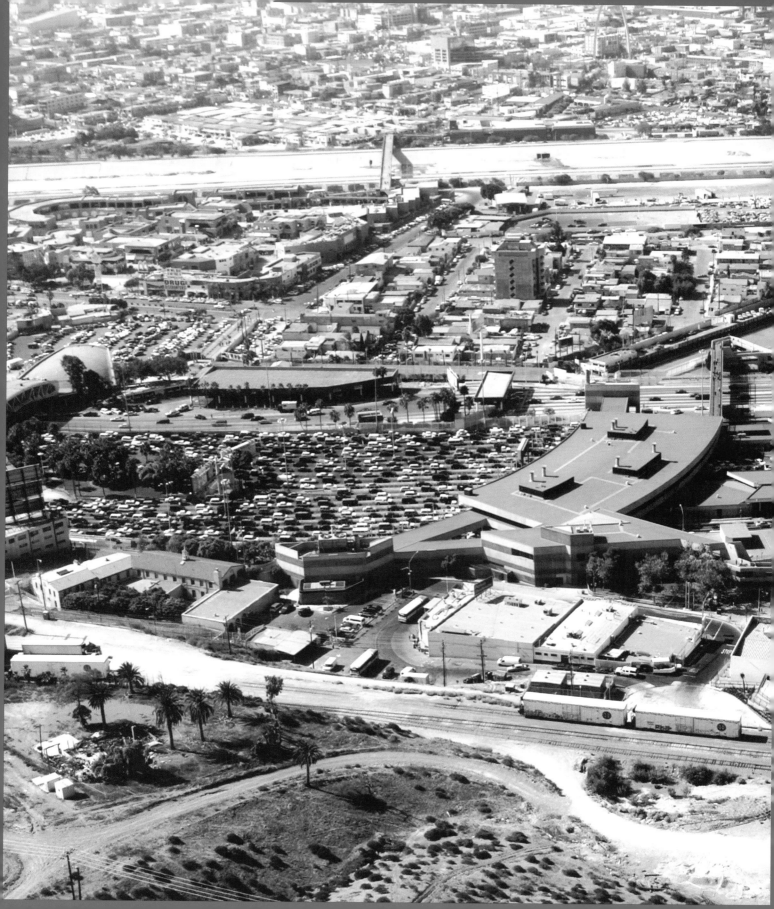

(…)Imaginative geographies fold distance
into difference through a series of
spatializations. They multiply partitions and enclosures that
demarcate *the same* from *the other*, at once constructing and
calibrating a gap between the two
by "designating in one's mind
a familiar space which is 'ours'
and an unfamiliar space
beyond 'ours' which is 'theirs'."
Derek Gregory[32]

The ordering processes of border spaces produce ambivalence. They are zones in which entities are tem-
porarily suspended in limbo, mobile and immobile, known and unknown. They are spaces that produce
"the stranger." A figure that is neither friend, nor enemy, the stranger is a boundary-straddling character
that defies accepted categories and thus produces anxiety.[33] The in-between transitional condition of the
stranger is only temporary, however. The socio-economic processes that produce border spaces (the legacy
of modernity's ordering principles) dictate that ambivalent identities must be fixed; they must be sorted,
separated, and put in their proper place.

At the San Ysidro Port of Entry, as with other ports of entry, this filtering process occurs at Secondary Inspec-
tion. After a primary inspection, customs agents must determine if an applicant should be recommended for
a more in-depth review at a secondary inspection point. This is where vehicles are subject to a more intense
search, documents are scrutinized more thoroughly, more probing questions are asked, and more evidence of
authenticity is required. From here, the heterogeneous element onto which social antagonism is displaced can
be expelled, thus maintaining the illusion of a cohesive homogenous nation-state.

Asymmetrically for Tijuana, the port of entry operates largely as the door for the expulsion of the deported other
from the US into Mexico. It rarely expels the other itself. It is a house with its front door permanently open.
The wall is "one way."[34] Mexico's expulsion of the other occurs at its southern border with Guatemala. There it
mirrors the filtering and ordering processes of the US customs and border control at the US-Mexico border.

The act of expelling the other, however, disavows the relationships and slippage between "us" and "them."
The ambivalent identity of the stranger may be classified and put in its proper place—the terrorist to
Guantanamo, the asylum seeker to the camp, the psychiatric patient to the mental facility, the artwork to
the institutional frame—but that act cannot erase the fact that one category cannot exist without the other;
they are produced in relation to one another. The fractures between "us" and "them" most often reflect
fractures within us.

By conflating the figure of the psychiatric patient with that of the undocumented migrant, Javier Téllez
demonstrates how "imaginative geographies . . . simultaneously conjure up and hold at bay the strange, the
unnatural, the monstrous."[35] The "illegal alien," perceived as a threat to the health of the nation, must be
separated from "authentic citizens," just as the "sane" must be separated from the "insane"—contamination
must be avoided at all costs. Téllez opens up the fault line of the border zone to demonstrate the absurdity
of expelling the other by firing an American citizen out of a cannon across the border fence from Mexico
to the US. By attempting to transform the border zone into a kind of Renaissance carnival involving the
"temporary suspension of all hierarchical distinctions and barriers among men . . . and of the prohibitions of
usual life,"[36] Téllez generated a space in which people who in life are separated by impenetrable hierarchical
barriers could potentially enter into free and familiar contact. This contact with the other opens up the pos-
sibility of recognizing the other in us. Téllez transforms the in-between into a zone in which we can imagine
other modes of operating in the world that celebrate the indeterminate, heterogeneity, and the relationships
and correspondences between things.

The fact that border spaces are in part produced through the process of ordering and expelling the other is becoming increasingly nonsensical in our interconnected world. Each of us is part of a network of relations that are embedded in power relations that span the globe, "a hierarchy in which a mobile elite transcends spatial barriers at the same time as a growing underclass remains either immobile as inhabitants of mega cities' shantytowns, or is forced into mobility as international refugees."[37] The impact that Judi Werthein's project *Brinco* had with art publics and non-art publics alike stemmed in part from the fact that it embodied the complex, uneven socio-economic dynamics that bind us together, enabling us as actors to invert, subvert, and transgress the established order of things. But did it transform us from consumers to co-conspirators or did it mirror our embedded consumptive behavior—the way in which we express our affiliation to "global" causes through patterns of consumption without really questioning the fact that perhaps it is the global consumerist project that is the problem?

Spatialized othering, however, also incorporates the narrative construction of territory, the construction of cognitive and imaginative borders that are internalized. Collectively we construct and (re)produce narratives of separation and difference that are often related to stereotypes and prejudices. Even though approximately 90 percent of San Diegans have visited Tijuana, they visit much less frequently than *Tijuanenses* visit San Diego,[38] not least in part due to the negative conceptions they have of Tijuana.[39] This border is, in a sense, far more pernicious, far more difficult to eradicate. The resistance that artist Maurycy Gomulicki and co-curator Tania Ragasol initially encountered when attempting to convince a group of San Diego model airplane pilots to cross the border into Tijuana to rehearse with a group of Mexican pilots is indicative of the kind of cognitive borders that construct difference. "Performed immobility"—the non-practice of border crossing as a result of multiple borders in people's minds—persists even without the existence of physical borders.[40]

Måns Wrange recognized that informational and mediated power is mobile, performed, and unbounded. He sought to intervene on internalized narratives of "otherness" that construct territoriality, by unleashing an oral virus that subverted and disrupted established discourses of difference.

Itzel Martínez del Cañizo worked with patients in a drug rehabilitation facility to create new imagined narratives of inclusion. She collaborated with individuals for whom the US-Mexico border is equivalent to the border between Earth and Mars, individuals who are maligned by their fellow *Tijuanenses* as "nacos" because they do not possess the requisite paperwork to cross the border. Martínez del Cañizo intervened on how narratives of otherness produce borders within the parameters of a shared city. The alternative scenarios of belonging that the patients constructed underlined the fact that there is a "third world" in every "first world" and a "first world" in every "third."

By transforming the border space into an in-between where notions of "otherness" and difference are rendered problematic and the division between "us" and "them" is dissolved, **inSite_05** artists were able to destabilize fixed identity positions and instead posit the idea of identities in a constant process of becoming through their collisions and encounters with the other.

Without borders nothing can exist, or at least we cannot know of it. At the border, something ends and something else begins. Or can begin. A difference thus exists the moment we become aware of a border. Border creates order. . . . In a world in which everything has become in-between . . . there are in fact certain vanishing points beyond which silence reigns. It is in the area past these vanishing points that micro-politics, macro-politics and possibilities of change have their domain. Ole Bouman[41]

Imaginative potentialities can emerge in the gaps between binary oppositions, at the precise points of intersection where mobility can mean immobility, where flux can mean rest, where order can be disorder, and where the self and the other merge to become collaborators and co-conspirators. It is here in the in-between, in the fault line of border spaces, where we can see the possibilities of change. As Bouman states: "Without borders nothing can exist, or at least we cannot know of it," but it is the fragile embryonic spaces that are created at the interstices between our conceptual borders where imaginative possibilities reign. They are spaces that are not fully conceptualized, localized and determined, and are thus free to keep becoming.

Donna Conwell *is a curator currently based in San Diego-Tijuana. She served as co-curator for* **Interventions**, **inSite_05**.

1 Jörg Bechmann, "Ambivalent Spaces of Restlessness: Ordering (im)mobilities at Airports," in *Space Odysseys: Spatiality and Social Relations in the 21st Century*, Ed. Jørgen Ole Bærenholdt and Kirsten Simonsen, Ashgate, 2004, p. 39

2 Kirsten Simonsen and Jørgen Ole Bærenholdt, "Introduction" to *Space Odysseys*, pp. 1–2

3 Michel de Certeau, *The Practice of Everyday Life*, University of California Press, 1984, p. 127

4 Doreen Massey, "A Global Sense of Place," in *Marxism Today*, June, pp. 24–29

5 Marc Augé, *Non-Places: Introduction to an Anthropology of Supermodernity*, Verso, 1995.

6 Jörg Bechmann, *Space Odysseys*, p. 27 (italics mine)

7 Answer phone at the San Ysidro Port of Entry.

8 Jörg Bechmann, *Space Odysseys*, p. 39. Bechmann talks about "flow managers" in relation to the ordering of mobility in airports.

9 There are two border-crossing points in the region: one at San Ysidro and one at Otay Mesa. I am focusing on the San Ysidro Port of Entry, as it is the principal gateway between San Diego and Tijuana.

10 *Blurred Borders: Trans-Boundary Impacts & Solutions in the San Diego-Tijuana Border Region*, Ed. Naoko Kada and Richard Kiy, International Community Foundation, 2004, p. 13

11 Derived from US Customs website information on border delay, available at www.uscustoms.gov

12 Residents who are able to provide proof of citizenship, residency, and financial solvency, and are able to pay a fee, are provided with a fast-pass card that enables them to bypass long queues at the border. Those without the SENTRI pass still account for the majority of daily crossers and increasingly wait times for fast-pass holders are getting longer due in part to the increase in demand for the service. (See: "Fast lanes at the border are slowing down," Diane Lindquist, in *The San Diego Union Tribune*, April 26, 2005.)

13 Otherwise known as the BCC (Border Crossing Card), laser visas are issued to Mexican visitors to the United States who can prove they have strong ties to Mexico, which would compel them to return after a temporary stay in the US. They are authorized to cross for seventy-two hours but do not have legal work authorization.

14 During 2002, Baja California residents in San Diego County purchased an estimated $1.6 billion in goods and services (Kenn Morris, "Moving Towards Smart Borders" in *San Diego Dialogue/Forum Fronterizo*, June 2003). A similar study undertaken by the Banco de Mexico estimated total retail spending by *Tijuanenses* in San Diego as $950 million during that same year (Banco de Mexico, 2002).

15 After 9/11 security was increased at the US-Mexico border, leading to an increase in wait times at the border.

16 The fact that the particular group of *maleteros* who are responsible for carrying baggage from Tijuana to San Diego through the US customs building are "officially" recognized and regularized at a local level (even if their existence is prohibited at a federal level) indicates not only how border crossers but also "flow managers"—whose job it is to facilitate mobility through the port of entry—negotiate with and contest the official discourse of unidirectional border mobility.

17 Interestingly, during his project development Bradford considered developing a flow gram that would chart the various thresholds of unidirectional mobility across the border. This would then be juxtaposed with the circular trajectory of the *maleteros*.

18 Doreen Massey, "A Global Sense of Place" in *Marxism Today*, p. 28 (Italics mine). Interestingly, all three projects downplayed Mexico in the consumerist project, framing the South as a casualty of consumerism/globalization without really exploring the role it plays in the perpetuation of that system.

19 Mark Bradford, *Project Proposal*, 2004 (Of course the experience of multiple temporalities is not just limited to border spaces, but Bradford argued that the experience was heightened in those kinds of spaces, in part because of the co-existence of mobility and immobility.)

20 Doreen Massey, "Politics and space/time" in *New Left Review*, 196, pp. 65-84

21 Malcolm Anderson, "The Political Science of Frontiers" in *Borders and Border Regions in Europe and North America*, Ed. Paul Ganster, Alan Sweedler, James Scott, Wolf Dieter-Eberwein, San Diego State University Press, 1997, p. 29. (The concept of the nation as an "imagined community," however, can be traced to Benedict Anderson.)

22 Wolfgang Zierhofer, "'Your Passport Please!' On Territoriality and the Fate of the Nation State" in *Space Odysseys*, p. 114

23 Ibid. p. 101

24 Shuddhabrata Sengupta discusses the idea of the imposter in "Nothing to Declare" in *Dialogue 1: Liminal Zones/ Coursing Flows*, **Conversations, inSite_05**, 2004, p. 16.

25 Forty percent of *Tijuanenses* claim they have family in San Diego according to *Blurred Borders: Trans-Boundary Impacts & Solutions in the San Diego-Tijuana Border Region*, p. 10.

26 The metaphor of the bridge was also used by Maurycy Gomulicki in his project *Aerial Bridge*, and reflects a process of re-imagining of the border space as a conduit for connections and relationships rather that a space of spatial segregation, as reflected in the metaphor of the wall.

27 Wolfgang Zierhofer, "'Your Passport Please!' On Territoriality and the Fate of the Nation State" in *Space Odysseys*, p. 105 (italics mine)

28 Peter Taylor, "World cities and territorial states: the rise and fall of their mutuality" in *World Cities in a World-system*, Ed. P.L. Knox and P.J Taylor, Cambridge University Press, 1995, pp. 48–62

29 The "liberal paradox" refers to the idea that the globalization of the free market has intensified social and economic dysfunction and voluntary and forced migration.

30 Judith Butler, *Bodies that Matter. On the discursive Limits of Sex*. Routledge, 1993, p. 2

31 Patrick French, "Passage Barré: Port Bou, September 26, 1940" in *Territories: Islands, Camps and Other States of Utopia*, KW-Institute for Contemporary Art, 2003, p. 232

32 Derek Gregory, "Connective Dissonance: Imaginative Geographies and the Colonial Present" in *Space Odysseys*, p. 203

33 Zygmunt Bauman, *Thinking Sociologically*, Blackwell, 2001, p. 155

34 Fran Illich, www.electronicbookreview.com/thread/technocapitalism/hacktivist

35 Derek Gregory, *Connective Dissonance: Imaginative Geographies and the Colonial Present*, p. 204

36 Mikhail Bakhtin, *Problems of Dostoevsky's Poetics*, University of Minnesota Press, 1984, p. 15

37 Ole B. Jensen and Tim Richardson, "Framing Mobility and Identity: Constructing Transnational Spatial Policy Discourses" in *Space Odysseys*, p. 834 (Referring to Zygmunt Bauman, *Globalization: The Human Consequences*, Polity Press, 1998).

38 *Blurred Borders: Trans-Boundary Impacts & Solutions in the San Diego-Tijuana Border Region*, p. 151

39 San Diego Focus Group, *The Good Rumor Project*, Måns Wrange and January 2004 KPBS/CERC Competitive Edge Research Poll.

40 Anke Strüver, "'Space Oddity': A Thought Experiment on European Cross-Border Mobility" in *Space Odysseys* (Stüver examines the non-practice of border crossing in the European Union in spite of the removal of borders as barriers to integration).

41 Ole Bouman, "Don't save art, spend it!" in *Manifesta 3: Borderline syndrome–Energies of defense*, European Biennial of Contemporary Art, 2000, pp. 15–16

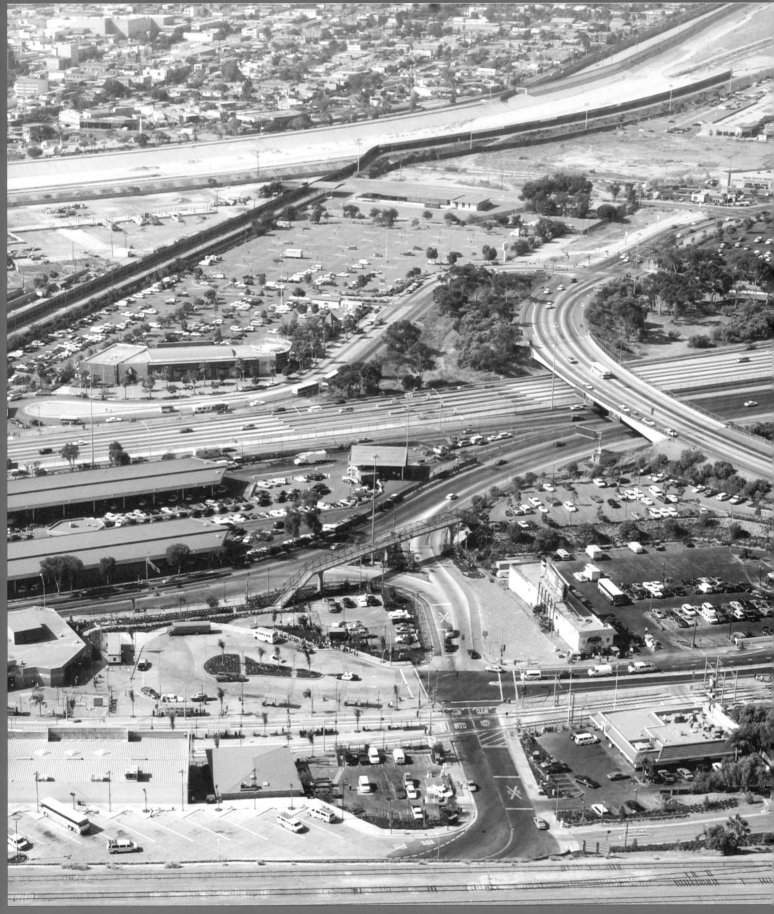

Residencies

2003–2005

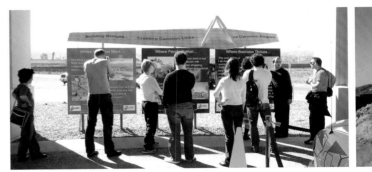

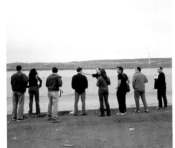

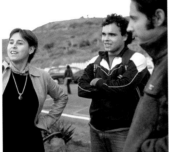

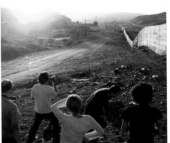

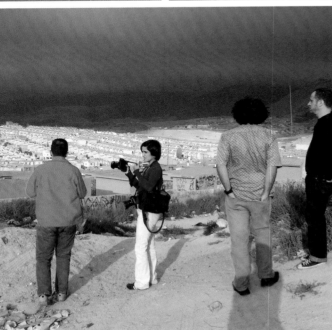

From its inception, **inSite**'s distinctive character has been shaped and challenged by its contextual nature.

The San Diego-Tijuana border region is a wildly overarticulated context that imposes its own priorities. As such the area has had a significant impact on **inSite**'s projects and its participating artists. The priorities of the context undermine the appeal of formalist object-based values or critically passive approaches commonly found in aesthetically pleasing urban art works subsumed under the label of "Public Art." Largely as a result of its extraordinary context, **inSite** has been able to develop and foster a practice of cultural intervention in the social fabric of the border region that is primarily processual and based on periodic residencies.

Over the course of the residencies—an average of six weeks in length—that were organized for **inSite_05**, artists had the opportunity to explore their experiences of being outsiders. In the best of cases, they were also able to participate in temporary group affiliations, circumstantial identities that are constantly eroding within the socially, economically, and politically complex territory of the border. Five interlocutors—Beverly Adams, Ruth Auerbach, Joshua Decter, Kellie Jones, and Francesco Pellizzi—were invited to participate in curatorial discussions with the artists at key moments during proposal development. As part of formal working sessions, as well as during informal exchanges in more relaxed settings and by email, they provided alternative critical perspectives, support, and ongoing feedback.

The actual experience of being in the region, unforeseen conflicts, and the growing anticipation of the critical potential of their work almost always destabilized the artists' initial expectations, prompting them to critically revise their initial proposals. The success of the residencies depended on maintaining a high degree of honest interchange. Actually being in the area, which was very demanding in terms of time and energy, contributed in a decisive way to the formation of a certain kind of ethical coherence, which was indispensable to the development of the artists' interventions. It is perhaps the specific experiences of artists in the border area that ensures that **inSite** reinvents itself version after version, avoiding becoming an institution with a fixed and permanent practice.

The residencies were scheduled in four key periods. The dates of the residencies depended on the evolution of the commissioned projects. For some artists the residencies were condensed, and for others they merged with trips dedicated to project production.

- The first group of residencies took place from October 2003 through January 2004. Small groups of artists overlapped over several consecutive weeks. This initial residency was conceived as an introduction to the area and its actors.
- The second residency took place between February 16 and May 6, 2004. It was organized on an individual basis with artists visiting the region and remaining for a period of seven to ten days. The focus of these visits was to define a theme or area of research.
- During this period—and prior to the general presentation of artists' proposals—a program for participating artists from the area was organized. (See *Working Sessions*, p. 38.)
- The third residency took place from May 22–30, 2004. The artists involved in **Interventions** participated in working sessions where they discussed their project proposals. These sessions were organized in small discussion groups composed of artists, curators, and interlocutors.
- The fourth residency occurred between January and May 2005 and, in most cases, formed part of the artists' individual production schedules. The artists commonly followed this residency with several visits to the area, the length and frequency of which depended on the production requirements of each project.

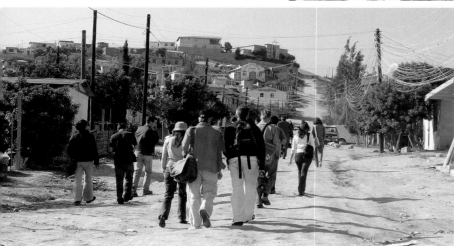

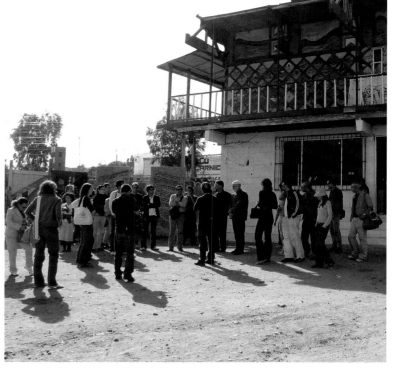

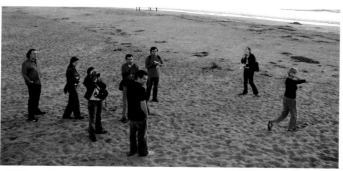

El carácter distintivo de **inSite** ha estado desde un principio perfilado y cuestionado por un *a priori*: su inevitable naturaleza contextual. Este territorio fronterizo ha actuado sobre cada proyecto y sus artistas, a la manera dura en que un contexto salvajemente articulador termina imponiendo sus prioridades de sentido. Prioridades que desestiman las sutilezas morfológicas o la docilidad crítica, usuales en obras artísticas emplazadas con suficiencia estética en el entorno urbano, bajo el rubro de arte público. Gracias a esa presión, **inSite** se ha conformado a través de los años como una práctica cultural de intervención en el tejido social del área de Tijuana San Diego, de condición prioritariamente procesual y basada en residencias periódicas.

A través de estas estadías –aproximadamente de seis semanas en total– los artistas han articulado su experiencia de diferencia y, en el mejor de los casos, han logrado participar temporalmente de alianzas identitarias en constante erosión en un marco urbano de gran complejidad social, económica y política. Con sus imprevistas colisiones, y ante la creciente sospecha de su potencial crítico, estas experiencias en el área han terminado casi siempre por devorar y/o distorsionar las expectativas de cada propuesta inicial. Cinco interlocutores –Beverly Adams, Ruth Auerbach, Joshua Decter, Kellie Jones y Francesco Pellizzi– fueron invitados a participar en el proceso de discusiones curatoriales, en momentos clave del desarrollo de las propuestas. Tanto como parte de estas sesiones formales, como de otros encuentros informales, en situaciones más relajadas, o incluso por *email*, los interlocutores proveyeron siempre de alternativas críticas, de apoyo y de seguimiento.

De las residencias ha dependido, en parte, la honestidad y la densidad de estos intercambios. Ese "estar aquí", demandante en tiempos y en energía, ha contribuido de manera decisiva a lograr cierta coherencia ética, imprescindible para las **Intervenciones**. La vulnerabilidad de la experiencia específica del artista en este contexto es quizá lo que ha garantizado que **inSite**, edición tras edición, se reinvente, y le ha evitado posicionarse como una institución que busca capitalizar un modelo de práctica permanente.

Las residencias de **inSite_05** estuvieron calendarizadas en cuatro periodos. Las fechas de cada residencia dependieron de la evolución de los proyectos comisionados. Para algunos artistas las residencias se compactaron y para otros se fundieron o expandieron con las estadías dedicadas a la producción.

- El primer bloque de residencias tuvo lugar entre octubre de 2003 y enero de 2004. Se escalonó en varias semanas consecutivas para distintos pequeños grupos de artistas, y estuvo concebido como una primera introducción al área y a sus actores sociales.
- La segunda residencia tuvo lugar entre el 16 de febrero de 2004 y el 6 de mayo de 2004. Fue organizada de manera individual, teniendo a cada artista por separado en estancias personalizadas de entre una semana y diez días, a fin de que cada uno pudiera definir el tema o área de su investigación.
- Entre el 1ero y el 3 de abril se organizó un programa de trabajo especialmente concebido para los artistas participantes del área, previo a la presentación general de propuestas. (Ver *Sesiones de trabajo con los artistas del área*, p. 39)
- La tercera residencia tuvo lugar entre el 22 y el 30 de mayo de 2004. Los artistas de **Intervenciones** asistieron todos al unísono, a fin de participar en las sesiones de presentación y discusión de sus propuestas. Estas sesiones se organizaron en pequeños grupos de discusión, entre los artistas mismos, los curadores y los interlocutores.
- La cuarta residencia tuvo lugar entre enero y mayo de 2005 y, en la mayoría de los casos, formó parte del proceso de producción de los proyectos. A esta residencia siguieron varios periodos de estancia en el área por parte de los artistas, dependiendo de los requerimientos de producción de su proyecto.

(de)Mapping
San Diego/ Gustavo Lipkau

The map has slowly disengaged itself from the itineraries that were the condition of its possibility […] The map thus collates on the same plane heterogeneous places, some received from a tradition and others produced by observation. But the important thing here is the erasure of the itineraries.

Escaping the imaginary totalizations produced by the eye, the everyday has a certain strangeness that does not surface, or whose surface is only its upper limit, outlining itself against the visible […] These practices of space refer to a specific form of operations ("ways of operating"), to "another spatiality" (an "anthropological", poetic and mythic experience of space), and to an opaque and blind mobility characteristic of the bustling city. A migrational, or metaphorical, city thus slips into the clear text of the planned and readable city. Michel de Certeau/ *The Practice of the Everyday Life*

→ Información del mapa traducida al español/ p. 367

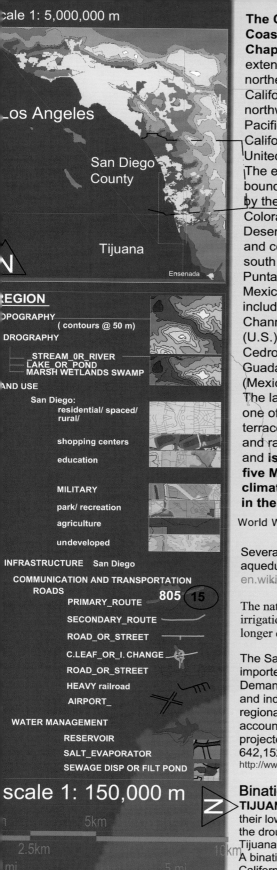

Scale 1: 5,000,000 m

Los Angeles

San Diego County

Tijuana

Ensenada

N

REGION

TOPOGRAPHY (contours @ 50 m)

HYDROGRAPHY

— STREAM OR RIVER
— LAKE OR POND
— MARSH WETLANDS SWAMP

LAND USE

San Diego:
residential/ spaced/ rural/

shopping centers

education

MILITARY

park/ recreation

agriculture

undeveloped

INFRASTRUCTURE San Diego

COMMUNICATION AND TRANSPORTATION
ROADS
PRIMARY_ROUTE **805** (**15**)

SECONDARY_ROUTE

ROAD_OR_STREET

C.LEAF_OR_I. CHANGE

ROAD_OR_STREET

HEAVY railroad

AIRPORT_

WATER MANAGEMENT

RESERVOIR

SALT_EVAPORATOR

SEWAGE DISP OR FILT POND

scale 1: 150,000 m N

5km

2.5km 10km

mi

5 mi

2.5 mi

The California Coastal Sage and Chaparral ecoregion extends from northeastern Baja California, Mexico, northward along the Pacific into southern California in the United States. The ecoregion is bounded in the east by the Colorado-Sonora Desert and continues south as far as Punta Baja, Mexico and includes the Channel Islands (U.S.) and Cedros and Guadalupe Islands (Mexico). The landscape is one of coastal terraces, plains, and rangelands and **is one of only five Mediterranean-climate ecoregions in the world.**

World Wildlife Fund © 2001

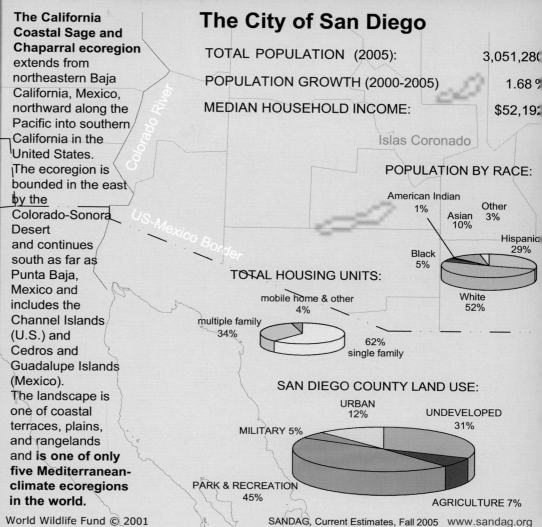

The City of San Diego

TOTAL POPULATION (2005): 3,051,280

POPULATION GROWTH (2000-2005) 1.68 %

MEDIAN HOUSEHOLD INCOME: $52,192

Islas Coronado

Colorado River

US-Mexico Border

POPULATION BY RACE:

American Indian 1%
Other 3%
Asian 10%
Black 5%
Hispanic 29%
White 52%

TOTAL HOUSING UNITS:

mobile home & other 4%
multiple family 34%
62% single family

SAN DIEGO COUNTY LAND USE:

URBAN 12%
UNDEVELOPED 31%
MILITARY 5%
AGRICULTURE 7%
PARK & RECREATION 45%

SANDAG, Current Estimates, Fall 2005 www.sandag.org

Several **cities** such as Los Angeles, San Diego, Phoenix, and Tucson (and Tijuana) have aqueducts leading all the way back to the **Colorado River**
en.wikipedia.org/wiki/Colorado_River_(U.S.) - 40k - En caché - Páginas similares

The natural course of the river flows into the Gulf of California, but the heavy use of the river as an irrigation source for Imperial Valley has desiccated the lower course of the river in Mexico such that it no longer consistently reaches the sea.

The San Diego region currently obtains approximately 80 to 90 percent of its supplies from water imported from Northern California and the Colorado River.
Demand for water in the Water Authority's service area falls into two basic categories: municipal and industrial (M&I), and agricultural. M&I uses currently constitute about 80 to 85 percent of regional water consumption. Agricultural water, used mostly for irrigating groves and crops, accounts for the remaining 15 to 20 percent of demand. By 2030, total normal water demands are projected to reach 829,030 acre feet (AF), which represents about a 29 percent increase from the 642,152 AF of demand that occurred in fiscal year FY 2005.4
http://www.eere.energy.gov/buildings/appliance_standards/pdfs/ca_petition_comments/29_sdcwa.pdf

Binational aqueduct for Tijuana pitched, but pipeline may not come in time

TIJUANA— Water has been in the news in recent days, as Baja California rainfall levels dip to their lowest in more than a decade and the city's Rodriguez Dam sits less than a quarter full. But the drought just underscores a far larger challenge: how to meet the rising water demands of Tijuana, the state's largest city, in the next few years.
A binational aqueduct built in conjunction with San Diego County could be the solution, but Baja California officials fear that even if the controversial $1.9 billion project is eventually approved, the pipeline can't be built in time to deflect Tijuana's approaching water shortage.
September 2002 **U.S. Water News Online**

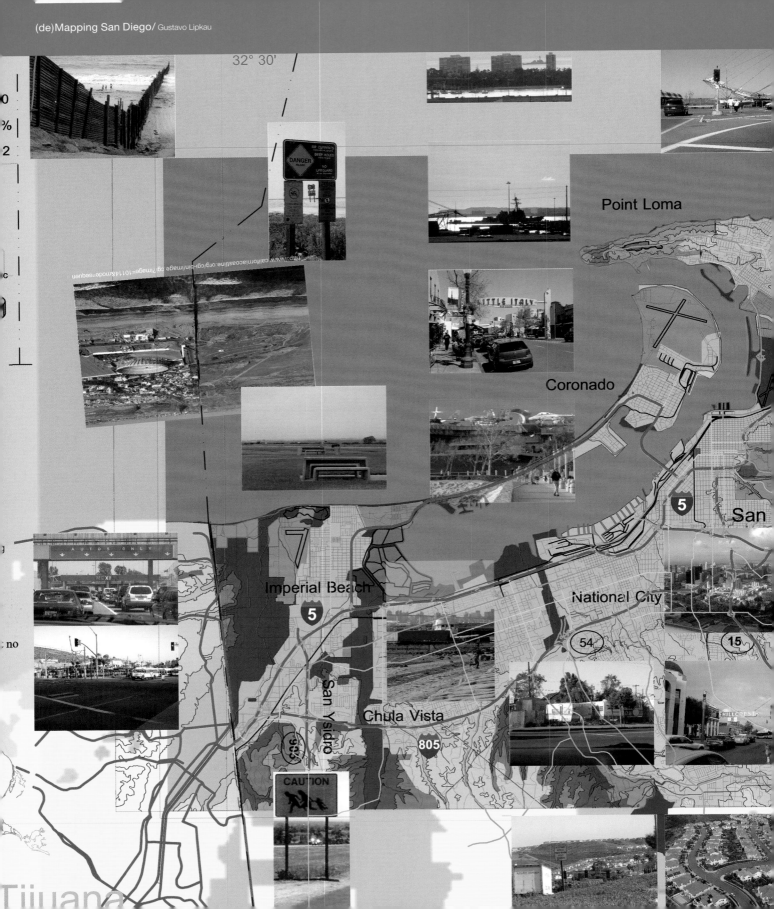

32° 30'

Point Loma

Coronado

LITTLE ITALY

5 San

Imperial Beach

5

National City

54

15

San Ysidro

905

Chula Vista

805

CAUTION

Tijuana

AUTOS ONLY

MEXI

DANGER

HILLCREST

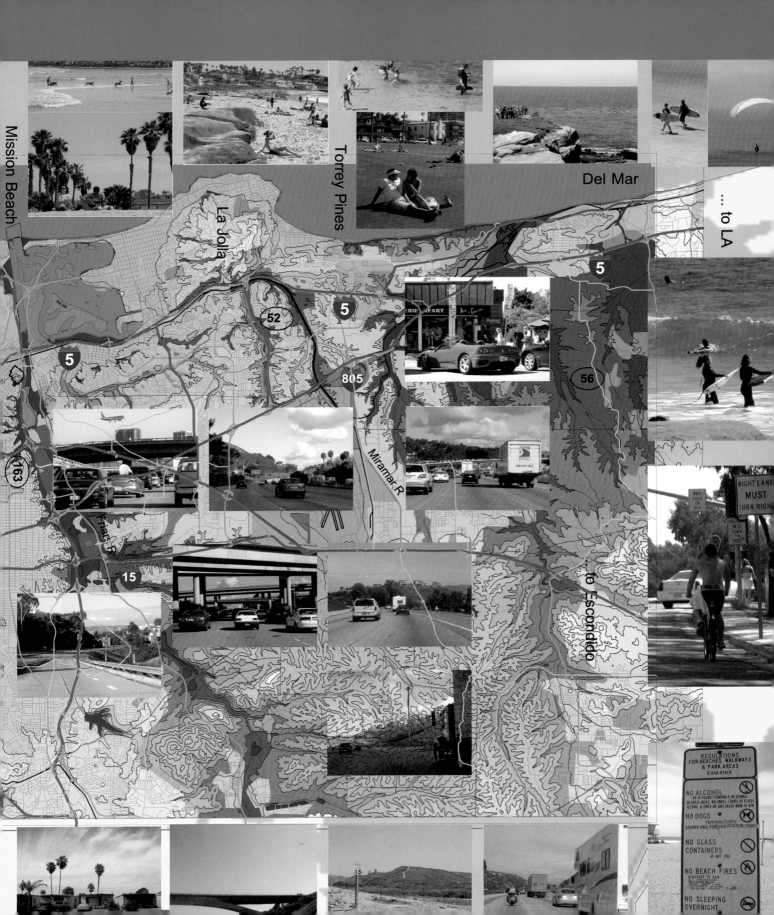

Mission Beach

La Jolla

Torrey Pines

Del Mar

... to LA

5

52

5

805

56

5

163

Miramar R

Friars R

15

to Escondido

RIGHT LANE
MUST
TURN RIGHT

REGULATIONS
FOR BEACHES, WALKWAYS
& PARK AREAS
OCEAN BEACH

NO ALCOHOL

NO DOGS

NO GLASS
CONTAINERS

NO BEACH FIRES

NO SLEEPING
OVERNIGHT

A VIEW OF TIJUANA-SAN DIEGO THROUGH THREE POSTCARDS
Tania Ragasol

Some months ago, while I was walking around *La esquina/ Jardines de Playas de Tijuana*, I noticed a couple kissing through a gap in the metal border fence that separates Tijuana from San Diego. He was standing on the US side while she stood on the Mexican side. The breach in the fence provided them with an opportune meeting place that did not involve crossing through some officially approved entrance/exit point, but the exchange flowed from one side to the other all the same. I asked myself: How did they arrange their date? Did they say: "Meet me at the gap in the fence" or "see you at the fence." The fence then was not necessarily an obstacle, but rather a space, a site for the encounter. Nonetheless, the question that lingers is: would they have been kissing in the same way had it not been for the obstacle wedged between them?

POSTCARD 1/ TERRITORY—FROM A BIRD'S-EYE VIEW

A transfrontier metropolis, by definition, is a place where the circulation of people, goods, and services across the border must be facilitated so that the boundary does not jam the economic circuitry of the region. The region must be allowed to fulfill its destiny and become a city/region operating in the global economy. Laurence A. Herzog[1]

In his book *The Image of the City*, Kevin Lynch describes five identifiable physical elements that influence the collective imagination of the city: paths, edges, districts, nodes, and landmarks. These elements refer to specific zones in the city as well as to the city in its entirety. Due to the specific focus of his analysis, Lynch overlooks "other influences acting upon the imaginary [of the city],"[2] which may be related to the social and economic dynamics of a given area. I wonder whether, rather than concerning a distinct subject of study, those "other influences" may in fact produce paths, edges, districts, nodes, and landmarks.

We can argue that the physical elements that Lynch cites are responsible for the existence and the location of what we refer to as setback: that zone of intended separation and isolation between cities, neighborhoods, and houses. Beyond their mutual relationship, setback and paths, edges, districts, nodes, and landmarks all influence what occurs socially and economically in the border region on a daily basis. At the same time these elements are also shaped and constructed by their context.

The first identifiable setback in the region is the one separating San Diego from Tijuana and Los Angeles: to the north, Camp Pendleton; to the south, the Tijuana Estuary, other natural reserves, and the border; to the west, the Pacific Ocean; and to the east, Southern California's mountains and deserts. The sterile quality of this urban configuration reproduces itself at a comparable scale in many of San Diego's neighborhoods. Alleys divide entire blocks, while houses and buildings are not built "wall to wall," but "breathe" on all four sides and are distinctly separate from one another. For the citizens of San Diego, physical urban elements ensure the existence of other borders at a civic as well as personal level. This "buffer zone" stands in direct contrast with the multitude of houses that devour Tijuana's hills and mountainsides. This degree of density is not only evident in the informal growth of peripheral neighborhoods, but is also visible in Tijuana's upper-class Chapultepec neighborhood

where we can see houses situated closely together. In Tijuana contact with one's neighbor is not something to be feared or prevented. We do not sense the same sense of sterilization, the same dread of personal contact.

When you arrive in Tijuana via plane, traversing a south to north trajectory, these differences become dramatically evident. From the air you can see how the inescapable border fence separates both cities. Tijuana appears to look north; its urban settlements press up against the dividing wall, whereas San Diego withdraws into itself and is orientated towards the sea, pointlessly attempting to ignore Tijuana. However, it is another image that strikingly illustrates the contradictions of the region. From above, the orography is one and the same: a shared mountain range, a single ocean, and a common desert terrain. As a single region, San Diego-Tijuana is bisected by a fence and connected by a highway. The flow of traffic from one side to the other is obvious, especially in a northerly direction, where cars line up at the San Ysidro border checkpoint. Interstate 5—which traverses the western coast of the United States from south to north until it reaches Canada—and Tijuana's Paseo de los Héroes form a continuous route that intersects with the border fence—at the San Ysidro checkpoint—as it makes its westward journey into the sea. From this distance, the highway and the border fence appear to be two

axes—the *cardo* and *decuman*—of a zone of flows and exchanges. The physical urban elements of the region can be read differently then: The border fence and the nexus formed by Interstate 5/Paseo de los Héroes appear to be the result of the region's dynamics of exchange, but they also intervene in and disrupt those everyday mechanisms of daily life.

The idea of a single shared territory breached by an arbitrary line of separation is the underlying theme of Paul Ramírez Jonas' project *Mi Casa, Su Casa*. Ramírez Jonas initially considered creating and symbolically distributing the "key to the city" for San Diego-Tijuana—a single key for the whole region, which would bear testimony to the region's distinct character as a zone of mutual dependence and exchange. A region whose everyday keys are passports and visas, which act as filters and provide conditions for entry and exit for those wishing to cross *la línea*.

But there are other border flows that ignore barriers, that are not so readily subject to filtering mechanisms. In his video *Osmosis and Excess* Aernout Mik explores the processes of economic exchange that exist in the region and how these processes have modified and, to a certain extent, unevenly shaped a shared urban landscape. The title of the project refers to the physical phenomenon of osmosis—which involves the diffusion of two distinct fluids of varying density through a semipermeable membrane interposed between them—and thus metaphorically alludes to the reciprocal influence that the economies of Tijuana and San Diego exercise over one another—an influence that traverses the border fence. "By drawing a portrait of Tijuana as defined by its transient flows, and its interdependent asymmetrical relationship with its US neighbor, Mik suggests that a city's social and economic narratives are embedded in the configurations and transformations of its local topologies."[3]

In his essay *Resisting the City* Mark Wigley notes: "There is always a sign on the highway, or a voice on the train or plane that tells you that you are now in such-and-such a city, and another sign to tell you when you have left. Why do they have to tell you? Because a city is not a physical object. It is a complex package with many different kinds of limits. The signs normally appear in an indeterminate zone, a vague territory that is only understood to be the outskirts of a place when a sign suddenly appears. The sign could easily be moved. There is nothing in the physical environment that confirms what the sign says."[4] This is an observation that is applicable to the San Diego-Tijuana region. The signs, the border fence, the checkpoints at San Ysidro and Otay, and even the traffic held up at the intersection of Interstate 5 and Paseo de los Héroes reveal the demarcation between one country and the other. Nonetheless, in counterpoint, the geography—the physical habitat—and its flows do not support this interpretation. The everyday social and economic activities of the region—at a personal and professional level—do not to mirror this imposed limit, and yet their tempo is shaped in relation to it, they negotiate around it, sometimes ignoring it, and sometimes accepting that they exist because of it.

→ Otras traducciones/ pp. 341–343

The existence of shared geographical, economic, social, and ecological characteristics within regions is usually ignored and repudiated—through the imposition of artificial obstacles—by cities, governments, and political policy making, even when dynamics of co-existence contradict this negation.

POSTCARD 2/ NOMADIC EXISTENCE AND BORDER FLOW

I am waiting in line, waiting in line. I am waiting in line
to leave the country. It's all quite natural, something you do everyday. To my left,
a family in a Nissan wagon; to my right, a gringo
with shades in a Mitsubishi sports car. Through the rear-view mirror
I see a girl in a Volkswagen. Ahead, a Toyota. We are going to leave the country
and it's all quite natural, something you do everyday. Luis Humberto Crosthwaite[5]

Today a large part of the urban population undoubtedly leads
a nomadic existence. Andreas Ruby[6]

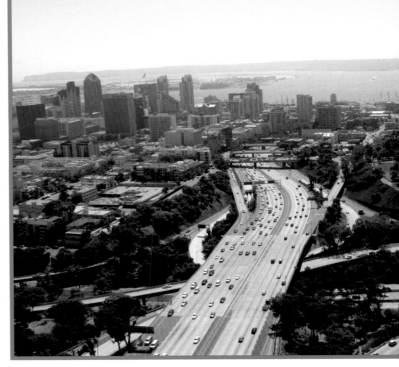

One of the first "survival strategies" you should adopt upon moving to San Diego-Tijuana is to acquire a car. Various forms of transportation exist on both sides of the border: In San Diego there is the car, the train, taxis, and the trolley—whose blue line takes you from downtown's Old Town to the San Ysidro checkpoint and vice-versa. In Tijuana there are the yellow fee-paying taxis, the orange-metered taxis (now red), the taxis with a set route, and the *calafias*.[7] Whether you need to manoeuvre yourself within the parameters of each city or to move between them, owning your own car is by far the most convenient and comfortable option. You can wait your turn to cross the border while seated in your car. You can listen to music as loud as you want, watch the sunset, and eat whatever you feel like, without restrictions, and without having to interact with a driver or other passengers.

For those of us who continually drive between the two cities, one of the most emblematic communication routes of the ritual crossing is the Interstate 5, which, depending from where you are standing, begins or ends precisely at the San Ysidro border checkpoint. The I-5 is a symbol that embodies the possibility of connection between the two cities as well as the continuous flows of the region. In the case of **Interventions** it becomes a metaphor for the "comings and goings" of the projects' development processes. During this journey, time and space become available for resolving emergent issues: making decisions, discussing permits that have been granted or denied, holding "meetings on wheels," discussing ideas with the artists, and suggesting and agreeing upon possible strategies. During that mental lapse—while listening to the radio—you can begin to understand how the region functions. You learn that radio stations in Tijuana and San Diego sell advertising space to businesses in both cities who promote their products to potential consumers on either side of the border fence; that you can buy a mattress in San Diego and have it delivered to your house in Tijuana without additional charge; that a taxi from Tijuana can pick you up at your home in San Diego and take you to the Tijuana airport; that there are Mexican radio stations whose programs are conducted entirely in Spanish, which are broadcast from the US side, and vice-versa. At times, submerged in the daily dynamics of the border crossing, it is easy to forget that you have entered another city/country—the radio signal continues to be received without interruption en route from Del Mar in California to Rosarito in Baja California.

While it is true that both sides of the border share a common "car culture," the experience of driving in each city is very different. In Tijuana you can spend many hours waiting in traffic during the rush hour and particularly while waiting in line to cross to San Diego. In San Diego your time is more likely spent traversing long distances via freeways to arrive at particular neighborhoods or cities. It is a well-known fact that the development of the US

car industry shaped the design of its cities. The US is now the country with the highest number of cars per capita and with the most freeways in the world. This phenomena is revealed by San Diego's plethora of parking lots and car dealerships, the size of which is mirrored by the multitude of car yonkes[8] in Tijuana—which tend to be full of US vehicles that have been appropriated by Tijuana and later abandoned as junk. Cars in Tijuana are usually secondhand and inherited from San Diego, whereas in San Diego cars are traded in every couple of years.

"In a culture that revolves around the automobile, car customization can be understood as a complex public enactment of status, group affiliation, cultural identity, and individual or group expression."[9] With *Some Kindly Monster*, Christopher Ferreria called upon two different groups of car customizers to participate in a collaborative transformation of a delivery truck, exploring how the car can serve as an identity icon and as symbol of belonging. The collaborative process involved the collision of diverse transformational strategies and cultural affiliations, leading to a hybrid outcome in which the multiple variations of local car culture were brought together. The circulation of the *Monster* through different zones in San Diego revealed the distinct urban and social borders within the city. These are borders that are navigated, negotiated, and passed through on a daily basis by those who move through San Diego's streets—borders that do not require one to leave the country.

It may well be that the figure that most clearly personifies the flows that nourish and shape the regions' social networks is the commuter.[10] In this transborder region the commuter tends to cross from Tijuana to San Diego in the morning and return in the evening—although there are also people living in San Diego who work in Tijuana or who have business on the other side of the border divide. In both cases, the journey back and forth involves hours of waiting and endless bureaucratic procedures. As Rubens Mano suggested when he inserted a visible sign inside the flow of border commuters, being part of the border crossing on a daily basis can come to function as an element of self-identification. While it is clear that Mano's approach recalls methodological strategies employed by biologists who "mark" their samples in order to study them, beyond merely identifying a border flow the artist sought to generate a new social network, linking together those individuals who wore a pin with the word "visible" inscribed on it. Intervening on how the act of "coming and going" renders you "other," Mano suggested that it is through the everyday process of commuting that a new territory of connection and identity is generated. As Andreas Ruby mentions in his text *Transgressing Urbanism*, "The commuter nomads, due to the long journey to and from work, spend several hours every day in traffic, which becomes a kind of home, while their actual homes function largely as expanded bedrooms, as is the case with some nomadic tribes in Africa."[11]

The lines of demarcation between the political divisions of the region do not inevitably impede its flows—even when some exchanges are hindered by obstacles that seek to control identity formations. Paradoxically, it is sometimes the presence of such "hindrances" that enables border flows to operate in more definite and efficient ways.

POSTCARD 3/ THE FIRST AND THE BEST

Hitherto defined as the quality of a place, urbanity is transforming into an atmospheric condition which is no longer necessarily bound to place or space. This transurban urbanity definitively steps beyond the chartered territory of urbanism. It can no longer be planned, for it occurs only if we perform it. Andreas Ruby[12]

Perhaps one of the most influential factors in the construction of a city's urban imaginary is its identifying motto. Tijuana and San Diego's mottos are particularly eloquent: In Tijuana we are told that "Aquí empieza la patria" ("Here the homeland begins") whereas San Diego is framed as "America's finest city." *Tijuanenses* are proud to be located in the northeast corner of Latin America whereas San Diego's inhabitants boast that their city has the best climate and is the cleanest and most orderly city in the US.

Being the starting point of the "homeland" transforms Tijuana into the northeast entrance point to Mexico, something that is translated into the sense of pride the *Tijuanense* feels for his city. Arriving by car from San Diego and driving along Avenida Paseo de los Héroes you traverse the Zona Río. The "bola" of the Centro Cultural Tijuana (CECUT) at its center rises up to greet you. The spherical building of the Omnimax Cinema ("la bola") in CECUT's plaza is considered the city's most emblematic cultural monument. Images of it can be found on postcards, and in books and tourist brochures. Tijuana's inhabitants hold "la bola" in great esteem, which explains

their initial apprehension when they first learned about the *infoSite* project—which was to occupy the northwest staircase of the building. Nevertheless, the construction was carried out without incident and all production permits were approved or in process. The "benefit of the doubt" that was afforded to the project and the administrative flexibility displayed by city hall was in direct contrast to the arduous procedures that had to be followed in San Diego to secure permits and a site for the San Diego *infoSite*.

After a long process of negotiation with various governmental agencies, authorization to locate the San Diego *infoSite* at a pedestrian zone in downtown was declined because it was argued that it might hinder pedestrian flow. Although its construction was finally approved for the parking lot in front of the San Diego Museum of Art in Balboa Park, this involved all manner of tortuous paperwork and bureaucratic procedures.

The difficulty encountered in building an ephemeral architectural structure in San Diego—in contrast to the relative ease with which the project was carried out in Tijuana—stems from San Diego's strict regulation of public life—regulation that is thought to ensure that it remains the "finest city." When living in San Diego, you must train yourself to be attentive to street signs, not only when driving but also while strolling through the city, its parks, or beaches. It is important to pay attention to the signs that tell one what one cannot do in "public" places: no littering, no straying from the approved path, no loitering, no drinking alcohol (in specific areas and at certain hours), no letting your dog off its leash (there are parks and beaches specifically for dogs), no glass containers, no smoking, no crossing the street even when there are no cars coming (unless the "walk now" sign is flashing at the stop sign). In many instances one cannot remain longer than two hours at a time in parking spots. Speed limits are strictly observed as are the opening and closing hours for bars and restaurants. You must always be careful to use the correct traffic lane ("right lane must turn right"). You need to know on what day and at what time you can park in front of your own house (in keeping with scheduled street cleaning and garbage collection). It is not that similar regulations do not exist in other cities, but rather that San Diegans are so zealous in observing them. The fines for breaking the rules are high, and society's disapproval is made manifestly evident to those who do not accept the patterns of established behavior or dare to defy their logic. Perhaps this obsession with controlling public space—transforming it into a territory of risk that must be approached responsibly—impedes the spontaneous creation of new ways of operating or the critical questioning of what is pre-established. Perhaps these spontaneous impulses are the essential stimuli that enable us to experience the public fabric, something that has laid dormant in our actions, something that is alive rather than artificial.

Might it be these internalized attitudes that dictate and perpetuate setback between houses, neighborhoods, and citizens? Curiously, the Tijuana and San Diego *infoSites* echo each city's distinct modes of being and the relations between individuals and their surroundings. Whereas the Tijuana *infoSite* employed the city's most emblematic urban symbol to take advantage of its location and its public, the San Diego *infoSite*—although also located in an important public intersection—"breathed" on all four sides, enabling the visitor to inspect it from all sides before daring to enter.

The extensive rules and regulations and the long negotiation processes that are required to obtain permission to intervene or act in public and private spheres in San Diego are so oppressive that they reveal—and also serve to perpetuate—society's fear of perceived "threats" and its aversion to "alterity." The refusal of the managers and owners of the buildings selected by Allora and Calzadilla to participate in their project *Signs Facing the Sky* reflects this fear. In one instance, a building administrator stated that placing illuminated signs on a building could transform it into a potential terrorist target. This lack of participation meant that the project was eventually reworked as a video piece, sidestepping the problematic issue of a physical installation. A similar situation occurred at a corporate level when **inSite** requested permission to use the façade of a McDonald's restaurant located at the border to depict a map tracing the activities of informal porters operating at the border for Mark Bradford's project. The answer was very similar and hinted at the possible threat of a terrorist attack. This sense of fear was also evident at an institutional level: the underlying reason that psychiatric institutions in San Diego refused to collaborate with Javier Téllez in his project *One Flew Over the Void (Bala perdida)* was due to the fear that a legal suit could be brought against the hospital or its doctors by the patients' families.

Nevertheless, on a personal level, generalized paranoia can be managed and overcome. During negotiations with the model airplane pilots participating in Maurycy Gomulicki's project *Aerial Bridge*, the participants were told that the final performance would take place in Tijuana—with certain rehearsals and planning meetings to take place in San Diego. This meant that all the collaborators had to cross into their neighbouring city. Whether or

not the Tijuana pilots crossed over to the US side of the border was largely determined by time constraints if the requisite visas were in order. The case of the San Diegan pilots was entirely distinct. Accustomed to a highly regulated mode of existence, crossing over to Tijuana signified an encounter with chaos. This generated a sense of distrust. Several US pilots declined to participate in the project because of their apprehension. For those who decided to take part, **inSite** and Gomulicki gave assurances that the trip to Tijuana would be safe and enjoyable.

However, what really transformed the US pilots' preconceptions about Tijuana was their interaction with the pilots from Tijuana. Proud of their city and culture, the Tijuana pilots invited "the Americans" to join them to fly on their flying field on several occasions. The San Diegan pilots reciprocated this invitation by inviting "the Mexicans" to join them. The activity of model airplane flying in San Diego and Tijuana is practiced in entirely different ways: in San Diego the hobby is considered to be a semi-professional activity second only to one's actual profession. It is carried out with the utmost seriousness and sobriety; drinking and smoking on the flying field is forbidden, and one rarely sees children or family members except during competition events. In

counterpoint in Tijuana the hobby is considered as a time for relaxation and entertainment. Practicing one's hobby often transforms into a social gathering involving one's family, a barbecue, and beer. The journeys that both groups of pilots made to each other's flying fields enabled the participants to coalesce as a team, respect each other's differences, and amalgamate their different practices. After the flying event, the Mexican pilots organized a get-together at a Tijuana restaurant and invited all the participants to celebrate the outcome of the project. The party that took place involved mutual expressions of gratitude and praise for one another's countries, cities, and work. The pilots recalled the process of negotiation and mutual give-and-take that they had experienced. This encounter enabled them to appreciate and truly experience what lay on *el otro lado* ("the other side").

In his essay *Resisting the City*, Mark Wigley states, "the city is not an object or a phenomenon, but a decision."[13] If that is the case, are the borders that hinder co-existence urban or human? How do physical obstacles and political divisions influence the creation of psychological and emotional barriers? How are identifiable physical urban features and social and economic dynamics mutually predetermined? Perhaps rather than "circumventing" physical barriers, the projects commissioned for **Interventions** acted on and inserted themselves into psychological and emotional borders, intervening in the everyday dynamics of co-existence and exchange that are specific to the region.

Tania Ragasol *is a curator based in Tijuana, San Diego, and Mexico City. She was co-curator of* **Interventions**, **inSite_05**.

Translation: www.languagedepartment.net

1 Laurence A. Herzog, "The Transfrontier Metropolis, A New Kind of International City" in *Harvard Design Magazine*, Winter/Spring No. 1, 1997, p. 4
2 Kevin Lynch, *La imagen de la ciudad*, Gustavo Gili, 1998, p. 61
3 Donna Conwell, "Aernout Mik" in *inSite/ Art Practices in the Public Domain, San Diego Tijuana*, printed guide for **inSite_05**'s public phase, **inSite**, San Diego-Tijuana, 2005.
4 Mark Wigley, "Resisting the City" in *Transurbanism*, V2_Publishing/NAi Publishers, 2002, p. 103
5 Luis Humberto Crosthwaite, "La fila" in *Instrucciones para cruzar la frontera. Relatos*, Joaquín Mortiz, 2002, p. 15
6 Andreas Ruby, "Transgressing Urbanism" in *Transurbanism*, V2_Publishing/NAi Publishers, 2002, p. 26
7 A popular term for one of the vehicles used for public transport in Tijuana.
8 Lots of abandoned or secondhand cars that generally originate in the US and have been left behind.
9 Donna Conwell, "Christopher Ferreria" in *inSite/ Art Practices in the Public Domain, San Diego Tijuana*, printed guide of **inSite_05**'s public phase, **inSite**, San Diego-Tijuana, 2005.
10 Commuters are people who travel to work or school everyday and come back to their homes or dorms at night. In relation to a border zone, specifically in the case of the the San Diego-Tijuana region, the commuter's daily journey often involves crossing from one country to the other.
11 Andreas Ruby, "Transgressing Urbanism" in *Transurbanism*, V2_Publishing/NAi Publishers, 2002, p. 28
12 Ibid.
13 Mark Wigley, "Resisting the City" in *Transurbanism*, V2_Publishing/NAi Publishers, 2002, p. 113

Working Sessions
With Artists from the Area

April 2004/ Working Sessions

Prior to the presentation of the artists' proposals, a specific program was developed for the participating artists living in the San Diego-Tijuana region who were well acquainted with the social dynamics of the area. The working sessions were organized to generate discussion about possible strategies of intervention and conceptual processes that could serve as a platform for the projects' unfolding development. The program included a field trip to a series of sites in the region that were selected by the participating artists. Each artist conducted an in situ presentation about the selected site to the group. The following day several group discussion sessions took place. The working sessions took place from April 1–3, 2004.

• **Field Trip:** Each participating artist was invited to choose and critically discuss a specific site in the area—with the understanding that the site could potentially be activated as public domain—to stimulate reflection concerning modes of interpreting urban space. The field trip also prompted discussion about how the specific conditions of each selected site are expressed through the cultural activities of its inhabitants and those who use it. This group exercise enabled participants to focus on each specific physical space's relationship to urban entropies and to trace the less evident connections between urban spatialities and cultural behaviors.

• **Discussion:** Taking the curatorial statement as a point of departure, each artist presented a concrete, local phenomenon they would be interested in intervening in. The subsequent discussions revolved around identifying low-key cultural dynamics within daily urban life and how to intervene on them by generating experiences designed to produce public domain.

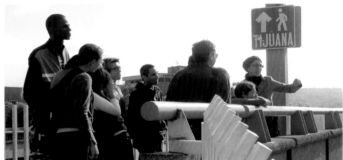

Para el caso de quienes vivían en la región Tijuana San Diego y estaban ya familiarizados con los conflictos y dinámicas del área, se organizó un programa específico previo a la presentación de propuestas. La idea consitía en sacar a discusión posibles estrategias de intervención y procesos de conceptualización que potenciaran los proyectos. El programa incluía un *Field Trip*> Estudio de campo en un lugar elegido por cada artista con una presentación *in situ* al grupo y, un día después, varias sesiones de discusión colectiva. Dicho programa de trabajo estuvo organizado entre el 1ero y el 3 de abril de 2004.

• *Field Trip*> **Estudio de campo:** El objetivo de que cada artista eligiera e introdujera críticamente un sitio de esta zona, entendido como esfera potencial de dominio público, buscaba reflexionar sobre los modelos de lectura del espacio urbano, y cómo las problemáticas específicas de cada lugar son expresadas por la acción cultural de sus habitantes y usuarios. Este ejercicio en grupo intentaba enfocar cada espacio físico como causa y efecto de las entropías urbanas, así como ayudarnos a rastrear los nexos menos evidentes entre las espacialidades urbanas y los comportamientos culturales.

• **Discusión:** Tomando como referencia el marco curatorial, cada artista presentó un fenómeno local concreto sobre el que les interesaría intervenir. Las discusiones versaron en torno a dinámicas culturales de bajo perfil en el marco de la vida urbana cotidiana, y a cómo intervenirlas con experiencias dirigidas a producir domino público.

FADING TRACERS
Osvaldo Sánchez

Practicing a discipline is different from emulating "a model." Peter M. Senge[1]

Furthermore, the fierce spacio-temporalities of contemporary daily life—driven by technologies that emphasize speed and rapid reductions in the friction of distance and of turnover times—preclude time to imagine or construct alternatives other than those forced unthinkingly upon us as we rush to perform our respective professional roles in the name of technological progress and endless capital accumulation. David Harvey[2]

We slowly proceed from a very simple-minded form of cohabitation—such as evolutionary or revolutionary ones—to a much fuller one, where more and more elements are taken into account. There is progress, but it goes from a mere juxtaposition to an intertwined form of cohabitation: How many contemporary elements can you build side by side, generating the series of simultaneities? Bruno Latour[3]

Cities, the public fabric, and borders could not have encountered a more celebrated moment in the contemporary art scene than they currently enjoy today. If **inSite** had been a project seeking to stage itself as a global spectacle, this would have been its starring moment. Although fortuitous, this prestigious accolade would not be groundless. The art world cannot boast many other projects that have operated for so many years in the indices between the urbanscape, public art practices, and border territory—in a site of geopolitical collision where local practices of transit, habitat, and territoriality transparently replicate the entropies of the global labor market and its consumer products. If we consider the now institutionalized stature afforded to *relational aesthetics*[4] along with the growing demand for parodies of globalization, a minimal revision of **inSite** from 1992 to 2001 reveals a surprising precedent in a region that was one of the first outsourcing fiefdoms. To these "fashionable" attributes we can add that it would be difficult to encounter a more munificent offshore urban laboratory than Tijuana-San Diego, at a time when urbanism and architecture have re-framed the city—even through their stylish modern utopias—as a socialized commodity of public culture.

Positioning **inSite** in the face of these "optimal" expectations required distancing ourselves from the art world's overarching impulses—a stance that was extremely challenging to maintain from a solely curatorial standpoint. Obviously, the union of the city, the public fabric, and the border could have provided a very "chic" theoretical platform to which one would only have to add a predictable list of international artists seduced by the representational dynamism of cities and borders. My curiosity, however, was piqued instead by the political nature of what we understand by the term "public" and the possibility of stimulating artistic strategies of intervention in everyday life. While potentially challenging the historical character of **inSite** as an international art event, the curatorial team nevertheless decided—in counter current to prevailing expectations—to encourage low-key interventions and to consciously reject an exhibition format and an art world public as the principal audience for the projects.

inSite's original conceptual themes—the urbanscape and the public fabric—seemed to be sufficiently exhausted by the most established of artistic practices, and perhaps for this reason they seemed pertinent topics to re-interrogate. We were interested in questioning the mental inertias underlying the stylization of the city as a repository of urban ornaments and the redemptive fictions of relational aesthetics.[5] The border, although equally "trendy," was more problematic. For those of us who have worked in the Mexican cultural context—where for years the polarities of the border region have stimulated an enormous volume of local artistic production involving the clichéd representation of institutionalized concepts of belonging—the border in and of itself, as a territorial and macropolitical demarcation, as a symbol of the historical disjunction between local maps and global itineraries, was an overly established topic that one should avoid at all costs. On the other hand, it was clear that operating within border flows could engender a more informed understanding of the social tactics that facilitate permeability (and not only in terms of borders). As a cognitive exercise, exploring permeability and flow would imply an emphasis on process, and would reveal the fragility of alliances and certitudes wrought during the production of an extraordinary (artistic?) experience.

My initial curatorial statement[6] thus emphasized an exploration of "public" from a specific methodological perspective: the work as the production of an experience of public domain by means of a processual logic of *commitment/ immersion/ incubation/ illumination* undertaken from a heuristic paradigm.[7] This initial statement contained a second theme: the urban grid as a palimpsest that is capable of revealing new connective topologies in the region. The urbanscape was framed not as socio-spatial representations of lifestyles but as simultaneous quasi-visible itineraries and the admixture of incidents in flux that reveal temporal identities' strategies of inscription.

But the curatorial model for **inSite_05** did not initially develop from an interest in theory, rather it came about as a result of two works from inSITE2000-2001, that paradoxically affected me more as a spectator than as one of the co-curators of the project.[8] These works were *The Rules of the Game* by Gustavo Artigas and *Blind/Hide* by Mark Dion.

The Rules of the Game was a highly memorable experience. Four adolescent sports teams—two from Tijuana and two from San Diego—prepared and co-created a disconcerting spectacle—a basketball game and a soccer game occurring at the same time, in the same place, and expounded by commentators in two distinct languages. This event transformed the limits of social friction and the dynamics of border flow into a critical visualization of the possibilities of co-existence. The project demonstrated the live self-construction of the public fabric by means of a liberating experience between heterogeneous individuals in unexpected circumstances. For the attending public as well as the co-participants—high school amateur sportsmen—engaging in the performance of the game enabled a heightened understanding—through a joyful and revealing experience—of the complex condition of the region. The work was a seemingly absurd fictional parody whose indices of random certitude challenged and healed the entropic flows with which the border region self-regulates.

Dion's *Blind/Hide* consisted in a bird-watching blind located in the Tijuana Estuary on the US side of the border fence that referenced the adjacent presence of a military training field for helicopter pilots. Even with its metaphorical density—the relationship between the ecological reserve and the orchestration of military display, between bird watching and surveillance, between the confrontational and obsessive maneuvers of the helicopters and the almost imperceptible routes of the migratory birds—*Blind/Hide* alluded to the actual experience of the pubic fabric at a visual level that I found interesting. The work reclaimed an intimate perimeter strip through a serene and curious exploratory process. It was an (in)visible project that employed the everyday as camouflage, an interactive experience without evident promises of entertainment. It was revealed—seen and/or partially glimpsed—as an "artwork" without recourse to indexes of presence or to the standard participatory procedures and rewards that tend to constitute so-called "art" or "public art" today.

These reflections opened up the possibility of drafting the curatorial framework of **inSite_05**. This framework focused on the production of the public fabric [as a proto-political organism] through everyday experiences of revelation [the construction of meaning] through art. For this we had to abandon the idea of the artistic object as a final product, reject representation as a discourse of political commitment, and emphasize the process of the production of an experience—not merely as a means of fulfilling the exhibitory impulses of the globalized contemporary art scene or conforming with what has locally been esteemed as "public art."

→ Otras traducciones/ pp. 343–352

As a tactical maneuver, the temporal framework of **inSite_05**—considering the demanding two-year program of artists' periodic residencies—perhaps signified a conscious disengagement from (and/or an indifference to) the prevailing anxiety and the bulimic instrumentalization of contemporary artistic production. A program of intensive artists' residencies, an emphasis on dematerialization, a collaborative process involving heterogeneous groups, and an intense context—easy to exploit referentially but challenging to intervene in—might potentially activate other artistic models of involvement and action. Perhaps a real immersion in the density of the context of San Diego-Tijuana would disable our ongoing flirtation with the global compulsions of consumerism, speculation, and accumulation. Perhaps **inSite_05** could enable us to interrogate the way in which our professional commitment and social status are regulated and also kindled by the dynamics of the market. Perhaps not all exhibitory models have to be a public relations exercise for the global economy.

This intervention would be translated, at the level of everyday life, as a better allocation of its elements and its instants as "moments," so as to intensify the vital productivity of everydayness, its capacity for communication, for information, and also and above all for pleasure in natural and social life. The theory of moments…would thus become, at the core of the everyday, a new form of specific pleasure linked to the totality… Henri Lefebvre[9]

The urbanists of the twentieth century should construct adventures. The most simple situationist act would consist in abolishing those souvenirs of the employment of time of our era; an era that, until today, has not fully realized its potential. Situationist International[10]

The essence of a cultural geography is precisely that analysis of the ambiguity or, in more political terms, of the struggle between various meanings. Designing public domain can then become a question of the stimulation of informal manifestations of diversity and the avoidance of interventions that are intended to make such [informal] manifestations impossible. Maarten Hajer and Arnold Reijndorp[11]

Employing the idea of *public domain* allows us to distance ourselves from what has been vulgarly instituted in the US as "public art."[12] The conscious reappropriation of the term public domain[13] involved challenging how the term is understood under legal terms as the usufruct of a territory—with the subsequent regulation of possible practices. We were interested in emphasizing the lived, heterogeneous, and erosive nature of the public fabric, and the continually re-negotiated experiential condition of all *domain* (*dominus*: authority of the lord). Employing the term public domain as a conceptual tool helps one to avoid reading the city as an ornamental display, and to instead probe and explore the real political dimension by which territory manifests itself as a practice of power.

Nevertheless, we were not interested in (re)presenting the politics of space. We did not intend to reinforce the inscription of ideologies through high-tech cadastral discourses. We were not concerned in bearing witness to how urban elements—through the organization of space and/or the construction of place—translate entropic models of social "cohesion." Nor were we hoping to illustrate fictions of progress—the informal secretions, the simulation of access, and the legacies of nostalgia and (self)exoticization. The specific challenges of engaging with Tijuana forced us to consciously avoid glamorizing the "congenital defects" of modernity and what has come after, and instead explore the way in which these "defects" are transformed into symbolic raw material [even as art criticism] for new global dynamics. This local "capital" that has been identified as the *urbanism of the informal* would require a different focus. The latent exoticizing impulses on either side of the border make themselves known by the strategic adoption of models of the informal and emergent and their perceived "regenerative" capacity. These impulses alert us to the urgency of questioning the suitability of these models as quotes or as recyclable repertoires. We cannot explore *the informal* as if it were only referring to urban settlements experiencing exponential densification (legally or illegally), services, or the demarcation and uses of space.

More than providing a resource of architectural typologies or models for the organization of space or to re-integrate the social use of territory and habitat, an analysis of the informal in this region should involve a more profound understanding of certain local tactics of resistance (including economic ones) against the entropic vortex

of the border region. These tactics continually operate beneath the morphosis of reconversions and simultaneities, between traffic and exchange, between translation and dyslexia, between estrangement and belonging.

The infinity of possible genetic combinations, the infinity of variations of human identity become discernible as an open field of enactment. Peter Weibel[14]

The investigative experiment that we proposed involved exploring the interdependence that exists between models of group belonging and the experiences that test and sanction the vitality of these models—what we understand as public domain. To conceptualize public domain in terms of experiences and not in terms of spatiality implied that the artists had to craft very precise situational initiatives, very delicate "moments." An awareness of the emotional demands and tensions that would be involved in implementing these successive experiences was not evident in the confident and assured initial curatorial statement:

> **But what is public domain?** Public domain is the situational equivalent of a collision zone. It is a heuristic restorative experience. Public domain is the constitutive action of a public, a coming together of free subjects in a context of contact-erosion-encounter-alliance. Public domain is the experience of ill-timed, fleeting, and uncontrolled interaction between the impulses of friction and of freedom. It is a means for making the foundations of the social contract politically sustainable. Public domain is the act of renewing and revitalizing the codes of coexistence among individuals with largely dissimilar behaviors, origins, rules, ideologies, and moral codes. Public domain is the process of catalyzing and operationalizing the negotiation of being named, seen, and approached by the other. It is the certainty of social mobility exercised in the ethical space of difference.[15]

Implementing artistic interventions in order to produce situations of public domain involved experiencing the interventions as constructions of meanings in and of themselves. It signified entering inter-subjective networks whose ephermal structures secreted an awareness of their political and public vitality.

The public fabric—as well as the urbanscape—would also not be (re)presented. **inSite_05**'s commitment to exploring the construction of "public" did not consist of attracting masses of cultural consumers to open forums, historically a justification for its civic nature, but in convoking spontaneous heterogeneous groups—not institutionalized communities—through a collaborative process that would be specific, focused, and unfold over the course of time. Beyond the exhibitory thrust in which each project would interface with the art world (with its opinion makers and its fervent professionals), we insisted that the formation of the public fabric—in terms of its everyday political articulation—was based on the process of communion that sustains the experience of that fabric and not on the consumption of image/spectacle. We hoped that producing these unusual "cultural situations" might reveal the raw material of the public fabric, raw material that would enable a reconfiguration—even in personal terms—of the political as a territorial practice and as social capital.

Communities and neighborhoods are key sites within which explorations occur, both in term of **the learning and construction of new imaginaries of social life** as well as their tangible realizations through material and social practices. D. Harvey[16]

Knowledge is contextual. Reality is relational…
Complexity would be the goal of evolution. Mihaly Csikszentmihalyi[17]

Let me shine **until I transform into being.** Goethe

In counterpoint to previous editions, **inSite_05** did not attempt to locate artistic interventions in a perceptual-spatial dimension [the visualization of the urbanscape and its connectors] by adding new urban monuments to the city. The interventions would this time be focused on the situational dimension of the public arena [the uneven script of its protagonists in flux]. In order to infiltrate this situational dimension, the curatorial team proposed operating from a heuristic paradigm. The heuristic—understood as *the art of discovery or a general theory of models*—would be implemented at a sensorial level, where situational linkages are forged to create a live network. While keeping in mind the idea of the *dérive*[18] as a heuristic means of comprehending urban space, the projects would avoid citing the Situationalists through—the now overly familiar—re-drafted maps of urban itineraries as ludic artifacts. Instead, the projects would stimulate dis-alienating experiences at the heart of urban flows without attempting to represent or asetheticize them.

Adopting a heuristic methodology would also ensure that the focal node of each project would not be located in the final result of the experience but in the paroxysms of its unfolding process. It would enable us to deduce possibilities of certitude [what we imagine as the possible versus what we know as the real?] from the erratic mobility and moments of crisis within the experience, and also from the synchronous actions of the co-participants at the heart of the process' simultaneities.

The *artistic* interventions should be understood literally as *experiences of revelation*. To intervene would signify the creation of an unprecedented situation capable of revealing tacit knowledge—indices of certitude experienced as belonging [ecstasy?]. This tacit knowledge would manifest itself as the visualization of the totality of the [social] network and embody the potential for self-creating the public fabric through the simultaneous inscription of the individual. Such experiments of association experienced as art practice—situations in which the emergent redistribution of power also occurs or is parodied—would stimulate one to consider the heuristic condition of all constitutions of the political and, finally, all production of public domain.

In symbolic growth experiences, the individual created/discovered important meanings out of that experience; meanings that were not objectively represented or inherent in the context or logical structure of the events themselves. W.B. Frick[19]

There exists certain writers, painters, musicians, in whose eyes a certain exercise of structure (and not only its thought) represents a distinctive experience, and both analysts and creators must be placed under the common sight of what we might call structural man, defined not only by his ideas or his languages but by his imagination—by the way in which he mentally experiences structure. Roland Barthes[20]

The heuristic paradigm exhibits an optimal logic of verification in the context of San Diego-Tijuana. The specific conditions of the border region induce a heuristic disposition through the everyday experience of operating in a situation of extreme complexity and flow. The construction of identities in the area—which tend to be over-signified—are mobilized, negated, and re-adjusted in this erosive in-between. The frictions [principally economic] of the border region are enacted through the continual experience of switching context, of commuting, and of the strategic employment of cultural masks. It is these heuristic models—whether they are consciously employed or not—that provide knowledge about the behavior of, and ways of operating in, border flow—flows that are always threatening to spill over because of the entropies of an overarticulated system.[21]

It was from the perspective of local specificity that the levels of co-participation would be determined.[22] The collaborative process also necessitated the "re-engineering" of artistic management and a contextual reconsideration of the global economy of art and its symbolic orders. It implied renouncing the notion of authorship—understood as the intellectual and technical administration of an "end result"—in favor of reconfiguring artistic achievement as a special human ability that induces and reveals the "vision" of an experience that is not necessarily perceptual. To intervene from this perspective also signified other challenges that were equally unexpected. In the context of these open-ended dynamics, the subsequent loss of control over the "end result" meant that we had to accept failure as a possible outcome.

However, perhaps the most difficult challenge was managing the inherent tensions that arise when one assimilates heterogeneous entities into a network. How could we temper the complex relationships between the co-participants' individual intentions—and their growing self-awareness that they were agents in a revelatory process—and the manipulative co-actions of the artist whose mission and ultimate objective might not be entirely in accordance with those of the wider group? The artists, curators, directors, and supporters of **inSite_05** needed to distance themselves from the established art system and re-think **inSite**'s history as an international contemporary art event. We would have to re-frame the artistic and intellectual challenges of the project in terms of deciphering the experiential paths of the network [the inner process of the experience], understanding that the possible poetics [the "artworks"] would be inseparable from the new perspectives they would engender.

An emancipation into living, under another name. D. Kahn[23]

Such dynamics of engagement have nothing to do with conventional forms of judgment or the subject/object division implied by normal planned actions. They have instead to do with perceptual and kinesthetic clues about familiar and customized "path" through local environments that involve modifying the surroundings as well as the habits of the human body. Laurent Trevénot[24]

Everyone from my generation will recall the scene from *Stalker*[25] when the main character throws a series of rings wrapped in gauze—as a kind of tracer: a handmade device to trace the course of a process—over a mined border zone whose worn pathways are constantly shifting and re-configuring. This image is familiar not only to those of us who have lived under a dictatorship: this devastated border, strongly militarized, the air of death of the in-between, and a man—a kind of *pollero*[26]—attempting to shepherd a group of people through a continually de-localized landscape to the other side. Frightened and determined individuals who are confused by the strange relationship between their innermost desires and the unknown—this prohibited zone, whose condition of possibility might allow one to become other. For many today, these scenes from Tarkovski's film would perhaps no longer be perceived as cryptic abstractions.

There was a moment in **inSite_05** in which I returned to this scene of the border in *Stalker* when to my surprise I saw how many proposals were employing the idea of the tracer to test and track certain processes and situations. Other "rings wrapped in gauze" were launched into the silence to open up small apertures through to *the zone*, in search of this place [better understood as en route to] whose condition of possibility might enable one to become other. But the tracers within the **inSite_05** projects were not used to traverse a specific border, the in-between was not the border crossing between Tijuana and San Ysidro and the US was not *the zone*. Rather they revealed how living in this border region might prepare one to attempt other crossings—other routes across other worn pathways that are also constantly shifting—thus demonstrating the vital importance of forging new itineraries.

The coming together and instigation of these alliances of co-participation was a critical moment for almost all of the projects. How could we suggest that the zone was a tacitly constructed network? How could we communicate that only by achieving this highly creative, voluntary, and open-ended network—through a transcendent body, through the pubic fabric—would it be possible to envision and re-signify this other network, which is belonging? We were not concerned with the *mise-en-scène* of a parody [of utopian communion] but of implementing a real experience [of no obvious utilitarian use] and in bringing about awareness [perhaps through a social game] of the interior of a zone of instability [a complex system]. This process [not necessarily ludic] might potentially reveal [beyond its resonance as "artwork"] a political vision of the malleable structure of the totality of the network.

Although this objective was the central node of the curatorial framework, I am not sure that the topics of my initial curatorial statement referred, even in a tangential way, to the concrete strategies that would have made it possible. It is true that the curatorial statement spoke of "not attempting to extend the field of representing what is real but rather in providing new experiences of the real" of "encouraging a certain degree of (in)visibility to veil everyday experiences of alienation" of "infiltrating the embryonic ebullience of the informal/border," and that the "true meanings of the projects would come from their processes of erosion—the result of those

fortuitous collisions that we are not capable of avoiding." However, the statement did not contain anything about the technical and methodological tools that would be required to articulate a tacit linkage between the co-participants—an indispensable element of all complex collaboration. What is more, it was not obvious that collectively forging a path as a group would involve the critical positioning of "one's own life [the artist and the co-participants], as a ready-made." (Georges Maciunas, letter to Tomas Schmidt, 1964)[27]

How to liberate life from these dynamics that suffocate it?
If the dynamics in question refer to the functioning of desire and correspond to the subjective politics of capitalist religion, then there is no way to disassemble them except by intervening in that dimension. **To meet this challenge we must place ourselves in a hybrid zone where the powers of healing, creating, and resisting come all together into play and the borderlines between art, politics and therapeutics become indiscernible.** Suely Rolnik[28]

When the same action has dramatically different effects in the short run and the long, there is dynamic complexity. When an action has one set of consequences locally and a very different set of consequences in another part of the system, there is dynamic complexity. When obvious interventions produce non-obvious consequences, there is dynamic complexity. Peter M. Senge[29]

The most demanding aspect of each **Interventions** project was managing the distribution of responsibilities and roles within a heterogeneous network on a full-time basis. How could the artists efficiently apply and improvise certain communicative skills in real time and in ever-changing situations? In addition, it would require identifying where and at what exhibitory level might the contents of the experience exercise a critical or liberating impact within expanding audiences without betraying the process. The projects would have to make this new communal territory [the network in process] visible and to re-adjust the orders of evaluation, which Trévenot calls "the pragmatic regime of commitment."[30] For those reasons, the implementation of the projects' processes demanded, above all, an in-depth understanding of social dynamics and the highly informed management of complex systems. It necessitated a distinct background [also in ethics] than that usually required for the mystified (re)presentation of a selected discourse (post-conceptual). Certainly, the curatorial team was not prepared in advance to tackle these processual practices. Perhaps it was partially because of this limitation that the curatorial interlocution ended up serving more to systematically verify the unfolding experience than a practical exploration of possible effective strategies.

In the beginning it seemed as if the challenges we faced in conducting the experiences were due to the specific characters of the collaborative groups—*maleteros*, model airplane pilots, war veterans, housewives, commuters, psychiatric patients, military spouses, etc.—elected by the artists. However, it soon became obvious that it was highly difficult to operate at an optimal level within strange territories of meaning where the experience was a real action in the world. This insider knowledge was not something that was at hand. A much more profound strategic vision [from the position of curatorial practice] about the interdisciplinary nature of these practices and the specific knowledge that would need to be applied [as much for the artists as the curators] in the development of their models would have been needed to ensure that all the projects were realized to their fullest critical potential. Certain projects that secreted, or positioned, themselves by means of economic networks would have perhaps required more precise specialist consultation about the operation of micro-businesses. Other projects that were more related to marketing, informational, or community networks would most likely have benefited from more time to develop and forge exchanges between co-participants, thus ensuring that the interventions in the heart of pre-established power structures would have been more effective and informed.

In addition to these conceptual and operational limitations, other more practical complications impeded the range and impact of a number of projects. **inSite**'s erroneous evaluation of human resources that would be required to carry out such a highly complex processual project jeopardized the internal dynamics of a number of the experiences. The restrictive temporal framework of **inSite** as an event also forced a specific rhythm and accelerated and/or shortened processes whose timings should have been determined by the nature of the projects themselves.

Certainly, stimulating networks did not imply the construction of communities. However, for each project to function as an unexpected mutuality, which had been recently and fragilely forged, was an enormous achievement.

Although for many the decision to inscribe a project of public art through an exercise in invisibility was incomprehensible, it was not a deliberate paradox. The initial curatorial statement urged the use of the critical power of tactics of unveiling. (In)visibility could signify "a minimum of image with a maximum of meaning," and also a minimum of display/exhibition with a maximum of production, a minimum of audience with a maximum of public, a minimum of interference with a maximum of critical mass, a minimum of future with a maximum of present. (In)visibility signifies the activation of other strategies of access and identification beyond the standard models of social cohesion and beyond the immediate mass gratification of the spectacle with all its "democratic" modes utilized to mystify the public fabric.

However, not all the artists and not every one involved in **inSite_05** were comfortable with inscribing the projects at a low-key level. The curatorial team's unusual position regarding the "public" (in)visibility of the whole project created systematic moments of tension over the course of the two years of **inSite_05**'s development. In particular, concerns were raised about the idea of focusing on small co-producing publics and not on large audiences of cultural consumers, of not organizing tours of the interventions, the absence of "artworks," the quantity of mobile and perceptually efflorescent projects, and the complete lack of exhibitory ambitions. **inSite_05** revealed the inherent contradictions that characterize any art project that is conceived as a large-scale event. It would be easy to mention the various ways in which **inSite_05**'s program and even specific components of the project seemed to contradict the strategies of intervention employed by the artists in their projects. However, even withstanding the inaugural discourses, the "special events weekends," the formal and informal tours to "see" quasi-invisible projects, at the "opening" moment it was still clear that the projects "existed" in another place. What could be "seen"—as an aesthetic and final document or product—only partially referred to the fleeting critical mass that underpinned the entire project. For those who wanted to "see" "artworks" there was the museum exhibition *Farsites*.[32]

But the (in)visible nature of the **Interventions** did not only derive from the absence of objects. The limited perimeter that framed the actions, displays, and meanings of the projects also imbued them with a degree of (in)visibility. The majority of the projects occurred within complex territories that had not been previously appropriated, but were delimited as new spatialities/temporalities, conquered by means of what Arjun Appadurai terms "the production of locality."[33] The production of locality is here understood as the revelation of a more complex relational awareness, which in the majority of the **Interventions** projects occurred as delocalized flows or as brief portable events. To operate within these mobilities and these passages in-between perhaps also necessitated more flexible structures.

Perhaps the subtle management of the degrees and veils of (in)visibility translated some sense of unrest, dissension, or exhaustion? Did this involve a less alienating ethical re-adjustment of modes of belonging in the framework of the construction of meaning?

To act in a low-key way constructs new, more limited, and testable orders of identity inscription—beyond the norms of institutionalized identity formation and adhesion. Above all, these more everyday modes create new platforms for status and social legitimization, enabling other experiences of personal self-disclosure and growth. In some cases (in)visibility also involves the tactical reduction of elements of presence as an intentional strategy. In this way interventions and their documentation can avoid commodification and fetishization.

Because of the extreme mutability at the heart of the practices of **inSite_05**'s **Interventions**, a number of the projects appeared to contradict their original networks and ethical commitments once they moved beyond (in)visibility. The fact that a number of projects utilized their submerged complexity—forged through the experience of collaboration and lying beneath the surface like an iceberg—to nurture an event, was a point of controversy. When in fact the process, in and of itself, and the concomitant experiences, had been condensed and transformed into an accident. This accident—a "final" situation planned as an event—deliberately and

transparently reveals the disjunction between a public strategically forged through a process of collaboration and the mystification of the public fabric.

Many comprehended works like *One Flew Over…the Void (Bala perdida)* by Javier Téllez as an example of image-spectacle staged for the global media and an art world public's (brought together by **inSite**) "collective" consumption. Perhaps this can serve as a diagnosis of our domesticization as spectators, which has facilitated this misunderstanding. How is it possible that our internalized devotion to the global synchrony of all mega spectacles is able to inhibit more subtle readings of the layers of the public fabric that have been removed from *the social*, and are revealed to us in the act of over-exhibition?

Learning to understand these submerged or re-appropriated narratives that were unleashed by the **Interventions** projects has been a difficult lesson—not in terms of disengaging in the face of vanishing evidence, but in the effort to accept and track the deliberate transmutation of the projects' relics. For Tania Ragasol, Donna Conwell, and myself, the question as to whether each project managed to transcend the idea of "artistic intentionality"—euphemistically entitled **inSite_05**'s public phase—has involved intense professional introspection.

We are not particularly interested in whether some projects have helped the artists improve their standing in the art market or not, rather we have asked ourselves where were the experiences really located? What did converting these experiences into "artworks" achieve? Where have these experiences taken us? And where have they taken the artists and the co-participants after two and a half years? It has been very surprising—being here in the region—to witness the way in which these small actions, these intense but relatively fleeting exchanges have awoken—also in us—latent possibilities for creation and exchange. It is not clear that this knowledge is professionally advantageous, but it has certainly stimulated a commitment to other models of political inscription.

Beyond the professional discourses generated about **Interventions**, we are convinced that the projects' final implementation as public actions occurred under the guise of indefinite and uncontrolled narratives. Once we let go of the process, abandoning all traces of the experience, no longer attempting to identify the projects as "artworks," these interventions have reappeared, delocalized as (public) re-appropriations of *the possible*. More than merely projects, the interventions have found their way into the regional public imaginary as fables, textured oral reconstructions of extraordinary and ephemeral acts forged through fragments of imperfect memories. Perhaps these types of intervention are inserted into the public fabric as open texts where the notions of "author" and 'hero' collapse. Perhaps **Interventions**' small contribution has been to challenge the real through the evanescent power of the tracer.

Osvaldo Sánchez *is a curator and critic based in San Diego-Tijuana and Mexico City. He served as artistic director for* **inSite_05** *and was co-curator of* **Interventions**.

Translation: Donna Conwell

1 Peter M. Senge, *The Fifth Discipline*, Doubleday, 1994.

2 David Harvey, *Spaces of Capital*, Routledge, 2001, p. 201

3 Bruno Latour, "Realpolitik to Dingpolitik," *Making Things Public*, ZKM/ MIT Press, 2005, p. 40

4 Nicolas Borriaud described the term that he coined in his book *Relational Aesthetics* as an aesthetic theory consisting of judging artworks on the basis of the inter-human relations which they represent, produce, or prompt. (See Nicolas Bourriaud, *Relational Aesthetics*, Les presses du réel, 1998.)

5 During the proposal discussions one of the most polemic topics was the tendency to conceptualize artistic interventions as authorial gestures (re)presented in the social sphere. With **inSite_05** we sought to distance ourselves from these (postconceptual) tautologies of the public fabric that are so successful in the contemporary art scene—capitalized as *mérde d'artiste* and then put to supposed "social" use as "critical" representations or even as "relational" amulets operating in new geographical boundaries and capable of simulating the savage energy of that which has not yet been transformed into brand.

6 The text *Bypass* was intended to serve as a curatorial framework for **inSite_05**; however, in the end it only acted as a platform for the **Interventions** projects, the *Mobile_Transborder Archive*, and *Ellipsis*. An edited version of the original curatorial statement can be consulted on the **inSite_05** website: www.insite05.org

7 Heuristic: From the Greek *heuristikein* meaning to discover or to find. Also used to signify "a problem-solving strategy, whose goal is utility rather than certainty. The heuristic researcher takes the realistic view that real life problems are too complex, interactive, and perceiver-dependent to lend themselves to comprehensive analysis and exact solutions." (See Martha Heineman, "The Heuristic Paradigm," *New Foundations for Scientific Social and Behavioral Research*, Loyola University of Chicago, 1995, pp. 207–208.)

8 inSITE2000-2001's curatorial team—in contrast to **inSite_05**—were primarily involved in selecting the artists and as consultants. The curators were not involved in the development of the commissioned projects or the periodic artists' residencies that took place in the area. The curatorial team for inSITE2000-2001 included: Ivo Mesquita, Susan Buck-Morss, Sally Yard (who resides in the border region), and the author.

9. Henri Lefebvre, "La Somme et la Reste" cited in "Theorie des Moments et Construccion des Situationnes," *Internationale Situationniste*, No.4, Librairie Arthéme Fayard, 1997.

10. "Editorial," *Internationale Situationniste*, No.3

11. Maarten Hajer and Arnold Reijndorp, *In Search of Public Domain*, NAi, 2001, pp. 36–37

12. "Today, even in contemporary art's professional circles 'public art' is usually understood as objects or actions in open space. This vision of 'public art' as aesthetic urban artifacts—rooted in monumental sculpture—survives not only because of the idea of the city as a unique mega-structure/gallery, but especially because of the use of these monumental symbols to sublimate social frictions that might surface within the harsh, adulterated urban context. These monumental *phalli*, emblems of power masquerading as 'public art,' have been used to identify plazas, 'revitalize' parks, 'beautify' natural spaces, regulate traffic, or as motifs for new urban 'developments.' This policy of 'beautifying' urban dysfunctionality is government on an epic scale, presumably civic in its nature, bizarre in its creation, but fruitful in its dividends. This type of 'public art' has been, and continues to be, a showcase for demagogic politics, tax-evasion schemes, the destruction of public patrimony, the misappropriation of public resources, and influence trafficking. Beneath its mask of progress and civic wellbeing, this 'public art' reads like a political thermometer. In more than one instance, it reflects not only the hypocritical subordination of municipal and city affairs to corporate interests, but also the recurring lack of coherent policies for urban renewal and conservation of patrimony. A review of any given governmental public art program uncovers the way in which these demagogic exercises obviate public complexity, free debate, professional and legal counsel, and fiscal responsibility. The state—at federal, district, and, in particular, municipal level—has historically been the most consistent supporter of the idea of 'public art' as institutionalized symbolic product." (See Osvaldo Sánchez, *Bypass*, curatorial statement [work in progress text], 2003, **inSite_05**.)

13. Public Domain (as defined by Wikipedia): "Openly available to everyone and not subject to copyright protection. Public domain often refers to software, but it can also refer more generally to any work of intellectual property."

14. Peter Weibel. "Art and Democracy," *Making Things Public*, ZMK, 2005.

15. Osvaldo Sánchez, *Bypass*, curatorial statement [work in progress text], 2003, **inSite_05**.

16. David Harvey, *Spaces of Capital*, p. 202

17. Mihaly Csikszentmihalyi, *Fluir*, Kairos, 1990, pp. 115–131

18. *Dérive*: French concept meaning an aimless walk, sometimes translated as "drift," probably through city streets, that follows the whim of the moment. For the Situationists it implied a mode of experimental behavior linked to the conditions of urban society; a technique of transient passage through varied ambiances. Also used to designate a specific period of continuous *dériving*. "The concept of the derive is unassailably linked to the recognition of the psychological effects and the confirmation of a ludic-constructive behavior that totally opposes the classical notions of the journey and the passage." (Guy Debord, "Theorie de la Dérive," *Internationale Situationniste*, No.2).

19. W. B. Frick, "The Symbolic Growth Experience: A Chronicle of Heuristic Inquiry and Quest for Synthesis," *Journal of Humanistic Psycology*, No.30, p. 68

20. Roland Barthes, "The Structuralist Activity," *An Essay*, Doubleday, 1972.

21. It is not inconsequential that the first curatorial statement was elaborated under the title of *Bypass*, as a metaphor for the urgent need to implement certain alternative strategies in a dense communicative structure of flows that confront growing obstructions.

22. Many of the artistic practices that are employed to undertake contextual intervention by producing an extraordinary experience—at distinct levels of aesthetic resonance—incorporate heuristic procedures—although generally on an unconscious level. This is the case whether or not the intervention is directed at the (in)stability of a [*cultural*] apparatus; or to infiltrate the levels of (in)visibility of the codes of apprehension [*features of identity*] or to explore the emergent moment of self-organization [*group awareness*].

23. Douglas Kahn, "The Latest: Fluxus and Music," *In the Spirit of Fluxus*, Walker Art Center, 1996.

24. Laurent Trevénot, "Which Road to Follow? The Moral Complexity of an 'Equipped' Humanity," *Complexities*, Duke University Press. 2002, p. 71

25. *Stalker* was made in 1979 and directed by Andrei Tarkovsky. Screenwriters Arkadi Strugatsky and Boris Strugatsky based the film on their novel *The Roadside Picnic*. "Near a gray and unnamed city is The Zone, an alien place guarded by barbed wire and soldiers. Over his wife's strenuous objections, a man rises in the dead of night: he's a stalker, one of a handful who have the mental gifts (and who risk imprisonment) to lead people into The Zone to The Room, a place where one's secret hopes come true. That night, he takes two people into The Zone: a popular writer who is burned out, cynical, and questioning his genius; and, a quiet scientist more concerned about his knapsack than the journey. In the deserted Zone, the approach to The Room must be indirect. As they draw near, the rules seem to change and the stalker faces a crisis." (Quoted from Aislinn Race and Roopesh Sitharan, "Conversation with Osvaldo Sánchez," *Curating Now'05*, California College of the Arts, San Francisco, 2005).

26. A *Pollero/Coyote* is a person who traffics undocumented migrants. Usually the *Pollero* is responsible for taking migrants from Mexico across to the US. The *Coyote* is the person who manages the trafficking business, sets the fee, and determines the procedures for the crossing.

27. If we were to determine a historical precedent to these kinds of processual projects that are focused on the everyday and on the social aspect of an experience and not on the aesthetic canon, we would refer not only to the theories of the Situationalists but also to Fluxus—specifically those works by Fluxus that were conceived as poetic-conceptual acts that transgressed the everyday order of meaning, placing in tension the relationship between the individual [*the artist*] and the group [*the audience*] with the aim of revealing something about the experience of coming together as a "public." Fluxus positioned the artistic act as gesture [*a sense of play/game*] in counterpoint to the everyday models instituted by the "system" as [*social*] capital. The action as the work was understood as the condensed present moment of temporal alliance among people unknown to one another. There were numerous reasons to refer to a reading of Fluxus during the unfolding process of these projects: John Cage's idea about the pure experience of the present and the de-personalization of the artist, and especially the notion of *event* that George Brecht introduced in 1959—understood as a complete experience of understanding that can emerge in a situation that is experienced in a multi-sensory way as a "maximum of meaning with a minimum of image." (For a perspective on Fluxus that is more centered on the cognitive weight of a experience see Kristine Styles, "Between Water and Stone: Fluxus performance: A Metaphysics of Acts," *The Spirit of Fluxus*, Walker Art Center, 1993.)

28. Suely Rolnik, "Life for Sale," *Farsites*, **inSite_05**, 2005, pp.140–159

29. Peter M. Senge, *The Fifth Discipline*, Doubleday, 1994, p. 71

30. Laurent Trevénot, *Which Road to Follow? The Moral Complexity of an 'Equipped' Humanity*, p. 76

31. Koun Yamada, The Gateless Gate, Wisdom, 2004.

32. *Farsites: Urban Crisis and Domestic Symptoms in Recent Contemporary Art* was an exhibition curated by Adriano Pedrosa for **inSite_05** in the Centro Cultural Tijuana and the San Diego Museum of Art (see *Farsites*, **inSite _05**, 2005).

33. "Thus, neighborhoods seem paradoxical because they both constitute and require context. As ethnoscapes, neighborhoods inevitably imply a relational consciousness of other neighborhoods, but they act at the same time as autonomous neighborhoods of interpenetration, value, and material practices. Thus, locality as a relational achievement is not the same as a locality as a practical value in the quotidian production of subjects and colonization of space. Locality production is inevitably context-generative to some extent. What defines this extent is very substantially a question of the relationships between the contexts that neighborhoods create and those they encounter." (See Arjun Appadurai, "The Production of Locality," *Modernity at Large*, University of Minnesota, 1996, p. 187.)

Unfolding Process
Summaries of key moments during the projects' development

Allora & Calzadilla

March–May 2004
Research and Proposal Discussion/ During their second residency in May 2004, Jennifer Allora and Guillermo Calzadilla focused on exploring the role of water and the military in the region. They met with various researchers, from the Urban and Environmental Studies Department at the Colegio de la Frontera Norte as well the Institute for Regional Studies of the Californias at San Diego State University. By mid-May, Allora and Calzadilla had developed a number of diverse proposals that included *Cinépolis*, a project that sought to involve the population of Tijuana in a collaborative venture to create a film about their city, and *Trust*, which sought to re-divert the flow of capital accumulated by multinational companies back into the local economy of Tijuana by creating an investment fund. By the end of May, Allora and Calzadilla agreed to focus on their idea entitled *Signs Facing the Sky* in which they proposed locating illuminated signs on the rooftops of buildings along the air-traffic path of San Diego International Airport. The signs would state the secrets, desires, and wishes of people who lived, worked, or frequented the buildings.

October 20–27, 2004
Field Research and Interviews/ In October 2004 Allora and Calzadilla surveyed the air-traffic path of San Diego International Airport and identified a number of buildings in and around the downtown area whose roofs would be visible from incoming planes. They selected a diverse group of buildings, ranging from residential apartments, to a retirement home, >

a hotel, and a bank-processing center. Allora and Calzadilla conducted a series of informal interviews with the people who lived, worked, and frequented the buildings in which they asked them to reveal a secret, a wish, or a desire. By reviewing satellite photos of the area, they were able to assess the feasibility of erecting signs depicting the collected phrases on the roofs of the buildings.

April–May 2005
Permission Denied and an Alternative Solution/ In April 2005 it had become clear that Allora and Calzadilla's initial proposal was seriously in question. Although every effort had been made to secure permission to erect or paint the signs, it was becoming increasingly obvious that the owners of the buildings were not going to agree to participate. The reasons given ranged from a concern that the buildings would become potential targets for terrorism to a lack of comprehension regarding what the project had to do with art. In May 2005 Allora and Calzadilla developed a potential solution in which they suggested dematerializing the project and employing the medium of video as a way of responding to the challenges of working in public space.

July 2005
Production of Video/ In July 2005 a helicopter shoot of the buildings in and around the San Diego flight path was organized. Allora and Calzadilla worked with an editor to revise the raw footage. They also worked with an expert in motion tracking to simulate the appearance of illuminated signs depicting San Diegans' desires, wishes, and hopes on the rooftops of the buildings. Finally, they sampled city sounds, which were then incorporated into the final video.

August 2005
Site and Installation/ In early August 2005 the owner of The Airport Lounge in San Diego agreed to let Allora and Calzadilla use his space for the projection of their video *Signs Facing the Sky*. Although Allora and Calzadilla initially toyed with the idea of projecting the video in the lounge area as well as on small monitors embedded into the bar, they finally opted for a more minimal approach, and the projection was set up in the open-air patio. The patio stands directly under San Diego International Airport's air-traffic path. As a result, visitors who came to see the projection were able to see planes passing overhead as they watched the video.

February 2004
Research in the Area/ Various factors played an important role in the development of Felipe Barbosa and Rosanna Ricalde's proposal during their second visit to Tijuana in February 2004. An initial trip to the Abelardo L. Rodriguez Dam, as well as a flash flood that forced Barbosa and Ricalde to transfer to another hotel, led the artists to consider the relationship between Tijuana's inhabitants and water. Barbosa and Ricalde also became interested in the presence of informal economies that surrounded the Puente México (Mexico Bridge). In particular, they were very attracted to colored bracelets that were sold as souvenirs and which vendors personalized with customers' names. As a result of these experiences, Barbosa and Ricalde began to think about the Puente México, which crosses the Tijuana River, and the way in which a country welcomes its visitors.

February 2004–November 2005
Secondary Inspection/ Although Barbosa and Ricalde's research focused primarily on Tijuana, during their stay in the area they continually crossed from Mexico to the US. In February 2004, while crossing from Tijuana to San Diego, they were stopped by border patrol officials and sent to Secondary Inspection for a more thorough review of their documentation. Detained for more than an hour, they were interrogated separately about the reasons for their visit. This was not the only time this happened. In the course of Barbosa and Ricalde's multiple trips to the area they were sent to Secondary Inspection numerous times. As such the experience played a key role in the development of their ideas about hospitality and how a country welcomes its visitors.

May 2004
Proposal Discussions/ In May 2004 Barbosa and Ricalde presented their project proposal. The text *Paper Machine* by Jacques Derrida, in its affirmation that hospitality in its purest form consists of welcoming an individual without imposing conditions and recognizing an individual by his or her name and not his or her occupation or identification documents, played a very important role in the development of their proposal. Taking Derrida's idea as a starting point, along with their own experiences in the border area, Barbosa and Ricalde presented their proposal *Hospitality*. They suggested creating a type of welcome mat on the Puente México, the bridge that connects the US-Mexico port of entry at San Ysidro with Tijuana's commercial district. Inspired by the colored bracelets sold at market stalls that flank the route across the bridge, Barbosa and >

Ricalde proposed inscribing the first names of people crossing over the floor of the bridge. They hoped to work in collaboration with a group of sign-painters and visual arts students. The artists felt that the project invited reflection about the concepts of welcome and hospitality.

February 2005
Inviting Collaborators to Participate in the Project/ During their initial visits to Tijuana, Barbosa and Ricalde noticed the liberal proliferation of hand-painted signs on the walls of houses and buildings, which advertised diverse services and businesses. In February 2005, a meeting was organized with sign-painters from the area with the aim of involving them in Barbosa and Ricalde's project. During that time, Barbosa and Ricalde also met with visual arts students from the Universidad Autónoma de California y la Universidad UNIVER and invited them to participate in the project. From then on, Barbosa and Ricalde decided that the sign-painters would lead the project's design and coordinate the students' work.

August 2005
Painting the Bridge/ Between February and August of 2005, Tijuana's municipal authorities granted permission for Barbosa and Ricalde to carry out their project on the Puente México. In the beginning of August 2005, Barbosa and Ricalde returned to Tijuana and began to paint the bridge, in collaboration with sign-painters and visual arts students. The initial plan was to begin by painting the names of migrants that Barbosa and Ricalde had obtained from the Casa del Migrante and the Casa de la Madre Asunta, and to later include the names of pedestrians who wished to have their names inscribed on the floor of the bridge. As the painting began passers-by immediately wanted to get involved and asked to have their names included. By August 26, 2005, the inauguration of **inSite_05**, the bridge was covered with a large number of names, written in Spanish, English, Chinese, Japanese, Korean, and Arabic. In the months following the inauguration, the patchwork of names continued to grow.

April 2004
Working Sessions and Developing Ideas/ In April 2004 Mark Bradford took part in a series of working sessions involving artists from the area. He was particularly inspired by a field trip in which the participating >

artists each selected a site in the region as a point of departure for discussion. Bradford found the port of entry from Tijuana to San Diego where pedestrian flows run parallel to vehicular traffic and where informal economies converge especially interesting. It was at this time that he began to explore the concept of "border time"—the psychological experience of time at the border—which would come to influence the formation of his project proposal. Following on from the working sessions Bradford began to explore a number of ideas related to the idea of mobility.

May 2004
Research and Final Proposal/ While researching ideas for his project proposal, Bradford spent considerable time exploring the San Ysidro Port of Entry. He became particularly interested in the work of people serving as informal porters at the border. The work of these *maleteros* seemed to encapsulate a number of Bradford's interests, including mobility, the porosity of the border, the informal economy, and the psychological experience of time at the port of entry. Bradford presented his draft proposal of *Maleteros* at the end of May during a series of working sessions about the artists' proposals.

August–November 2004
Working Sessions with the *Maleteros*/ In August 2004 Bradford began an outreach process with the *maleteros* of the San Ysidro Port of Entry. Over the course of numerous meetings, he discussed the possibility of developing a project in partnership with them. Their conversations addressed the relationships between the different *maleteros* groups, the specific characteristics of each faction, the degrees of legality and illegality involved in their work, and what additional provisions would enable them to improve their services and income. Bradford and the *maleteros* also discussed the formation of an unified porter identity.

January–July 2005
Permissions Denied/ As securing permission to locate a project dealing with the activity of informal porters at the border was particularly challenging, Bradford decided to develop a project with a number of mobile components that could be configured at a variety of potential locations. These components included carts, banners with logos, jackets, pins, and visual signs marking the *maleteros*' workstations. By August 2005, despite every effort, permission for installing the project on the US side of the border was denied. This was problematic because it undermined the concept of the circular flow of the informal economy of the *maleteros* around the San Ysidro Port of Entry and instead meant that the project had to focus on the Tijuana side. Three key locations were secured on the Mexican side: the parking lot, the taxi stand, and the bike shop—all key areas of activity for the *maleteros*.

>

August–November 2005
Installation and Operation/ During the activation of the project from August through November 2005, Bradford wrestled with and responded to diverse tensions and challenges inherent in a project that dealt with the dynamics of an informal economy. Such a dispersed project presented Bradford with a number of complex operational problems, including how to control the distribution of carts and tools and to what extent should he intervene to galvanize the participation of the *maleteros*. Bradford also had to respond to certain tensions between the different *maleteros* groups that came to the surface over the course of the project.

Bulbo

April 2004
Working Sessions with Artists from the Area/ In April 2004 Bulbo participated in working sessions that were organized for the participating artists from the San Diego-Tijuana area. As part of one of the exercises that was scheduled for these sessions each of the participants selected a specific site that they thought could be critically intervened on. Bulbo chose the San Ysidro Port of Entry in Tijuana because it was an area where heterogeneous groups of individuals converged on their way to San Diego. This experience, along with subsequent discussions about potential ways to intervene in complex situations where there are diverse groups of people, prompted Bulbo to reappraise and reanalyze the curatorial statement for **inSite_05**.

May 2004
Proposal Discussions/ In May 2004 Bulbo presented their project proposal. Seeking to capitalize on their previous experience of working with diverse groups in Tijuana, they proposed inviting several dissimilar individuals to participate in a workshop that would be centered on the issue of clothing and fashion in the San Diego-Tijuana region with a view to creating a new clothing line. Recognized more for their work as a media collective than as an "artistic" group, Bulbo had tended to utilize working strategies from the fields of publicity and anthropology. Discussion about their project proposal revolved around how important it was for Bulbo to distance themselves from the idea that their final project would be a televised piece and the significance of focusing instead on the experiential aspect of the process of collaboration between co-participants. From that point on, Bulbo determined that the core strategy for their intervention would be the implementation of a series of workshops.

>

July–September 2005
Recruiting Collaborators and Holding Workshops/ Between May and June 2005, Bulbo decided to recruit a number of project co-participants to collaborate in a series of creative workshops. In July 2005 seven selected participants began a series of nine workshop sessions held in Bulbo's offices. The weekly sessions focused on discussions about the design and consumption of clothing in the border region. Bulbo invited a number of individuals to attend the workshops as spectators. A series of garments were produced as an outcome of the workshops, as well as a significant amount of documentation that recorded the exchange of ideas and the collaborative creation process.

September–November 2005
Interventions in Commercial Centers in San Diego-Tijuana/ Between September and November 2005 Bulbo's project, entitled *The Clothes Shop*, entered a second phase. Over the course of this period the project was inserted into a series of commercial centers in San Diego and Tijuana. From September until the middle of October, workshop logbooks, videos documenting the project's process, and several garments generated by the participants of the workshop sessions were displayed in Pomegranate, an elegant fashion boutique in La Jolla, California. During four days in October, *The Clothes Shop* occupied a space at the Swap Meet Fundadores in Tijuana. In addition to selling custom-made garments, Bulbo and their collaborators—with the help of various silkscreens—personalized their customers' clothing utilizing designs produced by the workshops. *The Clothes Shop* was also housed in a kiosk at the Plaza Mundo Divertido commercial center in November. The plaza is very popular and there was a great deal of demand for both custom-made clothes as well as silkscreen designs.

November 2004–January 2005
Negotiating Permissions/ The process of soliciting permission to locate **inSite_05**'s San Diego *infoSite* at a plaza adjacent to the ballpark at Petco Park and the San Diego Convention Center began in November 2004. After a series of meetings with the Center City Development Corporation, the proposal was presented to The City of San Diego's Office for Special Events. However, given the proposed location's close proximity to the ballpark it was argued that it would obstruct pedestrian flows. As a result, Cruz suggested an alternative location in a neighboring cul–de–sac. As with the first proposed site, the alternative location was at the intersection of diverse pedestrian activity.

April–July, 2005
Relocating the InfoSite/ In April 2005 it became clear that permission to locate **inSite_05**'s San Diego *infoSite* in downtown would not be forthcoming. Towards the end of April the possibility of positioning the *infoSite* in front of the San Diego Museum of Art in Balboa Park became a distinct possibility. After a series of meetings with the director of the San Diego Museum of Art, the project was fully endorsed by the Balboa Park Cultural Partnership group. In June 2005 the Balboa Park Committee approved Cruz's application to temporarily locate the *infoSite* in the park grounds, and construction began in mid-August.

November 2005
Recycling the infoSite/ In early November 2005 possible options for the removal and disposal of **inSite_05**'s San Diego *infoSite* began to be explored. Various possibilities existed, ranging from donating it to a local nonprofit organization, to offering it to a community in Tijuana. Finally Dirt Cheap Demolition, a local recycling company, offered to salvage its component parts. They donated the money made from the sale of the materials to the Casa del Migrante in Tijuana.

Teddy Cruz

April–August, 2004
Identifying a Site/ Teddy Cruz began to develop his proposal for **inSite_05**'s San Diego information center—*infoSite*—in April 2004. A key requirement of the commission was that the *infoSite* should be located in an area where heterogeneous publics converged. With this in mind, Cruz began to map locations in the San Diego area that fulfilled this criterion. Finally, he proposed locating the *infoSite* in downtown San Diego, arguing that as a hub of commerce, leisure, and tourism it would ensure a wide and varied public. Cruz submitted his final proposal in late April. >

Christopher Ferreria

April 2004
Working Sessions with Artists from the Area/ During a field trip that was organized as part of a series of working sessions for artists from the area in April 2004, Chris Ferreria selected Plaza Boulevard and Highland Avenue in National City as a point of departure for discussion. While exploring the area, conversation focused on how both commerce and the car were loci for the intersection of Mexican and Filipino communities in the area. Paralleling the Filipino Catholic custom of block prayers in which a figurine of a child saint is passed from family to family and the Surrealist >

practice of exquisite corpse, Ferreria developed the idea of employing a vehicle as an object of exchange that would be passed from one car crew to another. The object-vehicle would become a site of collision where the aesthetics of diverse local car cultures would converge.

May 2004

Proposal Discussions/ In May 2004, during a series of working sessions in which the artists' proposals were discussed, Ferreria elaborated on his idea of working with distinct car crews from the area to intervene on and transform a step van. The discussions helped him explore potential modes of exchange and interaction that could be provoked after the vehicle was altered, as well as ways of infiltrating the social dynamics of the region. Along with his car crew proposal, Ferreria also discussed an additional proposal entitled *Hey Mr. DJ*, in which he proposed two simultaneous underground gatherings: one in San Diego and one in Tijuana in which DJs would interact with one another. Although this idea was eventually discarded, DJs would continue to play an important role in the development of his project.

November 2004–March 2005

Involving Collaborators/ From November 2004 through March 2005 Ferreria made extensive efforts to convince local car crews to collaborate with him on the transformation of a step van. He attended numerous car exhibitions, posted announcements on car customizer websites and in magazines, and attended local gatherings of car enthusiasts. It became clear that infiltrating these close-knit groups was going to be very challenging. Finally, in March he met with members of Asian import car crew Team Hybrid who agreed to participate. He also set up a working relationship with José Ramon Garcia, a motorcycle enthusiast/customizer who agreed to put a car crew together for the purposes of the project. At this time, he began a collaborative relationship with three local DJs: DJ Mane One (Mannie Putian), ThaiMex (Paul Phruksukarn), DJ Marlino (Marlino Bitanga). They jointly planned a series of live events that would transform the step van into a mobile DJ station, as well as the production of a mix CD that would be distributed free of charge.

August 2005–November 2005

Routes and Events/ In July 2005 Ferreria planned a series of routes for his transformed and tricked-out step van that would take place over the course of the public phase of **inSite_05**. They included the areas of La Jolla, Mira Mesa, Kearny Mesa, Linda Vista, Old Town, Point Loma, Downtown, Balboa Park, Hillcrest, National City, Chula Vista, and Eastlake. The sonic truck elicited a range of responses, ranging from incredulous and confused pedestrians in La Jolla, to screaming and excited adolescents in National City, to the camaraderie of lowrider drivers in Chula Vista who slowed down to take a good look, chat, and cruise for a while. Live DJ events at the Centro Cultural Tijuana, planned in conjunction with the van routes, drew large crowds, whereas members of the local homeless community joined in the dancing when an impromptu live DJ session took place outside of a local wine bar in San Diego.

Glassford & Parral

August 2004

Research in the Area/ Having been commissioned to create a public garden in Playas de Tijuana next to the US-Mexico border fence, in August 2004 Thomas Glassford and Jose Parral visited the Tijuana River National Estuarine Research Reserve Tijuana Estuary and the Border Field State Park, which are adjacent to the site. They visited the area, accompanied by the coordinator of the Tijuana Estuary's Coastal Training Program. This encounter afforded them greater access to information about the area and enabled them to consider the idea of extending the park to the US side of the Tijuana Estuary. Subsequent research steps included obtaining the relevant building permits, selecting the appropriate plants, and discussing how to develop the distinct spaces in the park area.

September 2004

Parral's Trip to Mexico City/ In September 2004 Parral traveled to Mexico City in order to meet and work with Glassford. After this meeting, it was decided that Parral would take charge of horizontal design, whereas Glassford would be responsible for the vertical level. Parral dedicated his time to selecting plants for the park and planning their distribution, while Glassford concentrated on designing urban fixtures.

September 2004–November 2005

Meeting with Communities/ From September 2004 to November 2005, Glassford and Parral were able to strengthen their relationship with potential project collaborators. They needed to ensure a consensus among the different communities of Playas de Tijuana in order to go ahead with the construction of their public park project. In addition to securing building permits, which were issued by municipal authorities, meetings were also held with residents of the area and the environmental group Grupo Ecologista Gaviotas in order to ensure the ongoing maintenance of the park beyond the public phase of **inSite_05**.

June–August 2005

Construction Process/ Construction of the public garden at Playas Tijuana began in spring 2005. There were numerous complications regarding the coordination of private and municipal assistance, the restricted timeframe for completing construction, and the expectations regarding the finalized park. The difficult internal negotiations and production difficulties meant that *La esquina/Jardines de Playas de Tijuana* was one of **inSite_05**'s most challenging projects. The park opened on August 27, 2005.

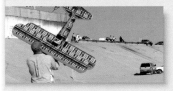

November 2003
Research in the Area/ During his first residency in the area in November 2003, Maurycy Gomulicki immediately noticed the almost constant air traffic passing over San Diego, as well as the strong military presence throughout the city. Following his first visit to Tijuana, his experiences at a number of key sites at the border played an important role in the development of his proposal. These sites included: the Tijuana riverbed where a yellow demarcation line divides Mexico from the US; Colonia Libertad, where he was moved by the sight of a couple who were sitting on the border fence at dusk, looking northwards; and the site to the east of Tijuana where the border fence abruptly ends, impeded by mountains and the desert. Gomulicki was very affected by the absurd presence of such an obstacle in the landscape and he began to reflect upon the romantic condition of the border region.

March 2004–February 2005
Visiting Airfields/ In March 2004, Gomulicki returned to the San Diego-Tijuana region with the intention of visiting model airplane airfields. His project proposal involved the idea of inviting a group of model airplane pilots to collaborate with him in flying model airplanes over the border at the Tijuana riverbed. He visited two airfields in San Diego—the Silent Electric Flyers of San Diego Field and the Chula Vista Model and Radio Control Club—several times. During this period, Gomulicki also began to research the technical aspects involved in the construction of model airplanes by visiting model airplane stores in San Diego. He proposed inviting his collaborators to create new personalized airplane models for the flying event.

March 2005
Inviting Collaborators to Participate/ Between March 2004 and April 2005, Gomulicki visited the Real del Mar Model Airplane Club in Tijuana. Gomulicki's proposal of a joint flying event that would involve the participation of model airplane enthusiasts from both sides of the border developed from the idea that the passion generated by a hobby could forge a relationship between very different individuals. He therefore attempted to secure the collaboration of pilots on both sides of the US-Mexico border. In April 2005 a group of pilots from San Diego and Tijuana agreed to participate in the project and they visited the proposed site for the flying event. During this visit Gomulicki and the pilots discussed the importance of securing the necessary permits for the performance and the site preparation, and cleanup that would be required for the event.

September 2005
Joint Flight Event/ On September 24, 2005, at 3:00 p.m., after a prior onsite rehearsal, the flying event took place in the Tijuana riverbed. As the result of an agreement reached between the pilots, Gomulicki was chosen to be Master of Ceremonies and given the task of introducing each participant and commentating on the performance as it unfolded. The pilots' planes flew in succession: "Crackle," "Avión Cebra" (Zebra Plane), "El Roquero" (The Rocker), "Pinkerton," "El chupa y sopla" (Suck and Blow), "Avión de la ciudad" (City Plane), "Dancing Blue Eagle," "Zarapito tira pollos" (Little Poncho Throws Wetbacks), and the helicopter "Soccer Ball." The choreography of the planes was executed by each pilot in accordance with the piece of music he had previously chosen for the program. During the performance the river sluice opened unexpectedly and sewage water began to flood the airstrip. However, the event continued regardless. The pilots, the production team, and the audience continued to enjoy themselves, despite the unusual circumstances.

April 2004
Research in the Area/ During his second residency in April 2004, Gonzalo Lebrija visited diverse real estate developments, both in Tijuana and San Diego, and interviewed a number of architects from the area. His research at that time focused on urban development and planning on both sides of the border. During an excursion by car he stumbled upon the Veterans Home in California-Chula Vista. As a result of this discovery, he visited the Veterans Memorial Museum in Balboa Park, the Veterans Association, and the VA Hospital at UCSD. At this point he decided to invite the residents of the Veterans Home in California–Chula Vista to collaborate with him on his project.

September 2004
Initial Workshops and Defining a Proposal/ In September 2004 Lebrija returned to the Veterans Home in California–Chula Vista in order to hold a workshop entitled *Every Man is an Artist*. This workshop involved creating sculptures with found materials. Lebrija also interviewed Abraham Shragge, curator of the Veterans Museum in Balboa Park, and visited the museum's storage facilities. From then on, Lebrija began to consider the possibility of creating an intervention in the museum. He proposed establishing a curatorial/artistic museographic intervention that would incorporate the experiences of a group of war

veterans. Lebrija decided that the nature of the intervention should be developed in the course of subsequent workshops with the veterans in the months that followed.

April 2005
Change of Plans/ After conducting an initial workshop session in September 2004, Lebrija returned to the Veterans Home in California–Chula Vista in April 2005 with the intention of continuing to work with the veterans. However, it became clear a continued collaboration would be impossible due to the deteriorating health of many of the participating veterans. During that period, Lebrija attended a number of events hosted by the Veterans Museum concerning ex-prisoners of war (ex-POWs). The way in which the POWs interacted with one another and the attending public, and the pride with which they shared their war stories, deeply affected Lebrija and enabled him to fashion a new proposal.

June 2005
Interviewing the POWs/ In June 2005 Lebrija returned to San Diego and conducted a series of interviews with a group of POWs. The POWs were more than happy to talk about the part they had played in diverse armed conflicts, as well as the public recognition they had received. By that point, Lebrija had redefined his project and decided to create an intervention in the central auditorium of the Veterans Museum. This intervention would consist of a video-installation, in which the service medals of war heroes would be reinterpreted in light boxes and juxtaposed with the POWs' own personal narratives.

August 2005
Intervention at the Veterans Museum/ Between June and August 2005, Lebrija edited and digitally mastered video interviews he had recorded with a group of POWs in San Diego. Due to scheduling conflicts, Lebrija was obliged to forego his first choice of location for his video installation at the Veterans Museum, deciding instead to locate it in the museum's library. The space seemed best suited to the layout requirements and the overall concept of the project. In August 2005 the library was prepared for the installation of Lebrija's intervention. The space was altered to transform the visitors' movement through the library as well as to accentuate the visual weight of its historic documentation. The opposing diagonals of the light boxes depicting the POWs' service medals became focal points, as did monitors depicting POWs talking about their wartime experiences.

August–November 2005
Oral Archive/ After the inauguration of his intervention at the Veterans Museum's library, in August 2005, Lebrija and the staff of the Veterans Museum began to discuss the possibility of continuing the project in some way. Given that the project had

centered on the compilation of oral narratives from ex-POWs, the Veterans Museum's team decided to take on the responsibility for creating an extensive oral history archive, in which the personal stories of war veterans would be recorded.

João Louro

November 2003
Research in the Area/ During his first visit to the area in November 2003, Louro toured various places of interest throughout the region. He visited Colonia Libertad, a community in Tijuana that backs onto the border fence. He explored junkyards throughout the city and followed the border fence to the east until it abruptly cuts off when it reaches desert and mountainous terrain. Louro was particularly captivated by the emblematic character of the car in the region.

March 2004
Defining a Proposal/ In March 2004 Louro returned to San Diego-Tijuana and presented an outline of his proposal. He intended to rescue a European luxury car that had been abandoned in a Tijuana junkyard and transform it into an artistic "jewel" by painting it gold. Louro hoped that the project would inspire reflection about the dynamics of cross-border recycling. During his visit he also explored La Jolla—an affluent area in San Diego—in order to investigate the possibility of exhibiting the "car-jewel" in a key site in the area. He also visited various auto repair shops and visited Colegio Patria in Tijuana, proposing that the school's elementary-level pupils participate in the project.

March–August 2005
Beginning Production/ In March 2005 Louro visited various Tijuana junkyards with the aim of selecting and purchasing a car, which would form the axis of his project. He also sought out advice regarding what would be the best way to apply gold leaf to the car and transform it from scrap metal into a jewel. After a long search, the perfect car was located in July 2005 and taken to the Sandoval workshop in Tijuana, where it was prepared for the gold leafing process.

August 2005
Exhibition and Auction/ *The Jewel/ In God We Trust* had its public debut in August 25, 2005, when the golden car was exhibited in the showroom of Ferrari and Maserati of San Diego in La Jolla. The following night, August 26, the car was auctioned >

at the home of Eloisa Haudenschild—president of the **inSite_05** board of directors—during a gala for invited guests. Once the car was sold, the money produced by the silent auction was used to facilitate the second stage of Louro's project.

October 2005
Workshops and Drawing on Dollar Bills/ In October 2005 Louro led a series of workshops at the Colegio Patria in Tijuana with third- and fourth-grade elementary school children. During the first workshop, Louro presented his project—*The Jewel/ In God We Trust*—and explained how he had rescued an abandoned car from a junkyard in Tijuana and transformed it into a jewel through the application of gold leaf. He also discussed the ecological importance of recycling and the impact of the car in the region. Louro then invited the participating children to draw motifs relating to the themes of his discussion on dollar bills that were obtained from the auction of the "jewel-car." One month later, the painted banknotes were returned to **inSite** and were distributed by volunteers in San Diego and Tijuana. The dollar bills were eventually reabsorbed back into the flow of capital between both cities.

Rubens Mano

October 2003
Research in the Area/ After a meeting with academics from the Colegio de la Frontera Norte (The Northern Border Institute) during his first visit to the area in October 2003, Rubens Mano became especially interested in the phenomenon of border commuters. Border commuters tend to be residents of Tijuana who cross the US-Mexico border everyday to go to San Diego to attend classes or to go to work. During this period, Mano also began to think about bilingualism in the area, and made a note of homophonic and homographic words between Spanish and English.

March–August 2004
Project Proposal/ During his second residency in March 2005, Mano visited the offices of Grupo Beta and the Casa del Migrante in Tijuana. He also had discussions with various artists from the area regarding life on the border. In August 2004 Mano presented his proposal to insert an icon-sign within the diverse currents of cross-border flows. As a way of tracing and revealing the network of border commuters and exploring the diverse narratives of belonging that are deeply rooted in border flows, Mano suggested that a group of students distribute a free pin—engraved with the word "visible"—in strategic locations in the border region. >

April–June 2005
Designing the Pin-Icon and Networking/ Between November 2004 and April 2005, Mano defined the design of the customized pin. During this time he also visited various universities in Tijuana and invited a group of approximately thirty university students to collaborate with him as "distribution agents." The expense involved in producing the desired number of pins with the specific material requested meant that Mano began to consider the possibility of producing the pins in China.

July 2005
Producing the Pin-Icon/ By July 2005 production of Mano's pin in China had stalled. After months of fruitless exchanges with the manufacturers in China, it seemed impossible that the pin would be completed to Mano's satisfaction. In July 2005 Mano moved the production of the pin to Brazil. The difficulties involved in completing the pin fabrication satisfactorily meant that scheduled distribution had to be delayed.

August–November 2005
Distributing the Pin-Icon/ In August 2005 Mano's pin began to be distributed for free by university students acting as "distribution agents." A second distribution stage took place at the end of October.

November 2005
Launching the Website/ In November 2005 the website www.visibleproject.org was launched. People participating in Mano's pin project were able to use the website to access more information. By this stage pins had been distributed throughout the border region for approximately two months.

Josep-maria Martín

September 2003–March 2005
Proposal Research Process/ In September 2003, during Josep-maria Martín's first trip to the area, he attended a working session at the Colegio de la Frontera Norte. As well as providing the participating artists with an opportunity to meet key researchers from the area, the session was also envisioned as a forum for artists to explore potential themes of interest. Martín was particularly interested in the work of researcher Olivia Ruiz, whose work explores the vulnerability of migrants at the Guatemala-Mexico border. In March >

2004 he returned to the area where he met and interviewed numerous researchers, activists, and advocates specializing in the field of migration. As part of his ongoing research he also traveled to Tapachula at Mexico's southern border in Chiapas. From May 2004 through March 2005 Martín conceived a number of ideas related to the theme of migration. They included commissioning a large-scale theatrical work, inviting the famous Norteño group Los Tigres del Norte to write a song about "positive migration," and constructing a temporary shelter for homeless people living in the sewers of the Tijuana River.

Itzel Martínez del Cañizo

April 2004
Que suene la calle (Let the Streets of Tijuana Be Heard)/ From 2003 through
2004 Itzel Martínez del Cañizo worked intensely on a collaborative research project, video-recording the lives of adolescent women in drug rehabilitation programs in Tijuana. By April 2004 Martínez del Cañizo had developed a promotional short of her film project entitled *Que suene la calle* and had recorded and edited some of the footage, although she still had to compile a lot more material. **inSite** invited Martínez del Cañizo to participate in **inSite_05**, offering to fund and support the completion of *Que suene la calle* and to commission a new project.

June–December 2004
Completing *Que suene la calle*/ After completing the final shots of the film *Que suene la calle* between June and December 2004, Martínez del Cañizo began the final edit and mastering process. At the same time, she decided that her next film project would deal with the utopia of belonging in the context of Tijuana. She decided to work in collaboration with a group of men being treated at the drug rehabilitation center Ciudad Recuperación in Tecate.

April 2005
Holding Workshops and Working with Collaborators/ In April 2005 Martínez del Cañizo visited Ciudad Recuperación, and began making contact with the patients. The artist developed a series of initial workshop sessions in which the patients used video cameras to represent themselves and discussed the potential qualities of an imaginary "ideal" city. Martínez del Cañizo and her co-participants began to develop a script for a film project in which patients at the center would construct alternative realities and fictions about an ideal city and their role >

in this new society. They would then record themselves enacting these fictions.

June–September 2005
Production and Post-Production of *Ciudad Recuperación*/
In July 2005 Martínez del Cañizo continued producing her film project *Ciudad Recuperación*. She invited women from Tijuana's business and financial sectors to collaborate on the project by contributing their ideas about the qualities of an ideal city. These testimonies would be combined with her work with patients at Ciudad Recuperación. After finalizing production details, she began the editing and mastering process. During this period, Martínez del Cañizo's other film project, *Que suene la calle*, premiered in Tijuana and San Diego. On August 27, 2005, it was screened in the Centro Cultural Tijuana and on September 22, 2005, it was shown at the Museum of Photographic Arts in San Diego.

October 2005
Presenting *Ciudad Recuperación*/ On October 22, 2005, the premiere of Martínez del Cañizo new film, *Ciudad Recuperación*, took place at the Multikulti—a derelict movie theater in Tijuana now used for cultural events. As part of the presentation, Tyjuas Steelo, whose music is included on the soundtrack of Martínez del Cañizo's film, *Que suene la calle*, held a live rap session after the screening.

Aernout Mik

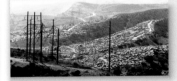

February–March 2004
Research Process/ During a research trip to Tijuana in March 2004 Aernout Mik became fascinated by the vast car junkyards—*corralones*—on the periphery of Tijuana, as well as the brightly colored pharmacies found on Avenida Revolución and close to the San Ysidro Port of Entry. He undertook a lengthy process of surveying, mapping, and photographing these sites. Heavy rains at the time caused extensive flooding and landslides. The vision of Tijuana inundated with water, combined with the striking images of car junkyards and pharmacies, played an important role in the development of Mik's final proposal. Mik also surveyed numerous potential locations for the projection of his final video work. He became very interested in the idea of utilizing an underground parking lot.

September 2004
Fox Studios and Developing a Proposal/ In September 2004 Mik visited Fox Studios Baja and toured the facilities. After learn- >

ing that the studio was originally built for the Twentieth Century Fox epic *Titanic*, Mik began to think about the possibility of creating a large-scale work. The studio's large water tanks and its reputation for being a premier facility for water-related work further stimulated Mik's burgeoning interest in incorporating a flood or mudslide in his final video. At this time he also took a trip to a community in Tijuana called Nido del Águila where the border fence, impeded by mountains and rough terrain, is abruptly cut off. Towards the end of September, Mik submitted two preliminary proposals. The first involved the construction of a false stage adjacent to the border fence at Nido del Águila where children would be filmed as they played at being border patrol officials. The second idea combined images of a flooded pharmacy with shots of Tijuana junkyards. Mik eventually decided to develop his second proposal.

November 2004–April 2005
Preproduction: Building a Set and Preparing Location Shots/
In November 2004 Mik conducted extensive preproduction work in Tijuana in preparation for his video shoot, which was scheduled to take place in February 2005. Seeking to recreate a pharmacy similar to those found on Avenida Revolución, Mik met with the director of The Medicine Company who owns and manages most of the pharmacies at the border. He agreed to let Mik record whatever footage he might need, as well as to assist with the design of the pharmacy set. Mik also scouted for extras at Colegio Principito-Patria and selected a group of children to participate in his location shots. Preproduction work continued after Mik's departure with constant communication between Mik and his collaborators and the Tijuana production team. After a false start in February when heavy rains led to the cancellation of the scheduled shoot, Mik and his team began work filming on March 22, 2005, and completed the shoot on April 1.

August 2005
Installing the Video Projection/ After a complex and challenging editing process, Mik completed his video in July 2005. In August 2005 Mik oversaw the installation of his video—*Osmosis and Excess*—in the Parkade parking facility in downtown San Diego. The installation presented a number of technical complications including the location of an enormous screen and the synchronization of a series of computerized projectors.

Antoni Muntadas

April 2004
Research in the Area/ During his second visit to the border region in April 2005, Antoni Muntadas met with artists and academics from San Diego and >

Tijuana and had several interesting discussions regarding the border and the dynamics and processes associated with crossing from one side to the other. One of Muntadas' most fruitful exchanges was with the members of Tijuana media-arts collective Bulbo. Muntadas visited their studio several times where he viewed and discussed some of the numerous documentaries they had produced about the border region for a weekly television program that was broadcast in Tijuana. He also met with young architects from the area. These meetings proved very influential and enabled Muntadas to think about shared social behavioral codes and architectural typologies on both sides of the border.

January 2005
Fashioning a Proposal and Recruiting Collaborators/ In January 2005 Muntadas returned to San Diego-Tijuana with a defined theme for his project: fear as an emotion that is translated on both sides of the border. The project proposal was envisioned as a continuation of his extensive research project *On Translation*. Muntadas proposed creating a video about fear. He wanted to explore the different perspectives that people from the border region have about the emotion and how it impacts the lives of border commuters—mainly inhabitants of Tijuana who cross the border everyday to study or work in San Diego. Muntadas invited Galatea Audiovisual—the video production company that produces Bulbo—to collaborate as producers. He decided that the documentary would be structured around two basic questions, which would be asked to a group of diverse individuals with differing ages, occupations, and income.

February–August 2005
Producing the Video/ Between February and July of 2005, Galatea Audiovisual conducted interviews with a group of more than twenty individuals from San Diego and Tijuana regarding their perception and understanding of fear in the region. In addition to these interviews, Muntadas also decided to include documentary and fictional video material about fear from the archives of Televisa (a leading Mexican television network). As a fundamental component of the project, **inSite** directors began to contact television stations in Washington, D.C., Mexico City, San Diego, and Tijuana with the hopes that they would agree to broadcast the media intervention. Between July and August of 2005 the video was edited, subtitled, and mastered, and the soundtrack was dubbed.

August and October 2005
Television Broadcast/ *On Translation: Fear/Miedo* was broadcast in Tijuana on Channel 12 at midnight on August 27, 2005, and in San Diego on KPBS at 10:30 p.m. on October 18, 2005. It was also televised in Mexico City. It was hoped that the media intervention would also be broadcast in Washington during the public phase period of **inSite_05**, however, this was not possible.

R_Tj-SD Workshop

May 2005
Emergent Commission/ Towards the end of May 2005, **inSite** lacked a concrete project proposal for the Tijuana *infoSite*. Due to the approaching date of **inSite_05**'s opening, it was imperative to begin construction as soon as possible. It was decided therefore that Torolab—who had been commissioned to design the Tijuana *infoSite*—would be asked to stand down and Tijuana architects collective, R_Tj-SD Workshop would be invited to take on the challenge of creating a new proposal. Gustavo Lipkau founded the R_Tj-SD Workshop in March 2005 with students from the Department of Architecture of the Universidad Iberoamericana de Tijuana. When **inSite** extended the invitation, the members of the R_Tj-SD Workshop were in the process of studying the Tijuana River and its relationship to the operation of the city. Their objective was to develop and promote architecture projects in the San Diego-Tijuana region. The commission to create a work of ephemeral architecture in the plaza of the Centro Cultural Tijuana that would house **inSite_05**'s *infoSite* gave the workshop the opportunity to reflect on the Tijuana River zone and Tijuana's public spaces.

July 2005
Design and Construction/ Less than a month after the R_Tj-SD Workshop was commissioned to create the Tijuana *infoSite*, the group produced detailed topographic blueprints of the site they had selected for the structure. They elected to employ the left-hand staircase that surrounds the Omnimax Cinema building of the Centro Cultural Tijuana. From a three-dimensional model of the Centro Cultural Tijuana that they designed on computer, they compared measurements made on site with original plans and began to design the structure. The Workshop developed a system of construction that allowed components of the structure to be augmented as it became necessary. They were able to free up openings by employing plywood for walls and surfaces, and wooden bars and planks of wood as columns and beams. After signing off on the engineering calculations, and obtaining the necessary construction licenses, the construction of the Tijuana *infoSite* got underway in July 2005.

August 2005
Press Response/ Days before the inauguration of the public phase of **inSite_05**, critical commentaries about the Tijuana *infoSite* appeared in the press. The principal criticism was the supposed "lack of authority" of the R_Tj-SD Workshop to superimpose the structure of the *infoSite* over an architectural landmark. The controversy soon dissipated once it was explained >

that the *infoSite* was only temporary and would not endanger the underlying structure of the Centro Cultural Tijuana. The negative press attention also began to shift once a more engaged debate began about the aesthetic qualities of the building and the parasitical structure that would temporarily "embrace" it.

Paul Ramírez Jonas

March 2004
Research in the Area/ During his second residency, in March 2004, Paul Ramírez Jonas became interested in the existence of post office boxes in San Ysidro. He was also influenced by keys sold in Tijuana's handicraft markets that are personalized with names and designs selected by customers. After that visit, Ramírez Jonas began to reflect upon the idea of the key as an icon, which connects public and private spheres.

May 2004–January 2005
Proposal Discussions/ Between May 2004 and January 2005, Ramírez Jonas redefined his proposal on several occasions. Nevertheless, his ideas always focused on the idea of a personal key as an icon that articulates the relationship between "open" and "closed" spaces. Throughout this period, Ramírez Jonas evaluated different strategies to relate public and private spaces. They included: the creation and symbolic distribution of the "key to the city" by changing and replacing public and private locks throughout San Diego and Tijuana and creating one master key; the construction of a window-door, which would be placed on the US-Mexico border fence as a connecting space for those who possessed the key; and dressing a tree in a park in San Diego and Tijuana with hundreds of keys. Some of these ideas were discarded, but many of them contributed to the development of Ramírez Jonas' final proposal.

January 2005
Defining the Project/ In January 2005 Ramírez Jonas returned to the San Diego-Tijuana area. As part of his research he met with President of the **inSite_05** board, Eloisa Haudenschild, and used her keys and her house to develop a narrative between keys and the spaces they access. After visiting the last surviving hardware store in downtown San Diego, Ramírez Jonas decided that his project would involve a series of public presentations that would deal with the subjects of access and trust. His aim was to promote an exercise of exchange and dialogue between members of the attending public. For this he needed a key-cutting machine, an assistant who would learn >

how to make copies of keys, and the participation of varied institutions, with diverse audiences, which would host his presentations.

June 2005
Developing the Project/ In June 2005 Ramírez Jonas began to photograph the key rings, keys, and the spaces that the keys opened of a heterogeneous group of individuals on both sides of the San Diego-Tijuana border. These images, in conjunction with his own reflections about the issue of trust and the generosity of the people participating in the project formed the content of the lectures. During this same period, a run of keys was printed that were based on a design by Ramírez Jonas. A key-cutting machine was also acquired and institutions throughout the border region confirmed their participation.

August–October 2005
Lecture Program/ Between August and October 2005, Ramírez Jonas' project unfolded by way of ten talks given in different places in San Diego and Tijuana. These talks were based on photographs that Ramírez Jonas had taken in June 2005 and dealt with the issue of access and the idea of the "key." At the end of each presentation, Ramírez Jonas invited the public to take part in an exchange of keys. Firstly, Ramírez Jonas duplicated his own house key, which was offered to a member of the attending public. That person then offered one of his or her personal keys to be duplicated. The duplicate was then given to another member of the audience. This process went on until the exchange came full circle and Ramírez Jonas received the last duplicate key of each session. Presentation after presentation, a network of access and trust developed through the exchange of the keys of those who attended the talks.

SIMPARCH

October 2004
Research in the Area/ In October 2004 Steve Badgett and Matt Lynch returned to Tijuana with a defined research topic: water and its purification for human consumption. They visited specific sites, including Ecoparque, where they studied the functioning of the collection plant and the treatment of wastewater and Fundación Esperanza México—a nonprofit agency dedicated to the development of community projects. This latter encounter enabled SIMPARCH to visit a number of Tijuana's informal communities. These experiences played a key role in the development of their proposal to create a plant to purify water using solar light that >

would reveal the problem of clean water supply in Tijuana.

April 2005
Contact with Communities/ Their interest in conducting *in situ* research prompted Badgett and Lynch to stay in Posada Esperanza in April 2005. This allowed them to interact with the communities of La Morita and the Ejido Lázaro Cárdenas. A family from each of these communities became involved in SIMPARCH's project, helping to install the artists' first table distiller prototypes in sunny areas in their homes. Each family supervised the functioning of the units and made use of the distilled water until SIMPARCH returned. At that point, SIMPARCH's project was conceived in two stages: First, to design and construct a water purification plant in the pedestrian crossing corridor at the San Ysidro Port of Entry as a kind of public fountain; and second, to donate the final water purification units to informal communities in Tijuana who lacked an adequate supply of clean water.

August 2005
Other Areas of Investigation/ Between April and August 2005, Badgett and Lynch perfected their design of a table water purification distiller and sought the advice of experts in the field. In August 2005 Badgett traveled to El Paso, Texas, and Cuidad Juarez in Chihuahua, in order to visit communities in which the use of solar-light water purification plants had been implemented. The trip played an important role in the final design of the table distiller that SIMPARCH would produce for their project, *Dirty Water Initiative*.

August 2005
Testing and Installing the Table Distillers/ In August 2005 Badgett and Lynch verified the functionality of the first water purification prototypes they had installed in La Morita and the Ejido Lázaro Cárdenas and began to mount a series of table distillers in the San Ysidro pedestrian corridor at the US-Mexico border. The Instituto de Administración y Avalúos de Bienes Nacionales (Institute of Real Estate Administration and Evaluations) approved the necessary permits to begin installation. SIMPARCH sought to insert the project within the dense circulation flows of people crossing the border by appropriating the model of a public fountain. They hoped to draw attention to one of Tijuana's most serious problems: the lack of an adequate supply of clean drinking water. The low-key installation and the relative invisibility of the piece corresponded to Badgett and Lynch's interest in focusing on basic functionality rather than other aesthetic considerations.

>

Javier Téllez

November 2004
Research in the Area/ After his first residency in the area, Javier Téllez decided that he wanted to work with two psychiatric institutions: one in San Diego and one in Mexico. His subsequent visits to the area during 2004 revolved around efforts to secure access to mental health institutions on either side of the border. After exhausting all options it became clear that a US institution was not going to agree to participate. In November 2004 Téllez traveled to Mexicali to visit the Centro de Salud Mental del Estado de Baja California (Mental Health Center for the State of Baja California). The hospital staff and the patients' families agreed to support the project and to assist in securing the voluntary participation of the patients.

April 2005
Fashioning a Proposal and Working with Collaborators/ Between November 2004 and April 2005, Téllez defined his proposal, which reflected his interest in the subject of mental and spatial borders in the context of San Diego-Tijuana. The proposal centered on the idea of holding a series of workshops involving a group of psychiatric patients. The aim of the workshops was to create an event that would include launching a human cannonball over the border fence separating Mexico from the United States in Playas de Tijuana. Téllez invited David "The Bullet" Smith to visit the area in December 2004 with the intention of involving him in the project. Due to the potential impact of the project, Smith proposed that his father, the legendary David "The Human Cannonball" Smith, should collaborate with Téllez instead. In April 2005 Smith Sr. and Téllez visited the Centro de Salud Mental del Estado de Baja California. During the visit the patients exchanged ideas with the artist and Smith Sr. about the themes of flight and borders. Téllez began to plan subsequent workshops in which the stage design, the program, and the publicity campaign for the cannonball performance would be developed.

June 2005
Workshops and Planning the Event/ In June 2005 Téllez began his workshops with the psychiatric patients of the Centro de Salud Mental del Estado de Baja California. The theme of coexistence and communion between Mexico and the United States was discussed during the workshops. The patients cut pieces of Mexican and US flags of different sizes in order to make one large collage—a "bi-national" flag that would later be used as the backdrop during the cannonball performance. Subsequent workshops in July 2005 also involved the idea of collage. The Banda del Estado de Baja California (Baja California State Band) simultaneously played the national anthems >

of both Mexico and the United States on the patio of the Centro de Salud Mental del Estado de Baja California. Given that the cannonball performance was inspired by circus iconography, another of the workshop exercises involved the patients' selecting different animal masks, costumes, and accessories. They used these props to dress up and plan their performance, which would take place prior to the launching of David "The Human Cannonball" Smith across the US-Mexico border. As part of that same workshop, the patients generated audio and video material for publicizing the event that would be broadcast on television, radio, and loudspeaker.

August 2005
The Spectacle and Launching the Human Cannonball/ On August 27, 2005, the patients of the Centro de Salud Mental del Estado de Baja California traveled by bus from Mexicali to Tijuana accompanied by family members and medical personnel. The event, with all the atmosphere of a town fair, began at 4:00 p.m. with the patients' parade from the Playas de Tijuana bullring to the stage. Passing through a dense crowd that filled the area in front of the border fence at the Playas de Tijuana beach, they followed behind a trumpeter who played "The Lost Boy." They carried homemade placards that read: "Don't scratch the tiger's balls," "The mentally ill are human too," "Living on drugs is not living," and "Down with intellectual segregation." After the patients' performance, which was conceived over the course of workshop sessions during the preceding months, "The Human Cannonball" was launched over the fence from Playas de Tijuana to the sands of Imperial Beach in San Diego.

Althea Thauberger

January–May 2004
Research and Choosing a Community/ Between January and March 2004, Althea Thauberger explored the natural desert landscapes/ecosystems in San Diego. She also attended revival Christian meetings and visited an RV park. After conversing with diverse groups of people ranging from church congregations to retirees, she decided that she wanted to work with young mothers. In late March she discovered Murphy Canyon—one of the largest military housing complexes in the world. She informally interviewed numerous people from military support organizations as well as a number of military spouses. By late May 2004, Thauberger decided that she wanted to work with military families.

>

October–November 2004
Defining a Proposal and Community Collaboration/ Thauberger was interested in developing a community choir project in which the participants would be actively involved in the development of the repertoire. She drafted a detailed proposal that was sent to numerous military spouse support organizations, Lincoln Management, who administered Murphy Canyon, and various military bodies. As a result the project garnered a number of collaborative partners from the community who agreed to help with outreach.

February–April 2005
Focus Group, Finding a Choir Director, and Outreach/ In February 2005 Thauberger held an informal focus group for military spouses in Murphy Canyon Chapel to test the level of interest in her proposal to establish a community choir. Although the turnout was minimal, the focus group was very useful. It underlined the importance of an extensive outreach campaign and highlighted possible organizations that could assist with spreading the word. During this time, Thauberger met with choir director Terry Russell who agreed to collaborate with her on the project. Establishing this relationship was vital because Thauberger would not be in the region at all times to oversee the choir rehearsals. It was therefore very important that she work with someone whom she trusted and felt shared her vision for the project. In late February Thauberger concentrated on an extensive outreach campaign and drafted a flyer advertising the choir that was distributed throughout the community. At the same time the chaplain of the Murphy Canyon Chapel offered the facility as a place to rehearse. In April 2005 the *Murphy Canyon Choir's* first rehearsal took place.

August 2005
Preview Performance/ Over the course of several months of rehearsals the *Murphy Canyon Choir*—a choir consisting of military spouses—coalesced into a core group of approximately twelve members. Although Thauberger had originally conceived of a much bigger choir, the final ensemble members were extremely committed and dedicated. By August 2005 the choir members, working in collaboration with composer-in-residence Scott Wallingford, had created five of their own compositions. Thauberger decided that it was important to hold a preview performance, which would allow the choir participants to familiarize themselves with singing to an audience and prepare them for the final performance in September.

September 2005
Final Performance and Site/ In the lead up to the *Murphy Canyon Choir's* performance, as part of the public phase of **inSite_ 05**, Thauberger surveyed the area in search of a suitable venue. She finally decided on the auditorium of Jean Farb Middle School.

The school was located in the heart of the Murphy Canyon community and could be reached by way of a narrow walkway across the canyon itself. The fact that the audience would arrive to the performance via this footpath was interesting to Thauberger. It seemed to foreshadow the fact that the audience was about to participate in something highly unexpected and it also seemed to metaphorically suggest the possibility of forging a relationship between the disparate art world and military publics that would be in attendance. Intense rehearsals took place at the venue prior to the performance. Thauberger asked Jennifer Martin from Military Outreach Ministries to provide an introduction to military life and the community of Murphy Canyon as audience members were shuttled from Balboa Park to the event. The final performance took place on September 25, 2005, at 3:00 p.m. Individuals from the military community as well as local and international art audiences attended the performance. After the recital the audience gathered in an outdoor patio area for afternoon refreshments.

Judi Werthein

April–December 2004
Defining a Proposal/ In April 2004 Judi Werthein developed the idea of creating a project about consciousness. She met with Christof Koch, Professor of Computation and Neural Systems at the California Institute of Technology and author of *The Quest for Consciousness, a neurological approach*, as well as other scientists from the Salk Institute in San Diego. She also met and conversed with fortunetellers, healers, and shamans from both sides of the San Diego-Tijuana border. During a series of working sessions in late May, Werthein discussed her idea of creating a platform for exchange and dialogue about consciousness. By December 2004 Werthein was unsatisfied with how her consciousness project was fleshing out and so she submitted an alternative final proposal. The proposal involved the creation of a limited-edition US-Mexico border-crossing shoe that would be produced in China, distributed free of charge to undocumented migrants, and sold as an "art object" in a fashionable shoe boutique.

January–May 2005
Research Process/ In order to finalize her design for her border-crossing sneaker, Werthein conducted extensive research. She met and conversed with undocumented migrants, activists, academics specialized in the field of migration, and *coyotes* who for a fee promised undocumented migrants safe passage from Mexico to the US. This research enabled Werthein to determine the key design elements of a sneaker that might potentially be used to cross the US-Mexico border. Werthein also met with **>**

various sneaker designers and manufactures. These meetings helped her to understand the complex process of producing a line of sneakers, as well as how she needed to craft her design so that it would be comprehensible to a manufacturer.

July 2005
Supervising Production in China/ In July 2005 after receiving a number of border-crossing sneaker prototypes from China that were not to her liking, Werthein decided that she needed to travel to HengJiaLi Shoes Inc to oversee the production of her shoe line herself. Although she was not permitted to enter the factory she was able to meet with designers and executives and explain her vision more clearly. The translation from design to sneaker product was hindered by communication difficulties, business protocols, and cost. Werthein engaged in a complex and challenging negotiation process, in which business models and modes of art making came into conflict.

August–November 2005
Distributing the Sneakers/ In August 2005 Werthein decided that she would distribute a number of her limited-edition border-crossing sneakers to undocumented migrants. From August through November 2005 she gave away shoes at numerous shelters for migrants who had been deported from the US to Mexico after attempting to cross "illegally." She also distributed shoes at sites along the border fence where migrants liaised with *coyotes*. At the same time, a high-end sneaker boutique in San Diego began to sell the sneakers for $215. Important art collectors from the area purchased the shoes as well as sneaker fans. The money made from the sales was funneled back into supporting the ongoing distribution of sneakers to undocumented migrants, and a donation from the sales was made to the Casa del Migrante—a migrant support organization.

November 2005
Media Attention and Public Interest/ In November 2005 the news that artist Judi Werthein was distributing border-crossing sneakers free of charge to undocumented migrants who were attempting to cross the US-Mexico border was picked up by the Associated Press and the BBC World Service. Within a matter of days the news item had spread around the world and Werthein was inundated with requests for television, radio, and newspaper interviews. She made appearances on numerous current affairs and news programs, including CNN and Fox News, and the project made the front page of the *New York Daily News*, New York's most widely circulated newspaper. **in-Site_05**'s blog became inundated with comments about the project. These ranged from virulent opposition to the project's perceived support of "ilegal" immigration to praise for the debate that it had stimulated.

Måns Wrange

September 2004–March 2005
Developing a Proposal/ In early September 2004 Måns Wrange submitted his first proposal, entitled *The Missing Word*. Arguing that "language is not merely a vehicle for communication…but also a tool of power… *that* can be used as an effective means of subjugation and control" (M.W.), Wrange sought to demonstrate that language could also be used as a positive and uniting force by inventing a new word that would be spread to the population of the San Diego-Tijuana region. However, just weeks earlier Rubens Mano had submitted a proposal entitled *Visible* that also incorporated the idea of a word that would be inserted into cross-border flows. With this in mind, in October 2004 Wrange drafted an alternative idea with the working title *The Unused Time Project* in which he explored the idea of pooling and employing unused time spent waiting to cross the US-Mexico border for a positive and creative purpose by borrowing the principles of distributed computing. By March 2005 it had become clear to Wrange that this idea was not fleshing out in the way he had hoped. Concluding that the project was over complicated, he submitted his final proposal, *The Good Rumor Project*. Interestingly, as with *The Missing Word*, *The Good Rumor Project* also involved the investigation of language as a positive socio-political tool. All three proposals incorporated the idea of small world networks as a means of disseminating the project and all sought to effect some positive social change in the region.

March–April 2005
Involving Collaborators/ In March 2005 Enrique Herrera from Metro Publicidad in Tijuana agreed to collaborate with Wrange as a marketing consultant and to help him develop a buzz marketing campaign for the dissemination of "good rumors" about people in the border region. Manuel Chavarín from VC Asociados also agreed to organize and lead a focus group in Tijuana, which would provide material for the positive rumors. By April 2005 Wrange was wrestling with the question of how to track the rumors. While initially exploring the idea of a survey, he visited and spoke with researchers from the Colegio de la Frontera Norte, but it was in discussions with Herrera that he began to conceive of the idea of tracking the rumors though a specially designed website.

June 2005
Focus Groups, Brainstorming, and Recruiting Nodes/ Between May and June 2005 focus groups took place in San Diego and Tijuana. The focus groups provided information that helped Wrange and his collaborators construct two "good rumors": one about Tijuana that would be spread in San Diego, **>**

and one about San Diego that would be spread in Tijuana. Towards the end of June 2005, Wrange chaired a working session with his key collaborators, including Enrique Herrera, marketing consultant, and focus group leaders Don Sciglimpaglia and Manuel Chavarín. In this meeting they discussed the criteria for the rumors and potential themes. Wrange also chaired a meeting designed to recruit people with broad social networks to help him spread the rumors.

June–August 2005
Constructing the Website/ From June through August 2005 Wrange worked with his collaborators in Stockholm and Dream Addictive in Tijuana to construct the website for *The Good Rumor Project*. By this time, Wrange had secured the collaboration of a variety of socially influential people—"nodes"—to help him spread "the good rumors." He was thus able to test out some initial templates of the website on them. Wrange aimed to track the profile of the participating "nodes," as well as the evolution of the rumor, both geographically and in terms of its content. By mid-August Dream Addictive was struggling to resolve certain technical issues, and key functions of the website were not yet operating. This delay was detrimental to the project. It meant that the rumor launch date had to be postponed, which affected the participating nodes' momentum of excitement and engagement with the project.

August–November 2005
Launching the Rumors and Tracking the Process/ Just prior to the launch of "good rumors" about San Diego and Tijuana, Wrange had numerous brainstorm sessions with his collaborators to finalize the content and story structure. At this time Wrange also began to work intensively with YonkeArte to produce a video that would help publicize *The Good Rumor Project*. The video-promo was shown during the closing weekend of **inSite_05** in November 2005. It was decided that the constructed rumors would not be revealed publicly so as to allow them to continue to proliferate throughout the region. As of today the rumors continue to spread and mutate through the border zone and beyond.

Related Activities

Key **inSite_05** events in which the artists, interlocutors, and curators from **Interventions** participated

Curatorial Outreach/ CCA San Francisco

Outreach/ A series of collaborative partnerships and exchanges with academic institutions and exhibition spaces dedicated to the visual arts were a vital aspect of the ongoing process of **inSite_05**. Between 2003 and 2005 the California College of the Arts in San Francisco and **inSite** established a highly productive collaborative partnership. Through a program orchestrated by Kate Fowle (co-chair, MA curatorial practice, CCA) graduate students became critically involved with both the history of **inSite** and the curatorial framework of **inSite_05**. During November 8–12, 2004, a group of students from CCA undertook a first site visit to the border region of San Diego-Tijuana.

Board of Directors Meeting/ March 2003/ Point of Departure

Board of Directors/ During their general meeting to review the development plan for **inSite_05**, **inSite**'s Board of Directors unanimously endorsed the conceptual platform for the next version of the project as well as the executive directors' proposal to appoint Osvaldo Sánchez as artistic director, Sally Yard as curator of **Conversations**, and Adriano Pedrosa as curator of the **Museum Exhibition**. The board also approved the continued engagement of the two executive directors, Michael Krichman and Carmen Cuenca. This meeting was the starting point for **inSite_05**.

Ute Meta Bauer (Curator *Transborder Archive*), Teddy Cruz, and Joshua Decter (Interlocutor)/ Dialogue 1

Liminal Zones/ Coursing Flows/ Shuddahbrata Sengupta • Teddy Cruz • Magalí Arriola • (moderator) Judith Barry/ David Harvey • Ute Meta Bauer • Joshua Decter • (moderator) Jordan Crandall/ Thursday, November 6, 2003, 9:30 a.m.–1:30 p.m./ Trustees Room, The Salk Institute, La Jolla.

This conversation focused on modes of participation in urban life. The panel considered the pulsing flows of people, messages, and meanings that throng the backwaters, and outskirts of cities, producing unofficial spaces and consensus.

Galas/ October 2004/ Haudenschild Residence

Galas/ As part of its fund-raising initiatives, **inSite** hosts a number of gala-auctions, organized by **inSite**'s President of the Board of Directors, Eloisa Haudenschild. The first fund-raising benefit for **inSite_05** involved an auction of contemporary artworks, and a never-ending flow of culinary delights, drinks, and music. Many of the artists that **inSite** has collaborated with over the years, as well as their galleries, continually support these events by contributing works of art to the auction. The event reaffirmed **inSite**'s intricate support network, enabling **inSite_05** to come to fruition.

Francesco Pellizzi (Interlocutor)/ Lecture 2

Urban and Sub-urban Borders: Airports and Museums/ Francesco Pellizzi/ Wednesday, November 17 2004, 7:30 p.m./ Instituto de Cultura de Baja California/ Av. Centenario 10151, Zona del Río, Tijuana

Francesco Pellizzi traced the relationship between airports and museums as key social spaces within urban contemporary life. In particular, he discussed their similarities as non-places and their transcendental symbolic qualities.

Raúl Cárdenas/ Dialogue 4

Urbanisms/ Raúl Cárdenas • Jose Manuel Castillo • Peter Zellner/ Centro Cultural Tijuana: Sala de lectura/ Friday, May 28, 2004, 7:00 p.m.

Three architects and urbanists from Mexico City, Tijuana, and Los Angeles discussed diverse models of urban development and their potential social impact using their own cities as critical laboratories.

Aernout Mik, Javier Téllez, and Kellie Jones/ Dialogue 5

Likenesses that Lie: Public Fictions/ Kellie Jones • Aernout Mik • Javier Téllez/ Performance Space, Visual Arts Facility, UCSD/ Thursday, November 18, 2004, 7:00 p.m.

By means of a reflection about narrative fictions on slavery in the US, Kellie Jones introduced a presentation of the work of Aernout Mik and Javier Téllez and its relationship to fiction as a critical strategy. The subsequent discussion session involved students from the University of California, San Diego.

inSite_05 Opening/ Centro Cultural Tijuana

Opening/ Although it is difficult to remember when **inSite_05** began to coalesce into a sustainable network, the public phase—or rather the launch of the exhibitory stage of the projects—was marked by a brief official inauguration. The opening ceremony took place at 7:00 p.m. on August 27 at the Centro Cultural Tijuana. A large party was held for the public and the inauguration of the *Farsites* exhibition took place.

Mark Bradford/ Dialogue 12

Reconnoiterings/ Alison Gingeras • Mark Bradford • Lauri Firstenberg • (moderator) Derrick Cartwright/ Friday, November 11, 3:00 p.m. – 5:30 p.m./ Institute of the Americas, Hojel Auditorium/ University of California, San Diego

Artist Mark Bradford presented *Maleteros*. Produced for **inSite_05**, it operated amidst the transactions and transitions of the San Diego/Tijuana border, where *maleteros*—porters—have created an efficient and largely informal micro-service business.

Gustavo Lipkau/ Dialogue 13

Encroachments/ Displacements/ Enrique Martin-Moreno • Cuauhtémoc Medina • Gustavo Lipkau • (moderator) Magalí Arriola/ Saturday, November 12, 10:30 a.m. – 1:00 p.m./ Centro Cultural Tijuana/ Paseo de los Héroes y Mina Zona Río, Tijuana

Gustavo Lipkau and R_Tj-SD Workshop intervened in the civic center of Tijuana, building the *infoSite* as a parasite to the Omnimax Cinema building at the Centro Cultural Tijuana. Lipkau and Alberto Kalach also proposed to re-figure and restore the beleaguered Tijuana River.

Måns Wrange/ Dialogue 14

The Average Citizen and Public Domain: Enclaves and Data-Dreams/ Maarten Hajer • Måns Wrange • (moderator) José Castillo/ Saturday, November 12, 3:00 p.m. – 5:30 p.m./ Centro Cultural Tijuana/ Paseo de los Héroes y Mina Zona Río, Tijuana

Måns Wrange's work probed the formation of public opinion and public domain, investigating circuits of information and networks of negotiation. Wrange turns inside-out the abstractions and fictions that come to represent ordinary citizens.

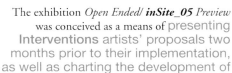

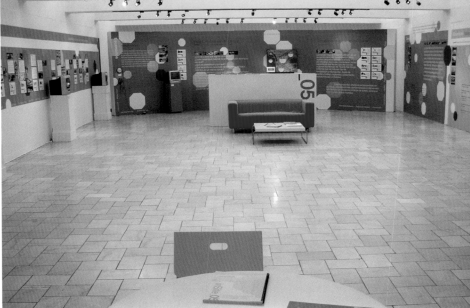

Tijuana
Instituto de Cultura de Baja California
Avenida Centenario 1015, Zona Río, Tijuana
Inauguración/ 8 de abril de 2005 8:00 p.m. – 6 de mayo de 2005

The exhibition *Open Ended/ **inSite_05** Preview* was conceived as a means of presenting Interventions artists' proposals two months prior to their implementation, as well as charting the development of other components of **inSite_05**. The exhibition was intended to help publicize **inSite_05** in the region and document the projects' complex artistic processes and unfolding collaborative partnerships. *Open Ended/ **inSite_05** Preview* was held at the Athenaeum Music & Arts Library in La Jolla and at the Instituto de Cultura de Baja California in Tijuana. The exhibition brought together information about **inSite_05**'s preliminary program: its periodic artists' residencies, dialogues, events, and the development of a series of proposals intended to simulate public domain experiences. *Open Ended/ **inSite_05** Preview* revealed and traced artistic interventions that between August 26 and November 13, 2005, would take the form of events and ongoing processes or would be accessible via documentation.

Open Ended
inSite_05 Preview Exhibition

San Diego
Athenaeum Music & Arts Library

1008 Wall Street, La Jolla, CA
Exhibition Opening/ April 1, 2005, 7:30 p.m.–May 7, 2005

*Final abierto, **inSite_05** Exhibición de proyectos*, fue una exposición concebida para presentar las propuestas de los artistas de **Intervenciones** dos meses previos a su implementación, así como avances del programa artístico de **inSite_05**. El objetivo era publicitar en la región el perfil de los proyectos y develar el complejo entramado de sus procesos de colaboración. La exposición tuvo lugar de manera paralela en Tijuana, en el Instituto de Cultura de Baja California, y en el Athenaeum Music & Arts Library en La Jolla, San Diego. *Final abierto* brindó un recorrido por el proceso de **inSite_05** previo al inicio de su fase pública, a través de esos dos años de residencias de artistas, simposios, eventos y producción de proyectos dirigidos a crear experiencias de dominio público. La muestra transparentaba, a manera de boceto, aquellos proyectos que más tarde tuvieron lugar como evento, se mantuvieron en operación, o estuvieron accesibles en documentación para el público en San Diego y Tijuana, desde el 26 de agosto y hasta el 13 de noviembre de 2005.

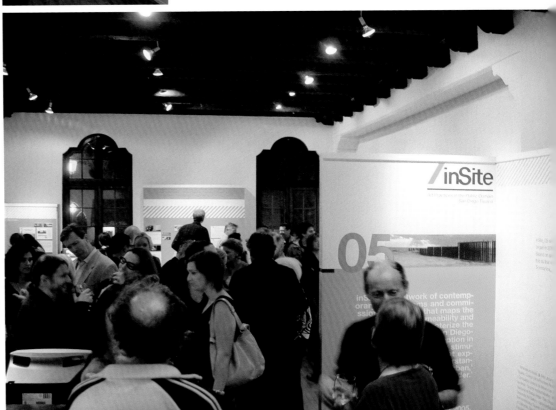

Practice is about trying, developing, cultivating, improving. Practice connotes repetition: to practice, to perfect. Practice becomes the rituals of life, continual acts of doing. And sustaining a practice—not just surviving in the business of art, but living in the space of art—means to know that the process is of greater value than the product; that the making…and even arriving at the making… exceeds the thing made, that the experience outweighs the material form.

Art-making is above all a process of inquiry. It takes skill and knowledge, valuing one's intuition and knowing that intuition is much more than a hunch, a fluke, or luck, that it is the surfacing of an inner knowledge we may not have known we possessed.

To launch into and carry out a process without a stated outcome is to allow that process of inquiry to unfold; to trust that the right way will arise; to wait, persevering through a blank open space, looking for guideposts, listening with a level of perception that enables us to move in ways we would not have found outside this process. Mary Jane Jacob/ *In the Space of Art*

→ Traducciones/ p. 274

Projects/
Interventions

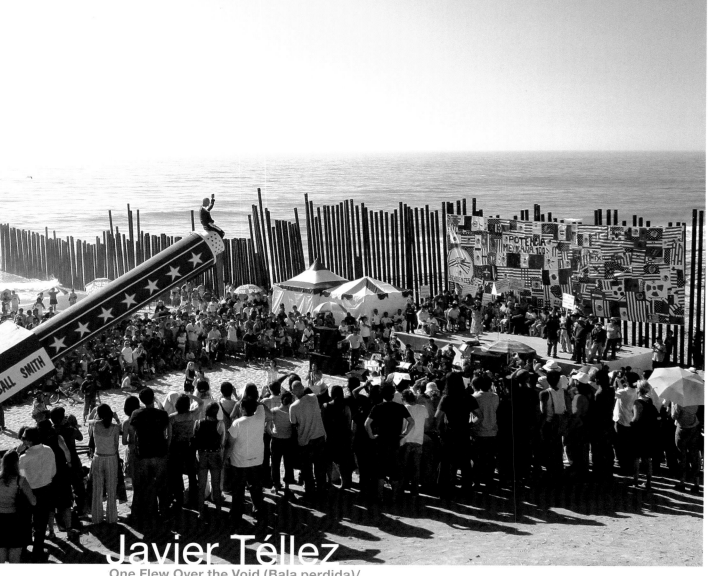

Javier Téllez

One Flew Over the Void (Bala perdida)/

Synopsis. As is a common feature of his work, Javier Téllez's project *One Flew Over the Void (Bala perdida)* involved a collaborative partnership with a group of psychiatric patients. On this occasion he worked with patients from the Centro de Salud Mental del Estado de Baja California (Mental Health Center for the State of Baja California) in Mexicali. This collaboration was initiated with the aim of co-creating an event and video recording the process and the final performance. Téllez employed the traditional circus figure of the human cannonball as a means of exploring the idea of spatial and mental borders in the context of San Diego-Tijuana. The event appropriated the model of a town fair, and climaxed with the firing of a human cannonball over the border between Mexico and the United States. During successive workshops, and an intense ongoing dialogue with the world's most illustrious human cannonball, David Smith, the patients and Téllez developed the entire spectacle, from the stage design to the music program, to the wardrobe and printed, radio, broadcast, and television publicity. The human cannonball's provocative trajectory from one country to another illustrated in a playful way the tensions inherent in the border zone. The poetic gesture was not only a political parody that garnered significant publicity, but also served to stimulate a new experience of critical association between the psychiatric institution and border demarcation. The event took place on August 27, 2005, at 4:00 p.m., where the border fence enters the sea and divides Playas de Tijuana and Border Field State Park.

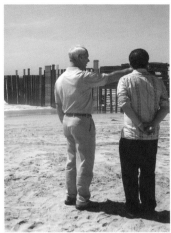

The discourse of "madness," like that of the circus, inscribes itself outside the norms of logic and common sense. Concentrating upon this peripheral language has been the focus of my work over the past decade. The convergence of the circus and mental illness is inevitable. "Madness"—like the circus—is outside the boundaries of rational norms; mental illness may be seen as liberation from the social, ethical, and linguistic boundaries imposed by society.

This is an advantage that the mentally ill share with the "trickster." They always tell the truth, as the saying goes, since they are the truth. It is important to point out that in my practice I maintain a critical approach similar to that of the tradition of the "grotesque," displaying monsters and marvels in the style of Barnum or of Tod Browning. There, the relations of object-subject and the fetishism of the other are obvious. In our case, the CESAM circus is a self-organized circus that did not attempt to exhibit pathology as a mark of difference—on the contrary: the aim was for all of us to enjoy our symptoms… and to fly over borders! J.T.

→ Otras traducciones/ p. 282

Agosto 2005/ Javier Téllez

Espectáculo y lanzamiento del hombre bala/ El 27 de agosto de 2005 los pacientes del Centro de Salud Mental del Estado de Baja California viajaron en autobús de Mexicali a Tijuana acompañados de familiares y personal médico. El evento, con ánimo de *kermesse* popular, dió inicio a las 4:00 p.m. con el desfile de los pacientes desde la Plaza de toros hasta el escenario, entre la multitud que colmaba la playa, frente a la barda fronteriza. Seguían a un trompetista que tocaba *El niño perdido* y portaban pancartas hechas por ellos mismos en las que se leía: "No le rasques los huevos al tigre", "Los enfermos mentales también somos seres humanos", "Vivir con drogas no es vivir", "No racismo intelectual". Tras el *performance* inaugural de los pacientes, concebido en las sesiones de taller durante los meses anteriores, Smith fue lanzado con su cañón por encima de la barda —desde Playas de Tijuana hacia la playa del Border Field State Park (Parque Estatal del Área Fronteriza), en San Diego.

Translated *Unfolding Process*/ p. 62

Sinopsis. Como es usual en su trabajo artístico, en *One Flew Over The Void (Bala perdida)* [Uno voló sobre el vacío (Lost Bullet)] Javier Téllez colaboró con pacientes psiquiátricos —esta vez del Centro de Salud Mental del Estado de Baja California, en Mexicali—, con el fin de crear conjuntamente un evento y registrar en video tanto su proceso como su *performance* final. Téllez trabajó sobre la idea de fronteras espaciales y mentales en el contexto de Tijuana San Diego, inspirado en la tradicional figura circense del hombre bala. El evento consistió en una especie de verbena popular, que tenía como clímax lanzar a un hombre bala sobre la frontera entre México y los Estados Unidos. A partir de sucesivos talleres de creación, y un intenso intercambio con el hombre bala más famoso del mundo, David Smith, los pacientes concibieron con Téllez todo el espectáculo del lanzamiento: la escenografía, el programa de música, el vestuario y los anuncios impresos, de perifoneo, de radio y de televisión. El llamativo trayecto del hombre bala de un país a otro permitió evidenciar de un modo lúdico las tensiones inherentes a la zona. El gesto poético del vuelo funcionó no sólo como una parodia política de gran repercusión noticiosa, sino también como detonador de una nueva experiencia de asociación crítica, entre institución psiquiátrica y demarcación fronteriza. El evento tuvo lugar el 27 de agosto de 2005 a las 4:00 p.m. justo donde la barda entra al mar, entre Playas de Tijuana y el Border Field State Park (Parque Estatal del Área Fronteriza).

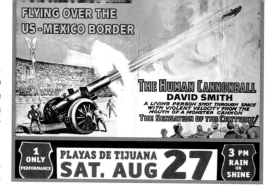

Lo carnavalesco es una de las principales estrategias de las que me valgo en mi trabajo. El elemento subversivo del carnaval, la inversión de las relaciones binarias, "el mundo boca abajo" que analizó Mikhail Bakhtin y que es, por supuesto, el motor fundamental de lo circense. El hecho de que de alguna manera sea un género cultural "del pasado" y en peligro de extinción hace al circo todavía más interesante como una forma que puede ser activada de manera política para generar nuevos significados.

El discurso de "la locura" se inscribe, como el del circo, fuera de las normativas de la lógica y del sentido común. Ha sido el foco de mi trabajo de la última década concentrarme sobre este lenguaje periférico. El encuentro entre el circo y la enfermedad mental es inevitable. La "locura" como el circo, se sitúa fuera de los límites de la normativa racional; la enfermedad mental puede ser vista como una liberación de los límites sociales, éticos y lingüísticos impuestos por la sociedad. Una ventaja que comparte el enfermo mental con el *trickster*: siempre dicen la verdad, dice el dicho, puesto que son la verdad. Es importante señalar que mantengo en mi práctica una relación crítica con la tradición esperpéntica de exhibición de monstruos y maravillas a lo Barnum o Tod Browning. Allí las relaciones de objeto-sujeto y el fetichismo de la diferencia eran obvias. En nuestro caso, el Circo CESAM, es un circo autogestionado que no pretendió la exhibición de la patología como diferencia, por el contrario: ¡Se quiere que todos disfrutemos nuestros síntomas... y volemos las fronteras! J.T.

A new idea has come up, which I hope will not be too alarming: I would like to hire a magician to perform his magic at the hospital during the residency for the TV spots. Basically it would just be an ordinary magic act. The important thing is that he should be a classic magician in a black suit with a top hat. His tricks should include making white doves and cards appear and disappear. He should also have a trunk where we can make a person "disappear." I realize that we have little time and funds, but I wanted to see if there was a chance of doing this. I don't think it would cost much if we hired a local magician of the kind that does a three-hour show at children's parties. The most important thing is to find the magician first and then we can see if we can fit him into the budget. Forgive me for improvising, but images sometimes come in a flash. A hug, Javier.
J.T./ Email/ "Re: I need a magician," July 3, 2005

The carnivalesque *is one of the main strategies that I employ in my work. The subversive element of the carnival—the inversion of binary relations, "the world upside down" that Mikhail Bakhtin analyzed and which constitutes the fundamental driving force of the circus.*

By virtue of it being somewhat a cultural genre of "the past," in danger of extinction, the circus becomes all the more interesting as a form that can be politically activated in order to generate new meanings. J.T.

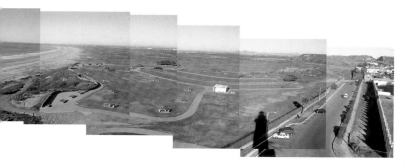

I don't want my sharp tone to be understood as a complaint on my part about your work—it stems from the difficulties and the stress that naturally arise from work complications. *I'm aware that the important thing, as far as possible, is for things to come out right at the end. But let's dream (no pun intended) the impossible too...* (Please don't put me on the infamous artists' emails notice board at the office).
J.T./ Email/ "Re: Information on Human Cannonball," June 20, 2005

I am very excited too about the aerial bypass that will break the record for the fastest border crossing: 60 kph. *Last week I went to see the Cole Brothers' Circus here in NY. They have a woman cannonball! (Ok, women "cannonballs" [ball breakers] are a dime a dozen, but this one was a real professional). The cannon car was a very beautiful sculptural object, with the U.S. flag and everything.*
J.T./ Email/ "Re: the bullet that killed Kennedy," July 27, 2004

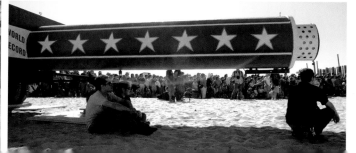

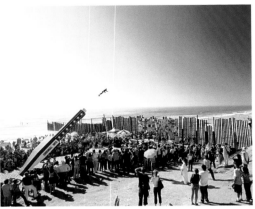

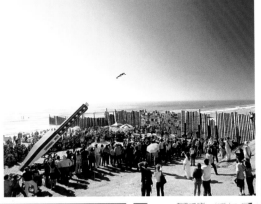

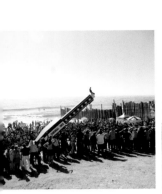

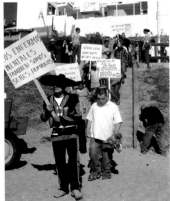

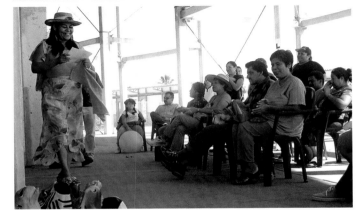

US Border Patrol agents allowed a man called the human cannonball to shoot himself across the border from Mexico to the United States. *The Border Patrol gave him special permission to do this because, as you know, they don't let just anyone cross the border.*

Jay Leno, September 8, 2005

 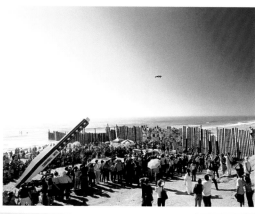 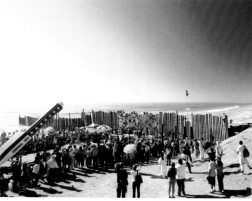 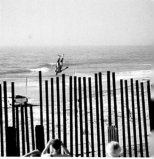

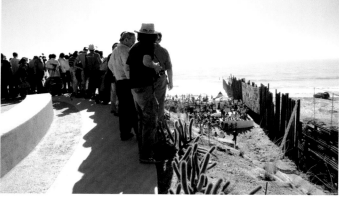 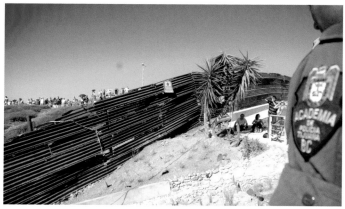

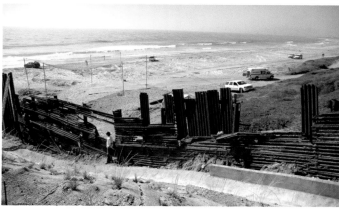 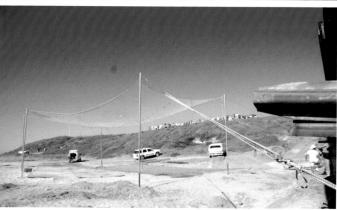

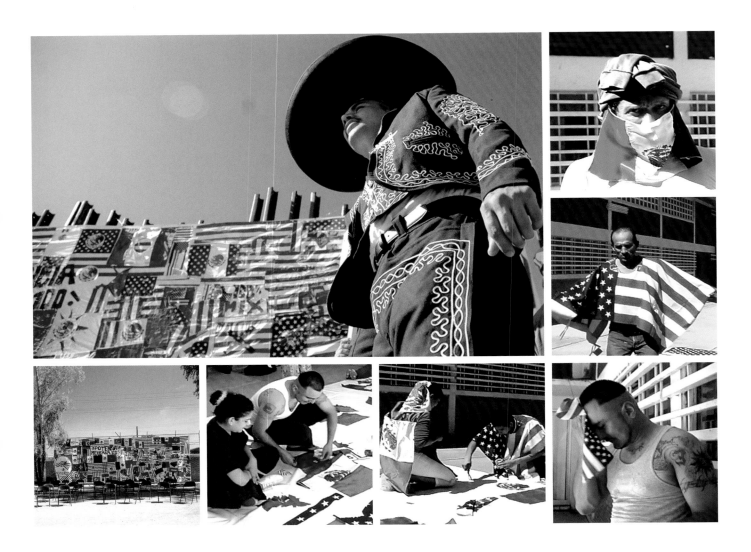

The unforeseeable pathos of madness functions here as a *Deus ex-machina*, turning the work into a mystery play, a "ritualistic" procedure in which our contractual illnesses are revealed. The dithyrambic display incarnates in and of itself the fragility of the artifice: the flag, the local police, the fence, the border patrol, the state music band, the patients, the art audience, the patients' relatives, national anthems, the neighbors, the circus fans, the art professionals. Our avoided entropies—including those that are internalized in foreseeable pockets of mental inertia—come out into the open when the marginal potential of their silencing is "publicly" exposed on "the outside."

Thus, by making use of the range of "otherness" and the subversive potential of what we call madness (or, in this case, by appropriating symbolic gestures to communicate through the arena of the circus the radical nature of other alternative logical possibilities), Téllez establishes the existing coercive correspondences between mental structure and social order, between psychiatric institution and the rule of law, between what is "borderline" and the limitations that prevail in adhering to any identity, between the carnival as therapy and the theatrics involved in the investment of power. All this unfolds while simultaneously raising questions about the contemporary art scene. O.S.

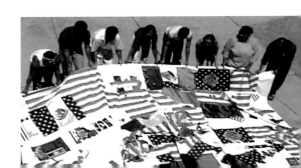

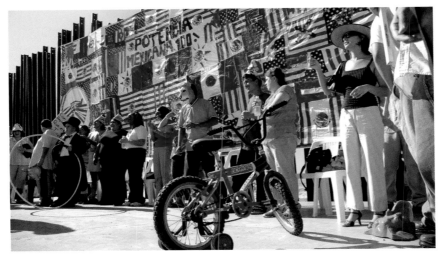

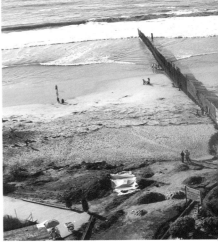

It is important to stress that the circus and the carnival when it is used metaphorically— with my ethical standards as practitioner placed at the fore—is not a topic that we should consider to be out of bounds. These retaining walls, like liminal spaces, reside in the moral abode of prohibitions that are made a priori. *The same ones that one wants to shake down and that are somehow the same color as those pigeonholes into which the deranged being has been placed.*

In the end, **the ethic of representation re-connects us with the historical theme of reforms and counter-reforms, which continues to embody itself at the border.** *This is why it may be good for our show to be on this side over here, which is to say over there.* J.T./ Email/ "....", December 5, 2005

Es importante subrayar que, mi responsabilidad ética como practicante por delante,
valerme metafóricamente del circo o el carnaval no es coto vedado. Estos muros de contención
como espacios liminales residen en la mora(l)da de las
prohibiciones a priori. *Las mismas que uno quiere sacudir*
y que de alguna manera son del mismo color que las casillas donde se ha colocado
al enajenado.

Al fin, **la ética de la representación nos re-liga al tema histórico de reformas**
y contrarreformas que precisamente se sigue encarnando en la frontera. *Por ello quizás es bueno*
que nuestro espectáculo esté del lado de acá, es decir de allá. J.T./ Correo electrónico/ "....," 5 de diciembre de 2005

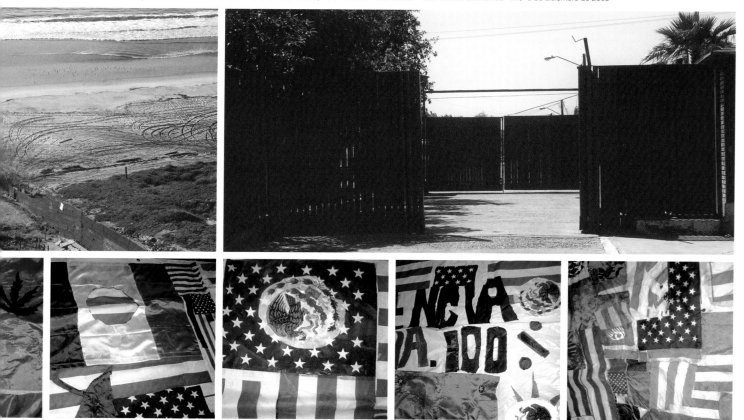

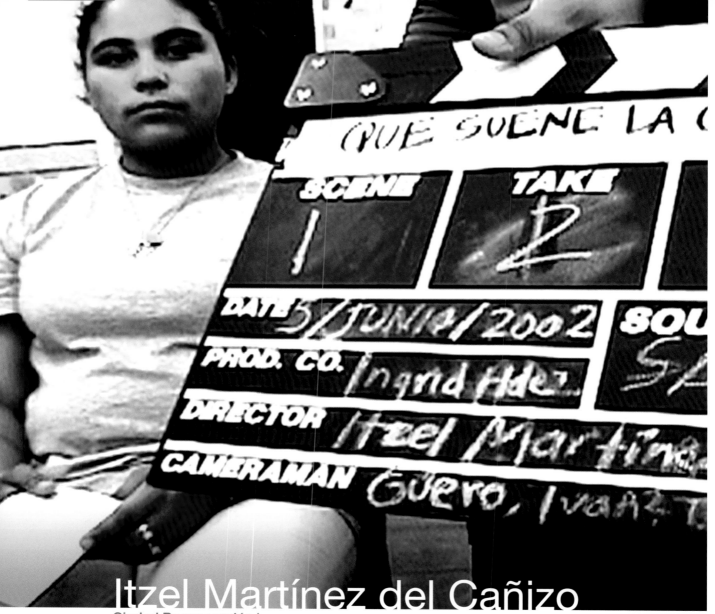

Itzel Martínez del Cañizo

Ciudad Recuperación/

Synopsis. After three years of researching and videotaping the dramatic stories of a group of young women undergoing drug rehabilitation in Tijuana (*Que suene la calle [Let the Streets of Tijuana Be Heard]*, 2003–2005), Itzel Martínez del Cañizo took on the task of creating a new video for **inSite_05** entitled *Ciudad Recuperación (Recovery City)*. As part of this new project, she worked with a group of male patients at a voluntary detoxification program for adults in Tecate. Martínez del Cañizo intervened in the center's processes of rehabilitation through the development of an imaginative game. The group of patients employed video cameras to forge personal narratives about an ideal city, imagining a dignified and inclusive place of their own, constructing a possible Tijuana that would be reinvented according to the desires and ideals of its recovering citizens. In addition to the patients' vision of an ideal city, *Ciudad Recuperación* also includes, in contrast, the testimonies of another social group: upper- and upper-middle-class women of Tijuana. The recovering drug abusers who use the video camera to explore and represent the ideal conditions for their social inclusion is conjoined with interviews with women from Tijuana's privileged classes. These women also imagine and describe an ideal city where they have a place. *Ciudad Recuperación* functions as an essay on the utopia of belonging within the context of the social reality of Tijuana.

Images: Color stills from *Que suene la calle*/
Workshops at Ciudad Recuperación (in color)
Working sessions with artists from the area>
Imágenes: Fotos fijas a color de *Que suene
la calle*/ Talleres de colaboración en Ciudad
Recuperación (a color)/ Sesiones de trabajo
con los artistas del área

La intención principal de mi trabajo radica en construir una plataforma de relaciones concretas para revertir su manera de pensarse a sí mismos reflexivamente, y con ello iniciar un juego con cámara de video en donde se permitan, en una confidencia colectiva, la libertad de definir el rostro de la realidad que desean: crear una video-realidad a la medida. I.M.C.

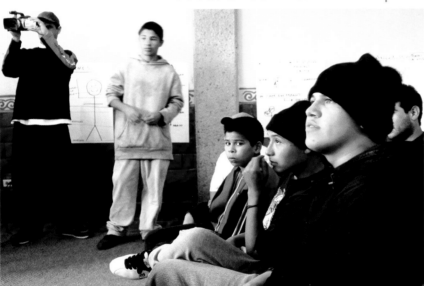

Abril 2004/ Itzel Martínez del Cañizo

***Que suene la calle*, un proyecto por finalizar/** Desde el año 2003 Itzel Martínez del Cañizo investigó y filmó en video la vida de mujeres adolescentes en programas de rehabilitación por uso de drogas en Tijuana. Titulado *Que suene la calle*, el proyecto contaba en abril de 2004 con un corto promocional y una buena parte de material ya grabado y editado, faltando aún material por grabar y producir. La invitación a Martínez del Cañizo para participar en **inSite_05** proponía la finalización de ese video y la comisión de un nuevo proyecto.

→ Otras traducciones/ p. 280

Translated *Unfolding Process*/ p. 58

Sinopsis. Tras haber investigado y filmado en video durante tres años la historia dramática de jóvenes mujeres internas en programas de rehabilitación de drogradicción en Tijuana (*Que suene la calle*, 2003-2005), Itzel Martínez del Cañizo creó un nuevo video para **inSite_05**: *Ciudad Recuperación*. En este nuevo proyecto trabajó con los hombres internos en un programa voluntario de desintoxicación para adultos, interviniendo sus procesos de rehabilitación a través del desarrollo de un juego de ficción. Los internos, cámara en mano, forjaron en grupo una narrativa personal en torno a la ciudad ideal, donde ellos imaginan un espacio propio, digno, integrado: una Tijuana tal vez posible, que se reinventa a la medida de los deseos e ideales de sus habitantes en recuperación. Además de esta visión de los internos de *Ciudad Recuperación,* el video contrapone el testimonio de otro grupo social formado por mujeres de la clase alta y media alta tijuanense. La manera en que los drogadictos de *Ciudad Recuperación* autorrepresentan las condiciones ideales de su reinserción social es intervenida con entrevistas a mujeres de un sector privilegiado de esta ciudad, quienes a su vez imaginan la misma ciudad, igualmente ideal, donde se ven personalmente integradas desde su propia perspectiva. *Ciudad Recuperación* funciona como un ensayo sobre la utopía de la pertenencia en el marco de la realidad social de Tijuana.

Strategies for survival and social inclusion vary depending on diverse factors, such as economic status and opportunities for education. Frequently, that search for social inclusion and belonging brings with it experiences that, for many, may be alienating. With *Ciudad Recuperación* Martínez del Cañizo attempts to stimulate new codes of inscription and cohabitation among individuals with diverse backgrounds and interests. By posing the question:

"What would your ideal city be?" and suggesting the fictitious construction of an alternative reality, the project inspired a dis-alienating experience. Individuals' imaginations were reawakened as they explored the idea of reaching a communal consensus. T.R.

Images: Stills from *Ciudad Recuperación*/ Workshops and production process> Imágenes: Fotos fijas de *Ciudad Recuperación*/ Talleres y proceso de producción

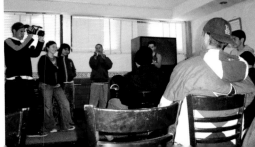

On the one hand, a group of men in a drug rehabilitation center drew up a constitution for the city and, camera in hand, acted out a day in this new life. For their part, a group of middleclass women forged their ideal city through words. The two groups created a new reality, visible only within the confines of this video. I.M.C.

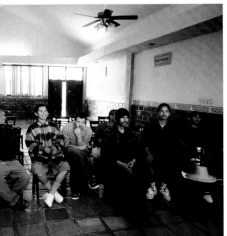

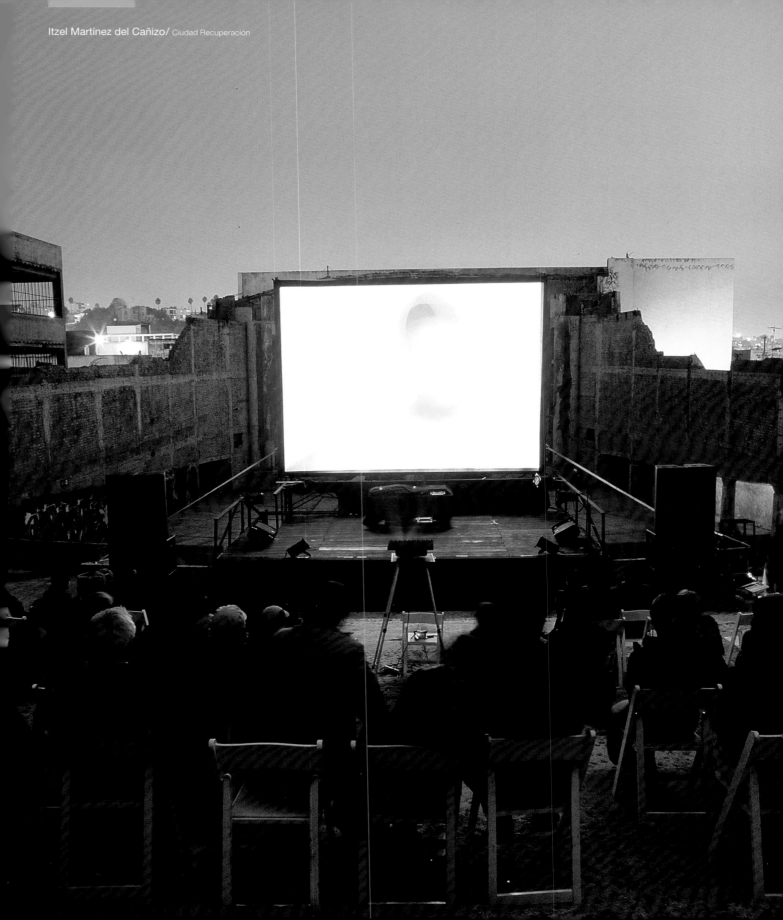

A self-representational approach implies that the collaborators will take a personal interest in the work that is created. This is the key element for the video-game to begin to exist. Here, the power of discourse and its range is not up to me alone; rather, it is shared and negotiated by the participants' own choices regarding themselves and their lives. Much joint work is required to reach such a degree of intimacy. We become accomplices, confidants, and momentarily even friends. **The key, to my mind, is my sincerity, my personal and profound interest. So that, more than an element that engenders vulnerability, I believe it to be the master key for accessing those very problematic worlds.** An external perspective, an innovative approach, and good intentions are always welcome. Before making a decision, I start by listening and observing over a long period of time. I enjoy seeing everything that unfolds before me, but I pay most attention to the narratives they construct about themselves through their unconscious actions, in their daily acts, in daily conversations, in their contradictions. I try to base my choices on all of that, so that my voice, which is implicit in the work, becomes a synthesized weaving together of all that I was able to see and read during the experience in the field and of the choices that they consciously made concerning themselves. I.M.C.

I have decided to intervene using the healing dynamic of art and the development of a game in which patients of the rehabilitation center, using a video camera, will build a fictitious new possibility for themselves and their environment: designing, with complete creative freedom, a new city. **Their own city. A city that is both a product of Tijuana and a denial of it.** That is reinvented according to the desires and ideals of the patients. Conceptually appropriating the name of the rehabilitation center to symbolically construct a videoreal city.

Images: Film premiere at Multikulti/ Still from *Ciudad Recuperación*> Imágenes: *Premiere* en Multikulti/ Foto fija de *Ciudad Recuperación*

The drug addicts at Ciudad Recuperación that have lived on Tijuana's streets have built a reality based on their own patterns and value (anti-value) structures, that in the street are generated and continually transformed. Their codes of thought and language thus grow out of elements that define the realities of the street. Without losing sight, at the same time, of the fact that it is they who transform the culture of the street in a constant process.

I'm not interested in investigating the life histories that have brought this group of men to a rehab center. But taking these experiences, now an integral part of their worldviews, as a starting point, to then intervene in their own subjectivity (adults with great experience in the world of addictive mental fiction).

The main intention is to build a platform of concrete relations through which to invert their way of thinking about themselves and initiate a game with the video camera in which patients enjoy the freedom to define the face of the reality they desire, in an environment of collective trust: create a custom video reality. By using the video camera as an instrument to tell stories and to legitimate realities (from fiction to documentary) I hope to generate an encounter with the other, and with the other, a series of specific interactive processes. I.M.C./ Statement

Las estrategias de supervivencia e integración social varían dependiendo de diversos factores entre los cuales se encuentran el estatus económico y las oportunidades de educación. Frecuentemente esa búsqueda por integrarse y pertenecer, conlleva experiencias que para muchos pueden resultar enajenantes. *Ciudad Recuperación* se propone como el vehículo para estimular nuevos códigos de inscripción y convivencia entre sujetos con intereses e historias diversas. Al plantear la pregunta:
"¿Cómo sería tu ciudad ideal?" y sugerir la construcción ficticia de una realidad alternativa, el proyecto desata un ejercicio desalienante en el que la imaginación individual es fomentada con la idea de alcanzar un consenso comunitario. T.R.

According to the National Addictions Survey, Tijuana is the number one city for drug consumption. It should not go unnoticed that the city is situated at the US-Mexico border crossing, the most heavily trafficked border in the world. It is for that reason that I have decided (for the development of this artistic project [based on self-representation]) to intervene in the dynamics of a place where change is attempted from the perspective of Tijuana's citizens: a rehabilitation center curiously named Ciudad Recuperación.

I.M.C./ Statement

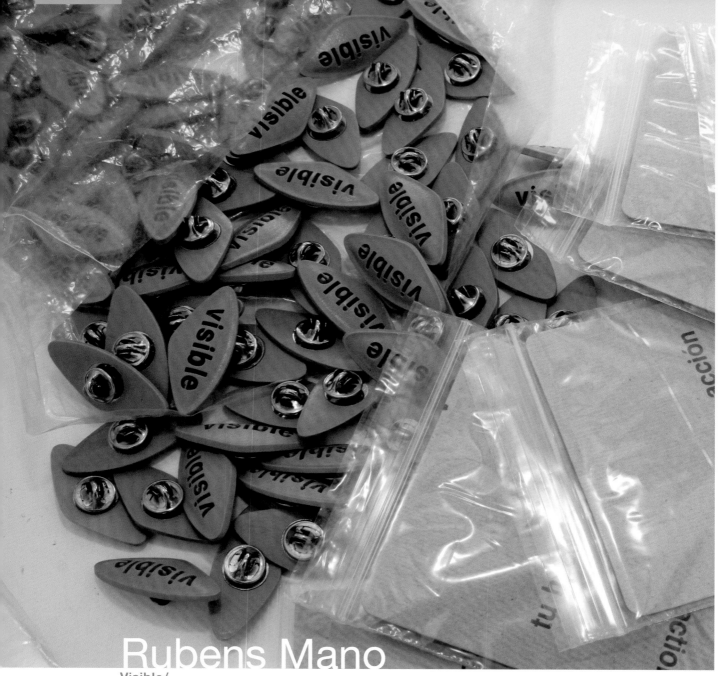

Rubens Mano

Visible/

Synopsis. Rubens Mano developed a low-profile artistic action, which he sought to locate within pre-existing transborder flows. His project, entitled *Visible*, considered the creation of a limited-edition pin, which was introduced into the cross-border flow of commuters (individuals who travel from Tijuana to San Diego everyday in order to work or go to school). *Visible* involved the complimentary distribution of a pin, which was accompanied by a text that related the project to the cross-border flows of the region. With every new pin distributed a submerged network of association developed among the recipients of the pin. The purpose of the project was to reveal and delineate the presence of less visible narratives existing within border flows. *Visible* was developed through a process of intense personal interchange between the artist and a group of volunteers. Mano decided to maintain the project's presence in the area via a website—**www.visibleproject.org**—which would ensure the possible evolution of new channels of pin distribution and access after **inSite_05**.

The creation and insertion of a sign in the urban fabric allows for the possibility of constructing another territoriality within certain urban flows and narratives. It is possible to comprehend the project in terms of everyday relationships, but perhaps it can only be fully perceived within the field of the visual image. R.M.

Images: Research process/ Icon-signs and their distribution> Imágenes: Proceso de investigación/ Señal-*pin* y registro de su distribución (a color)

Marzo–Agosto 2004/ Rubens Mano

Propuesta de proyecto/ Durante su segunda residencia en marzo de 2005 Mano visitó las oficinas del Grupo Beta y la Casa del Migrante en Tijuana, y sostuvo intensos intercambios acerca de la vida en la frontera con varios artistas del área. En agosto de 2004 Mano presentó su propuesta. Aludiendo a una empatía con el fenómeno del *commuter*, el proyecto consistía en la creación e inserción de una señal identitaria en la corriente de los flujos fronterizos; y ello con el fin de identificar las posibles narrativas existentes en su interior. La señal —un *pin* o broche grabado con la palabra "visible"— sería distribuida gratuitamente por un grupo de estudiantes en sitios estratégicos de esta área.

→ Otras traducciones/ p. 279

Translated *Unfolding Process*/ p. 57

www.visibleproject.org

The nature of certain flows and narratives created on the edge of the geopolitical maps of Mexico and the US, principally the result of contact between two different yet interdependent cultural structures and economies, is the setting for my proposal. Essentially the project focuses on the degrees of correspondence that exist between the occurrence of "unannounced" systems and the formation of "places." A context that may be understood in the grounds of everyday relations but can only be perceived in the field of the image.

Sinopsis. Rubens Mano concibió una acción de bajo perfil que buscaba una amplia dispersión exponencial al interior de los flujos fronterizos. Su proyecto, titulado *Visible,* consistía en la creación e inserción de una señal en la corriente de los *commuters* [personas que viajan diariamente para asistir a clases o al trabajo, en este caso, de un lado de la frontera al otro]. *Visible,* comprendió la distribución gratuita de una señal-*pin* —acompañada de una breve misiva— haciendo de cada persona que la recibía y/o distribuía un agente constitutivo de esa alianza sumergida que se conformaba como red. Una red en perpetua expansión y movimiento, formada por los portadores y/o distribuidores del *pin.* El propósito era revelar, o delinear, la presencia de otras narrativas existentes, no tan visibles, al interior de los flujos fronterizos. Este proyecto fue desarrollado como un intenso intercambio personal entre el artista y un grupo de voluntarios. *Visible* se propuso mantener su presencia en la zona a través de un sitio *web* en Internet —**www.visibleproject.org**— que garantizara nuevos modos de distribución y acceso a la señal-pin, posteriores a **inSite_05**.

Titled *Visible* (a word that has the same meaning and spelling in English and Spanish), the project proposes the visualization and construction of "another" territorial dimension in the flow that permeates the region San Diego-Tijuana. Intermediated by a network of "agents/operators," the proposal arises not with the intention of vindicating or creating an *a priori* image of any one social group but to implement a "territorial device," which will enable different social groups to experience an encounter in the course of daily relations.

The action consists of the creation and insertion of a signal, or image, into certain cross-border flows with the purpose of revealing, or delineating, the presence of many other, less visible narratives and systems. The signal—designed with the word "visible"—will not be associated with a product or concrete referent, company or campaign, but will point towards the delicate relation between artistic interventions into the field of social relations and the identification of these with the daily manifestations which they seek to approach.

Designed to "propagate" or "interrupt" the image, the pieces (or supports) are indelibly associated with the unleashing and eventual sustaining of the action, relating the enflaming of the "territory" to a certain type of inscription (of whoever bears the word) and the transformation of the user in "agent," bearer of a "visibility."
R.M./ Statement

Visible suggests communication between apparently distinct identities. Waiving translation, the use of this word seeks to inscribe the wearer inside another network of relationships required for transposing a space exhausted by immediate readings. R.M.

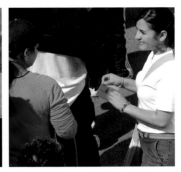

La naturaleza de determinados flujos construidos en el borde de los territorios geopolíticos de México y Estados Unidos, principalmente los relacionados con el contacto entre dos estructuras culturales tan distintas, se presenta como el paisaje de interés para mi propuesta. En un plan más aproximado, las intenciones del proyecto estarían ligadas a los grados de permeabilidad existentes entre esos flujos y los territorios en los cuales se insertan.

Denominado *Visible* (palabra con el mismo significado y la misma ortografía tanto en inglés como en español) el proyecto propone la "visualización", o "construcción", de una red de "agentes" capaces de aflorar la presencia de un eventual flujo social subliminal. El propósito no es reinvindicar o calificar esa visibilidad, ni proveer una imagen *a priori* de un posible conjunto, sino evocar la existencia de un campo aglutinador de anhelos y deseos no explícitamente manifiestos en las relaciones cotidianas.

Por tratarse de un hecho subliminal a los procesos sociales establecidos y mantenidos entre los dos países, la "visibilidad" de esa otra red sería alcanzada solamente en el tiempo y estaría condicionada a la adhesión y concordancia de los usuarios a las ideas del proyecto.

La acción consiste en la creación e inserción de una señal o imagen en el interior de determinados flujos fronterizos, con el propósito de revelar, o delinear, la presencia de otras narrativas existentes no tan visibles.
R.M./ Propuesta

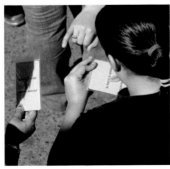

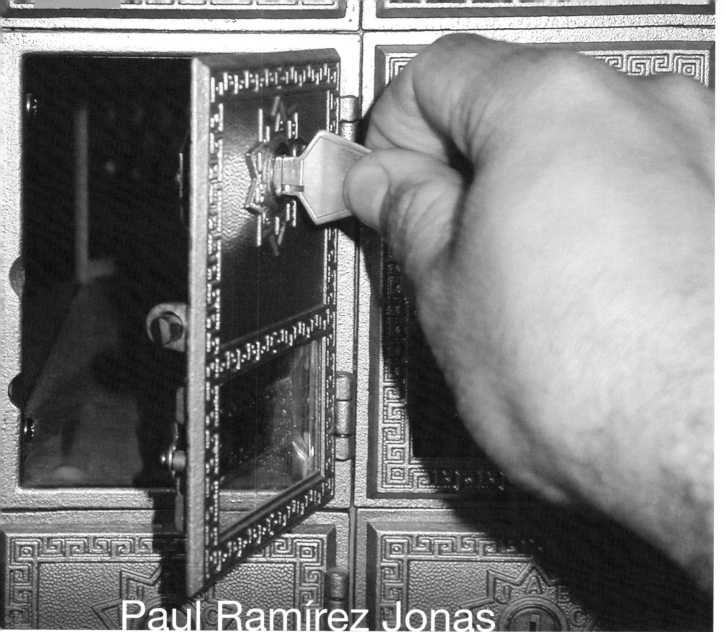

Paul Ramírez Jonas
Mi Casa, Su Casa/

Synopsis. With *Mi Casa, Su Casa (My House, Your House)*, Paul Ramírez Jonas developed a series of public presentations to promote a dialogue on the definitions of access and trust. *Mi Casa, Su Casa* manifested itself as a program of talks on how we experience the limits between public and private space, and what is consigned as "open" or "closed" space. Ramírez Jonas employed the icon of the personal key as the center point of interaction for his illustrated talks. At the end of each talk, the artist, equipped with a key-cutting machine, initiated a multiple exchange of copied keys between those in attendance. As each audience member consented to swap his or her key, allowing it to be copied, each received in exchange the copy of a key belonging to someone else. *Mi Casa, Su Casa* put into practice an exercise of trust between strangers. The key, representing the possibility of access, gave rise to a dialogue about reciprocity and faith in others. Presentation after presentation, an imaginary network of access and trust was created. Public and private realms were exposed in the individual gesture of this key exchange and in its narration. For this reason, perhaps, *Mi Casa, Su Casa*, as an artistic proposal, began at the point where each presentation ended. The talks were given between August and October of 2005 in venues throughout San Diego and Tijuana.

It begins with a photo of an individual. It continues with a photo of their keychain on the palm of their hand. It ends with an individual photo of each key in the keychain paired with the space/object it unlocks. At the conclusion of each lecture the attending public will be invited to exchange keys with the artist and each other. All the equipment necessary to duplicate keys will be available, along with blank keys engraved with a symbol of trust and generosity. Anyone willing to have one of their keys duped onto these custom keys, will receive someone else's key in exchange. As the exchange can be anonymous, the security provided by the keys does not have to be undermined. P.R.J./ Statement

Agosto–Octubre 2004/ Paul Ramírez Jonas

Programa de conferencias/ Entre agosto y octubre de 2005 Ramírez Jonas desplegó su proyecto a través de diez charlas en distintos recintos tanto en Tijuana como en San Diego. Las pláticas partían de las fotografías tomadas en junio de 2005 para hacer un relato acerca de los distintos niveles de acceso y lo que puede considerarse como "llaves". Al finalizar cada presentación, Ramírez Jonas invitaba al público asistente a llevar a cabo un ejercicio de intercambio de llaves. Esta acción comenzaba siempre con la llave de la casa del artista, que era duplicada y ofrecida a uno de los asistentes. Éste daba una llave propia a cambio, a su vez duplicada y el duplicado era obtenido por la siguiente persona en la línea, siendo Ramírez Jonas quien se quedaba con el último duplicado de cada sesión. De esta manera, presentación tras presentación se iba creando una creciente red imaginaria de acceso y confianza con las llaves anónimas de aquellos que asistían a las charlas.

Images: Research process and residencies/ Lecture (in color)> Imágenes: Proceso de investigación y residencia/ Foto de una charla (a color)

→ Otras traducciones/ p. 281

Translated *Unfolding Process*/ pp. 60–61

Sinopsis. Con el título de *Mi Casa, Su Casa*, Paul Ramírez Jonas concibió una serie de presentaciones públicas capaces de accionar una experiencia de diálogo en torno a las definiciones de *acceso* y *confianza*. *Mi Casa, Su Casa* se manifestó como un programa de pláticas sobre cómo vivimos los límites entre espacio público y privado, y qué se consigna como espacio "abierto" o espacio "cerrado". Estas pláticas ilustradas tuvieron en el icono de la llave personal su centro de interrelación. Al final de cada plática el artista, provisto de una máquina duplicadora de llaves, inducía a un intercambio múltiple de llaves copiadas entre los asistentes. Al acceder parte del público a intercambiar su llave, permitiendo que fuera copiada ahí mismo, recibía a cambio la copia de la llave de alguien más. *Mi Casa, Su Casa* ponía en práctica un ejercicio de confianza entre extraños. La llave como representación de la posibilidad de acceso era el vehículo que daba pie a un diálogo sobre la reciprocidad y la fe en el otro. Presentación tras presentación se fue creando una red imaginaria de confianza y de nuevos accesos. El dominio de lo público y el dominio de lo privado se manifiestaron expuestos en el gesto individual de este intercambio de llaves y en su relato. Por eso quizá *Mi Casa, Su Casa* como propuesta artística comenzaba ahí donde terminaba cada presentación. Las pláticas fueron impartidas entre agosto y octubre de 2005, en sedes diversas de Tijuana y San Diego.

I really do want to give one of the talks at the jail and would prefer to be as accommodating as need be rather than cancel it. Your idea, Tania, of leaving a key along with their belongings (that they receive when they are released) strikes me as very, very intelligent, creative, charming, brilliant.

My internal deadline for finishing the design for the keys is next Friday. I have experimented with images similar to those we saw at the office (hands offering or receiving keys) but not drawn like icons, rather as sketches of specific hands. The difference is very subtle but effective. The language is no longer so authoritarian—it's more intimate. The drawing is no longer disposable but more like a small miniature that one admires.
P.R.J./ Email/ "Re: about jail," June 29, 2005

Images: Research and documentation/ Digital collage and graphics by the artist/ Final key>
Imágenes: Investigación y documentación/ Montaje digital y gráfico del artista/ Llave definitiva.

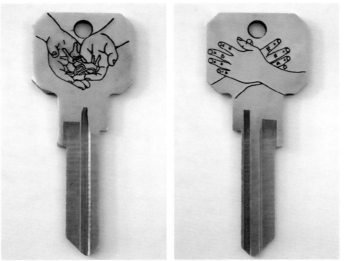

I like the implication of a continued life for the piece. You could imagine that it will go on and on, "opening" doors in the cities. It is doable. It is impervious to people saying "No" because if someone says no we can just move on to someone else. We've just got to make an initial chain of 10. It makes a postman just as interesting as a mayor because the importance of each person is relational not "essentialist." It would be great if some of our 10 are there as themselves, as citizens, and some are there as the institution they embody. In other words some people give up a key to their personal life, while others give up a key to their business or the institution that they represent.

P.R.J./ Email/ "Re," April 12, 2005

Images of the lectures> Imágenes de las charlas

Lecture Schedule> Calendario de charlas

AUGUST> AGOSTO

- **Tuesday> Martes 23, 6:00 p.m.**
 Centro Cultural de la Raza/ SD
- **Wednesday> Miércoles 24, 12:00 p.m.**
 Fundación Esperanza/ TJ
 (Hope Foundation)

SEPTEMBER> SEPTIEMBRE

- **Friday> Viernes 23, 4:00 p.m.**
 Centro de Protección a la Niñez, DIF/ TJ
 (Child Protection Center)
- **Tuesday> Martes 27, 11:00 a.m.**
 Penitenciaría de la Mesa/ TJ
 (La Mesa Penitentiary)
- **Wednesday> Miércoles 28, 7:00 p.m.**
 Instituto de Cultura de Baja California/ TJ
 (Baja California Cultural Institute)
- **Thursday> Jueves 29, 4:00 p.m.**
 The School of Art, Design and Art History,
 San Diego State University/ SD

OCTOBER> OCTUBRE

- **Tuesday> Martes 18, 7:30 p.m.**
 Athenaeum Music & Arts Library/ SD
- **Wednesday> Miércoles 19, 6:00 p.m.**
 Tijuana River National Estuarine Research
 Reserve/ SD
- **Thursday> Jueves 20, 7:00 p.m.**
 Woodbury School of Architecture/ SD
- **Friday> Viernes 21, 8:00 p.m.**
 El Lugar del Nopal/ TJ
 (The Nopal Cactus Place)

inSite has also been very keen on choosing and stirring me towards ideas that rely heavily on **inSite**'s role as a producer. I want an honest and realistic assessment on your part. Have the logistics and ambitions of all these projects overwhelmed **inSite**? I don't want to compromise the quality of my work and I need to know if I need to think of this as something I can make by myself, with the budget provided, or can I still rely, and to what extent, on **inSite** to produce substantial aspects of the piece.

I just want to be clear about what I have to work with...
I think we can still do something great.

Where would contemporary art be without having embraced failure as a strategy?

P.R.J./ Email/ "The mayor has been overthrown," April 27, 2005

MI CASA, SU CASA/ Lecture
Paul Ramírez Jonas

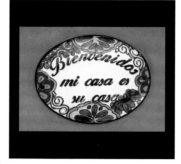

■ Welcome to this lecture. It is called *Mi Casa, Su Casa*, which is a lecture and also a work of art. It begins with portraits of people who live in this area of Tijuana and San Diego—the border area. ■ One of the first people I would like to introduce you to is called Oscar. ■ Oscar is standing in Border Field State Park, which is where he works. Like many people in this area he has dual nationality. He is a part of both countries. ■ Mostly, he lives in San Diego but he has family in Mexico as well as a house in Mexico; and so, because of that, he has two sets of keys. ■ One set of keys is for the United States, which is the green area over this line. You can actually see the border here; and the other set of keys is for another country, for Mexico, which is below that line. I asked him to show me one by one, all the keys in his keychain; and to show me what they open. ■ The first place where he took me with the first key of his American keychain was his

home in San Diego. In many ways, it is very beautiful and typical Southern California home. ■ On the left side of the house is a gate that is never locked; and leads to his organic vegetable garden. It is quite beautiful and has a drip irrigation system. ■ There is an identical and symmetrical door on the right side of the house. It leads to his organic orchard—where he grows these beautiful peaches. I think that they were ripe, but he didn't give me any. ■ Oscar has many loves and hobbies. He is an amateur architect, an avid motorcycle driver, a woodworker and he rides an airplane and a boat. He took me to the incredibly compact and small workshop he has at home. There he showed me the key to one of his most precious possessions: his motorcycle. He loves everything to do with freedom and fast movement. ■ This key you see

here, gives access to an extremely tidy closet where he keeps all his tools. ■ As part of his job—he has a really interesting job working for the state park service—, he has a state government master key that opens every exterior door of the Border Field State Park visitor's center. For example, the small key opens the back rooms and unlocks the bathrooms at the beginning of the day. It also opens: the video library where they store documentation and A.V. equipment, the library where different kinds of lectures happen, the actual main doors that the public goes through to enter the center, a utility closet where electrical and plumbing and AC are controlled, doors that go to classrooms, and storage closets. Essentially, it is a master key.

■ This other small key is pretty interesting as well. It separates the public parts of the public building from the staff parts of the building. The key controls these three doors: one behind the visitor center's reception desk, a side entrance for the employees, and Oscar's office. So basically with that key, the inner core of the building that is reserved for the staff is locked away from the visitor's part of the building. ■ This seemingly humble and innocuous looking key is a California State Park service master key. It opens a series of identical padlocks throughout the state of California. These padlocks lock gates that block roads that lead into different parts of the park system. In this instance, it simply controls access to the parking lot to the visitor center. But I have to stress the power of this small key: it can open any gate, closing any road, in any state park in California because all of the padlocks are identical. ■ What is interesting about Oscar's keys is that many of his keys don't actually belong to him.

He is the keeper of these keys because he works for the public; and as our representative, he has access to public land and public property. He is the keeper of the keys for places and property that actually belong to us—the public. Simple things, such as the van that he drives to work and around the park are owned by the state. The vehicle is opened with this key over here on the left. ◼ Inside the van, you find another kind of key. Slowly, conventional keys like the ones we have in our pockets right now are being replaced by new technologies. The key inside the van is a transponder, and it is a key that actually opens the door between Mexico and the United States. ◼ With this key, these sensors over here detect that it is Oscar and his van coming through. A camera double checks the identity of the driver to the code of the transponder, and it allows Oscar to cross from Mexico into the United States quickly through an express lane—without having to stop at a checkpoint. If you think about it, it is a key with a surprising amount of power. ◼ Oscar continued his tour of the spaces that he can unlock for me. He took me to another gate that he thought he could open with the small California state park key; but instead there was a combination padlock. There was nothing to worry about. In this case, the key was a series of numbers that is stored in Oscar's memory; he simply keyed it in and opened the gate for me. ◼ Understandably, he asked me not to show you these numbers. Unlike a conventional key that would have to be in your possession and in turn you would have to take to a hardware store to be copied, seeing these four numbers would mean that the key had already been duplicated—it would be enough for you to memorize the combination and possess the same access that he has. ◼ Finally, he took me to this remarkable gate. He was going to open with his "Fish and Wildlife key." His "Fish and Wildlife key" grants him access to federal land. That is because the federal government controls the fish and the wildlife, while the state park land is controlled by the state of California. The piece of land that he wanted to

show me is actually a piece of land that he could have also opened with the small state park key, which opens this small padlock over here, which you will recognize as being identical to the one on the gate of the parking lot. Border Patrol also needs to access this land, as it is right on the border. Thus, they have added their own padlock. The military have training grounds through here, so they have their own padlock as well. Finally, there are some road improvements being done. A construction company needs to open the road and they have added their own padlock. The way to solve the problem of access to this land that is not in dispute, but that is controlled by several different players, is to extend the links of the chain with locks. As long as you can open one of the links of the chain, you have a way into this road. ◼ Here you see the gate in question and the road. The road actually leads to a special place called Friendship Park, which has public amenities, which Oscar can also open. ◼ This is a men's bathroom, that is opened with the small state park key in Oscar's keychain. ◼ Friendship Park made me think about what happens when there are more locks than keys. This is a park that sits right on the border. It is a public park that at the moment is not open to the public due to the current situation between these two countries. The situation is one where one country is trying to lock the other country out of its territory.

The result is that the fence that separates the two splits the park in half, and because they haven't figured out exactly what they are going to do with this current fence that is too easy to cross, or the new fence that is too wide and would swallow the park whole… the temporary solution, is to not let anyone into the park. It has become a no man's land. ◼ In this park, there is a monument to the friendship between the two countries. It has become an inadvertent but fitting monument to the situation between these two nations. The obelisk finds itself wedged in the fence separating the two countries. It is like a key inserted and stuck in a lock. ◼ You can see

him to come up with a vehicle that would take us into that space. He went further and invented the airlock. That's because he wanted our bodies to leave the spacecraft and belong to space… He wrote: "The Earth is the cradle of the mind, but we cannot live in a cradle". He was a unique visionary who died without ever seeing any of his dreams come true. He left a number of drawings like this one where astronauts are floating around and looking at the stars through windows. ■ We had to wait a few decades until Hermann Oberth published a book on space travel that was widely read, accepted, and believed. At last people began to think: "We can do this. We can build one of these keys. We can open outer space". ■ Still, we had to wait a little longer until 1926, when the American Robert Goddard built the first functioning key or rocket. It didn't really open space. It couldn't quite leave the atmosphere, but we had it. We had it. We had something that actually worked. ■ Finally, during World War II, as an instrument of war, Dr. Werner von Braun designed and made the V2 rocket. After the war, it was used to create the first rocket that could leave the atmosphere. ■ The first sentient being, the first inhabitant of earth, that actually became free and crossed the threshold into free space, was a dog named Laika. Here we see Laika on the top of Sputnik 2, the Russian rocket, on November 3, 1957, about to launch into space. She went up there, into orbit, where her body remains trapped forever. There was no way to return; but her mind left the cradle. ■ When I was growing up, and I think when a lot of us where growing up, I thought we would all have one of these keys in our keychain. I believed we would all be able to open space and travel beyond our atmosphere. But that seems to be an ever-receding future that will never come to be. ■ In any case, I am sorry to have digressed and let's get back down to earth, so to speak, ■ we are speaking about a very specific situation ■ and about a very specific space ■ and we are going back to it. ■ Here we are ■ in San Diego ■ and Tijuana ■ again ■ and we are seeing the Friendship monument between the two countries. We are on the American side. ■ We can hop over the fence and land on the other side, ■ now we can see the Mexican side of the monument in the neighborhood of Playas de Tijuana. Playas de Tijuana is a beautiful beach community where Dr. Cesar lives. ■ I went to visit Dr. Cesar and he was very kind to show me his keys. ■ He does not have that many keys in his keychain. He uses them to get into the house. Technically speaking however, he doesn't use these keys to get into his house. ■ He uses this to get into his house. It is the remote control built into his car and opens the garage gate. Only then does he drive into his house. ■ However, to have access to that remote control, first he needs to open the door of his car with this key. But even before he can do that, he needs to disable the alarm with the remote that you see here. It is really a three-step process in which he enters the house through the door through the garage through the car. ■ Once in the garage, he uses this key to open one door, through an inner patio ■ and onto a second door that leads to the kitchen. He is finally home. ■ The last key in Cesar's keychain is the key to the glove compartment of his car. But this is not the end of the story. Inside the glove compartment is another set of keys. What happens is that when Cesar gets into his car ■ he grabs his other set of keys, and

in this picture here, an aerial view of the area. Friendship Park is on the top and the other half of Friendship Park is in Mexico. You can actually see the border as a visible straight line in the landscape. Can you see the circle that is bisected by that line? At the center of that circle is the obelisk. Above the line we have San Diego and below we have Tijuana. ■ This is the border between the two and we can go further up and we can see Playas de Tijuana, which is a beautiful neighborhood of Tijuana, and more of the park and also some of the training areas for the military, ■ and here again we see the border between San Diego and Tijuana. We see downtown Tijuana and a landing strip also used for military training purposes, as well as the beginnings of a beach community in San Diego. ■ Again here is the border, and we see San Diego and at this point all of Tijuana. ■ Further up again, this is the border between San Diego and Tijuana. ■ Now we see the border between San Diego and Tijuana one more time; but we can see all of Los Angeles and part of Baja and again…

■ Here is the border between the two cities, now seeing all of California and all of Baja. ■ Here again is the border between San Diego and Tijuana. I want to show you one last time the border between San Diego and Tijuana. ■ At this point speaking of borders between these two cities does seem absurd. The only border that is visible is the border between outer space and our own planet earth. And this border is essentially locked because we cannot fly or move through it with our bodies —with our natural means. ■ In 1903, Konstantin Tsiolkovsky, who was a very humble Russian schoolteacher, dedicated his life to the idea of unlocking outer space. Without ever performing an experiment, he derived all the formulas and all of the underlying theories necessary for space travel. ■ He wrote a book called *Free Space* and in it, for example, you can see an illustration of the first spacecraft. There is really nothing different between this drawing and a contemporary spacecraft. Today everything is more refined and sophisticated, but the principles are all here, in Konstantin's drawings and writings. You can see how he even drew the astronauts floating in zero gravity. I think of Konstantin's spacecraft as the first key for outer space. If you think about it, keys allow us to travel through space. Therefore, a rocket is essentially a key. ■ Speaking of rockets, he also came up with designs for both liquid or solid fuel rockets. ■ He was truly obsessed with the notion that we belonged in outer space. It wasn't enough for

almost like Superman transforming through a costume, Cesar is transformed from a private individual into a public individual. For this other set of keys are the keys that he uses when he is a doctor. It is not a pure set, it is intermixed with other keys. ■ For example the work set of keys includes the front door to his house, which is a formal entrance for guests. He usually enters through the kitchen and rarely enters through the front. That entrance is for special occasions. ■ He has a small key that opens the gates of the parking lot of the clinic where he works. ■ Another key opens the padlock of the gate for the sidewalk entrance to the clinic. ■ He has something that you probably all have in your pockets right now. I call it a mystery key. It is a key that he no longer remembers what it was for, but he hesitates to throw away because perhaps it opens something of great value. ■ He also has a key to the glass entrance to the clinic. This glass door made me think that glass denotes that everyone is welcome, that the building is always open. But in reality you still have to lock it, so the lock is concealed at the base of the door. ■ Second to last, we have the door of the office where he practices medicine. ■ The last key in his keychain opens the PO box where he gets his mail. Like many residents of Tijuana, Cesar receives his mail in the United States. Every time he picks up his mail ■

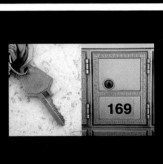

he has to cross the border ■ and he uses this key to open the PO box. This is actually a duplicate of the key that I showed you previously. The dupe is not in his keychain ■. It is in a keychain that belongs to Benjamin ■. How is it that Benjamin has Cesar's key? It is because of Benjamin's job as a driver. He runs errands, drives the children to school, picks up people at the airport. He carries people back and forth. He does all sorts of jobs for Cesar's family and others. In that capacity, he has to have keys with access to Cesar's life—so he can do his job. ■ Look here, he has a key to his car and the car alarm, ■ but he has the master key to the front door of Cesar's house as well. ■ There is an astonishing element of trust in this relationship. It reminded me of this print by Goya called, *La Confianza*—which means trust in English. In it, you see that to own someone's keys is an act of interpenetration. It is intimate. To give out your keys you need a great amount of trust. It is more or less like having access to another person's body. ■ Benjamin, of course, has his own set of keys. His personal set of keys.

Here they are. ■ But his relationship with others is so intermixed that even among his personal set of keys we find three keys to all the exterior doors of Cesar's house. ■ Additionally, he has a key to an office building of another of his clients. One that he picks up from work. ■ Finally, we see the keys to his home. This is the key to the padlock of the gate to his house. ■ Here is the front door to his house. ■ I found this next key to be very moving. It is the key to his children's bedroom. It made me reflect about how such a small metal object can have great deal of power that is both symbolic and actual. I wished that I could make a small sculpture like this key. ■ This is a key to another bedroom. ■ And lastly, we see a key to the back door. With his keychain, the house, which is a little bit like a fortress, became porous. We went through the front, we went through the middle, and we came out at the other end. The keys literally opened the space up and we went through it. ■ This back and forth between locked doors and going back and forth between countries to pick up mail, to commute, to run errands, and the repeated crossing which I had to do to take these photographs made me ponder on what kind of keys open bigger spaces. The spaces that we have seen so far have been pretty much of the same scale. I wondered what could open spaces that are vast such as this type of space. ■ This is where we live. There is not much more space than this. I have several types of keys, so to speak, that open up this space. ■ For example, I am from Honduras, and my passport is a key. ■ People that are in countries that are marked in green can enter Honduras with their passports without any special visa. Here's Honduras. As I said, all these countries in green are free to enter Honduras. They just show their passport and it opens the land. I have another passport, ■ it is an American passport. You can see that the United States is also in green. I can also enter Honduras with my American passport. I can enter my home country with both keys. ■ Some doors only open one way. Now I am showing you what countries can enter the United States freely with their passports. As you can see, it is a diminished set and please note that Honduras is not in that set. I cannot enter my other home with both keys. ■ For this project, I have

to come to Mexico several, several times. In green, you can see all the countries that can enter Mexico with their passport and no additional visa. It is a bigger set of countries than the United States, but it also ex-cludes Honduras. I need my American key to enter Mexico. As it turns out, my Honduran passport is only good to enter Honduras. It is not a very useful key. However, being a dual national has certain advantages. For example, in Tijuana I met Selene. Like myself, Selene is a dual national and she uses both her Mexican and American passport to move around. She lives in Tijuana, but she studies in San Diego. She has lived in San Diego but she has also lived in Tijuana. She moves back and forth. Here is her keychain. Her keychain references the bi-national na-ture of her life. It has a UCSD ornament, a little bull that speaks of her Hispanic cul-ture and a heart, but it also has her Ralphs' club bar code thingy from San Diego. She is shopping in a super market in San Diego, and yet she is living in Tijuana. This is the key to the front gate that leads into her patio. There are two doors you cross to enter her house. One is a very solid metal door. This key opens it. A second key opens a weaker wooden door. She also has this kind of key in her keychain. It opens her favorite beer: Paci-fico. These two are more mystery keys. They are not ex-actly mysteries because she remembers what they open. They belong to the old apartment she had when she lived in La Jolla, in San Diego. One was for the mailbox and one was for the apartment door. Why does she hold on to these keys? Why do any of us keep inoperable keys? Could we actually have sentimental at-tachments to these little pieces of metal? Can they represent a space we used to love? In her patio, I couldn't help but notice that she had several caged birds. I decided to take a look at them because they were another kind of locked space. The doors are actually un-locked, it's just that the birds don't know how to open them, so they are confined. I knew it was a bit of a cliché, the notion of birds as prisoners… I tried to imagine where these birds would go if they could open the doors? If they flew high up this is what they would see. They would have this bird's-eye view of Tijuana and San Diego. From the bird's perspective, there would be

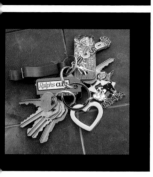

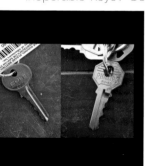

no visible separation between the two cities. They would appear as one. I once had a very similar vantage point between the two countries. I climbed to the highest moun-tain in Texas. From the top, I could see both Mexico and the United States, and from my bird's-eye view, it appeared as one piece of land. There was no visible border. In any case, back to Selene. If it gets too late, or she has too busy a schedule, Selene sometimes spends the night in San Diego. She then goes to the community of San Ysidro and stays at her grandmother's house—so she has a key to that door. As it turns out, Selene also works for **inSite**, which commissioned this lecture. She has keys to the office building of the institution. She can enter the building. She can enter the office. She is inside **inSite**. **inSite** is a non-profit organization and they raise money to create this show every couple of years. As a non-profit organization, they have to have a certain amount of governance. They have a director, board members, treasurer, etc. This is the key of the treasurer's BMW. I have never met the treasurer and I have never seen the car, but I did meet Helena, his wife, and she had a spare key to the car in her keychain. Here are Helena's keys. Helena's keys are similar to the keys we've seen so far. We are beginning to see a pattern. She has a small key to the office supply closet in her office. She has a key to her office door and she has the key to the building where her office is located. She also has a mystery key, one that she has no memory of what it opens, but the key is engraved with the message "do not duplicate" so it must be too im-portant to throw away. She has a car key, and she has a key to her home. At the time, her home was being renovated so we couldn't really go in. Instead, she showed me all of the different keys to the house, since this was still a tour of her keychain. This is a key that is on its way to becoming a mystery key. The key used to open this door that is now being becoming a wall. You can see the door's faint outline in the new plywood. In a few months, this key will be one of those keys that Helena doesn't remember what it was for. While her house is being renovated she uses this key to open this cute little garage apartment that she is subletting near her house. It is interesting for me to see it, because it made me realize that this happens quite a bit in Southern California. People convert their

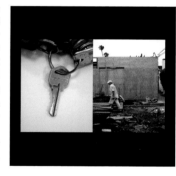

garages into apartments and then they rent them out. It makes sense because there is such a close relation between cars and homes. For instance, here is an-other Southern California garage and it is actually used how a Southern California garage should be properly used: it is the entrance

into the house. ■ You open it with your remote control, and then you enter through the garage into the house. The remote control is usually kept in your car. ■ The car has its own set of keys and an alarm with a remote disabler. ■ It is Cecilia's car. ■ These are Cecilia's keys. Like Helena, Cecilia lives in San Diego, but she actually works in Tijuana. She does a reverse commute. ■ Most key chains have some kind of ornament hanging from them. ■ I decided to check this one out. ■ Wonderful! It is a painting. And not just any painting, it is a very famous painting. ■ It is *Las Meninas* by Velázquez. People are always wondering about who is it exactly in the painting that is going through the back door. Wouldn't it be great to make a small artwork that could go into people's key chains? So it can be the real thing, an actual work of art in your keychain, instead of a reproduction of a Velázquez? In any case, as I was telling you, Cecilia lives in San Diego and ■ she crosses the border everyday to go to work in Tijuana. She actually has two jobs. When I went to visit her, she had just been appointed to a second job and she had just received the key to this new office. ■ The key led me to this interesting door for which you only need a key when it is not between nine to two or four to seven Monday through Friday, or when it is not Saturday between nine to one. The door is only locked half the time and open the rest of the time. ■ She also has a key to the Instituto de Cultura de Baja California, of which she is the director. She can open the whole place. ■ She has a key to the storage place where the office supplies for the institute are kept. ■ She has an old key to a lock that was changed that doesn't open anything anymore—a mystery key. ■ She has a key where the museum's supplies for packing and conserving works are kept. ■ She has the key to the administrator of the museum's office, ■ and a key to a little closet where water and crackers and other snacks are kept. ■ The last key is a key to her office. ■ Inside her office, we see Francisco sitting down. Francisco has been my companion in these adventures. We have been driving around. We make contacts, phone calls, appointments. We go around from door to door. We photograph people. We photograph their doors. At this point, I turned to Francisco and said: "Show me your keys!" ■ Here they are. Francisco is another person whose life is between two countries. ■ He took me to his apartment and we unlocked the gate to it. ■ To the right of the gate, another key opens a stairway to the second-floor apartments. ■ In front of the gate, there is an additional door that leads to the first-floor apartments where he lives. ■ His door has two locks and therefore two keys. ■ He lives in apartment number 2. ■ He took me to his mother's house in Tijuana, which has a beautiful ornate gate. ■ Inside his mother's house, there is a metal door that is always locked that leads into the kitchen. ■ Here is the metal door. ■ Past that metal guard door, there is a second door that is always unlocked that leads to the

kitchen. ■ There is another entrance door on the side. ■ In the back of his mother's house is a gate that separates the neighbor's house from her house. It is a door between two homes. Another key on his keychain is for his mother's car. ■ We had to cross the border to go find his mother's car and photograph it. ■ Even though she is a resident of Tijuana, Francisco's mother works as a teacher in San Diego. ■ Since he also had a key to the car's trunk, and we were being diligent, we opened the trunk and photographed the space inside of it. ■ Francisco's dad lives in San Diego and Francisco stays there half of the week. He uses this key to enter the house. ■ The last stop is another post office box. ■ Like many *Tijuanenses*, Francisco and his mother rent a PO box in San Diego to receive their mail. ■ I paused to think about how letters open spaces that would otherwise not be available to you. To be more exact, the postage in a letter is a key to potentially inaccessible spaces. ■ Look at this letter, you put the postage on the right, you write the address of the space that you are living in on the left, and the address of the space you want to go to in the middle. Presto! You have access to a locked space. For example, you could reside in Nicaragua and want to visit me in the USA. Very likely you could not get a visa, but you could send your words through a letter. In a fashion, you have opened a door. ■ Another example, I might want to send a letter to the most remotely inhabited place on earth, the island of Tristan da Cunha. The island is supplied by a mail boat that only goes there three times a year. And yet, as remote as it is, I want to have access to that space. With the proper postage I can enter it. ■ Some isolation is not just a matter of geography. Perhaps someone from Tristan Da Cunha wants to talk to a prisoner. This is true. In this post 9/11 world detainee "S" is a real someone who is detained at this address in England in Her Majesty's Prison at Bellmarsh. Not only, is "S" tightly locked up with virtually no access to him—even his identity is locked. For reasons of security he is only known as "S". However, even someone in this situation can be reached, unlocked, by a letter. ■ Stamps may even have the power to unlock imaginary spaces. A letter can go from an almost fictional person like "S" to a completely fictional space like Santa Claus' home in the North Pole. ■ However, most of the time letters allows us to enter the spaces of normal people like Eloisa. ■

Eloisa lives in San Diego. ■ She has the most minimal keychain we have seen so far. It only has three keys: ■ a bar code that allows her to enter her gym, ■ and a very sophisticated key that opens her car. ■ Inside her car there are two remotes. ■ One opens the gate that leads into her house. ■ The second one has three buttons, one for each of the garage doors of her house. ■ ■ ■ Now she is inside her house. ■ The third key is the only conventional key. It is the master key to all of the spaces in her home; ■ but before she can open any door she needs to disable the alarm. We increasingly have the need to save numbers and passwords in our memory. These are our new keys, and our memory our new keychain. ■ For example, with the right code you can enter the virtual space of Eloisa's phone mailbox and listen to her messages. The same goes for credit cards, ATMs, websites, etc. ■ I decided to photograph every place that can be

opened with Eloisa's master key. ■ It opens the front door, the doors from the inner court yard to the dinning room, to the kitchen, to the garage, and from the left side of the house to the garage, the laundry room, another door to the laundry room, the office off the kitchen. ■ In Spanish these are called keys; they turn on the water. ■ In the back of the house the double doors to the office off the kitchen, dining room, foyer facing the entrance door, and reading room. ■ On the right side the key opens a concealed door that caterers can use to bring food in and out during large parties. ■ The tennis courts are always open. No need for a key. ■ Behind the house is a guesthouse. The key opens the door to the gym, foyer, bar, and disco. ■ You arrive to the back of the property through this door of the guesthouse. ■ Back there the key is not needed to open the door to the boiler room and central AC

unit—no lock on this door. ■ But I found a curious small door back there. I asked Eloisa, "What is that?" She replied, "Open it up." ■ The key revealed a stash of house paint. This was an unusual space that made me think of all the spaces we have not seen so far. ■ I asked Eloisa about them and she took me to this frightening basket full of perhaps a hundred keys. Like most people Eloisa just carries the most essential keys. The basket stored the keys for things that she doesn't use everyday. In our tour so far, we have essentially seen very similar kinds of spaces: home and work, car and spare key, and so on. But in this world every space can be defined as open or closed, locked or unlocked, and each and every one of these spaces has a key. Let's sit here for a second and think about them ■■■■■ ■■■■■■■ This last key, the key to a museum, is very important for me because I am an artist. I often want to be inside the museum and show my work in it, and most of them are not open to that. I though it would be great to have a key that would let me enter an exhibition space: ■ a key such as this, which opens the Centro Cultural de la Raza in San Diego. I had the luck of meeting the owner of this key: ■ Nancy, the

director of the Centro. Here she is. ■ She keeps her keys hanging from her purse. Two sets. She showed me the underbelly of a cultural institution. Behind the pristine exhibition white walls you can see something like this: ■ the workshop, ■ the kitchen where they prepare for openings and events, ■ the water heater, ■ and I made fun of Nancy because she had a spare key to the water heater in her keychain. ■ This key was for the electrical panels on the outside, but they recently changed the locks. ■ A supply closet. ■ The donation box. ■ Her van, which she has named, pronounced in Spanish, C-si-la. It is the van that she uses to ferry her family and all of the visiting artists back and forth. ■ She took me to her house, where she showed me her pickup truck, ■ and finally the apartment where she lives—you need both these keys to open the front door. ■ Like most of the people who collaborated in this project, Nancy was incredibly generous. When I started this art work I didn't realize it would require that people expose their entire lives to me: where they lived, where they worked, their mess, their tidiness, their hobbies, their wealth, their lack of wealth, their connection to their parents, etc. I realize now, what an incredibly generous act it was on their part, to allow me to do this. It demanded some degree of trust around keys—the epitome of lack of trust. ■ I decided to make this drawing based on Nancy's hands and engrave it on a few hundred key blanks ■. On the other side I engraved this drawing ■. ■ The blanks are over here on this table. They are the blanks for the fourteen most commonly used keys. I also have a key-copying machine. I want to invite you to be part of an exercise: an exercise in trust. I am going to duplicate the key to the front door of my house (sound of his keys jiggling). I am going to give away a duplicate of my house key copied onto one of these custom engraved keys (sound of duplicating machine running). Anyone here can have my key, but in return that person has to give something in return. That person has to choose a key from their keychain, allow me to dupe it onto the engraved key's blank, and let me give it away to another person in the audience. You have to trust a little, but not too much. There is very little risk, you are giving someone who doesn't know where you live a copy of a key to something—but they don't know what it is… so you are safe. But there some trust is required. A little porosity is created. Are there any takers? Will anyone here take my key?

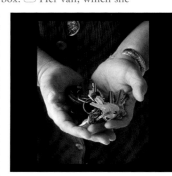

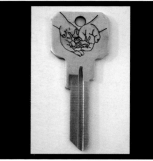

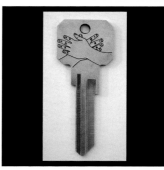

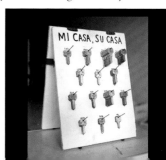

Josep-maria Martín

A Prototype for Good Migration> Un prototipo para la buena migración/

Synopsis. Josep-maria Martín proposed creating a space that could potentially sustain experiences of renewal and learning among young undocumented migrants deported to Tijuana after unsuccessfully attempting to cross the US-Mexico border. Martin sought to co-design a space annexed to the Casa YMCA in Tijuana by working in conjunction with Tijuana architect, Sergio Soto, the staff and residents of the Casa YMCA de Menores Migrantes, and a number of activists, academics, and migrant support agencies. He proposed that the space should provide the adolescents temporarily housed there with a retreat—a space in which to rest, think, listen to music, read, or view the urban landscape. Martín also suggested that the space could house youth-oriented programs addressing issues of migratory flows, human rights, and the personal deliberations that shape the weighty decision to migrate. Due to differences between the curatorial team and the artist regarding the project's ethical coherence, the commission was cancelled.

Since its foundation in 1991, the Casa YMCA de Menores Migrantes has provided free provisional shelter to approximately 2500 children per year from various parts of Mexico and Central America, who in their effort to cross over to the US "illegally" have been detained, arrested, and deported to Mexico. Minors between the ages of eleven to seventeen can stay in the shelter for a maximum of eight days or until their families are located.

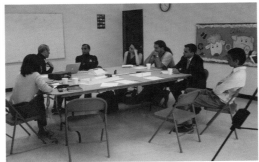

Images: Research trip to the Guatemala-Mexico border/ Meetings and interviews with project consultants/ Production process and final building (in color)> Imágenes: Viaje de investigación a la frontera Guatemala-México/ Reuniones y entrevistas con consultantes del proyecto/ Proceso de construcción y vistas del edificio (a color)

Sinopsis. Josep-maria Martín propuso la creación de un espacio que pudiera sustentar potencialmente experiencias de renovación y aprendizaje entre los jóvenes migrantes indocumentados, deportados a Tijuana después de haber intentado infructuosamente cruzar la frontera México-Estados Unidos. Martín buscaba en principio codiseñar un espacio anexado a la Casa YMCA de Menores Migrantes de Tijuana, trabajando en conjunto con el arquitecto tijuanense Sergio Soto, el personal y los residentes de la Casa YMCA, y un número de activistas, académicos y agencias de apoyo a migrantes. Propuso que el espacio debería alojar temporalmente a los adolescentes, además de proporcionarles un retiro —un espacio para descansar, pensar, escuchar música, leer o mirar el paisaje urbano. Martín también sugirió que el espacio diera cabida a programas orientados hacia los jóvenes, referentes a temas como los flujos migratorios, los derechos humanos y las deliberaciones personales que dan forma a la importante decisión de migrar. Debido a diferencias entre el equipo curatorial y el artista respecto a la coherencia ética en el posicionamiento y la operación del proyecto, la comisión fue cancelada.

→ Otras traducciones/ p. 280

Cancelled Commission. *A Prototype for Good Migration* was the only **inSite_05** project that was cancelled when it was in a production phase. The process involved a substantial investment of energy and resources, and it was considered a major failure for the curatorial team. Beginning in November 2003 and continuing through May 2005, Josep-maria Martín's successive proposals were related to the theme of migration. It took more than a year and a half of disagreements to reach an agreement regarding a final proposal. From the curatorial team's point of view, the difficulty in finalizing the proposal was due to the vagueness of the artist's ideas and, more importantly, the problematic ethical implications of his proposed models of intervention. In May 2005 Martín became interested in focusing his project on the creation of a house or shelter for migrants. In the San Diego-Tijuana border region, there are more than a dozen nongovernmental and government institutions of this kind that run diverse programs, have complex support networks, and clearly defined operational commitments. Many of the discussions between the artist and the curatorial team revolved around how an intervention that sought to create another space for assisting migrants could be understood in artistic terms. Considering **inSite**'s lack of financial resources and man-power, how would we guarantee the permanence of such a space? How would we handle the ethical responsibility involved in the implementation and subsequent operation of such an initiative? In May 2005 Martín agreed to develop his project in collaboration with one of the most established and prestigious migrant support institutions in Tijuana: La Casa YMCA de Menores Migrantes. The Casa YMCA is a nongovernmental shelter for minors and adolescents who have unsuccessfully tried to cross the US-Mexico border without relevant documentation and have been deported to Mexico. Martín's final proposal for **inSite_05** involved the design of a modest extension to the YMCA building, which would provide a new space in which to develop an intensive education program for minors. Martín proposed bringing together an interdisciplinary network of collaborators to work on the project—including institutions and prominent individuals from the region—in order to create a program of talks and workshops, as well as a space to access reference materials for both study and recreation. The program—as well as the activation of a network of exchanges that would furnish the program's content—was the conceptual node of the intervention. One month prior to the inauguration of the space the ma-

jor problem continued to be the lack of an outline for the educational program, or a draft that would allow for a process of feedback and dialogue to be established between the curatorial team and the artist. In the meantime, Martín insisted on adding a subtitle to his project title. This brought the ongoing disagreement to a head. Martín was insistent on the new title: *A Prototype for Good Immigration: Youth Center for Education and Information on the Border*. How could we commit ourselves to support a collaborative project that would be calling itself "Youth Center for Education and Information on the Border" when it was not our role to administer and position the space but the Casa YMCA's? Based on what credentials? What was our level of commitment in the face of such a responsibility to the public? Martín refused to rethink the way he wished to inscribe his project. The curatorial team decided to cancel the commission. In accordance with the directors of **inSite_05** construction was completed, the space was equipped, and donated to the Casa YMCA de Menores Migrantes.

I thought we were trying to find spaces of growth and commitment. Just as you don't agree with my work, I must tell you that I don't agree with the way in which you have curated this piece.
Regards, Josep

J.M./ Email/ "Re: Commitment," to: Osvaldo Sánchez, August 18, 2005

Septiembre 2003–Marzo 2005/ Josep-maria Martín

Proceso de investigación y propuestas/ En septiembre de 2003, en su primer viaje a la zona, Josep-maria Martín asistió a una sesión de trabajo en el Colegio de la Frontera Norte. Este encuentro se había previsto como un foro para que los artistas exploraran temas de interés potencial. Martín estaba particularmente interesado en el trabajo de la investigadora Olivia Ruiz, cuyo trabajo explora la vulnerabilidad de los migrantes en la frontera entre México y Guatemala. En marzo de 2004, Martín regresó a la zona, donde conoció y entrevistó a numerosos investigadores, activistas y abogados especializados en el campo de la migración. Como parte de esta investigación en proceso también viajó a Tapachula, Chiapas, en la frontera sur de México. Desde mayo de 2004 hasta marzo de 2005, Martín tuvo en mente sucesivas ideas muy variadas relacionadas con el tema de la migración. Éstas sugerían la comisión de una obra teatral de gran escala; también invitar al famoso grupo de música norteña Los Tigres del Norte a escribir una canción acerca de la "migración positiva", así como construir un refugio temporal para la masa sin hogar que vive en los albañales del Río Tijuana.

Translated *Unfolding Process*/ pp. 57–58

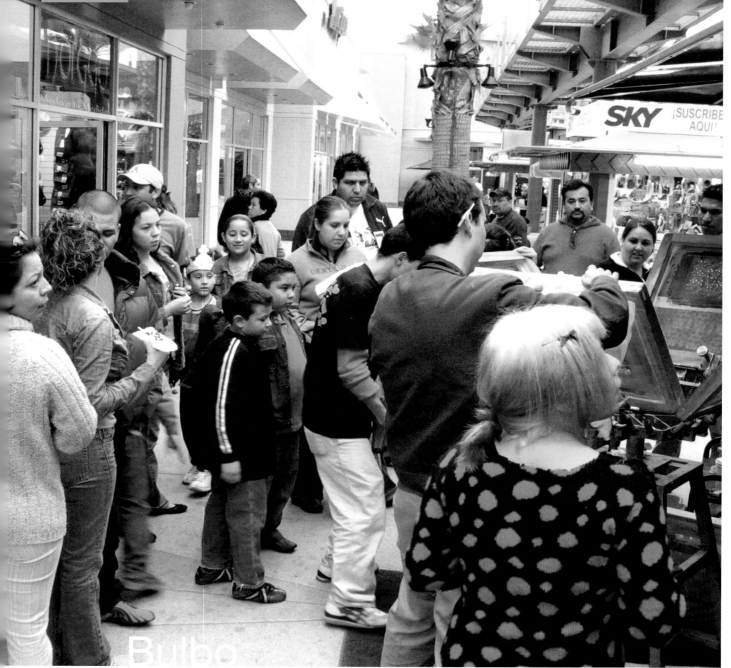

Bulbo

The Clothes Shop> La tienda de ropa/

Synopsis. *The Clothes Shop* was developed by Tijuana collective Bulbo as an attempt to stimulate a collective creative experience about clothing worn in the Tijuana-San Diego border region. The project involved the participation of a diverse group of people from varied professional backgrounds and different economic strata. It included a series of production workshops as well as the joint operation of exhibition spaces and clothing sales over a period of two months. The workshop was intended to serve as a platform for experimental aesthetic inquiry into the subject of clothing as well as a space in which to discuss the processes and sites involved in the production, exhibition, and consumption of clothing. Bulbo inserted *The Clothes Shop* in formal and informal commercial venues, as well as in wholesale and retail sales centers in both cities (La Jolla and downtown Tijuana). They documented the experience live in real time with a webcam. Bulbo also edited a video that documented the process for television and Internet broadcasts.

Seven people from different contexts (a lawyer, a cook, a visual designer, an actor, a rocker, a dancer, and a gothic girl) got to know each other during a two-month period in which they worked together in a workshop. The objectives of the workshop were for the participants to think about clothing; the processes of making and designing it, and what we communicate through it. Bulbo/ Project logbooks

Creativity is an act of courage[...] Anyone who dares to create, to overcome limits, not only participates in a miracle, but also comes to realize that in the process of becoming, he becomes the miracle. Joseph Zinker/ *Creative Process in Gestalt Therapy*

Images: Research process/ Working sessions with artists from the area/ *The Clothes Shop* at Mundo Divertido (in color)> Imágenes: Proceso de investigación/ Sesiones de trabajo con los artistas del área/ *La tienda de ropa* en Mundo Divertido (a color)

Mayo 2004/ Bulbo

Discusión de la propuesta/ En mayo de 2004 los integrantes de Bulbo presentaron su propuesta de proyecto. La idea retomaba su experiencia de trabajo con grupos disímiles en Tijuana para seleccionar a personas de muy diferentes perfiles, con quienes generar un taller sobre el vestuario en la región. Posicionado más como un colectivo de medios que como un "grupo artístico", Bulbo había trabajado con estrategias relacionadas con la publicidad y el registro antroplógico. La discusión de su propuesta giró en torno a la pertinencia de que el proyecto se alejara de la idea del registro como un producto a ser televisado y se enfocara más en el aspecto vivencial del proceso de colaboración entre coparticipantes.

Translated *Unfolding Process*/ pp. 52–53 → Otras traducciones/ p. 276

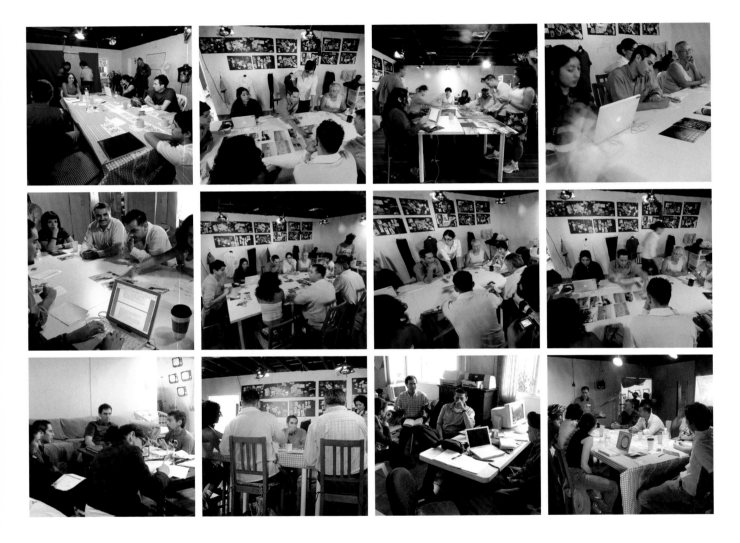

Sinopsis. *La tienda de ropa* del grupo tijuanense Bulbo consistió en una experiencia de creación colectiva en torno al vestuario en la región fronteriza de Tijuana San Diego. El proyecto incluyó un taller de producción con la participación de personas de diferente formación profesional y estrato económico, así como la operación conjunta de focos de exhibición y venta de ropa, a lo largo de dos meses. El taller se propuso como una investigación estética experimental en torno a la ropa, y a la vez como un foro de discusión acerca de los procesos y espacios de producción, exhibición y consumo de ésta. *La tienda de ropa* intervino los circuitos comerciales, formales e informales, así como de venta de mayoreo y menudeo de ambas ciudades —de La Jolla en San Diego a la Zona Centro de Tijuana. Bulbo registró en vivo dicha experiencia a través de un programa accesible en tiempo real en Internet, y a su vez editó la pieza como resgitro final en formato de video, con el objetivo de trasmitirlo también como documento, sea por televisión o en línea.

Clothes are like flags.
Bulbo

Sessions. The workshop sessions took place over nine consecutive weekends between July and September 2005. Each session had a specific goal, ranging from introducing each individual to the group and negotiating the dynamics of collaboration, to defining field research, technical exercises, and developing critical insights into clothing from the region. Not only did the workshops become the central node for the collaborative experience, they also served as the creative space in which garments were designed and produced for sale at *The Clothes Shop*. Each workshop session was documented in detail and transmitted live over a webcam.

For further information and details about the project, please visit:

www.latiendaderopa.org

Clothes and documentation relating to *The Clothes Shop* were first publicly displayed in Pomegranate—a high-end boutique in La Jolla. **We intervened on the consumptive inertia of the customers who regularly frequent the boutique by surprising them with items of clothing that embodied a series of rich and complex narratives; stories from the other side of the border fence.**

Since it was the official inauguration of **Bulbo's project, many members of the art world attended. At times it seemed as if we were invading the boutique with a party instead of intervening in the space.** The situation changed a few days later when the garments could be calmly looked at by the residents of La Jolla. Bulbo/ Project logbooks

Images: Intervention at Pomegranate boutique> Imágenes: Intervención en la *boutique* Pomegranate

The Clothes Shop was installed at the Swap Meet Fundadores during two weekends. It was positioned as if it were any other stall. **The silkscreen machine was an important element of the stand.**

Visitors to the stall could purchase a shirt or bring their own clothing. They were then able to select a design that had been created in the workshops to print on their garment. There was a broad selection of colors and design options. They could also buy purses, pants, and shirts that had been produced by the workshop participants. Koty, the seamstress, was also on hand to modify the customers' clothes.

Bulbo/ Project logbooks

Images: Implementation of the project at Swap Meet Fundadores> Imágenes: Implementación del proyecto en Swap Meet Fundadores

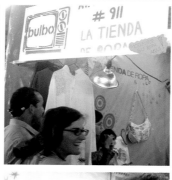

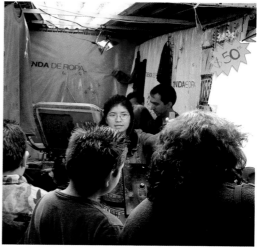

Plaza Mundo Divertido is a shopping center that attracts primarily teenagers and young adults who go there to watch movies, bowl, or play videogames. During the weekend families visit the center's restaurants and stores.

The Clothes Shop set up shop at Plaza Mundo Divertido from October 22 to November 13, 2005. It was open on Wednesday, Friday, Saturday, and Sunday from 12:00 p.m. to 8:00 p.m.—the days when the center was at its busiest.

Initially, visitors to *The Clothes Shop* were unsure of its purpose and their attention focused on the price of the garments on sale. However, when they discovered that they could get their clothes silk-screened with a unique design for free they were surprised. The gathered crowd talked amongst themselves until one person dared to take a garment off and have it silk-screened. After that the rest followed. This, in turn, resulted in a conversation about the nature and process of the project itself.

Bulbo/ Project logbooks

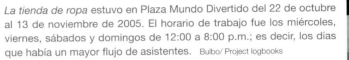

La tienda de ropa estuvo en Plaza Mundo Divertido del 22 de octubre al 13 de noviembre de 2005. El horario de trabajo fue los miércoles, viernes, sábados y domingos de 12:00 a 8:00 p.m.; es decir, los días que había un mayor flujo de asistentes. Bulbo/ Project logbooks

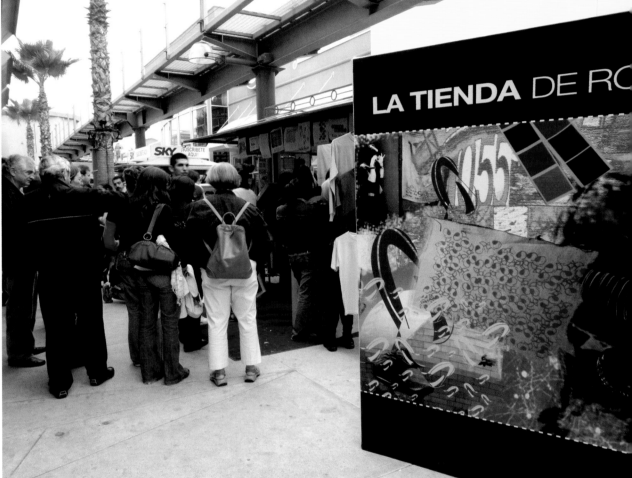

Images: Implementation of the project at Plaza
Mundo Divertido> Imágenes: Implementación
del proyecto en Plaza Mundo Divertido

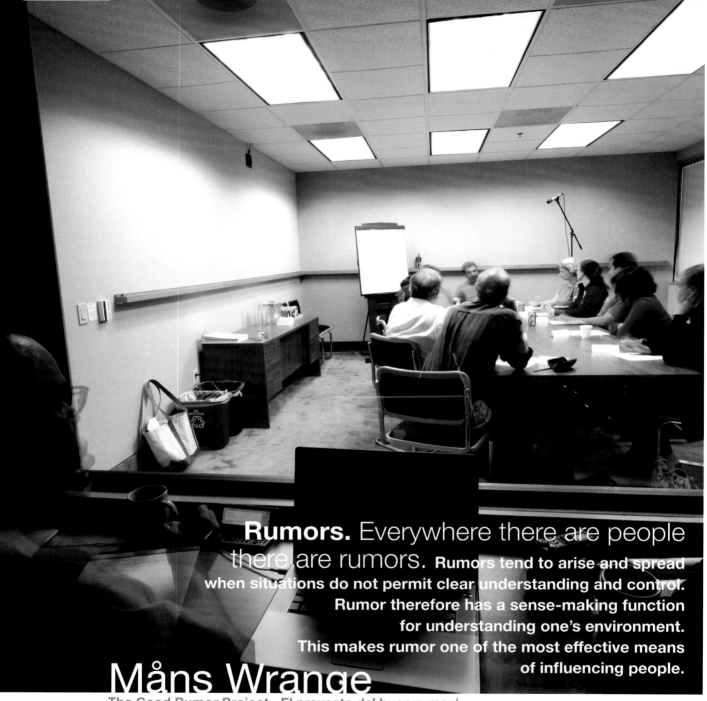

Rumors. Everywhere there are people there are rumors. **Rumors tend to arise and spread when situations do not permit clear understanding and control. Rumor therefore has a sense-making function for understanding one's environment. This makes rumor one of the most effective means of influencing people.**

Måns Wrange

The Good Rumor Project> El proyecto del buen rumor/

Rumors are thus systematically employed in wars, in business, in the stock market, as well as in politics. But rumor is not only a process of communicating unconfirmed information. Rumor also contributes to the process of constructing an "us" and "them." Several studies conducted by social scientists suggest that most rumors are negative because the act of ascribing negative characteristics to people outside of one's own social circle contributes to the development of a positive group self-image. As a result, rumors often reinforce the sense of difference between ethnic, cultural, and socioeconomic groups. Rumor is, in fact, a significant contributing factor in acts of violence, prejudice and discrimination.

M.W./ Introduction to promotional video

Rumors are not just idle speculation.
They are based on xenophobic tendencies or our society's fears.
Rumors are an echo of ourselves.
They reveal the desires, fears, and obsessions
of a society. Dr. Jean-Noel Kapferer/ *Rumors: Uses, Interpretations, and Images*

What would happen **if the negative and destructive process of rumors**
could be inverted into a positive and constructive force?

Images: Research process and residencies>
Imágenes: Residencias y proceso de inves-
tigación.

Desarrollo de propuesta/ A principios de septiembre de 2004, Måns Wrange envió su primera propuesta, titulada *The Missing Word* [La palabra perdida]. Argumentando que "el lenguaje no es meramente un vehículo para la comunicación [...] sino también una herramienta de poder" (MW), Wrange buscó demostrar que el lenguaje también podría usarse como una fuerza positiva y unificadora por medio de la invención de una nueva palabra que pudiera diseminarse en la zona fronteriza de Tijuana San Diego. Sin embargo, apenas unas semana antes Rubens Mano había enviado una propuesta titulada *Visible*, que también incorporaba la idea de una palabra susceptible de insertarse en los flujos que atraviesan la frontera. Con esto en mente, en octubre de 2004 Wrange bosquejó una idea alternativa con el título provisional de *The Unused Time Project* [El proyecto del tiempo desperdiciado], en la que exploraba la idea de acumular y emplear el tiempo desperdiciado mientras se espera cruzar la frontera. Hacia el mes de marzo de 2005 estaba claro para Wrange que esta idea no iba desarrollándose como él esperaba. Habiendo llegado a la conclusión de que el proyecto era demasiado complejo para llevarse a cabo, envió su propuesta definitiva: *El proyecto del buen rumor*, que a su vez implicaba una investigación sobre el lenguaje en cuanto herramienta sociopolítica de carácter positivo. Las tres propuestas incorporaban la idea de "pequeños mundos interconectados" en cuanto medios para diseminar el proyecto, y las tres buscaban efectuar un cambio social positivo en la región.

→ Otras traducciones/ pp. 284–285

Translated *Unfolding Process*/ pp. 64–65

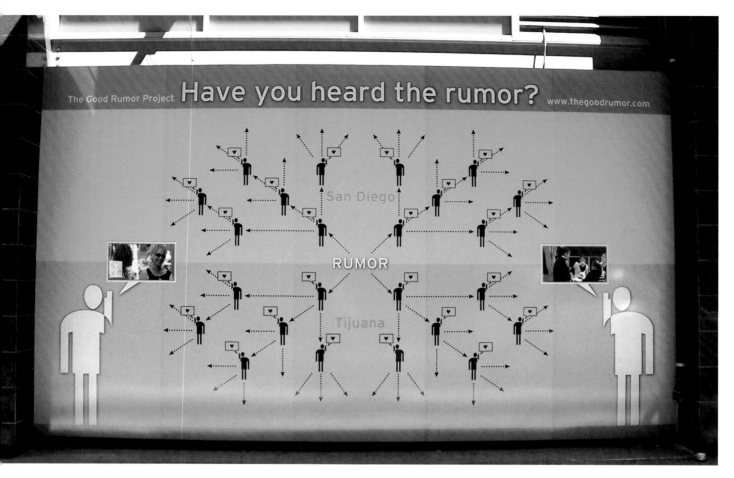

Synopsis. *The Good Rumor Project* appropriates and replicates the model of a socio-political experiment. Seeking to invert the negative effects of rumor, Måns Wrange and his collaborators created two "good rumors"—one concerning Tijuana that was spread in San Diego and one about San Diego that was spread in Tijuana. In contrast to conventional rumors, which tend to be formulated by one group of people about another group of people, the "good rumors" were constructed in dialogue with the actual subjects of the rumors through a series of focus groups. The "good rumors" were disseminated through a multifaceted strategy that combined advanced marketing techniques—viral/word-of-mouth marketing—with structures borrowed from rumor theory, as well as recent research on small-world networks and social network analysis.

A selection of people from San Diego and Tijuana were recruited as "nodes" to spread the "good rumors," and the evolution of the rumors throughout the border region was tracked by means of an interactive website. A video produced in collaboration with Yonke Art both tracked and helped to publicize the project. Over the course of **inSite_05** the rumors spread exponentially, appearing in magazines, on radio programs and in blogs. They never really achieved a tipping point in the sense that they became prevalent throughout the region; rather, over time they seemed to mutate. It became ever more difficult to track their evolution as they were absorbed back into the narrative threads of the border area.

By appropriating the advertising strategy of word-of-mouth marketing and employing it to promote a positive sense of trust and partnership instead of rampant consumerism, Wrange inverts and subverts late capitalism's tropes of social coercion. The collective participation of social actors in the construction of narrative fictions that were inserted into the communication networks of the border region reveals how society is predicated on an evolving communicative process. It suggests the political potential for citizens to be actively involved in co-creating the polis through their communicative acts.

The **small world phenomenon** (also known as the small world effect) is the hypothesis that everyone in the world can be reached through a short chain of social acquaintances. The concept gave rise to the famous phrase six degrees of separation after a 1967 small world experiment by psychologist Stanley Milgram, which found that two random US citizens were connected by an average of six acquaintances. M.W./ Statement

Rumores acerca de "los otros" también están presentes en la vida apacible y ordinaria, aun cuando (y quizás especialmente cuando) una ideología oficial de tolerancia prohíbe la manifestación abierta de la hostilidad.

Véronique Campion-Vincent/ *Rumor Mills: The Social Impact of Rumor and Lengend*

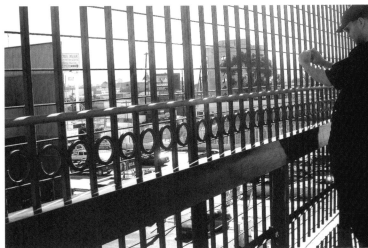

With a gun pointed towards my head, I could of course finalize the project but it is against my principle to produce art for shows just because I have to. I must feel motivated and that it can meet my high standards. Anyway, don't freak out yet. The good news is that I have another proposal that we are getting more and more enthusiastic over. It's the "Plan B" that I talked to you about: *The Good Rumor Project.*
M.W./ Email/ "Proposal," March 10, 2005

Rumors often serve as a window into the underlying fears, anxieties, and sentiments of a community. [...] It is often rumor that attributes incorrect causes and motivations, fuels misperceptions, and escalates conflicts. [...] The US government recognized the destructiveness of stateside rumors during World War II, and actively sought to monitor and control them. They established the Office of Facts and Figures, the Office of War Information, and even devoted portions of Presidential radio addresses to issue information and produce publications as "antidotes" to rumor. These offices conducted undercover investigations to pursue sources of particularly malicious rumors. Private rumor clinics, often consisting of recurring magazine or newspaper articles, were also implemented to refute rumors. (Allport and Postman 1947a) Whether planted or naturally occurring, keeping tabs on circulating rumors is imperative if propaganda operations are to be detected and effective counteractions initiated.

Captain Stephanie Kelle/ *Rumors in Iraq: A Guide to Winning Hearts and Minds*

Sinopsis. *El proyecto del buen rumor* se apropia del modelo de un experimento sociopolítico. Buscando invertir los efectos negativos del rumor, Måns Wrange y sus colaboradores crearon dos "buenos rumores" —el primero, sobre Tijuana se difundiría en San Diego; y el segundo sobre San Diego se expandiría en Tijuana. A diferencia de los rumores convencionales, que en general son formulados por un grupo de gente acerca de otro grupo de gente, estos "buenos rumores" de Wrange intentarían ser construidos a partir de rumores reales o potenciales, gracias al diálogo con una serie de grupos especializados. Estos "buenos rumores" se diseminaron por medio de una estrategia multifacética que combinaba técnicas de mercado avanzadas —la palabra/virus propia de un mercadeo "de boca a boca"— con estructuras tomadas de la teoría del rumor, así como investigaciones recientes sobre las pequeñas redes mundiales y los análisis de relaciones de grupo. Un número de personas de San Diego y Tijuana fueron reclutadas en calidad de "nodos" para expandir los "buenos rumores". La evolución de los rumores a través de la zona fronteriza fue seguida por medio de un sitio *web* interactivo. Un video producido en colaboración con Yonke Art sirvió tanto para estudiar y dar seguimiento como para filtrar la presencia del rumor. En el transcurso de **inSite_05**, los rumores se expandieron exponencialmente, apareciendo en revistas, en programas de radio y en *blogs*. Aunque nunca alcanzaron un punto culminante en el sentido de imponerse de golpe en toda la región, los rumores reaparecieron en momentos inesperados y más bien con el tiempo fueron mutando. Se volvió cada vez más difícil comprobar su evolución a medida que eran reabsorbidos por las narrativas de la frontera.

Al apropiarse de una estrategia publicitaria —la palabra transmitida "de boca en boca"— y usarla para promover un sentido positivo de confianza y camaradería en lugar de un consumismo rampante, Wrange invierte y subvierte los tropos de coerción social del capitalismo tardío. La coparticipación de agentes sociales en la construcción de estas ficciones narrativas insertadas en las redes de comunicación de la región fronteriza, revela hasta qué punto la sociedad se funda en un proceso comunicativo en evolución. Esto devela la existencia de un potencial político para los ciudadanos que se involucran activamente en la cocreación de la *polis* a través de sus actos comunicativos.

The thinking is that in a media universe that keeps fracturing
into ever-finer segments, consumers are harder and harder to reach;
some can use TiVo to block out ads or the TV's remote control to click away from them,
and the rest are simply too saturated with brand messages to absorb another pitch.
So corporations frustrated at the apparent limits of "traditional" marketing are increasingly open
to word-of mouth marketing. One result is a growing number of marketers organizing veritable
armies of hired "trendsetters" or "influencers" or "street teams" to execute "seeding programs,"
"viral marketing," "guerrilla marketing." What were once fringe tactics are now increasingly
mainstream; there is even a Word of Mouth Marketing Association.

Rob Walker/ "The Hidden (in Plain Sight) Persuaders," *The New York Times*, December 5, 2004

- It shouldn't have a negative effect but rather have
 the potential to generate something positive.
- It should have a self-fulfilling effect, in the process of
 spreading it could eventually become reality.
- It should not be easy to check whether it is true,
 but at the same time it shouldn't make people feel cheated
 after we have revealed that it was a social experiment.
- It shouldn't reinforce the stereotypes of people from TJ
 and SD, but instead promote some sort of a partnership
 between TJ and SD.

M.W./ Email/ "The criteria for the rumor," July 6, 2005

Los rumores no son sólo especulación. Están fundados en las tendencias xenofóbicas que alimentan los temores de nuestra sociedad. El rumor es un eco de nosotros mismos. Y revela los deseos, temores y obsesiones de una sociedad.

Dr. Jean-Noel Kapferer/ *Rumors: Uses, Interpretations, and Images*

Rumor has been recognized as one of the most important contributing factors to violence, prejudice and discrimination.

Terry Ann Knopf/ *Rumors, Race, and Riot*

Positive Opinions of Tijuana/ Family orientation • Work ethic • Personal opportunities • Conscientious • Friendly, helpful, and welcoming, cordial • Down to earth, humble/ **Positive Opinions of San Diego/** Better jobs, homes, and schools • More access to money and opportunities • Better quality of living • A mixture of people, religion, and cultures • Sophisticated/modern • Not as biased/ not as much discrimination/ more tolerance • Wages are fair • Working conditions better • Better healthcare • People are more honest • More educational opportunities/ Everyone can be educated • SD people love to party, drink, and shop • People are laid back and friendly • Friendly and helpful • Frugal, want to get a good deal • More leisure time/ **Negative Opinions of Tijuana/** Lawless and dangerous • Corruption of police and politicians • Schools and medical facilities not as good as US • Unclean • Lower standard of living • Lower education standards/ **Negative Opinions of San Diego/** Privileged • Arrogant • Don't care about conditions in Tijuana • Not very concerned about helping • We don't like them • Cost of living • Ignorant about Tijuana/

San Diego

Focus Groups/ Summary of the highest ranked opinions from the focus groups*

Tijuana

Positive Opinions about San Diego/ San Diegans are friendly, educated and hard working • Latinos come to Tijuana to visit their families and to have a good time • In San Diego they pay you by the hour and they work more productively • There is a friendship between the two cities • It would appear that discrimination does not occur in San Diego • They are very considerate to pedestrians • There is a very good standard of living/ **Positive Opinions about Tijuana/** We are hospitable, approachable and very happy • We are very warm towards friends and family • We are hard workers • You eat better here • It is cheaper. Here a margarita costs $1 and over there it costs $5/ **Negative Opinions about San Diego/** People from San Diego only come here to get drunk • US migration officials are rude, especially the Texan and Latino ones • They are culturally ignorant. They are not able to distinguish between Mexicans, Spanish, Indigenous Mexicans, and Native Americans. They have no understanding of history • They are very individualistic. They are not even interested in their own neighbors • Their press is very biased; they only show bad news about Tijuana • They are arrogant and intolerant • They think that we need to learn English more than they need to learn Spanish • Here we support our children until they get married. In San Diego they don't even give their children a glass of water after they turn 18/ **Negative Opinions about Tijuana/** People think that Tijuana is very dangerous and dirty and everything is about kidnapping and drugs • They think that Mexico is like it is in the movies • They think all of us are stupid, lazy, poor, uneducated and corrupt • They think that we are only good enough to work in a maquiladora • They think that we are spendthrifts and disorganized • They are even afraid of the Tijuanan police • We treat the "gringos" better than we do our own countrymen from Tijuana • Financiers are afraid to invest here/

*The focus group sessions were commissioned by **inSite** as part of Måns Wrange/ OMBUD project research. Manuel Chavarín, director of VC Asociados, led the Tijuana Focus Group, and Don Sciglimpaglia, professor of marketing at San Diego State University, led the San Diego Focus Group.

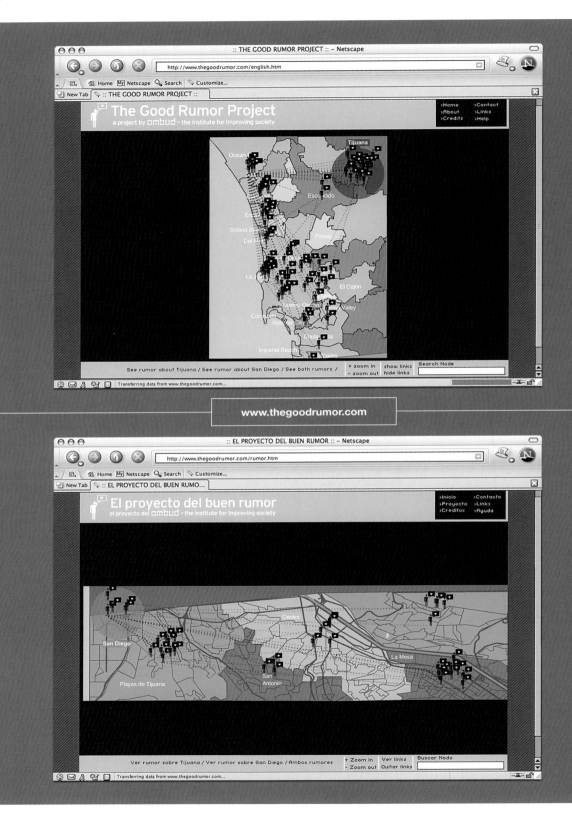

www.thegoodrumor.com

> In prejudice and conflicts,
> rumors express emotions and anxieties that are preexisting,
> but also fuel and strengthen them. Rumors about "others" are also present in
> Stereotypes not only distort reality the peaceful and ordinary life, even when
> but also create it, (and perhaps especially when)
> locking accusers and accused an official ideology of tolerance forbids
> in an all too real prison of envy and fear. the open expression of hostility.
>
> Véronique Campion-Vincent/ *Rumor Mills: The Social Impact of Rumor and Legend*

The Good Rumor Project is a social experiment that seeks to invert the more common negative effects of rumor through the construction of a series of "good rumors" that are systematically spread and tracked as they evolve through the border region of San Diego-Tijuana.

Background. According to several scientific studies, rumors often help to develop a positive self-image of one's own social group by ascribing negative characteristics to people outside this group. As a result, rumors often reinforce the sense of difference between national, ethnic, and socio-economic groups. This is especially the case in border areas such as the US and Mexico frontier.

Project. *The Good Rumor Project* takes its starting point from the following questions: What would happen if a positive "good rumor" about people in San Diego and Tijuana was created, in contrast to the negative rumors that normally circulate about the populations on either side of the border? And what if the subjects of the rumor were actively involved in constructing it?

Spreading the rumors

Two "good rumors" are being systematically spread in San Diego and Tijuana. This has been achieved by means of a strategy that draws on ideas developed in recent sociological research on how influential ideas are spread through people's social networks. People from every level of society, who are influential in their social groups, have been targeted and contacted by the project group. These socially influential people (referred to in the project as "nodes") were invited to collaborate in the project by spreading the "good rumor." In addition to this, the nodes have also been asked to invite three new people to participate as nodes by continuing to spread the rumor and by inviting three new nodes. As each successive generation of nodes recruits three additional nodes, the rumor continues to spread in ever increasing intensity throughout the San Diego-Tijuana border region.

Tracking the rumors

Finally, each participating node has also been asked to fill in a few demographic facts on the project's website in order for the rumor to be tracked geographically as well as socio-economically. Via an interactive sociogram on the website, the nodes, as well as anyone who is interested in the project, can follow how the rumor travels from person to person in the border area. Additional research will also be conducted in the media, the Internet, etc., in order to determine how the content of the rumor has changed during circulation and what impact this has had.

M.W./ Introduction to *The Good Rumor Project* website

Junio–Agosto 2005/ Måns Wrange

Construcción de la página *web*/ De junio a agosto de 2005, Wrange trabajó con sus colaboradores en Estocolmo y con Dream Addictive en Tijuana para elaborar su *website*. Por esas fechas ya Wrange contaba con un buen número de personas con cierta influencia social —"nodos"— quienes lo ayudarían a esparcir los buenos rumores sobre San Diego y Tijuana. Wrange pudo probar con ellos algunos de los formatos iniciales del *website* con el propósito de rastrear el perfil de los "nodos" participantes, asi como de la evolución del rumor tanto en el sentido geográfico como de su contenido. A mediados de agosto, Dream Addictive todavía lidiaba con problemas técnicos y funciones clave del *website* aún no operaban. Este atraso fue en detrimento del proyecto obligando a posponer el lanzamiento del rumor, y afectando la colaboración entusiasta en un momento tan crucial.

Translated *Unfolding Process*/ pp. 64–65

Allora & Calzadilla

Signs Facing the Sky> Signos mirando el cielo/

Synopsis. *Signs Facing the Sky* is a fictitious depiction of the city as an aerial landscape. Allora and Calzadilla conducted a series of informal interviews with people living, working, and frequenting buildings located beneath the San Diego flight path, in which they asked them to reveal their hidden dreams and desires. They then combined footage of downtown San Diego, which was recorded from a birds-eye perspective to mirror the view of the city as it is seen from incoming airplanes, with motion tracking animation. The result is an aerial view of the city in which illuminated rooftop signs depict the wishes and secrets of San Diego's inhabitants.

Through a collage of appropriated texts, Allora and Calzadilla have created a cinematic discourse about the city in which the voices of San Diego's residents intersect and overlap. This fictive space in which the city's inhabitants become active agents in the construction of the polis, inscribing their personal narratives of fear, hope, and desire on its architectural fabric, maps a "subjective" experience of the city. By creating a relationship between urban space and the desires of its populace, Allora and Calzadilla suggest the possibility that the city is constructed through the collective fantasies of its inhabitants.

Signs Facing the Sky was projected in the open-air patio of The Airport Lounge in San Diego for the duration of the public phase of **inSite_05**. The patio stood directly under the flight path and in close proximity to the San Diego International Airport. The sight of planes passing overhead during the projection created a discursive parallel between reality and fiction.

Images: Research process and residencies/ Video installation at The Airport Lounge/ Still from the video> Imágenes: Residencias y proceso/ Instalación del video en The Airport Lounge/ Foto fija del video

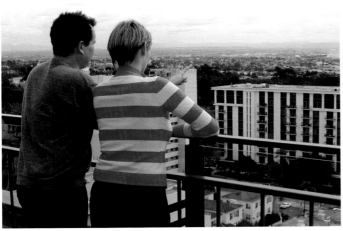

→ Otras traducciones/ pp. 274–275

Translated *Unfolding Process*/ p. 50

Octubre 2004/ Allora and Calzadilla

Investigación de campo y entrevistas/ En octubre de 2004, Allora y Calzadilla investigaron el área urbana justo debajo de la ruta de tráfico aéreo de San Diego e identificaron un número de edificios en el centro de la ciudad cuyos techos serían visibles desde los aviones a su llegada al aeropuerto internacional. Seleccionaron un grupo de edificios, desde departamentos residenciales hasta asilos de ancianos y centros de operaciones bancarias. Allora y Calzadilla llevaron a cabo una serie de entrevistas informales con la gente que vivía o trabajaba en los edificios, pidiéndoles que revelaran un secreto, un deseo o una fantasía. Revisar las fotos satelitales del área les permitió cerciorarse de la viabilidad de erigir letreros visibles en los techos de los edificios.

Sinopsis. *Signos mirando el cielo* es una representación ficticia de la ciudad y sus voces vista como un paisaje aéreo. Allora y Calzadilla llevaron a cabo una serie de entrevistas informales con la gente que vive y trabaja en los edificios que se encuentran debajo del corredor aéreo de San Diego. En estas entrevistas pidieron a sus interlocutores que revelaran sus sueños y deseos ocultos. Luego combinaron material fílmico de una perspectiva aérea del centro de San Diego con tomas virtuales de letreros de neón que daban voz a los secretos de los entrevistados. El resultado es una visión panorámica de la ciudad como si ésta fuese vista desde los aviones entrantes, en la cual los mensajes iluminados en los techos de los edificios discursan sobre los deseos de sus habitantes.

Por medio de un *collage* de citas tomadas de sus entrevistas, Allora y Calzadilla crearon un discurso cinemático sobre la ciudad, en el cual las voces de los residentes de San Diego se intersectan y se superponen. Este espacio ficticio en el que los ciudadanos se vuelven agentes activos en la construcción de la *polis*, al inscribir sus narrativas personales de miedo, esperanza y deseo sobre el tejido urbano, mapea una experiencia "subjetiva" de la ciudad. Al crear una relación entre el espacio urbano y los deseos de su población, Allora y Calzadilla sugieren la posibilidad de que la urbe se construye a través de las fantasías colectivas de sus habitantes.

Signos mirando el cielo se proyectó en un patio al aire libre de The Airport Lounge en San Diego durante la fase pública de **inSite_05**. El patio estaba ubicado justamente debajo del corredor aéreo de la ciudad, en la vecindad del aeropuerto internacional de San Diego. La presencia continua de aviones pasando por encima de las cabezas de los espectadores durante la proyección creaba un discurso paralelo entre la realidad y la ficción.

El objetivo de *Signos mirando el cielo* era llamar la atención sobre lo que normalmente se omite o se suprime en la práctica lingüística oficial de la ciudad y, en un plano ideal, montar una confrontación crítica entre el lenguaje dominante registrado en el paisaje de la ciudad y lo que se considera su remanente excesivo (las denominadas "voces" de la población). La obra negoció el terreno entre lo que podría constituir una esfera social democrática, en donde voces encontradas reclaman para sí el espacio público, y las actuales condiciones productivas del espacio en un centro urbano del capitalismo tardío en el que los intereses comerciales orientan la mayoría de los esquemas de desarrollo y, en consecuencia, tiende a imponerse el tipo de lenguaje que se encuentra en las calles y edificios de la ciudad; es decir: la publicidad, los anuncios espectaculares, los letreros comerciales, etcétera.

Los enunciados en y por sí mismos eran ruinas escritas, fragmentos de enunciados más largos que encierran universos de posiciones de identidad construida tanto subjetivas como sometidas desde un punto de vista social. El propósito no era infiltrar una demanda moral en los textos incluidos en *Signos mirando el cielo*, como si esas expresiones fuesen más auténticas, reales o moralmente correctas que aquellas que se encuentran en los anuncios espectaculares de las calles, sino más bien presentar esos fragmentos como intersecciones entre flujos múltiples y en su mayoría conflictivos que producen y reproducen identidad, así como mantener estas fuerzas en tensión. A&C.

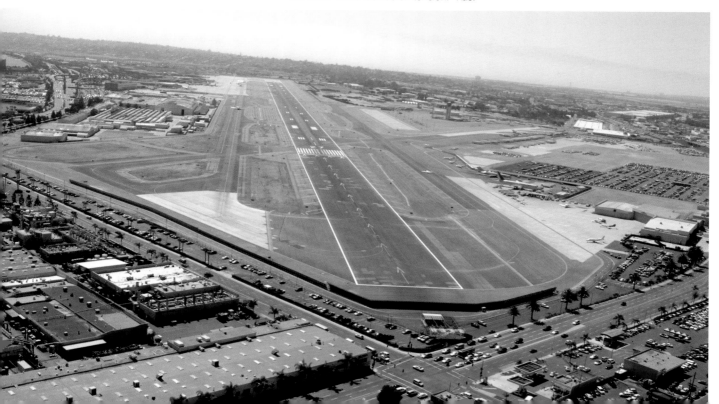

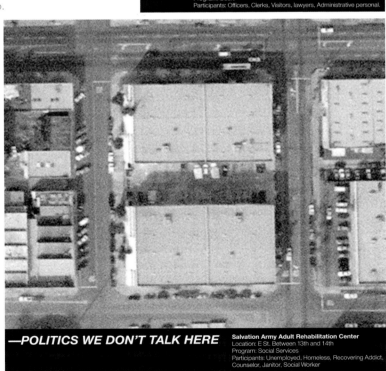

—MY TONGUE IS KARATE
Court House
Location: Union St. & Front St., Bet. Union and Broadway
Program: Court
Participants: Officers, Clerks, Visitors, lawyers, Administrative personal.

We have attached here a Word document with a selection of buildings and texts. We have spent some considerable time going over the statements that we've gathered and have tried to select those statements which, for us, were the most open to multiple meanings and interpretation, that were related in some way to the building but not necessarily illustrative of its program. We hope that you find them as interesting as we do.
A&C./ Email/ "Project," February 25, 2005

Film Shots

1. Various Angles: 90-degree angle; vertical, looking down, 45-degree angle and horizontal
2. Velocity: Fast, slow, and completely stop in the air
3. Zoom: Super zoom almost abstract, more open, and panoramic
4. Helicopter: Turning right, turning left, turning 360 degrees, going up; going down

A&C./ Email/ "Film Instructions," June 22, 2005

What about showing our video on the planes that land in San Diego, talk to some airlines and ask them if they would like to screen it on the plane monitors...? The video is 3 minutes and 22 seconds long. What do you think? A&C./ Email/ "IDEA!!" July 23, 2005

Images: Research process/ Mock-ups from selected buildings by the artists> Imágenes: Investigación y proceso/ Fotomontajes digitales de los edificios seleccionados por los artistas

—POLITICS WE DON'T TALK HERE **Salvation Army Adult Rehabilitation Center**
Location: E St. Between 13th and 14th
Program: Social Services
Participants: Unemployed, Homeless, Recovering Addict, Counselor, Janitor, Social Worker

WHO LET THEM IN?
SOMETIMES IT'S NICE TO PRETEND
THE SITUATION WAS CREATED BY GOD
MY EVER-UNFINISHED BODY
WORLDS END…ALL THE TIME
I NEED SOMEONE TO MAKE ME FAMOUS
I WILL WIN THIS TIME
THEY'RE HARMLESS JOKES
DEMANDS, DEMANDS
I WRITE RUINS
ECONOMIES OF SCALE
WE NEED MORE EXPLANATIONS
WHEN THE DAYS ARE MARCHING
THIS IS FATE
FOREIGN WARS
MILLIONS UPON MILLIONS
WHAT ARE THEY INGESTING
IT DOESN'T SURPRISE ME
IT WILL COMPLETELY ALTER THE WORLD
AT EXACTLY 80 SECONDS
ONE REALLY FUN WAR
A SMALL VICTORY
BORDER…ORDER
NO MATTER WHAT THE COST
THE OLD PROPHESY
I TRY TO ASSIMILATE
SATISFY THE MINORITIES
THE PUBLIC IS SCATTERED
THEY WILL WORK FOR LESS
THE STATE OF POVERTY
I'M NOT SORRY
THERE ARE NO EXCEPTIONS
RIDICULOUS VERDICTS
IT'S A PLACE THAT CONSUMES YOU
MY GOD WILL TEACH THEM
IT WAS ME, I'M SO SORRY
SAME ROUTINE EVERY DAY
I FEAR NAKED LIFE
NOT A MURDER, A HERO
THOSE WONDERFUL DAYS
LIVING IN OUR FIRST HOME
DESPERATE NEEDS
I LISTEN FLUENTLY
SPEAKING OUT FOR JUSTICE
I THINK OF MYSELF AS A MAN FIRST
THE GREAT THING IS WE ARE FREE
THEY WERE IN THEIR HOMES WHEN IT HAPPENED
IT'S AN OUTRAGEOUS LIE
HOW DO WE APOLOGIZE?
THERE'S NOT MUCH I WOULDN'T GIVE TO GO BACK
NOBODY IS LISTENING
MY EVER-UNFINISHED BODY

¿QUIÉN LOS DEJÓ PASAR?
A VECES SE SIENTE BONITO PRETENDER
COMO SI LA SITUACIÓN FUERA CREADA POR DIOS
MI CUERPO SIEMPRE INACABADO
EL FIN DEL MUNDO... TODO EL TIEMPO
NECESITO A ALGUIEN QUE ME HAGA FAMOSO
ESTA VEZ SÍ GANARÉ
SON SÓLO CHISTES INOFENSIVOS
DEMANDAS, DEMANDAS
LO QUE ESCRIBO ES RUINAS
ECONOMÍAS DE ESCALA
NECESITAMOS MÁS EXPLICACIONES
CUANDO LOS DÍAS PASAN Y PASAN
A ÉSTO SE LLAMA DESTINO
GUERRAS EXTRANJERAS
MILLONES Y MÁS MILLONES
ESO QUE ESTÁN INGIRIENDO
YA NO ME SORPRENDE
ALTERARÁ TOTAMENTE AL MUNDO
EN EXACTAMENTE 80 SEGUNDOS
UNA GUERRA EN VERDAD DIVERTIDA
UNA DIMINUTA VICTORIA
FRONTERA... ORDEN
NO IMPORTA A QUÉ COSTO
LA VIEJA PROFECÍA
APENAS TRATO DE ASIMILAR
SATISFACER A LAS MINORÍAS
EL PÚBLICO SIGUE DISPERSO
TRABAJARÍAN POR MENOS
UN ESTADO DE POBREZA
NO LO LAMENTO
SIN EXCEPCIONES
VEREDICTOS RIDÍCULOS
ES UN LUGAR QUE TE VA CONSUMIENDO
MI DIOS LES ESCARMENTARÁ
ERA YO, Y LO LAMENTO MUCHO
LA EXACTA RUTINA TODOS LOS DÍAS
TEMO A LA VIDA COMO ES
NO UN ASESINATO, UN HÉROE
AQUELLOS DÍAS MARAVILLOSOS
VIVIENDO EN NUESTRA PRIMERA CASA
NECESIDADES DESESPERADAS
ESCUCHO CON FLUIDEZ
HABLANDO A FAVOR DE LA JUSTICIA
ANTE TODO, PIENSO EN MÍ COMO HOMBRE
LO MEJOR ES QUE SOMOS LIBRES
ELLOS ESTABAN EN SUS CASAS
CUANDO TODO SUCEDIÓ
ES UNA MENTIRA EXASPERANTE
¿CÓMO PODRÍAMOS PEDIR DISCULPAS?
NO HAY MUCHO QUE NO PUDIERA DAR
A CAMBIO

Recently in Ghent, we had the chance to see the work of the pioneering conceptual artist, Douglas Huebler's, *Variable Piece = 11 Rowley Massachusetts*, 1971, which resonated with some of our intentions and procedures in making *Signs Facing the Sky*. For this work, Huebler enlisted a group of students, in exchange for a $10.00 donation to the local high school, to ask residents in Rowley to describe to them life in their small town. Many people were reluctant to take part in this experiment, and the gaps said as much about the town, its openness and attitude towards public expression as did the few descriptions that were finally collected and documented. Perhaps the chance that we had to see this work is a result of our privileged position to travel freely to many places in the world, mostly upon the invitation of art institutions, but this status we accept with all the accompanying responsibility that such freedom entails.

In this instance, we were able to confront a historic work of conceptual art and tease out the affinities and divergences with our own artistic practice nearly 25 years later. What became most clear to us, upon seeing this work, is an intricate relationship between process and concept so lucidly exemplified, in addition to registering an early example of the so called "ethnographic" or "documentary" approach to art argued about in regards to public art in the 1990s. It raised a number of productive questions about the artist's role in relationship to the subjects depicted, the representational systems utilized in its mode of address, as well as the critical possibilities and limits of certain forms of artistic engagement.

These questions were all relevant to us in the development of our project for **inSite**. *Signs Facing the Sky* was conceived of, first and foremost, as a response to the unique location, history, and public that make up the city of San Diego. In terms of its artistic procedure, it utilized both conceptual and process based strategies. It considered under what conditions a representation of the city could be formulated, with an implicit understanding from the outset that this would only be a partial, fragmented, and inconclusive view. It considered what method would work best in producing such an account, which, for us in this instance, was the survey—and to this end, over the course of our two-year involvement with **inSite**, we met informally with hundreds of San Diego inhabitants.

The motivation for creating *Signs Facing the Sky* was to create a representation of the city that worked in a dialectical manner against normalizing representations of the city as projected through advertising, city beautification schemes, and tourist imagery. *Signs Facing the Sky* offered instead a disjunctive, dangerous, sometimes honest, sometimes wishful account of the city inhabitants' identity and their ideas about the city. Instead of the typical San Diego Visitors Bureau's projection of the city: eternal sunshine, relaxation, idyllic settings, and "evolving neighborhoods," the potential viewers of *Signs Facing the Sky* were confronted with expressions such as "My God will teach them," "Nothing…it's history," "I try to assimilate," or "Not a Murderer, a hero."

By mixing the verbal with the visual, architectural, and urban fabric of the city, *Signs Facing the Sky* attempted to connect to its geographic location through a staging of the disembodied voices of its inhabitants, introducing a new textual layer and lexicon of phrases

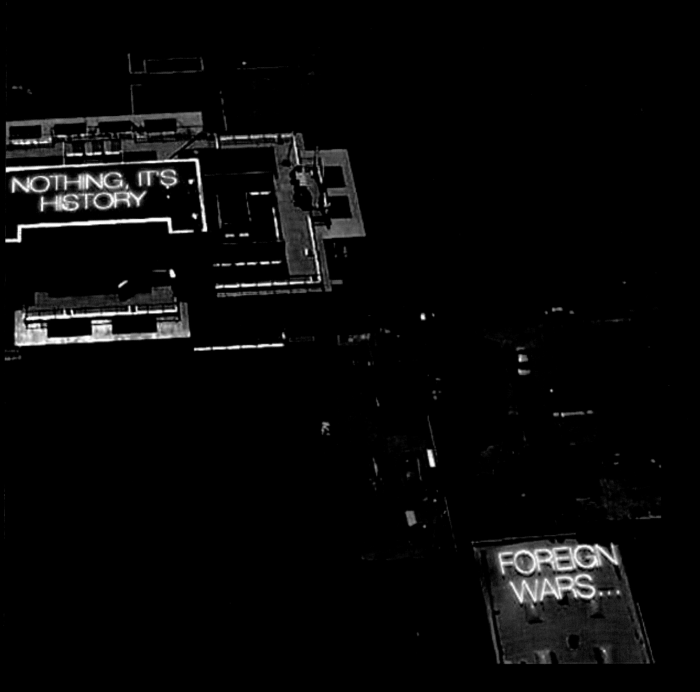

into the cityscape. The expressions collected were intended to be placed on the rooftops of buildings—a site that will surely become the next contested ground of development. With the media gaze more and more directed from the satellite's perspective, these vast horizontal planes and underutilized voids in the urban will certainly figure more prominently. *Signs Facing the Sky*'s aim was to call attention to what is normally omitted or suppressed in the city's official linguistic practice and hopefully to stage a critical confrontation between the dominant language registered in the cityscape and what is considered its excessive remainder (the so-called "voices" of the population). The work negotiated the terrain between what might constitute a democratic social sphere, in which competing voices mutually lay claim to public space, and the actual productive conditions of space in a late-capitalist urban center in which commercial interests guide the majority of developmental schemes and consequently tend to dominate the type of language found on the city streets and buildings: i.e., advertising, billboards, commercial signage, etc.

The statements in and of themselves were written ruins, fragments of larger thought statements which themselves encode universes of subjective as well as subjected and socially constructed identity positions. It was not the intention to lay a value claim on the kinds of texts included in *Signs Facing the Sky* as though those expressions were somehow more authentic, real, or morally correct than those founds on the billboards on the streets but rather to present these fragments as intersections between multiple and often conflictive flows that produce and reproduce identity and to hold these forces in tension.

In regards to the notion of travel, as it pertains to those coming to a city from somewhere else as well as to those who dwell in a permanent or transitory manner in a place, *Signs Facing the Sky* was concerned with the distances covered both mentally as well as geographically. Each text or phrase became a point of intersection where identifications could converge or diverge. One could enter into the imaginary space of a particular phrase, follow the chain of associations it might trigger, wonder about who might have said such a statement, compare it to a neighboring text, surmise the intentions of such a provocation, be repelled by it and look away, or survey the cacophonic whole, among the many other modes of entry and exit that such a textually based work offers.

Finally, the use of video as a means to realize this project offered us a tool to locate these expressions within a limited space-time continuum. The work exists as a video, dated 2005. It is a fly-by of the downtown area, seen from a bird's-eye view, which lasts a mere three minutes in length. A prerequisite of the moving image is its temporal and transient nature. This medium condition offered us a more transparent frame in which to realize this project since the city's daily population flow is as dynamic as the multiple and shifting frames that make up the video image. If we were more technically savvy this work could have become a potentially endless digital video with new texts appearing with each new pass over the semi-fixed urban infrastructure (since both the people who occupy any particular part of the city at any given time are in constant flux as well as their individual thoughts and positions ever open to ongoing and emerging change). However, as a fixed tomb of a particular moment in time, (the history of the recorded images reminds us), the video work exists as an unique, inconclusive fragment that surveyed the contradictions, translations, assimilations, and appropriations of ideas and values for the life and survival of particular individuals living in the entangled cityscape of San Diego between 2003 and 2005.

A&C.

The motivation for *Signs Facing the Sky* was to create a representation of the city that worked in a dialectical manner against normalizing representations of the city as projected

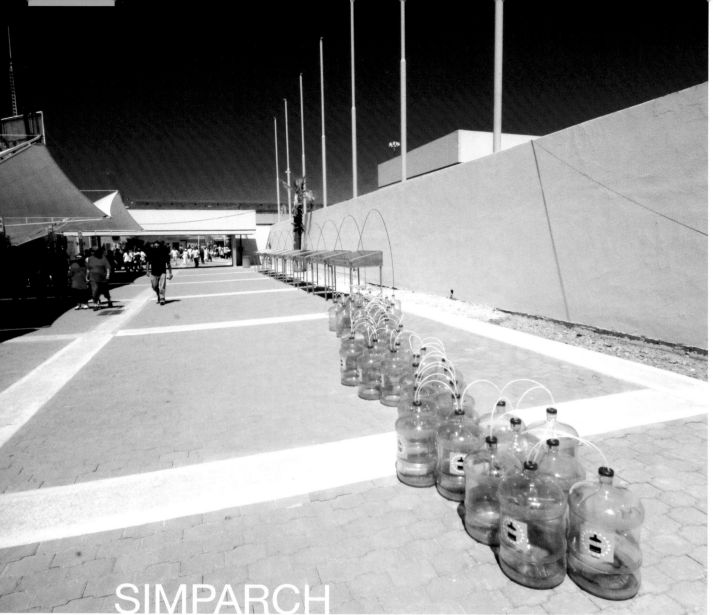

SIMPARCH

Dirty Water Initiative> Iniciativa del agua sucia/

Synopsis. SIMPARCH's project for **inSite_05** began with a rigorous research process into the theme of water. They were particularly interested in exploring the topic in relation to Tijuana, which has enormous problems with water management and experiences difficulties with its collection, treatment, and use. SIMPARCH visited various informal communities in Tijuana with the collaboration and assistance of Fundación Esperanza (Hope Foundation). They proposed an experiment in direct utility: to purify water for human consumption using solar light. The project, entitled *Dirty Water Initiative*, consisted of two phases. The first phase involved the construction and installation of a group of small purifying plants, which were fashioned to resemble a public fountain and located in the pedestrian border-crossing corridor from San Ysidro to Tijuana. The display of these glass-enclosed solar distillers, rather than serving as aesthetically pleasing urban monuments, was intended to expose the problems concerning water in the region, as a serious crisis requiring inventive solutions. SIMPARCH sought to make a direct impact, not only on border crossers but also at a community level in the nearby informal and underprivileged settlements. The purifying plants were then removed and donated for everyday use in family homes in various communities in Tijuana. The project managed to alter the traditional concept of the "public fountain" as an urban monument and, at the same time, suggest a modest solution for community self-sustainability.

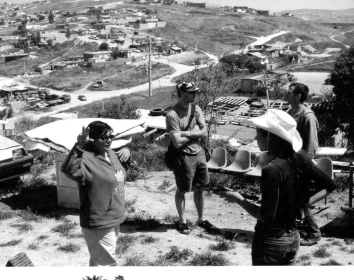

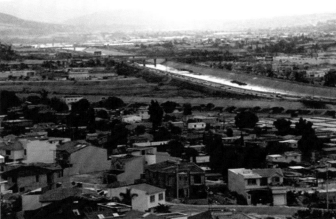

Images: Research and production process/
Project display at the US-Mexico border (in
color)> Imágenes: Proceso de investigación/
Instalación del proyecto en el paso fronterizo
(a color)

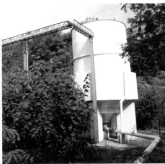

Investigación en el área/ En octubre de 2004 Steve Badgett
y Matt Lynch regresaron a Tijuana con el tema de su investi-
gación definido: el agua y su potabilización. La visita a sitios es-
pecíficos como parte de su investigación incluyó: el Ecoparque,
en donde estudiaron el funcionamiento de su planta de cap-
tación y tratamiento de aguas residuales; y la Fundación Es-
peranza México —agencia sin fines de lucro dedicada al desa-
rrollo de proyectos comunitarios. Este encuentro les permitó el
acceso a comunidades informales de Tijuana, lo que constituyó
un factor clave en el desarrollo de su propuesta para potabilizar
agua utilizando la luz solar.

→ Otras traducciones/ p. 282

Translated *Unfolding Process*/ p. 61

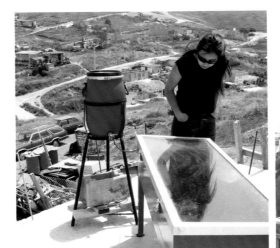

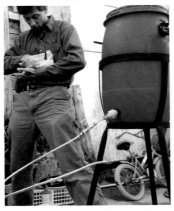

Sinopsis. El proyecto del colectivo estadounidense SIMPARCH partió de una rigurosa investigación de campo en varias comunidades informales de Tijuana, en colaboración con la Fundación Esperanza. Desde un inicio se enfocaron en la problemática del agua en esta zona fronteriza, especialmente en Tijuana, donde existen enormes problemas en el manejo del líquido —desde la captación, hasta su uso y su tratamiento. SIMPARCH se propuso una empresa de utilidad directa: potabilizar agua utilizando la luz solar. El proyecto, titulado *Iniciativa del agua sucia*, constó de dos etapas; la primera de ellas fue construir e instalar un grupo de pequeñas plantas potabilizadoras, a manera de "fuente pública", en el corredor del cruce peatonal de San Ysidro a Tijuana. La segunda consistía en la donación de estas plantas a comunidades de Tijuana para su uso. El despliegue de estos destiladores solares, sellados con vidrio, más que un efecto estético a escala urbana, pretendía transparentar el problema del agua como uno que requiere de soluciones, y buscaba lograr un impacto directo no sólo en los transeúntes del área sino a nivel comunitario en los asentamientos informales y de bajos recursos. Con posterioridad las plantas fueron trasladadas y adoptadas para su uso cotidiano en casas familiares de varias comunidades de Tijuana. El proyecto lograba trastocar el concepto tradicional de "fuente pública" como monumento urbano y a la vez proponía una solución modesta a la autosustentabilidad comunitaria.

The stills are sealed glass-covered shallow basins that are supplied water via an elevated tank of non-drinkable water. The sun heats the water in the basins causing it to evaporate onto the underside of the glass. This condensation then flows down to a channel, which directs the distillate to a tube where it collects in a vessel outside of the still. SIMPARCH

Dirty Water Initiative

As an opportunity to work in the thriving, economical, noninstitutional realm of Tijuana's informal communities, SIMPARCH is proposing to purify water in Mexico using the simple technology of solar water distillation. The project has two phases: the first is to construct and install a small purification facility in a public location; the second is to relocate the facility permanently to a community where it would be useful and appreciated.

SIMPARCH's project for **inSite_05** will consist of an array of solar stills for purifying water not considered clean enough to drink. The stills are sealed glass-covered shallow basins that are supplied water via an elevated tank of undrinkable water. The sun heats the water in the basins causing it to evaporate onto the underside of the glass. This condensation then flows down to a channel, which directs the distillate to a tube where it collects in a vessel outside of the still.

The site location offered is the plaza at the end of the pedestrian walkway from the border. SIMPARCH values this site for the project as it relates to the idea of a de facto fountain or public/pedestrian water source. The logistics of collection and distribution of the purified water will need to be addressed. Although an important criteria for the distillation process is that the stills receive maximum exposure to the sun without the hindrance of shadows, placement of the work will be contingent upon permissions granted by the border agency in charge of the plaza.

It is our hope after this exhibit runs it course that the SIMPARCH installation will be moved to a community in need of drinking water, thus having a second life as a functioning mini-purification plant. SIMPARCH/ Statement

Iniciativa del agua sucia

Como una oportunidad de trabajar en el próspero terreno económico y no institucional de las comunidades informales de Tijuana, SIMPARCH propone potabilizar agua en México mediante la aplicación de una sencilla tecnología, es decir, utilizando la energía solar para destilar el líquido. El proyecto consta de dos etapas; la primera de ellas es construir e instalar una pequeña planta potabilizadora en algún sitio público, y la segunda implica trasladar dicha planta para asentarla de manera permanente en una comunidad en donde sea valorada y resulte de utilidad.

El proyecto de SIMPARCH elaborado para **inSite_05** constará de un conjunto de destiladores solares que servirán para potabilizar el agua no purificada. Las alcataras están constituidas por recipientes poco profundos sellados con una tapa de vidrio, a los que se les provee del líquido por medio de un tanque elevado de agua no potabilizada. El sol calienta el fluido contenido en los recipientes y ocasiona su evaporación, misma que se concentra en la parte anterior del cristal. El vapor condensado desciende a un canal que conduce el producto destilado a través de un ducto para, finalmente, recolectar el líquido en una vasija ubicada al exterior de la alcatara.

El sitio que se propone para llevar a cabo este proyecto es la plaza que se localiza al final de la calzada peatonal de cruce fronterizo en la Garita de San Ysidro. SIMPARCH valora este lugar para el proyecto, pues se relaciona con la idea de una fuente *de facto* o de un manantial público para los peatones. Todavía está por decidirse cuál será la logística de la recolección y distribución del agua potabilizada. Aun cuando un criterio relevante para la puesta en marcha del proceso de destilación es que las alcataras reciban la máxima exposición solar sin que haya interferencia alguna de sombras, el emplazamiento de esta obra dependerá de la obtención de los permisos que deberá conceder la agencia fronteriza a cuyo cargo está el funcionamiento de la plaza.

Esperamos que una vez concluida esta muestra, la instalación de SIMPARCH se traslade a una comunidad que requiera de agua potable, para que de esta manera adquiera vida posterior como miniplanta potabilizadora de agua en funciones. SIMPARCH/ Propuesta

Agosto 2005/ SIMPARCH

Prueba e instalación de las mesas destiladoras/ En agosto de 2005 Badgett y Lynch verificaron el funcionamiento de los primeros prototipos instalados en La Morita y el Ejido Lázaro Cárdenas y comenzaron la instalación de las mesas destiladoras en el corredor peatonal de San Ysidro, en el cruce de Estados Unidos a México. La instalación del proyecto en esa zona estuvo supeditada al permiso otorgado por el Instituto de Administración y Avalúos de Bienes Nacionales. El proyecto buscaba insertarse a manera de "fuente pública" dentro del denso flujo de circulación como una estrategia para llamar la atención sobre uno de los problemas más graves de Tijuana. El bajo perfil de despliegue "artístico" y la reducida visibilidad a escala urbana de la pieza respondieron al interés de Badgett y Lynch por mantenerse apegados a su funcionalidad básica más que a otras consideraciones estéticas.

Translated *Unfolding Process*/ p. 61

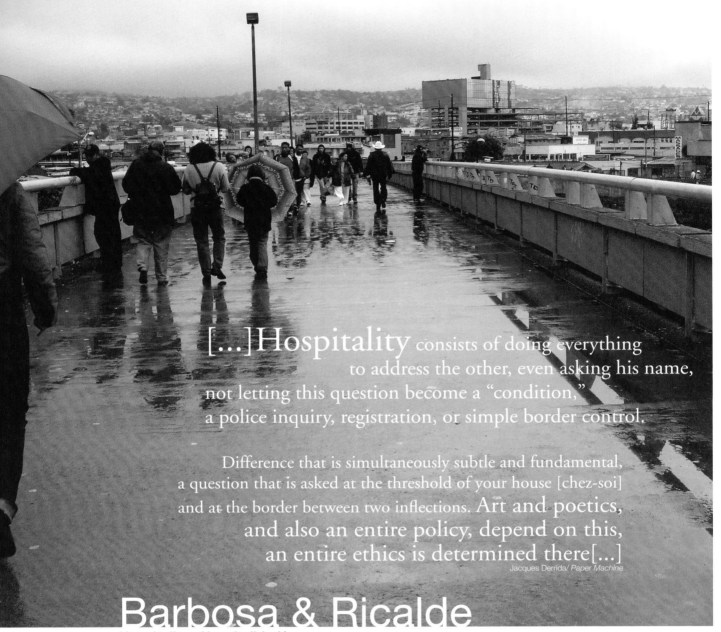

[...]Hospitality consists of doing everything to address the other, even asking his name, not letting this question become a "condition," a police inquiry, registration, or simple border control.

Difference that is simultaneously subtle and fundamental, a question that is asked at the threshold of your house [chez-soi] and at the border between two inflections. Art and poetics, and also an entire policy, depend on this, an entire ethics is determined there[...]

Jacques Derrida/ *Paper Machine*

Barbosa & Ricalde

Hospitality> Hospitalidad/

Synopsis. Barbosa and Ricalde proposed transforming the Puente México (the pedestrian bridge that crosses the Tijuana River and is adjacent to the international border crossing at San Ysidro) into a "welcome mat." The project, entitled *Hospitality*, was inspired by the use of first names on brightly colored woven bracelets that are sold in handcraft market stalls along the border. The work encourages reflection on the notion of "welcome" through an exploration of the nature of hospitality. This meditation is tied to the specificity of the area—a border zone where we alternate between the role of guest and host. *Hospitality* transforms the Puente México, as a space of transit, into a site that generates connection between strangers. Barbosa and Ricalde invert the idea of the souvenir, by encouraging pedestrians to print their name-identity on the bridge—like a series of fingerprints superimposed over the city as it receives them. In August 2005 the visual carpet, created in collaboration with Tijuana sign-makers and art students, began to grow as passersby requested that their first names be added to the bridge. This continued until the entire surface of the bridge was covered in brightly colored first names.

[...]¿La hospitalidad consiste en interrogar a quien llega? ¿Consiste en preguntar a quien viene: "¿cómo te llamas?", "dime tu nombre"?, ¿cómo debo llamarte yo que te llamo, que quiero llamarte por tu nombre? [...] ¿O será que la hospitalidad comienza en la acogida incuestionable, en la disolución mutua, en la disolución de la pregunta y del nombre? ¿Es más justo o más amable preguntar o no preguntar? ¿Llamar a alguien por su nombre o sin un nombre? ¿Dar uno nuevo o tomar un nombre ya dado? ¿Se ofrece la hospitalidad a un sujeto?, ¿a un sujeto identificable?, ¿a un sujeto que ha sido identificado con un nombre?, ¿a un sujeto de derecho? ¿O la hospitalidad se da a los otros antes de que ellos se identifiquen?, ¿antes de que se conviertan —o sean convertidos— en sujetos de derecho, en sujetos identificables por su apellido?

Jacques Derrida/ *Papel Máquina*

This proposal is based on the idea of the welcoming of the other. Whoever this other is. Without demanding the other's surname, we propose to inscribe his name—one which he likes to have, one by which he likes to be called—on the land that welcomes him. B&R./ Statement

Images: Puente México/ Mexican hand-crafted bracelets> Imágenes: Puente México/ Pulseras artesanales mexicanas

→ Otras traducciones/ p. 275

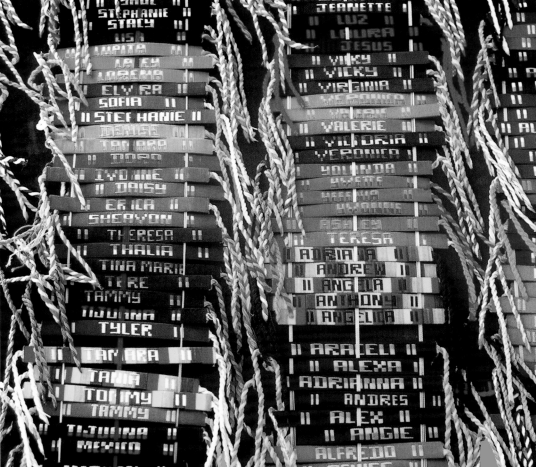

Sinopsis. Felipe Barbosa y Rosana Ricalde se propusieron cubrir a manera de alfombra de bienvenida el Puente México que atraviesa el Río Tijuana a la altura de la línea divisoria internacional, cerca del cruce fronterizo de San Ysidro. El proyecto, titulado *Hospitalidad*, se inspiró en el uso del nombre propio, tal y como aparece en las coloridas pulseras tejidas que se venden en los mercados artesanales de esta frontera. La pieza buscaba una reflexión en torno al término de *acogida* bajo el cuestionamiento de qué es la hospitalidad en la especificidad del área, ya que en una zona fronteriza todos somos huéspedes o somos anfitriones en algún momento. *Hospitalidad* transforma a ese lugar de paso —el puente que enlaza el punto de cruce fronterizo con la zona turística y comercial de Tijuana— en un sitio de conexión entre extraños, y a su vez invierte la idea del *souvenir*, al promover el estampado del nombre-identidad del caminante como huella en la ciudad que lo acoge. Esta alfombra visual, realizada en colaboración con un grupo de rotulistas y de estudiantes de arte de Tijuana, fue creciendo a partir del mes de agosto de 2005 —con nombres propios y colores a petición de los propios trauseúntes— hasta cubrir por completo la superficie del puente.

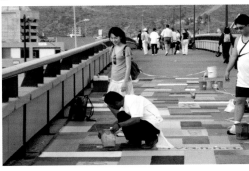 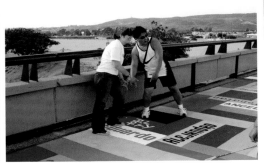 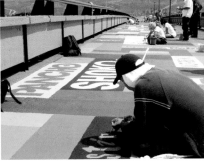

HOSPITALITY
Marisa Flórido Cesar

Hostility. A curious term. *Hostis*, in Latin, means hostile, enemy, but also, as Jacques Derrida observes, "guest."[1] The ambivalence of this etymon leads us to think about the ways we draw borders with the other who, immediate and strange, threatens our home, our culture, our territory, our place. The guest bears witness to the disorder that inhabits the house, the silences and intimate secrets. The hostile person can corrupt customs, alter the familiar order of things. The other can question identities, demolish places. Proximity becomes difficult, sometimes intolerable.

Alterity. But, how do you leave aside alterity, banish it from our neighborhood, close ourselves to the difference through which each of us reinvents ourselves as singularities? It is our ineluctable condition: the I is always others through others and with others.

Hospitality. The laws of traditional hospitality suppose the acceptance of the other in a territory, conditioned by rules and pacts: a surname is required; an identity and the social status of foreigner are granted, constituting the other as subject to law. Transforming hospitality without reservations into a contract reduces the threat of the other's difference: let him adjust to the customs and language of this place! Conditional hospitality entails violence: force the other into a sameness and suppresses his singularity.

The place. To whom does this place, this territory, this nation belong? This appears to be the fundamental question, a question of roots and origins, the question of man. But why understand it as a question of native soil, ontological and ethnic, from which the subject derives, from where an "I" is enunciated and recognized as identical to itself? How do you think about it from this vortex from which the concepts of border, citizenship, nation, and identity are shaken? How to understand it except from the border bridge, from a place that isn't a place, from a route that defies fixation?

The bridge. Interrogation without answer, the bridge is an entrée, a passageway towards the other, an opening into infinite alterity. >

Febrero 2005/ Barbosa y Ricalde

Invitación a colaboradores/ Durante sus primeros viajes a Tijuana Barbosa y Ricalde identificaron la bizarra proliferación de letreros pintados a mano en paredes de casas y edificios anunciando distintos servicios y comercios. En febrero de 2005 se organizó una reunión de trabajo con rotulistas del área, quienes podrían resultar potenciales colaboradores para su proyecto. Durante esa misma visita Barbosa y Ricalde se reunieron también con estudiantes de artes visuales de la Universidad Autónoma de California y la Universidad UNIVER, invitándoles al proyecto. A partir de ahí, Barbosa y Ricalde acordaron un mayor involucramiento de los rotulistas en el diseño del entramado y en la coordinación del trabajo con los estudiantes.

Translated *Unfolding Process*/ p. 51

> It is necessary to examine its mystery to found an "unconditional hospitality," the enigmatic experience of welcoming the other, as Derrida defined it.

The gesture. The place "does not belong to the host or the invited visitor but to the gesture with which one welcomes the other."[2] The absolute or unconditional hospitality, proposed by the philosopher, breaks with hospitality in the usual sense, with right and the pact of hospitality. "…Absolute hospitality requires that I open up my home and that I give not only a foreigner (provided with a family name…) but to the absolute, unknown, anonymous other, and that I let them arrive, and take place in the place I offer them, without asking of them either reciprocity (entering into a pact) or even their names…"[3]

Marisa Flórido Cesar is a freelance curator. She is currently based in Rio de Janeiro.

1 Anne Dufourmantelle and Jacques Derrida, *Anne Dufourmantelle convida Jacques Derrida a falar Da Hospitalidade,* São Paulo, Ed. Escuta, 2003.
2 Anne Dufourmantelle, *op.cit.,* p. 40
3 Jacques Derrida, *op.cit.,* p. 25

The name. "What's your name?" Felipe and Rosana ask the person who arrives his Christian name, and write it in this place without place, bridge and tense boundary between the US and Mexico. They don't ask his family name, a document, and a context of origin: this gesture invites us to reflect on the delicate operation of hospitality. It's the gesture as place, as no-place, as welcomed: a call to rethink the relations with this other with which we share the world. It's a show of solidarity and openness towards the other, the unconditionality prior to any contract, which may lead to the necessary application of hospitality. A bridge extended across two instances, the absolute and the conditioned, so that hospitality is not violated or forgotten in its beginnings. Art and poetry, a policy and an ethic move across this bridge.

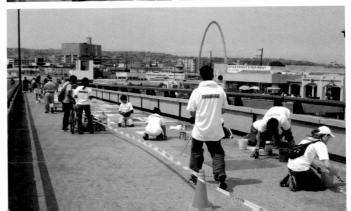

[...]Unconditional friendship and hospitality implies acceptance of the other as the other. If in the West the concept of hospitality includes the submission of the foreign to the laws of the home culture, unconditional hospitality should be ruled not only by acceptance of the (social, cultural, and moral) differences of the other, but above all by the knowledge that contact with the unknown provides[...] Jacques Derrida/ *Paper Machine*

[...]En la amistad y en la hospitalidad incondicionales está implícita una aceptación del otro en cuanto al otro. Si bien en Occidente se considera que la ley de la hospitalidad determina el sometimiento del extranjero a las leyes de la casa, la hospitalidad incondicional debería pautarse no sólo por la aceptación de la diferencia (social, cultural, moral) del otro, sino sobre todo por el aprendizaje que proporciona el contacto con lo desconocido[...]

[...]La hospitalidad consiste en hacer todo para dirigirse al otro, en concederle incluso antes de preguntarle su nombre, evitando que dicha pregunta se

Does hospitality consist of asking who's there? Does it consist of asking who's coming? What's your name? tell me your name, what should I call you, I who wish to call you by your name? [...] Or does hospitality begin in the unquestioned welcome, in the mutual dissolution, in the dissolution of the question and the name? Is it fairer or friendlier: ask or not ask? Call someone by their name or with no name? Give a new name or take a name that's already given? Do you offer hospitality to a subject? To an identifiable subject? To a subject who has been given a name? To a subject by right? Or is hospitality given to others before they identify themselves? Before they convert themselves—or are converted—in subject, in subjects by right, in subjects identifiable by their last name?

Jacques Derrida/ *Paper Machine*

transforme en "condición", en un interrogatorio policial, en una averiguación de antecedentes o en un simple control fronterizo. Es una diferencia al mismo tiempo sutil y fundamental, es la pregunta que se formula en el umbral de "en-casa" [*chez-soi*] y en el umbral entre esas dos inflexiones. Un arte y una poética, pero también toda una política, se involucran en ello, toda una ética se decide allí[...]

Jacques Derrida/ *Papel Máquina*

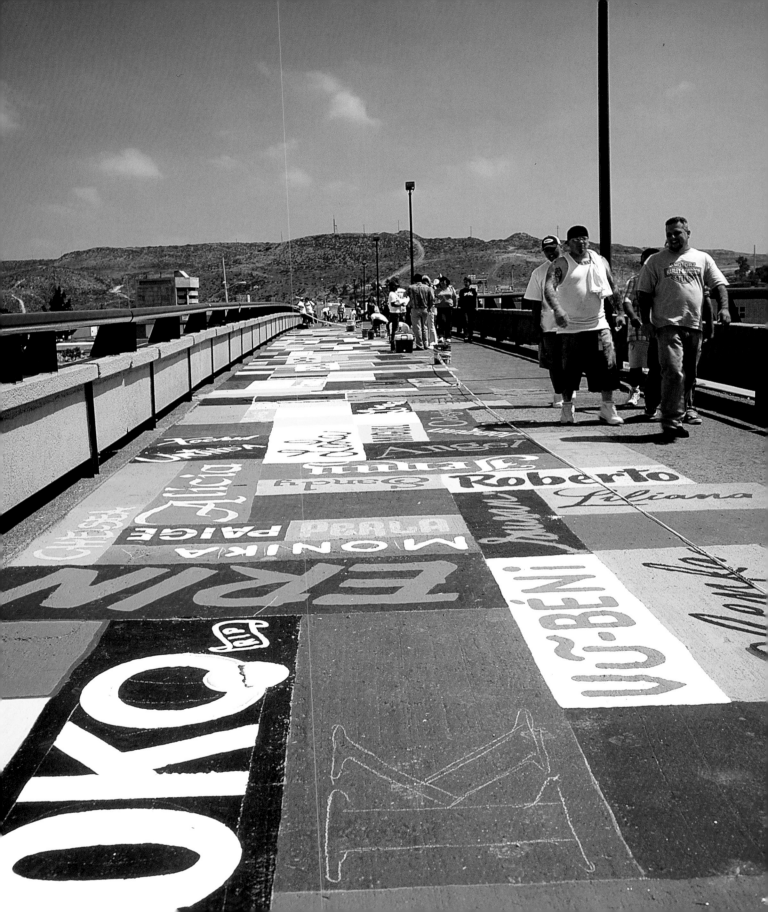

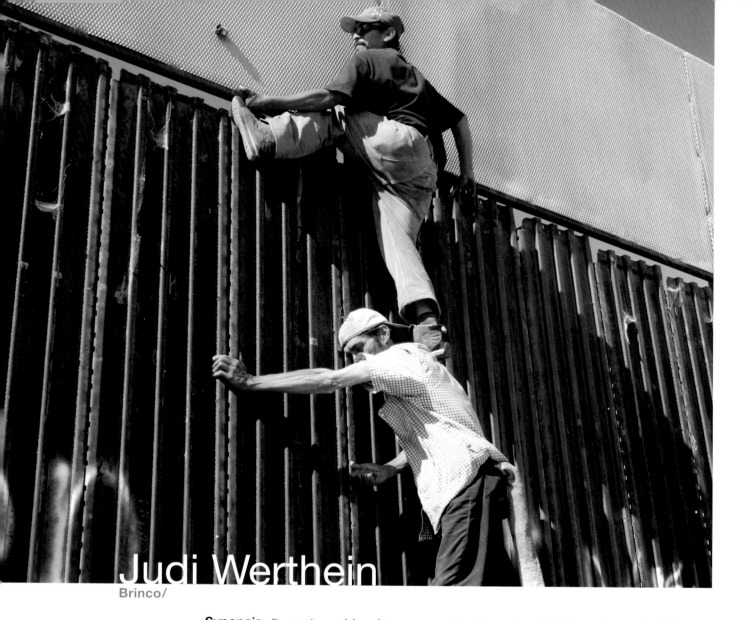

Judi Werthein

Brinco/

Synopsis. By creating and launching a new sneaker line, trademarked *Brinco* (Jump), Judi Werthein fashioned an object that embodies a complex and sophisticated critique of the contradictions at the heart of NAFTA, international labor policies, and corporate globalization. Werthein's sneaker incorporates motifs that both reference, and could potentially facilitate, undocumented migrants' efforts to illegally cross the US-Mexico border. Underscoring the tensions sparked by the decline in maquiladoras production and employment in Tijuana brought on by increased global competition, the sneakers were manufactured in China. Through August–November 2005 Werthein distributed the "border-crossing" sneakers to undocumented migrants at the Casa del Migrante, the Casa de la Madre Asunta, and the Casa YMCA de Menores Migrantes-Tijuana—organizations that provide support and services for deported migrants—as well as along the border fence. In counterpoint to their potential utilitarian use, the sneakers were also sold as limited-edition art objects in Blends, a high-end sneaker boutique located in downtown San Diego. In November 2005 the Associated Press released an article about the project and a deluge of press and public interest followed. Werthein appeared on CNN and Fox News, and magazines, newspapers, and radio stations around the world covered the story. *Brinco* stirred up debate about immigration law and the paradox of economic and political policies that promote the cross-border movement of goods, services, capital, and commodities, while simultaneously seeking to prevent the movement of labor.

By forging a relationship between a high-end sneaker boutique, an international art event, and undocumented migrants, Werthein brought into collision three interdependent components of the prevailing global economic model of circulation and exchange.

Brinco traces a relationship between the economic manipulation of the art object, which is circulated, exchanged, and collected as commodity and symbolic capital, and brand fetishism. As consumers have become fixated on labels that are equated with certain lifestyles and social status, the construction of urban identities has become increasingly centered on brand affiliations. By employing an iconography associated with Mexican migrant workers and Chinese assembly plant workers, Werthein created a branding strategy that addresses the social separation of labor from consumers. Co-opting this prevalent model of group identification, she supplanted it with new dynamics of association between global labor and consumers who increasingly want to understand the conditions under which their clothing and other consumables are made. D.C.

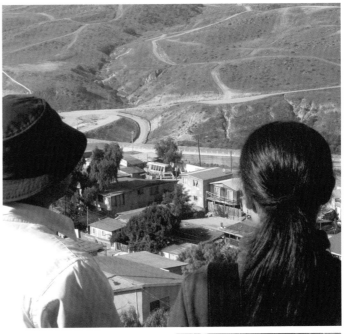

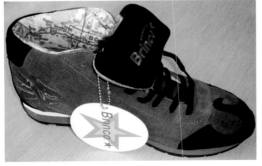

Images: Research process/ Final *Brinco* sneaker> Imágenes: Proceso de investigación/ Tenis *Brinco*.

→ Otras traducciones/ p. 284

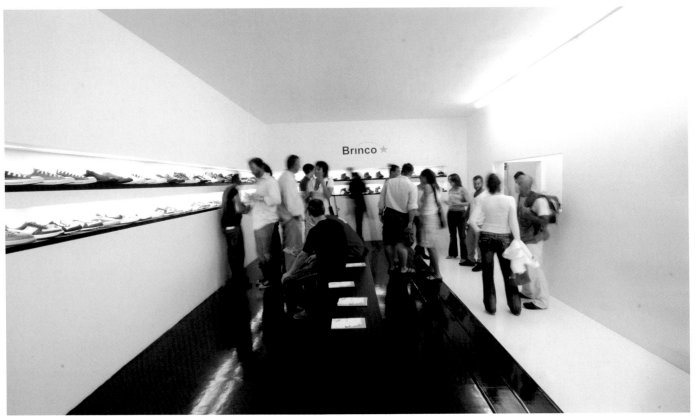

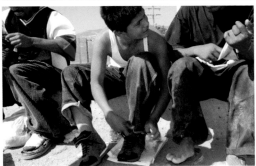

Sinopsis. Al crear y lanzar una nueva marca de zapatos tenis, registrada como Brinco, Judi Werthein diseñó un objeto que representa una crítica compleja y sofisticada a las contradicciones que se encuentran en el corazón del Tratado de Libre Comercio, así como de las políticas internacionales y la globalización corporativa. El tenis de Werthein incorpora motivos que por un lado se refieren a los esfuerzos de los indocumentados para cruzar ilegalmente la frontera México-Estados Unidos, y por el otro los facilitan potencialmente. Con el fin de emplazar las tensiones generadas a partir del declive de la producción y el empleo en las maquiladoras de Tijuana, resultado de la competencia global, los tenis fueron manufacturados en China. Entre agosto y noviembre de 2005 Werthein distribuyó los "tenis para cruzar la frontera" a los migrantes indocumentados que se encontraban en la Casa del Migrante de Tijuana —organización que brinda apoyo y servicios a los migrantes deportados— así como a lo largo de la frontera. En contraste con su utilidad potencial, los tenis también se vendieron, en edición limitada, como objetos de arte en Blends, una tienda de lujo localizada en el centro de San Diego. En noviembre de 2005 la Associated Press publicó un artículo acerca del proyecto, al que siguió una avalancha de interés por parte de los medios de comunicación y el público. Werthein apareció en CNN y Fox News, en revistas, periódicos y estaciones de radio de todo el mundo que cubrieron la noticia. *Brinco* provocó el debate en torno a la ley de inmigración y la paradoja que envuelve a las tendencias económicas y políticas que fomentan el intercambio fronterizo de bienes, servicios, capital y comodidades, al tiempo que buscan frenar el flujo de la fuerza de trabajo.

This product was manufactured by workers in China who were paid a minimum wage of $42 per month and worked 12 hours a day.

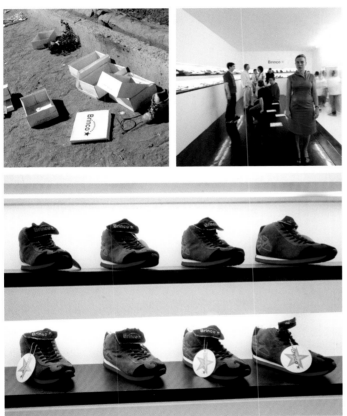

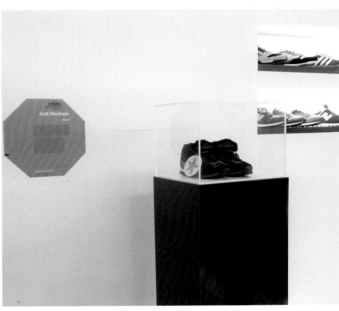

Images: Launch of *Brinco* at Blends/ Sneakers distribution at the border> Imágenes: Lanzamiento de *Brinco* en Blends/ Distribución de los tenis en la frontera.

Noviembre 2005/ Judi Werthein

Atención de los medios e interés público/ En noviembre de 2005 la historia de que la artista Judi Werthein estaba distribuyendo, gratuitamente, zapatos tenis para cruzar la frontera de México a los Estados Unidos a los indocumentados, fue reportada por la Associated Press y el BBC World Service. En cuestión de días la noticia se dispersó por el mundo y Werthein se vio inundada de solicitudes de entrevistas para la televisión, la radio y los periódicos. Werthein apareció en varios programas de noticias, como los noticiarios de CNN y FOX, y el proyecto ocupó la primera plana del New York Daily News, el periódico de mayor circulación en Nueva York. El *blog* de **inSite_05** se congestionó de comentarios que iban desde individuos que estaban virulentamente en contra del proyecto y su supuesto apoyo a la inmigración "ilegal", hasta aquellos que activamente lo apoyaban mediante preguntas y nuevas opiniones sobre los migrantes.

Translated *Unfolding Process*/ pp. 63–64

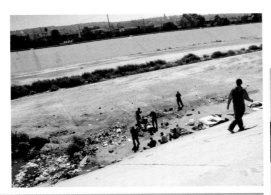

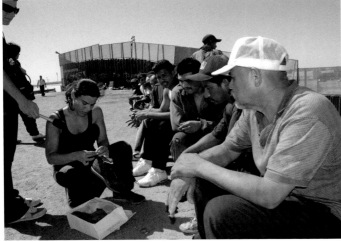

Al forjar una relación entre una boutique de tenis de lujo, un evento artístico internacional y los migrantes indocumentados, **Werthein propició la colisión de tres componentes interdependientes del modelo económico global prevaleciente de circulación e intercambio.** Brinco establece una relación entre la manipulación económica del arte objeto —que circula, se intercambia y colecciona como un lujo y un capital simbólico— y un fetichismo de marca. D.C.

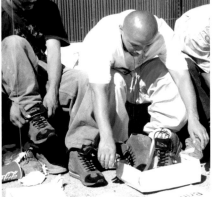
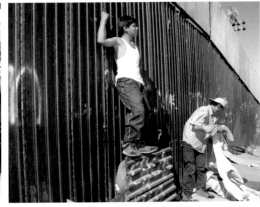

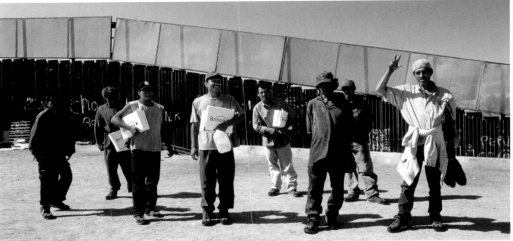
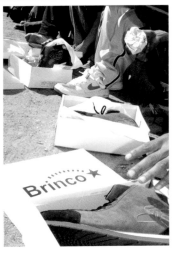

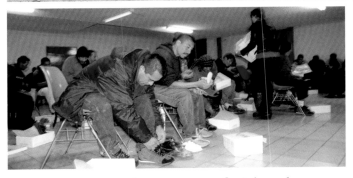

A medida que los consumidores se han familiarizado con etiquetas asociadas a ciertos estilos de vida y estatus social, la construcción de identidades urbanas se ha centrado cada vez más en afiliaciones de marca. Al emplear una iconografía relacionada con los trabajadores migrantes mexicanos y un grupo de obreros chinos de una planta de producción, Werthein creó

una estrategia de marca referida a la separación social entre el trabajo y los consumidores. Al apropiarse de este modelo dominante de identificación de grupo, lo suplantó con nuevas dinámicas de asociación entre trabajo global y consumidores que cada día están más interesados en entender las condiciones bajo las cuales su ropa y otros bienes de consumo se fabrican. D.C.

Blog. A selection of unedited extracts from web blogs about *Brinco*, which encapsulate some of the core themes of the discussion that centered around the project during **inSite_05**'s public phase.

The blogs were consulted from November 2005 through January 2006.

inSite_05 Blog

Public User | 11.22.05 | 14:41 PM

First, a good portion of western USA was stolen from Mexico. Second, people enter illegally because Americans (white, yellows, black) can pay them lower salaries. Third, I know USA history, system, etc, better than the average American, got a degree in sociology (b level qualification) and speak 4 languages, but USA embassy don't accept me, because I don't have "enough" money to go legally. Fourth, why don't bush ask god when he choose the whites in usa that the world is for them? (i can't find it in the torah or the bible).

Public User | 11.19.05 | 10:19 AM

For those of you that are opposed to illegal immigration......the LAW is on your side you don't have to argue with these idiots that don't want to protect America from turning into Mexico. Now we just need to do something to shut down the corporations and 'sympathetic artists' (that seem to make a lot of money off of stupid shoes) they should be penalized for their actions.

Public User | 11.19.05 | 10:14 AM

May we not forget that the same people that are putting together this artistic programs are illegal immigrants also.

Public User | 11.19.05 | 00:52 AM

For those of you that are so fiercely opposed to "illegal immigration", please remember that many of you came in a very similar fashion ! (that particularly goes to "white americans" who seem to have forgotten about the mass extermination of the Natives here.) And even if the US decided to enforce the laws and provide amnesty, do you REALLY think that would stop illegal immigration? Look at Europe for example. Their formely lax policies encouraged massive immigration! and many still take massives risks to travel to a better life in Europe... so laws don't stop immigration. Also, don't forget that these poor immigrants DO put money into the US economy by living here, buying food and clothes and all that. There are even some who pay taxes, whether they know it or not. And for those of you who either don't know or have ignored it, Mexico's 2nd or 3rd largest source of income is US dollars sent in from immigrant workers. illegal immigrants come not only from Mexico, but from all parts of the world, so if you're going to be so hateful, don't forget to hate Africans and Asian immigrants, too. And if you want to complain about how the US government does nothing to help the nations of the Third World better themselves, look at US foreign policy in places like Latin America and China. You're as much to blame for their inequality and poverty as anybody else.

Public User | 11.18.05 | 19:15 PM

if the outside governments did more for their people then they would not have to come to the USofA.They could stay home and be proud of it.instead people come to the USofA and brag about their "homeLand" send their money there and rag about the USofA. What's up with that?

Public User | 11.18.05 | 15:11 PM

Buenas tardes. I work in the social service field. Let me inform those that are ignorant to how services are received; 1. You must have a state ID. 2. You must have a social security number. Without these two items you can not receive assistance. NO free FOOD, NO free MEDICAL attention, NO free HOUSING, NO free RIDE. Undocumented immigrants from any country whether they are from Albania to Zimbabwe are not a burden. People come to work, not to lounge around at PUBLIC HOUSING receiving free FOOD and free WELFARE DOLLARS. Undocumented immigrants are the people who save social security, because we have over spent it. Their dollars go into the pot, but they can't get any of it back. Lets ask the big dogs where the all the tax monies are going that these hard working people are deducted. This year alone there were 42.5 million tax dollars that were not claimed because of there were no social security numbers to file tax returns. Let's get it right. I will be buying a pair of these shoes.

Public User | 11.18.05 | 09:32 AM

Sandy, you missed the whole point. The soes where made in China with slaves (just like the shoes YOU are wearing RIGHT NOW) as a way to criticize the fact that some people look at "undocumented workers" as something that hurts them economically but they can't seem to realize they suppport this kind of labor EVERY SINGLE DAY OF THEIR LIVES. Now you know.

Public User | 11.18.05 | 04:24 AM

These $250 sneakers were made in China at slave/walmart wages (cost $17). If the artist and sponsors really wanted to help Mexicans they would have made them in Mex at fair wages. If the artist & money backers really wanted to help Mexicans they would have made the sneakers in Mexico at a living wage. Not in China for Walmart wage for $17.00!

Public User | 11.17.05 | 17:37 PM

I can't believe you guys are arguing about this. There is so much wrong with this discussion. First of all everyone needs to realize that we live in the WORLD not just a corner of it and just because there is a line on a map somewhere it doesn't give us the right to all the good stuff. Do you not realize why people risk their lives for jobs that pay pennies? They are not taking anything away from you. I would like to see you work bent over in the fields on 110 degree days for 9 or more hours everyday in all kinds of thankless jobs. These people are trying to take care of their families.We are the lucky ones that only have to deal with obnoxious people in traffic. These people are risking their lives so that their children can eat. And besides this artist has found a way to help in a way that may save lives. That is a good thing. I wish I would of thought of it. She has only got me thinking of what I can do to help. Like I said we live in the world and the fact that our country is the richest one only makes our responsiblity bigger. These are our brothers and sisters. We should treat them better.

BRINCO Footwear Model Spec

1. MAKE ENTIRE SHOE SAME SHAPE AS SAMPLE WITH SAME INNER PADDING

FOLLOW THE ATTACHED
COLOR SAMPLE

OLIVE GREEN

MUSK GREEN

COCOA BROWN

BLOOD RED

100% POLYESTER
LINING PRINTED

1cm WIDE
VELCRO

VELCRO TOP STICHED
OLIVE GREEN

SAME ADIDAS ART NO. 012548 SAMPLE
EYE-LETS

100% COTTON TWILL
FLAT DRAWCORD WITH
PLASTIC TIPS AT END

COCOA BROWN
SUEDE APPLIQUE AT
TOEBOX WITH 3mm
TOP STICHING COCOA
BROWN

OLIVE GREEN
SHINY ACTION LEATHER

BLOOD RED SHINY ACTION
LEATHER APPLIQUE WITH 3 mm
GOLD THREAD TOP STICHING

MUSK GREEN
SHINY ACTION LEATHER
WITH 3mm GOLD THREAD
TOP STICHING

LATERAL VIEW

Public User | 11.17.05 | 17:23 PM

You are a disgrace to America. Go back to Argentina. We don't need you or your sucky shoes here. The Mexicans need to stay in their own country and make it better. There are plenty of Americans who go into Mexico and truly help by building homes and improving life for the Mexicans. You on the other hand are like a disease.

Public User | 11.17.05 | 16:02 PM

I, on the other hand, find it even more amazing that I have to share this soil with un educated Americans, (or at least with a severe case of historical amnesia) that love to point fingers to workers with no documents, but can't remember their own heritage, you embarrass me, and you embarrass yourself. Please pick up a book, they don't bite.

Public User | 11.17.05 | 14:24 PM

I find it amazing that there are so many people so willing to defend an ILLEGAL activity. We have people crossing the southern border of the U.S. illegally to "better" their lives, which I have no opposition to, just do it legally. The cost to our medical facilities is horrendous. Our healthcare facilities are strapped already. Also, Miss Lopez seems to want to call Americans "LAZY". Yes, there are lazy Americans, and that problem needs to be addressed. If our people are so lazy, why are there so many Illegals that come here with there hands out in the welfare lines??? How in hell do they get it?? I am tired of paying my hard earned tax dollars to people that have not contributed any tax dollars to the system. It is bankrupting our system. I agree with Sari Dever about the actions of Judi Werthein. I also believe that she, Miss Werthein should be in Mexico to encourage the Mexicans to help develope their own country. If Mexican people want to come here, they also need to learn English, it would help their ability to move around in society.

Public User | 11.17.05 | 14:07 PM

In response to Shari's posting, here is some information on the supposed cost of illegal immigration. Some of these statistics were presented clearly in an editorial in the May 1996 issue of the journal, American Demographics: "Do illegals hurt the economy? Probably not. Providing public education for children of illegal aliens costs about $3.1 billion in the seven key states in 1993-94, according to the Urban Institute. Illegal aliens in prison cost about $471 million a year, and they consume about $445 million more in Medicaid funds. But these costs are offset by

about $1.9 billion in taxes paid by illegals and billions more in consumer spending." (Edmondson 3) Furthermore, I think it is wonderful that Judi Werthein has chosen to help her fellow human beings. Her shoes are not causing or further encouraging people to risk their lives to seek out a better life, ensuring consumers will have cheap produce to sell and contractors can take home a bigger slice of the pie thanks to cheap labor. She is merely attempting to make that inevetible journy one that will not end tragically.

Public User | 11.17.05 | 12:20 AM

First of all take your jobs? These poor mexican people come here and earn nothing, they just take the jobs that a bunch of you lazy people won't take. How do you think you eat every night. Who picks your vegtables? I bet you would'nt work in the fields, especially if you'd know how much you'd get paid. If you had a heart you would'nt be making inhumane comments like you do. Educate youself first about the people who come here and do contribute to our country. All this illeagally immigration(especially with our mexican people) started to get more attention after 9-11, why is it that they have only mentioned the board crossers, there are many other illegal immigrants in this country illeagally. Yeah they come here to earn a living and better their families to raise them in a better enviorment. It may not be your problem, but when you family ancestors came here, i am sure that's what they had in mind and you know that you family traces back t0 another country other than america. I'm outraged when ignorant people say "get out of our country" anyone who knows their history knows that we all came after native americans who were here first.

www.newshounds.us

Claudo | 11.18.05 | 09:24 PM

When the buddies (Fox and Friends)introduced the sneaker segment, E.D. said that it was something that "would make your blood boil." They described the sneakers in scathing terms and obsessed about Ms.Werthein engaging in possible "illegal" activities because she was "encouraging" illegal immigration. Like the good little "compassionate" conservatives that they are, they avoided any discussion of the perils of the journey north. Following the sneakers, they had Rep. Duncan Hunter (from bizarro republican world) discuss the advantages of a wall

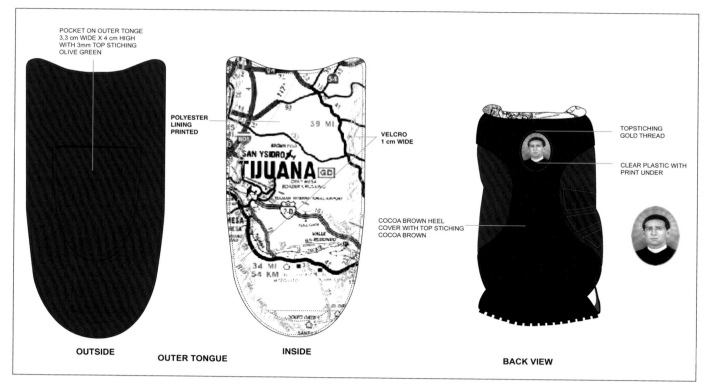

POCKET ON OUTER TONGE
3,3 cm WIDE X 4 cm HIGH
WITH 3mm TOP STICHING
OLIVE GREEN

POLYESTER
LINING
PRINTED

VELCRO
1 cm WIDE

COCOA BROWN HEEL
COVER WITH TOP STICHING
COCOA BROWN

TOPSTICHING
GOLD THREAD

CLEAR PLASTIC WITH
PRINT UNDER

OUTSIDE **OUTER TONGUE** **INSIDE** **BACK VIEW**

between Mexico and the US which I'm sure really reved up the red staters. I later watched Gibson's segment. Ms. Werthein was superb. The great white one could not shake her. The piece de resistance was when he asked her about the small male face on the back of the sneaker heel (Friends thought it was "some Mexican"). She calmly responded that it was St. Toribio Romo Gonzalez, the patron saint of migrants "approved by the Vatican". Gibson had no comeback. It was priceless.

Robrob | 11.21.05 | 12:36 AM

Put some air jordans up in there for sale too. Fox is stupid!!! Fighting illegal immigration is a little like fighting prostitution. Everyone claims to be against it but then you wonder, if no one supports it why is it so popular?

William the Bloody | 11.23.05 | 03:01 PM

This whole debate is bloody insulting. This stupid bint isn't fooling anyone with this bollocks. Of course she is supporting illegal immigration, why else put a bloody map in the shoes?? You bleeding heart liberals are all alike with your "they risk their lives to come here" crap. She should be charged with aiding the commision of a crime. Bloody Al Queada ponces have been caught sneakin' across the border and you people act like nothing is wrong with it. I came here legally and am a citizen paying taxes, which they don't. I think the ranchers down south should be allowed to shoot the sodding idiots crossing their land on site. Filthy beggars. You mock FOX because they cast the light of truth on your sodding crap weasel lives. Better scurry off under the fridge cockroaches, your time of prominence is gone!

Walka Walka | 11.27.05 05:50 PM

The production of border sneaky sneakers in and of itself is harmless. However, the action of providing sneakers at no charge to those attempting to cross illegally is dangerous. Lets face it, anything a group does to encourage a "jump" may influence someone who might not otherwise feel safe to make the trip. Illegal immigration IS undermining our country's security and social/economic infrastructer!!

People should be bothered by the totality of events surrounding the production of these shoes. It is yet another slap-in-the-face to the citizens of our country. Ask yourself this, "Why in gods green earth would you ignore mass illegal immigration in a world chalk full of hate for

the american way of life?" The answere is simple, "You don't." There is no country designed to support the denizens from sociasy and politically corrupt countries. Its not US vs. Mexico! It's US vs. Losing a way of life that was hard won. Perhaps Mexicans should consider fighting harder to improve their country, because this one is no longer the golden egg they think it is.

www.nathangibbs.com

Craig | 11.17.05 | 02:31 PM

This is ridiculous, my family had to wait at Ellis Island for a chance to come here and work. You can't have people encouraged to break the law to come in here and become illegal workers!!

Lupe | 11.17.05 | 02:47 PM

So, Mr. Deluca, your family waited at Ellis Island for a chance at a piece of the pie, like everyone else. Aren't you glad your family made it? You are here to enjoy it too! My family gained legal residency after traveling across illegally and I don't think their efforts are better or worse than your parents'. Same goal, just a different way of doing it. Your family did it illegally, too. Just because there was an organized process at Ellis Island doesn't make it justified.

Nathan | 11.17.05 | 03:27 PM

Illegal immigration should be treated like treason… All illegal immigrants do is take jobs away from hard working american citizens. If they don't like their country, change it… don't come here and ruin ours.

www.gizmodo.com

Erzengel | 02.22.06 | 02:11 AM

Men these things are very old news… first things first, my dear Gringos, Brinco means Jump, plain and simple. It could also be translated as Skip. Now, about the ugly bastard son of my country flag... these shoes were some sort of art proyect as far as i knew.

What makes me angry, as a mexican, is that they were designed by an Argentinean. In the last years we got plenty of illegals from there here, so he/she/it could design them to help Argentinean illegals to get to México. But maybe a pair of white-blue shoes were less apealing than our Aztec Power.

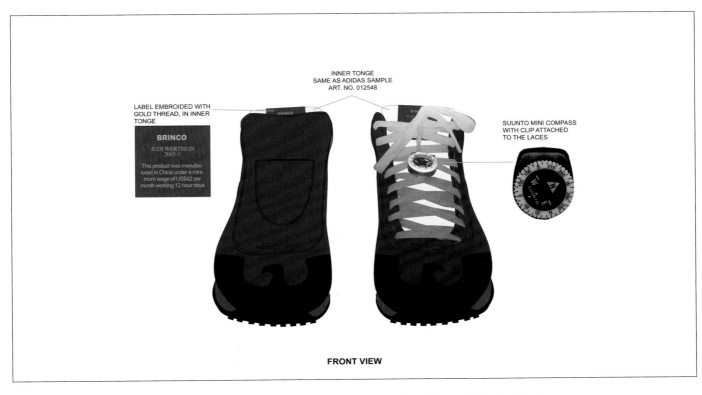

LABEL EMBROIDED WITH
GOLD THREAD, IN INNER
TONGE

BRINCO
JUDI WERTHEIN
2005 ©
This product was manufac-
tured in China under a mini-
mum wage of US$42 per
month working 12 hour days

INNER TONGE
SAME AS ADIDAS SAMPLE
ART. NO. 012548

SUUNTO MINI COMPASS
WITH CLIP ATTACHED
TO THE LACES

FRONT VIEW

www.freerepublic.com

To: Americanwolf

This bitch needs to be arrested. May she rot in jail.

To: golfboy

Very poetically put! :)

To: Americanwolf

I saw this on Fox and all I coud think of is "How do you get these damn things to explode like Reids?"

To: Dutchgir

(probably get banned for this one but!!!)

A 2 mile wide field of landmines along the entire border... :)

To: Americanwolf

I could not believe that woman had the nerve to say it was "art". Yeah and so is my cats' litter box.

To: visualops

And when she said it she had this Sh!t eating grin on her face... arrogant priss that she was (Support the Minutemen Civil Defense Corp...Doing the Job our government won't !)

To: Americanwolf

Yes, I noticed that too! Dang that crap makes me mad!

To: MassRepublicanFlyersFan

After watching France burn for weeks, you'd think people like her would purchase a clue concerning the risks of massive immigration.

To: MassRepublicanFlyersFan

Werthein, who immigrated legally from Argentina to Brooklyn in 1997, sells the shoes for $215 to well-heeled customers at galleries like Printed Matter in Chelsea. Not only a slap in the face by aiding and abetting illegals; she is price gouging legal Americans stupid enough to pay $215 for this crap!

To: kenth

George Bush also aids illegal immigration. In fact George Bush is pro illegal immigration. We've been duped by Bush. The guy is just as bad as Clinton.

To: MassRepublicanFlyersFan

i'd like to buy a pair ...then kick her right up her ass the entire border!

www.wholewheatblogger.com

Judi Werthein is has only been a citizen of the U.S. for 8 years,which she claims is legal. I not sure what gives her the right to incourage illegal mexicans in the name of art. I think her art (real art) and the sneakers should be given away to mexican (free) along with a flash light,map back to mexico, and a list of local agencies that promote education,and self-help in your own country.

Kim | 11.20.05 | 11:48 AM

You're right about those things, Tony.

There's a Wendy's down by where I work that has had complete employee turnover several times. The last time I was there, there was maybe one Hispanic working in the kitchen. I'm just sick of people advocating illegal immigration into this country. This includes people like Judi Werthein and entire organizations that are, in effect, aiding criminals. Securing the borders and restricting access to America is not fascist, it's not extremist, it's the right thing to do. Unfortunately, there are too many people who think that America should mean open borders. I don't.

Steve | 11.20.05 | 12:05 AM

I understand the sentiment. I respect it, but you've also gotta include the following list of people who enable illegals:

Wal-Mart

Virtually every fast food place I've ever visited

People who employ maids, janitors and bus boys

And the U.S. Marines, who have had quite a few Mexicans earn their citizenship through service. Even posthumously

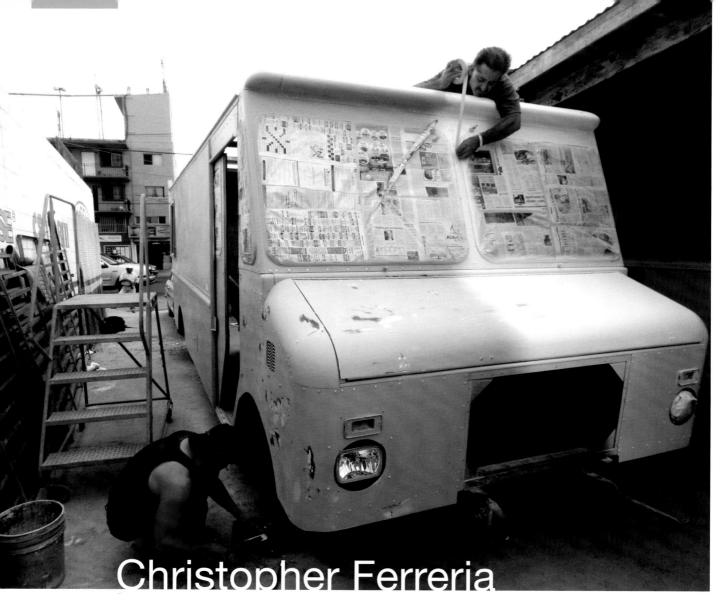

Christopher Ferreria

Some Kindly Monster> Un cierto monstruo amable/

Synopsis. Chris Ferreria's project, *Some Kindly Monster*, was inspired by the expressive car cultures that define much of Southern California, and in particular the communities of Southeast San Diego and National City. By bringing together two distinct car customizers, who would not normally collaborate together, Ferreria sought to create a "hybrid-monster" vehicle that would embody his co-participants' divergent aesthetics. In addition, Ferreria enlisted the contribution of three locally based DJs who created a CD based on sampled field recordings taken from specific neighborhoods in San Diego. The audio pieces were played on a sound system installed in the vehicle while it navigated a series of vehicular routes throughout the city. The DJs also held impromptu sound events from August through November 2005 as part of **inSite_05**'s programming.

In a culture that revolves around the automobile, car customization can be understood as a complex public enactment of status, group affiliation, cross-culture identities, and individual or group expression. Whether Asian import, low-rider or hot rod, the diverse car clubs of Southern California have clearly demarcated aesthetic traditions, historical narratives, and territories of belonging. In bringing together two car customizers from distinct car crew backgrounds—Asian import and hot rod—Ferreria's monster truck becomes a collision zone, embodying how identity formation (and its expression through cultural forms) is always a continually renegotiated process.

When a family hosts the Santo Ninyo, or other figurine, prayers are offered in hopes of them being heard and granted. It's an act of communal faith in a power that listens via the figurine. The prayers, as communal events, make apparent the connections between individuals, families, and communities that transcend distance. The prayers become occasions for not only reaffirming one's faith, but also one's relationship to others and to something bigger than the self.

The project's process evoked the ways in which the Santo Ninyo prayers revealed relationships and spaces that already existed and created ones waiting to emerge.

The Monster became a kind of pilgrimage site. It moved and was handed over to be kept and cared for by those in San Diego and Tijuana. People activated it, engaged with it. c.f.

Noviembre 2004–Marzo 2005/ Christopher Ferreria

Colaboradores involucrados/ Desde noviembre de 2004 hasta marzo de 2005 Ferreria hizo grandes esfuerzos para convencer a los equipos de automovilistas de la comunidad local para que colaboraran con él en la transformación de un camión repartidor. Asistió a varias exhibiciones de coches, puso anuncios en revistas y páginas electrónicas para fabricantes de autos, y asistió a reuniones locales de entusiastas del mundo del automóvil. Quedó claro que infiltrarse en estas células de grupos cerrados no iba a ser fácil. En marzo conoció a miembros del importante equipo asiático de automovilistas Team Hybrid, quienes estuvieron de acuerdo en participar. También estableció una relación de trabajo con José Ramón García, fanático/fabricante de motocicletas, quien estuvo de acuerdo en colaborar en el proyecto. En este periodo comenzó una relación de cooperación con tres DJs locales: DJ Mane One (Mannie Putian), ThaiMex (Paul Phruksukarn), y DJ Marlino (Marlino Bitanga). Juntos planearon una serie de eventos en vivo haciendo del camión una estación móvil de DJ, así como la producción de un CD mezclado que sería distribuido gratuitamente.

Images: Research process/ Final vehicle> Imágenes: Proceso de investigación/ Vehículo terminado.

→ Otras traducciones/ pp. 277–278

Translated *Unfolding Process*/ pp. 53–54

Sinopsis. El proyecto de Christopher Ferreria, *Un cierto monstruo amable*, se inspiró en las expresivas culturas del coche que definen mucho del sur de California, y en particular las comunidades del sureste de San Diego y de National City. Al reunir a dos distintos fabricantes de coches, que de otra manera no habrían colaborado juntos, Ferreria buscó crear un "monstruo híbrido", esto es, un vehículo que encarnara las estéticas divergentes de los coparticipantes. Además, Ferreria contó con la contribución de tres DJs locales, quienes crearon un CD basado en grabaciones sampleadas con registros de campo tomados de vecindarios específicos de San Diego. Las piezas de audio fueron tocadas en un sistema de sonido instalado en el vehículo, mientras éste recorría una serie de rutas vehiculares a lo largo de la ciudad. Los DJs también realizaron presentaciones improvisadas entre agosto y noviembre de 2005, como parte de la programación de **inSite_05**.

En una cultura que gira en torno al automóvil, la fabricación de coches puede entenderse como un complejo acto público de estatus, filiación de grupo, identidades en cruces culturales y expresión individual o de grupo. Ya sea con coches importados de Asia, de bajo perfil o rearmados, los diversos clubes de carros del sur de California han marcado claramente tradiciones estéticas, narrativas históricas y territorios de pertenencia. Al reunir a dos fabricantes de coches de distinta procedencia —de importación asiática o carros armados para competir— el "camión monstruo" de Ferreria se convirtió en una zona de colisión, esto es, en la representación de cómo la construcción de una identidad —y su expresión a través de formas culturales— siempre será un proceso de continua renegociación.

Images: Construction process> Imágenes: Proceso de construcción.

The biggest challenge was translating the open-ended, process-oriented nature of the project without reducing it to a simple "pimp my ice cream truck," pitch to potential co-participants. For anyone who took the time to listen, I had to figure out what would be the hook for each person. What is this for? Why is this being done? Is this really art? I was selling the project. Ultimately, it was the novelty of the project's formal premise that appealed to those who eventually joined the *Monster* project. The relationships, at their very core, were always based upon a mutual respect for each other's histories, knowledge, skills, and possibilities of contribution. But tensions always arose because of the strong personalities that existed within the group. I needed to make clear in the very beginning my particular vision of the project and the goals I wanted to achieve. But each co-participant had to define for themselves their own specific goals. Once they finally claimed a space within the project, even if unspoken, each of them became fully present. Some people work well under specific direction, others only need to be supported while doing what they do best. The trick became how present I was going to be within the process.

To overstate the obvious, *Some Kindly Monster* was more of a process of constant negotiation as opposed to overcoming something. And I took this as a good thing. Negotiation meant that people were engaged. They were invested. The *Monster* was about creating a space in which every co-participant felt supported and integral to the project, while also creating an awareness of and an engagement with each other's role in the larger scheme of things. And while none of us, including myself, really knew what was going to happen in the end (and the project on some level still lives), nor fully understood what it all meant as the process unfolded, there was a desire to see the project to its completion.

The process was organic. It was messy. It was slow and exhausting. It was alive. It was definitely painful, and euphoric, at times. So what really happened? A lot of talking, a lot of translation. Not necessarily the kind between different national tongues, although there was a lot of that.

Rather, between different ways of relaying ideas and relating to each other, by speaking directly, through insinuation and suggestion, through action and by example. It was about learning how to better read situations and the ways we spoke to each other. C.F.

Images: Project's events>
Imágenes: Distintos eventos.

175

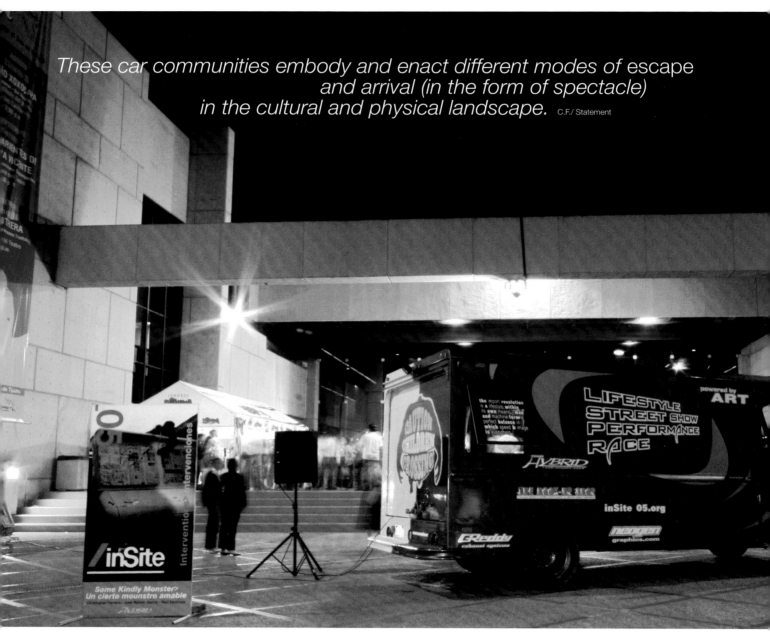

These car communities embody and enact different modes of escape and arrival (in the form of spectacle) in the cultural and physical landscape. C.F./ Statement

Routes

LA JOLLA/ Friday, September 9/ 4:30 p.m./ start/ westbound La Jolla Parkway at State Route 52/ Ardath Road westbound/ Torrey Pines Road westbound/ Girard Avenue southbound/ Pearl Street westbound/ La Jolla Boulevard northbound/ Prospect Street northbound/ Torrey Pines Road eastbound/ La Jolla Village Drive Interstate 805/ **stop/**

MIRA MESA/ Friday, September 16/ 4:30 p.m./ start/ eastbound Miramar Road at Interstate 805/ Kearny Villa Road northbound/ Mira Mesa Boulevard westbound/ Interstate 805/ **stop/**

KEARNY MESA-LINDA VISTA-OLD TOWN-LOMA PORTAL/ Friday, September 30/ 4:30 p.m./ start/ eastbound Clairemont Mesa Boulevard at Interstate 805/ Convoy Street southbound/ Linda Vista Road southbound/ Morena Boulevard southbound/ Taylor Street southbound/ Rosecrans Street southbound/ Lytton Street eastbound/ Barnett Avenue eastbound/ Pacific Highway southbound/ Interstate 5/ **stop/**

DOWNTOWN SAN DIEGO-BALBOA PARK-HILLCREST/ Friday, October 14/ 3:30 p.m./ start/ southbound Kettner Boulevard at Interstate 5/ Hawthorn Street westbound/Harbor Drive southbound/ Broadway eastbound/ Front Street southbound/ Harbor Drive eastbound/ 5th Avenue northbound/ Broadway eastbound/ Park Boulevard northbound/ University Avenue westbound/ Washington Street westbound/ Interstate 5/ **stop/**

NATIONAL CITY-PARADISE HILLS-BAY TERRACE-ENCANTO/ Friday, October 21/ 3:30 p.m./ start/ northbound Highland Avenue at State Route 54/ Division Street eastbound/ Valencia Parkway northbound/ Skyline Drive eastbound/ Meadowbrook Drive southbound/ Paradise Valley Road westbound/ 8th Street westboaund/ Plaza Boulevard westbound/ Interstate 805/ **stop/**

Monday, October 31/ 3:30 p.m./ start/ REPEAT National City route for the afternoon/ REPEAT Downtown route for late afternoon/evening/ **stop/**

Inspired by the local colored car cultures that define much of the lives of youth in Southeast San Diego and National City, the first phase of this project explores the notions of escape, departure, and arrival through a literal vehicle or mode of transport. [...] Using the idea of *escape* as the conceptual basis, the car crews should draw upon their divergent aesthetics: the cool, Japanese anime aesthetics of Asian import enthusiasts and the Baroque tendencies of lowriding clubs. [...] Asian imports exaggerate a hyperfunction of speed in the tricked out engine (or at least in an oddly cosmetic vision of speed through exterior body kits), or lowriders in their disruption of the flow of traffic through supposed (non)function of extreme decoration and slow speed. The overlap occurs in their extended presence through sound: bass-heavy car audio systems and the roar of exhaust pipes. C.F./ Statement

BONITA-CHULA VISTA-EASTLAKE/ Friday, November 4/ 3:00 p.m./ start/ Eastbound H Street at Interstate 5/ U-turn H Street at Proctor/ Valley Road & Mt. Miguel Road westbound/ Otay Lakes Road northbound/ Ridgeback Road westbound/ Rancho Del Rey Parkway westbound/ Avenida Del Rey northbound/ Otay Lakes Road westbound/ Bonita Road westbound/ Interstate 805/ **stop/**

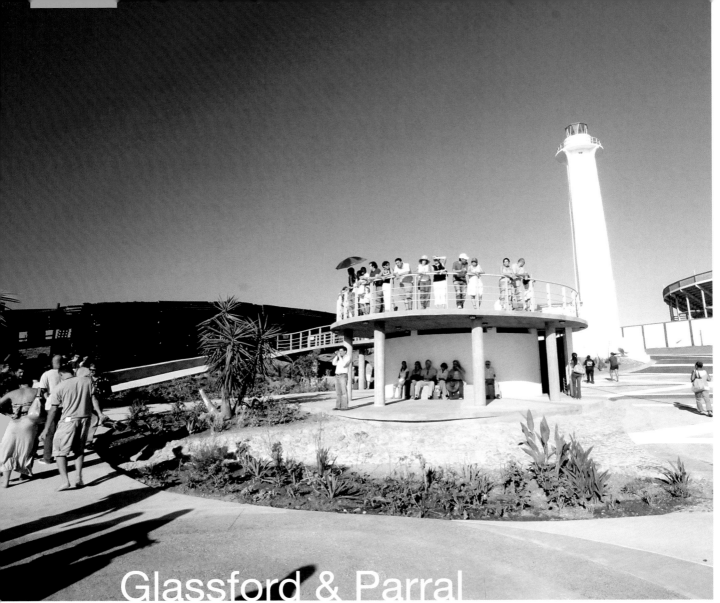

Glassford & Parral

La esquina/ Jardines de Playas de Tijuana/

Synopsis. *La esquina/ Jardines de Playas de Tijuana [The Corner/ Tijuana Beach Gardens]* was commissioned by **inSite** as an urban rehabilitation project for the area of Playas de Tijuana where the border fence dips into the Pacific Ocean. The Tijuana bullring, the border fence, and the Playas de Tijuana's tourist corridor demarcate the renovated area. The intervention was not so much an "artistic" project per se; rather, it was conceived as a response to Tijuana's ecological crisis and the disfunctionality of its urban planning project, and was intended to facilitate the recovery and development of communal areas. Thomas Glassford and Jose Parral took on the challenge of designing the park project and immediately focused on aesthetically transforming the area into a recreational zone with great ecological importance. To this end, they refrained from overlaying the area with new artistic or cultural monuments and, instead, sought to respond to the particular conditions of the landscape and its historical importance as a site of demarcation between Mexico and the US. The challenges involved in negotiating the creation of the garden were manifold, and included preventing the increasing erosion of the land, limiting traffic circulation, improving basic services, and, above all, generating new patterns of growth and urban restructuring while respecting Tijuana's natural environment. The design of *La esquina/ Jardines de Playas de Tijuana* renders more visible the ecological interconnectedness of the region.

Comenzamos a pensar en formas de compensar y desarrollar un lugar de recreación y reunión para la gente que gravita naturalmente por ahí. En esencia, el sitio es un *cul-de-sac*, y decidimos elevarlo por medio de una serie de plataformas espirales interconectadas que estimularían el tiempo transcurrido allí y asegurarían sus actividades (viendo hacia el otro lado). También propusimos una extensión hacia el oeste por medio de un muelle que resaltaría el significado de la frontera en forma de una celebración —como lo opuesto a un cuchillo. Pero un momento: ¿Cómo nos involucramos tanto en elaborar el epítome de esta separación, de esta barda, de este icono de muerte para tantos que han intentado cruzarlo? La medida de qué tan lejos ha ido todo esto puede determinarse mediante la proposición de un nuevo diseño para la cerca: algo que sea más humano, más artístico y cultural. T.G./ *Homeland Insecurity*

La esquina/ Jardines de Playas de Tijuana is the only permanent project commissioned by **inSite**. From its conception, it was intended to stimulate reflection about the relationship between ecology, public use, and the historical monument. The garden area was designed as an urban project for public use—limited in scope and in budget, but capable of reconfiguring the territory and providing a model for informed intervention in the everyday life of the region. The permanence of the area and its care will depend on neighborhood organizations, ecological groups, and municipal authorities' capacity for dialogue and self-organization.

[…]I don't think that the scale had such an imprint or influence on the working process or result of the work. I have always felt that the spatial reaction of any piece that I have been involved with is primary to its experience. **More important were the social implications of adapting to the social confines and influence of the public domain, that it would be used and adopted wholeheartedly and not be an act of imposition from our part onto theirs.** T.G.

Images: Documentation of the site/ Residencies/ Final project (in color)>
Imágenes: Residencias y proceso/ Proyecto final (a color)

→ Otras traducciones/ p. 278

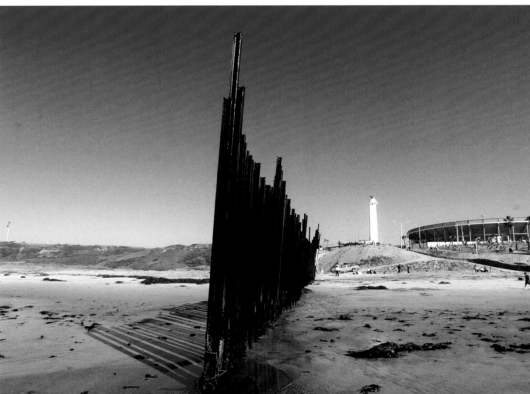

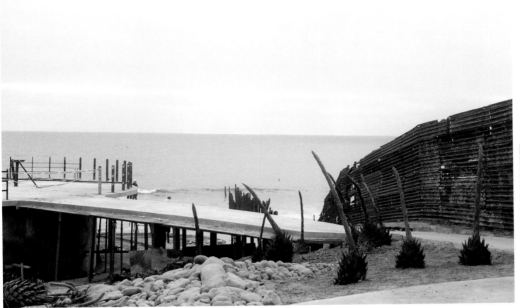

During the opening of the *La Esquina* various people, including not only my Mexico City gallerist, cultural attaches of all cuts, and even inSite board members (all people who where familiar with what I had been working on for the previous year and a half) asked me "where is your piece?" knowing that they were in the right location in accordance with the maps and signage of that day's events. At first I found myself perturbed by the invisibility of the site, that it was so given and normal in accordance to what one might expect to find in this location, a fluid functional park area. After first readdressing with some curiosity as to what they expected to find and simply letting them know that they where basically standing on and in the work at that moment of questioning, I realized that this was one of the best results that we could have expected: complete assimilation. Having worked from the beginning with Jose on the idea that it should be the most grass roots planning and neutral environmental installation to be adopted by the community, even at this initial moment of "inaugurating" it had already been considered status quo. Obviously this is not the most typical form of presentation in a biennial-esque environment, one of assimilation as opposed to standing out and making an individual mark, although for anyone who knew the dumpsite that existed beforehand, the transformation was significant. T.G.

What intrigued me most about this collaboration was the ability to work directly with the artist and the open-ended structure of our investigation that allowed us to create our own problems instead of having them defined beforehand. This unique combination of client and collaborator also produced its own set of issues. Everyone involved was continually defining the project. Those who participated influenced the project every step of the way. Now when looking back, what interested me the most was the process itself and the measures taken to solidify the end result. The landscape is amazing as it continues to change when other processes take place other than your own. J.P.

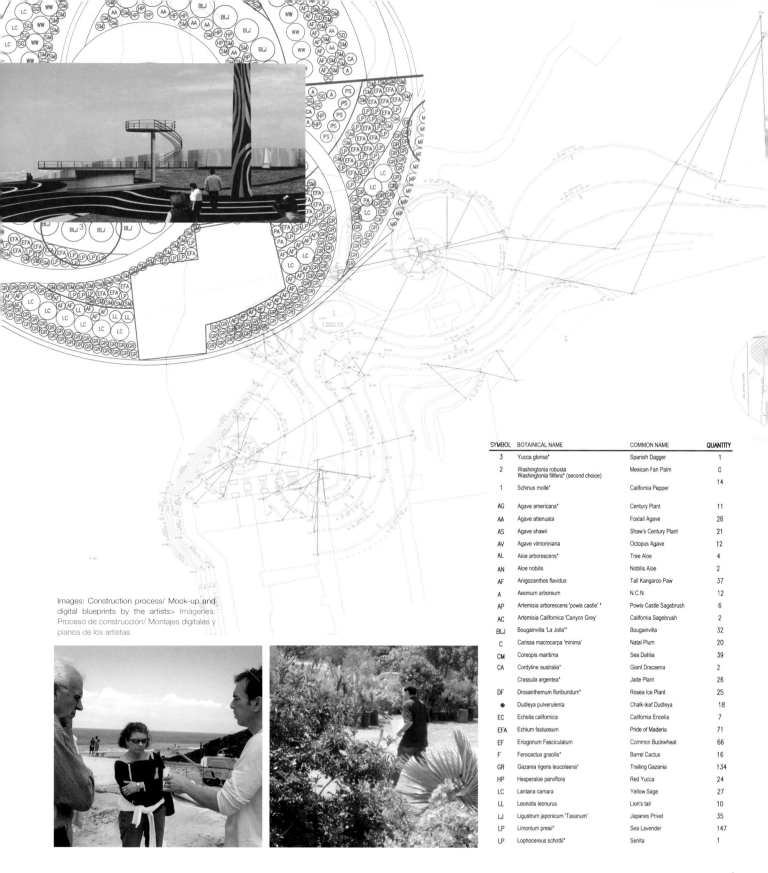

Images: Construction process/ Mock-up and digital blueprints by the artists> Imágenes: Proceso de construcción/ Montajes digitales y planos de los artistas

SYMBOL	BOTANICAL NAME	COMMON NAME	QUANTITY
3	Yucca glorisa*	Spanish Dagger	1
2	Washingtonia robusta Washingtonia filifera* (second choice)	Mexican Fan Palm	0 14
1	Schinus molle*	California Pepper	
AG	Agave americana*	Century Plant	11
AA	Agave attenuata	Foxtail Agave	26
AS	Agave shawii	Shaw's Century Plant	21
AV	Agave vilmoriniana	Octopus Agave	12
AL	Aloe arborescens*	Tree Aloe	4
AN	Aloe nobilis	Nobilis Aloe	2
AF	Anigozanthos flavidus	Tall Kangaroo Paw	37
A	Aeonium arboreum	N.C.N.	12
AP	Artemisia arborescens 'powis castle' *	Powis Castle Sagebrush	6
AC	Artemisia Californica 'Canyon Grey'	California Sagebrush	2
BLJ	Bougainvilla 'La Jolla'*	Bougainvilla	32
C	Carissa macrocarpa 'minima'	Natal Plum	20
CM	Coreopis maritima	Sea Dahlia	39
CA	Cordyline australia*	Giant Dracaena	2
	Crassula argentea*	Jade Plant	26
DF	Drosanthemum floribundum*	Rosea Ice Plant	25
⊕	Dudleya pulverulenta	Chalk-leaf Dudleya	18
EC	Echelia californica	California Encelia	7
EFA	Echium fastuosum	Pride of Maderia	71
EF	Eriogonum Fasciculatum	Common Buckwheat	66
F	Ferocactus gracilis*	Barrel Cactus	16
GR	Gazania rigens leucolaena*	Trailing Gazania	134
HP	Hesperaloe parviflora	Red Yucca	24
LC	Lantana camara	Yellow Sage	27
LL	Leonotis leonurus	Lion's tail	10
LJ	Ligustrum japonicum 'Taxanum'	Japanes Privet	35
LP	Limonium presii*	Sea Lavender	147
LP	Lophocereus schottii*	Senita	1

The reconstruction of a spatial "code"

—that is, of a language common to practice and theory,
as also to inhabitants, architects and scientists—may be considered from a
practical point of view to be an immediate task. The first thing such a code would
do is to recapture the unity of dissociated elements, breaking down the barriers
as that between private and public, and identifying both confluences and
oppositions in space that are at present indiscernible.

Henri Lefebvre

Sinopsis. *La esquina/ Jardines de Playas de Tijuana* fue un proyecto comisionado a fin de lograr una reestratificación urbana en el perímetro que enmarcan el mar, la barda fronteriza, la plaza de toros y el comienzo del corredor turístico de Playas de Tijuana. Esta intervención, más que propiamente artística, se planteó como una propuesta conciliada en busca de nuevos valores de reanimación, de rescate y de desarrollo de espacios comunitarios en la actual situación de emergencia ecológica y de disfuncionalidad de los programas urbanos en Tijuana. *La esquina/ Jardines de Playas de Tijuana* centró su interés en reanimar estéticamente el área como una zona de esparcimiento, de gran peso ecológico. Para ello se abstuvo de invadir la zona con nuevos monumentos artísticos o culturales, y buscó consolidar el propio potencial del paisaje y el valor simbólico histórico de la demarcación de límites fronterizos, sin nuevos agregados. El reto de este proyecto de Thomas Glassford y Jose Parral fue negociar la creación de estos jardines, conseguir los apoyos necesarios para evitar la erosión creciente del terreno, limitar la circulación de coches, mejorar los servicios básicos y —sobre todo— poder sugerir la posibilidad real de ejercer nuevos patrones de crecimiento y reordenamiento urbano desde una perspectiva de respeto al entorno natural en Tijuana. *La esquina/ Jardines de Playas de Tijuana*, desde su propio diseño, explicitó el carácter regional de los balances ecológicos en esta zona.

La esquina/ Jardines de Playas de Tijuana fue el único proyecto con carácter permanente comisionado por **inSite**. Su propósito, desde un inicio, estuvo dirigido a motivar una reflexión sobre las relaciones entre ecología, uso público y monumento histórico. El espacio/jardín en sí mismo, más que el objeto de un divertimento autoral, se planteaba como un programa urbano de uso público, limitado en extensión y en presupuesto pero capaz de redefinir este territorio y de proveer de un prototipo de intervención culta e informada sobre la cotidianidad de la región y sus potencialidades de asociación. La permanencia del espacio y su cuidado dependerá de la capacidad de coordinación y diálogo permanente entre organizaciones vecinales, grupos ecologistas del área y la dirección municipal.

Investigación en el área/ En agosto de 2004 —a sabiendas de que su proyecto implicaba una comisión específica de parque público en el área de Playas de Tijuana—, Thomas Glassford y Jose Parral visitaron The Tijuana River National Estuarine Research Reserve (Reserva Nacional de Investigación del Estuario del Río Tijuana) y el Border Field State Park (Parque Estatal del Área Fronteriza). Cerrada al público en aquel momento, la visita a la zona se dio en compañía del coordinador del Coastal Training Program (Programa de Entrenamiento Costero) de la entidad. Este encuentro les permitió un mayor acceso a la información sobre el área, y les fue útil para plantear la posibilidad de que su proyecto de parque se extendiese también al lado americano del estuario. Los siguientes pasos de la investigación incluyeron la obtención de los permisos pertinentes de construcción, la selección de plantas y la discusión del uso de los espacios.

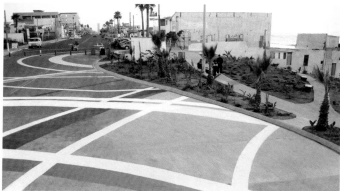

Translated *Unfolding Process/* p. 54

HOMELAND *IN*SECURITY
Thomas Glassford

I grew up with a view—literally—of the border: "la frontera," or in my more personal interpretation, the frontier. My parents' home backed up to the Rio Grande, or Río Bravo when viewed from the other side. This lack of agreement between the cultures or countries, differing names in one language for the same river, still seems appropriate. This hometown—Laredo, Texas, and Nuevo Laredo, Tamulipas—is one of the oldest communities on the border today. In 1839 with the drawing of the new river boundary between Texas and Mexico, 'Laredo' and the surrounding border communities refused to take sides and consequently created there own city-state and country, a little known federalist effort within the history of the Americas, the Republic of the Rio Grande. This belligerence and intolerance lasted briefly and in the end of its short-lived border independence, families who felt an irrepressible allegiance dug up their graves and moved over to the other side of the river to create the new Laredo. Such border-conflict exotica is relatively unimportant today, other than to recognize the emotional equilibrium of those who live along this cauterized zone. Those whom I choose to refer as "border rats." I especially like to use this term in reference to people from the region who feel at times that they have escaped its demise and provincial character, instead of recognizing all of the privileges that it has given them. I use the term for myself.

One moves in different directions as a rat. Scurrying culturally one way, then in retreat, defending the

opposing direction the next. Never really satisfied with what one understands or feels comfort with in one community and justifying also the other side and its positive effects. Basically a border community, in the healthy sense of the idea, traditionally has one foot on both sides, and unfortunately for some of us growing up within this environment, gives way to a sense of insecurity, of not really belonging to either side. A gray zone; a gray rat.

Although I speak questionably of this region's environment, I feel very fortunate to have grown up within that diversity. Not simply the exotic nature of cultural differences but the pushing and pulling of hybridization in general.

Recently I flew to San Diego, only to find myself going in and out of the airport's security system in Mexico City, trying to secure my exit and, ultimately, my reentry visa. I currently live in Mexico with an FM2 visa, an immigrant status that in my visa document identifies me with an early twentieth-century-looking black and white photo taken in a document facilitator's studio adjacent to the immigration offices where it was issued, on the street of Ejército Nacional. With my hair slicked back by the photographer's comb and water pistol to expose my forehead and ears and its grainy high contrast black and white finish, I feel that, every time I open the booklet, I am looking at an image of my grandfather having arrived at Ellis Island. Unfortunately, on that Wednesday the booklet was no longer in my possession, having been withheld during my last entry into the country—it

had too many entrance and exit stamps and was in need of replacement, a process that has been delayed and which consequently prompted the necessity to procure a tentative document at the airport, one I was told would take but a few moments to expedite. Upon finally finding the appropriate office and desk, forty-five minutes prior to my departure, it was explained that the procedure would in fact take twenty-four to forty-eight hours. This failed to unnerve me, even as it slightly aroused my irritation, aware that the supervisor was watching me and that the attendant, through his inter-office window, was my only hope; depending on how coolly I proceeded, it was ultimately in his hands. Negotiation: a basic tool learned through years and a lifetime of cultural hybridization. I had rigorously researched in the previous days the process needed to travel without my appropriate papers, but had I simply acted indignant in the face of so much disinformation, had I taken on the classic "gringo" role, I surely would've been punished by a much more exorbitant form of inconvenience. Instead, I was treated royally to the process of signing, copying, and paying for my temporary exit and entrance visa, including one document in which I had to give oath that I was not under any penal process and not a criminal in flight. Generally I wouldn't have even bothered to go through such degrees of paperwork and legality of residence, if it could be avoided as it can be by any sensible, irresponsible, culturally oriented human being. Being an artist working in Mexico was hardly such a threat

that one felt the need to secure one's papers, at least not in the past for me, and I only "regularized" myself a couple of years after my son was born there six years ago, realizing his vulnerability in relationship to my lack of formality, having lived in the country on a tourist visa for eleven years at that point. In the end why would I even bother? Having another passport to travel with in certain parts of the world where a US passport holder might feel stressed after this current government is done with its war on terror might be one reason. Another is the simple perversity of claiming a stake to a fatherland where I have spent a large percentage of my life at this time. (Hailing from the border I have always felt that if the US is my motherland, Mexico is in turn the father, or vice versa.)

Thinking of this also makes me reflect on a situation that took place nine years ago when for simple facility of securing funding for the public arts project **inSite**, co-executive director Carmen Cuenca suggested to CONACULTA, the equivalent in Mexico of the National Endowment for the Arts (NEA), that some of the artists invited, including myself, Francis Alÿs and Melanie Smith, all of us under the rubric of Mexican artists—that we be naturalized: a term I have always found disturbing. In this case it would have meant a relatively simple process like those expedited for soccer stars that immigrate quickly so as to play on international teams. Obviously there was some dissent as to the number of Mexican artists included and the legitimacy of those on the list; after all, even Rubén Ortiz-Torres had entrenched himself in the US, no? This is a classic situation that I find myself in to this day, and it is reflected in what follows. Be it the exoticism and influence of my practice as an artist in what seems ironic, to some minds, of an inverse migration or the simple pigeonholing of culture: a Texas artist, southwest, Chicano, Chicanglo (or was that chic Anglo?), Mexican, US, or the dreaded ex-patriot status of "American living in Mexico." Obviously in the end I don't feel any of this should matter but over drinks of tequila last night with others involved in the Mexico City scene of the 1990s, I realized >

> that one can only bring what one has to the table and if you weren't there fifteen years ago and didn't live the moment and what that led to, in the political, social and cultural developments, then you needed someone else to tell you about it. So ultimately I assume my position.

Mexican social life is strong and traditional. Family life, social bonding through environment, education, and group formations are prevalent. On any given Sunday afternoon one is expected to be having lunch and spending time with family. Inevitably, this same rigor has led many individuals living in Mexico to form their own family units—in this case, those of foreigners living in Mexico City in the beginning of the 1990s. There emerged a happenstance setting: a congregation formed in 1990 by a group of artists, writers, and historians arriving in Mexico from different locations. Many of us chose to live in the city center, the historical, then downtrodden and rough, but invigorating heart of the Centro. This was not a place inhabited by the privileged social and cultural classes of Mexico but simply visited during the day or on weekends to absorb its history and to revisit the old cantinas and restaurants. Another reason that we chose this area was for its abundance of space in the colonial structures, cheap rent, an excess of visual stimuli, and potential materials at every turn. The influence of this very rich and historical conglomeration impregnated the work we began to produce there. The center's past, the oldest historical and ongoing urban environment in the new world and its many layers built upon each other, had its impact. Moreover, there was a rich access to materials and talleres or shops to fabricate parts and elements of our work.

So, then, to return to forms of kinship: it is very complicated to rent property in Mexico without a family. All contracts must be signed by a fiador, or a property owning co-signer who will guarantee that the rent be paid and the rental property preserved. Obviously, some of us found this favor to ask difficult and arranging to rent out a floor in a building as an artist was not exactly the ideal for some of the proprietors (much less if you happened to be a foreigner). Consequently, there were a couple of buildings in particular in the Centro, one being on the side street off the Zócalo, calle Licenciado Verdad, the other a few blocks further north on the Plaza Santa Catarina, where inevitably we found ourselves primarily ensconced after other artists had arranged previous relationships with the owners and established what in one case in particular, with señora Susana, served as an extension to the family as well. While we would often share meals together, drink together and live in each other spaces, we also began to organize exhibitions and projects in that we hadn't found many other alternatives to show our work. Through this community of "extranjeros en el centro," we began to exert some influence within the cultural/social infrastructure of the city, sharing our studio-homes by means of exhibitions, meals, parties, and other disorganized events. When we began to show our work along with other Mexican artists in more formal settings and galleries we also became more entrenched as a separate movement due to our style of work and method, but primarily as a family unit or artistic circle. At certain moments accused of being cultural colonizers and on one memorable occasion even called by the gallery owner who today represents my work in Mexico, out of irritation that we were disrupting the style of work she then sold, I was christened the artist who lived in "la ratonera (or rat hole) de Licenciado Verdad." Hence, back to being a rat.

Today I find myself in another opposing vista. I am working presently on a project for **inSite** in the San Diego-Tijuana region, positioned literally on the border again, this time primarily with a view from the south. This locality troubles me but with another set of parameters. The project is a permanent park along the fence in Tijuana's Playas neighborhood. The northwest corner of the city and country where the Gulf War tarmac fence plunges into the waves of the Pacific and what has become one of the most iconic man-made divisions and borders in the world today.

In the past I personally would have avoided this site like the plague, especially as an artist working for a project like that of **inSite**, which brilliantly imposes itself on a bi-national region. For many artists and scholars invested in cultural studies, this site is easy pickings on the wounds of the border to further exploit. Inevitably, we found that it was impossible to avoid this site as we searched for an area on which to build a park and in this case to transform the location into the cultural icon that it has become: a place for the community, beachgoers, Mexican national tourists, and others who come to this very specific site to see the wreckage of such division. Again, the opportunity to afford a view, in this case of the Border Field State Park with its massive acreage and estuary beyond in deep contrast to the overpopulated foothills and parched landscape of Tijuana. Given the lack of physical space by which to extend ourselves with "a park" in this location, we began to think of ways to compensate and develop a turnaround and gathering place for the people who naturally gravitate there. In essence the site is a cul-de-sac and we decided to simply elevate this into a series of spiraling, connected platforms that would stimulate the time spent here and secure its activities

(viewing the other side). We also proposed a western extension by means of a pier that remarks the border in the form of a celebration—as opposed to a knife. But still: how could we get so involved in further epitomizing this separation, this fence, this icon of death for so many who have tried to cross it? The extent of how far this has gone can be determined by proposing a new design for the fence: something somehow more humanized, artistic, and cultural. Again, the perversity of the border and within that environment, the rat in the trap.

This text is published courtesy of *Mandorla*.

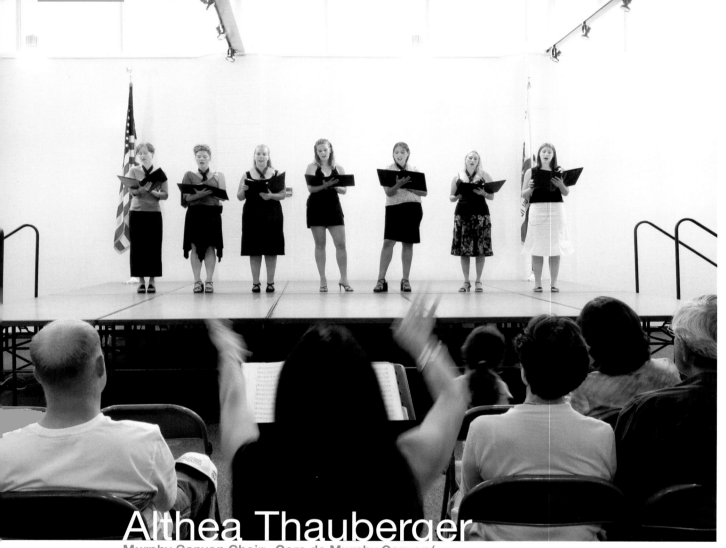

Althea Thauberger
Murphy Canyon Choir> Coro de Murphy Canyon/

Synopsis. Althea Thauberger's project for **inSite_05** was a community choir initiative involving a one-time performance at Murphy Canyon, possibly the largest military housing complex in the world and home to more than 2,500 military families. Working in partnership with a group of military spouses residing predominantly in Murphy Canyon and experienced choir director Terry Russell, Thauberger strove to generate a unique community choir experience. During weekly rehearsals over the course of more than six months the participants worked with composer-in-residence Scott Wallingford to craft a series of their own compositions based on their experiences and musical tastes. The final performance took place at Jean Farb Middle School in Murphy Canyon on September 25, 2005. It was attended by a diverse and varied public, ranging from members of the military community to international curators and art enthusiasts. Viewers of the performance were shuttled into the community via bus and were provided with an onboard tour guide—Jennifer Martin from Military Outreach Ministries—who presented an introduction to the area and life in the military. Following the performance, the participants and the public gathered outside for drinks and refreshments.

Murphy Canyon Choir was in part a response to the challenges of military family life, where separation from relatives and friends, coping with dependent children without the support of a partner, and the navigation of unfamiliar environments can all contribute to a sense of isolation. Thauberger sought to provide the participating military spouses with a platform to generate new interpersonal relationships in the community, as well as a means of becoming actively involved in the construction of their own social representation and intervening on prevailing stereotypes that are often perpetuated through the media.

Some questions which have led to this proposal are:

- How is it possible to represent a community?
- How can a community be involved in their own representation?
- How can these essentially documentarian interests be incorporated into poetic forms?
- How can a project be both a conduit for meaningful personal expression and also for community development?

Why a choir? **A choir epitomizes community.** The *Murphy Canyon Choir* will echo the existing community—a group of individual, diverse voices that come together within a collective. Singing is something anyone can do, and is a basic (perhaps the most basic) form of artistic expression. Choirs immediately and successfully invite collaboration and bring performers and audiences together. There may be some resonance with existing military musical traditions —group performance like marching bands— that the community may relate to.

Why military spouses? **Military spouses' lives are largely dominated by caring for others.** Many may have given up pursuing individual talents or goals when they chose this lifestyle. This project proposes something that is for their fulfillment and personal development. Military spouses are an underrepresented part of the community. Young families are always looking to the future. The project will be enriched by this forward look. The participants may not only develop new friendships and support in their community, but will develop musical skills that could have lasting benefits for themselves and their children.

Why Murphy Canyon? **Murphy Canyon has the largest population to draw from, and has existing outreach infrastructures.** Being so spread out, Murphy Canyon residents may feel isolated. The project may help overcome isolation. Murphy Canyon is set in a spectacular natural location, which, if the performance it to be held there, visitors would pass through on the way.

A.T./ Community Proposal

La energía de un recital de música vocal puede despertar un particular nivel humano de conexión entre los ejecutantes y las audiencias. Creo que la presentación del Murphy Canyon propició una forma de reconocimiento interpersonal, y como había un abismo ideológico entre los individuos presentes, este estira y afloja fue más intenso [...] A.T.

Febrero–Abril 2005/ Althea Thauberger

Trabajo en equipo, un director para el coro y difusión del proyecto/ En febrero de 2005, Thauberger sostuvo una reunión informal con esposas de militares en la Capilla de Murphy Canyon para evaluar el interés que había despertado la propuesta de un coro comunitario. Aunque el resultado obtenido entonces fue mínimo, la reunión de grupo fue muy útil. Subrayó la importancia de una campaña de difusión y sacó a flote la existencia de organizaciones que podrían ayudar a pasar la voz. Por estas fechas Thauberger conoció a la directora de coro Terry Russell, quien accedió a colaborar con ella. Establecer esta relación de confianza, y compatir una misma visión del proyecto fue de vital importancia, ya que Thauberger no estaría en la región todo el tiempo para la supervisión de cada uno de los ensayos. A finales de febrero Thauberger se concentró en una campaña exhaustiva y bosquejó un volante para promover el coro, mismo que fue distribuido en toda la comunidad. Al mismo tiempo, el capellán de Murphy Canyon puso a disposición del proyecto la capilla para los ensayos. En abril de 2005 se llevó a cabo el primer ensayo del *Coro de Murphy Canyon*.

→ Otras traducciones/ pp. 282–283

Translated *Unfolding Process*/ pp. 62–63

Hope that all is going well for you both. I meant to get an update to you yesterday re: Wed. night's rehearsal, but never found a free moment. Rehearsal went very well I think. Donna was there at the beginning, so she can give feedback as well. The daycare has moved to the nursery and the room next door. That portion seemed to go very smoothly. We had several new singers Wed. night: **Hazel, Leah, Toni** and **Carissa...there might have been one or two more that I am forgetting**—all with strong voices. The group is beginning to "gel" a bit I think. **Amy** wrote two verses and a chorus of a song (words only), which she shared with the group. **Kim** told me she also has a song written but would rather it be shared by me anonymously. **Christina** brought red folders for everyone to put their music in, Amy

is setting up a chat board at Yahoo groups and **Heather** is organizing a snack list so one person can bring a treat each week. Also, **Natalie** took the left over water and will bring it back next week. **All these volunteers represent "ownership" and enthusiasm for the project**—I think.

Terry Russell/ Email/ "Choir Wed, nite rehearsal," April 15, 2005

Hi everyone, I have been thinking about decorations and outfits since last night, and have kind of changed my mind since seeing you all in that space. The space is quite institutional and after thinking about it, I don't think there is a way to decorate it in order to un-institutionalize it, if that makes sense. I believe that the way to introduce the visual sense of individuality is though you all, the performers.

I really want you all to dress as you wish. Wear your favorite outfit. Wear something far-out, ultra cool, understated, whatever you want! I promise not to change my mind again.

Big thanks everyone. A.T./ Email/ "[micmcc] outfits/decorations," September 20, 2005

Images: Portraits of the choir/ Rehearsals>
Imágenes: Retratos de los miembros del coro/
Ensayos

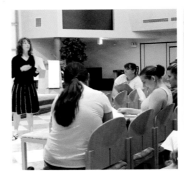

Song List

Wife of A Hero | Tina Carattini
Soloists: Amy Heise, Heather Bankson, Liz Wolfe
Voice: Amy Heise

Working Title (The Name Game) | Scott Wallingford

Forever | Diana Butler

Sun Went Down (doo-E-dop) | Scott Wallingford

Home | Amy Heise, Tina Carattini & Liz Wolfe
Soloists: Amy Heise, Heather Bankson, Amanda Skidmore, Diana Butler

Waiting | Diana Butler

Story of Love | Amy Heise & Tina Carattini
Soloists: Diana Butler, Tracy Condren, Amy Heise, Jennifer Ramert, Amanda Skidmore

You and Me | Jennifer Ramert

The Murphy Canyon Choir met once a week for a two-hour period. Initial rehearsals largely focused on vocal coaching and establishing the participants' range. Later on the participants were asked to bring in ideas for their own compositions. Some found the idea of generating their own songs very intimidating; others submitted very detailed lyrics and melodies. The number of participants fluctuated for a period, with choir numbers varying from week to week. The group had yet to gel as certain personalities dominated and clashed. By the end of July 2005, however, it had become clear that the choir was coalescing into an ensemble group rather than a large-scale choir, which had been originally envisioned. As the group stabilized the rehearsals became more focused and productive. Towards the end of September the rehearsals shifted to the auditorium of the Jean Farb Middle School where Murphy Canyon Choir's final recital would take place. The participants worked with Thauberger to choreograph and plan the performance.

Sinopsis. El proyecto de Althea Thauberger para **inSite_05** consistió en la iniciativa de un coro comunitario que involucró su presentación en vivo en Murphy Canyon, posiblemente el complejo militar residencial más grande del mundo y el hogar de más de dos mil quinientas familias de militares. Trabajando en conjunto con un grupo de esposas de militares que en su mayoría residían en Murphy Canyon y con la experimentada directora coral Terry Russell, Thauberger trabajó para generar una experiencia comunitaria única. Durante los ensayos semanales del taller de más de seis meses, las participantes trabajaron con el compositor en residencia Scott Wallingford para dar forma a una serie de composiciones propias basadas en sus experiencias y sus gustos musicales. La presentación final se llevó a cabo en la Jean Farb Middle School de Murphy Canyon el 25 de septiembre de 2005. Asistió un público diverso, que incluía desde miembros de la comunidad militar hasta profesionales del arte internacionales y personas interesadas en arte contemporáneo. Los asistentes a la presentación del coro fueron llevados a Murphy Canyon en un autobús provisto de una guía a bordo —Jennifer Martin, del Military Outreach Ministries (Ministerio de Extensión Militar)— quien ofreció una introducción al área y a la vida militar. Después de la presentación, los participantes y el público asistente se reunieron a compartir un refrigerio.

El *Coro de Murphy Canyon* nació en parte como una respuesta a los desafíos que plantea la vida familiar militar, donde la separación de los parientes y amigos, la crianza de los niños sin el apoyo de una pareja y el transportarse a ambientes desconocidos puede contribuir, en su conjunto, a generar una sensación de aislamiento. Thauberger buscó que las esposas de los militares que participaron en el proyecto tuvieran una plataforma para generar nuevas relaciones interpersonales en la comunidad, así como medios para involucrarse activamente en la construcción de su propia representación social y modificar estereotipos dominantes que suelen perpetuarse a través de los medios masivos de comunicación.

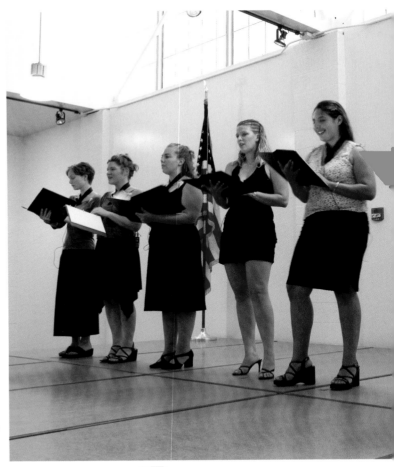

[…]Perhaps an identification was initially only possible on an emotional level, cracking open the possibility to critically consider that, whether ideologically on a par or not, **we are all implicated (economically, politically, psychically, socially, geographically) in the activities of the US military. Many socially conscious (civilian) San Diegans are not aware that they live alongside so many military families, or of the realities of their neighbors' lives.** Perhaps some were inclined to consider this during the concert. Perhaps there was a moment of understanding that relinquishing "us and them" stances could promote social understanding and transformation. The seeming transparency of ideologies that were manifested during the concert perhaps caused some to reflect on the way we all build defenses, meanings, and justifications in the midst of the absurdity and banality and madness of being in this world. A.T.

inSite_05

Murphy Canyon Choir seeks members

Calling all Murphy Canyon Spouses

Do you sing in the shower or the car?
Do you sing along with the radio or hum lullabies?
Do you write music or have an interest in learning?

Previous experience is not necessary
Free vocal coaching
Free certified childcare at every rehearsal

inSite, a San Diego-based arts organization, in collaboration with Lincoln Management and other military and local support organizations, are pleased to announce an exciting new community project

Don't miss this unique opportunity for self-expression, musical development, and community building

Please contact us for more information at: murphycanyonchoir@insite05.org
619-230-0005 X 13 (Donna Conwell)

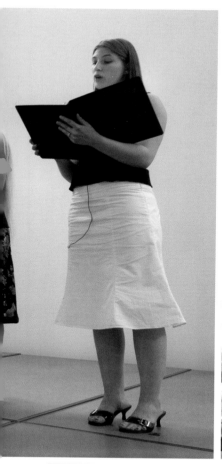

I would like to believe that the performance prompted a kind of recognition and connection of humanity, and that because there was such an ideological gulf, this identification was even more moving. There is something about the vulnerability of the performers and their voices that I think enabled a particular empathy. A.T.

Septiembre 2005/ Althea Thauberger

Función final y ubicación/ Para la organización de la función del *Coro de Murphy Canyon*, como parte de la fase pública de **inSite_05**, Thauberger inspeccionó el área buscando un escenario adecuado. Finalmente se decidió por el auditorio de la Jean Farb Middle School. La escuela se encontraba en el corazón de la comunidad de Murphy Canyon y para llegar había que atravesar un estrecho corredor sobre el propio cañón. El hecho de que el público llegara a la función a pie, a través de este paisaje, resultó de interés para Thauberger. Parecía prefigurar el hecho de que iban a participar en algo inesperado y también parecía sugerir metafóricamente la posibilidad de forjar una relación entre el disparatado mundo del arte y los públicos militares comunitarios a quienes estaba destinado el proyecto. Intensos ensayos se llevaron a cabo en el auditorio de la escuela antes de la función. A fin de acompañar el desplazamiento del público en autobuses desde Balboa Park para asistir al evento, Thauberger le pidió a Jennifer Martin, del Military Outreach Ministries (Ministerios Militares de Extensión), que durante el trayecto hacia el sitio hiciera una introducción sobre la vida militar y la comunidad de Murphy Canyon. La función final tuvo lugar el 25 de septiembre de 2005 a las 3:00 p.m. Miembros de la comunidad militar y públicos de la comunidad artística local e internacional se dieron cita para la función. Después del recital, el público se reunió en el patio exterior para compartir un refrigerio.

Images: Recital/ Shuttle service to the performance/ Social gathering after the choir presentation/ Outreach poster> Imágenes: Recital/ Servicio de traslado al *performance*/ Convivio tras la presentación del coro/ Cartel de convocatoria.

Translated *Unfolding Process*/ pp. 62–63

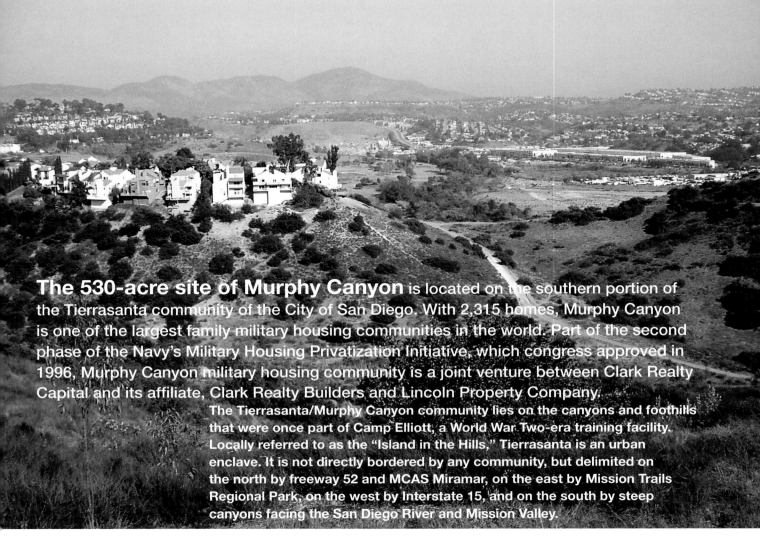

The 530-acre site of Murphy Canyon is located on the southern portion of the Tierrasanta community of the City of San Diego. With 2,315 homes, Murphy Canyon is one of the largest family military housing communities in the world. Part of the second phase of the Navy's Military Housing Privatization Initiative, which congress approved in 1996, Murphy Canyon military housing community is a joint venture between Clark Realty Capital and its affiliate, Clark Realty Builders and Lincoln Property Company.

The Tierrasanta/Murphy Canyon community lies on the canyons and foothills that were once part of Camp Elliott, a World War Two-era training facility. Locally referred to as the "Island in the Hills," Tierrasanta is an urban enclave. It is not directly bordered by any community, but delimited on the north by freeway 52 and MCAS Miramar, on the east by Mission Trails Regional Park, on the west by Interstate 15, and on the south by steep canyons facing the San Diego River and Mission Valley.

Murphy Canyon Yahoo Group. A selection of unedited extracts from messages posted by the choir members. This Yahoo Group was activated between April and September 2005.

Date: Thursday, April 14, 2005, 1:11 p.m.

From: micmcc moderator

Hello Murphy Canyon Choir Ladies...I sent the following email to make you aware of our new Yahoo Group. Please feel free to begin posting as soon as you like, on any topic. I chose to make this an open board, just in case there our some of us out there, who are chatterboxes, like myself! Thank you! Talk with you all soon.

Date: Wednesday, April 20, 2005, 11:09 p.m.

From: Tina

Hi all. Just wanted to know what everyone thought of practice today. This project is gonna be really difficult. Hopefully we can pull it off by October. I had a good time tonight and hope everyone else did. Talk to all of you soon!

Date: Friday, April 22, 2005, 6:37 p.m.

From: Carissa

What's going on with everyone? Has anyone written any more songs since the last class? Well I have some poetry I'm going to bring in, in hopes that it will help us out. I've had over 17 poems published so maybe it will, who knows? Don't have too much fun this weekend! –Carissa

Date: Tuesday, April 26, 2005, 12:08 p.m.

From: Mystekmoon

I think sometimes people are afraid or intimidated by the unknown, mostly probably concerned with our talent and afraid to join, but oh they have no clue how talented we are. I've been singing my entire life, and when I heard us sing for the first time as a choir it was the most moving thing I have heard in years. Ok, enough babbbbbbbling.... See you all tomorrow.

Date: Wednesday, May 11, 2005, 9:44 p.m.

From: Mystekmoon

It's all good dear. We have missed ya though, along with Diana who wasn't there tonight (hopefully having that baby!!!) We had some new faces join us. It was wonderful. I made it in late to practice due to being stuck at dinner (but I caught the last 1/2). I think we have a total of 3 songs mostly completed and composed that we are currently working on, and 3 others being composed at the

moment. It's really wonderful. We had a new ballad, anonymously written, that we all sang tonight. It is very, very beautiful. I'm so excited to see things coming along. A lot of faces missing today though, due from sickness and other things. But, I have faith we will GROW in time, both in voice and song. LOL. Can't wait to see you next week!

Date: Wednesday, May 16, 2005, 10:00 p.m.

From: Diana Butler

Hey all, I'm bummed that there's no practice this Wednesday. I wanted to show off my new baby boy! I had him Sunday morning at 5:05 am. Get this: he weighs 10lbs 5oz and 21 1/2 inches long. We named him Keegan Flynn Butler. He looks just like his daddy. I just got home like 20 minutes ago. It feels good to be out of the hospital. Amy if you want to come by and see him your more than welcome. Actually everybody is. I will talk to ya'll soon. Have a good night. Diana

Date: Wednesday, June 15, 2005, 12:57 p.m.

From: Mystekmoon

Ok, guess with my stressful week I'm feeling the need to vent, so I apologize ahead of time if this message comes across too strongly. OK, its great and all that the church lets us use space, but once again, we have 4 months, less than 14 practices, only 4 of 13 songs to work on, and somehow practice gets cancelled. Call me crazy, but we can't afford these set backs. Thanks for listening, Amy

Date: Thursday, June 16, 2005, 1:41 p.m.

From: Mystekmoon

Hopefully Terry and Althea have been reading our posts, and hopefully, just maybe, we wont have to deal with more lack of space issues, but just incase I volunteer my home, or garage, or whatever. It's small, but it's something. And I have children so bringing your own to play with mine would work great!!! I live in a one-story unit as well, with a husband home every afternoon, so he could help tend to everything as well. Let me just clarify one thing. This is important to me, important enough to find any means possible to make is successful. I like to think of myself as proactive. I would love to get together twice a week, so I'm volunteering my home for that as well. Maybe we could discuss this and get all your views. *Cheers

Date: Thursday, June 16, 2005, 2:00 p.m.

From: Diana Butler

I totally agree with you. This is important to me too. I love to sing. I really think that we should be meeting twice a week. I hope that they are reading this. I was going to volunteer my house or garage but I have to clean it first, we still have boxes in it. But whatever, I'm willing. We need the practice. We should all decide soon, or are we waiting for the next practice if that one doesn't get cancelled! Go to go, baby is calling me. Have a good day. Diana

Date: Thursday, June 16, 2005, 8:38 p.m.

From: Michelle Mcallister

It's not the members point of view that has driven me away completely, it is the fact that I have a lot going on in my life and not enough time to devote myself completely to this choir, which isn't fair to me or the choir. I honestly did not want to leave the choir but I have to for my family's sake. With a special needs child there is a lot of stress involved, more than people know. And my husband is getting ready to go to another unit at camp Pendleton but we are trying to stay in our current housing unit since we have only been here since February. We don't want to have to move again, and we have services set up for Trevor which we have worked very hard to get set up. If we have to move we would have to get services set up for him all over again. So between being stressed out about my housing issues and things with Trevor I just haven't been able to concentrate completely on the choir. I haven't been enjoying the choir like I did at first and that is because I am so stressed out. I honestly don't want to give up the choir. it is killing me to give this up. I believe in this choir and it is an amazing opportunity but I have to do what is best for my family and not for myself. Trust me if I could work something out where I could meet with you all twice a week I would but it is impossible especially once my husband starts driving everyday to camp Pendleton.

Date: Thursday, June 16, 2005, 10:29 p.m.

From: Mystekmoon

Hello Everyone! This website was set up to help us all relate better and for us to discuss choir issues without taking up rehearsal time. Lately it seems that some of us feel it has had more negative effects than positive. I'm truly sorry for anyone if they are feeling this way. My earlier posts were simply a way

to find other ways to work TOGETHER as a team, as a whole, to help find other options if choir is cancelled. I fully realize that none of this is the fault of anyone in particular, including Terry and althea. They are angels for doing all that they have done, and for giving us this awesome opportunity. I think that with everyone's day-to-day stress some of the things that I wrote may have been portrayed negatively, but it was by no means meant to be. I was simply trying to help us all BE as ONE, and find alternatives in helping not only each other out, but inSite as well. We are supposed to use this as a discussion board for any matters we may want to discuss or get opinions on, and that is all I was simply doing. I love all of you very much, and I don't think that anyone has wrongfully tried to take over, or take control, where it is not her place. All posts, including my own, have been to simply help out where it may be needed...or not. And as Althea said, this is what our message board was built for, to discuss our feelings, and discuss projects and ideas and such. Volunteering my home for extra practices was merely a friendly gesture because I know how much we all want to make this project happen!! "With God all things ARE Possible" All my love to you all. Amy

Date: Tuesday, June 28, 2005, 11:52 a.m

From: Tracy C

Hello, Will I be able to get copies of the music this time? I only have Wife of a Hero. I don't think I'll be able to make it tomorrow, my husband and I are taking our kids to the zoo for the day but I will try to be there. If not, I'll see you Thursday for sure! See you then. Tracy

Date: Saturday, July 16, 2005, 9:03 p.m.

From: lizzie tosch

Ok ladies, I noticed that we had some conflict on the solo issues in some of our songs. You know instead of just blurting out which solos we want, I think we should try out for them and have the choir members as a whole decide. That way we can put the ladies with different singing abilities with the songs that would bring out the best in them. I'm just brain storming on how we can keep practices fun instead of a headache with all of the arguing. Just an idea, I know it's been a few days since practice but this is the first time I've been able to sit down at my computer. Any thoughts?

Date: Thursday, July 28, 2005, 6:38 p.m.

From: Sandra Turnage

Hey it's Carissa! Well I have some terrible news to share with you unfortunately. As you know I am in the navy. Well I am in the process of switching commands right now. I am leaving shore duty and going to sea duty. I will be stationed on the US Boxer. They are out to sea right now and don't come back until sometime until September. I am being flown out to Okinawa in Japan this Sunday to meet the ship as they arrive there. With that in mind I'm not going to be here to practice or anything like that. Therefore I will have to leave the choir. I am so sorry to do this to everyone. And I wish everyone and you the best of luck with the choir. I really hate doing this as I have already come so far with the music. Keep me posted if you can on the choir. Best wishes-Carissa!

Date: Saturday, April 30, 2005, 11:43 a.m.

From: dbutler1018

Hey people, it's Diana! I'm really bored and I just wanted to say hi. Also Tina you have an awesome voice! I can see you singing country music! Does anybody know if there's anything that I can do to make me go into labor! I want this baby out!!!!!!!!!!!!! Ok Bye!

Date: Sunday, May 1, 2005, 8:22 p.m.

From: Sandra Turnage

Well this is Carissa, and I know exactly how you feel about the baby thing. I just had a boy 3 months ago. You can have sex, or you can do a lot of physical exercise. Either of those 2 things will help you out. Good luck girl!

Date: Sunday, May 1, 2005, 8:55 p.m.

From: Diana Butler

Sex is out of the question. My husband is in Iraq so I'll try the physical exercise. Thanks. Tuesday I'll be going to the zoo and doing a lot of walking hopefully that will work.

Date: Monday, May 2, 2005, 7:30 a.m.

From: Sandra Turnage

Well if I don't see you at choir on Wednesday I'll know that it worked. Is this your first child? Bear with it girl before you know it, it'll all be over.

THE OUTSIDERS' PERSPECTIVE
Mary-Kay Lombino

On September 18, 2005, a group of savvy contemporary art viewers boarded a bus in Balboa Park, San Diego, and was transported onto the grounds of Murphy Canyon, a sprawling military complex, which houses more than 2,500 families near the United States-Mexican border. The journey from the park to a school auditorium, where Althea Thauberger's performance was held, proved to be unexpectedly transformative. On board the bus was a young woman, about twenty-three years old, who was there to offer some insight into life at Murphy Canyon and answer questions. She was a military wife and mother of small children, much like the performers who volunteered to participate in Thauberger's choir. Her attitude was upbeat, cheerful, and welcoming, and while she hinted at some dissatisfaction with her situation—such as the unfortunate events that kept her husband deployed throughout most of her recent pregnancy and first four months of her youngest child's life—she was generally accepting of the military structure that framed much of her behavior, lifestyle choices, and prospects. She described her experience as a sunny alternative to the poverty, unemployment, and uncertainty that many young Americans are faced with today. The audience members, while many of them no-doubt arrived with various left-leaning political and ideological affiliations, were hearing another side of the story tinged with the practical realities of everyday life, and, as a result, were forced to rethink their own disapproving pre-conceived notions of life on a military base.

Once the audience arrived in the auditorium and took their seats among the friends and families of the performers, another interesting shift occurred. Those who lived in this military community clearly belonged there, making the art viewers the outsiders—displaced from their comfortable surroundings of an art gallery or museum, or even an urban setting. Even though the bus had only carried them a few miles away from the city center, they had crossed into unfamiliar territory. Sitting among the "insiders," they were deprived of the typical voyeuristic experience of observing a set of unsuspecting subjects. In other works by Thauberger, such as *Songstress* (2001–02) and *A Memory Lasts Forever* (2005), two video works that also involved community volunteers participating in musical performances, such voyeurism is inevitable. Even though, as in *Murphy Canyon Choir*, the subjects sing in their own words with their own sentiments, a certain distance between subject and viewer is created by the video format that prevents any possibility of the two-way, human-to-human interaction available in a live performance. In the Murphy Canyon auditorium, the emotional content of the songs, coupled with the palpable pride of the "insider" members of the audience, discouraged any smug judgments or art-world, knowing reactions. Art viewers were invoked to accept the women on stage at face value, much like the women have accepted their fates as the wives of often-absent husbands who might not make it home safely. This point was driven home in the heartfelt, if clichéd, lyrics that expressed the difficulty of waiting for their heroes to return and praying for their lives, but never once uttered any doubt or questioning of the war, not to mention the policies and people behind it. Instead, one could sense the true mutual support these families provide for one another, and the knowledge that war has united, rather than divided, this small, yet deeply affected portion of the population.

Mary-Kay Lombino *is the Emily Hargroves Fisher '57 and Richard B. Fisher Curator at The Frances Lehman Loeb Art Center at Vassar College. She was invited to the* **Murphy Canyon Choir'***s performance by the artist. Lombino is based in Poughkeepsie, New York.*

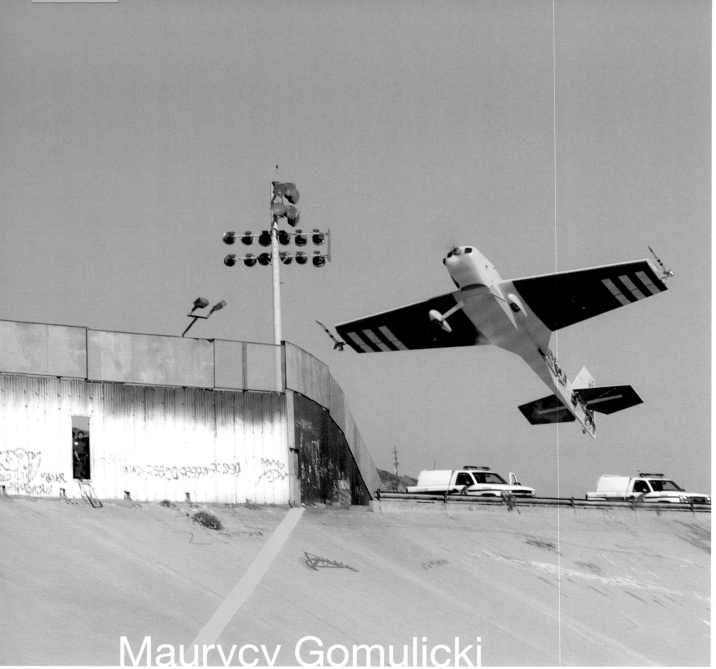

Maurycy Gomulicki

Aerial Bridge> Puente aéreo/

Synopsis. Maurycy Gomulicki's project, *Aerial Bridge*, consisted of the preparation and realization of a one-off flying event that was organized in partnership with model airplane enthusiasts from clubs in San Diego and Tijuana. Intrigued by the way in which the passion for a hobby can connect diverse individuals, Gomulicki worked for more than a year with the pilots to design and construct new model airplanes for the event. Through this collaborative process, which was based on an exploration of the model airplane pilot's personal fantasies, Gomulicki encouraged the transgression of the barriers between established cultural modes of belonging and social adhesion. After an arduous process involving frequent interchanges between the project collaborators, as well as complex modification to the event site, the performance took place on September 24, 2005, in the cemented riverbed of the Tijuana River, where a yellow line painted down the center of the river channel demarcates the US-Mexico border.

Images: Research process/ Final event (in color)> Imágenes: Proceso de investigación/ Evento final (a color)

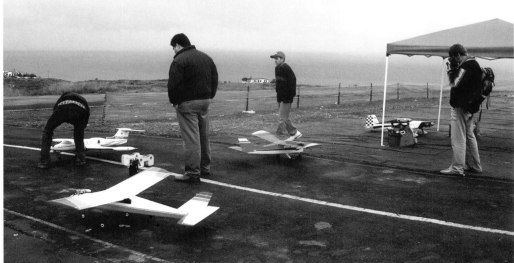

Aerial Bridge—with all it finally amounted to as an experience—could not have taken place without this extended lapse of time, not because of the complexity of its production, but because of the human dynamics involved, dynamics that turned out to be key. Creating a project with **inSite** meant working with communities—one may have ideas, but one has to learn how to give that role over to the people involved. One has to know how to avoid exclusion and face that challenge. [...] **My project wouldn't exist without the people participating in it. Even if all the airplanes might have been as spectacular as some them turned out to be, had they all been designed by an artist, they would have never had the same lyrical power.** This power derived from the fact that the designs sprang from the people who made them—honestly and in their own individual way. M.G.

→ Otras traducciones/ pp. 278–279

Marzo 2004–Febrero 2005/ Maurycy Gomulicki

Visitas a campos de vuelo/ En marzo de 2004 Gomulicki regresó a Tijuana San Diego con el propósito definido de visitar campos de vuelo de aeromodelismo. Su propuesta de proyecto contemplaba ya la idea de invitar a un grupo de pilotos aeromodelistas a colaborar con él en el vuelo de modelos aéreos sobre la franja fronteriza, usando el río canalizado como pista. Visitó varias veces dos campos de vuelo en San Diego: el Silent Electric Flyers of San Diego Field (Campo de Vuelo de los Voladores Silenciosos de San Diego) y el Chula Vista Model and Radio Control Club (Club de Modelos Aéreos a Control Remoto de Chula Vista). Durante este periodo Gomulicki comenzó una investigación técnica sobre la construcción de modelos aéreos a través de las tiendas de aeromodelismo en San Diego, a fin de proponer a sus colaboradores la creación de nuevos modelos personalizados.

Translated *Unfolding Process*/ p. 55

Desde hace varios años mi trabajo está enfocado hacia la fantasía

Sinopsis. *Puente aéreo*, de Maurycy Gomulicki, consistió en la preparación y la realización de un espectáculo de vuelo conjunto entre miembros de clubes de aeromodelismo de San Diego y Tijuana. Gomulicki —interesado en cómo la pasión por un *hobby* es capaz de conectar a personas muy diferentes— trabajó por más de un año con los pilotos de ambos lados de la frontera a fin de construir nuevos modelos de aviones, especialmente para este evento. A partir de este esfuerzo colaborativo, basado en el despliegue de las fantasías personales de los pilotos, Gomulicki se propuso transgredir las barreras establecidas por los modelos culturales de pertenencia y adhesión. Tras un arduo proceso de intercambios, de permisos y de acondicionamientos técnicos, el espectáculo tuvo lugar el 24 de septiembre de 2005 a las 3:00 p.m., sobre el lecho de concreto del Río Tijuana, justo donde cruza la línea amarilla de la división territorial.

la cual reconozco como un espacio donde lo ingenuo y lo (mutuamente e inconscientemente) perversamente sofisticado se mezcla, mutando para crear manifestaciones de "lo más increíble" y "lo más deseable". Dentro de mis exploraciones en las fantasías comunes los grupos más frecuentes son proveedores y coleccionistas. Coleccionismo y *hobbysmo* tienen una parte que me asusta: la parte mecánica. El mundo de coleccionistas/*hobbystas* me empieza a interesar de verdad cuando corta con la idea de réplicas y series, y empieza a fijarse en aspectos y contextos más personalizados. Lo atractivo de este universo de coleccionistas/*hobbystas* es la verdadera pasión y capacidad de abrirse que posean hacia el tema de su interés. La tarea que queda es proponer otra mirada, un distinto contexto, una nueva posibilidad de actuación. Durante mis visitas a los *flying fields* me he encontrado con mucha "gente grande", apasionada por su fantasía. **En mi vida he recibido mucha de esta pasión por la vida de parte de mi abuelo, lo que encuentro vital como experiencia.** M.G.

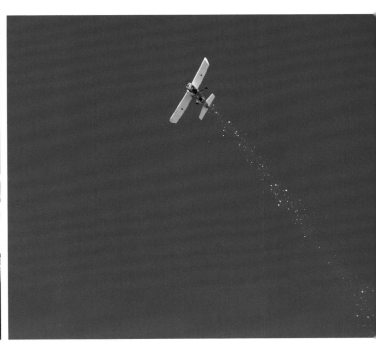

The presence and power of the aerial myth is solidly founded in the North American conscience. At San Diego's bay there exists a physical, sensorial fact of aerial transit and military aerial movement. (It is in fact where the military allows itself most to be seen at first sight.) In San Diego one can see a lethal Cobra helicopter, touch the motor of the legendary Messerschmitt Me-262, or stand below the shadow of the Black Bird SR-71. *Top Gun, The Right Stuff, Werner von Braun,* and *The Spirit of St. Louis* are alive here and San Diego, nevertheless, not without reason, is proud of them. "The military and pilots are the most romantic people that exist"—states a friend from San Diego. Flying has always been the largest (after combating death) human desire. Today it has became a tool for oppression/ destruction. The motive for flying appears in relation to questions of: Liberty/Aerial space property/Aerial borders. The place (border zone) is saturated in DREAMS/HOPES always in presence of KNOWN/UNKNOWN (both sides). Liberty and limits are key words in border contexts.

The idea is to activate the river zone of Tijuana. Its architectural qualities and lineal structures offer a sort of industrial park with an admirable spatial clarity in contrast to the everyday urban chaos of Tijuana. The site is now practically empty except for a few cases of abandoned souls that pass by there. The yellow border line painted on the river's concrete bed serves as a natural and symbolic line for airplane takeoff. The inclined riverside walls are naturally fit for spectator benches. The all so close presence of the open border is disturbing and absurd.

Images: Pre-production process/ Final event (in color)> Imágenes: Proceso de preproducción/ Evento final (a color)

I would like to propose the creation of personalized planes (note: these should not be intended as replicas of real planes but of one's own fantasy, thus proposing personal identity in the artifact versus national aerial world identity context—aerial forces).

>

My passion for airplanes that I want to share is the beauty of their flight and the exciting things that can be done with the airplane in space. I will want to develop that rather than something that will be strange, unusual, or americanized. I hope that is acceptable to the project.

Regards,
Tim
Tim Attaway/ Email/ "Re: AFTER THE CLUB MEETING," February 23, 2005

> I would like to propose simultaneous flights and acrobatics (on both sides) as a poetic exercise. I would like the groups, depending on the chosen activity (building, piloting), to meet together frequently to work/elaborate ideas. I also can imagine "mixed groupings": a builder that elaborates his personal plane and a skillful pilot who would put it to flight. [Objective: to stress the approximation in the process (real time) independent of the approximation in the moment of the event (lyrical time). I would like to achieve a dynamic in which participants can brainstorm the same ideas or propose new ideas (activate conscience in and of the process)]. M.G./ Statement

Hey Tania, are the Americans coming? If so, can you tell them that after the meeting in Real del Mar they are invited to fly with us. Please let them know so they can bring their airplanes. Weather permitting; we'll be flying from 1:00 p.m. and providing a barbeque at the field. I'm a little worried about the forecast, which I include below.

Thanks,
Alan
Alan Andere/ Email/ "Re: Saturday," February 17, 2005

Images: Pre-production process/ Final event (in color)> Imágenes: Proceso de preproducción/ Evento final (a color)

The final performance was an ephemeral act—as are the dynamics of **inSite** because it is a semi-invisible project. **The crude urban forces (with the sudden flood of sewage on the "airstrip") lent an even more absurd sense of drama to the event—in keeping with the intentions of the participants.** The snow flurry of silver dust expelled by Humberto's plane reached its lyrical peak as it passed over the sewage. The subsequent meeting of the pilots was extremely moving; with everyone's heart on their sleeve.

It was foolish to propose a romantic act within a communal framework. Because of the cultural consciousness of the border, it inevitably involved engaging in a dialogue in which "politically correct" and ethical questions were embedded. **Performing a romantic act and ensuring that others, as well as myself, could understand it, was a challenge. I can't underestimate the amount of reflection it generated, but it was a life changing experience.** M.G.

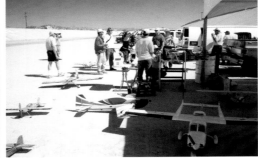

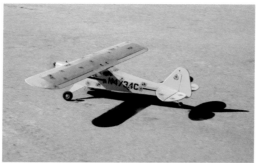
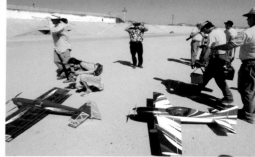

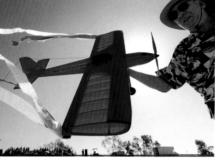
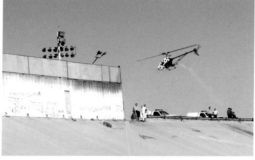
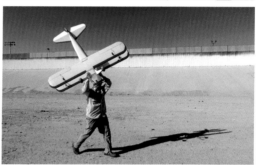

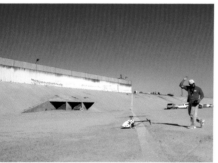
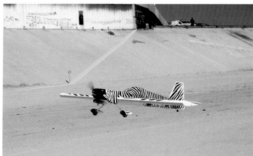
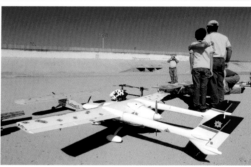

Marzo 2005/ Maurycy Gomulicki

Invitación a colaboradores/ Entre marzo de 2004 y abril de 2005 Gomulicki visitó el Club de Aeromodelismo Real del Mar, en Tijuana. Teniendo como eje de su propuesta la idea de que la pasión por un *hobby* puede generar un vínculo entre personas muy distintas, su interés consistía en lograr la colaboración de pilotos a ambos lados de la frontera. En abril de 2005 los participantes de ambas ciudades quedaron definidos. Durante esta etapa los pilotos y Gomulicki visitaron el río, donde tendría lugar el espectáculo de vuelo. Un tema importante de discusión en este encuentro fue la previsión de los permisos requeridos, y las necesidades de acondicionamiento y limpieza del cauce del río para la realización del evento.

Translated *Unfolding Process*/ p. 55

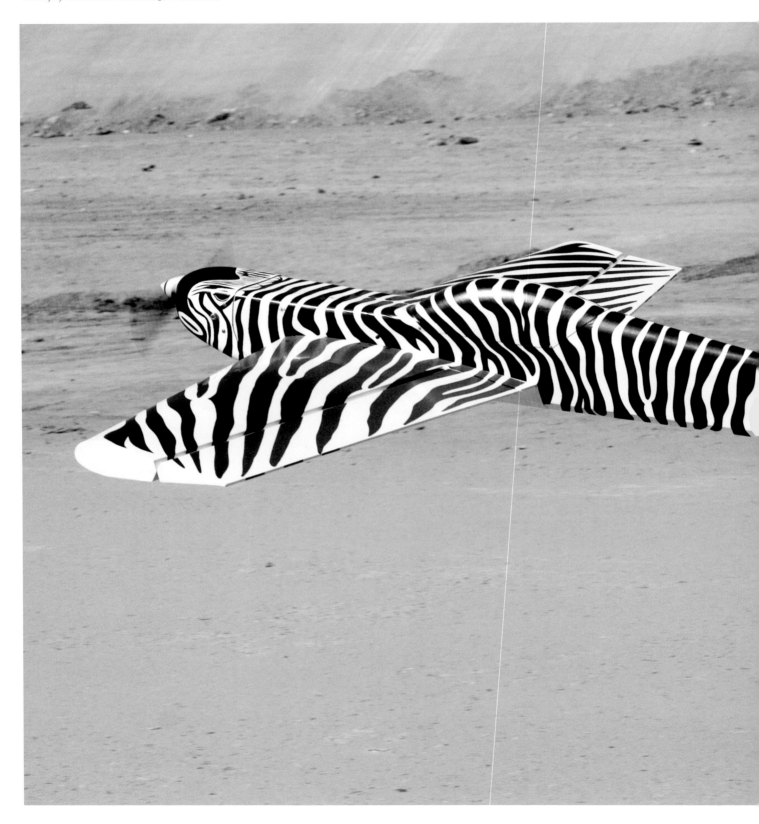

For many years my work has focused on fantasy that I recognize as a space where ingenuity and (mutually and unconsciously) sophisticated perversity mix, mutating and generating manifestations of "the most incredible" and "the most desirable."

Inside of my explorations into common fantasy, the most frequent groups are suppliers and collectors. Collecting and hobbyism share a side that scares me: the mechanical part. The collector and hobbyist's world began to really interest me when it cut off the idea of replicas and series and began to concentrate on more personalized aspects and contexts. The most attractive aspect of the collectors/hobbyists' universe is the true passion and capacity to open themselves up when positioned in front of the subject of their interest. During my visits to the RC Flyer Fields, I found myself surrounded by many older people, passionate about their fantasy. **In my life I have had a lot of contact with this passion by way of my Grandfather, which I find vital to my life experience.** M.G.

Septiembre 2005/ Maurycy Gomulicki

Evento de vuelo conjunto/ Tras un ensayo anterior en el sitio, el 24 de septiembre de 2005 a las 3:00 p.m. se realizó el evento de vuelo. Como resultado del acuerdo entre todos los pilotos Gomulicki fue elegido como maestro de ceremonias, a fin de introducir a cada participante y comentar su acción en vivo. Así volaron uno a uno: Crackle, Avión Cebra, El Roquero, Pinkerton, El chupa y sopla, Avión de la ciudad, Dancing Bule Eagle, Zarapito tira pollos y el helicóptero Soccer Ball. Cada piloto ejecutó la coreografía de su vuelo acorde a la pieza musical que había elegido previamente para el programa. Un momento crucial e inesperado fue cuando el agua del río comenzó a inundar intempestivamente la pista de despegue y aterrizaje, al haber sido abierta —al parecer— una de las esclusas del río. No obstante, el evento continuó, en una divertida adecuación a las circunstancias tanto por parte de los pilotos, como del equipo de producción y de la audiencia.

Translated *Unfolding Process*/ p. 55

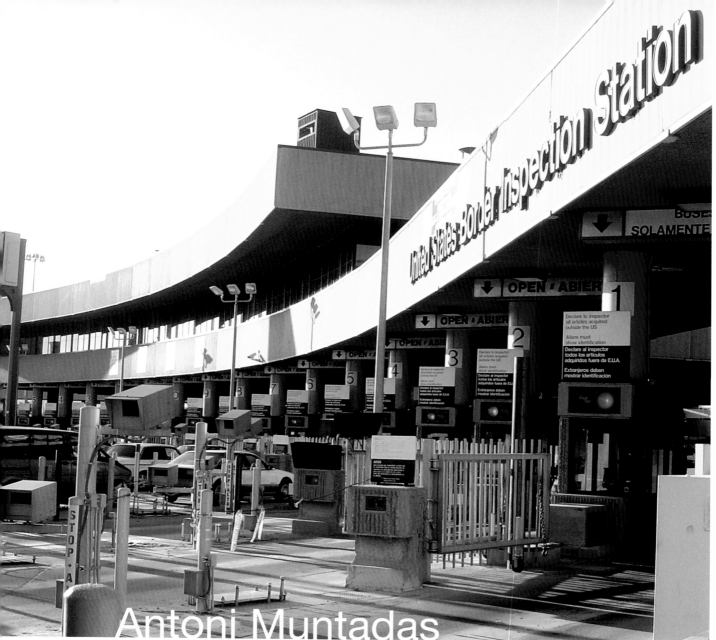

Antoni Muntadas
On Translation: Fear/Miedo/

Synopsis. *On Translation: Fear/Miedo* is a television intervention by Antoni Muntadas, which was inserted in broadcast programming in the US and in Mexico. It features interviews with people who experience the inherent tensions of the San Diego-Tijuana area on a daily basis, combined with archive footage dealing with the concept of fear at the US-Mexico border. The video also incorporates additional found footage from the media and elsewhere, as well as clips from fictional films that focus on the subject of fear. With *On Translation: Fear/Miedo* Muntadas seeks to illustrate how fear is an emotion that is translated on both sides of the border from very different perspectives. It is a cultural-sociological construct always intimately tied to the political and economic domain. *On Translation: Fear/Miedo* was telecasted during the months of August through November of 2005. To date, it has been broadcast on television channels in three out of four key locations that influence and affect the border zone, either as centers of power and decision-making or places that are greatly impacted by policies emanating from those centers: Tijuana, San Diego, Mexico City, and Washington, D.C. (during the period coinciding with **inSite_05** transmission was not possible in Washington, D.C.).

The most ancient of vehement passions, the most basic of the chemically-triggered impulses we call emotions. A loud noise, the acrid scent of a predator, a sudden movement caught in peripheral vision, the gathering dusk—Fear is an evolved response to such stimuli[…]
The private experience of fear can be public, instrumental outcome, consciously deployed or subliminally leaching into policy decisions, fear can function as a political tool.

Carolyn Jones/ *Doubt Fear*

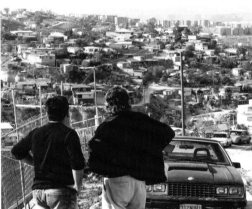

On Translation: Fear/Miedo refiere a variadas interpretaciones con respecto al miedo de distintos actores sociales de la zona fronteriza, y su yuxtaposición con imágenes de archivos audiovisuales preexistentes. El proyecto alude a los sistemas de emisión de información y a cómo ciertas estrategias de manipulación ideológica impactan a nivel emocional en los habitantes de esta zona, a ambos lados de la frontera.

Images: Research and residencies>
Imágenes: Residencias y proceso de investigación

Enero 2005/ Antoni Muntadas

Propuesta y colaboradores/ En enero de 2005 Muntadas regresó a Tijuana San Diego con el tema de su proyecto definido: el miedo como emoción traducida a ambos lados de la frontera, y ello como una continuación de su ya extensa investigación *On Translation* [Sobre la traducción]. Propuso la elaboración de un video en torno a las distintas perspectivas que sobre el miedo tienen los habitantes de la zona y cómo este sentimiento impacta en la vida de los *commuters* [personas que viajan diariamente para asistir a clases o al trabajo, en este caso, de un lado de la frontera al otro], e invitó a Galatea Audiovisual —la casa productora cuyo proyecto cultural es Bulbo— a colaborar como productores. El documental estaría estructurado en torno a dos preguntas básicas hechas a personas de edades y perfiles diversos en la zona: ¿Cuál es tu manera de entender el miedo/fear? y ¿Cómo percibes el miedo en la frontera desde las perspectivas de San Diego y Tijuana según tu experiencia?.

→ Otras traducciones/ p. 281

Translated *Unfolding Process*/ p. 59

On Translation: Fear/Miedo is part of a series of projects that Muntadas has been developing since 1994, which explore the themes of translation and interpretation and are subsumed under the general title of *On Translation*. In these projects Muntadas has explored the multiple viewpoints and interpretative possibilities that abound in the public sphere. In particular Muntadas' work focuses on how aspects of the public sphere are positioned as dominant discourses, and how they are distributed, appropriated, and reinterpreted. His projects become a dissection of the media's political structure and its public responsibility.

On Translation: Fear/Miedo refers to various social actors' diverse interpretations of fear in the border zone. This is juxtaposed with pre-existing archival footage. *On Translation: Fear/Miedo* alludes to informational systems and how ideological strategies have an emotional impact on the inhabitants of the border zone. While *On Translation: Fear/Miedo* is an intervention which inserts itself into television programming, other projects which are part of the *On Translation* series have involved video, internet, magazines, books, and billboards.

Sinopsis. *On Translation: Fear/Miedo* es un proyecto de intervención televisiva de Antoni Muntadas a partir de la producción de un video en el cual se reúnen entrevistas a personas que viven cotidianamente las tensiones en la zona de Tijuana San Diego e imágenes de archivos televisivos que refieren al término de fear/miedo en la frontera entre México y los Estados Unidos. El trabajo también incorpora otros materiales documentales y periodísticos, así como fragmentos de filmes de ficción que aluden al miedo. *On Translation: Fear/Miedo* busca exponer cómo el miedo es una emoción traducida a ambos lados de la frontera desde perspectivas muy diferentes; una construcción cultural/sociológica que siempre remite al ámbito político y al económico. *On Translation: Fear/Miedo* comenzó a ser transmitido entre agosto y noviembre de 2005. Hasta el momento ha intervido canales televisivos de tres de las cuatro locaciones que de algún modo conectan los centros de poder y toma de decisiones de ambos países con los sitios donde estas políticas cotidianamente se manifiestan: Tijuana, San Diego, Ciudad de México y Washington DC. (Lograr su transmisión en Ciudad de México y Washington DC fue imposible en el marco temporal de **inSite_05**).

Images: Video production process/ Stills from video> Imágenes: Producción del video/ Fotogramas del video.

On Translation: Fear/Miedo forma parte de la serie de proyectos en torno a temas de traducción e interpretación que, con el título general de *On Translation*, Antoni Muntadas ha desarrollado desde 1994. Muntadas explora la multiplicidad de puntos de vista y posibilidades de interpretación en torno a contenidos relacionados con la esfera pública, y cómo estos contenidos son emplazados como discurso dominante, para de ahí ser distribuidos, apropiados, impugnados o reinterpretados. En general, las obras devienen una disección de la estructura política de los medios de comunicación y de sus garantías públicas.

Febrero–Agosto 2005/ Antoni Muntadas

Producción del video/ Entre febrero y julio de 2005 Galatea Audiovisual entrevistó a un grupo de más de veinte personas de Tijuana San Diego en relación a su idea y percepción del miedo en la zona. Además de estas entrevistas, Muntadas consideró la inclusión de material visual tanto documental como de ficción existente en los archivos de Televisa. Como componente fundamental del proyecto, la dirección de **inSite** comenzó el contacto con estaciones televisoras de Washington, Ciudad de México, San Diego y Tijuana a fin de incluir el video en su programación. Entre julio y agosto de 2005 se llevaron a cabo en el estudio de Galatea Audiovisual los trabajos de edición, subtitulaje, musicalización y masterización del trabajo.

Translated *Unfolding Process*/ p. 59

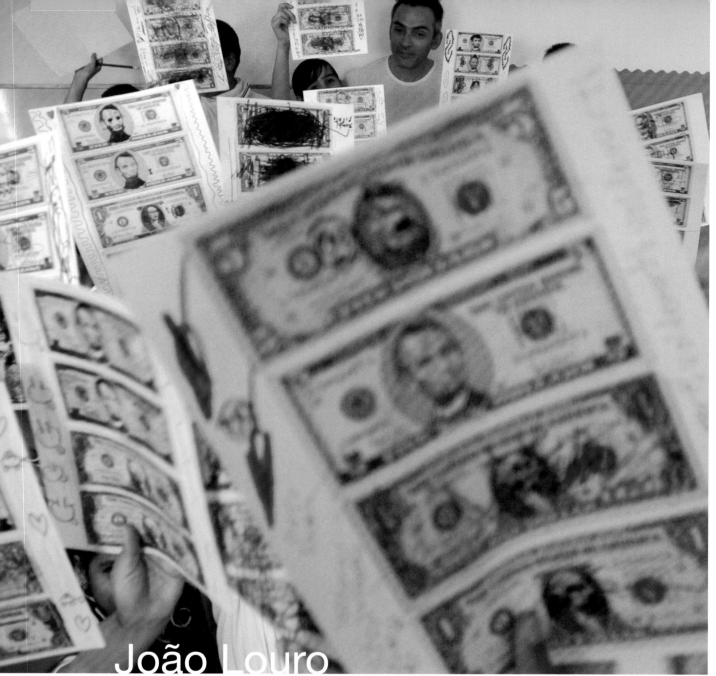

João Louro
The Jewel / In God We Trust/

Synopsis. In *The Jewel/ In God We Trust*, João Louro reveals the complex dynamics of recycling and exchange that characterize the border region by employing the metaphor of a car and by manipulating the role that symbolic capital plays in the global economy. The project began with Louro selecting a European car, which he recovered from a junkyard in Tijuana and transformed into a "jewel," endowing it with a new skin of gold leaf. Once the car was transformed into a "luxury object"—a golden sculpture—the car-jewel was exhibited and, later, auctioned as an artwork in San Diego. The money raised by the auction was delivered to an elementary school in Tijuana, where the students used the banknotes as drawing material. Transformed into intervened currency, the "vehicle" took on another life, which was just as complex in terms of symbolic meaning. The money was then redistributed and recycled back into the economic flows of the border region, crossing back into San Diego and reentering the US economy.

The title **The Jewel / In God We Trust** indicates the two phases of this project. It deals with the rehabilitation of an economic cycle (the intense recycling in the border zone), focusing on the purpose of the process.

A European car is recovered from a junkyard in Tijuana and transformed into a "jewel," giving it a new life on the other side of the border. A displacement of value is brought about by art. The object itself, without being touched by the artist, ceases to be garbage and instead becomes a sumptuous object. J.L./ Statement

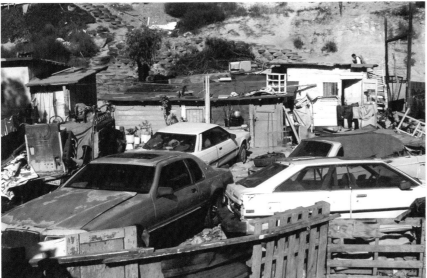

Images: Project implementation at Colegio Patria (in color)/ Research and production process> Imágenes: Implementación del proyecto en el Colegio Patria (a color)/ Procesos de investigación, documentación y producción

Octubre 2005/ João Louro

Talleres de dibujo sobre los billetes/ En octubre de 2005 Louro visitó el Colegio Patria en Tijuana para conducir los talleres con niños de 3ero y 4to de primaria. En estos talleres el dinero obtenido durante la subasta del coche-joya el 26 de agosto de 2005 fue intervenido por los alumnos con plumones y crayolas de colores. Tras una presentación en la que expuso a los estudiantes su proyecto y explicó la importancia ecológica del reciclaje y el impacto del coche en esta área, Louro invitó a los niños a dibujar sobre los billetes motivos relacionados con la problemática. Un mes después los billetes intervenidos fueron devueltos a fin de ser distribuidos por voluntarios tanto en San Diego como en Tijuana, de modo que los mismos se reintegraran eventualmente al flujo económico entre ambas ciudades.

→ Otras traducciones/ p. 279

Translated *Unfolding Process*/ pp. 56–57

Sinopsis. En *The Jewel / In God We Trust* [La joya / En Dios confiamos] João Louro se propuso emplazar las dinámicas de reciclaje que caracterizan a la frontera, usando la metáfora de un coche y manipulando reiteradamente el rol del valor simbólico al seno de las economías contemporáneas. El proyecto partió de elegir un carro europeo recuperado de la basura en Tijuana y transformarlo en "joya", sumándole una nueva piel de hoja de oro. Una vez convertida esta chatarra en "objeto de lujo", en tanto escultura aúrea, el coche-obra fue exhibido y luego subastado en San Diego. El dinero de la subasta fue entregado a una escuela primaria de Tijuana con el fin de ser usado por los niños como soporte de dibujo, agregándosele al papel moneda nuevas imágenes. Como papel intervenido, este "vehículo" ganó una otra vida propia, igualmente compleja en el campo del valor simbólico, con el fin de que volviese, quizá, a reciclarse de regreso, al entrar y ser usado de nuevo como efectivo en el mercado estadounidense.

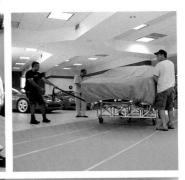

Images: Car crossing the border from Tijuana to San Diego/ Presentation-cocktails at Ferrari and Maserati of San Diego> Imágenes: Coche cruzando de Tijuana a San Diego/ Cóctel de presentación en Ferrari and Maserati of San Diego

Images: Workshops centered on intervening on banknotes at Colegio Patria in Tijuana>
Imágenes: Talleres de intervención de billetes en el Colegio Patria en Tijuana

Dear revolutionaries, in the way Debord taught us.

Some instructions:

1. Let everyone working at **inSite** each be given some banknotes (15 banknotes each, but with the possibility of more for "participative" people so they can "abandon them.")

2. Let Tijuana and, of course, San Diego be "inundated" with banknotes (I have special affection for the mall and Hillcrest. The Coronado hotel, like a dream, where the movie *Some Like it Hot* was filmed is a must at all costs.) This is a job that Michael and Carmen could do, dressed in 007 attire; in daDaCraPs (which I leave open without wanting to be too demanding as far as casting).

3. Have sent to me a (generous) quantity of banknotes to be abandoned in Lisbon and Portugal, and in international fairs (Basel and Arco, of course Miami's Basel, but that one's gone… I feel special affection for a child who painted them all black, among others). Here I will make them valuable. The work's final blow "In God We Trust"… you write DadaTrust.

4. The banknotes sent to me will have to come by normal post (USPS).

I loved this project.

Kiss

Dada&joAo&dada

J.L./ Email/ "Let it rain money," December 5, 2005

Images: The car guilding process/ Banknotes intervened by pupils of Colegio Patria> Imágenes: Proceso de dorado del coche/ Billetes intervenidos por los alumnos del Colegio Patria

217

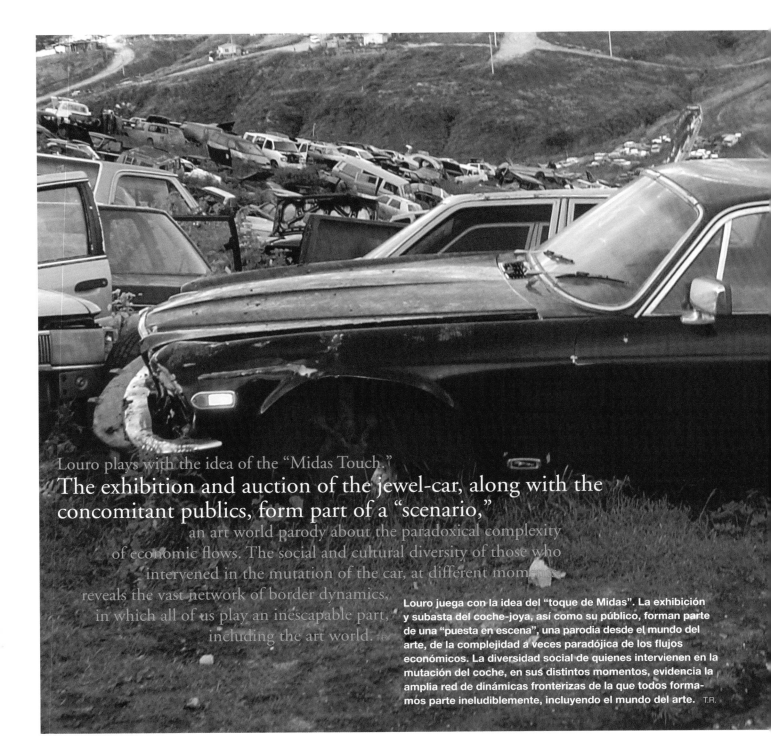

Louro plays with the idea of the "Midas Touch."
The exhibition and auction of the jewel-car, along with the concomitant publics, form part of a "scenario," an art world parody about the paradoxical complexity of economic flows. The social and cultural diversity of those who intervened in the mutation of the car, at different moments reveals the vast network of border dynamics, in which all of us play an inescapable part, including the art world. T.R.

Louro juega con la idea del "toque de Midas". La exhibición y subasta del coche-joya, así como su público, forman parte de una "puesta en escena", una parodia desde el mundo del arte, de la complejidad a veces paradójica de los flujos económicos. La diversidad social de quienes intervienen en la mutación del coche, en sus distintos momentos, evidencia la amplia red de dinámicas fronterizas de la que todos formamos parte ineludiblemente, incluyendo el mundo del arte. T.R.

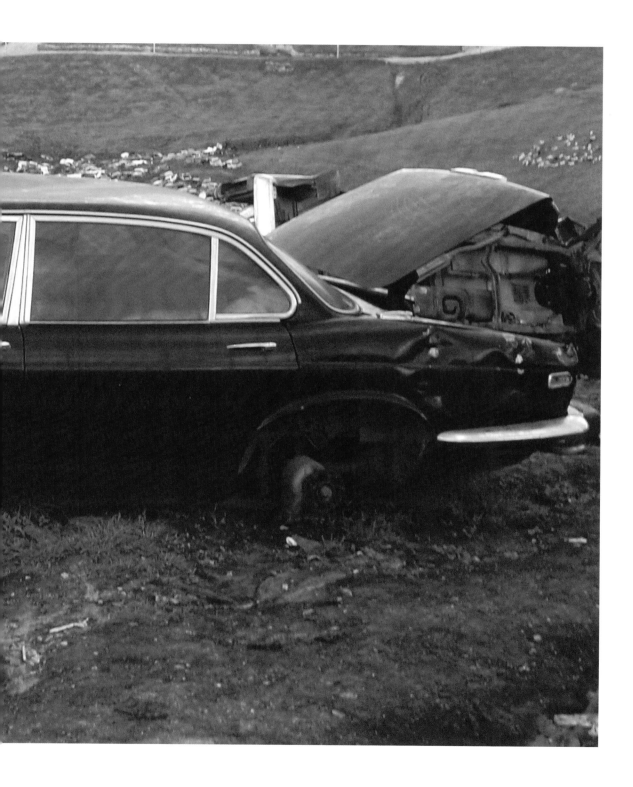

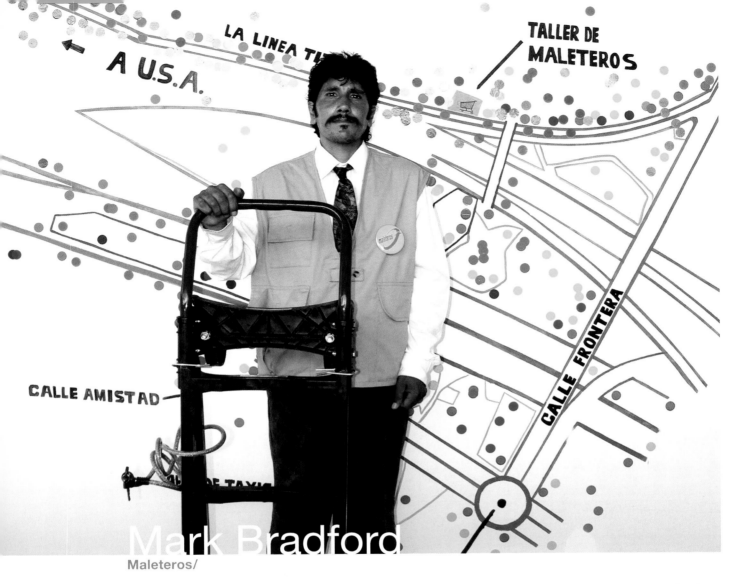

LA LINEA T...

TALLER DE
MALETEROS

← A U.S.A.

CALLE FRONTERA

CALLE AMISTAD

...OF TAXI...

Mark Bradford
Maleteros/

Synopsis. Mark Bradford's project, *Maleteros* (porters), was an exercise in empowering and making visible an informal labor community. Through an extended process of dialogue and exchange, Bradford worked with a group of unofficial porters—who have been peddling their services at various access points at the US-Mexico border for more than two decades—to co-create a visual "porter identity." Through the supply of customized equipment, the informal branding of key work areas, and the provision of a temporary work space, Bradford provided the *maleteros* with a platform from which to negotiate their social representation and public visibility.

By revealing the existence of underground communities that carve out social spaces at the border and ease the cross-border flow of goods and people, Bradford sought to disrupt the familiar reading of the San Ysidro Port of Entry as a highly formal site, replete with mechanisms of control and surveillance. Instead of tracking a vertical trajectory between the cities of San Diego and Tijuana, Bradford mapped the intricate relationships of informal economic exchanges that routinely penetrate and circulate around the border.

Longstanding differences between various *maleteros* groups came to the surface during the process—in particular between those who had a measure of official recognition and those who did not. However, individual *maleteros* continued to discuss ways in which to continue the project, hoping to secure a degree of solidarity in order to defend their work at the border, underline its importance, and work towards a unified *maleteros* presence.

I was exploring the sites of the *maleteros* at the border and it's all about oral tradition. It is passed from one person to another, and so I started to use the networks that were already in place so that people would understand the project, and it kind of just became translated from one person to another. M.B./ Garage Talk I

Images: Final implementation of the project at the bikeshop (in color)/ Research process and documentation/ Working sessions with artists from the area> Imágenes: Implementación final del proyecto en el local de bicicletas (a color)/ Documentación y proceso/ Sesiones de trabajo con los artistas del área

→ Otras traducciones/ pp. 275–276

Abril 2004/ Mark Bradford

Sesiones de trabajo y desarrollo de ideas/ En abril de 2004 Mark Bradford participó en una serie de sesiones de trabajo que involucraban a artistas del área. Ahí lo inspiró un recorrido de trabajo de campo en el que cada uno de los artistas participantes seleccionó un sitio como punto de partida para la discusión. Bradford se interesó especialmente en el cruce fronterizo de San Ysidro, donde los flujos de transeúntes corrían al parejo del tráfico vehicular y donde las economías informales creaban concentraciones especialmente inusuales. Fue en este momento cuando comenzó a explorar el concepto de "tiempo de frontera" —la experiencia psicológica del tiempo en la frontera— que vendría a influir en la formación de su proyecto. Después de las sesiones de trabajo, Bradford comenzó a explorar varias ideas relacionadas con la idea de movilidad.

Translated *Unfolding Process*/ pp. 51–52

Images: Digital mock-ups by the artist/ Documentation> Imágenes: Montajes digitales por el artista/ Documentación

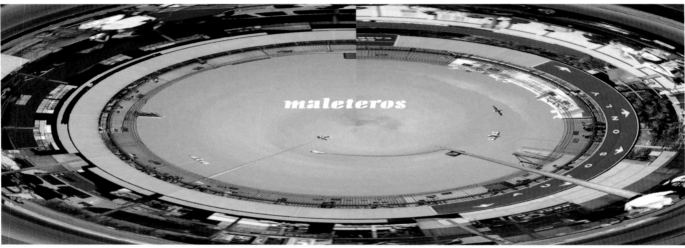

Sinopsis. El proyecto de Mark Bradford, *Maleteros*, fue un ejercicio para dar poder y hacer visible una labor comunitaria. A través de un proceso extendido de diálogo e intercambio, Bradford trabajó con un grupo de cargadores informales —que habían estado ofertando subrepticiamente sus servicios en varios puntos de acceso de la frontera México-Estados Unidos durante más dos décadas— para cocrear una "identidad visual de cargador". Mediante el suministro de equipo adecuado, la delimitación de áreas clave de trabajo y la seguridad de un espacio de trabajo temporal, Bradford hizo posible que los maleteros tuvieran una plataforma desde donde negociar su representación social y su visibilidad pública.

Al desvelar la existencia de comunidades clandestinas que buscan para sí mismas espacios sociales en la frontera y que facilitan el flujo de personas y de bienes a través de la misma, Bradford buscó romper con la apreciación convencional de la garita de San Ysidro como un sitio altamente formal, ocupado por mecanismos de alto control y vigilancia. En lugar de trazar la estela de una trayectoria vertical entre las ciudades de San Diego y Tijuana, Bradford hizo el mapa de las intrincadas relaciones de los intercambios económicos informales que rutinariamente penetran y circulan alrededor de la frontera.

Añejas diferencias entre los diferentes grupos de maleteros salieron a la superficie durante el proceso —en particular entre los que disfrutaban de una cuota de reconocimiento oficial y los que no. Sin embargo, maleteros individuales no dejaron de discutir vías alternas de continuar el proyecto, con el objetivo de asegurar un nivel de solidaridad que les permitiera defender su trabajo en la frontera, subrayar su importancia y trabajar con la mira puesta en la presencia unificada del maletero.

It is not my intention to import a network to facilitate this project
but to a larger extent work with the people from the region.
I feel this will respect the already functioning economy
of the area and through the project's mechanism
of day to day engagement build trust and communication
**in an area where politics, surveillance,
and police scrutiny govern the lives of its citizens.**

M.B./ Statement

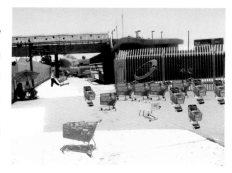

The carts' role will be assigned an ambiguous status
—both invisible/visible in the flow of the border region
while engaging ideas of consumerism, nomadism, and circulation—
to illustrate the notion that, in theory, the border region is a place where
social exchanges can occur, even if in the most predictable forms.

M.B./ Statement

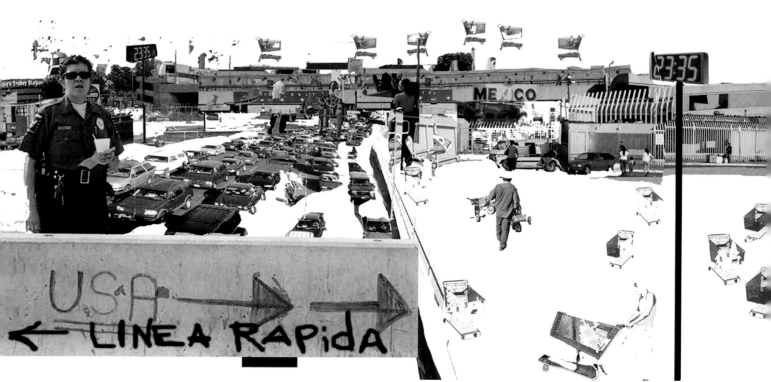

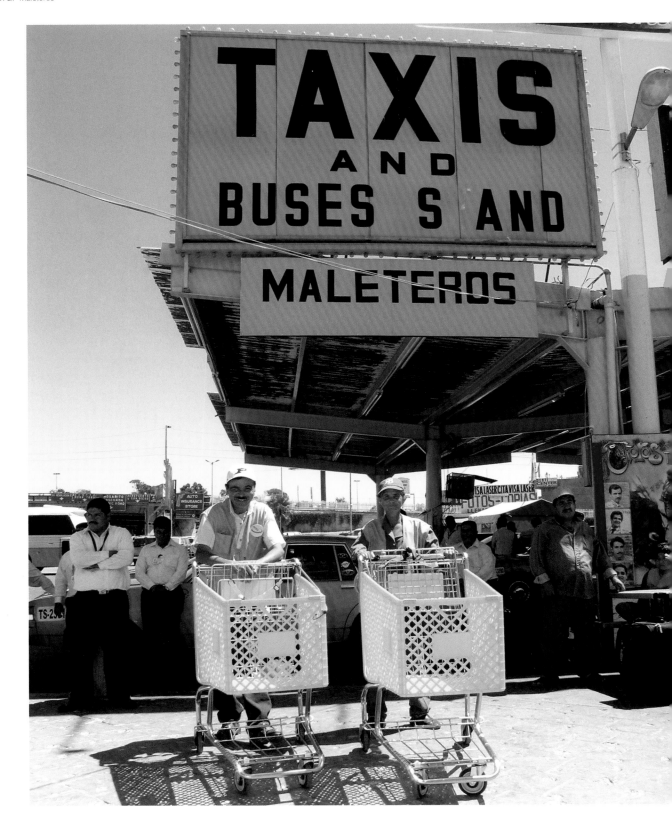

MALETEROS

A small cadre of people who earn a living carting heavy items in shopping carts for people who have brought merchandise north or who are returning from vacation has sprung up out of necessity in the region.

They wait their turn for clients, charging $1-$3 for their service. Another group of cart-pushers works north of the border. The load carriers represent one of those informal border businesses that spring up of necessity, such as the people who peddle coffee and snacks to those waiting to cross by car into the United States. Continually harassed by both Mexican and US border patrols, the workers are forced to wait behind the pedestrian corridor causing them to lower their prices as they are not able to push their loads as far. The cart carriers typically work seven days a week, often from 7:00 a.m. to 8:00 p.m. On good days, they can make about $20. M.B./ Statement

Images: Final implementation of the project>
Imágenes: Implementación final del proyecto

JUST ACROSS THE WAY

Kellie Jones/ Interlocutor

Wielding shopping carts and bright new vests and caps, the *maleteros* of the San Ysidro-Tijuana border crossing checkpoint wended their way back and forth for several meters on each side of the line. Their presence demonstrated in microcosm the contentious, internecine, physical, and economic symbiosis that constitutes the US-Mexico border and the international political relationships that they symbolize. By bringing attention to this supposed underground economy resting along the boundary Mark Bradford's *Maleteros* project for **inSite_05** brought us literally into the heart of these issues. By creating a branded identity for this informal sector, Bradford acknowledged their contributions to economic flows, taking their work out of the shadows. Fast forward to spring 2006 as demonstrations across the US signal the need for recognition of this intertwined and yet ignored relationship on a broad national scale, and the vital obligation to visualize invisible workers forming the bedrock of the US economy and of the "American" dream. A dream that should not only be looked at as the bling of hyper-capitalist gain, but which encompasses safety, support, education, home, and a happy life that all in the Americas and the "in" world should be able to consider their own. Like the *maleteros* emerging from the relative shadows into the light with their shining vests, caps, and carts, workers who shuttered shops May 1 came out of every corner of every industry onto the picket lines, hundreds of thousands strong, to have America see and acknowledge them and not just turn a blind eye to the labor that drives the US.

Bradford's project demonstrated art's ability to reveal and intervene in these realities. It shed light too on the changing nature of notions of site-specificity and public art. It also laid bare the artist's own production as elastic and flexible with an ability and desire to interact with life and society at large. Bradford is primarily a painter of abstract yet map-like paintings for whom geography, and particularly the geography of Southern California, is present tense and active. The jump from two dimensions to three and from metaphoric to real intervention in the world in this sense seems not only logical but also desirable as a way to inspire and inform the work, and make it relevant on a variety of levels.

Kellie Jones *is a curator and writer currently serving as associate professor in Art History and Archaeology at Columbia University. She is based in New York. Jones acted as an Interlocutor for* **Interventions**, **inSite_05.**

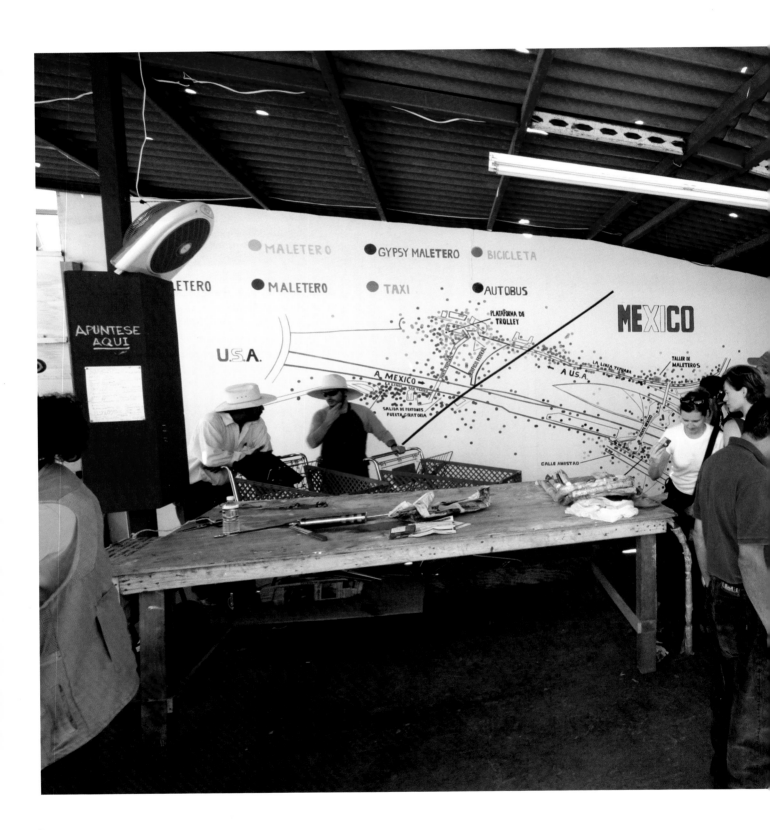

I feel that the "memory of the official 100 days" will cling to the area and give them the possibility of continuing in these quasi-legal areas. I believe that once something is changed it is changed. **I am not sure what it is to become, but it will never be that thing again.** M.B.

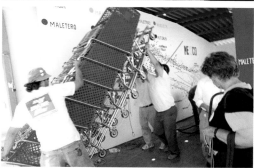

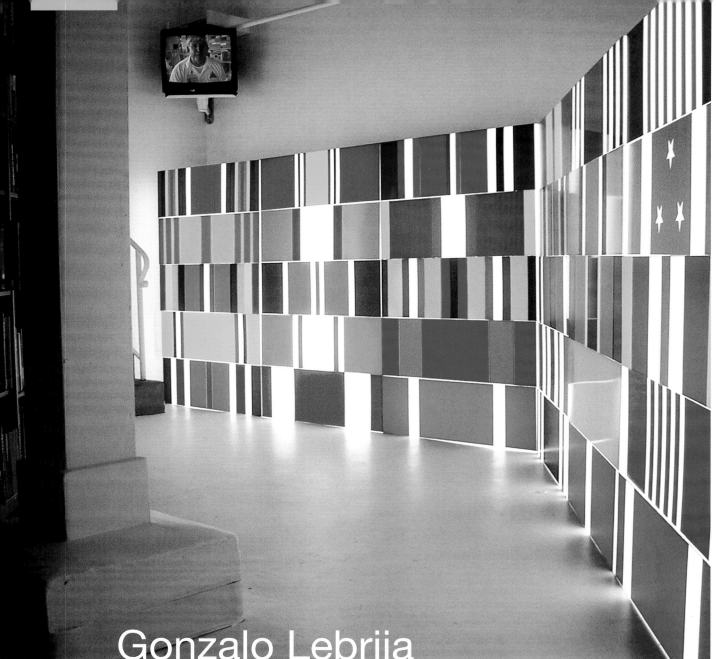

Gonzalo Lebrija

Heroes of War> Héroes de guerra/

Synopsis. After more than a year working with war veterans, Gonzalo Lebrija developed *Heroes of War*, an artistic intervention in the Veterans Museum's library in San Diego. Lebrija originally intended to intervene in the museum's "official" historical narratives by co-creating an alternative curatorial vision that would incorporate the lived experiences of a group of veterans residing at the Veterans Home of California-Chula Vista. During his research process, however, Lebrija participated in the periodic meetings of former prisoners of war. This experience opened up another field of interest: military paraphernalia and veterans' testimonies. Lebrija decided to film a series of POWs talking about their role in successive wars, as well as the public recognition of their service. Lebrija combined these interviews with sculptural elements that he modeled after the geometric configurations of military service ribbons to create a video installation that proposed an alternative pathway through the dusty bookshelves of military history. *Heroes of War* was an intervention that activated a space between formal military rhetoric and the complex lived reality of witnesses of war.

For starters, the basic idea is to engage the veterans' imaginations in order to create a possible exhibition. The combination of historical past, silence, and leisure strikes me as interesting, like potential strategies that reverberate in the imaginations of the veterans.

G.L./ Email/ "Gonzalo," August 2, 2004

Images: Final installation (in color)/ Research process and workshops at the Veterans Home in California-Chula Vista/ Veterans Museum interior view and paraphernalia> Imágenes: Instalación final (a color)/ Documentación y talleres en la residencia para veteranos en Chula Vista/ Interior del Veterans Museum y parafernalia

Junio 2005/ Gonzalo Lebrija

Entrevistas a ex-POWs/ En junio de 2005 Lebrija regresó a San Diego y realizó entrevistas a un grupo de ex-prisioneros de guerra (ex-POWs) contentos de hablar de su desempeño en las distintas guerras en las que participaron y del reconocimiento público a sus acciones. Para ese momento Lebrija había re-definido el proyecto: intervendría la nave central del Veterans Museum con una videoins-talación en la que las barras de honor otorgadas a los héroes de guerra serían reinterpretadas en cajas de luz y yuxtapuestas con las historias personales de los ex-POWs. A partir de entonces comenzó la producción de la pieza y se invitó a los ex-POWs a ser entrevistados en video.

→ Otras traducciones/ p. 279

Translated *Unfolding Process*/ pp. 55–56

The idea of the returning hero forms part of the citizens of the San Diego's collective imagination. The site of the world's largest naval fleet, San Diego is home to the most important port on the American continent's Pacific coast. In addition to accommodating various military bases, the city also has several monuments and institutions that honor the memory of the American soldier. *Heroes of War* refers to the strategies that are used to gather the witness testimonies of military personal and present them to the public. Lebrija reinterprets some of the most representative icons of "official" military discourse and gives a voice to the protagonists of the events. By incorporating the personal accounts of a group of veterans into the "official" history of battles and conflicts on exhibit in the Veterans Museum, *Heroes of War* acts as a platform for exercising new codes of representation and affiliation. T.R.

Sinopsis. *Héroes de guerra* de Gonzalo Lebrija consistió en una intervención al espacio de la biblioteca del Veterans Museum de San Diego, tras más de un año de trabajo con veteranos de guerra. La intención original era intervenir la propia museografía del museo, creando un discurso curatorial más cercano a la propia experiencia creativa del grupo de veteranos residentes en el hogar Veterans Home of California-Chula Vista. Como parte de todo el proceso de investigación Lebrija también participó en las reuniones periódicas de los ex-prisioneros de guerra, POW's (por sus siglas en inglés, *prisoners of war*). Estas experiencias definieron un otro campo de interés, más cercano a la parafernalia militar y al testimonio de los veteranos. Lebrija filmó a personas concretas, que discursaban sus vidas en relación al reconocimiento público y a su desempeño durante sucesivas guerras. Con estas entrevistas a héroes de guerra, y con la viva geometría de sus condecoraciones de honor, Lebrija creó una instalación de video que proponía otra vivencia de recorrido entre las empolvadas estanterías de libros de Historia militar. Una intervención que se activaba entre la retórica formalista militar y la identidad compleja de sus testimoniantes.

My initial idea, involving the interaction between veterans and the museum dedicated to them, has been modified over time by different circumstances. The information collected and the great interest generated by this first collaboration transformed my curiosity for the military culture of one of the most powerful countries in the world—and perhaps the one that gives most importance to this in terms of economy and ideology—into a profound artistic-military investigation that highlights two characteristics of the military machine: the recognition of the hero, his glory, and the personal memories of the vulnerable man. G.L./ Statement

Images: Production and final installation at the Veterans Museum> Imágenes: Producción e instalación final en el Veterans Museum

Images: Video stills and installation view>
Imágenes: Fotos fijas del video e instalación

Bearing in mind that the project's objective is to get the museum involved, it would be good to organize the workshops with that as a focus. **We should think in terms of exercises that might generate links between the personal and the public, the past and the present, between the veterans' memories in relation to the institutional discourse of the museum.** For example, I'm thinking of creating a photographic survey of the museum's artifacts—objects, photos, writings, uniforms—printing them and using them as index cards in order to begin to establish appropriate relationships for the story that interests us, and in order to generate some sort of exhibition display.

Another idea could involve what we had considered before regarding a World War II illustration book. This would probably only serve as an exercise in order to practice the idea of intervention in relation to art. They could probably write over the images using a white marker. **They have a style of writing that's not very common anymore and it's just incredible. I'm looking for the not so obvious relationships. We'll figure out how to go about it.** At the moment, they're only ideas to get the dialogue going and to help define the workshop program.
G.L./ Email/ "Re: Gonzalooooo is back," November 24, 2004

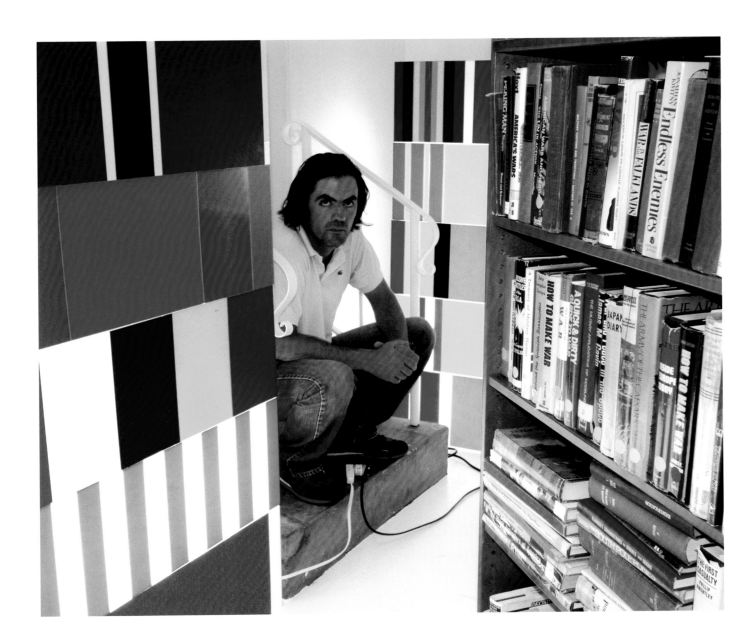

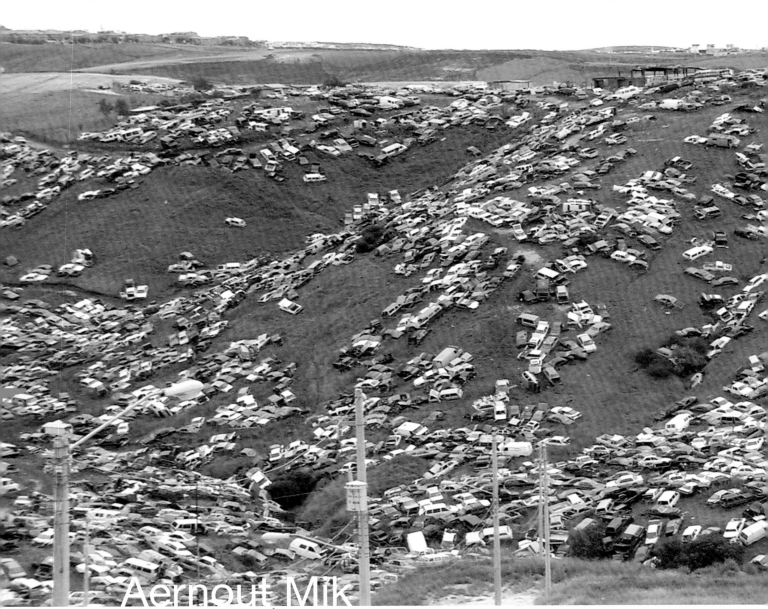

Aernout Mik
Osmosis and Excess> Ósmosis y exceso/

Synopsis. Aernout Mik's video installation *Osmosis and Excess* interlaces images of car junkyards—*corralones*—that are found at Tijuana's urban periphery with scenes of a Tijuana pharmacy inundated with mud. By referring to the flow of US cars into Mexico, which are eventually discarded and abandoned on Tijuana's barren hillsides, as well as the acquisition of cheap pharmaceutical goods by US customers, Mik explores the routes of economic exchange and circulation that connect Mexico and the US. *Osmosis and Excess* was shot on location in Tijuana and at Fox Studios in Baja California in high-definition video.

Osmosis and Excess was installed in the Parkade parking facility in downtown San Diego. Located near the San Diego baseball stadium, Petco Park, the Convention Center, and San Diego's commercial and tourist hub, the Gaslamp Quarter, the site stands at the intersection of diverse and varied public flows. A wide range of individuals made use of the parking facility, including tourists, employees working in downtown, and shoppers. Mik employed three suspended computerized projectors to create a high-definition panoramic image that floated above the stationed cars like a phantasmagoria.

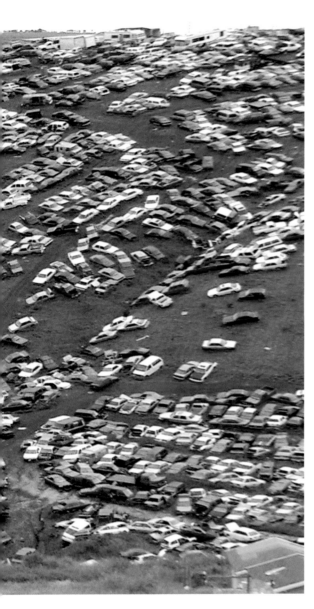

By drawing a portrait of Tijuana as defined by its transient flows, and its interdependent asymmetrical relationship with its US neighbor, Mik suggests that a city's social and economic narratives are embedded in the configurations and transformations of its local topologies. Focusing on the residue or vestiges of circuits of exchange and commerce, Mik reveals the way in which the contemporary city comprises numerous related networks, itself part of a larger global conduit through which the world economy circulates. The essential entropic condition of the city is reflected by Mik's territories of excess—landscapes that in a state of decay and degradation modify existing urban conditions. D.C.

Images: Color still from video/ Research process> Imágenes: Foto fija a color del video/ Proceso de investigación

→ Otras traducciones/ pp. 280–281

Al hacer un retrato de Tijuana tal y como la definen sus flujos en tránsito, y su relación interdependiente y asimétrica con su vecino norteamericano, Mik sugiere que las narrativas sociales y económicas de una ciudad están engastadas en las configuraciones y transformaciones de sus topologías locales. Concentrándose en el residuo o los vestigios de los circuitos de intercambio y comercio, Mik revela la forma en que la ciudad contemporánea comprende numerosas redes interconectadas, éstas mismas parte de un conducto más grande y global a través del cual circula la economía del mundo. La condición esencial entrópica de la ciudad aparece reflejada en los territorios excesivos de Mik —paisajes que en un estado de decadencia y degradación modifican condiciones urbanas existentes. D.C.

Sinopsis. La instalación de video de Aernout Mik *Ósmosis y exceso* entrelaza imágenes de corralones —depósitos de autos— que se encuentran en la periferia urbana de Tijuana con escenas de una farmacia local inundada de lodo. Al hacer referencia al flujo de automóviles de Estados Unidos a México, que con el tiempo se desechan y abandonan en las faldas yermas de los cerros de Tijuana, así como a la adquisición de bienes farmacéuticos baratos por consumidores norteamericanos, Mik explora las rutas del intercambio económico y la circulación que conecta a ambos países. *Ósmosis y exceso* se rodó en una locación en Tijuana y en los Fox Studios de Baja California en video de alta definición.

Ósmosis y exceso se instaló en el estacionamiento Parkade, en el centro de San Diego. Situado en la zona comercial y turística de San Diego conocida como Gaslamp Quarter, cerca del estadio de béisbol de San Diego —Petco Park— y del Centro de Convenciones, el sitio se encuentra en la intersección de flujos de públicos diversos y variados. Un espectro amplio de personas hace uso del estacionamiento, como turistas, empleados que trabajan en el centro y vendedores. Mik se sirvió de tres proyectores digitales suspendidos para crear una imagen panorámica de alta definición que flotara por encima de los carros estacionados como una fantasmagoría.

Images: Film production process/ The Fox Studios Baja set> Imágenes: Proceso de producción del filme/ Locación en foro de Fox Studios Baja

In the video installation *Flood* I want to juxtapose and interweave footage from the Tijuana car-dump-dominated landscapes and scenes shot in a local pharmacy flooded by mud. Together, the cars and the drugs form a metaphor of the circulation of commodities between Tijuana and San Diego. Used cars move in large numbers from the US to Mexico and, when finally really broken, get dumped on its empty hills, transforming the city's peripheral landscape. The car dumps have no clear border but dissolve in the Tijuana landscape, poured as a thick liquid on the local topography. Sometimes the cars are shining like jewels in the sun, denying their essential entropic condition. In the other direction, a stream of cheap drugs finds its way back into the United States for treatment of American illness, desires, and fears. They are sold in bright and clean pharmacies across the city (so much in contrast with the city's dusty appearance), often open for twenty-four hours. Stacked in ingenious geometric patterns and in the most fantastic colors, the medicines are offered to the needy Americans.

The mud question is concerning my **inSite** project. Although I still haven't fully decided which path I will follow in the end exactly (this will depend on the other material I asked for—what I will decide in the end)…When you cannot find material it is also ok. A.M./ Email/ "Re: Mud," April 13, 2004

Both represent different manifestations of excess. Both modify a landscape—an inner and an outer landscape. On a macro and a micro level they also have a strange accidental correspondence in their visual appearance.

In both situations a mixture will be made of documentary footage and fragments of on-location and set-created scenes. The scenes will involve some actors, but the main focus will stay on the objects, as if the circulation of objects is taking place independent of people.

In the work a pharmacy is flooded by mud and its roof is damaged by heavy rain that has fallen. From some collapsed shelves large quantities of small medicine boxes have dropped in the mud. The result is an excessive amount of color, packages, and pills, in order and out of order, on the shelves and spread out in the mud, creating a miniature landscape.

Children play a connecting role in the two situations. In the pharmacy they are playing in the mud with some packages of pills, using them as if they are cars, making their way through the mud. In one of the car-dump landscapes they are hitting piñatas (some of them representing members of the US border patrol), until they burst. The sweets are scattered around on the ground, mimicking at the same time the sprawl of abandoned cars behind them and the accumulation of pills in the mudded pharmacy. A.M.

Febrero–Marzo 2004/ Aernout Mik

Proceso de investigación/ Durante un viaje de investigación a Tijuana en marzo de 2004, Aernout Mik se sintió fascinado por los inmensos cementerios de automóviles —corralones— que se encuentran en la periferia de Tijuana, así como por las farmacias de colores brillantes que están en la Avenida Revolución, cerca del cruce fronterizo de San Ysidro. Emprendió entonces un largo proceso de investigación, mapeo y fotografía de estos sitios, en un momento en que las fuertes lluvias de esa temporada provocaron grandes inundaciones y deslaves. La visión de Tijuana inundada de lodo, combinada con las imágenes de los corralones y las farmacias, jugó un papel importante en la visualización de la propuesta final. Mik también analizó locaciones potenciales, entre ellas un estacionamiento subterráneo, para la proyección de su video final.

Translated *Unfolding Process*/ pp. 58–59

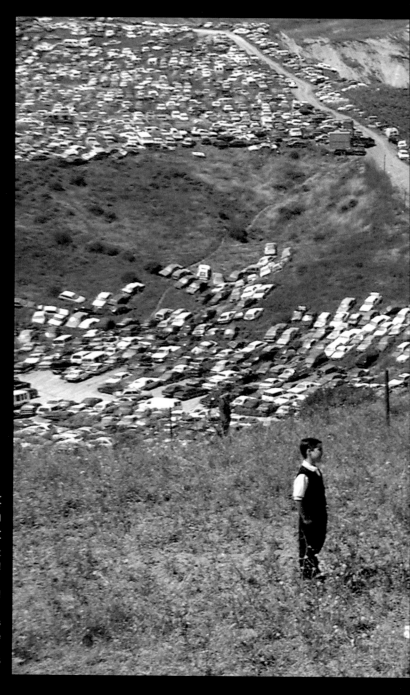

And now I started to edit in little bits and pieces and it is not easy for me because it is quite different from my previous edits. I never made a piece that consisted of so many different elements, I almost feel like I am a real filmmaker!

But the material looks very good!

I hope all is going well with you and the others and that the projects from my fellow artists are running well. I am sure that after my shoot the **inSite** organization can handle any thing!
A.M./ Email/ "Re: Hello from San Diego," May 17, 2005

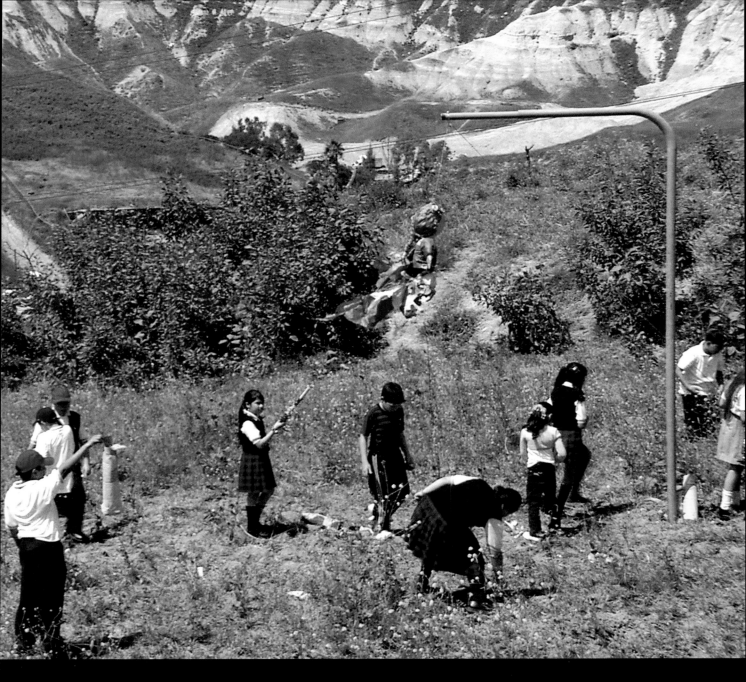

The stream of pills
and the stream of cars,
both crossing the border in opposite
directions, belong to each other. AM

The staged is brought in by me to stimulate the latent potentialities of the documentary to come to the surface. By staging these partly uncodifiable scenarios, recollected from the collective unconsciousness, the excessive quality of the scenery in the documentary's material gets amplified, and is brought to a boiling point. Started as a dual strategy, theatrical rehearsal and documented existing social rituals soon behave like doubles, somersaulting into each other.

Osmosis and Excess tells about how two separate adjoining systems leak into each other. This is further presented in the piece in a geographical sense, how streams of fetishized commodities pass the border and change it into a porous arena.

But it is also performed on a visceral visual level; hills filled with abandoned cars, herds of cows and sheep, groups of children, toy cars in the mud, medicine boxes on shelves, sweets scattered around, etc., all seem to share affinities. Dichotomies slowly dissolve into chains of multitudes. A.M.

SAVE UP TO
30%

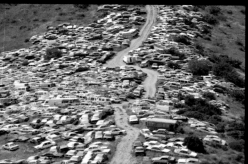

remises are set by the US, producing a cultural flood, and responded to by Tijuana in a rather inert way (the car landscapes), and in an energetic and twisted mimetic way (the pharmacies). Besides this, the apocalyptic is never shown isolated, but always in connection with colorful stimulation, play and aggression, casual boredom, and peaceful entropy. It is ust a momentum in this transformative cycle.

A.M.

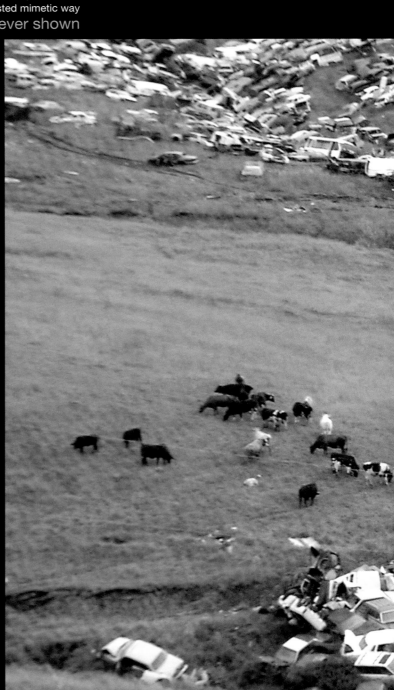

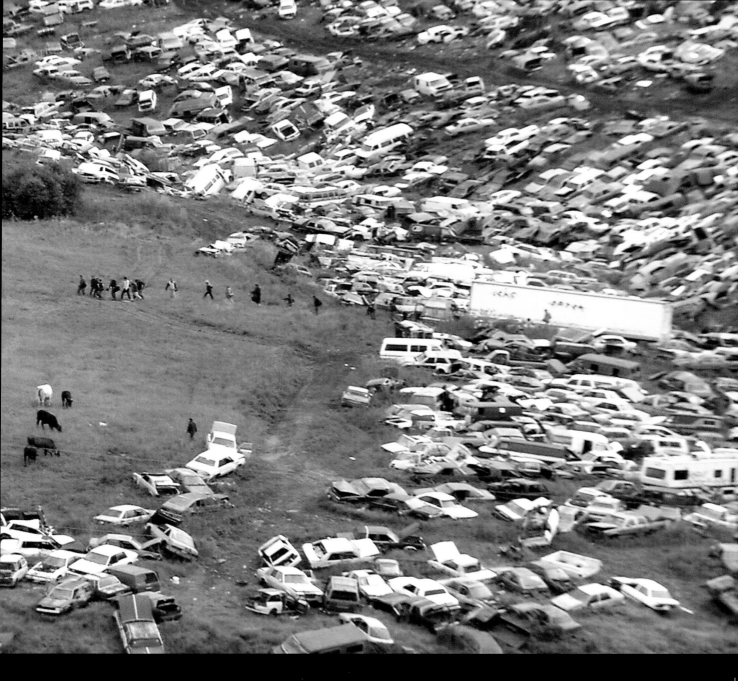

infoSites/
August 25–November 13> Del 25 de agosto al 13 de noviembre

Operating hours> Horarios de operación

San Diego

Thursday & Friday> Jueves y viernes	2:00 – 6:00 p.m.
Saturday> Sábado	10:00 a.m. – 6:00 p.m.
Sunday> Domingo	12:00 – 6:00 p.m.

Tijuana

Tuesday–Friday> Martes a viernes	11:00 a.m. – 7:00 p.m.
Saturday & Sunday> Sábado y domingo	11:00 a.m. – 4:00 p.m.

infoSites
San Diego-Tijuana

The *infoSites* were commissioned as ephemeral architectural projects designed to house the **inSite_05** information centers in San Diego and Tijuana. The commission imposed three guiding principles on the designers. Firstly, each architect was asked to select a site where diverse, heterogeneous publics converged. Secondly, the designed space was expected to accommodate the specific requirements of the *infoSite* program. Divided into three key functions, the space had to include an information desk with instant access to project-related material and products for sale, a second area for research, and a third area for web-based consultation, viewing projections and listening to aural material. Thirdly, the architects were limited to a budget of $40,000, which meant that they had to utilize low-cost materials and come up with creative ideas for producing the space.

The centers functioned as reception areas for **inSite_05** visitors and as venues for educational exchanges. An extensive body of information was made available though diverse media, ranging from video interviews

with the artists, projections of the artists' previous work, computer terminals with access to the **inSite_05** website and commissioned online projects, and music stations with sound elements from certain projects and extracts from **inSite_05**'s sound component, *Ellipsis*. The research area included texts and essays about public art, the city, and artistic practices involving process and co-participation. This was envisioned as a way of facilitating understanding of **inSite_05**'s less accessible and more complex projects.

Ultimately, the *infoSites* were installed in two locations: at the parking lot of the San Diego Museum of Art in Balboa Park, and on the Omnimax Cinema at the Centro Cultural Tijuana in Tijuana.

Los *infoSites* fueron comisionados como proyectos de arquitectura efímera a fin de albergar los centros de información de **inSite_05** en Tijuana y en San Diego. La comisión imponía varias directivas al proyecto: A) El sitio, a elegir por el artista, buscaría insertarse al seno de una confluencia cautiva de público heterogéneo. B) El espacio a crear debería de responder al programa del *infoSite*, dividido en tres bloques de funciones: un área información inmediata y ventas; una segunda área para consulta de fuentes; y por último, un área de consulta digital y de proyección y sonido. C) El presupuesto de los *infoSites* tendría un límite modesto para tal empeño, 40 mil dólares, lo que sugería considerar materiales de bajo costo y soluciones ingeniosas para la producción del espacio.

Estos centros funcionaron como lugares de acogida a los visitantes de **inSite_05**, y sirvieron además como lugar para intercambios educativos. Una variedad de medios y soportes dieron cabida a una extenso cuerpo de información —desde videos con entrevistas a los artistas, proyecciones de sus trabajos previos, conexión digital al *website* de **inSite_05** y a los proyectos comisionados para la red y piezas que incluían sonido, o con *tracks* pertenecientes al componente sonoro de **inSite_05**. Asimismo las áreas de consulta contaban con libros y compilaciones de ensayo en torno al arte público, a la ciudad y a las prácticas artísticas de proceso y co-participación, a fin de facilitar otras fuentes para la comprensión de aquellos proyectos de **inSite_05** que eran menos accesibles o más complejos.

Los *infoSites* estuvieron finalmente localizados en la plaza de estacionamiento frente al San Diego Museum of Art, en Balboa Park, San Diego; y en la explanada, frente al Omnimax del Centro Cultural Tijuana, en Tijuana.

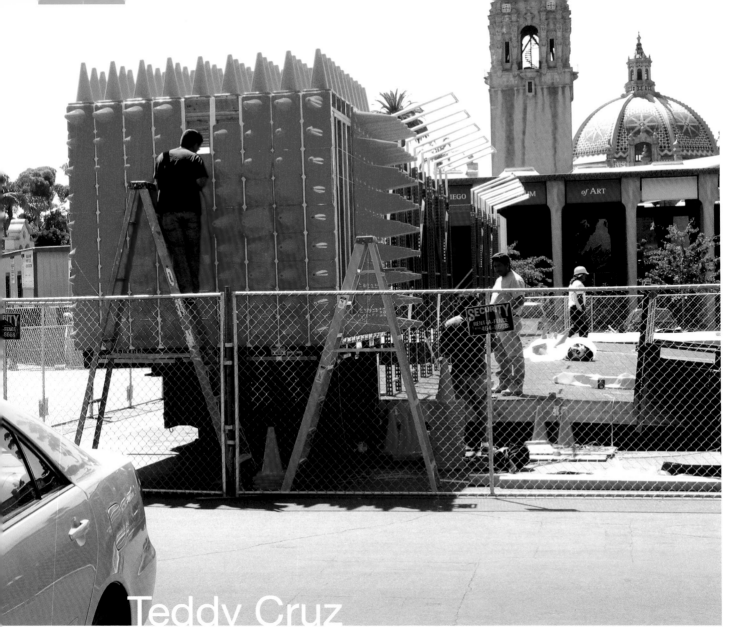

Teddy Cruz
San Diego infoSite/

Synopsis. Teddy Cruz's San Diego *infoSite* is a commissioned work of ephemeral architecture that was inserted within existing strategies of cross-border recycling. The temporary structure combined salvaged materials with elements related to recycling processes—such as truck beds used to transport crushed cars to recycling plants—and dynamics of transit and transportation. The design components not only characterize the "spaces of flow" in the border region, but also refer to materials that are utilized in the construction of emergency habitats. Through the transformation of use—the way in which a packing material can become a building material—Cruz posits a sustainable architectural practice.

In a city in which public space is increasingly diminished and demarcated by parking lots, the decision to locate the San Diego *infoSite* in the site of twenty-eight parking spaces in front of the San Diego Museum of Art was, in part, fueled by a desire to appropriate the space for alternative public use. The San Diego *infoSite* was a temporary architectural strategy for the (re)occupation and recovery of a public space that had hitherto been primarily associated with traditional white cube exhibitions.

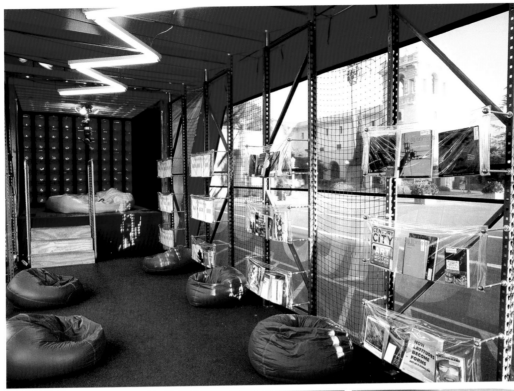

Images: Construction of the San Diego *infoSite* (in color)/ Interior of the San Diego *infoSite* (in color)/ Working sessions with artists from the area/ Research process> Imágenes: Construcción del *infoSite* de San Diego (a color)/ Interior del *infoSite* (a color)/ Sesiones de trabajo con los artistas del área/ Proceso de investigación/

Abril–Julio 2005/ Teddy Cruz

Reubicación del infoSite/ En abril de 2005 quedó claro que el permiso para localizar el *infoSite* en el centro de la ciudad no estaba garantizado. Hacia fines de abril, la posibilidad de ubicar el *infoSite* frente al San Diego Museum of Art en Balboa Park se volvió otra posibilidad. Después de una serie de reuniones con el director del San Diego Museum of Art, el proyecto fue aprobado en su totalidad por la Balboa Park Cultural Partnership (Asociación Cultural de Balboa Park). En junio de 2005 el Balboa Park Committee (Comité de Balboa Park) aprobó la solicitud de Cruz para ubicar temporalmente el *infoSite* en las áreas del parque y la construcción comenzó a mediados de agosto.

→ Otras traducciones/ pp. 276–277

Translated *Unfolding Process*/ p. 53

Sinopsis. El *infoSite* de San Diego proyectado por Teddy Cruz fue un trabajo comisionado de arquitectura efímera que buscaba emplazar las estrategias de reciclaje existentes en el área fronteriza. La estructura temporal combinó elementos recuperados con elementos relativos a procesos de reciclaje —desde contenedores de camiones para transportar coches chocados hasta plantas de reciclaje— y dinámicas de tránsito y transportación. Los componentes diseñados no sólo aludían a los "espacios de flujo" en la región fronteriza, sino que también citaban materiales que son utilizados en la construcción de hábitats emergentes. A través de la transformación del uso —la forma en que un elemento empacado se puede convertir en un material de construcción—, Cruz intentó proponer una práctica arquitectónica sustentable.

En una ciudad donde el espacio público disminuye cada vez más y se demarca por la aparición de estacionamientos, la decisión de situar el *infoSite* de San Diego en el mismo lugar que ocupan veintiocho lugares de estacionamiento frente al Museum of Art se debió, en parte, al deseo de apropiarse de ese espacio y darle un uso público alternativo. El *infoSite* de San Diego fue una estrategia arquitectónica temporal para la (re)ocupación y recuperación de un espacio público que hasta ahora se había asociado predominantemente con exposiciones tradicionales de arte.

Teddy Cruz's *infoSite* showcased his architectural ideas, asking us what is building material and to think of it as information. His interest in the strategies for living on both sides of the line, how these manifest as physical and architectural interventions into space, and translations of the same across boundaries, is energizing. But do these nomadic notions of lived experience translate for the positive or become part of global marketing, one more gimmick replacing aesthetic possibility for change with trend? Kellie Jones

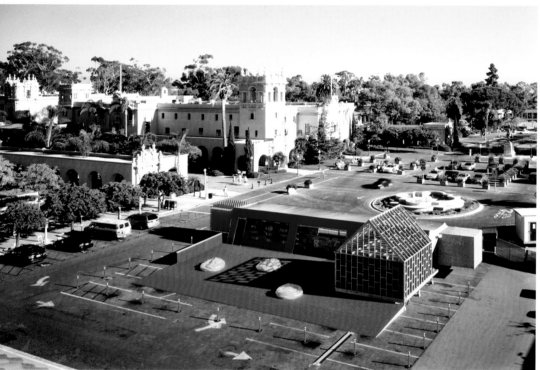

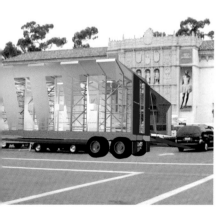

Images: Mock-up designs/ *infoSite* model/ Panoramic view of the *infoSite* at Balboa Park> Imágenes: Montaje digital/ Maqueta del *infoSite*/ Vista panorámica del *infoSite* en Balboa Park

Conceptual Framework

We continue to question how our proposal for the *infoSite* can meaningfully address San Diego's urbanism and engage a variety of publics locally and regionally.

- **infoSite/** All programmatic elements requested by **inSite**, necessary for the *infoSite* to function as an informational platform.
- **Transit(e)/** The *infoSite* is a process to explore issues of transborder mobility, recycling energies, displacement, and transference of resources and infrastructure from one city to another.
- **Para-site/** The *infoSite* is a tool piercing at the incremental privatization of San Diego's public space encroaching itself into downtown as an event carrying public and social programs for the city.
- **Outside / inSite/** We continue to ask what sort of peripheral (to the internal programming of the *infoSite*) uses can our proposal engage in order to attract a variety of publics not only within downtown proper, but also from its adjacent communities. We think that the *infoSite* can serve as a community facilitator, a cultural platform that can compensate for the lack of independent artistic venues and infrastructure in the city.
T.C./ Statement

It is clear that very easily, one risks romanticizing these environments, and in a sort of ethnographic gaze, patronizing their fragile conditions. We cannot forget that they are the product of resistance and transgression. In a time when architecture has been so distant from the political ground and the social fabric that shapes it, **the critical observation of these settlements and the assessment of possible tactics of intervention to assist their organic evolution is a risk worth taking.** T.C./ *Border Postcards: Chronicles from the Edge*

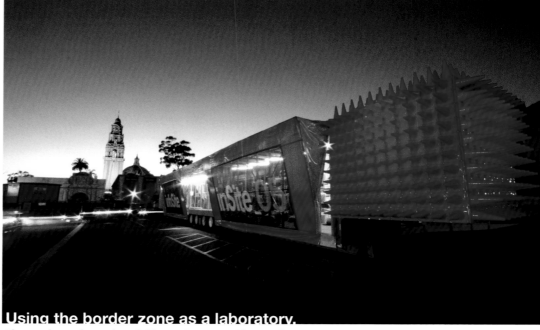

Using the border zone as a laboratory, then, has inspired the observation of thriving conditions in existing neighborhoods, focusing on the dormant potentialities of under-utilized elements of the urban infrastructure. Many lessons can still be learned from the great transnational metropolis stretching from San Diego to Tijuana, as it embraces recurring waves of immigrants from around the world. A different notion of housing can emerge out of this geography, pregnant with the promise of generating an urbanism that admits the full spectrum of social and spatial possibility.
T.C./ *Border Postcards: Chronicles from the Edge*

[…] As we temporarily appropriated the parking lot across from the San Diego Museum of Art in Balboa Park, the systems and materials that would be used as infrastructure to support this house would be choreographed to form a series of environments that would speak of temporality and mobility, not necessarily of salvaged materials. They were conceived less as emblematic elements or symbolic references and more as performatic and operational pieces that would facilitate the moving of construction materials and the house itself after the event. Also, they were useful in convincing city agencies that this was a portable pavilion and not a "structure" in its most conventional definition. To facilitate permit requirements, then, the trucks were an essential component of the narrative for permitting purposes. Everything hinged from them: the ramp/lawn was attached to the trucks and not to the ground, as were the tent and the house. This allowed us to convince the plan checkers at the city that we did not have any "heavy" anchoring systems that would damage the pavement at the site, and the fact that the trucks had wheels in place made it structurally sound while exonerating *infoSite* from being called a "building." Also, the truck beds were strategically selected for their height.

The selection of certain materials and systems for the pavilion such as the red tent, pallet racks, plastic shelves, etc., was made in order to facilitate installation in terms of time (off-the-shelf clip-on systems) and money (pre-fab affordable systems). The main structure in the tent was a "clip-on" system of racks, from which many other ready-made systems would hinge, such as the plastic bags acting as shelves, T.V. racks, etc. The tent was pre-built off-site and installed as a skin on top of the framing systems. This was negotiated as a way to respond to one main requirement from the municipality in order to obtain the construction permit: the structure had to resemble a tent-pavilion and could not be entirely "sealed," in other words it had to be "open to the elements."

On the other hand, other systems and materials such as the traffic cones, the Astroturf lawn, the chain link screens, etc., were selected to engage the urban vernacular found in traffic graphics and industrial-commercial surfaces and to find a new "use" for such systems. The traffic cones became a skin that filtered air and sound, defining a particular atmosphere to the sound room, while maintaining the "porosity" required by the municipality. The Astroturf "lawn" became the ramp of access to *infoSite*. Conceived as a commentary on the obsession with "greenness" of the suburbs […] this lawn for the *infoSite*'s migrant house was not just a static image (as the front lawns of many tract homes in suburban subdivisions tend to be—never used for anything other than as visual commodities), it was used as temporal public space as people "hung out," exchanged information, and played with and in the pavilion, etc.

In essence, then, my intention was not to keep the project in the realm of representation, the symbolic or metaphorical dimension only, but to actually embody the transferring of the house into Tijuana at the end of the event [Cruz's original proposal involved employing an existing house as part of his design]. Here is where I find a series of problematic aspects of the project that could have been resolved better as part of the process of negotiation with other entities in order to economically and politically facilitate the house's transfer into Tijuana. Even though the narrative I submitted to **inSite** clearly described that one of the main intentions of the project dealt with the actual moving of this house across the border, I realize now I did not emphasize enough the need to consider incorporating such possibility into the budget for *infoSite*. I also realize that throughout the process of conceptualizing, drawing, and processing the legal building permits as well as constructing the pavilion, I did not do enough to promote conversation with everyone involved about researching the possible agencies that could have facilitated such process, as well as mapping what kind of economical and political procedures we needed to anticipate to achieve the transfer. By the end of the design and development process, and after months of presenting the project to countless agencies, boards and politicians, both the curators and director of **inSite** and our team were so focused on getting the permits approved in order to initiate construction on time and keeping the tight economic resources in check that the aspect of transferring the house at the end of the event became a low priority. T.C.

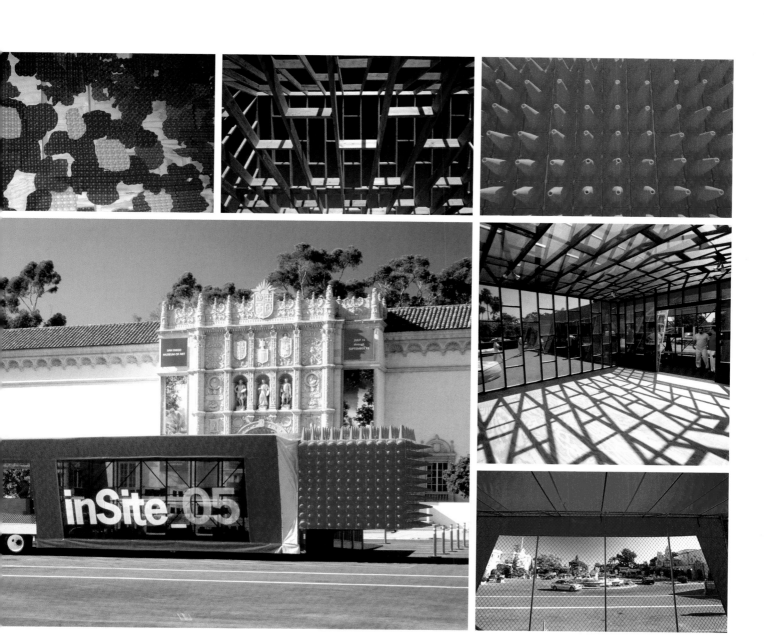

A Tijuana speculator travels to San Diego to buy up little bungalows that have been slated for demolition to make space for new condominium projects. The little houses are loaded onto trailers and prepared to travel to Tijuana, where they will have to clear customs before making their journey south. **For days, one can see houses, just like cars and pedestrians, waiting in line to cross the border. Finally the houses enter into Tijuana and are mounted on one-story metal frames that leave an empty space at the street level to accommodate future uses. One city profits from the material that the other one wastes.** Tijuana recycles the left over buildings of San Diego, recombining them into fresh scenarios, creating countless new opportunities open to the unpredictability of time and programmatic contingency. T.C./ Statement

Torolab
Tijuana infoSite/

Images: Mock-up and digital designs/ Several proposals for the Tijuana *infoSite*> Imágenes: Diseños digitales/ Distintas propuestas para el *infoSite* en Tijuana.

Cancelled Commission. When Torolab was first invited to participate in **inSite_05** and to submit an architectural proposal for the design of the temporary **inSite_05** information center in Tijuana, the group was a collective consisting of architect Raúl Cárdenas and designer Marcela Guadiana. Shortly thereafter, the professional partnership between Cárdenas and Guadiana dissolved. Since it was decided that Cárdenas would keep the artistic trademark of Torolab he continued to manage the project. In March 2004 Torolab prepared an initial proposal for the *infoSite* in Tijuana. Presented as a three-dimensional animation, the proposal was a spectacular visual attraction, with tremendous potential for mass public appeal. The project included an open-air skating rink that would be open in summer, a magnificent voluminous structure six times larger than had originally been considered, and a sophisticated structural technology of curved scaffolding, which at that point was not available in the area (and, at that time, had not been budgeted). All these aspects indicated that the proposal's utopian impulse, as well as Torolab's enthusiasm for their design, would overshadow the basic objective of the commission for **inSite_05**, which was to have an information center open to the public on the day of its inauguration in Tijuana. Working with another group of collaborators, Torolab presented a second proposal, which consisted of the use of multiple stacked containers—connected to each other by exterior ramps—which would house the *infoSite*'s program. The proposal, although reformulated again and again, remained devoid of functionality and of financial viability. Its presentation—still anchored in the utopian inclinations of the initial proposal—dispensed with any technical verification and with the necessary construction plans. From March 2004 until February 2005—a year full of international commitments for Cárdenas—the possibility of obtaining a project that could extend beyond Torolab's initial designs was finally exhausted. Towards the end of May of 2005, with less than three months until **inSite_05**'s inauguration—and lacking an executive proposal to present to the *infoSite*'s constructors—**inSite**'s curatorial team and directors decided to cancel the commission. We have included Torolab's initial proposal here, as we deem this book to be an appropriate place to share the remarkable challenges that Torolab faced generating the Tijuana *infoSite* proposal.

The Tijuana *infoSite* was finally conceived, designed, and delivered as a construction project within the limited space of two months by the R_Tj-SD Workshop, under the direction of architect Gustavo Lipkau.

→ Otras traducciones/ pp. 283–284

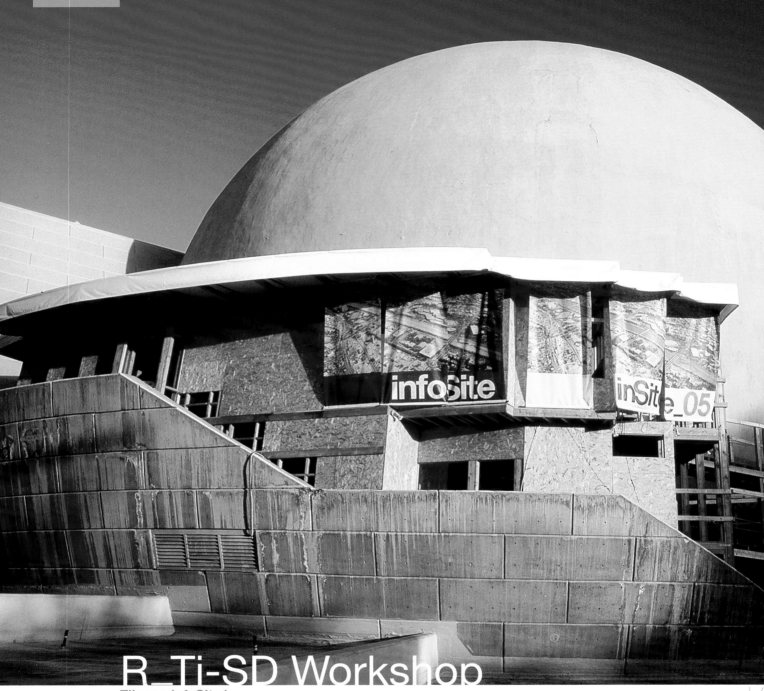

R_Tj-SD Workshop

Tijuana infoSite/

Synopsis. The R_Tj-SD Workshop, consisting of a group of young architects and architecture students from the Universidad Iberoamericana in Tijuana, and led by Mexican architect and urbanist Gustavo Lipkau, was invited by **inSite** to design the Tijuana *infoSite*. This was the second time that the project had been commissioned. The urgency of the architectural assignment necessitated the implementation of a speedy technical and construction timeline. By inserting an extremely light and formally simple parasitical structure over the concrete sphere of the Centro Cultural Tijuana (which houses the Omnimax Cinema), the R_Tj-SD Workshop produced an ephemeral architectural intervention that acted as a skin of wood and glass. The concrete sphere known as "la bola" (the ball) is the symbolic cultural landmark of Tijuana. The temporary building with its fretwork floor and ramps was in use from August 26 to November 13, 2005. The *infoSite* unfolded in a convex manner, following the recess of one of the exterior lateral stairways of the spherical monument.

Mayo 2005/ R_Tj-SD Workshop

Comisión emergente/ A fines de mayo de 2005, ante la emergencia de aún carecer de un proyecto ejecutivo con vistas a comenzar la construcción del *infoSite* en Tijuana, se decidió cancelar la comisión a Torolab. El equipo curatorial de **inSite_05** acordó que fuera un colectivo de creación de Tijuana quien asumiera el reto de aceptar la comisión emergente en un marco de dos meses, por lo que se invitó al taller R_Tj-SD Workshop a realizar la nueva propuesta de arquitectura efímera. En marzo de 2005 Gustavo Lipkau había fundado el taller con alumnos del departamento de arquitectura de la Universidad Iberoamericana de Tijuana. Al momento de esta invitación el equipo se encontraba estudiando el Río Tijuana y su relación con el funcionamiento de la ciudad, con el objetivo de desarrollar y promover proyectos arquitectónicos con base en estudios territoriales en la región de Tijuana San Diego. La comisión del proyecto en la plaza del Centro Cultural Tijuana les dio la oportunidad de llevar a cabo un ejercicio de reflexión en torno a la Zona Río y los espacios públicos de Tijuana.

Translated *Unfolding Process*/ p. 60

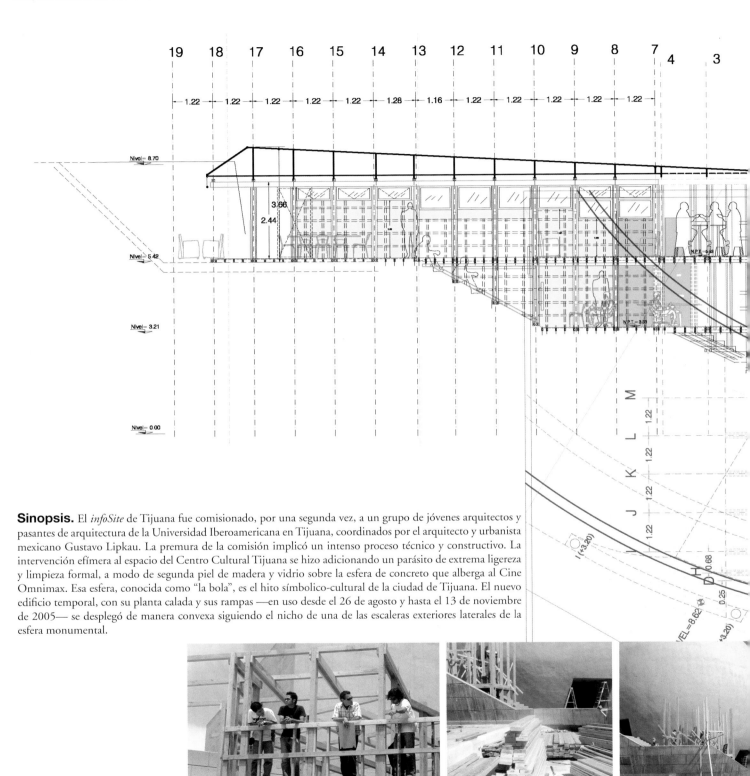

Sinopsis. El *infoSite* de Tijuana fue comisionado, por una segunda vez, a un grupo de jóvenes arquitectos y pasantes de arquitectura de la Universidad Iberoamericana en Tijuana, coordinados por el arquitecto y urbanista mexicano Gustavo Lipkau. La premura de la comisión implicó un intenso proceso técnico y constructivo. La intervención efímera al espacio del Centro Cultural Tijuana se hizo adicionando un parásito de extrema ligereza y limpieza formal, a modo de segunda piel de madera y vidrio sobre la esfera de concreto que alberga al Cine Omnimax. Esa esfera, conocida como "la bola", es el hito símbolico-cultural de la ciudad de Tijuana. El nuevo edificio temporal, con su planta calada y sus rampas —en uso desde el 26 de agosto y hasta el 13 de noviembre de 2005— se desplegó de manera convexa siguiendo el nicho de una de las escaleras exteriores laterales de la esfera monumental.

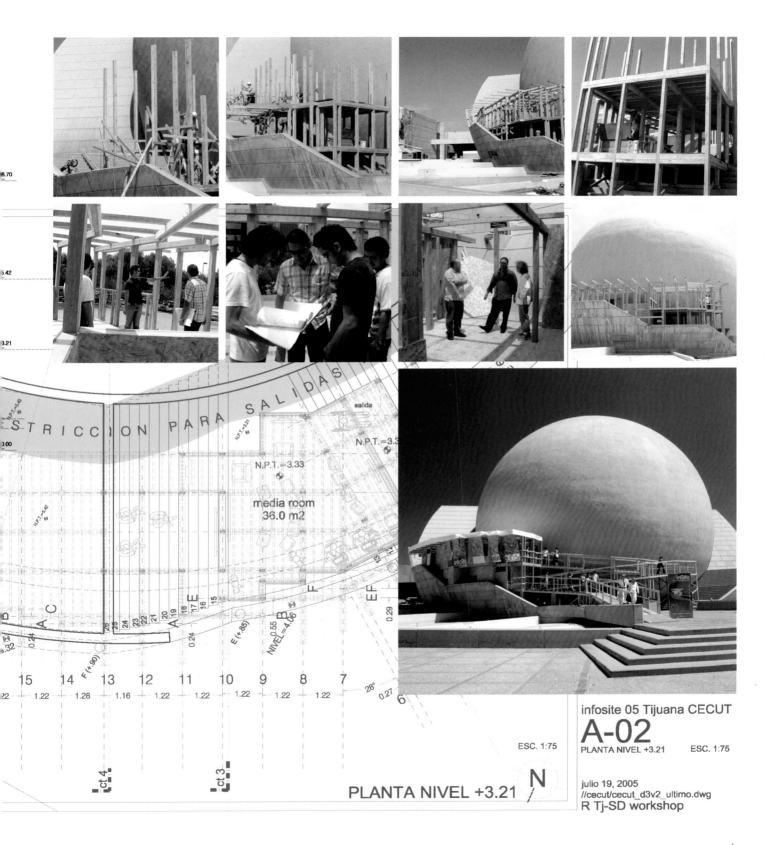

STRICCION PARA SALIDAS

salida

N.P.T.=3.33

N.P.T.=3.33

media room
36.0 m2

PLANTA NIVEL +3.21

N

ESC. 1:75

infosite 05 Tijuana CECUT

A-02

PLANTA NIVEL +3.21 ESC. 1:75

julio 19, 2005
//cecut/cecut_d3v2_ultimo.dwg
R Tj-SD workshop

Our proposal was to work around "la bola" (the ball) of the CECUT's Omnimax Cinema—Tijuana's most emblematic building—by installing the *infoSite* around the sphere. We wanted to transform the interstice formed by "la bola's" emergency exits and use it to generate a series of architectural spaces by extending the stair landings with lightweight platforms, and by making all possible levels accessible by a system of ramps. **The idea was to create a pavilion that would act as both a space and a route, and would take over the entire northwest plaza of CECUT. It would even lead visitors to the top of the sphere so they could enjoy a view of the city. Since the design and construction deadline was tight and the budget was very limited, we had to work in stages.** We therefore began by drawing the ramps in detail and only began to build them after the pavilion was almost finished and in place. The final extension of the ramp to the "north pole" of "la bola" is still just an idea to be carried out on another occasion. All the structures were designed not to affect the cinema building in any way. They stemmed from studying the geometry of the cinema—as the focus of our intervention—and taking into account the site's main construction feature: the impossibility of using any kind of screws or anchorage. G.L.

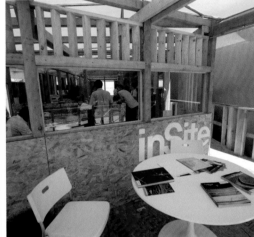

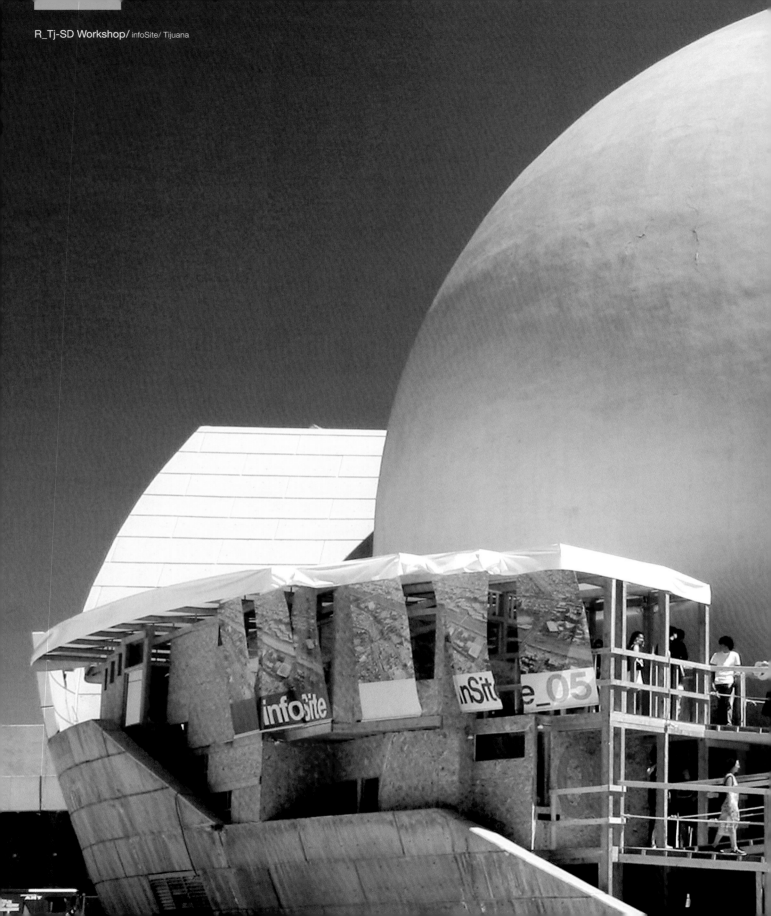

We proposed employing a wooden structure (made of grid modules) based on timber columns and bars linked with girders both at the base or foundation and at the intermediate level and ceiling. The intermediate level was assembled with a frame of beams and three-ply planks to make it function structurally as dividing screens, along with the walls themselves. The cover was a white plastic tarpaulin stretched on a framework of variable sections of steel tubes. The construction method mirrored wooden scaffolding, and made use of the techniques and materials of construction carpentry. This made the structure economical, easy to build, and reusable, so it could later be sold.

A month was spent designing the structure, a month constructing it, three months operating it, and a week dismantling and selling the timber. The sale of the materials meant that we recovered about half the project costs, thus increasing the chances of augmenting the initial construction budget. Another possibility discussed at the time was to dismantle and store the structure, thereby making the *infoSite* a dismountable structure for use perhaps as a "summer pavilion" for CECUT. G.L.

Planteamos intervenir sobre "la bola" misma, como se conoce al Cine Omnimax del CECUT, el edificio más emblemático de Tijuana: instalar el *infoSite* alrededor de la esfera, transformando el intersticio que crean sus salidas de emergencia y generando ahí los espacios requeridos por el programa arquitectónico al extender los descansos de las escalinatas con plataformas ligeras, haciendo accesibles todos los posibles niveles con un

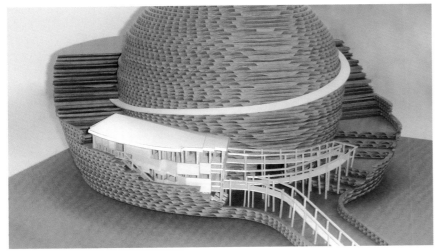

sistema de rampas. La idea era crear un pabellón que fuera a la vez espacio y recorrido, que se apropiara con ello de toda la plaza norponiente del CECUT y que, incluso, pudiera llevar al visitante a la cúspide de la esfera para atestiguar la ciudad. Como el tiempo de diseño y construcción, así como el presupuesto, era muy apretado fue necesario pensar en etapas. Así fue que sólo comenzamos a dibujar a detalle, y luego construir las rampas, cuando el pabellón estaba ya casi terminado y a flote. La extensión final de la rampa hasta el polo norte quedó sólo como idea para una siguiente oportunidad. Todas las estructuras se idearon para que su construcción fuera totalmente inofensiva al edificio del cine, y resultaron del estudio de la geometría de dicho edificio; partiendo del hecho de que éste constituía el terreno de la intervención —un sitio cuya característica constructiva principal es lo inoperable de cualquier taquete o anclaje.

Planteamos una estructura de madera —modulada en retícula— a base de columnas de polines y barrotes ligados con trabes, tanto en su base o desplante, como a nivel de entrepiso y techumbre. El entrepiso se armaría con un enviguetado y planchas de *triplay* para hacerlo funcionar estructuralmente como diafragmas, al igual que los muros. La cubierta sería de lona plástica blanca sobre armaduras de sección variable a base de tubo de

acero. La obra pretendía enfrentarse como un andamiaje de cimbra, con las técnicas y los medios de la carpintería de obra, por lo que resultaría económica y fácil de construir, además de reutilizable, por lo tanto vendible al final.

R_Tj-SD Workshop/
Israel Kobisher
Carlos Augusto Paz
Erick Miguel Pérez
Roxana Quezada A.
Norma Angélica de la Torre
Coordinador/ Gustavo Lipkau

Un mes de diseño, un mes de obra, tres meses de funcionamiento y una semana para desmantelar desensamblando y vender la madera. Con dicha venta se recuperaría alrededor de la mitad del costo del proyecto y se alimentaría la posibilidad de aumentar el presupuesto inicial de la obra. De manera paralela, se planteó la posibilidad de desmantelar y guardar la estructura, convirtiendo al *infoSite* en una estructura desarmable, quizá un "pabellón de verano" para el CECUT. G.L.

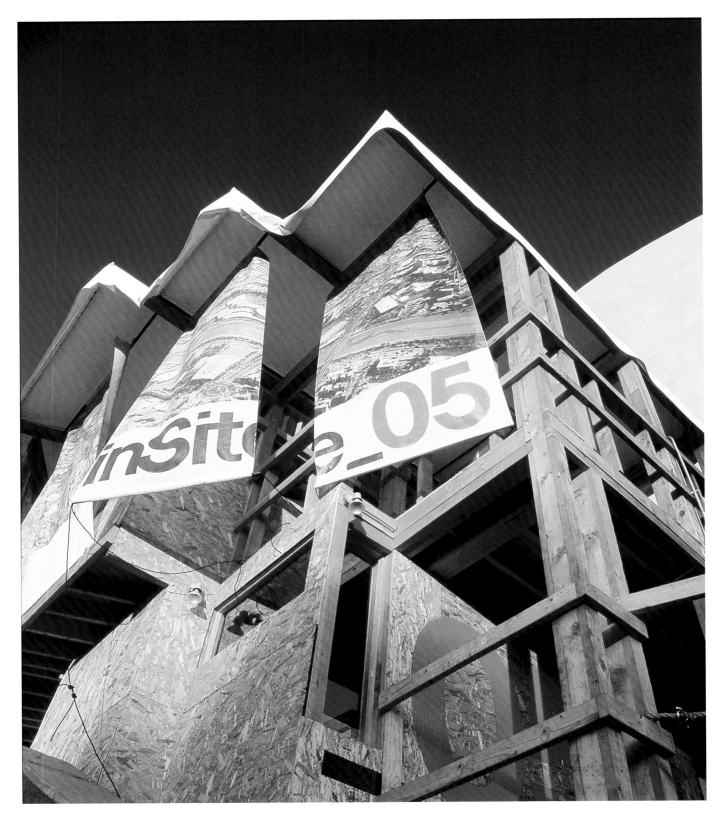

Traducciones
al español/ Versiones originales/ Intervenciones/ Por proyecto

Escenas filmadas

1- Varios ángulos:

Ángulo de 90 grados; vertical, vista hacia abajo, ángulo de 45 grados y horizontal.

2- Velocidad:

Rápida, lenta y completamente detenida en el aire.

3- Acercamiento:

Súper *zoom* casi abstracto, más abierto y panorámico.

4- Helicóptero:

Volviendo a la derecha, volviendo a la izquierda, volviendo 360 grados, yendo hacia arriba; yendo hacia abajo.

A&C./ Correo electrónico/ "Instrucciones de filmación", 22 de junio de 2005

¿Sería posible exhibir nuestro video en aviones que aterrizan en San Diego, hablando con algunas lineas aéreas y preguntando si les gustaría proyectarlo en sus monitores...? El video es de 3 minutos y 22 segundos de duración. ¿Qué piensan?

A&C./ Correo electrónico/ "¡IDEA!!", 23 de julio de 2005

Hace poco, en Gante, tuvimos la oportunidad de ver la obra del artista pionero conceptual Douglas Huebler titulada *Variable Piece = 11 Rowley Massachusetts*, 1971, que reflejaba algunas de nuestras intenciones y procedimientos en la elaboración de *Signos mirando el cielo*. Para esta obra, Huebler reclutó a un grupo de estudiantes, a cambio de una donación de 10 dólares para la escuela secundaria local, para que le pidieran a los residentes de Rowley que describieran la vida de su pueblo. Mucha gente se mostró renuente a participar en este experimento, y los silencios dijeron tanto del pueblo, su apertura y actitud hacia la expresión pública, como las pocas descripciones que finalmente se recabaron y documentaron. Tal vez la oportunidad que tuvimos de ver esta obra sea el resultado de nuestra posición privilegiada de poder viajar libremente a muchos países del mundo, sobre todo gracias a la invitación de instituciones artísticas, pero este estatus lo aceptamos con toda la responsabilidad que acarrea semejante libertad.

En esta instancia tuvimos la oportunidad de confrontar una obra histórica de arte conceptual, y derivar de ahi las afinidades con nuestra propia práctica artística y las divergencias a casi 25 años de distancia. Lo más claro para nosotros al ver esta obra fue la intrincada relación entre proceso y concepto, ejemplificada de manera muy lúcida, así como el registro de un ejemplo temprano de la llamada aproximación etnográfica o documental al arte, opuesta al arte público de la década de 1990. La obra de Huebler propició cierto número de preguntas sobre el papel del artista en relación con los temas que aborda, los sistemas de representación utilizados en su modo de aproximación, así como las posibilidades críticas y los límites de ciertas formas de compromiso artístico.

Estas cuestiones fueron relevantes en el desarrollo de nuestro proyecto para **inSite**. *Signos mirando el cielo* fue concebido, primero que nada y sobre todo, como una respuesta a la ubicación única, la historia y el público de la ciudad de San Diego. En términos de procedimiento artístico, recurrimos a estrategias tanto conceptuales como basadas en un proceso. Consideramos bajo qué condiciones podría formularse una representación de la ciudad, en el entendido, implícito desde el comienzo, de que esto sólo redundaría en una mirada parcial, fragmentada e inconclusa. Consideramos qué método funcionaría mejor para producir ese recuento, el cual, para nosotros en esta instancia, era el sondeo —y para este fin, durante los dos años que duró nuestra relación con **inSite**, nos entrevistamos informalmente con centenares de habitantes de San Diego.

La motivación para *Signos mirando el cielo* fue crear una representación de la ciudad que funcionara en una forma dialéctica contra las representaciones normalizadoras de la ciudad tal y como éstas se proyectan a través de la publicidad, los esquemas de embellecimiento urbano y la imaginería turística. *Signos mirando el cielo* ofrecía en cambio una disyuntiva peligrosa, a veces honesta, a veces el reflejo ingenuo de la identidad de los habitantes de la ciudad y sus ideas acerca de la misma. En vez de la típica proyección de la ciudad que ofrece la Oficina para los Visitantes de San Diego: sol eterno, relajación, escenarios idílicos y "vecindarios en evolución", los espectadores potenciales de *Signos mirando el cielo* eran cuestionados por expresiones como: "Mi Dios les enseñará", "Nada... es historia", "Trato de asimilar" o "No un asesino, un héroe".

Al mezclar lo verbal con lo visual, lo arquitectónico y la fábrica urbana de la ciudad, *Signos mirando el cielo* trató de conectarse con su locación geográfica a través del montaje de las voces descorporizadas de sus habitantes, introduciendo en este paisaje urbano una nueva capa textual y un léxico de frases. Quisimos colocar las expresiones coleccionadas en los techos de los edificios —un lugar que seguramente se convertiría en el próximo terreno de debate sobre el desarrollo. Con la mirada de los medios cada vez más dirigida desde una perspectiva satelital, estos vastos planos horizontales y vacíos desaprovechados en un sentido urbano tendrán sin duda una importancia cada vez mayor. El objetivo de *Signos mirando el cielo* era llamar la atención sobre lo que normalmente se omite o se suprime en la práctica lingüística oficial de la ciudad y, en un plano ideal, montar una confrontación crítica entre el lenguaje dominante registrado en el paisaje de la ciudad y lo que se considera su remanente excesivo (las denominadas "voces" de la población). La obra negoció el terreno entre lo que podría constituir una esfera social democrática, en donde

Introducción a Intervenciones

Intervenciones ha sido por más de diez años el nódulo de **inSite**, al comisionar prácticas artísticas relacionadas con *lo público, lo urbano y lo fronterizo*. Las sucesivas ediciones de **inSite**, documentan el devenir histórico de las prácticas de intervención, desde la escultura a escala urbana hasta la instalación en sitio específico, desde *performances* hasta procesos y situaciones sin resultado objetual.

Para **inSite_05** las **Intervenciones** fueron comisionadas a un total de 22 artistas, en el interés por retar las dinámicas de asociación pública, sus prácticas de intercambio y, en consecuencia, inducir nuevos imaginarios políticos en el marco de la cotidianidad. Los proyectos deberían articularse desde una base procesual, de colaboración a mediano plazo, sin aspirar a consagrarse desde el objeto estético o desde ningún otro modelo de representación perdurable.

Las **Intervenciones** de **inSite_05** se desarrollaron a lo largo de casi dos años, desde su etapa de investigación hasta su producción final. Los proyectos tuvieron una fase pública, abierta a otras audiencias, entre el 26 de agosto y el 13 de noviembre de 2005.

Osvaldo Sánchez

Práctica significa tratar, desarrollar, cultivar, mejorar. Una connotación de *práctica* es repetición: practicar, perfeccionar. La práctica se convierte en los rituales de la vida, actos continuos que implican un hacer. Y sostener una práctica —no sólo sobrevivir en el negocio del arte, sino vivir en el espacio del arte— significa saber que el proceso es más valioso que el producto; que el hacer... e incluso el llegar al hacer... excede a la cosa hecha, que la experiencia pesa más que la forma material.

Hacer arte es sobre todo un proceso de búsqueda. Requiere habilidad y conocimiento, que pone a prueba la intuición de cada quien y el saber que la intuición es mucho más que una corazonada, una casualidad o una suerte, que es la emergencia de un conocimiento interno que quizá no sabíamos que teníamos. Emprender y llevar a cabo un proceso sin un resultado declarado es permitir que ese proceso de búsqueda se realice; tener la certeza de que la forma correcta aparecerá; esperar, perseverar a través de un espacio abierto y en blanco, buscar las guías, escuchando con un nivel de percepción que nos permite movernos en modos que no habríamos encontrado fuera de este proceso.

Mary Jane Jacob/ *In the Space of Art*

Allora & Calzadilla

Hemos anexado un documento de Word con una selección de edificios y de textos. Hemos pasado un tiempo considerable revisando los textos que reunimos y hemos tratado de seleccionar los que, para nosotros, eran los más abiertos a significados e interpretaciones múltiples, que se relacionaban en cierto sentido con el edificio pero no necesariamente ilustraban su programa. Esperamos que ustedes los encuentren tan interesantes como nosotros.

A&C./ Correo electrónico/ "Proyecto", 25 de febrero de 2005

voces encontradas reclaman para sí el espacio público, y las actuales condiciones productivas del espacio en un centro urbano del capitalismo tardío en el que los intereses comerciales orientan la mayoría de los esquemas de desarrollo y, en consecuencia, tiende a imponerse el tipo de lenguaje que se encuentra en las calles y edificios de la ciudad; es decir: la publicidad, los anuncios espectaculares, los letreros comerciales, etcétera.

Los enunciados en sí mismos eran ruinas escritas, fragmentos de enunciados más largos que encierran universos de posiciones de identidad construida tanto subjetivas como sometidas desde un punto de vista social. El propósito no era infiltrar una demanda moral en los textos incluidos en *Signos mirando el cielo*, como si esas expresiones fuesen más auténticas, reales o moralmente correctas que aquellas que se encuentran en los anuncios espectaculares de las calles, sino más bien presentar esos fragmentos como intersecciones entre flujos múltiples y en su mayoría conflictivos que producen y reproducen identidad, así como mantener estas fuerzas en tensión.

Con respecto a la noción de *viaje*, en la medida en que ésta corresponde a aquellos que llegan a una ciudad de cualquier parte así como a aquellos que habitan de manera permanente o transitoria en un lugar, *Signos mirando el cielo* se ocupaba de las distancias cubiertas en forma tanto mental como geográfica. Cada texto o frase se volvió un punto de intersección donde las identificaciones podían converger o divergir. Uno podía entrar en el espacio imaginario de una frase particular, seguir la cadena de asociaciones que ésta podía disparar, imaginar quién podría haber hecho esa afirmación, compararla con un texto aledaño, conjeturar las intenciones de tal provocación, sentirse repelido por ella y mirar a otro lado, o investigar el todo cacofónico, entre los muchos otros modos de entrar y salir que ofrece una obra basada en textos como ésta.

Finalmente, el uso del video como medio para realizar este proyecto nos ofreció una herramienta para situar estas expresiones dentro de un continuo espacio-tiempo limitado. La obra existe como un video, fechado 2005. Es un sobrevuelo por el área del centro de la ciudad, vista desde el "ojo de un pájaro", con una duración de apenas tres minutos. Un prerrequisito de la imagen en movimiento es su naturaleza temporal y transitoria. Esta condición promedio nos proporcionó un marco más transparente para realizar este proyecto, ya que el flujo diario de la población de la ciudad es tan dinámico como los marcos múltiples y cambiantes que constituyen la imagen del video. Si hubiésemos sido más sabios en un sentido técnico, este trabajo podría haberse convertido en un video digital potencialmente infinito, con nuevos textos que aparecerían después de cada corte sobre la infraestructura urbana semifija (ya que la gente que ocupa cualquier punto de la ciudad en un momento dado está en constante flujo, en el mismo sentido en que sus pensamientos y posiciones individuales están expuestos a un cambio y una emergencia en constante movimiento). Sin embargo, como la tumba fija de un momento particular en el tiempo (la historia de las imágenes grabadas así lo demuestra), el video está ahí como un fragmento inconcluso que repasa las contradicciones, traducciones, asimilaciones y apropiaciones de ideas y valores de la vida y supervivencia de individuos particulares que habitaron el enredado paisaje urbano de San Diego entre 2003 y 2005.

A&C.

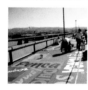

Barbosa & Ricalde

Esta propuesta tiene como base la idea de la acogida al otro. Sea quien sea ese otro. Sin exigir un apellido, se propone inscribir su nombre —aquel que le gusta tener, aquel por el cual le gusta ser llamado— en aquella tierra que lo acoge.

B&R./ Propuesta

HOSPITALIDAD
Marisa Flórido Cesar

Hostilidad, término curioso. *Hostis*, en latín, significa hostil, enemigo, pero también es el huésped, como observa Jacques Derrida[1]. Esa ambivalencia etimológica nos lleva a pensar de qué forma trazamos nuestras fronteras con el otro, inmediato y extraño, que amenaza nuestra casa, nuestra cultura, nuestro territorio, nuestro lugar. El huésped puede testimoniar lo indomesticable que habita la casa, los silencios y secretos de la intimidad. Lo hostil puede corromper la costumbre, alterar el orden familiar de las cosas. El otro puede cuestionar las identidades, demoler los lugares. La proximidad se torna difícil, a veces casi intolerable.

Alteridad. Pero ¿cómo no tocar la alteridad, no dejarla respirar en nuestra vecindad, no abrirnos a la diferencia a partir de la cual cada uno se reinventa como singularidades? Es nuestra ineluctable condición: el yo es siempre otros a través de otros y con otros.

Hospitalidad. Las leyes de la hospitalidad tradicional suponen la aceptación del otro en un territorio, siempre condicionada a reglas y pactos: le demanda un nombre de familia, le atribuye una identidad y un estatus social de extranjero que lo constituyen como sujeto de derecho. Transformando el don en reservas en contrato, reduce la amenaza de su diferencia: ¡que él se acomode a las costumbres y a la lengua del lugar! La hospitalidad condicional conlleva una violencia: asemeja al otro y suprime su singularidad.

El lugar. ¿A quién pertenece el lugar, el territorio, la nación? Parece ser la cuestión fundamental, cuestión de raíces y de orígenes, cuestión del hombre. Pero, ¿por qué entenderla como un suelo fundador y nativo, ontológico o étnico, del cual deriva el sujeto, de donde un yo se enuncia y se reconoce como idéntico a sí mismo? ¿Cómo pensarla sino desde este vórtice de donde los conceptos de frontera, de ciudadanía, de nación, de identidad son hoy sacudidos? ¿Cómo entenderla sino desde un puente fronterizo, desde un lugar que no es lugar, desde un pasaje que niega anclaje?

El puente. Interrogación sin respuesta, el puente es una entrada, un pasaje rumbo al otro, una apertura a su alteridad infinita. Es necesario abordar su misterio para instaurar una "hospitalidad incondicional", esa experiencia enigmática del acogimiento del otro como la definió Derrida.

El gesto. Pues el lugar "no pertenece ni a aquél que hospeda, ni al invitado, y sí al gesto por el cual uno ofrece acogida al otro"[2]. La hospitalidad absoluta o incondicional, propuesta por el filósofo, rompe con la hospitalidad en el sentido usual, con el derecho o el pacto de hospitalidad: "la hospitalidad absoluta exige que yo abra mi casa y no apenas la ofrezca al extranjero (provisto de un nombre de familia, etcétera), sino al otro absoluto, desconocido, anónimo, que yo le ceda lugar, que yo lo deje llegar, y tener un lugar en el lugar que le ofrezco, sin exigir de él ni reciprocidad (la entrada en un pacto), ni siquiera su nombre"[3].

El nombre. "¿Cómo te llamas?" Felipe y Rosana le preguntan a aquél que llega su nombre de pila, para escribirlo en ese lugar sin lugar que constituye el puente en la frontera tensa entre Estados Unidos y México. No le exigen un nombre de familia, un documento, un contexto originario: es sobre la delicada operación de la hospitalidad que su gesto nos invita a reflexionar. Pues es el gesto como lugar, como sin-lugar, como acogida: un llamado a repensar las relaciones con ese otro con el cual compartimos este mundo. Es la apertura solidaria a él, la incondicionalidad anterior a cualquier contrato, lo que tal vez pueda conducir a la necesaria puesta en práctica de la hospitalidad. Un puente extendido entre sus dos instancias, la absoluta y la condicionada, para que la hospitalidad no sea violada y olvidada en su principio. Un arte y una poética, una política y una ética transitan por ese puente.

Marisa Flórido Cesar es curadora independiente. Vive y trabaja en Río de Janeiro.

[1] DUFOURMANTELLE, Anne y DERRIDA, Jacques. *Anne Dufourmantelle convida Jacques Derrida a falar Da Hospitalidade.* São Paulo, Ed. Escuta, 2003.
[2] DUFOURMANTELLE, Anne. Op.cit. p.40
[3] DERRIDA, Jacques. Op.cit. p.25

Mark Bradford

Estaba explorando los sitios de maleteros en la frontera y todo tiene que ver con la tradición oral. Pasa de una persona a otra, y por lo tanto empecé a usar las redes que ya existían, de modo que la gente pudiera entender el proyecto y así éste pudiera traducirse de una persona a otra.

M.B./ Charlas de garaje I

No es mi intención importar un modo de trabajo para facilitar el proyecto, sino extender mi trabajo con la gente del área. Me parece lo necesario en relación a la economía que ya funciona en esta zona, y a los mecanismos de compromiso diario que proveen de confianza y de comunicación. Hablamos de una zona donde la política, la vigilancia y el escrutinio policial gobiernan la vida de los ciudadanos.

M.B./ Propuesta

Al rol de los carritos se le asignará una condición ambigua —invisibles/visibles en el flujo de la región de la frontera, al mismo tiempo que se impregnan de ideas de consumismo, nomadismo y circulación— para ilustrar la noción de que, en teoría, la región fronteriza es un lugar donde los intercambios sociales pueden ocurrir, incluso en las formas más predecibles.

M.B./ Propuesta

En la región ha crecido por necesidad un pequeño grupo de gente que se gana la vida cargando objetos pesados en carritos de supermercado para personas que compraron mercancía en el norte o que regresan de vacaciones.

Esperan su turno para atender a los clientes, a los que les cobran de 1 a 3 dólares por su servicio. Otro grupo de cargadores trabaja en la parte norte de la frontera. Los maleteros representan uno de esos negocios informales de la frontera que brotan por necesidad, como la gente que vende café y refrigerios a los que esperan cruzar en coche a los Estados Unidos. Continuamente los

molestan las patrullas fronterizas tanto de México como de Estados Unidos, por lo que se ven obligados a esperar detrás del corredor para peatones; esto provoca que bajen sus precios, ya que no pueden llevar la carga más allá. Los cargadores trabajan por lo general los siete días de la semana, las más de las veces de 7:00 am a 8:00 pm. Cuando les va bien, pueden reunir alrededor de 20 dólares en un día.

M.B./ Propuesta

AL OTRO LADO DEL CAMINO
Kellie Jones

Con carritos de supermercado, flamantes chalecos y gorras, los maleteros de la frontera San Ysidro-Tijuana que cruzan el puesto de revisión emprendieron el camino de ida y vuelta a lo largo de varios metros de cada lado de la línea. Su presencia demostró, en microcosmos, la simbiosis contenciosa, destructiva, física y económica que constituye la frontera Estados Unidos-México y las relaciones políticas internacionales que ellos simbolizan. Al llamar la atención sobre esta supuesta economía subterránea que descansa a lo largo de la frontera, el proyecto *Maleteros* de Mark Bradford para **inSite_05** nos puso literalmente en el corazón de estos temas. Al crear una identidad específica para este sector informal, Bradford reconoció sus contribuciones a los flujos económicos, sacando su trabajo de las sombras. Hacia la primavera de 2006, manifestaciones a lo largo de los Estados Unidos señalaron la necesidad, a una gran escala nacional, de reconocer esta relación imbricada y sin embargo ignorada, y la obligación vital de visualizar a los trabajadores invisibles que conforman el cimiento de la economía de los Estados Unidos y del "sueño ameri-cano". Un sueño que no sólo debe ser visto como la consecuencia de la ganancia hipercapitalista, sino que abarca seguridad, apoyo, educación, casa y una vida feliz que todos en las Américas y en el mundo pueden considerar como una aspiración propia. Como los maleteros que salieron de las sombras relativas a la luz con sus flamantes chalecos, gorras y carritos, los trabajadores que cerraron sus talleres el primero de mayo salieron de cada esquina de cada industria para unirse a los contingentes de manifestantes. Cientos de miles de hombres, para que América los viera y los reconociera y no sólo le diera la espalda a la labor que conduce a los Estados Unidos.

El proyecto de Bradford demostró la capacidad del arte para revelar e intervenir en estas reali-dades. Echó luz en la naturaleza cambiante de nociones de especificidad de lugar y arte público. También dejó en claro que la propia producción del artista es elástica y flexible, con una capaci-dad y un deseo de interactuar con la vida y la sociedad. Bradford es ante todo un pintor de obras abstractas y cartográficas para quien la geografía, y en especial la geografía del sur de California, está presente y activa. El salto de las dos a las tres dimensiones y de lo metafórico a la interven-ción real en el mundo, parece no sólo lógico sino también deseable como un modo de inspirar e informar la obra, y hacerla relevante en una variedad de niveles.

Kellie Jones *es curadora y escritora. Actualmente es profesora asociada de Historia del Arte y Arqueología en Columbia University. Vive en Nueva York. Jones fue interlocutor para las* **Intervencio-nes** *de* **inSite_05**.

Siento que la "memoria de los 100 días oficiales" funcionará en el área y les dará la posibilidad de continuar en estas áreas cuasi legales. Creo que una vez que algo se cambia, ese algo ha cambiado. No estoy seguro de lo que vendrá, pero nunca será lo mismo.

M.B.

Bulbo

Siete personas provenientes de contextos muy distintos (un abogado, una cocinera, una diseñadora, un actor, un rockero, una bailarina y una chica *dark*) conviven y colaboran durante más de dos meses en un taller que tiene como objetivo reflexionar acerca de la ropa, los procesos de manufactura, el diseño y lo que se comunica a través de la indumentaria.

Bulbo/ Bitácora del proyecto

La creatividad es un acto de valentía [...] Aquél que se atreve a crear, a trasponer límites, no sólo participa de un milagro, sino que llega además a descubrir que en su proceso de ser, él es el milagro.

Joseph Zinker/ *Creative Process in Gestalt Therapy*

La ropa es una bandera.

Bulbo

Sesiones. Las sesiones de taller tuvieron lugar durante nueve fines de semana consecutivos entre julio y septiembre de 2005. Cada sesión tuvo un objetivo preciso; desde introducir a cada individuo al grupo y negociar una dinámica de colaboración, hasta definir la investigación de campo, los ejercicios técnicos y el proceso de reflexión crítica en torno al vestuario en la región. Los talleres no sólo constituyeron el nodo de la experiencia de colaboración, también produjeron los artículos que se ofertaron en *La tienda de ropa*. Cada sesión de taller fue documentada en detalle y trasmitida en vivo por *webcam*.

Para más información y detalles de las bitácoras del proceso visitar/ **www.latiendaderopa.org**
Bulbo/ Bitácora del proyecto

La primera vez que se mostraron al público las prendas y el material de documentación sobre *La tienda de ropa* fue en Pomegranate, una exclusiva *boutique* ubicada en La Jolla, California. Allí se aprovechó la inercia de consumo de las personas que regularmente visitan este lugar para regalar-les una sorpresa desde el otro lado del muro fronterizo, una rica historia detrás de cada prenda.

Debido a que era la inauguración oficial del proyecto de Bulbo, asistió mucha gente que pertenece al circuito del mundo del arte, por lo cual a veces daba la impresión de estar invadiendo una tienda con una fiesta en vez de intervenirla.

Esta situación cambió en los días posteriores, donde las prendas estaban en reposo absoluto para ser observadas minuciosamente por la gente de La Jolla.

Bulbo/ Bitácora del proyecto

Durante dos fines de semana *La tienda de ropa* se instaló en el Swap Meet Fundadores como un puesto más de los que abarrotan ese lugar. Aquí, el pulpo de serigrafía era un integrante más de *La tienda...*

Los visitantes podían adquirir una camiseta y decidir en dónde querían imprimir los diseños que previamente se habían hecho en el taller. La gama de colores y opciones de diseño era muy amplia; también podían traer ropa propia y decidir en dónde querían imprimir los diseños. Se vendían también las bolsas, los pantalones y las camisas resultado de los talleres. Los clientes podían también modificar sus prendas pues estaba Koty, la costurera.

Bulbo/ Bitácora del proyecto

Plaza Mundo Divertido es un centro comercial que atrae principalmente a jóvenes y adolescentes que van a ver una película, jugar boliche o videojuegos. Durante los fines de semana asisten familias a los restaurantes y a las tiendas.

La tienda de ropa estuvo en Plaza Mundo Divertido del 22 de octubre al 13 de noviembre de 2005. El horario de trabajo fue los miércoles, viernes, sábados y domingos de 12:00 a 8:00 pm; es decir, los días que había un mayor flujo de asistentes.

En un principio, los asistentes a *La tienda de ropa* en Plaza Mundo Divertido mostraban desconfianza y su atención giraba en torno a los precios de las prendas. Pero cuando descubrían que el primer estam-pado de serigrafía era gratis había un asombro en sus rostros. Muchos tenían que corroborarlo con sus compañeros, hasta que había un valiente que se quitaba una prenda y escogía un gráfico, y los demás lo seguían. Esta acción daba pie a un diálogo con la gente sobre la naturaleza del proyecto.

Bulbo/ Bitácora del proyecto

Teddy Cruz

El *infoSite* de Teddy Cruz muestra de manera compacta sus ideas arqui-tectónicas, al preguntarnos por el significado del material de un edificio y al pedirnos que pensemos en ello como información. Su interés por las estrate-gias para vivir en ambos lados de la frontera, cómo esto se manifiesta bajo la forma de intervenciones físicas y arquitectónicas en el espacio, y traduccio-nes de esto mismo a través de las fronteras, resulta estimulante. Pero ¿estas nociones nómadas de la experiencia vivida se traducen positivamente, o se convierten en parte del mer-cado global, una artimaña más que reemplaza la posibilidad estética de cambio con una tendencia?

Kellie Jones

MARCO CONCEPTUAL

Seguimos averiguando la forma en que nuestra propuesta para el *infoSite* podría dirigirse sig-nificativamente al urbanismo de San Diego y llamar la atención de una variedad de públicos

tanto a nivel local como regional.

• **infoSite:** Todos los elementos programáticos requeridos por **inSite**, necesarios para que el *infoSite* funcione como una plataforma informal.

• **Transit(e)ar:** El *infoSite* es un proceso para explorar formas de movilidad transfronteriza, reciclar energías, así como el desplazamiento y la transferencia de recursos e infraestructura de una ciudad a otra.

• **Para-site:** El *infoSite* es una herramienta que atiende la creciente privatización del espacio público de San Diego que se concentra en el centro de la ciudad, como evento que trae consigo programas públicos y sociales en beneficio de la ciudad.

• **Outside / inSite:** Seguimos averiguando la clase de usos periféricos (a la programación interna del *infoSite*) que podría propiciar nuestra propuesta para atraer una variedad de públicos no sólo dentro del centro de la ciudad propiamente dicho, sino de las comunidades adyacentes. Creemos que el *infoSite* puede ser de ayuda a la comunidad, así como una plataforma cultural que pueda compensar la falta de alternativas artísticas independientes e infraestructura en la ciudad.

T.C./ Propuesta

Es claro que con mucha facilidad uno aventura la romantización de estos ambientes, y en una suerte de mirada etnográfica avala sus frágiles condiciones. No podemos olvidar que éstas son el producto de la resistencia y la transgresión. En un tiempo en el que la arquitectura ha estado tan alejada del terreno político y la estructura social que la informa, la observación crítica de estos asentamientos y la enunciación de posibles tácticas de intervención para ayudar a su evolución orgánica, constituyen un riesgo digno de emprenderse.

Así pues, el uso de la zona de la frontera como laboratorio ha inspirado la observación de las condiciones de prosperidad de los vecindarios existentes, en especial el potencial latente de los elementos subutilizados de la infraestructura urbana. Muchas lecciones se pueden aprender de las grandes metrópolis transnacionales que van de San Diego a Tijuana, ya que éstas comprenden olas recurrentes de inmigrantes de todo el mundo. Una noción diferente de alojamiento puede emerger de esta geografía, preñada con la promesa de generar un urbanismo que admita todo el espectro de la posibilidad social y espacial.

T.C./ *Border Postcards: Chronicles from the Edge*

A medida que nos apropiábamos temporalmente del estacionamiento que se encuentra frente al San Diego Museum of Art, en Balboa Park, los sistemas y los materiales que servirían como infraestructura para sostener esta casa serían coreografiados. El objetivo sería formar una serie de ambientes que hablarían de una temporalidad y una movilidad, no necesariamente de materiales recuperados. Aquéllos fueron concebidos menos como elementos emblemáticos o referencias simbólicas, y más como piezas performáticas y operacionales que facilitarían la transportación de los materiales de construcción y de la casa misma después del evento. También sirvieron para convencer a las agencias de la ciudad de que esto era un pabellón transportable y no una "estructura" en su sentido más convencional. Para no contravenir los requisitos del permiso, los camiones fueron un componente esencial en la historia de estos trámites. Todo se movió a partir de ellos: la rampa/césped se fijó a los camiones y no al suelo, al igual que la tienda y la casa. Esto nos permitió convencer a los supervisores del proyecto, comisionados por la ciudad, de que no teníamos ninguna suerte de sistema de cimentación "pesada" que dañara el pavimento del lugar, y el hecho de que los camiones tuvieran ruedas hacía esto estructuralmente coherente, al tiempo que exentaba al *infoSite* de que se le tildara de "edificio". Asimismo, las camas del camión fueron seleccionadas estratégicamente por su altura.

Ciertos materiales y sistemas para el pabellón —como la tienda roja, los libreros de metal desarmables, las estanterías de plástico, etcétera— fueron seleccionados con el objetivo de facilitar la instalación en términos de tiempo (sistemas de ensamblaje por medio de argollas metálicas desmontables) y dinero (sistemas prefabricados). La estructura principal de la tienda era un sistema de costillares metálicos con argollas adheribles, del cual dependerían muchos de los demás sistemas de ensamblaje prefabricado —como las bolsas de plástico que hacían las veces de repisas. La tienda se construyó fuera del lugar y se instaló como una piel superpuesta a los sistemas estructurales. Esto se hizo así como una respuesta al principal requerimiento de la municipalidad, a fin de obtener el permiso para la construcción: la estructura tenía que parecer la tienda de un pabellón y no podía estar del todo "sellada"; en otras palabras, tenía que estar "abierta a los elementos".

Por otro lado, otros sistemas y materiales —como los conos para el tráfico, el césped de Astroturf, la cadena que ligaba las pantallas, etcétera— fueron escogidos para concordar con el decorado urbano que se encuentra en las gráficas de tránsito y las superficies industrial-comerciales, y para darle un nuevo "uso" a estos sistemas. Los conos para el tránsito se convirtieron en una piel que filtraba el aire y el sonido, logrando así una suerte de atmósfera connatural a un estudio de sonido, al tiempo que mantenía la "porosidad" requerida por la municipalidad. El "césped" Astroturf se convirtió en la rampa de acceso al *infoSite*. Concebido como un comentario sobre la obsesión por lo "verde" típica de los suburbios... este césped pensado para la casa del migrante del *infoSite* no era sólo una imagen estática (los jardines delanteros de la mayoría de las casas prefabricadas de los

lotes suburbanos tienden a usarse sólo como lujos visuales); fue utilizado como espacio temporal público, ya que la gente "pasó el rato", intercambió información y jugó en el pabellón y con éste.

En resumen, mi intención no era mantener el proyecto en el reino de la representación, la dimensión simbólica o metafórica, sino conseguir la transferencia de la casa a Tijuana al final del evento. [Cruz en su propuesta inicial propuso adicionar una casa en desuso a la estructura de su diseño]. Aquí es donde encontré una serie de aspectos problemáticos del proyecto que pudieron haberse resuelto de una mejor manera como parte del proceso de negociación con otras entidades, para facilitar en lo económico y lo político el traspaso de la casa a Tijuana. Aunque el resumen que envié a **inSite** decía claramente que una de las principales intenciones del proyecto tenía que ver con el desplazamiento de la casa a través de la frontera, me di cuenta hasta entonces de que no había puesto suficiente énfasis en la necesidad de incorporar esa posibilidad en el presupuesto para el *infoSite*. También me di cuenta de que a lo largo de todo el proceso —consistente en conceptualizar, ubicar y procesar los permisos legales tanto para el edificio como para la construcción del pabellón— no hice lo suficiente para promover la discusión con todos los involucrados sobre el recuento de las posibles agencias que pudieran facilitar ese proceso, así como la detección de qué tipo de procedimientos económicos y políticos necesitábamos para anticipar la consumación de la transferencia. Al final de los procesos de diseño y desarrollo, y después de meses de presentar el proyecto a incontables agencias, juntas y políticos, tanto los curadores como el director de **inSite** y nuestro equipo estábamos tan concentrados en conseguir la aprobación de los permisos para iniciar la construcción a tiempo y no mermar nuestro limitado presupuesto, que el asunto del traslado de la casa al final del evento se volvió una necesidad secundaria.

T.C.

Un especulador tijuanense se dirige a San Diego con el fin de adquirir pequeñas casas rústicas cuya demolición estaba programada para dedicar el espacio que éstas ocupaban a proyectos futuros de construcción de condominios. Tales viviendas se colocan en remolques y se preparan para ser transportadas a Tijuana, en donde deberán pasar la aduana antes de continuar su viaje hacia el sur. Durante días, puede observarse una hilera de casas, como si se tratara de automóviles o peatones haciendo fila para cruzar la frontera. Por fin, las viviendas ingresan a Tijuana; se les coloca en estructuras de metal de un sólo piso, dejando así espacios libres en el nivel de la calle para permitir su empleo futuro. Una de las ciudades aprovecha el material que la otra desecha; así Tijuana recicla las edificaciones que San Diego no utiliza y las transforma en escenarios frescos, creando múltiples y novedosas oportunidades, abiertas a los caprichos del tiempo y a la contingencia programática.

T.C./ Propuesta

Christopher Ferreria

Cuando una familia alberga al Santo Niño, u otra figurita, ofrece plegarias para que éstas sean escuchadas y satisfechas. Es un acto de fe comunitaria sobre un poder que escucha a través de una figurita. Las plegarias, en tanto acontecimientos comunitarios, vuelven aparentes las conexiones entre individuos, familias y comunidades que trascienden distancias. Las plegarias se vuelven ocasiones no sólo para reafirmar la propia fe, sino también las relaciones de uno con los otros y con algo más grande que el yo.

El proceso del proyecto evocó las formas en que las plegarias al Santo Niño revelan relaciones y espacios que ya existen y crean otros que esperan emerger. El *Monstruo* se convirtió en una suerte de sitio de peregrinaje. Se movió y se pasó de mano en mano para ser resguardado y atendido por gente de San Diego y Tijuana. La gente lo activó, se comprometió con él.

C.F.

El mayor reto fue traducir la naturaleza abierta del proyecto orientada a un proceso, sin reducirla a un simple "mira mi camión de helados" por parte de los coparticipantes potenciales. Para todo aquel que se tomó la molestia de escuchar, tuve que pensar cuál sería el gancho para cada persona. ¿Qué sentido tiene esto? ¿Para qué se hace? ¿Es realmente arte? Estaba vendiendo el proyecto. En el último de los casos, era la novedad de la premisa formal del proyecto lo que llamaba la atención de aquellos que, con el tiempo, se unieron al proyecto *Monstruo*. Las relaciones, en su mero núcleo, siempre se basaron en un respeto mutuo por las historias, el conocimiento, las habilidades y las posibilidades de contribución de cada uno. Pero las tensiones siempre afloraban debido a las fuertes personalidades que existían dentro del grupo. Necesitaba dejar en claro desde el principio mi visión particular del proyecto y las metas que quería alcanzar. Pero cada coparticipante tenía que definir para sí sus propias metas específicas. Una vez que reclamaban para sí mismos un espacio dentro del proyecto, aunque esto fuera de manera tácita, todos y cada uno se hacían plenamente presentes. Algunas personas trabajaban bien bajo una dirección específica, otras sólo necesitaban asesoría mientras hacían lo que mejor sabían hacer. Mi duda era saber cuán presente tendría que estar dentro del proceso.

Para remarcar lo obvio, *Un cierto monstruo amable* fue más bien un proceso de negociación

constante entendido como lo opuesto a la idea de salvar un obstáculo. Y yo tomé esto como algo positivo. Negociación significaba que la gente estuviera comprometida. Que eran reconocidos. El *Monstruo* trataba de crear un espacio en el que cada coparticipante se sintiera apoyado por el proyecto y una parte integral del mismo, al tiempo en que también se creaba una conciencia de roles y un compromiso con los roles de todos y cada uno dentro de un esquema más amplio. Y si bien ninguno de nosotros, incluido yo mismo, sabía realmente qué iba a pasar al final (y el proyecto en cierto sentido aún vive) ni entendía del todo qué era lo que todo esto quería decir a medida que el proceso se desarrollaba, existía el deseo de ver el proyecto terminado.

El proceso fue orgánico. Fue caótico. Fue lento y agotador. Fue vivo. Fue definitivamente doloroso y eufórico a ratos. De modo que, ¿qué fue lo que pasó realmente? Mucha conversación, mucha traducción. No necesariamente el tipo de traducción entre diferentes lenguas nacionales, aunque hubo mucho de eso. Más bien, entre diferentes modos de transmitir ideas y contarlas a cada uno, hablando directamente, mediante la insinuación y la sugerencia, mediante la acción y el ejemplo. Se trató de aprender cómo leer mejor una situación y las formas en que nos comunicamos los unos con los otros.

C.F.

Estas comunidades que se forman alrededor de los coches, incorporan y representan diferentes tipos de "escapes" y de llegadas (en forma de espectáculo) dentro del paisaje físico y cultural.

La primera fase de este proyecto está inspirada en la colorida cultura automovilística que define una buena parte de la vida de los jóvenes en el sudoeste de San Diego y de National City, y consiste en investigar las nociones de *escape*, *partida* y *llegada* usando, literalmente, un vehículo o medio de transporte. [...] Los equipos que modifiquen el coche deben usar, como base conceptual, la idea de *escape* y poner en práctica diferentes estéticas para realizar las modificaciones: ya sea la fría estética de los *anime* japoneses, importada de Asia, o la tendencia barroca de los clubs de *lowriders*. Estas comunidades automovilísticas encarnan y llevan a cabo distintos modos de escape y llegada (en forma de espectáculo) en el paisaje cultural y físico. Las importaciones asiáticas exageran una hiperfunción de la velocidad al intervenir los motores (al menos incorporando una extraña visión cosmética de la velocidad por medio de accesorios exteriores al cuerpo del coche), mientras que los *lowriders* interrumpen el flujo vehicular por medio de una supuesta (no)función generada a partir de la decoración extrema y la baja velocidad. La superimposición se lleva a cabo en su presencia extensiva a través del sonido, con el uso de sistemas de audio con bajos muy fuertes o el rugido de los tubos de escape.

C.F./ Propuesta

Glassford & Parral

[...] No creo que la escala dejara esa marca o influencia en el proceso de trabajo o en el resultado de la obra, dado que siempre he sentido que la reacción espacial a cualquier pieza en la que he estado involucrado repercute en primer lugar en su experiencia. Más importantes eran las implicaciones de adaptarla a los confines sociales y a la influencia del dominio público; que fuera usada y adaptada sinceramente y que no fuera un acto de imposición de nuestra parte.

T.G.

Durante la inauguración de *La esquina* muchas personas, no sólo mi galerista de la Ciudad de México, sino agregados culturales de todos los tipos e inclusive miembros del equipo de **inSite** (todos ellos familiarizados con mi trabajo del año y medio anterior) me preguntaban: "¿Dónde está tu pieza?", a sabiendas de que estaban en el lugar indicado en los mapas y en la cartelera de ese día. Al principio me sentí desconcertado por la invisibilidad del sitio, que fuera tan aparente y normal según lo que uno esperaría encontrar en ese tipo de espacio —el área de un parque fluido y funcional. Luego de redirigir su atención y dejar que cayeran ellos solos en la cuenta de que estaban parados en y adentro de la obra en el momento de formular su pregunta, me percaté de que éste era uno de los mejores resultados que podía haber imaginado: la completa asimilación. Como ya había trabajado con Jose (Parral) desde el principio en la idea de que ésta debía ser la instalación de planeación ambiental y neutral con más hierba a ser adoptada por la comunidad, ya desde el momento de su "inauguración" a ésta se le consideraba parte del *status quo*. Obviamente no era la forma más adecuada a una presentación del tipo "bienal", tratándose de una asimilación distinta a estar de pie frente a la obra y hacer un comentario individual; aunque para todo aquel que supiera que éste había sido un basurero en otro tiempo, la transformación era significativa.

T.G.

La reconstrucción de un "código" espacial —es decir, un lenguaje común a la práctica y a la teoría, así como a los habitantes, arquitectos y científicos— ha de ser considerada, desde un punto de vista práctico, como una tarea inmediata. Lo primero que un código tal haría sería recapturar la unidad de los elementos disociados, derribando las barreras entre lo privado y lo público, e identificando dichas confluencias y oposiciones, en el espacio, hasta el presente indiscernibles.

Henri Lefebvre

Lo que más me intrigó de esta colaboración fue la capacidad para trabajar directamente con el artista y la estructura abierta de nuestra investigación, que nos permitió crear nuestros propios problemas en lugar de tenerlos definidos de antemano. Esta combinación única de cliente y colaborador también produjo sus propios temas. Todos los involucrados estaban definiendo el proyecto continuamente. Aquellos que participaron influyeron en el proyecto en cada una de sus etapas. Ahora, cuando miro hacia atrás, lo que más me interesó fue el proceso mismo y las medidas tomadas para solidificar el resultado final. El paisaje es impresionante a medida que va cambiando, cuando otros procesos toman lugar en vez de los tuyos propios.

J.P.

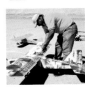

Maurycy Gomulicki

[...] *Puente aéreo* —con todo lo que finalmente resultó ser como experiencia— no podía ocurrir sin ese dilatado lapso de tiempo, y no por razones de complejidad de producción sino por las dinámicas humanas, que en su caso resultaron esenciales. Uno dispone de sensibilidad y de ideas —hacer este proyecto con **inSite** fue hacerlo con comunidades— pero hay que aprender a entregarlas a la gente, saber desechar inmediatamente toda exclusividad y ponerlas a prueba. [...] Mi proyecto no existiría sin la participación de la gente. A pesar de que los aviones podían ser todos tan espectaculares como resultaron algunos, aun si todos hubieran sido diseñados por un artista, nunca hubieran tenido la fuerza lírica que tuvieron gracias a cómo respondieron a la idea de la gente que los hizo, honestamente, a su modo propio.

M.G.

La presencia y el poder del mito aéreo está sólidamente fundamentada en la conciencia norteamericana. En la bahía de San Diego es un hecho físico sensorial la presencia del tránsito aéreo y del movimiento aéreo militar. (Es de hecho donde lo militar más se deja percibir a primera vista). En San Diego es donde uno puede ver el letal helicóptero Cobra, tocar el motor del legendario Messershmidt Me-262 o pararse bajo la sombra del Black Bird SR-71. *Top Gun*, *The Right Stuff*, Werner von Braun y el Spirit of Saint Luis están vivos aquí y San Diego, no sin razón, está orgulloso de ello. "Los militares y los pilotos, son la gente más romántica que hay" - Comentario de un amigo sandieguense.

El vuelo fue desde siempre el más grande deseo del humano (después de combatir a la muerte). Hoy se volvió también una herramienta de opresión/destrucción. El motivo del vuelo aparece conforme cuestiones de: libertad/propiedad del espacio aéreo/ fronteras aéreas. El lugar (zona fronteriza) está saturado de sueños/esperanzas siempre en presencia de lo conocido/desconocido (a ambos lados). *Libertad* y *límites* son palabras clave en el contexto fronterizo.

La idea es activar la zona del Río Tijuana. En su determinación arquitectónica y su estructura lineal ofrece una especie de parque industrial con una admirable claridad del espacio en contraste con el cotidiano caos urbano de Tijuana. El sitio ahora esta prácticamente desierto, excepto por pocos casos de almas abandonadas que pasean por allí. La línea amarilla fronteriza pintada en el lecho de concreto del río forma una natural y simbólica línea de despegue para los modelos de aviones. Los costados inclinados se prestan naturalmente para instalar unas bancas para espectadores. La presencia tan cercana de la frontera abierta es inquietante y absurda.

Quisiera activar la creación de aviones personalizados (*ergo*: no réplicas de aviones reales, sino fantasías propias proponiendo identidad personal del artefacto *versus* contexto de identidad nacional del mundo aéreo-fuerzas aéreas).

Quisiera proponer vuelos simultáneos y acrobacias conjuntas (a ambos lados) como ejercicio poético desenajenante. Quisiera que los grupos, dependiendo de la actividad escogida (construcción, acrobacias) se encontraran frecuentemente para trabajar/realizar ejercicios. También me imagino "parejas mixtas": un constructor que elabora la creación personal y un hábil piloto que la vuela. [Objetivo: reforzar la aproximación al proceso (tiempo real) independiente a la aproximación en el momento de la acción (tiempo lírico)]. Quisiera lograr una dinámica en la cual los participantes pudieran desarrollar las mismas ideas o proponer nuevas (activar una conciencia en y de proceso).

M.G./ Propuesta

Mi pasión por los aeroplanos que quiero compartir es la belleza de su vuelo y las cosas emocionantes que pueden hacerse con el aeroplano en el espacio. Me gustaría desarrollar esto en vez de algo que fuera extraño, inusual o americanizado. Espero que sea aceptable para el proyecto.

Saludos,
Tim

Tim Attaway/ Correo electrónico/ "Re: DESPUÉS DE LA REUNIÓN DEL CLUB", 23 de febrero de 2005

Oye Tania, ¿¿vienen los americanos?? Si es así, les puedes decir que después de la reunión en Real del Mar, están invitados a volar con nosotros. Por favor coméntales para que se traigan sus aviones. Si el clima lo permite, estaremos volando a partir de la 1:00 pm y tendremos carne asada en el campo. Me preocupa el pronóstico que incluyo abajo.

Gracias,
Alan

Alan Andere/ Correo electrónico/ "Re: del sábado", 17 de febrero de 2005

El *performance* final fue una acto efímero —así es también la dinámica de **inSite** como proyecto semi-invisible. Las brutas fuerzas urbanas (con la repentina inundación de aguas negras sobre la "pista de vuelo") le agregaron un aún más absurdo dramatismo al evento, confirmando el ánimo de los participantes. La platinada nieve de diamantina soltada al aire por el avión de Humberto encontró su momento perfecto sobre estas aguas. El posterior encuentro de los pilotos fue realmente conmovedor, los corazones de todos estaban sobre la mesa.

Fue una necedad proponer un acto romántico dentro de un marco comunitario; lo que inevitablemente implica dialogar con la presencia de cierta "corrección política" y también ética en la conciencia cultural fronteriza. Trabajar un acto romántico y hacérselo entender tanto a los demás como a mí mismo fue un reto. No puedo medir el grado de reflexión que generó, pero fue una experiencia real a nivel de vida.

M.G.

Gonzalo Lebrija

Básicamente, y en primera instancia, la idea es trabajar con la imaginación de los veteranos para producir una posible exposición. Me parece interesante la combinación de pasado histórico, silencio y espacio de esparcimiento como herramientas potenciales que repercuten en la imaginación de los veteranos.

G.L./ Correo electrónico/ "Gonzalo", 2 de agosto de 2004

La idea del héroe que regresa a casa forma parte del imaginario colectivo de los habitantes de la ciudad de San Diego. Sede de la mayor flota naval en el mundo, San Diego es el puerto más importante del continente americano en la costa del Pacífico. Además de acoger a varias bases militares, la ciudad cuenta con diversos monumentos e instituciones que honran la memoria del soldado americano. *Héroes de guerra* también refiere a las distintas estrategias en las que los testimonios materiales de los soldados son rescatados y presentados al público. Lebrija reinterpreta algunos de los iconos más representativos del discurso formalista militar y da voz a los protagonistas mismos de los sucesos. Al incorporar las historias personales de un grupo de veteranos de guerra a La Historia de las batallas y los combates expuesta en el Veterans Museum, el proyecto funciona como una plataforma para ejercitar nuevos códigos de representación y afiliación.

Tania Ragasol

Mi idea inicial, que implicaba la interacción entre dichos personajes y el museo dedicado a ellos, se fue modificando al correr el tiempo por distintas circunstancias. La información recabada y el gran interés que suscitó esta primera colaboración hicieron que mi curiosidad inicial por la cultura militar de uno de los países más poderosos del mundo —y quizá el que más importancia dé a esta faceta en la costa del Pacífico— se transformara en una investigación profunda de carácter artístico-militar que puso en relieve dos características propias de la maquinaria armamentista: el reconocimiento al héroe, su gloria, y los recuerdos personales del hombre vulnerable.

G.L./ Propuesta

Pensando en que el objetivo del proyecto es intervenir el museo, sería bueno hacer los talleres y las mecánicas en relación a ésto, pensando en ejercicios que puedan establecer vínculos entre situaciones que vayan de lo personal a lo público, del pasado al presente, de sus memorias en relación al artificio del museo. Por ejemplo, se me ocurre hacer un levantamiento fotográfico de las posesiones del museo —objectos, fotos, escritos, uniformes— e imprimirlas y usarlas como fichas para empezar a establecer relaciones adecuadas al relato que nos interesa, para fijar un posible *display* a través de alguna mecánica.

Otra de las ideas puede ser la que habíamos pensado con el libro de ilustraciones de la Segunda Guerra Mundial, a lo mejor sólo como ejercicio para practicar la idea de intervención en relación al arte. A lo mejor podrían escribir a pulso con plumón blanco sobre las imágenes —ellos tienen un tipo de letra que ya no se usa y es increíble—, buscando relaciones que no sean obvias. Ya pensaremos en cómo hacerlo. Por lo pronto son sólo ideas para avanzar en el diálogo y para poder definir el programa.

G.L./ Correo electrónico/ "RE: Gonzalooooo is back", 24 de noviembre de 2004

João Louro

The Jewel/ In God We Trust marca desde el título las dos fases constitutivas de este proyecto. Se trata de la rehabilitación del ciclo económico —de intensivo reciclaje en esta zona fronteriza— partiendo del final mismo del proceso. Un desplazamiento del valor operado desde el arte, donde el objeto mismo, sin ser tocado por el artista, sale de su condición de basura y adquiere una condición de objeto suntuario.

J.L./ Propuesta

Queridos revolucionarios, en lo que nos enseña Debord.

Algunas instrucciones:
1. Que toda la gente que trabajó en **inSite** tenga su colección de billetes (15 billetes. Pero abierto a más billetes para gente "participativa" para "abandonarlos").
2. Que Tijuana y por supuesto, San Diego, sea "inundadada" con billetes (tengo especial afecto por el *mall* y Hillcrest (mucho); el hotel; como un sueño, el Hotel Coronado, donde se filmó la película *Some Like it Hot* (imperdible) por todos los motivos. Tarea que Michael [Krichman] y Carmen [Cuenca] podrían hacer, de 007 *suit*, en daDaCraPs; (y que dejo en abierto sin querer ser demasiado exigente con el *casting*).
3. Que me sea enviada un cantidad (generosa) de billetes para que se pueda abandonar en Lisboa y Portugal; en ferias internacionales (Basel y Arco, claro que Miami Basel, pero ya fue... Tengo especial amor por un niño que los pintó todos de negro, entre otros). Aquí los hago valiosos, el último golpe de la obra *In God We Trust... you right DadaTrust*.
4. Los billetes que me sean enviados tendrán que venir por correo normal (USPS).

Este proyecto me encantó.

BESO
Dada&joAo&dada

J.L./ Correo electrónico/ "Que lhueva dinero", 5 de diciembre de 2005

Rubens Mano

La creación e inserción de una señal en el paisaje es capaz de instaurar otra territorialidad al interior de ciertos flujos y narrativas. Un contexto posible de ser comprendido en el terreno de las relaciones cotidianas, pero posible de ser percibido solamente en el campo de la imagen.

R.M.

Visible propone la comunicación entre identidades aparentemente distintas. Sin reivindicar una traducción, el uso de esta palabra busca inscribir a su portador en otra red de relaciones, necesaria para rebasar un espacio agotado por sus lecturas inmediatas.

R.M.

Josep-maria Martín

Desde su fundación en 1991, la Casa YMCA de Menores Migrantes ha proporcionado refugio provisional a aproximadamente 2,500 niños por año. Provenientes de varias partes de México y América Central, en el intento por cruzar ilegalmente la frontera con los E.U. han sido detenidos, arrestados y deportados a México. Menores entre los 11 y los 17 años pueden permanecer en el refugio por un máximo de 8 días, o hasta que sus familiares sean localizados.

Comisión cancelada

Un prototipo para la buena migración fue el único proyecto de **inSite_05** cancelado ya avanzada su producción. Su proceso implicó un gasto sensible de energía y de recursos, y fue una ardua derrota para el equipo curatorial. Desde un inicio en noviembre de 2003 y hasta mayo de 2005, las sucesivas propuestas de Josep-maria Martín estuvieron relacionadas con la migración. Llegar a una propuesta final significó más de un año y medio de desacuerdos, que desde el ángulo curatorial referían a la vaguedad de las ideas y, sobre todo, al trasfondo ético de sus modelos de intervención. Hacia mayo de 2005, Martín estaba interesado en que su proyecto artístico fuera una casa o un albergue para migrantes. En la zona fronteriza de Tijuana San Diego existen más de una docena de instituciones no gubernamentales y gubernamentales de este tipo, con programas, redes de apoyo y compromisos de operación de una gran solidez. Muchas discusiones versaron en torno a cómo entender una intervención desde el arte que pretendía crear un otro espacio de asistencia al migrante, sin contar con los recursos financieros ni humanos que garantizasen su permanencia, y ante la responsabilidad ética que exigía la implementación y el funcionamiento ulterior de tal iniciativa. En mayo de 2005, Martín aceptó que su proyecto pudiera crecer al seno de una de las instituciones de este tipo más sólidas y prestigiadas en Tijuana: la Casa YMCA para Menores Migrantes. Un albergue no gubernamental, para menores y adolescentes que han intentado infructuosamente cruzar sin documentos la frontera, y luego han sido deportados al lado mexicano. La propuesta final para **inSite** acordaba el diseño de una modesta ampliación del edificio, que diera cabida a un programa de educación intensiva para los menores. Martín convocaría a una red de colaboración interdisciplinaria entre personalidades e instituciones del área, a fin de conformar un programa de charlas y talleres, así como materiales de estudio y de esparcimiento. Este programa, así como la activación de la red de intercambios de la cual deberían de emanar sus contenidos, era precisamente el nodo conceptual de su intervención. Un mes previo a la inauguración, el problema mayor seguía siendo no contar con un esbozo del programa educativo, o de algo que permitiera una retroalimentación o diálogo entre la curaduría y el artista.

Mientras tanto, envió una línea que se debía agregar al título de su proyecto: *Un prototipo para la buena migración: Centro de formación e información juvenil sobre la frontera*, lo que constituyó el punto final del desacuerdo. ¿Cómo inscribirnos en ese acuerdo de colaboración, en un espacio que no nos correspondía administrar ni posicionar, con algo que de pronto se calificaba a sí mismo como un "Centro de formación e información juvenil sobre la frontera"? ¿Con qué créditos? ¿Cuál era el nivel de compromiso ante tal responsabilidad pública? El artista no aceptó repensar su modo de inscribir el proyecto. El equipo curatorial decidió cancelar la comisión y acordar con los directivos de **inSite** finalizar la construcción y el equipamiento del espacio para donarlos a la Casa YMCA para Menores Migrantes.

Yo creía que estábamos intentado encontrar espacios de crecimiento y compromiso. Igual que tú no estás de acuerdo con mi trabajo, también tengo que decirte que yo no estoy de acuerdo con la manera en que has comisariado [curado] esta pieza.

Un saludo,
Josep

J.M./ Correo electrónico/ "Re: Compromiso", 18 de agosto del 2005

Itzel Martínez del Cañizo

Por un lado, un grupo de hombres internos en un centro de rehabilitación de drogas formuló una nueva constitución de ciudad y, cámara en mano, autorrepresentó un día en esta nueva vida. A su vez, un conjunto de mujeres de distinguido nivel cultural construyó con palabras sus ideales. Entre unos y otros crearon una nueva realidad de vida, visible sólo en las dimensiones de este video.

I.M.C.

[...] La propuesta de la autorrepresentación implica que los colaboradores sientan un interés propio con el trabajo a crear, y esta es la principal clave para que el juego de video comience a existir. Aquí el poder de discurso y registro no sólo cae sobre mis hombros, sino que se comparte

y se negocia con la selección que ellos hacen sobre sí mismos y sus vidas. El alcanzar a llegar a la intimidad requiere de mucho trabajo conjunto. Nos hacemos cómplices, confidentes y hasta amigos fugaces. La clave, a mi modo de ver, es mi sinceridad, mi interés personal y profundo. Así que más que un elemento que genere vulnerabilidad, creo que es la llave maestra para acceder a esos mundos tan problematizados. Siempre es bienvenida una mirada exterior con una propuesta novedosa y buenas intenciones. Yo comienzo a escuchar y a observar por un largo periodo antes de empezar a tomar decisiones. Me gusta ver todo lo que se desarrolla frente a mí, pero pongo especial atención en los discursos que ellos construyen de sí mismos en sus acciones no conscientes, en sus actos cotidianos, en sus pláticas del día a día, en sus contradicciones. Intento que mis selecciones estén basadas en todo ello, que mi voz implícita en la obra sea un tejido sintetizado de todo lo que logré ver y leer durante el tiempo de la experiencia en el campo, y las selecciones que conscientemente ellos hicieron sobre sí mismos.

I.M.C.

A partir de esta perspectiva es que he decidido intervenir desde el arte en su propia dinámica rehabilitadora, a través del desarrollo de un juego. En donde con cámara de video se permitan, desde la ficción, construir una nueva posibilidad para sí mismos y su entorno: diseñando con plena libertad creativa una ciudad. La suya propia. Una ciudad que es resultado de Tijuana pero que reniega de ella; que se reinventa a la medida de los deseos e ideales de sus adictos habitantes. Retomar conceptualmente el nombre de este centro de rehabilitación para simbólicamente construir una ciudad video-real.

Los drogadictos de Ciudad Recuperación que han sido formados en las calles de Tijuana, han construido su realidad con base en los mismos patrones y estructuras de valor (antivalor) que en la calle se generan y transforman continuamente. Sus códigos de pensamiento y lenguaje son entonces resultado de los elementos que definen a estas realidades callejeras. Sin perder de vista que, a su vez, son ellos mismos quienes van transformando a la cultura de la calle en un ejercicio constante.

No me interesa indagar en las trayectorias de vida que han llevado a este grupo de hombres a internarse en un centro de rehabilitación, sino partir de estas experiencias ya adheridas a su cosmovisión para desde ahí intervenir en su subjetividad (adultos con gran experiencia en el mundo de la ficción mental adictiva). La intención principal se centra en construir una plataforma de relaciones concretas donde revertir su manera de pensarse a sí mismos reflexivamente, y con ello iniciar un juego con cámara de video en donde se permitan, en una confidencia colectiva, la libertad de definir el rostro de la realidad que desean: crear una video-realidad a la medida.

Por medio de la utilización de la cámara de video como instrumento de poder para construir historias y legitimar realidades (desde la ficción y el documental) busco generar un encuentro con el otro, con lo otro, a través de una serie de procesos interactivos específicos.

I.M.C./ Propuesta

Según la Encuesta Nacional de Adicciones Tijuana es la ciudad número uno en el consumo de drogas. No gratuitamente está situada en la frontera más transitada de América. Es por eso que he seleccionado para el desarrollo de este proyecto artístico (basado en la autorrepresentación) intervenir en las dinámicas de un lugar en el que buscan hacer un cambio en Tijuana desde sus habitantes: un centro de rehabilitación curiosamente llamado Ciudad Recuperación.

I.M.C./ Propuesta

Aernout Mik

La cuestión del lodo tiene que ver con mi proyecto para **inSite**. Aunque todavía no he decidido cabalmente qué camino seguiré al final (esto también depende del otro material que pedí, y que decidiré al final)... Aunque cuando no puedes encontrar material tampoco hay problema.

A.M./ Correo electrónico/ "Re: Lodo", 13 de abril de 2004

En la instalación de video *Flujo* [título provisional de la primera propuesta] quiero yuxtaponer y entretejer pietaje de los paisajes dominados por los tiraderos de automóviles de Tijuana y escenas de una farmacia de la localidad inundada de lodo. Juntos, los carros y las medicinas formarán una metáfora de la circulación de bienes entre Tijuana y San Diego. Coches usados circulan en grandes cantidades de Estados Unidos a México; y cuando por fin se vuelven inservibles, se amontonan en las colinas vacías, transformando el paisaje periférico de la ciudad. Los tiraderos de automóviles no tienen una clara demarcación, pero se disuelven en el paisaje de Tijuana, vaciados como un líquido espeso en la topografía local. A veces los carros brillan como joyas con los rayos del sol, negando su condición esencialmente entrópica. Por otro lado, un flujo de medicamentos baratos encuentra su camino de

regreso a los Estados Unidos para el tratamiento de las enfermedades, los deseos y los miedos de los norteamericanos. Se venden en farmacias flamantes y limpias a lo largo de la ciudad (en marcado contraste con la apariencia polvorienta de la ciudad), que la mayoría de las veces están abiertas las 24 horas. Amontonadas en ingeniosos patrones geométricos y con los colores más fantásticos, las medicinas se ofrecen a los norteamericanos que las necesitan.

Carros y medicinas representan diferentes manifestaciones de excesos. Ambos modifican un paisaje —un paisaje interior y exterior. En un nivel macro y micro, también existe entre ellos una extraña correspondencia accidental en su apariencia visual.

En ambas situaciones se hará una mezcla de pietaje documental y fragmentos de escenas tanto en locaciones como en escenarios creados. Las escenas involucrarán el trabajo de algunos actores, pero el enfoque principal seguirá estando en los objetos, como si la circulación de los objetos fuera independiente de la gente.

En la obra, una farmacia se inunda de lodo y el techo se daña por las intensas lluvias que han caído. De unas estanterías colapsadas han caído al lodo grandes cantidades de cajitas de medicinas. El resultado es un conjunto excesivo de color, paquetes y pastillas, en orden y desorden, en las estanterías y dispersos en el lodo, creando un paisaje en miniatura.

Los niños juegan un papel conector en las dos situaciones. En la farmacia están jugando en el lodo con algunos paquetes de píldoras, usándolos como si fueran carritos que señalan una carretera en el lodo. En uno de las paisajes de los tiraderos de basura los niños aparecen pegándoles a unas piñatas (algunas de ellas representan miembros de la patrulla fronteriza de los EU) hasta que se rompen. Los dulces se riegan en el suelo, haciendo eco de los montones de coches abandonados que están detrás y la acumulación de pastillas en la farmacia enlodada.

A. M./ Propuesta

Ahora he comenzado a incluir trocitos y pequeñas piezas, y no es fácil para mí porque es totalmente diferente de mis ediciones anteriores. Nunca hice una pieza que consistiera de tantos elementos diferentes, ¡casi me sentí como un realizador de cine de verdad!

¡Pero el material se ve muy bien!

Espero que todos ustedes y los demás estén bien, y que los proyectos de mis compañeros artistas estén marchando igual de bien. ¡No me cabe la menor duda de que después de mi filmación la organización de **inSite** puede manejar cualquier cosa!

A.M./ Correo electrónico/ "Re: Saludos desde San Diego", 17 de mayo de 2005

El flujo de pastillas y el flujo de carros, ambos cruzando la frontera en sentidos opuestos, pertenecen el uno al otro.

A.M.

Realicé este montaje para estimular las potencialidades latentes del documental que saldrá a la superficie. Al montar estos escenarios en parte incodificables, recabados del inconsciente colectivo, el carácter excesivo del decorado en el material del documental se amplifica y se lleva a un punto de ebullición. A partir de una estrategia dual, el ensayo teatral y los rituales sociales documentados pronto se comportan como dobles que condicionan el uno al otro. *Ósmosis y exceso* habla de cómo dos sistemas separados colindantes se filtran entre sí. Esto adquiere en la pieza un sentido geográfico ulterior: cómo los bienes fetichizados cruzan la frontera y se vuelven una arena porosa. Pero esto también se lleva a cabo a un nivel visual visceral: colinas repletas con carros abandonados, rebaños de vacas y de ovejas, grupos de niños, coches de juguete en el lodo, cajas de medicina en estanterías, dulces regados alrededor, etcétera; todo parece tener afinidades entre sí. Las dicotomías se disuelven en cadenas de multitudes.

A.M.

Lo apocalíptico es fruto de la violencia de la frontera; aquí no existe lo "otro". Las premisas están sentadas por los EU, que producen un flujo cultural, y Tijuana las corresponde de un modo más bien inerte (los paisajes de carros), y en una forma mimética torcida (las farmacias). Además de esto, lo apocalíptico nunca aparece aislado, sino siempre en conexión con una estimulación colorida, juego y agresión, aburrimiento casual y entropía pacífica. Es sólo un momento en este ciclo transformador.

A. M.

Antoni Muntadas

La más antigua de las pasiones vehementes, la forma más básica de los impulsos químicos que llamamos emociones. Un ruido fuerte, el perfume ácido de un predador, un movimiento brusco percibido por la visión periférica, la penumbra que envuelve —miedo es la respuesta que surge de esos estímulos… La experiencia privada del miedo puede volverse pública, y devenir instrumento —conscientemente o subliminalmente dirigido— en las decisiones políticas. El miedo puede funcionar como arma política.

Carolyn Jones/ *Doubt Fear*

Aún cuando On Translation: Fear/Miedo es una intervención inserta en la programación televisiva, otros proyectos previos que forman parte de la serie On Translation involucran video, Internet, revistas, libros, documentos y vallas publicitarias.

Paul Ramírez Jonas

Comienza con la foto de un individuo. Continúa con la foto de su llavero en la palma de su mano. Termina con la foto individual de cada llave en el llavero junto con el espacio/objeto que ésta abre.

Cada vez que concluya una conferencia, al público asistente se le invitará a intercambiar llaves con el artista y entre ellos mismos. Todo el equipo necesario para duplicar las llaves estará al alcance, junto con llaves vírgenes grabadas con un símbolo de confianza y generosidad. Todo aquel que quiera cambiar sus llaves por una de estas llaves falsas recibirá a cambio la llave de otro. Como el intercambio puede ser anónimo, la seguridad proporcionada por las llaves no debe socavarse.

P.R.J./ Propuesta

Realmente quiero dar una de las charlas en la cárcel, y prefiero acomodar la charla de cualquier modo y no cancelarla. Tu idea, Tania, de dejar una llave con las pertenencias que reciben al salir me parece super inteligente, creativa, encantadora, genial.

Mi fecha meta interna para terminar el diseño de las llaves es el viernes. He experimentado con imágenes parecidas a las que vimos en la oficina (manos ofreciendo o tomando llaves) pero dibujadas no como iconos sino como dibujos de manos específicas. La diferencia es muy sutil pero efectiva. El lenguaje ya no es tan autoritario sino íntimo; el dibujo ya no es desechable, sino al contrario, es como una pequeña miniatura que uno admira.

P.R.J./ Correo electrónico/ "Re: de la cárcel", 29 de junio de 2005

Me gusta la implicación de vida continuada para la pieza. Puedes imaginar que ésta seguirá y seguirá su marcha, "abriendo" puertas en las ciudades. Es factible. Es impermeable a que la gente diga "no", porque si alguien dice "no" podemos preguntar a alguien más. Sólo tenemos que hacer una cadena inicial de 10 personas. Esto convierte a un cartero una persona tan importante como un alcalde, porque la importancia de cada persona es relacional, no "esencialista". Sería genial si alguno de nuestros 10 colaboradores estuviera ahí en representación de sí mismo, como ciudadano, y algunos estuvieran ahí como parte de la institución que representan. En otras palabras, algunas personas darán la llave que da acceso a su vida personal, otras a su negocio o a la institución que representan.

P.R.J./ Correo electrónico/ "Re", 12 de abril de 2005

inSite también ha sido muy puntual en decidirme y dirigirme a optar por ideas que se atengan al papel productor de **inSite**. Quiero una evaluación honesta y realista de tu idea. ¿La logística y las ambiciones de todos estos proyectos rebasan a **inSite**? No quiero comprometer la calidad de mi obra y necesito saber si debo pensar en esto como algo que puedo hacer yo solo, con el presupuesto acordado, o si debo depender, y hasta qué punto, de **inSite** para producir aspectos sustanciales de mi pieza.

Sólo quiero ser claro acerca de lo que tengo para trabajar... Creo que aún podemos hacer algo grande. ¿Dónde estaría el arte contemporáneo si no hubiera asumido el fracaso como estrategia?

P.R.J./ Correo electrónico/ "Re: de la cárcel", 29 de junio de 2005

SIMPARCH

Las alcataras están constituidas por recipientes poco profundos, sellados con una tapa de vidrio, a los que se les provee del líquido por medio de un tanque elevado de agua no potabilizada. El sol calienta el fluido contenido en los recipientes y ocasiona su evaporación; el vapor condensado se concentra en la parte anterior del cristal y desciende a un canal que conduce el producto destilado a través de un ducto para, finalmente, recolectar el líquido en una vasija ubicada al exterior de la alcatara.

SIMPARCH

Javier Téllez

Ahora hay una idea nueva que espero no alarme mucho: Quisiera conseguir a un mago de alquiler para que haga un acto de magia en el hospital durante esta residencia para los *spots*. Sería fundamentalmente un acto de magia común. Lo que sí es importante es que sea un mago clásico de traje negro y sombrero de copa. Que cuente entre sus actos con la aparición y desaparición de palomas blancas y barajas. También que tenga un baúl donde podamos "desaparecer" a una persona. Sé que estamos con poco tiempo y bajo presupuesto, pero quería ver la posibilidad de que esto se hiciese. Pienso que no debe costar mucho si contratamos uno local de los que van a fiestas infantiles por tres horas. Bueno, lo importante primero es buscar al mago y luego vemos si cabe en el presupuesto. Perdona la improvisación, pero a veces las imágenes ocurren como destellos.

Un abrazo,
Javier

J.T./ Correo electrónico/ "Re: necesito un mago", 3 de julio de 2005

No quiero que las asperezas que producen dificultades y el estrés natural de las complicaciones del trabajo sean entendidas como un reclamo de mi parte hacia el trabajo de ustedes. Soy consciente de que al final lo importante para todos es que las cosas salgan bien dentro de lo posible. Pero también soñemos (*no pun intended*) lo imposible... (por favor no me pongan en la cartelera de frases célebres de la oficina).

J.T./ Correo electrónico/ "Re: Information on Human Cannonball", 20 de junio de 2005

Aquí yo también muy entusiasmado con el *bypass* de puente aéreo que establecerá el récord de cruce fronterizo más rápido: 60 kmph. La semana pasada fui al circo de Los Hermanos Cole aquí en NY. ¡Tienen una mujer bala! (bueno mujeres-balas abundan, pero ésta era una profesional de a de veras). El *cannon-car* era un objeto escultórico muy hermoso, con la bandera americana y todo.

J.T./ Correo electrónico/ "Re: la bala que mató a Kennedy", 27 de julio de 2004

Los agentes de la Patrulla Fronteriza de los Estados Unidos permitieron a un hombre conocido como *La bala humana* que se lanzara él mismo a través de la frontera, de México a los Estados Unidos. La Patrulla Fronteriza le dio un permiso especial para hacer esto porque, como ustedes saben, no dejan que cualquiera cruce la frontera.

Jay Leno/ 8 de septiembre de 2005

El *pathos* imprevisible de la locura, funciona aquí como un *Deus ex-machina*, convirtiendo a la pieza en un misterio, en un procedimiento "ritual", donde son develadas, en vivo, nuestras enfermedades contractuales. El despliegue ditirámbico encarna en sí mismo la fragilidad del artificio: la bandera, la policía municipal, la barda, la guardia fronteriza, la banda de música estatal, los pacientes, el público de arte, los familiares de los pacientes, los himnos nacionales, los vecinos, los amantes del circo, los profesionales del arte. Nuestras eludidas entropías —también las internalizadas en previsibles inercias mentales— quedan al descubierto, al exponerse "públicamente", en "el afuera", el potencial marginal de su silenciamiento.

De este modo, al echar mano al registro de alteridad y al potencial subversivo de lo que denominamos locura, —o en este caso, apropiándose de gestos simbólicos que traducen desde lo circense la radicalidad de otras lógicas alternas— Téllez emplaza las correspondencias coercitivas existentes entre estructura mental y orden social, entre institución siquiátrica y estado de derecho, entre *borderline* y límites de adhesión identitaria, entre el carnaval como

terapia, y los espectáculos de investidura de poder —no sin abrir siempre preguntas, también al interior de la escena del arte contemporánaeo.

Osvaldo Sánchez

Althea Thauberger

Algunas preguntas que condujeron a esta propuesta son:

¿Cómo se puede representar una comunidad? ¿Cómo puede involucrarse una comunidad en su propia representación? ¿Cómo estos intereses esencialmente documentales pueden incorporarse en formas poéticas? ¿Cómo un proyecto puede convertirse en un medio para la expresión personal significativa y también para el desarrollo de una comunidad?

¿Por qué un coro?

Un coro epitomiza una comunidad. El *Coro de Murphy Canyon* reflejará la comunidad existente —un grupo de individuos, voces diversas que se conjuntan dentro de un colectivo. Cantar es algo que cualquiera puede hacer, y es la forma básica (quizá la más básica) de expresión artística. Los coros, de manera inmediata y exitosa, invitan a la colaboración y reúnen a los públicos y a los ejecutantes. Podría haber alguna relación con las tradiciones existentes de música militar —presentaciones de grupo como las bandas militares— con las que la comunidad también podría identificarse.

¿Por qué las esposas de los militares?

Las vidas de las esposas de militares están dominadas en gran medida por un sentido de sacrificio. Muchas de ellas quizá renunciaron a desarrollar talentos o a alcanzar metas individuales cuando escogieron este tipo de vida. Este proyecto propone algo que es para su cumplimiento y su desarrollo personales. Las esposas de los militares son una parte de la comunidad no del todo reconocida.

Las familias jóvenes siempre están mirando al futuro. El proyecto se enriquecerá con esta mirada a largo plazo. Las participantes no sólo podrían desarrollar nuevas amistades y apoyos dentro de su comunidad, sino que podrían desarrollar habilidades musicales con beneficios a largo plazo para ellas mismas y sus hijos.

¿Por qué Murphy Canyon?

Murphy Canyon tiene una gran población apta para colaborar y cuenta con una infraestructura de gran alcance. Siendo tan grande el área, los residentes de Murphy Canyon pueden sentirse aislados. El proyecto podría ayudar a superar este aislamiento. Murphy Canyon se encuentra en una locación natural espectacular; si la presentación se lleva a cabo ahí, los visitantes tendrán oportunidad de verla en el camino.

A.T./ Presentación a la comunidad

Espero que todo vaya bien para ustedes dos. Quise ponerlos al día ayer en "re: el ensayo del miércoles por la noche", pero nunca encontré un rato libre. El ensayo estuvo muy bien, hasta donde creo saber. Donna estuvo ahí en el comienzo, de modo que también pudo participar en la retroalimentación. La guardería se ha pasado al cunero y al cuarto de al lado. Esa parte parece marchar muy bien. Tuvimos muchos nuevos cantantes la noche del miércoles: Hazel, Leah, Toni y Carissa... pudo haber uno o dos más que estoy olvidando —todos con fuertes voces. El grupo está empezando a "cuajar". Amy escribió dos versos y el coro de una canción (sólo palabras), que compartió con el grupo. Kim me dijo que ella también tiene una canción escrita pero que preferiría compartirla conmigo de manera anónima. Christina trajo *folders* rojos para que todos pusieran su música en ellos, Amy está montando un panel de conversación en Yahoo! Groups y Heather está organizando una lista de bocadillos para que cada quien traiga una probadita cada semana. También, Natalie se llevó el agua sobrante y la traerá de vuelta la próxima semana. Todos estos actos voluntarios representan "propiedad" y entusiasmo con respecto al proyecto —me parece.

Terry Russell/ Correo electrónico/ "Coro miércoles, ensayo nocturno", 15 de abril de 2005

Hola a todos:

He estado pensando en decorado y vestuario desde anoche, y he cambiado de parecer desde que los vi a todos en ese espacio. El espacio es completamente institucional y después de pensarlo no creo que haya forma de decorarlo para desinstitucionalizarlo, si tal palabra significa algo. Creo que la forma de introducir el sentido visual de individualidad es a través de todos ustedes, los ejecutantes. De verdad quiero que todos ustedes se vistan como quieran. Lleven su ropa

favorita. Lleven algo inesperado, ultra cómodo, sencillo, ¡lo que quieran! Prometo no cambiar de opinión de nuevo.

Muchas gracias a todos.

A.T/ Correo electrónico/ "[micmcc] equipamiento/ decorados", 20 de septiembre de 2005

Lista de canciones

Esposa de un héroe. Tina Carattini
Solistas: Amy Heise, Heather Bankson, Liz Wolfe

Voz. Amy Heise

Título de trabajo (El nombre del juego). Scott Walingford

Para siempre. Diana Butler

El sol se pone (doo-E-dop). Amy Heise y Tina Carattini

Casa. Amy Heise, Tina Carattinni y Liz Wolfe
Solistas: Amy Heise, Heather Bankson, Amanda Skidmore, Diana Butler

Esperando. Diana Butler

Historia de amor. Amy Heise y Tina Carattinni
Solistas: Diana Butler, Tracy Condren, Amy Heise, Jennifer Ramert, Amanda Skidmore

Tú y yo. Jennifer Ramert

El *Coro de Murphy Canyon* se reunía una vez a la semana durante un periodo de dos horas. Los primeros ensayos se concentraron en asesorías vocales y en establecer la tesitura de los participantes. Más adelante, a los participantes se les pidió que aportaran ideas para sus propias composiciones. A algunos, la idea de generar sus propias canciones les pareció muy intimidante; otros enviaron letras y melodías muy detalladas. El número de participantes fluctuó durante un tiempo, y los números del coro variaron de una semana a otra. El grupo aún tenía que consolidarse, ya que ciertas personalidades dominaban y chocaban. A finales de julio de 2005, sin embargo, era claro que el grupo estaba derivando en un ensamble más que en un coro de gran formato, como se había pensado en un principio. A medida que el grupo se estabilizó, los ensayos se volvieron más concentrados y productivos. Hacia finales de septiembre de 2005 los ensayos se hicieron en el auditorio de la Jean Farb Middle School, donde se llevaría a cabo el recital del *Coro de Murphy Canyon*. Los participantes trabajaron con Thauberger para coreografiar y planear la presentación.

Tal vez una identificación fue sólo posible en un principio a un nivel emocional, que dejó abierta la posibilidad de considerar críticamente el hecho comprobable de que, ya sea que nuestras posiciones ideológicas estén en una parte o en la otra, todos nosotros estamos implicados (económicamente, políticamente, socialmente, geográficamente) en las actividades del ejército de los EU. Muchos (civiles) sandieguenses con conciencia social no están al tanto de que viven junto a un gran número de familias de militares, o de las realidades de las vidas de sus vecinos. Tal vez algunos se sintieron movidos a considerar esto durante el concierto. Tal vez hubo un momento en que se hizo evidente que la renuncia a las posiciones *nosotros* y *ustedes* podría promover el entendimiento y la transformación sociales. La aparente transparencia de ideologías que se manifestaron durante el concierto tal vez provocó que algunos reflexionaran sobre la forma en que todos nosotros construimos defensas, significados y justificaciones en medio del absurdo, la banalidad y la locura de estar en este mundo.

A.T

Me gustaría creer que el recital propició una suerte de reconocimiento y conexión con la humanidad, y esto porque había un abismo ideológico tal que esta identificación resultó conmovedora... Hay algo en la vulnerabilidad de los intérpretes y sus voces que me hace sentir una particular empatía.

A.T.

Los 530 acres que ocupa el sitio de Murphy Canyon se localizan en la parte sur de la comunidad de Tierrasanta de la Ciudad de San Diego. Con 2,315 casas Murphy Canyon es una de las comunidades integradas por familias de militares más grandes del mundo. Como parte de la segunda fase de la Iniciativa de Privatización de Hogares para los Militares de la Marina, que aprobó el congreso en 1996, la comunidad militar de Murphy Canyon es el resultado de la afortunada conjunción

de Clark Realty Capital y su afiliada Clark Realty Builders, y Lincoln Property Company. La comunidad de Tierrasanta/Murphy Canyon se encuentra en los cañones y en las faldas de las colinas que una vez fueron parte de Camp Elliott, un campo de entrenamiento militar de la época de la Segunda Guerra Mundial. Conocido por los lugareños como la Isla en las Colinas, Tierrasanta es un enclave urbano. No colinda directamente con ninguna otra comunidad, pero está delimitada al norte por la Route 52 y MCAS Miramar, al este por el Mission Trails Regional Park, al oeste por la Interestate 15 y al sur por los escarpados cañones que dan al San Diego River y a Mission Valley.

LA PERSPECTIVA DEL VISITANTE
Mary-Kay Lombino

El 18 de septiembre de 2005 un grupo de conocedores del mundo del arte contemporáneo abordó un autobús en Balboa Park, San Diego, y fue transportado a Murphy Canyon, un complejo militar gigantesco que aloja a más de 2,500 familias cerca de la frontera Estados Unidos-México. El trayecto del parque al auditorio de la escuela, donde se llevó a cabo la presentación de Althea Thauberger, operó una metamorfosis inesperada. A bordo del autobús iba una joven, de unos 23 años, que estaba ahí para ofrecer una visión panorámica de la vida en Murphy Canyon y responder preguntas. Era esposa de un militar y madre de unos niños pequeños, al igual que las demás cantantes que se ofrecieron a participar en el coro de Thauberger. Su actitud era alegre y acogedora, y al tiempo que hablaba de lo insatisfactorio de su situación —los hechos desafortunados que mantuvieron a su esposo lejos de casa durante la mayor parte de su embarazo más reciente y los primeros cuatro meses de vida de su hijo menor— aceptaba en términos generales la estructura militar que condicionaba, en buena medida, su conducta, sus elecciones y expectativas de vida. Se refería a su experiencia como una buena alternativa a la pobreza, el desempleo y la incertidumbre de muchos de los jóvenes norteamericanos que enfrentan el mundo de hoy. Los miembros del público, en su mayoría de tendencias políticas e ideológicas de izquierda, mientras escuchaban el otro lado de la historia —teñido de las realidades prácticas de la vida cotidiana— se vieron obligados a repensar sus nociones condenatorias y preconcebidas de la vida en una base militar.

Una vez que el público llegó al auditorio y ocupó sus asientos entre los amigos y los familiares de los intérpretes, ocurrió otro cambio interesante. Los que vivían en la base militar sin lugar a dudas eran de allí, lo cual convertía a los invitados en fuereños —sacados, para los efectos del concierto, del cómodo entorno de una galería de arte o un museo, incluso de un escenario urbano. A pesar de que el autobús sólo los había apartado unas cuantas millas del centro de la ciudad, habían llegado a un territorio que no les era familiar. Sentados entre las personas "de adentro", se vieron privados de la típica experiencia *voyeurística* que consiste en observar una serie de temas inesperados. En otras obras de Thauberger, como *Songstress* (2001–2002) y *A Memory Last Forever* (2005), dos obras en video que también involucraron a una comunidad de voluntarios que tomaron parte en conciertos musicales, ese *voyeurismo* es inevitable. Aun a pesar de que, como en *Coro de Murphy Canyon*, los intérpretes canten en sus palabras con sus propios sentimientos, se crea cierta distancia entre el ejecutante y el espectador por el formato de video, que prohíbe toda posibilidad de interacción bilateral, de humano a humano, característica de una presentación en vivo. En el auditorio de Murphy Canyon, el contenido emocional de las canciones, aunado al orgullo palpable de los miembros "internos" del público, desalentó cualquier juicio altivo o reacciones propias de un conocedor del mundo del arte. El público conocedor no tuvo más opción que aceptar a las mujeres en el escenario tal como eran, en el mismo sentido en que las esposas habían aceptado sus destinos como las parejas de unos maridos las más de las veces ausentes, que tal vez no lleguen a casa a salvo. Este punto se trató en las letras de las canciones, que no obstante ser trilladas resultaron muy emotivas en la expresión de lo difícil que es aguardar el regreso de sus héroes y rogar por sus vidas. Sin embargo, en las letras nunca manifestaron duda o cuestionamiento alguno acerca de la guerra, tampoco mencionaron la política y la gente detrás de ella. En cambio, uno pudo sentir el apoyo mutuo y sincero que estas familias se han brindado las unas a las otras, y la certeza de que la guerra ha unido, en lugar de dividir, a esta pequeña, y no obstante profundamente afectada, parte de la población.

Mary-Kay Lombino es curadora Emily Hargroves Fisher '57 y Richard B. Fisher en el Frances Lehman Loeb Art Center, Vassar College. Lombino fue invitada a la presentación del Coro de Murphy Canyon *por la artista. Vive en Poughkeepsie, Nueva York.*

Torolab

Comisión cancelada

Cuando por primera vez se invitó a Torolab a participar con una propuesta de arquitectura efímera para crear el centro de información de **inSite_05** en Tijuana éste era todavía un colectivo, esencialmente conformado por el arquitecto Raúl Cárdenas y la diseñadora Marcela Guadiana. Poco tiempo después, terminada la relación profesional entre ambos, Cárdenas seguiría solo con el proyecto, al detentar el *copyright* artístico de Torolab. En marzo de 2004, Torolab elaboró una primera propuesta para el *infoSite* en Tijuana. Presentada como animación tridimensional, ésta resultaba un atractivo divertimento visual, con un fabuloso potencial como programa de atracción pública. La inclusión de una pista de patinaje a cielo abierto durante el verano en

Tijuana, la magnificencia volumétrica de un edificio seis veces mayor a lo considerado y una tecnología estructural sofisticada de andamiajes curvos —inexistente en el área y entonces aún no presupuestada—, anunciaban ya que el impulso utópico de la propuesta, y la congratulación de su imaginario, opacarían la consideración básica de que el objetivo de la comisión era que ésta ocurriese como un hecho arquitectónico: es decir, que **inSite_05** tuviese un centro de información abierto al público el día de su inauguración en Tijuana. Ya con otro grupo de colaboradores, Toro-lab presentó una segunda propuesta consistente en el uso de múltiples *containers* sobrepuestos para albergar las funciones del programa, conectados entre sí por rampas exteriores. La propuesta, aunque reformulada y después vuelta a reformular, se mantenía carente de funcionalidad y de viabilidad financiera, y su presentación —todavía anclada en el aliento utópico de la propuesta inicial— prescindía de cualquier verificación técnica y de la información constructiva necesaria. De marzo de 2004 y hasta febrero de 2005 —un año cargado de compromisos internacionales para Cárdenas—, las posibilidades de obtener un proyecto que rebasara la promesa de un dibujo esmerado se vieron finalmente agotadas. Hacia finales de mayo de 2005, a menos de tres meses de la inauguración de **inSite_05**, y ante la emergencia de carecer aún de un proyecto ejecutivo a presentar a los constructores, el equipo curatorial y los directores de **inSite**, decidieron cancelar la comisión. Consideramos incluir aquí la propuesta inicial de Torolab por parecernos que este libro es un espacio idóneo para compartir el reto de su imaginario.

(Finalmente, el *infoSite* de Tijuana fue concebido, diseñado y entregado como proyecto ejecutivo para su construcción, en un marco límite de dos meses, por el colectivo R_Tj-SD Workshop bajo la dirección del arquitecto Gustavo Lipkau.)

Judi Werthein

Este producto fue manufacturado por trabajadores en China a quienes se les pagó un salario mínimo de 42 dólares por mes y trabajaron 12 horas diarias.

Måns Wrange/ OMBUD

Rumores. Dondequiera que haya personas, también habrá rumores. Los rumores surgen y se difunden cuando la situación no permite que existan entendimiento claro y control. El rumor, entonces, cumple una función para el entendimiento del entorno; esto hace del rumor uno de los medios más efectivos para influenciar a la gente. En consecuencia, los rumores se implementan sistemáticamente en las guerras, en los negocios, en la bolsa de valores, así como en la política. Pero los rumores no sólo son un proceso para comunicar información que no ha sido confirmada, sino que también contribuyen al proceso de construcción del concepto de *nosotros* y de *ellos*. Varios estudios llevados a cabo por científicos sociales sugieren que la mayoría de los rumores son negativos puesto que el acto de atribuir características negativas a personas fuera del grupo social contribuye al desarrollo de una imagen positiva del propio grupo, y como resultado, los rumores generalmente refuerzan la percepción de diferencia entre grupos étnicos, culturales o socioeconómicos. De hecho, los rumores constituyen uno de los factores que más contribuyen a la violencia, el prejuicio y la discriminación. ¿Qué ocurriría si los procesos negativos y destructivos de los rumores se pudieran revertir hacia una fuerza positiva y constructiva?

M.W./ Introducción al video promocional

El fenómeno del mundo pequeño (también conocido como el efecto del mundo pequeño) es la hipótesis que estipula que todas las personas del mundo pueden ser contactadas a través de una pequeña cadena de conocidos sociales. El concepto dio pie a la famosa frase: "seis grados de separación", a partir de un experimento de mundo pequeño llevado a cabo por el psicólogo Stanley Milgram en 1967, en el cual se encontró que dos ciudadanos de los Estados Unidos escogidos al azar estaban vinculados por un promedio de seis conocidos.

M.W./ Propuesta

Desde luego que con una pistola en mi cabeza podría finalizar el proyecto, pero va contra mis principios producir arte para *shows* sólo porque tengo que hacerlo. Debo sentirme motivado y que esto puede alcanzar a mis altos estándares. De cualquier forma, no pierdan la fe. La buena noticia es que tengo otra propuesta que nos está entusiasmando cada vez más. Es el "Plan B" del que les he hablado: *El proyecto del buen rumor*.

M.W./ Correo electrónico/ "Propuesta", 10 de marzo de 2005

Con frecuencia los rumores sirven como ventana para asomarse a los miedos, ansiedades y sentimientos que subyacen en una comunidad [...] Con frecuencia es el rumor lo que genera causas

y motivaciones incorrectas, alimenta percepciones erróneas e intensifica conflictos [...] El gobierno de los EU reconoció el poder destructivo de rumores generados en el interior del país durante la Segunda Guerra Mundial, y activamente buscó monitorearlos y controlarlos. Establecieron la Oficina de Hechos y Figuras, la Oficina de Información Bélica, e incluso dedicaron partes de los mensajes radiofónicos de la Presidencia para emitir información y producir publicaciones como "antídotos" al rumor. Estas oficinas llevaron a cabo investigaciones encubiertas para encontrar las fuentes de rumores particularmente maliciosos. Clínicas privadas de rumores, consistentes en su mayoría en artículos recurrentes de revistas o periódicos, también se implementaron para refutar rumores. (Allport y Postman, 1947.) Seguir el desarrollo de rumores, ya sean sembrados o nacidos espontáneamente, es imperativo si han de detectarse operaciones de propaganda y tomarse medidas efectivas para contrarrestarlas.

Capitán Stephanie Kelle/ *Rumors in Iraq: A Guide to Winning Hearts and Minds*

Lo cierto es que en un universo de medios que sigue fracturándose en segmentos cada vez más finos, los consumidores son más y más difíciles de alcanzar; algunos pueden usar TiVo para bloquear anuncios o el control remoto de la TV para alejarlos de ellos, y el resto está simplemente demasiado saturado de mensajes comerciales para absorber uno más. Así, corporaciones estancadas en los límites aparentes del *marketing* "tradicional" están cada vez más abiertas a la estrategia de mercado conocida como *de-boca-en-boca*. Uno de sus resultados es un número cada vez mayor de vendedores que organizan auténticos ejércitos mercenarios de "colocadores de marcas" o "influenciadores" o "grupos callejeros" para ejecutar "programas seminales", "marketing viral", "marketing de guerrilla". Lo que una vez fueron tácticas extremas, ahora son tácticas cada vez más comunes; inclusive ahora hay una Asociación de Marketing de Boca a Boca.

Rob Walker/ "The Hidden (in Plain Sight) Persuaders." *New York Times*

- No debe tener un efecto negativo, sino más bien tener el potencial de generar algo positivo.
- Debe tener un efecto autosatisfactorio de modo que, al diseminarlo, pueda con el tiempo convertirse en realidad.
- No debe ser fácil corroborar si es verdadero, pero al mismo tiempo no debe hacer que la gente se sienta estafada después de que hayamos revelado que se trataba de un experimento social.
- No debe reforzar los estereotipos de la gente de Tijuana y San Diego, sino promover una suerte de parentesco entre Tijuana y San Diego.

M.W./ Correo electrónico/ "los criterios para el rumor", 6 de julio de 2005

El rumor ha sido reconocido como uno de los factores que más contribuyen a la violencia, el prejuicio y la discriminación.

Terry Ann Knopf/ *Rumors, Race and Riot*

Grupo de enfoque en San Diego/ Resultados

Opiniones positivas sobre Tijuana
Muy orientados al núcleo familiar
Concienzudos, muy dedicados
Amistosos, solidarios y hospitalarios, cordiales
Muy aterrizados, sencillos, modestos

Opiniones positivas sobre San Diego
Hay mejores trabajos, mejores opciones de casa y escuela
Más acceso al dinero y más oportunidades
Una gran mezcla de personas, religiones y culturas
No hay discriminación, hay mucha tolerancia
Los salarios son justos
Mejores condiciones de trabajo
Mejor sistema de salud
La gente es honesta
Todos reciben educación
Son frugales, prefieren hacer un trato justo

Opiniones negativas sobre Tijuana
Peligrosa, no hay respeto a las leyes
Hay corrupción policial y política
Las escuelas y los servicios médicos no son tan buenos
como en Estados Unidos
Es sucio
Bajo nivel de vida
Bajo nivel educativo

Opiniones negativas sobre San Diego

Viven de sus privilegios
Arrogantes
No les importan las condiciones de Tijuana
No les interesa mucho ayudar
Los tijuanenses no les gustamos
La vida es muy cara
Son ignorantes sobre Tijuana

Grupo de enfoque en Tijuana/ Resultados

Opiniones positivas sobre San Diego

Son cordiales, educados, más trabajadores
La gente latina viene a Tijuana a visitar a sus parientes y disfrutan mucho
Allá pagan por hora y trabajan mejor
Hay una amistad entre las dos ciudades
No se siente la discriminación
Son muy considerados con los peatones
Hay muy buen nivel de vida

Opiniones positivas sobre Tijuana

Somos hospitalarios, accesibles y muy alegres
Somos más calurosos con amigos y con la familia
Somos buenos para el trabajo duro
Aquí se come mejor
Más barato, las margaritas cuestan un dólar y allá cinco

Opiniones negativas sobre San Diego

Soló vienen a emborracharse
Los oficiales de migración son groseros, en especial los tejanos y los latinos asimilados
Como te ven, te tartan
Son culturalmente ignorantes, no distinguen entre mexicanos, españoles, indígenas. No saben de historia
Son muy individualistas, no les interesan sus propios vecinos
Manipulan las noticias, sólo pasan malas noticias de acá
Son prepotentes e intolerantes
Piensan que nosotros tenemos más necesidad de hablar inglés que ellos de hablar español
Aquí apoyamos a los hijos hasta que se casan, allá ni un vaso de agua les dan después que cumplen los 18 años

Opiniones negativas sobre Tijuana

Piensan que es muy insegura y sucia y que todo es secuestro y drogas
Piensan que México es el de las películas
Nos ven a todos como tontos, pobres, flojos, incultos y corruptos
Creen que únicamente somos buenos para la maquila
Piensan que somos despilfarradores e improvisados
Le tienen miedo hasta a la policia de acá
Tratamos mejor al gringo que a los propios tijuanenses
Los inversionistas tienen miedo de invertir aquí

*Las sesiones de grupos de enfoque fueron comisionadas por **inSite** como parte del proceso de investigación de Måns Wrange. Manuel Chavarin, director de VC Asociados dirigió el grupo de enfoque de Tijuana, y Don Sciglimpaglia, profesor de mercadotecnia en San Diego State University, dirigió el grupo de enfoque de San Diego.

En el prejuicio y los conflictos, los rumores expresan emociones y ansiedades preexistentes, que sin embargo también los alimentan y refuerzan. Los estereotipos no sólo distorsionan la realidad sino que también la crean, encerrando a acusados y acusadores en una prisión muy real de envidia y miedo.

Véronique Campion-Vincent/ *Rumor Mills: The Social Impact of Rumor and Legend*

El proyecto del buen rumor es un experimento que busca invertir el efecto comúnmente negativo de los rumores a partir de la creación de un "buen rumor". Este rumor positivo será sistemáticamente difundido y rastreado en la región fronteriza de San Diego Tijuana.

Antecedentes: De acuerdo con diversos estudios científicos, los rumores a menudo ayudan a desarrollar una imagen propia positiva del grupo social del que se forma parte, al atribuirle características negativas a quienes no pertenecen a él. Como resultado de lo anterior, dichos rumores con frecuencia refuerzan las diferencias que separan a grupos nacionales, étnicos y socioeconómicos, situación que se presenta de manera particular en las zonas fronterizas, tal y como sucede entre México y los Estados Unidos.

Proyecto: *El proyecto del buen rumor* parte de las siguientes interrogantes: ¿Qué sucedería si comenzara a generarse un "buen rumor", positivo, relacionado con los habitantes de Tijuana y de San Diego, que contrastara con los murmullos negativos que normalmente circulan respecto a las poblaciones de ambos lados de la frontera?, y ¿qué ocurriría si dicho rumor fuera construido por las mismas personas que son sujeto del rumor?

Difusión de los rumores: Los dos "buenos rumores" se propagaron de manera sistemática en Tijuana y San Diego, utilizando una estrategia basada en investigaciones sociológicas recientes con respecto a la forma en que ciertas ideas influyentes son difundidas por medio de las redes sociales de la gente. Se contactó a unos cuantos centenares de personas provenientes de todos los niveles de la sociedad y que tienen alguna influencia en sus respectivas redes ciudadanas. Estas personas de influencia social, quienes reciben el nombre de "nodos" en el proyecto, fueron invitadas a colaborar, esparciendo el "buen rumor" entre quienes conforman su red de contactos o grupo social. Asimismo se les pidió convocar a tres personas más a participar como "nodos" y a continuar con la propagación del rumor, induciendo a tres nuevos "nodos", y así sucesivamente. De esta manera, el rumor sería difundido exponencialmente en Tijuana y en San Diego.

Rastreo de los rumores: Finalmente, cada "nodo" debió llenar algunos datos demográficos que aparecen en el portal del proyecto en Internet para estar en posibilidad de rastrear el rumor, tanto de manera geográfica como socioeconómica. Por medio de un sociograma interactivo que se encuentra en dicho portal, los "nodos", al igual que cualquier persona interesada en este proyecto, pueden seguir la forma en que el rumor pasa de persona en persona a lo largo del área fronteriza. Asimismo, se llevarán a cabo investigaciones adicionales en los medios de comunicación, Internet, etcétera, para determinar la manera en que el contenido del rumor se ha ido modificando mientras ha estado en circulación.

M.W./ Introducción a la página *web* de *El proyecto del buen rumor*

...CON TUTTO

Eloisa Haudenschild/ Afterword by the president of the **inSite_05**
Board of Directors/

The most gratifying aspect of **inSite** is the impact it has had on the lives of so many people, an impact that has less to do with the works of art created for each version of the project, and more to do with the sustained, committed presence in the region of so many artists, curators, and intellectuals over an extended period of more than two years. The caliber of these individuals' contribution—their minds, their temperaments—has had an immeasurable influence. **inSite**'s strength stems from that ongoing process of social friction—those friendships and alliances that not only involve professional exchanges, but which shape our points of view, our tastes, and our sense of social/ethical commitment. It is that inspirational power, that is increasingly reaffirmed—even after numerous versions of the project—that continues to amaze me.

It is hard to speak on behalf of a board of directors. It is easy to end up writing an overly formal text full of ready-made and trite phrases. From a personal perspective, however, I would like to say that I am extremely thankful for the way that **inSite** has continually responded to and challenged my need for change, my curiosity, and my sense of surprise. Since my initial involvement in 1993, what has interested me most about **inSite** has been its ever-changing structure, its capacity to open up new interstices between what we understand by "art" and the intricate web of personal experiences that underlie art practice—those located behind its "presence." Between one **inSite** and the next there is another interstice—a lapse or apparent pause in which to rethink the next project, a tabula rasa where it is possible to generate new ideas, new challenges, and engage new artists. That ability to shift, to change, has been a great lesson.

inSite has had a very important educational impact both at a personal and at an institutional level. It has sparked changes that are sometimes imperceptible but nonetheless relevant. In the case of the board of directors, for example, being involved in **inSite** has taught us not only to understand art from a broader perspective, but also even how to put a collection together, and, above all, to consolidate and also re-affirm our commitment as collectors and as philanthropists to the artistic community and to championing public freedoms. This learning process is an integral

part of the ongoing adventure of working within an organization that is always open to new ideas and is not motivated by self-seeking ambitions and personal aggrandizement.

Within a board of directors different models of participation always exist; diverse motivations play out that are always highly personal. A project such as **inSite** necessitates a very unique board of directors. Many members have supported the critical and alternative nature of this project for over a decade. It is not a board where one becomes a member in order to raise one's public profile, or to extend one's influence, stature, or reputation. The profile of our board is very unusual, and that is a great source of pride for us. We are certainly not entrepreneurs seeking to administer culture.

Today our ongoing challenge is to ensure that **inSite** continues to be part of the everyday cultural life of the area. This is an enormous undertaking. Since 1994, when **inSite** first created the largest network of cross-border cultural alliances that has ever existed in San Diego-Tijuana, it made its mark on the history of the region. **inSite** has had an impact not only on the region's cultural agenda, but also on the cultural geography of many institutions on both sides of the border. Sometimes **inSite**'s significance has been marginalized, and a few institutions have overlooked the role the project has played in the border area since 1992. However, many other leading cultural institutions in San Diego and Tijuana have been **inSite**'s invaluable partners, and we have grown together through mutual collaborations and unforgettable experiences. In particular, these institutions include the San Diego Museum of Art, the University of California, San Diego, the Centro Cultural Tijuana, the Athenaeum Music Arts & Library, the Instituto de Cultura de Baja California, and countless other small, community, and non-governmental organizations.

We continue to be very satisfied with the ongoing development of **inSite** and **inSite_05**'s complex, multifarious layers of interpretation and action, and the subtlety of its levels of visibility. Far from intimidating us, it has acted as a stimulus to the entire board of directors. Fortunately, we have always been able to extend support to curators and artists alike and to move **inSite** in whatever direction they have wanted to take it.

As with every version of the project, during **inSite_05** it was very gratifying to see how regional, and even international, confidence in our work has grown. It is also important to recognize the invaluable support extended to us by a number of highly prestigious philanthropic institutions. This growing support is extremely satisfying given the apprehensive response we initially faced when we first began holding residencies for artists and curators in 1994. Since then, we have tried to be very aware of the new situations that each **inSite** creates, through its artists and through its curators. That is exactly where **inSite**'s relevance lies, because each new situation demands that each of us takes on different roles.

It is for all these reasons, and thanks to the generosity of our numerous collaborators, co-participants, and patrons with whom we have shared many pleasurable and challenging experiences, that we are here once again, ready to dive in *con tutto*.

Eloisa Haudenschild *is a major collector of contemporary art and president of the* **inSite_05** *board of directors.*

→ Otras traducciones/ p. 370

inSite_05

inSite_05/ **Conversations**/ Dinner/ Krichman Cuenca Residence/
Pacific Beach, Friday, November 19 @ 6.00PM

**Michael Krichman and Carmen Cuenca and
the Board of Directors of inSite
invite you for dinner and cocktails
to welcome the participants in
Lecture 2 • Dialogue 5 • Dialogue 6
of inSite_05/ Conversations**

Krichman Cuenca Residence 5237 Ocean Breeze Court San Diego, CA 92109

For directions and to RSVP, please contact Maryann at maryann@insite05.org or 619.230.0005 x12.

inSite_05

inSite_05/ Closing Weekend
Dessert, Dancing & Drinks/ Haudenschild Residence/ La Jolla/ Friday, November 11 @ 8:00pm

Eloisa and Chris Haudenschild and the Board of Directors of inSite
invite you to join them for dessert, dancing and drinks
to celebrate Closing Weekend, and thank inSite_05 participants,
collaborators, and supporters.

Haudenschild Residence: 1870 La Jolla Rancho Road, La Jolla, CA 92037
Space is limited. Please RSVP by Tuesday, November 8th to Maryann Moore at maryann@inSite05.org
or 619.230.0005 x 12.

Interventions/ Third Residency/ By Invitation Only/
inSite invites you for
cocktails and a presentation of the artists' extant work/
inSite Office: #710 13th. Street and G. Suite 305. Downtown/ May 25 & 26 @ 6:30 - 9:00 pm >

Intervenciones/ Tercera residencia/ Programa por invitación/
inSite le invita a usted a un coctail con motivo de la presentación
que los artistas de Intervenciones harán de su obra previa/
inSite Office: #710 13th. Street and G. Suite 305. Downtown/ May 25 & 26 @ 6:30 - 9:00 pm

contact: maryann@insite05.org
contacto: papus@insite05.org

inSite_05

inSite_05/ Interventions/ Third residency/
Welcome party/ Home of **Karen & Ed Mercaldo**/ Del Mar/
Sunday May 23 2004 @ 6:00 pm

Karen and Ed Mercaldo and the Board of Directors of inSite
invite you to join them for cocktails and supper to welcome
the inSite_05 Interventions artists for their third residency.

Mercaldo Residence 117 Sixth Street Del Mar CA 92014

For directions and to RSVP, please contact Maryann at maryann@insite05.org or 619.230.0005 x12.

inSite_05

inSite_05/ Interventions/ Closing Lunch/
Home of Lucille & Ron Neeley/ Del Mar/
Saturday May 29 2004 @ 12:00 pm

Lucille and Ron Neeley and the Board of Directors of inSite
invite you to join them for lunch to celebrate the conclusion
of the inSite_05 Interventions third residency.

Please contact Maryann for directions and to RSVP. maryann@insite05.org or 619.230.0005 x12.

inSite_05

inSite_05/ Conversations/ Dinner/
Schoepflin Residence/ La Jolla/
Thursday May 27 2004 @ 7:30 pm

Hans Schoepflin and the Board of Directors of inSite
invite you for dinner and cocktails to welcome
the participants in the second inSite_05 Conversations.

Schoepflin Residence 1326 Murilands Drive La Jolla, CA 92037

For directions and to RSVP please contact Maryann at maryann@insite05.org or 619.230.0005 x12.

Conversations is sponsored by: **BBVA Fundación Bancomer • Panta Rhea Foundation**

TRANSITORY AGENCIES AND SITUATIONAL ENGAGEMENTS: THE ARTIST AS PUBLIC INTERLOCUTOR?

Joshua Decter/ Interlocutor

Find a city. Find myself a city to live in. Talking Heads[1]

We are concerned with the understanding of how cities and societies change on the basis of collective projects and societal conflicts generated through history. Our questions address the issue of how and why the creators challenge the dominants.... Manuel Castells[2]

'Where do I belong?' seems to be the question that plagues so many of the discussions that I participate in. As a constant lament it refers to dislocations felt by displaced subjects towards disrupted histories and to shifting and transient national identities. Irit Rogoff[3]

Where, then, to begin?

Perhaps, with some of the many questions generated by **Interventions**...

For instance, at the theoretical, material, dissolution of (b)orders?

With the vexing issue of how we might begin to trace the repercussions, the reverberations, of creative acts upon the fabric of cities, upon the imaginations of citizens?

Or, prior to that, how it is possible to make a claim for art's material, symbolic, ideological, political, or libidinal viability in relation to mundane life-circumstances? Through the reconsideration of various models of socially responsive practice?

With the disappearance of art's materiality into networked flows of social encounters? Or, the re-distribution of cultural production into the flows of trans-urban environments, through processes of cooperation, collaboration, negotiation, infiltration, and intervention?

Do city-based curatorial initiatives and art projects (whether sponsored by municipalities, private and corporate sources, or synergies between various financial and political supports) function to induce citizens to re-imagine their relationship to lived urban territories?

Alternatively, do we re-start with questions of readership, audience, collaboration, and participation? For instance, what is the readership for this text? Who receives this discourse, and, as reading is always a collaborative act with the author, participates in the construction of its meaning? Who is engaging in this discursive encounter, this imaginary conversation?

→ Otras traducciones/ pp. 352–361

Likewise, what were the audiences for **inSite_05**'s **Interventions**, and how did these receivers collaborate in the formation of possible significations? Perhaps, through a form of participatory spectatorship in the process of encountering the transient events constructed by the participating artists and architects, as these situations unfolded over the course of four weekends from late summer 2005 through late fall 2005?

Those practitioners, curators, organizers, intellectuals, and others who have intervened with such questions probably understand that they, we, are at once privileged and marginalized, relevant and irrelevant (immaterial), safely ensconced and vulnerable, talking to ourselves as much as to others, searching for even a fugitive consequentiality in the face of pressures to behave all-too politely. Yet, are we rehearsing strategies that ensure the exclusivity of our specialized cultural enclave? Or, do we have an unbroken faith that certain artistic practices do, actually, trigger unexpected transformative moments at some point down the line of communicative social encounters, potentially expanding our discursive interactions and publics?

What is this place? Edward Soja[4]

Where to commence, again? At the beach in Playas, outside of Tijuana, on a hot August day, bodies melting in the sun, watching a gringo get shot from a cannon over the dilapidated yet threatening metal fence that separates Mexican sand from US sand, and in the process transecting a group of psychiatric patients staging their version of a political demonstration? Here, perhaps, in Javier Téllez's *One Flew Over the Void (Bala perdida)* project, does the spectacle dissolve into the event, and the event into something more ephemeral—the product of a process that momentarily creates a space of creative impunity, and of ethical inquiry (regarding the nature of Téllez's collaboration with the patients), that is only made possible through a complex network of institutional negotiations and permissions? We all flew over that border on that sun-drenched inaugural afternoon, but did we all land in the safety of a net(work) of spectators?

And so, do we begin with these fecund artistic and situational paradoxes?

With more basic questions concerning the history of site-specificity, artistic engagements with public space and urban social territories, the complexities of artistic research and collaboration, or, the conceptual vicissitudes of process-oriented artworks?

Instead, at a moment of transaction: exchanging a copy of your house key for a stranger's key, releasing your suspicion just long enough to allow the possibility of someone else to transgress your enclave without permissions? To re-imagine, as Paul Ramírez Jonas might have desired for us through his *Mi Casa, Su Casa* project, questions of trust and community. Further, the extent to which the more we securitize the boundaries that putatively separate us from others, whether in terms of official national borders or gated private communities, the more distrust, fear, and suspicion is generated—a potentially endless cycle. For those who exchanged the key of their own domicile for the key of another's home, this symbolic act of trust temporarily suspended this cycle of distrust and fear, a kind of post-utopian rupture, in which normative controls were abandoned, perhaps only to return the next morning.

Do we return to the process of **inSite_05** itself, at that place of continuous interchange between the imagination of artists, architects, local and visiting, an interpenetration of familiarity and the unknown, a commingling of strangers and friends, over a two-year period of research, development, production, articulation, presentation, disappearance, and dissolution?

Or, with what's on television tonight? A soap opera? *Desperate housewives*? *American Idol*? Is it possible that you're viewing a transmission of reflections upon fear? At midnight, the issue of fear re-emerges via a television broadcast, a series of talking-head interviews with citizens of both the Tijuana and San Diego environs, ruminations on a condition that strikes deep at the heart of the border/post-border situation, translated into the discourse of mass media. With *On Translation: Fear/Miedo*, Muntadas posits an interruption in the normative flows of our mainstream infotainment industry, alerting television viewers (by definition, an unpredictable, diverse, and homogenous audience that we often assume, rightly or wrongly, to be passive consumers), about what they might be sublimating before drifting off to sleep, to dream of what they fear the most... the others over the boundary, on that putative other side, in other words, ourselves.

Have we reached a new phase in the development of art and architectural projects that operate on liminal levels, like the production of critical shadows, rumors, distinct urban mythologies, silent resistances?

Transmitting a rumor about one city, or the other city, without recognizing that particle of information as a rumor, yet participating in the circulation and dissemination of the rumor nonetheless. Måns Wrange's *The Good Rumor Project* is an insertion of dual rumors into the stream of transnational communications and miscommunications about Tijuana and San Diego, and might be understood as a way to produce unusual linguistic slippages and spillages, transgressions of stereotypical (rhetorical) representations of urban lives. Language, itself, as a constituent element of public space, a benevolent viral agent infiltrating networks of social exchange.

Re-thinking the potential interconnections between mainstream and critical methods of research, development, implementation, process, production, events, products, and anti-products?

Encountering an unusually designed sneaker while perusing a hip store in downtown San Diego, and, while in the process of deciphering its iconography, you notice that there is a map of the border between Tijuana and San Diego imprinted within the shoe. Judi Werthein's *Brinco*, a sneaker designed as a practical navigation system for border-crossers, and as an index of the globalized relations of labor and production that are ultimately connected to the social, political, and subjective complexities of migration and immigration, gains *ambulatory* symbolic power through its status as a *critical design object* camouflaged as a normative product of consumer society… or is it the other way around? At another location, now in Tijuana, just feet from the border near the dry riverbed, these same shoes are distributed to migrants endeavoring to cross, illegally, into California territory, perhaps for the first time, or perhaps to rejoin their families. What did the migrants make of the sneakers? Will they be empowered through the act of wearing these utilitarian-critical-metaphorical artifacts, or, become actors in a transmission of cultural meanings and values beyond their scope of understanding? And if it is both, and more, aren't such complexities and contradictions truly provocative?

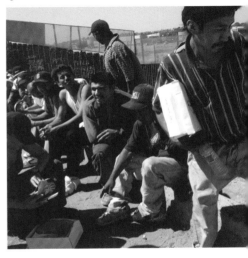

A delicate alteration in the established flows of informal economic systems that already cross-pollinate with official structures…

You might have found yourself just over the border from San Ysidro, within the initial environs of Tijuana, moving through this territory, observing the flow of bodies, goods, transactions, and various economic systems. You might have encountered another kind of "shop" within this strip populated by small entrepreneurial establishments that offer products and services to the pedestrian border-crossers. With *Maleteros*, Mark Bradford effectively negotiated a set of new relationships with people who function as *maleteros* within this zone of informal economies. By modifying a location for the distribution of new shopping carts, and devising a mapping system indicating the multiple nodes and trajectories of economic traffic generated by the *maleteros* (effectively the porters of the border zone), and other official/unofficial figures, Bradford discretely re-inscribed a complex and often invisible set of relations.

… generating a hybridized mesh of economic transactions and social interactions?

Or, in a Tijuana shopping mall, on a warm Saturday evening, you might have been selecting the design for a new shirt, the chosen pattern silk-screened as you waited, within the framework of a temporary outdoor clothing shop? What is this establishment? Is it an entrepreneurial endeavor, a cultural project, or something else? You might have asked related questions encountering the same types of clothing products within the context of a La Jolla clothing store, such as… who produced these designs? This is *The Clothes Shop*, a project by the Tijuana-based Bulbo collective, which has been consistently engaged in the orchestration of events, projects, radio and television shows (among other projects) that respond to the dynamics of youth culture(s) within TJ. For their **Interventions** project, Bulbo developed a complex process of collaboration with individuals from diverse economic and social backgrounds in Tijuana, and worked with them to develop a new line of clothing designs—designs that were arrived at through an indexing, distillation, and translation of observations of particular locations in the city. In a sense, Bulbo, a "localized" cultural collective, became temporarily "de-localized" through their re-inscription within the institutional frame of **inSite_05**, yet the multilayered tactics of their project returned them, in a sense, to local communities.

The codification of languages of cultural representation, literally and symbolically mobilized across diverse neighborhood boundaries, found an energized embodiment in Chris Ferreria's *Some Kindly Monster*. This tricked-out, souped-up, low-rider-inflected, DJ-blasting, ice cream truck functioned as an activator of affiliations and dis-affiliations, a mobile sign of hybridized racial, cultural, and aesthetic conditions.

Here, returning to this textual site, the essay occasionally suggests a subjective pathway through the captivating complexities of **inSite_05**. And so, it seems obligatory to be transparent about the trajectory of my engagement with **Interventions**. In the winter of 2003, at a meeting in New York City, the artistic director of **inSite_05**, Osvaldo Sánchez, first approached me to engage as one of the interlocutors (a phrase that he proposed) for the **Interventions** component of the exhibition. He introduced the basic framework of his methodology in relation to past versions of **inSite**. My interest was activated, yet I didn't entirely understand why he had approached me, a New Yorker, to engage in (post)border artistic engagements within the environs of Tijuana-San Diego. It is from the urban environs of NYC—a city-space that has become the homogenized extrusion of hypostatized late-capitalist desires, perhaps the incarnation of another phase of enlightened decadence that some believe may be a premonitory sign of the decline of this so-called Empire—that I have been embedded within a fabric of contradictory social, ideological, psychological, cultural, and class relationships that cannot be easily sorted out. Sánchez and I would meet again, some months later in Mexico City to continue the discussion, and although it still remained unclear to me as to what **Interventions** would become, I opened myself to the process.

What, precisely, or imprecisely, would it mean to engage with the four other interlocutors—Beverly Adams, Ruth Auerbach, Kellie Jones, and Francesco Pellizzi—in conjunction with Sánchez, the participating artists and architects, the associate curators—Tania Ragasol and Donna Conwell—the executive directors—Michael Krichman and Carmen Cuenca—and others? Interlocution was not a notion that I had previously associated with an exhibition process: my mode of operation had usually been to conceptualize and organize exhibitions, primarily as an independent agent, wherein I privileged the (imagined) uniqueness of my curatorial framework as a means of distinction from the pack. My ambivalence regarding curatorial teams or committees was due to an anxiety of my "authorship" being consumed by bureaucratic protocols, and an uncertainty that anything of quality or relevance could be arrived at through collective decision-making (potentially involving debilitating compromises). Refreshingly, within **Interventions**, the interlocutors were not asked to function as a curatorial team, since Sánchez had already selected the artists, and his associate curators assigned to the participants. Rather, our mode of operation was to offer critical response to the evolution of the artists' and architects' projects for **Interventions**, during late 2004 through 2005. As interlocutors, we were at once inside and outside, within and without, at once complicit and exempt, engaging in subtle navigations through psychological, ideological, linguistic, and cultural territories. I recall that the initial roundtable meeting with some of the **Interventions** artists was characterized by a mixture of skepticism, confusion, curiosity, and good will. We were all somewhat disoriented at that early stage, and the artists perhaps less than enthusiastic that their proposals would be scrutinized by a band of outsiders. Yet on some basic level, the ambiguity of our circumstances was emancipatory, since we were all participating in a new kind of process, more transparent than usual. However, it is important not to overplay the significance of the interlocutors, since our initial contact with the artists was limited, and perhaps gained more traction as the process unfolded, as increased levels of trust were solidified.

According to one dictionary, the word interlocutor has two definitions:
Somebody who takes part in a discussion or conversation/ A performer in a minstrel show who acted as the presenter and stood in the middle and bantered with the end men.

The Oxford Dictionary offers a somewhat more nuanced approach:
Interlocutor, derived from the noun Interlocution, the Latin origin being: interloqui 'interrupt (with speech).'

From Wikipedia, the free encyclopedia:
In colloquial use, an **interlocutor** (IPA: /ɪntəˈlakjutəˌ/) is simply someone taking part in a conversation.

The term also has several other specialized uses: In politics, it describes someone who informally explains the views of a government and also can relay messages back to a government. Unlike a spokesperson, an interlocutor often has no formal position within a government or any formal authority to speak on its behalf, and even when he or she does, everything an interlocutor says is his or her own personal opinion and not the official view of anyone. In music, it was the term for the master of ceremonies in a minstrel show. A blackface character, like the other performers, the interlocutor nonetheless had a somewhat aristocratic demeanor, a "codfish aristocrat." It is also the name given in Scots law to the formal order of the court.

To function as an interlocutor within **inSite_05** required one to become a kind of porous border territory of intermediation: negotiating as much with one's own conflicted perspectives on the viability of art's always tenuous negotiation with social space, politics, as with the doubts, hopes, skepticisms, and idealisms of the other various participants. Not an arbiter, instead a generator of critical feedback, an occasional translator of possible meanings. The interlocutor sessions, which not all of the artists participated in (for logistical reasons due to their residency schedules), generated some truly engaging, and occasionally contentious, moments of discursive interaction—a provocative model for the conceptual development of an exhibition.

At this juncture, it is perhaps requisite to cite a number of the key ideas offered by Sánchez in *Bypass*, what might be characterized as an in-process framework for the **Interventions** project, and which was distributed at a key moment in the develop of **inSite_05**. These textual excerpts are not used here as a litmus test for the relevancy of the curatorial ideas, nor as the criterion against which the adequacy or efficaciousness of the participating artists' response to this framework (or their resistances) will be judged, but rather as a representative index of a strongly articulated curatorial framework:

> Bypass *attempts to envision the city as a social fabric whose survival is dependent upon its flows. As a result, it strives to stimulate novel experiences of public domain and the implementation of alternate modes of citizenship. …*inSite_05*'s artistic essence will reside primarily in revisiting the suitability or pertinence of certain captivating, heuristic, and symbolic strategies that historically have been approached through art and which still constitute what we understand as artistic. These strategies include esthetic representations, environmental experimentation, the dissemination of informational archives, parodies of political events and mass spectacles, models of affiliation and community consensus, records of daily occurrences and cultural resistance, and so on. …Even at the risk of fracturing* inSite*'s a priori identification as a cultural event showcasing legitimate talents, the overarching challenge in* inSite_05 *is to empower each project to suborn, clone, and de-institutionalize these artistic strategies, in order to re-inscribe them as breathtakingly innovative creative experiences with broad anthropological significance. Only in this way can we contribute new channels for the cultural flows that now converge via myriad streambeds to make up the urban social fabric. …When we speak of invisibility, we are referring to that which escapes the corporatization of symbolic cultural values and, ultimately, what today we recognize as "public." The invisible is that which is not embedded in the times and spaces institutionalized by the market, by the public rituals of the State, and by the entertainment industry. …In recent years, a growing number of artists have engaged—usually through processes—from a certain invisibility of daily events, or from the realm of the informal, or from domains that are not recognized as public, or from and for groups that are not easily discernable. These projects, all of them processual, inscribe what is public as an intervention in the temporal, in the evolution of the constitutive process of identity and flow—and not as an intervention in a spatial dimension. Their aim is not to extend the field of representing what is real, but rather to provide new ways of experiencing* the real.[6]

And now, back to the representation of the real through the written word, which is always already a de-representation, it required a few trips out to the con-urban territory of San Diego-Tijuana to become comfortable with the idea of engaging in the **inSite_05** process. In 2003, I participated as a respondent in the **Conversations** event, *Liminal Zones, Coursing Flow*s (with Jordan Crandall, David Harvey, and Ute Meta Bauer), at the Salk Institute in La Jolla. During this trip, a group of us was taken on one of Teddy Cruz's counter-touristic, pedagogical bus tours, which departed from San Diego, traversing interstitial dis-urban territories, through to various zones within Tijuana. This tour (partially reconstructed here by memories at once stable and fragile, materializing and dissolving, perhaps akin to the notion of a post-border condition) had been designed to familiarize those of us who were relatively uninformed, or misinformed, about the architectural, urban, and social conditions of the area.

On the bus, in front of an audience (captive, yes, but curious), including a few of the participating artists, one or two patrons, some cultural intellectuals, **inSite** organizers and others, Cruz delivered, via microphone, a research-laden de-coding of TJ, which also transmitted his political/ethical commitment to developing alternative architectural engagements within this complex and challenging urban territory. At some point in Tijuana, the bus stopped, we were asked to disembark, our gazes directed towards what appeared, at least to me, as a kind of densely organized favela, or shantytown, constructed from materials discarded within, and recycled from, the urban landscape. This was a kind of dilapidated instant-neighborhood, a grouping of informal architectures that constituted an apparently unregulated, and not necessarily sustainable, urban habitat produced through tactics of survival. Predictably enough, I was disturbed not only by the living conditions of the inhabitants, but with my own complicity as an observer of what appeared to be a "third world" environment, at once experiencing the pangs of residual (gringo?) liberal guilt, and confused about what I was supposed to do with this (counter?)-anthropological experience. Take a picture? Could this become one of the potential settings for an artist's **Intervention** within **inSite_05**? The platform of a community-based engagement designed to improve conditions on the ground? Although I was inspired by Cruz's discourse and commitment, I was also skeptical about my own presence in this situation (perhaps typical of a New Yorker's self-protective caution).

So I endeavored to utilize this experience to initiate a process of building an immunity to the creeping disease of demoralization, even cynicism, that afflicts those of us who have begun to lose the capacity to operate beyond our own limited self-interests within the context of the art world. For those of us who have begun to lose the capacity to imagine that art practices, curatorial organization, and related cultural labor might occasionally have the capacity to interrupt the normative patterns of daily human traffic, the habits of mind, even for just a brief moment. To what extent does one's primary locus of habitation inflect upon one's imaginary and practical projection of what is possible… for example, in relation to the potentialities of context-responsive art practices? Ironically, in the mega-metropolis of New York City, it is easy to be cut off from the world, even though there is a persistent belief that New York is the world, and not merely in that quaint historical sense of the grand cosmopolitan blender of multiple immigrant populations, or the postulation that inevitably, everything of cultural importance flows or transits through the urbane filter of NYC.

Within disparate cities in the US such as New York and San Diego (a condition amplified since 9/11), we understand that "public space" has become something of a *readymade* domain: over-regulated, patrolled, increasingly securitized and surveilled, a placeholder for the eventual arrival, or appearance, of what might be described as "public art." These days, there is an excruciatingly careful, tricky, deferential process of negotiation with municipal agencies, political leaders, and private/corporate sponsors that must be cultivated as a prerequisite for gaining temporary or enduring permissions to segments of public space, whether we are referring to public art organizations, or to city-based exhibitions that have utilized the city as a platform for the development of art projects. "Public space," certainly within the US, is normatively defined and identified as an outdoors location (a sidewalk location, a building façade), or an interior space trafficked by numerous pedestrians, that can be made ready to receive either pre-existing, modifiable, or newly commissioned works… putatively "public" artworks. In general terms, the mega-city becomes a platform for the positioning of works within specific urban locations, works which often function as representational signifiers within, and in relation to, an urban-scape. Meaning is generated for, and is transmitted in relation to, citizens (those who comprise multiple "publics"), through encounters with works in the fabric of the city. The encounters constructed for these urban citizens, these average viewers/passersby, are usually passive in character, although opportunities for more "interactive" or "participatory" engagements occasionally arise. The public becomes an audience, perhaps only temporarily, at these encounter-moments, yet is this public-as-audience activated in any substantial way? And, for that matter, where have the spaces for acts of social impunity gone? Do the various forms of "public art," or even socially responsive practices (constructed as they are through a network of obligatory permissions), constitute an imaginary space of impunity… perhaps, vicariously, for the citizen?

And what of the environs of Tijuana, in which questions of space, of publics, might be more complicated, perhaps less regulated, a peculiar interpenetration of formal and informal economies, habitats, legalities, and identities? An opportunity for intervention? The claiming of spaces of impunity, with or without permission? Or, is this the rhetoric of a misguided neo-utopianism?

… complete insubordination to habitual influences … construction of architecture and urbanism that will someday be within the power of everyone. Guy Debord[8]

inSite has functioned, throughout its history, as a nexus through which artists and architects have been given an opportunity to research and develop unusual strategies and tactics of engagement, collaboration, community-based participation, infiltration, and, within the 2005 version, notions of intervention. It can be identified as the only ongoing exhibition event within the United States—or, more specifically, a bi-national, transborder, cooperative event between the US and Mexico—that has remained committed to pushing the envelope on socially based, context-driven, collaboratively oriented practices. And, by logical extension, a commitment to re-testing what constitutes the public's relationship to "public art." For anyone interested in these ongoing debates and discussions surrounding the issue of artmaking in relation to public space, or, to phrase it more conventionally, the historical and contemporary complexities of public art, context-specificity, and social engagement (and to utilize another possible phrase, "contextually responsive" practices), the evolution of **inSite** is paradigmatic. It is tenable to suggest that **inSite_05** was a process that actually began with the first iteration of **inSite** in 1992, and all subsequent versions. I do not wish to overplay the historical perspective, nor seek to downplay the specificity of **inSite_05**, but rather to re-emphasize, for the less initiated reader, the subtle interplay of ideas, methods, politics, identities, commitments, struggles, and achievements that can be identified along this multiyear trajectory. It is not my remit, nor desire here, to reconstruct this history. Rather, I'm proposing that the curatorial framework established for the **Interventions** component of **inSite_05** is, in a refreshingly transparent manner, a reflexive challenge to the precursors (most recently inSITE2000-2001 wherein Sánchez was part of the curatorial team). **inSite_05**'s curatorial statement offers a rigorous rethinking of **inSite**'s relationship to questions of public art, the San Diego-Tijuana border region, site-specificity, community-based cultural production, and the politics of artistic engagement.

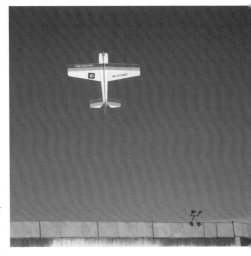

Although the San Diego-Tijuana border environs has been the primary organizing force of previous incarnations of **inSite**, it is with **Interventions** that the border—at least on curatorial-theoretical terms—has become an increasingly figurative presence, an increasingly dematerialized territory of investigation, on both theoretical and practical terms. To invoke a central precept articulated by Sánchez, the emphasis has shifted towards thinking of the con-urban environs of greater Tijuana and San Diego as a *liminal zone* of continuous flows and counter-flows. Although previous iterations of **inSite** had been contingent, to one degree or another, upon a process of research and project development undertaken by artists, architects, and other cultural producers, involving permutations of the **inSite** organization as a commissioner of community-based and context-driven projects, it became apparent that the organizational aim of Sánchez was to amplify the potentiality of process as a curatorial and artistic methodology—even, in a sense, the *process of process*, on both theoretical and practical terms. And, significantly beyond this, to coax the **Interventions** participants to consider the notion of *public as a process*.

…the right to the city is not simply about access to what the city contains. The right to the city is a right to change the city, to transform the city, and it has to be also a right that is inherent. By claiming space in public, by creating public space, social groups themselves become public. David Harvey[9]

The artists and architects who participated in **Interventions** sought to conceptualize and implement unprecedented modes of exploring territorial complexities without offering a *representational fetish* of the border as a literal boundary separating/joining the two nation-states. This is not to suggest, however, that the border is no longer present to us as a demarcated territory, or that it is completely absent from the considerations (and eventual projects) of the participating artists and architects. How could it completely disappear from view, on either theoretical or pragmatic terms? Even those participants who utilized the territory of the border area in a more situationally specific way, such as Téllez's human cannonball event on the beach at Playas, or Gomulicki's radio-controlled flying club demonstration on the Tijuana riverbed, managed to defer from a representational

re-codification of the boundary. How? On one level, quite straightforwardly, by not littering the area, even temporarily, with objects that could be readily, or even fugitively, identifiable as *public art sculptures*. I am thinking, as one example, of Bradford's shopping carts deployed within the San Ysidro area as part of the existing *maleteros* system, Wrange's dissemination of reciprocal good rumors about San Diego and Tijuana through a network of pre-selected groups of individuals (nodes), and Werthein's distribution of utilitarian-aesthetic wearable cultural products designed to agitate.

In relation to Sánchez's curatorial frame (in particular his ruminations on conditions of invisibility and notions of 'public'), one of the more perplexing yet thought-provoking experiences that I can recount concerns the São Paulo-based artist Rubens Mano, a participant in **Interventions**. I encountered Mano only once, at an informal lunch break, on my first journey out to San Diego in 2003 as a respondent for the **Conversations** event. He was engaged in preliminary research for his project, *Visible*, and we exchanged a few pleasantries. After that encounter, both Mano, and his *Visible* project, remained, fundamentally, *invisible* to many of us who sought to locate it as a materialized phenomenon… beyond rumor and innuendo. Invisibility sometimes has a way of generating a certain degree of mystique and intrigue, without question. Mano's project might be emblematic, inadvertently or strategically, of the intriguing contradictions of **Interventions**: an artistic intervention into the liminal territories of the transurban region of Tijuana-San Diego, that virtually disappeared from view. And, in a sense, might have been conceptualized and designed to disappear from the view of normative art-seeking audiences… a type of resistance to visibility that also functioned, metaphorically, as a divergence from institutional visibility, or at least emblematic of an anxiety about institutional affiliation and identification. Was this a planned, strategic disappearance into the liminal social sphere, or a *tactical withdrawal from presence?*

Have we entered the realm of the work of art in the age of *appearances and disappearances*, between visibility and invisibility, re-surfacing and de-surfacing at tactical moments of engagement… and disengagement? When can we consider a project to be developed as a strategy of calculated disappearance? A programmed obsolescence? Yes, perhaps, I am invoking a contradictory scene, in which our desire for art and architecture to have a socially engaged vocation is often thwarted by our own limitations as to what might constitute engagement, or intervention. And, really, what do we want art to accomplish? Is the engineering of a public experience, a social interaction, sufficiently differentiating? Testing, perhaps, the viability of artists and their work to activate new relations (symbolic, material, semiotic, spiritual, ideological) between "people" and their context? Or, are we rehearsing a kind of theoretical and strategic return to that territory of debate that has been raging for at least a century, which perhaps had its most fecund articulation with the protagonists of the Frankfurt School theorists: i.e., the political in relation to the aesthetical, the aesthetical in relation to the political, the politics of aesthetics, and the aestheticization of politics…debates which ultimately addressed notions and strategies of commitment in relation to social, ideological, economic conditions, on both the macro and micro levels?

For **Interventions**, the preferred methods of operation by the artists and architects included: the staging of a transitory event, the cultivation of ephemeral collaboration with citizens on "personal" and "political" levels, the insertion of a linguistic unit into the flow of communication, a participatory inscription into an existing sub-system of commerce and survival, the production of a commodity with dual functions and with multiple ideological identities (depending upon context of usage), such as with Werthein's unprecedented *Brinco* project, the border-crossing shoe that was distributed at disparate socio-economic points in Tijuana (e.g., the Casa del Migrante, the site where the border fence intersects with the Tijuana River, and at a high-end sneaker store in downtown SD). *Brinco* reached its apex of symbolic distribution and exposure as it penetrated the mainstream media, spurring ideological debates on news outlets such as CNN and Fox News at a time of deepening political divisions regarding immigration and the Mexico-US border—a rare instance of art provoking broader publics to critically reflect on a complex human, political, and economic situation.

I often think back upon a remark by Måns Wrange during the first of the Garage Talks (panel discussions with selected **Interventions** artists) that I moderated during the opening weekend in late August 2005. Wrange, in a moment of bemused frustration, alluded to the ubiquity of public space: specifically, that the territory of "white cube" space of the gallery or museum is as much a public space as the street, because there is always a continuous flow of bodies, an interface of definitions (between inside/outside, private/

public, etc.). Wrange was referring to the interstitial character of social spaces, even within the regulated environments of mega-cities. Indeed, Wrange's project for **Interventions**, *The Good Rumor Project*, to a certain extent alludes to this condition, as he utilized notions adapted from 'rumor theory' to develop focus groups in both San Diego and Tijuana to generate a good rumor about each city. Two rumors, apparently circulating through these territories (and perhaps beyond), for nearly one year, with only the participating "nodes" knowing the rumors, and the rest of us perhaps having absorbed the rumors at a liminal level… the invisible contact point between speech acts, social interaction, and the detonation of meaning at the interstitial moments. Wrange selected one "public" location for the visual re-presentation of this conceptually complex yet utterly accessible project: a promotional video document (produced in the style of a corporate or social-scientific report), discretely displayed on the side of a hotel building in downtown San Diego, a gesture in the direction of a didactic projection of the framework of the project into the street: the urban territory conventionally associated with the public space suitable for "public art." But, of course, Wrange's project actually demanded a very different conception and experience of the "public" space wherein "public art" can be conjugated: conjugated, in this instance, through social communication, like a viral mode of contamination, linked to Wrange's judicious application (and testing) of rumor theory. Beyond research, conceptualization, organization, and implementation, this is where the "art" is: at those interstitial moments of contact, within the liminal, beyond appearance, seeking another mode of post-representational economy, somehow enunciated through social flows. Yet I am still in the dark, I remain ignorant of the actuality of these rumors; the information remains withheld, and with the frustration there comes a resignation to the notion that we don't need to know everything, to understand all. Just to smile, and imagine what the rumors might be.

Returning to questions of audience(s), reception, communication, and translation, and to another moment at the initial Garage Talks event, during the opening weekend of **inSite_05**: Paul Ramírez Jonas offered a rather poignant meta-commentary on his presence at this panel discussion, and rather than explaining his project to the audience, he proceeded to articulate, persuasively, that it was not appropriate for him to explain anything to this particular audience, because they were not the intended receivers of his project. This kind of strategic refusal by Ramírez Jonas actually would make more sense to me a few months later, when I finally had an opportunity to witness one of the final presentations of his *Mi Casa, Su Casa* project, which he had been offering at distinct locations throughout the San Diego and Tijuana environs (including, a women's prison in Tijuana). The version I saw was presented at a college in San Diego. Ramírez Jonas presented a sequence of images, discussed issues related to the conceptual development of his project, and then invited the audience that evening (as he had been doing at each of his presentations of *Mi Casa, Su Casa*), to consider giving him a copy of a key to open the door of their home, which he would duplicate immediately on-site, and give to another member of the audience in exchange for the key to unlock a door in their home, and so on and so forth. If one were to engage in this symbolic and actual exchange of keys (as I did), you would receive from the artist a memento, a gift memorializing this unusual contract in trust, an artifact designed by the artist: a key engraved, on one side, with the representation of two hands overlapping, and on the other, two hands holding keys, suggesting the kind of bond of trust established at that moment between two individuals, involving the sharing of instruments to facilitate mutual transition (mutual trespassing) through portals of privacy in the city, suburbia, and beyond. To me, *Mi Casa, Su Casa* is fundamentally about trust, community, security, the safety of the private domain, the regulated conditions of public social space (versus private property, or the ownership of one's space), and how it might be possible to intervene actively in compelling individuals, and by extension, communities, to reconsider their trepidation about the person living next door, across town in another economic enclave, or even on the other side of the border.

I would argue that the projects by Wrange, Ramírez Jonas, Werthein, Bradford, and Mano begin with the premise of the individual as a border that constitutes an aspect of the public, of public territory: the body, the subject, as an interstitial territory that marks a distance between other bodies, subjects, and subjectivities in the realm of "public" interface… which can also be a privatized experience. The border of you as a place of compromise, a zone of negotiation, that facilitates movement across distinct places, other bodies, breaths, odors, politics, ideas, emotions, potentials, representations, silences, disappearances, regulations, impunities. How your own bodily, ideological, linguistic, and other borders rub up against other people's borders in those places of social interpenetration, zones of public and/or private commingling and communication within urban and related environs.

Returning to the Playas location, an art/architecture collaboration re-activates a relatively neglected and disused zone proximate to the border-beach and the bullring, giving various local and regional communities an opportunity to experience this territory as a public recreational garden/parkland. Utilizing indigenous flora, and collaborating with a range of local people, a new kind of access to this specific territory is facilitated by Thomas Glassford and Jose Parral's collaboration, *La esquina/Jardines de Playas de Tijuana*. Framed in relation to the extant context, and thereby re-framing this place, the design is an intervention conceptualized and actualized as a sustainable situation, in terms of environmental issues and public use. An intervention that will undergo transformations and mutations that are not yet clear; hopefully, the project will function as a significant model for how to develop public-use sites in ways that are responsive to distinct constituencies and political/social agendas.

In more general terms, **Interventions** provokes us to think again about the viability of art—whatever art actually is today—to penetrate into the social fabric of life in some deeper, more resoundingly effective way than at any moment previously, perhaps to the extent that it disappears or evaporates into the regulated and unregulated flows of local, regional, and transnational systems. Like a rumor, an urban legend or myth, a whispered possibility, a folkloric narration:

Did you hear about that artist's project, perhaps months after the "show" closed, through mass media networks? Did it navigate the streams of our social unconscious in such a way that we were not even aware that it was in our midst… yet it triggered certain mutations in our patterns?

Imagine parking your rent-a-car in the underground lot of a building in downtown San Diego, noticing, projected just above eye level, images of rolling hills covered with disused cars, or of workers unearthing the floor of a *farmacia* (itself, a set re-created in Fox Studios Baja, a simulation of the real thing, even better than the real thing because it can be subjected to artistic manipulations). Like an unexpected drive-in movie (itself, an almost obsolete form of cinema in the US), the underground garage world of Aernout Mik's *Osmosis and Excess* is surreptitiously transformed into a place wherein filmic narrative triggers reflection upon the subterranean interpenetrations between distinct moments captured from post-agrarian, dis-urban landscapes… at once real and confected. A cinematic return of the repressed, proposing unexpected symbolic flows of topographical-cultural interconnection between the imaginary/real environs of TJ and SD, that, if paying a little attention to their surroundings, any citizen or tourist might encounter on the way to the shopping mall, or a baseball game in downtown SD.

Another location in San Diego: The Airport Lounge, a popular youth-oriented establishment in the city, and an occasional watering hole for the **inSite_05** crew and participants. In the outdoor patio area, where your eyes and ears will inevitably be drawn to the sky every few minutes, as it is directly under the final flight path for airplanes landing at the San Diego airport, a video projection documents a project by Allora & Calzadilla, *Signs Facing the Sky*. The siting of the document is clever, as their project involved the inscription of phrases (collected by the artists during their research conversations with people who live or work in buildings along the airport flight path), on the rooftops of these edifices, visible only to airplane passengers arriving into town. But is the projection at The Airport Lounge a document of this adjusted urban topography, actual evidence of the messages by the city's workers and residents to airborne travelers? Or, does the video function as the conceptual trigger for the hallucination of a possible project in "public space"… beyond the public space of the bar? Or, is the whole thing an elaborate simulation of an unrealized project?

Shifting to the dry bed of the Tijuana River, on a balmy late September afternoon, observing the aerial moves of radio-controlled airplanes designed and choreographed by two flying clubs—one from San Diego, the other from Tijuana. Crisscrossing in the air, the literal and imaginary demarcation line painted across the dry artificial riverbed, with border patrol agents from both countries looking on, perhaps alternatively entertained, perplexed, and anxious. The airplanes might have assumed the role of agents of transgression, but permission was granted as a prerequisite to the staged event, *Aerial Bridge*, and carefully orchestrated by Maurycy Gomulicki. The artist had identified, located, and persuaded the members of these two flying clubs to begin meeting together to discuss their mutual hobbies, develop possible design approaches to the planes, and strategize the orchestration of the event itself. It is the artist's "penetration" into the world of these flyers, the collaborative process that the artist so painstakingly

engineered, the bridge he constructed between the two clubs, that remains the most significant residue. The question remains as to the signifying value of the event itself, beyond transitory spectacle and entertainment; perhaps, as an evidentiary moment, a demonstration that, yes, something sufficiently distinct was enacted here.

And now we have arrived at another bridge, or bridging mechanism, the Puente México, which spans across the Tijuana River, and is a locus of handcraft markets and related small entrepreneurial enterprises for locals and tourists alike. You can have your name embroidered, in short order, by one of these entrepreneurs, and the team of Felipe Barbosa and Rosana Ricalde adopted/adapted this basic element within the urbanscape as the inspiration for their *Hospitality* project, transposing this process onto, quite literally, the surface of Puente México. As the bridge already has a symbolic function as a place of welcome, of transition into Tijuana, the artists gave pedestrians the opportunity to have their names painted onto it, this process eventually generating a kind of linguistic mosaic, a collection of name-traces, of subjects who had crossed through this territory. It remains unknown, at least to me, as to whether my name was ever inscribed there, and it is not relevant. The process, itself, is relevant as an example of basic social transactions with individuals moving through this transitional structure within the city, which established a level of accessible conviviality that inflected this urban node in a poignant manner.

On another pleasant SD afternoon, sitting with other audience members in a building located within a military base in the San Diego area, observing a chorus of women—wives of enlisted men serving in Iraq and other global deployments—as they presented a program of songs of their own composition. Songs dedicated to their husbands, songs celebrating faith and motherhood and marital commitment, songs that signaled an ideological perspective not necessarily consistent with one's own. Althea Thauberger's *Murphy Canyon Choir* delivered rather unexpected, even odd results: as a collaborative, performance-oriented venture, its conceptual premise and process was certainly ambitious, yet I was left wondering whether the artist had erred in not becoming more deeply involved, even as a kind of subtle agitator, in the scripting of these songs. I recognize that Thauberger wished to defer from a strategy that might appear to be agit-prop in an ideologically familiar way, preferring instead a type of authorial invisibility in which she facilitated/orchestrated the "creative" desires of others in a relatively neutral manner, imagining that this would be sufficiently transformative as an experience. However, at the end of this performance, while somewhat empathetic with these women's life-situations, and understanding the difficulty of their positions in relation to military regulations, I found the lack of any, even subtly inscribed, questioning of their own ideological assumptions and belief systems to be unnerving.

In Balboa Park San Diego, deep within the intimate quarters of the Veterans Museum's library, you might have encountered an altered context. Video interviews with selected former servicemen played on monitors, proximate to an illuminated structure that featured an abstracted inventory of ribbons received for combat. Perhaps this was a kind of multimedia social sculpture, functioning as a re-framing device for the inventory of books that had been organized on the library's shelving units. Gonzalo Lebrija's *Heroes of War* endeavored to re-activate a place of commemoration through the active collaboration of men who were a part of US military history, inscribing their subjective recollections (oral histories) into a place of archival/historical memory. From my understanding, this was a difficult process of negotiation and collaboration for Lebrija, due to the complexities of working and communicating with individuals who might have had a different notion of what artmaking should be (perhaps, Thauberger, with her project, encountered similar communicative difficulties). The final "product" of Lebrija's process, at least for me, was actually a declaration of experiential solidarity with these war veterans, reflecting the dignity with which the artist nourished relationships with his collaborators.

In terms of questions of collaboration, on political, ideological, and ethical terms, it might be instructive to consider how Téllez worked with psychiatric patients to develop the pseudo/real political demonstration performed within the *One Flew Over the Void (Bala perdida)* event-project, Thauberger's process of collaboration with the military wives, Lebrija's interlocutions with retired servicemen, Bulbo's creative researches with Tijuana residents, or Wrange's nodes, in relation to Itzel Martínez del Cañizo's approach to the process and language of documentary in *Let the Streets of Tijuana Be Heard*. In her video, del Cañizo creates a framework in which both the technical means of documentation (video cameras) and the scripting of narrative scenarios are handed over to her "subjects": adolescent women in drug-treatment programs, living on the fringes of Tijuana society,

reflecting upon how they did anything and everything to survive, even as they engaged in self-destructive activities. This video reveals the artist's interest in contesting certain traditional methods of documentary production (perhaps, also, a recognition of the deconstruction of documentary that has been ongoing for a number of decades), while also seeking to create a framework in which these marginalized citizens might just be able to articulate some degree of *agency* for themselves, beyond therapeutic catharsis. In other words, to *facilitate* an experience that, perhaps against the odds, might actually generate a productive difference in their daily existence: i.e., a practice of participatory culture as an instrument of benevolent intervention.

Perhaps, it is this effort to generate, or facilitate, some degree of *aesthetic instrumentality* so as to trigger amplified levels of subjective political agency that ultimately connects many of the **Interventions** projects.

So, how to conclude, or, to begin again? With more questions? Maybe, through our engagement with **Interventions**, we are seeking some redemption from the supposed social irrelevance of art, from the anxiety that even as art appears to approach a more intimate "relational" coupling with the real, it slips further away from consequentiality?

Or, with some broader, paradigmatic, questions, such as: What does it mean for artists, today, to "intervene" in public, within public space, in relation to distinct publics? *What is public?* And, why should various 'publics' be interested in an exhibition project such as **Interventions**, beyond the relatively insular contingents of cultural intellectuals and producers who have become engaged with the **inSite** milieu? Why should these issues be important for us today, when we could just as easily devote our energy and time to maintaining lifestyle, and seeking investment opportunities? Who do we think we are, anyway, with our claims, petite or grande, for art's potential reconnection with economic, ideological and cultural narratives, and social flows, with the life and death of our cities? What do we want from those publics that might prefer to reject these claims, or to merely ignore them?

A space is genuinely public, as Kevin Lynch once pointed out, only to the extent that it really is openly accessible and welcoming to members of the community that it serves. It must also allow users considerable freedom of assembly and action. And there must be some kind of public control of its use and its transformation over time. William J. Mitchell[10]

We enter into these kinds of ruminations, which are not merely rhetorical, because of a curiosity to test out the possible reconstitution of the artist's civic role.

There is no need to agree upon one definition of the public, of public space, of the social, of engagement, of intervention, of infiltration, or commitment, or struggle. Just to be straightforward about our objectives, desires, limitations, dreams, pragmatics, and the many complexities and contradictions encountered along the path of most resistance. Of course, if one believes that it is necessary to apply pressure upon habits of mind, upon conventions of idea and action, resistances should be anticipated, if not welcomed.

Yet we need to be realistic about what and who our various audiences and/or publics are, while seeking connections to the imaginations of broader constituencies, come what may.

Perhaps, to re-mobilize our artistic, cultural, and intellectual activities as a force of reconnection, but not necessarily reconciliation, with ideologically disparate audiences, publics, receivers. A new ethics of engagement might seem reactionary, particularly if we still endorse the notion that artists have the capacity, perhaps even the responsibility, of blasting ethical considerations. Yet what is the alternative?

One of my general concerns has been, throughout my involvement with **Interventions**, the always vexing question of how to connect the dots, so to speak, between these artistic/architectural interventions, the attendant range of theoretical discourses that constitute the intellectual framework on the border/post-border condition, and those diverse audiences/constituencies that might constitute something called *a public*. This relation seems quite unpredictable, difficult to "map," impossible to control, or dangerous to anticipate. But how might we speak more effectively across the discursive borders in relation to how **inSite** performs itself, so to

speak, for multiple publics? What of the various audiences, publics, constituencies—what is their relationship to these kinds of discourses and practices? How to find ways to effectively translate certain kinds of complex projects to the citizens of a given city, or to the cultural tourists who fly in for a few days? Not a new issue, certainly, and one which often gets left behind, perhaps, as a result of a frustration with not being able to discern the "effect" of artistic/cultural interventions. Should we endeavor to further develop this skill-set, in order to gain a better, and more realistic, understanding of the consequences of our activities, our commitments? Are such questions too "pragmatic"? Did **Interventions** function as a tool in this process, as a platform for the initiation of such questions?

I would propose that **inSite** in general, and **Interventions** in particular, gained its primary agency in terms of the question of how it might still be possible to be committed in today's art culture, to continuously reinvent a political agency. **Interventions**, ultimately, was an exhibition project that generated more questions than answers, revealing itself to be a living contradiction, in the best possible sense. A dense network of interrelationships, provoking a re-engagement with questions of the commitment of cultural workers (by this I refer to artists, curators, architects, intellectuals, organizers, activists, etc.), asking us to reflect upon contemporary artmaking as a form of agency for networking into/with/through social and political systems. Rather than merely paying lip service to questions and complexities concerning the ongoing redefinition of the already contested province of "public art," the function and role of artists as producers of *platforms* and *situations* that test new possible relations between artwork and receiver (or, between artwork and receiver in a participatory/collaborative process of meaning), and the dynamics of art practices dematerializing and rematerializing within domains of social life, **Interventions** pushed the envelope for all of us who were involved.

Ultimately, all of our nuanced discourses, best intentions, ethical reflections, moral dilemmas, strategic and tactical choices, and real and apparent ideological and political commitments, must be tested out in terms of our actions in the social realm of the city, on the streets, in daily encounters, in other moments of urban interface… even with others who may not share our values, ideologies, aspirations, or, our contradictions. As cultural producers, do we need to be on the front lines of social struggles, or testing the limits of public space, or the agency of art practices, wherever this might take us? I've asked myself such questions, again and again, particularly since assisting, in the fall of 2005, with the distribution of Werthein's *Brinco* sneakers to migrants on the Tijuana River, and at La Casa del Migrante. What was I doing in that situation? Functioning as an agent of salutary cultural intervention, or participating in an action of unknown consequences?

I have included this passage as a way of suggesting that the issues, art practices, cultural engagements, and questions generated during **Interventions** do find their points of connection and convergence, indirectly and directly, with other geopolitical situations—including, and beyond, border/post-border locations. **inSite**, as an evolving idea and organization, demonstrates that it is possible to be creative and responsible in bringing together artists, architects, curators, intellectuals, and others to re-imagine notions of public and the urban through interconnections between local, regional, national, and global phenomena. Further, that **inSite** has the capacity to develop an even broader network of individuals (a distributed community), who ask difficult questions, seek new forms of cultural agency, and engage as interlocutors with, potentially, new publics.

What is next then? What would be the shape of things to come? Could the Israeli and the Palestinian territories —already approaching world record densities—remain as they are: frontiers without borders? Would the viscous Garden-State of yesterday's nationalism finally become the solid City-State of tomorrow's globalism—imploding rather than exploding? Zvi Efrat[11]

Joshua Decter *is a curator and critic currently serving on the graduate faculty of the Center for Curatorial Studies at Bard College. He is based in New York. Decter acted as an Interlocutor for* **Interventions**, **inSite_05**.

1 Talking Heads, "Cities," 1979.
2 Manuel Castells, *The City and the Grassroots: A Cross-Cultural Theory of Urban Social Movements*, 1984.
3 Irit Rogoff, *Terra Infirma: Geography's Visual Culture*, 2000.
4 Edward Soja, *Postmodern Geographies: The Reassertion of Space in Critical Social Theory*, 1989.
5 Paul Virilio, *The Fire Tomorrow*, 1985.
6 Osvaldo Sánchez, *Bypass*, curatorial statement for **inSite_05**, 2003.
7 Michael Dear and Gustavo Leclerc, *Postborder City: Cultural Spaces of Bajalta California*, 2003.
8 Guy Debord, *Introduction to a Critique of Urban Geography*, 1955.
9 David Harvey, *Dialogue 1: Liminal Zones/ Coursing Flows*, **Conversations**, **inSite_05**, 2004, p. 47
10 William J. Mitchell, *City of Bits*, MIT Press, 1995.
11 Zvi Efrat, *borderlinedisorder*, 2002.

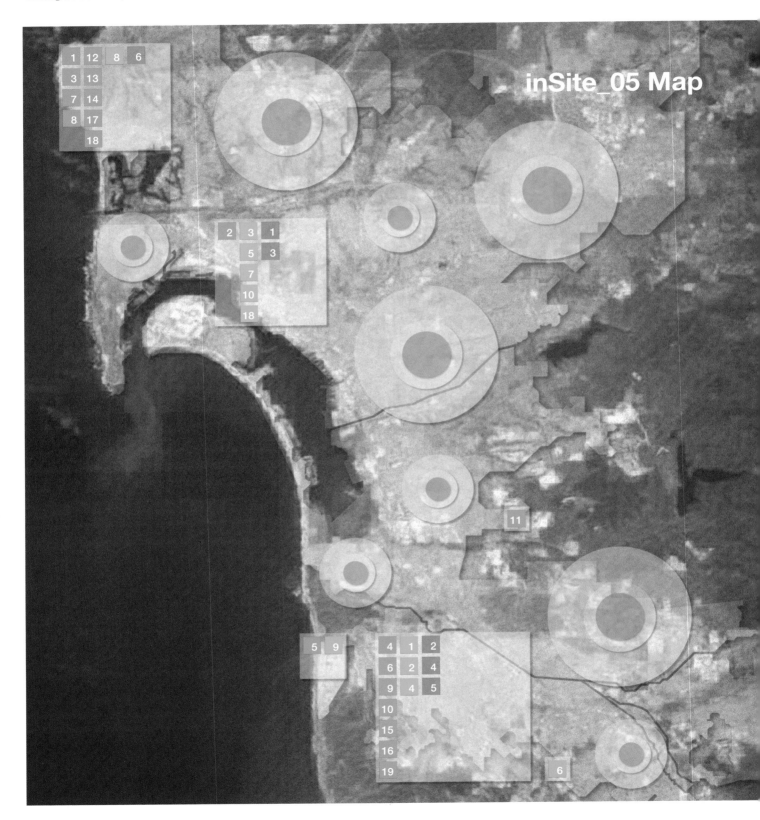

inSite_05 Map

Events> Eventos

August> Agosto

25

1 ● **Interventions> Intervenciones/** João Louro/ *The Jewel: In God We Trust*/ Store> Tienda: Ferrari-Maserati of Southern California, La Jolla/ Cocktail> Cóctel

26

2 ● **Conversations> Conversaciones/** Teddy Cruz • Jens Hoffman • Roberto Tejada/ Museum of Photographic Arts, Balboa Park, San Diego

3 ● **Interventions> Intervenciones/** João Louro/ *The Jewel: In God We Trust*/ Private Auction> Subasta privada

27

4 ● **Interventions> Intervenciones/** Itzel Martínez del Cañizo/ *Que suene la calle*/ CECUT, Tijuana/ Premiere> Estreno

5 ● **Interventions> Intervenciones/** Javier Téllez/ *One Flew Over the Void (Bala perdida)*/ Playas de Tijuana (Close to the lighthouse> Junto al faro), Tijuana/ Event> Evento

28

6 ● **Interventions> Intervenciones/** Chris Ferreria • DJ Marlino/ *Some Kindly Monster> Un cierto monstruo amable*/ CECUT, Tijuana

7 ● **Conversations> Conversaciones/** Garage Talks> Charlas de garage/ Private Residence> Residencia privada

September> Septiembre

23

8 ● **Conversations> Conversaciones/** Dialogues> Diálogos/ Athenaeum Music & Arts Library, La Jolla

24

9 ● **Interventions> Intervenciones/** Maurycy Gomulicki/ *Aerial Bridge> Puente aéreo*/ Zona Río, Puente México, Plaza Viva Tijuana, Tijuana

10 ● **Scenarios> Escenarios/** *Ellipsis> Elipsis*/ Hans Fjellestad • Liisa Lounila • Magaly Ponce • Damon Holzborn • Iván Díaz Robledo/ Ex-hipódromo Caliente, Tijuana

25

11 ● **Interventions> Intervenciones/** Althea Thauberger/ *Murphy Canyon Choir> Coro de Murphy Canyon*/ Jean Farb Middle School, San Diego

12 ● **Conversations> Conversaciones/** Garage Talks> Charlas de garage/ Private Residence> Residencia privada

October> Octubre

21

13 ● **Conversations> Conversaciones/** Dialogues> Diálogos/ Daniel Joseph Martinez • Julie Mehretu • Sam Durant • Steve McQueen/ Hojel Auditorium, Institute of the Americas, UCSD, San Diego

14 ● **Scenarios> Escenarios/** Online Project> Proyecto en red/ *Tijuana Calling*/ Mark Tribe • Luis Hernández • Ricardo Domínguez • Coco Fusco • Anne-Marie Schleiner • Alex Rivera • Fran Ilich • Ángel Nevarez • Ricardo Miranda/ CRCA, Calit2 Auditorium, UCSD, San Diego

22

15 ● **Scenarios> Escenarios/** Online Project> Proyecto en red/ *Tijuana Calling*/ Mark Tribe • Luis Hernández • Ricardo Domínguez • Coco Fusco • Anne-Marie Schleiner • Alex Rivera • Fran Ilich • Ángel Nevarez • Ricardo Miranda/ Instituto de Cultura de Baja California, Tijuana

16 ● **Interventions> Intervenciones/** Itzel Martínez del Cañizo/ *Ciudad recuperación*/ MultiKulti, Cine Bujazán, Tijuana/ Premiere> Estreno

23

17 ● **Conversations> Conversaciones/** Garage Talks> Charlas de garage/ Private Residence> Residencia privada

November> Noviembre

12

18 ● **Conversations> Conversaciones/** Dialogues> Diálogos/ Hojel Auditorium, Institute of the Americas, UCSD, San Diego

13

19 ● **Conversations> Conversaciones/** Dialogues> Diálogos/ CECUT, Tijuana

August 26–November 13> 26 de agosto –13 de noviembre

1 **Felipe Barbosa & Rosana Ricalde/** *Hospitality> Hospitalidad/* Puente México-Plaza Viva Tijuana, Tijuana

2 **Mark Bradford/** *Maleteros/* San Ysidro Port of Entry, (pedestrian crossing areas)> Puerta de San Ysidro, cruces fronterizos peatonales, TJ-San Ysidro

3 **Måns Wrange/** *The Good Rumor Project> El proyecto del buen rumor/* L Street, between 5th & 6th Ave. Downtown, San Diego

4 **SIMPARCH/** *Dirty Water Initiative> Iniciativa del agua sucia/* San Ysidro Port of Entry, (pedestrian crossing corridor to Mexico)> Puerta de San Ysidro, cruce peatonal a México

5 **Jennifer Allora & Guillermo Calzadilla/** *Signs Facing the Sky> Signos mirando el cielo/* The Airport Lounge, Little Italy, San Diego

6 **Josep-maria Martín/** *Commission Cancelled> Comisión cancelada/* Casa YMCA de menores migrantes, Tijuana/ Donation> Donación

7 **Aernout Mik/** *Osmosis and Excess> Ósmosis y exceso/* Parkade 6th Ave., Downtown, San Diego

8 **Bulbo/** *The Clothes Shop> La tienda de ropa/* Pomegranate Boutique, La Jolla, San Diego/ Swap Meet Fundadores, TJ/ Plaza Mundo Divertido, TJ

9 **Jose Parral & Thomas Glassford/** *La esquina/ Jardines de Playas de Tijuana/* Playas de Tijuana, Tijuana

10 **Gonzalo Lebrija/** *Heroes of War> Héroes de guerra/* The Veterans Museum, Balboa Park, San Diego

August 27–November 13> 27 de agosto –13 de noviembre

1 **San Diego Museum of Art/** *infoSite SD/* Teddy Cruz

2 **Centro Cultural Tijuana/** *infoSite TJ/* R_Tj-SD Workshop

3 **San Diego Museum of Art/** Museum Exhibition> Exposición/ *Farsites> Sitios distantes*

4 **Centro Cultural Tijuana/** Museum Exhibition> Exposición/ *Farsites> Sitios distantes*

5 **Centro Cultural Tijuana/** *Mobile_Transborder Archive> Archivo móvil_transfronterizo*

6 **Athenaeum Music & Arts Library/** *Mobile_Transborder Archive> Archivo móvil_transfronterizo*

● **Parking stops and activities** of the *Mobile_Transborder Archive>* **Paradas y actividades de la unidad móvil del** *Archivo móvil_transfronterizo/* Scenarios> Escenarios/ Curator> Curador: Ute Meta Bauer

● **TV Broadcasts> Transmisiones televisivas/** (Tijuana & San Diego)/ Interventions> Intervenciones/ Antoni Muntadas/ *On Translation: Fear/Miedo*

● **Dispersion of visual signs> Flujo de señales/** Tijuana, San Diego/ Interventions> Intervenciones/ Rubens Mano/ *Visible*

● **Free distribution> Entrega gratuita/** Tijuana/ Interventions> Intervenciones/ Judi Werthein/ *Brinco*

● **Presentation of car> Presentación de coche/** San Diego/ **Cash flow> Flujo de efectivo/** Tijuana/ Interventions> Intervenciones/ João Louro/ *The Jewel / In God We Trust*

● **Vehicle-sound unit in permanent circulation with programmed DJ events> Vehículo intervenido con programa sonoro en circulación permanente/** San Diego, Tijuana/ Interventions> Intervenciones/ Chris Ferreria/ *Some Kindly Monster> Un cierto monstruo amable*

● **Lectures by the artist in diverse locations> Charlas con diapositivas en sitios diversos/** San Diego, Tijuana/ Interventions> Intervenciones/ Paul Ramirez Jonas/ *Mi Casa, Su Casa*

● **Live online streaming of workshops> Transmisiones en vivo de los talleres accesibles en línea/** Bulbo/ *The Clothes Shop> La tienda de ropa/* www.latiendaderopa.org

● **Rumor spread through the participation of nodes> Rumor transmitido con la participación de "nodos"/** Måns Wrange/ *The Good Rumor Project> El proyecto del buen rumor*

Opening Weekend
August 25–28
Events

Thursday Aug 25

● 6:00 p.m.–8:00 p.m./ **Interventions:** Preview of the auction component of João Louro's project *The Jewel/ In God We Trust/* Ferrari & Maserati of San Diego/ 7477 Girard Avenue, La Jolla, CA 92037

Friday Aug 26

● 12:00 p.m./ Opening of San Diego *infoSite* (**inSite_05** information center). A project by Teddy Cruz. In front of the San Diego Museum of Art/ 1450 El Prado, Balboa Park, San Diego, CA 92101

● 2:00 p.m.–5:00 p.m./ **Conversations/** Talks and dialogues. Teddy Cruz (architect/ urbanist, UCSD) and Jens Hoffmann (curator, ICA, London). Moderated by Roberto Tejada (professor, UCSD)/ Museum of Photographic Arts/ 6149 El Prado, Balboa Park, San Diego, CA 92101/ **Conversations** were curated by Sally Yard

Saturday Aug 27

● 10:00 a.m.–5:00 p.m./ **Interventions/** Opening of the public phase of the **Interventions** projects in San Diego and Tijuana

● 12:00 p.m./ Opening of Tijuana *infoSite* (**inSite_05** information center). A project by R_Tj-SD Workshop. The Esplanade, Centro Cultural Tijuana, Paseo de los Héroes y Mina, Zona Río, Tijuana

● **Scenarios/** Opening of *Mobile_Transborder Archive/* Exhibition and mobile station on site/ A project curated by Ute Meta Bauer in collaboration with Elke Zobl/ Centro Cultural Tijuana

Saturday Aug 27

● 1:00 p.m.–2:00 p.m./ Premiere of *Que Suene la Calle (Let the Streets of Tijuana be Heard)*, a film by Itzel Martínez. Co-Produced by **inSite_05/** Centro Cultural Tijuana/ Theatre

● 3:30 p.m.–4:30 p.m./ **Interventions/** *One Flew Over the Void (Bala perdida)*, an event-based project by Javier Téllez/ Playas de Tijuana/ On the beach, on the Mexican side of the US-Mexico border fence

● 5:00 p.m./ **Interventions/** Presentation of *La esquina/ Jardines Playas de Tijuana*, an urban renewal project by Thomas Glassford and Jose Parral/ Playas de Tijuana/ At the lighthouse, near the bullring

● 7:30 p.m./ Inauguration of the public phase of **inSite_05/** Centro Cultural Tijuana/ The Esplanade (in front of the Tijuana *infoSite*), Paseo de los Héroes y Mina, Zona Río, Tijuana

● 7:30 p.m.–10:00 p.m./ **Museum Exhibition/** Opening of *Farsites: Urban Crisis and Domestic Symptoms in Recent Contemporary Art/* Curated by Adriano Pedrosa/ Centro Cultural Tijuana

● 8:00 p.m.–9:00 p.m./ **Interventions/** *Some Kindly Monster*, a mobile project by Chris Ferreria (featuring DJ Marlino "da5footafunk")/ Centro Cultural Tijuana/ The Esplanade, Paseo de los Héroes y Mina, Zona Río, Tijuana

Sunday Aug 28

● 12:00 a.m./ **Interventions/** *On Translation: Fear/ Miedo*, a project by Antoni Muntadas, live broadcast, Canal 12, public presentation at Cervecería Tijuana/ Blvd. Fundadores #2951, Col. Juárez

● 10:00 a.m.–5:00 p.m./ **Interventions/** Opening of the public phase of the **Interventions** projects in San Diego and Tijuana

● 10:30 a.m.–12:30 p.m./ **Interventions/** *Garage Talks*, a dialogue with **inSite_05** artists (Måns Wrange, Mark Bradford, Bulbo, Judi Werthein, and Paul Ramírez Jonas) and curatorial interlocutors (Joshua Decter, Beverly Adams, and Ruth Auerbach)/ Haudenschild Residence

● 7:00 p.m.–9:00 p.m./ **Interventions/** *Brinco*, launch of a product-based project by Judi Werthein/ Blends/ 726 Market Street, San Diego, CA 92101

● 9:00 p.m.–12:00 a.m./ Last Call/ Fifty Seven Degrees Wine Bar (no-host)/ 1330 G Street, San Diego, CA 92101

Other Interventions projects to visit in San Diego/

August 26–November 13

● **Allora & Calzadilla/** The Airport Lounge, 2400 India Street, San Diego, CA 92101

● **Aernout Mik/** In the public parking lot of 6th. Ave. between K & L (Parkade), Downtown San Diego. In front of the Omni Hotel

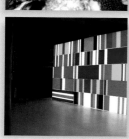

● **Gonzalo Lebrija/** The Veterans Museum, Balboa Park, 2115 Park Boulevard, San Diego, CA 92102

● **Måns Wrange/** L Street, between 6th and 5th, Parkade, Downtown San Diego. The parking lot in front of the Omni Hotel

Other Interventions projects to visit in Tijuana/

August 26–November 13

● **SIMPARCH/** *Dirty Water Initiative/* At the pedestrian crossing from San Ysidro toward Tijuana, past the gate on the left-hand side of the corridor

● **Mark Bradford/** *Maleteros*, a piece in motion, is located at the San Ysidro border crossing. To visit the principal location of this project go straight through the corridor past where SIMPARCH's piece is located. Pass through the turnstile at the end of the corridor, where the yellow cab stop is located, walk left, and look for the pedestrian bridge that extends over the flow of traffic headed toward the United States. At the sidewalk on the other side where the crossing toward the United States is located, you will find (about 100 meters from the crossing line) a space known as "el local de las bicicletas" or the "bicycle shop"

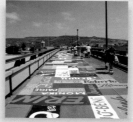

● **Barbosa & Ricalde/** *Hospitality/* Coming back from the *Maleteros* location, go over the bridge, continue walking toward the yellow cab stop, through the parking lot toward a street called Avenida Mazatlan. Cross the street and after about 50 meters you will see the entrance of the commercial plaza known as Plaza Viva Tijuana. Enter the plaza and walk about 100 meters until you reach the bridge that crosses over El Río Tijuana, or the Tijuana River

These 3 projects were located near the border

● **Bulbo/** *The Clothes Shop/* To get to Bulbo's display, first locate the Aguacaliente Tower (la Torre de Aguacaliente) at the Colonia Juarez, and then take the street known as Avenida de la Television, which goes up toward the T.V. tower for Channel 12, Tijuana (Canal 12). It is about 10 minutes in car from the CECUT. Avenida de la televisión #911. Colonia Juárez

● **Casa YMCA/** This project was not completed by the artist. His collaborator, architect Sergio Soto, designed the structure, which was donated to the Casa YMCA. Blvd. Cuauhtémoc Sur #3170, Col. Chula Vista, Tijuana, C.P. 22410

Special Weekend II
September 22–25
Events

Thursday Sep 22

● 5:00 p.m.–6:00 p.m./ San Diego premier of *Que suene la calle* (*Let the Streets of Tijuana be Heard*), a film by Itzel Martínez del Cañizo. Co-Produced by **inSite_05/** Museum of Photographic Arts/ 6149 El Prado, Balboa Park, San Diego, CA 9210

Friday Sep 23

● 2:00 p.m.–5:00 p.m./ **Conversations/** Dialogue/ Kyong Park (artist, architect, and founder of the International Center for Urban Ecology in Detroit) in conversation with Shuddhabrata Sengupta (Member of the Raqs Media Collective, Dehli, India). Moderated by Teddy Cruz (architect/urbanist, UCSD)/ Athenaeum Music & Arts Library/ 1008 Wall Street, La Jolla, CA 92037

● 5:00 p.m.–7:00 p.m./ **Interventions/** Presentation/ Reception for Bulbo's *The Clothes Shop*/ Pomegranate/ 1152 Prospect St., La Jolla, CA 92037

● 6:30 p.m.–8:00 p.m./ **Scenarios/** Opening in San Diego of the *Mobile_Transborder Archive/* Exhibition and mobile station on site/ A project curated by Ute Meta Bauer in collaboration with Elke Zobl/ Athenaeum Music & Arts Library/ 1008 Wall Street, La Jolla, CA 92037

Saturday Sep 24

● 3:00 p.m.–5:00 p.m./ **Interventions/** *Aerial Bridge*, a performance-based project by Maurycy Gomulicki/ Puente México/ Plaza Viva Tijuana

Sunday Sep 25

● 11:00 a.m.–1:00 p.m./ **Interventions/** *Garage Talks*, a dialogue with **inSite_05** artists (Chris Ferreria, Javier Téllez, Maurycy Gomulicki, Itzel Martínez del Cañizo, Hans Fjellestad, and Magaly Ponce). Moderated by **inSite_05** interlocutor Joshua Decter/ Haudenschild Residence

Sunday Sep 25

● 3:00 p.m.–5:00 p.m./ **Interventions/** *Murphy Canyon Choir*, a performance-based project by Althea Thauberger/ Jean Farb Middle School/ Murphy Canyon Youth Center/ 4867 Santo Rd., San Diego, CA 92124

Special Weekend III
October 20–23
Events

Thursday Oct 20

● 7:00 p.m.–8:00 p.m./ **Interventions/** Lecture by Paul Ramírez Jonas as part of the series, *Mi Casa, Su Casa/* Woodbury School of Architecture, Woodbury University/ 1060 8th Ave, Suite 200, San Diego, CA 92101

● 6:00 p.m.–8:00 p.m./ Evening hours for San Diego *infoSite* (**inSite_05** information center). Located in front of the San Diego Museum of Art/ San Diego Museum of Art/ Parking Lot, 1450 El Prado, Balboa Park, San Diego, CA 92101

● 6:00 p.m.–9:00 p.m./ **Museum Exhibition/** Evening viewing in San Diego of *Farsites: Urban Crisis and Domestic Symptoms in Recent Contemporary Art/* San Diego Museum of Art, Balboa Park

● 8:00 p.m.–10:00 p.m./ No-host cocktail reception at Airport Lounge. (Opportunity to view *Signs Facing the Sky*, an **Interventions** project by Allora and Calzadilla)/ 2400 India Street, San Diego, CA 92101

Friday Oct 21

● 2:00 p.m.–4:00 p.m./ **Conversations/** Dialogue/ *Just for the Fun of it, Just for the Sake of it, Live.../* Artists Julie Merhetu, Steve McQueen, and Sam Durant in conversation with Daniel J. Martinez/ Institute of the Americas, Hojel Auditorium/ University of California, San Diego, 10111 North Torrey Pines Road, San Diego, CA 92037

Special Weekend IV
November 11–13
Events

Friday Oct 21

● 5:00 p.m.–7:00 p.m./ **Scenarios/** *Tijuana Calling*, a presentation of commissioned online projects by Ricardo Domínguez & Coco Fusco, Anne-Marie Schleiner & Luis Hernández, Fran Ilich, Ángel Nevarez & Alex Rivera and Ricardo Miranda Zúñiga/ A project curated by Mark Tribe. Event hosted by the Center for Research and Computing in the Arts, UCSD/ University of California, San Diego/ Cal-(IT)2 Building, Engineer's Lane, La Jolla, CA 92093

Saturday Oct 22

● 12:00 p.m.–5:00 p.m./ **Interventions/** *The Clothes Shop*, a project by the Tijuana collective Bulbo commisioned for **inSite_05**, will intervene in the comercial space of Plaza Mundo Divertido on Saturday, October 22/ Plaza Mundo Divertido/ Vía Rápida Pte 15035, Fraccionamiento San José, Desarrollo Urbano Río Tijuana (Stall #89 near the bowling alley "bol-bol")/ From October 22 to November 13, 2005/ Open: Wednesdays, Fridays, Saturdays, and Sundays

● 4:00 p.m.–6:00 p.m./ **Scenarios/** *Tijuana Calling*, a presentation of commissioned online projects by Ricardo Domínguez/ Coco Fusco, Anne-Marie Schleider/ Luis Hernández, Fran Ilich, Ángel Nevarez/ Alex Rivera and Ricardo Miranda Zúñiga/ A project curated by Mark Tribe/ Instituto de Cultura de Baja California/ Av. Centenario 10151, Zona Río, Tijuana

● 8:00 p.m.–9.00 p.m./ **Interventions/** *Ciudad Recuperación (Recovery City)*, premiere of video project by Itzel Martínez del Cañizo/ MultiKulti Cultural Center/ Calle Constitución 1313, entre 6ta. y 7ma, Zona Centro, Tijuana

Sunday Oct 23

● 11:00 a.m.–1:00 p.m./ **Interventions/** *Garage Talks*, a dialogue about the curatorial process of **inSite_05**. Moderated by Sally Stein/ Haudenschild Residence

● 7:00 p.m./ Last Call/ Fifty Seven Degrees Wine Bar (no-host)/ 1330 G Street, San Diego, CA 92101

Friday Nov 11

● 10:30 a.m.–1:00 p.m./ **Conversations/** Dialogue/ *Maximum City, Breathless Reach*/ Suketu Mehta • Vasif Kortun • (moderator) Steve Fagin/ Institute of the Americas, Hojel Auditorium/ University of California, San Diego/ 10111 North Torrey Pines Road, San Diego, CA 92037

● 3:00 p.m.–5:30 p.m./ **Conversations/** Dialogue/ *Reconnoiterings*/ Alison Gingeras • Mark Bradford • Lauri Firstenberg • (moderator) Derrick Cartwright/ Institute of the Americas, Hojel Auditorium/ University of California, San Diego/ 10111 North Torrey Pines Road, San Diego, CA 92037

Saturday Nov 12

● 10:30 a.m.–1:00 p.m./ **Conversations/** Dialogue/ *Encroachments/ Displacements/* Enrique Martin-Moreno • Cuauhtémoc Medina • Gustavo Lipkau • (moderator) Magalí Arriola/ Centro Cultural Tijuana/ Paseo de los Héroes y Mina, Zona Río, Tijuana

● 3:00 p.m.–5:30 p.m./ **Conversations/** Dialogue/ *The Average Citizen and Public Domain: Enclaves and Data-Dreams*/ Maarten Hajer • Måns Wrange • (moderator) José Castillo/ Centro Cultural Tijuana/ Paseo de los Héroes y Mina, Zona Río, Tijuana

[...] nothing is more plausible for those who are free from theories than to be seen by things. [...] In general, or at least originally, he conceives "visibility" as an absolutely reciprocal relation: everything that he sees also sees him. [...] it is part of his unprejudiced conception of the world to consider himself "looked at" by the world.

Günther Anders[1]

THE BORDERS INSIDE
Francesco Pellizzi/ Interlocutor

In the ceremonial hut of the "mushroom-priestess" Doña Apollonia, on Oaxaca's Sierra Mazateca, there were no partitions or separations—all celebrants united as if within a magic circle around the small altar for the night-long joint voyage of spirit-ingestion. In the Cenacolo ("dining-room") of the ex-Nunnery of Santa Apollonia, in Florence, a large fresco by Andrea del Castagno occupies the entire end-wall, representing the Last Supper, decorated by elaborate faux-semblant marble panels and horizontally partitioned by the image of the long dinner table. Sitting at their own communal tables, the nuns would have faced the row of Apostles, Christ in the middle—all except one, Judas Iscariot. The Traitor sits alone in front of the Christ, his back to the room, on the viewer's side of the table, thus partaking of an ambiguous, liminal place, in between the transcendent space-time of the first Eucharist and that of the nuns' worldly meal. He is handsome, upright and assertive, almost appearing to engage Christ in front of him in a "sacra conversazione" impenetrable to the Apostles, as if they were immersed in a collective dream. Judas is our world, facing Christ's other world; but it is also as if he were the only one who truly sees the great divide between these two worlds—not just a follower but a tragic Antagonist, equally bound to a sacrificial destiny. Andrea del Castagno was probably not a Gnostic, yet (perhaps inspired by the Gospel of St. John) he presents us with an image of separation and Betrayal as a constitutive element of the Revelation: Judas is and is not an Apostle, does and does not embrace the divinity of Christ, is and is not an essential instrument of Salvation. In a reversal of the Satanic knowledge of the Fall, which separated Man from God (thus requiring a Covenant), Judas's awareness re-connects them in the fire of Destruction. We—at least in the West—are still also his heirs as part of this Christian world in which the problem of power, newly linked to both a transcendence of the sacred and a cult of worldly governance, is at once upheld and ever skirted. Yet in Chilchotla, with the "Catholic" Doña Apol-

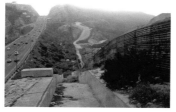

lonia, one still had no sense (in the 1970s) that there was any other power to be reckoned with other than that of the communion within.

An "interlocutor" is expected to insert his words into the pauses and discontinuities of the discourses of others, but I do not view **inSite_05** as an assemblage to be scrutinized through the cracks of its hybrid texture.[2] Thinking back on its long process of development and on the resulting events, what lingers for me are not so much its deliberate discontinuities—despite many high moments of trans-cultural surprise and unexpected encounters—as the sense of an extended network of myriad paths and connections, as if a new artificial nervous system, both artificial and organic, had been extended over the urban/sub-urban SW corner of the United States and the NW corner of Mexico. It was indeed an ambitious effort, delicate and difficult, that sought to escape from all the nationalist (and trans-), globalist (and anti-), localist (and metro-corporative) traps of the ubiquitous metastases of "Biennials," daringly moving its high-wire performance along two tenuous but resilient threads: that of the *border* (which is also a precipice, and *barranca*) and that of the *times* (which is also the encroaching of mediatic events and the wear of oblivion). The pervasive register, however, was that of multiple and varied collisions, whose kaleidoscopic (and even, in a sense, *folkloric*: form-as-mask) flaring-up revealed demo-economic and political dis-placements within a vast settlement texture that are generally hidden behind recent yet already well-entrenched forms of *belonging*—to place, neighborhood, community, language, ethnicity, resources, etc. **in-Site_05** found an improbable, movable ground as in between these determinations—without encouraging self-satisfied evasions, nor, for that matter, ideologically political engagements: This was accomplished by

a circuitous strategy of not trying to hit, penetrate, or remove obstacles (*walls*), but of finding new, alternative pathways—as does our own nervous system when it is obstructed or damaged. **inSite_05** appears to me, in retrospect, as this almost palpable mind that gradually extended the reach of its thought and action, for more than two years, all over the Tijuana-San Diego region, and whose effects will now linger there for quite some time: The urban/sub-urban settlement has no external walls, but the bisecting one in its middle is a membrane against which

"Catholic") than those on the Mexican one: Tijuana may derive its name from the native Yuman language, in which "Tiwan" means "close to the sea," and the city's motto is *Aquí empieza la patria* (The fatherland starts here), which would imply a southward movement quite opposite to the prevalent flow of migrants, though its official translation for tourists is: *Gateway to Mexico* (thus also implying southward movement). Again with reference to southbound tourists given to frequent pendulum-like visits, it is also called *The Most Visited City in the World*, and its border crossing the busiest in the world. Yet, it is also an asymmetrical one: While there is no real obstacle between San Diego/San Ysidro and Tijuana, enclosures of all sorts limit movement in the opposite direction, and even *within* the downtown San Diego region: A gigantic horizontal building, running roughly north-south and parallel to the coastline, like a colossal glass wall, shuts off the harbor from the downtown area. To even see the ocean—which remains in any event unreachable (unlike in Tijuana)—one must climb it by an elevator, or stairs, so as to reach the observation terrace on the opposite side. The highways and throughways that connect, also "north-south," the various parts (one hesitates to call them neighborhoods) of the San Diego region, also appear to function as barriers, as much as arteries, within the urban sprawl.

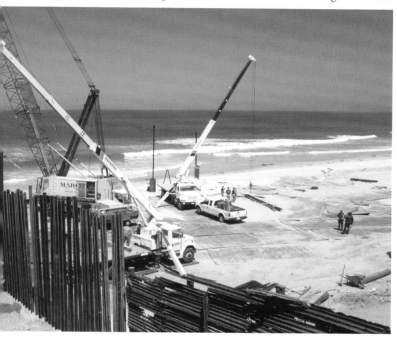

inSite_05—reversing Paul Valéry's image of the relation of profundity to infinity—sought to uncover visible and invisible, self-conscious and spontaneous threads of hidden—or possible—communal life:

> *"Deep thought" is a thought that has the same potency as the sound of a gong in a vaulted hall. It makes perceptible spaces where things one does not see, and perhaps don't even exist, must be; yet, the intensity of that resonance makes them compelling. If the hall were not finite, the sound of the gong would be lost without reflection: There is therefore no depth that might relate to any "infinity."* [3]

Finding the defining limits within such a geographic and socio-political entity, and making them vibrate, has been one of the aims and achievements of the project.

Geographically, **inSite**'s regional setting and operation can also be viewed as having a cross-like structure: There is the "horizontal" axis of a river that is also a barrier (though for the most part without water and closed off by the opposite movement of the surf), and there is the "vertical" movement of roads, migrants, and tourists, which has something of the periodicity of surf and tides. Myriad comings and goings counter the abstract stillness of the border-line. Certainly somebody must have noticed that the names on the American side are often more "Mexican" (that is,

→ Otras traducciones/ pp. 361–367

There is more to any border, and to this one in particular, than unequal flow and national/ethnic discriminations. The logic of the border stands for a questioning of those distinctions as much as for their reaffirmation and enforcement. Border region identities are always in flux between weakening and intensification, negation and boasting—swings one can observe sometimes even over the span of a few hours, as people move back and forth between languages and settings, allegiance and estrangement. Unequal borders—acting more like valves than filters—separate incommensurable entities. One cannot ignore the semi-colonial roots of this urban/sub-urban condition in Southern California, a territory that is in part ex-colonial (in relation to Spain), in part doubly colonial (in relation to both New Spain and the annexation of 1848). Alexandre Kojève reminded us that the true colonial/imperialist relation is the one in which one state/national entity draws from another entity (ethnic, regional, and/or national) more resources than it provides in exchange—something that was not invariably the case in historical settings of foreign domination. But he also proposes, somewhat paradoxically, that the model of "distributive capitalism," as originally promoted, for instance, by the 'capitalist' Henry Ford & Co., is the only true historical fulfillment of Marx's predictions (the Soviet model, to the contrary, being a centralized, "state-bound" one, and hence not truly Marxian).[4] There is a potential tension-contradiction between these two diagnoses—as between an *internal* incremental/distributive model (despite the colossal growth of inequalities, of which we are now witnesses) and an external one of labor and resource exploitation. But in any event the border situation between the United States and Mexico, particularly in

Southern California, maintains a permanent clash between these two configurations, at the same time that it masks and preserves their basic dynamic patterns of interaction. **inSite_05** has chosen to address the underlying causes of this condition by a series of circuitous approaches and revelations: by looking into and approaching them as much from the *inside*—in a sort of local microscopic vision—as, telescopically, from as far away as Scandinavia, South America, New York City, and Canada, articulating a juxtaposition of regionally generated and foreign-inspired interventions towards what could be called a *dis-placed* awareness of its contradictions and intrinsic complexity. As Robert Hullot-Kentor has observed to me, "knowledge of something from within is the emphatic concept of experience," and **inSite_05** has dug into this submerged stratigraphy, bringing to light underlying texts that re-*present* some of the old and new urban mythologies of the frontier's Babelic agglomeration.

But all of **inSite_05**'s works also are, necessarily, "interventions in the temporal," and time is rite: This, in turn, enacts a conscious assumption of the *flow*—private or public, individual or collective. Without "rite" one cannot have chemical reactions or works of any kind, or play of any sort, as all exertion of the "power of play" implies an energetic-ritual investment. Yet, time is invisible, so that the rite is, also, the *visibility* of time. Still, one must always remember that the rite is not, in itself, a spectacle (even less, "entertainment")—it is the *localized* experience of the temporal (but also of the archetypical and the *numinous*). In this sense, the rite has inevitably to do with death—that is, it visualizes the limit. But there are many different "deaths": among others, the one that has to do with "ancestors"—death behind us, or also the memory of death—and the one that *shades* the future. In between this temporal visibility/invisibility of the rite lies a fundamental symbolic knot (in the sense indicated before), which **inSite_05** has unraveled. These are two modes of the temporal always in collision, in our late-modern world, among other reasons because they relate in opposite ways to the *genius loci*: In Southern California this double relation is further complicated by the Great Divide. The ancestors are and are not there, so that it remains problematic and intrinsically un-settled in which vital, and ritual, time the artists of **inSite_05** insert their own *Passagenwerke*, their own ritual *parcours*, through the world of commodities and towards the un-known, *and back* (which is a condition of ritual work). Because this "unknown country" of the frontier is a Purgatory: that of our quasi-sacrificial and re-cognizable urban world. In the modern impossibility to invest this bisected universe with the cosmo-logical circularity of ritual, **inSite_05** sets up networks such as that of the para-messianic *Good Rumor*—invented by a man from Sweden (Måns Wrange)—as a *virtual* anti-rite: the hint, always questionable, always uncertain, of Good Tidings—as impossible as their intentional evidence is *real*. A similar anti-ritualistic, and also *almost* invisible intent can be inferred for the "transversal community" formed, among the daily commuters flowing across the Ti-

juana-San Diego border, by Rubens Mano (from São Paulo). He made many of them wear a *Visible* (and recognizable) sign, to manifest for a specific amount of time precisely their will to *belong* to this *transient*, ephemeral group, thus adopting a "third," artificial identity—neither "here" nor "there"—as an unnamed chapter of **inSite**. Perhaps these "adepts" will generate other adepts, and recognize each other, in a sort of pseudo-cultic chain (possibly extending itself as far and wide as the network of the *Good Rumor*), thus mirroring, in a way, what Carmen Cuenca described to me, while we crossed the border from Tijuana one night, as the uncanny capacity that its American officers have of guessing "who is who" among those driving across from the other side.

In the seeming present impasse about the relevance of object-making in the context of an art-as-commodity market gone wild—probable signal, as so often in the past, of an impending world financial crisis—**inSite_05** has sought to dissolve the fetishistic *objectuality* of the San Diego-Tijuana border. It has extended over and across it a web of indecipherably

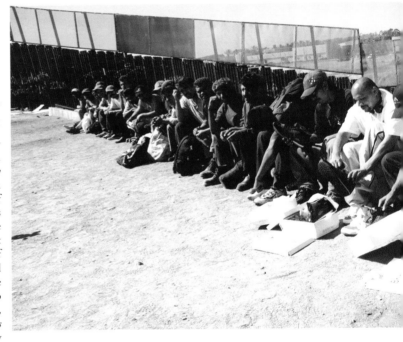

perceptible parallel relations, meant in time to extend their effectiveness over new associative spaces. "A-politically," for the time being, yet against the grain of current political trends, all **inSite_05** works bring into evidence the paradoxically empty and *over-determined* nature of the settlement "corridor" in which they take shape: its late-industrial and post-industrial urban dis-topia, in fact, an *a-topia*, as being uniquely marked by the negative aura and vibration of the barrier *within*. In fact, the border is not a place: It is *non-place* fully charged with un-reality. Yet, again paradoxically, its only intense relational context is with human spaces that connect, intermittently, with this *forbidden* (hence "sacred") limit, which is also, we should not forget, a potential instrument of "sacrifice": If you attempt to get through by force—as Remus did at the foundation of Rome—you get killed. Death always hovers around the sacred, this hypostasis of the separation of inner and outer realms;

but here, what is "inside," and what "outside"? This is one of the key symbolic paradoxes tackled by **inSite_05**.[5]

A Texan from Laredo (Thomas Glassford, now living in Mexico City), who comes from the experience of having also grown up on the "Great Divide," together with a San Diegan of Mexican descendent (Jose Parral), dared to face the *void*, which both separates and connects the two profoundly alien urban sprawls on the edge of the Pacific Ocean. They built a public desert-garden by the Tijuana beach, around a small spiraling construction, with an encompassing view of the ocean and overlooking the recent but already worn-looking border fence delimiting it on the American side. The fence's forbidding function is almost disguised by the sublime veneer of its funky appearance and variegated sea-salt rust. In the middle of this wall, a neatly cut-out window makes it possible to gaze at the border patrols and high-wattage floodlights across, and even to witness—as I did—amorous encounters between couples coming from opposite sides. This is indeed a corner (*La esquina*) of the northwestern world (in the Southwest): Turning from it, one does not find oneself in the Tropics, but either surrounded by slums, *maquiladoras*, and tourist traps, or facing, on the *other side*, the magical mirror-image of a stretch of desert wasteland—looking almost artificial, like those used to isolate and control dangerous beasts in large urban zoos—which is actually the southwest corner of the United States. Thus this *esquina*, created by **inSite_05**, is not just an oasis of leisurely commonality between loci of geopolitical tension, it is a poetic take-over of the *gulf* that is at once opened and bridged by the Great Fence—and hence allegorically akin to pseudo-initiatory late-Renaissance fantasy sculpture gardens, such as Bomarzo, or earlier imaginary alchemical ones, such as the one in the *Hypnoerotomachia Poliphili*. Here the tourist becomes a migrant, and vice versa; but as they dream of exchanging roles, something unexpected may take place—the almost tangible intimation of other voyages....

One can only *dream* of jumping over the Wall; but an Argentinean (Judi Werthein, who lives in Brooklyn, New York) devised—imaginatively and concretely—a pair of shoes, linking the desperate longing for migration, on one side, with the equally desperate conspicuous consumption of fancy exercise gear on the other. Sneaky quasi-illegal gift-giving with all-too-legal custom-made outsourcing. Her *Brinco* sneakers, hand-outs to prospective clandestine migrants, could then be returned by them to the artist, in exchange for double the price that those same sneakers were sold for at a San Diego luxury store. Not a single pair was ever returned: Their magic was more powerful than the value of the money. The work, while providing a sort of tool kit for inter-national trespassing—complete with map, compass, protective saintly icon, and all—is not a manifesto of socio-political propaganda (as it was interpreted by many a hypocritically "outraged" politician and media reporter). It evokes, rather, dire needs and shut-off fulfillment, re-bounding hope and desert desolations, commodious commodity (including that of a *portable* "art object"), and practical mass design. It will from now on be impossible to look at what used to be called "tennis shoes," at and around the border, without gauging the range of their range and *efficacy of use*—real and symbolic—against those of **inSite_05**'s *Brinco*.

Many of the works of **inSite_05** bring the *symbolic* to bear on the *all-too-real* in ways analogous to those of the two just described. And the symbolic itself, within them, consists in the capacity to hold two (or more), often opposite, values into simultaneous evidence, so as to express, by heterogeneous elements, often *un*-speakable contents. These symbolic actions and constructs do not exist per se, in isolation, yet they are ever full of *un*-reasonable and contra-dictory potential, contrasting emotional and speculative identifications, swinging between possibilities that, while remaining incompatible, maintain within each work their balanced ontological intensity. Symbolic thought, here as always, tangibly posits the possibility of the impossible, but also, and with equal force, the present intolerability of the possible. The urban-poetic investment of **inSite_05** is like a multifaceted acknowledgement of what the Italian writer Giorgio Manganelli once alluded to as the archetypical secret language inscribed into the fabric of all cities:

From immemorial time, cities have always been symbol-machines, magical drawings traced on the world's pavement, places which in a texture of streets, hills, consecrated and civilian buildings, told a sacred story.[6]

inSite_05 does not shy away from facing this hidden, or at least for the most part, in-visible sacredness of the border urban environment, injecting in its existing textures new, ad hoc, figurations of emotive and intellective contents, aimed, so to speak, at *re-activating* them. Thus, in the profoundly diffident and even conflictive milieu of the border-crossing, it promoted the "hospitable" intervention of a young Brazilian couple (Felipe Barbosa and Rosana Ricalde). They proceeded to cover a key walking bridge, or overpass, in the Tijuana border area, with the names of countless visitors, inscribed in a rainbow of different colors, just like the name-tags and wrist-bands sold on street stands nearby (but also evoking strips of military decorations). Here, the act of naming oneself, in a sort of concerted and coordinated collective graffitism, counters both the anonymity and impermanence of tourism—or we should now perhaps say, the *permanence* of its impermanence—and the intrinsically transitory nature of the border. At the same time, it also calls attention to it in that the colorful names had already faded from the wear of passage two months after they were painted. Analogously, a Southern Californian (who was raised in Honduras and now lives in New York City, where all and everything must at all times be locked up) has transformed the powerful sign of the house-key into a symbol of potential openness and exchange. "My home is yours" delves into the realm of purity and danger—yet also into the opposite of those decadent and "desperate" suburban games in which keys and spouses are swapped for a night. In these as in several of the other works of **inSite_05**, the symbolic knot consists also of this conjunction of elements at once "highly related" and "unknown to each other." They delineate, in every instance, the confines of a new a-topicality, in a sort of un-learning of the rigidity of existing public/private realms, in order to re-create (i.e., re-learn) them, and of re-connecting them in order to disarticulate (i.e., reveal) them.

A *parody* is an alternate song, or an added poem, that displaces the original content, then creates an interstitial sense, which lies entirely in the relation between the new and the old: In a way, then, it is *nowhere*. But parody, as a parallel text, can reveal the pomposity and congealing seriousness of another text; and there can also be parodies—and quite refreshing ones—of sublime and profound creations of the spirit. As such, parody can be one of the paths around the deadness of existing clusters of relations, uses of physical settings, and social discriminations. While humor runs through **inSite_05** like a subtle, ever-present electric current, making trans-cultural nerves twitch (though without the slightest hint of one-dimensional prankishness), parody was an ever-present *chanson ajoutée*, giving every long-prepared undertaking and every fleeting event a tone and color of lightness: A deadly serious light-heartedness, for sure—like that often displayed by children at play. In **inSite_05** every single work must be taken at face value, quite literally (so to speak), and yet is also alongside of a reality that is all too often hard to believe, when one truly looks at it—as the authors of the **inSite_05 Interventions** do—with unflinching "imagination of gaze" and no "lack of profound distraction."[7]

Years ago, Chris Burden parodied some of the lore and obsessions surrounding the border by throwing little paper airplanes, filled with marijuana (perhaps another name for "Tia Juana"?), from the US side *back* into Mexico: He was highlighting and countering the prevailing flow of

mind-altering paranoia, and thereby also revealing the futility of the colossal control machine that sustains the drug market and its *costs*. Recently, in New York City, a group of Cooper Union students (lead by Jana Leo, a Spanish "architect-philosopher"), dropped hundreds of paper airplanes so they glided down in spirals from the top floor of the central hall in the new MoMA galleries, around Barnett Newman's *Broken Obelisk*—to the consternation of guards and Friday free-admission art devotees and tourists. At **inSite_05**, a Polish man (Maurycy Gomulicki, who lives in Mexico City) brought together two associations of remote-control model-plane builders, who had until then totally ignored even each other's existence, to stage an "air show" inside the dry riverbed along the border that separates their respective communities. Or perhaps we should say that these two clubs of passionate craftsmen, amateur technicians, and *bricoleurs* realized that they belonged to a "community" only in the process of discovering their mirror-image across the gulf of language, traditions, religion, political convictions (or the lack thereof), etc. An anthropologist (such as I am, by training) cannot fail to think of the great number of archaic societies—and even aspects of our modern ones—in which the consciousness of the socius is—often even spatially and visually—defined precisely by the adoption of fundamental dichotomies *and symmetries* as constitutive of the body-public. Here **inSite**'s intervention has in fact *re-enacted* the communal substratum of the border rift by bringing it to the fore into a non-competitive show—and *spectacle*: There was a public of *aficionados*, from both sides—of its intrinsic alienation, thereby also transcending it in celebration and looking forward to future contact and association. And perhaps this is also how rituals—which often involve repetition and refraction of unique events—might still be developed (even in the absence of the divine): not erasing, but voicing, orchestrating, and bringing into

the open—even, as in this instance, *acrobatically*—the hidden closures, and sorceries, of division.

In an analogous way, this is how a South American now living in New York City (Javier Téllez) staged a unique open-air stunt, with the enthusiastic and hyper-sensitive participation of some of Tijuana's *gente tocada* (the expression is of the Mexico City painter Claudia Pérez Pavón)—delicate and fragile guests of a mental ward acting as co-organizers as well as privileged audience and actors in a costumed musical procession and *staging* of the event: This consisted in the propelling of David Smith, a famous circus performer known as the "Human Cannonball," over the "void"—as Téllez called it—of the westernmost extremity (which, as Josef Beuys once noted, looks to the "East") of the most guarded border in the world—from the Mexican onto the American side. It was as much a symbolic *enactment* of bodily trans-lation (in its etymological sense of trans-portation and trans-feral) over the border's void-of-meaning, as the actual intensification, or newly realized fullness of meaning within the psychiatric enclosure, but also a "lost bullet" (*bala perdida*), a one-time flight-without-return that echoed that of emigrants forever unable to go back to their families and roots (and also perhaps, though more remotely, the one-way journeys of also desperate suicide bombers). Here again, the "private" and the "public" were interchanged and subverted. That was done too, though in a more meditative way, by an artist from Guadalajara (Gonzalo Lebrija), who gently penetrated the Veterans Museum and its library, the quiet historical center of the San Diego US Navy base (the largest in the world), and inserted the half-forgotten/half-suppressed memories and narratives of former prisoners of war. These were narratives that the museum administration had not considered worthwhile recounting—perhaps even recollecting—until then—or even that it would be acceptable and significant to make these memories public and share them. In this, as in several other projects of **inSite_05**, a process of practice and awareness was set in motion that is likely to perpetuate itself, reverberating well beyond the space-time limits of the "art-event." This will almost certainly happen in the case of the forlorn spouses of servicemen (and servicewomen) on active war duty with whom an artist from Saskatoon in Canada (Althea Thauberger) gradually instituted, orchestrated, and staged the composition and harmonizing of choral songs from disparate and even discordant private worlds of pain and longing.

Again on the Tijuana side, a young collective called Bulbo, which locally produces programs, publications, and events by various means, took upon itself to address the significance of the fashions of teenagers today—so manipulated and exploited by commercial interests, even, or more so, in the poverty of the border urban environment. But what, they asked themselves, if *designing and making* new clothes became a truly "public" activity, in which people could join them in all aspects and phases of the operation? What sorts of dressing-up (or down) would take place in such an experiment, what sort of objects would be produced, how would they be used and circulated? Would the bodies to be covered become themselves like beacons of the social body at large, carrying

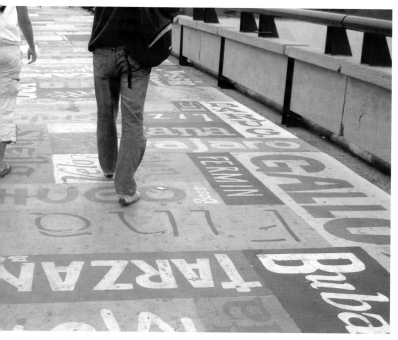

We hear much talk about "re-contextualization" these days, as a panacea to the supposed ills of *globalism*. Yet, the *authentic* never has any need to be re-contextualized, because it is defined and shaped by its own unique *locality*, within and without. And the authentic is simply that which, at any given time and place, is real—and, as such, *necessary*—the way drinking water is: This may have been alluded to by an American collective (SIMPARCH) in collaboration with a Mexican foundation (Fundación Esperanza): Can the critical scarcity of health and hope, so prevalent in the harsh conditions of the border passage, be purified, symbolically, by a sun-distilled flow? In such a life-and-death context *transparency* can perhaps point the way towards a less antiquated humanity:

> *To be able from time to time to enjoy the sky he used a small round mirror. Having clouded it with his breath and then rubbed it against his calf he looked for the constellations. I got it! He cried speaking of the Lyre or the Swan. And often he added that the sky had nothing.*[8]

In the Vedic texts that constitute one of the Indo-European roots of our Western tradition, there appears a word—*loka*—which is said to denote "the world," as something opposite to the domain of the private, and of "the home." It is also the realm of life as it is, as opposed to the normative one of how it should be (*dharma*). In close analogy with the semantic range of the French *monde* it also denotes "the common people," as opposed to "specialists" (for instance, in ancient India, ritual experts and grammarians). I find this old notion relevant to what **inSite_05** is all about, all the more so if one remembers the original sensory connotations of the Vedic term, which referred to the experience of an open space, or "clearing," delimited by the surrounding forest (as in some early Germanic, Latin, and other later cognates) and hence also a place of heightened visibility and "brilliance." In the hybrid landscape of Southern California's gated and un-gated neo-colonial cloisters (or ghettoes?), **inSite_05** has created a constellation of *clearings*, spaces of intense communal clarity, not—principally at least—through the fashioning of objects, or the erection of monuments, but in the mobilization of cohesive forces hidden in the openings, and cracks, of its social forests and their symbols.

home-made (yet communal) fashion out into the open spaces of public interaction? In other words, would the new coverings become an *un-covering* of (barely suspected) cohesive potentials hidden under the cloths of division and convention? **inSite_05** was about generating *operational* questions, and this particular *factura*—or *hechicería*—was accomplished in Tijuana, by the Bulbo members under the mild tutelage of an older, wise pensioner. They move with great ease on both sides of the border and know all there is to know about both regions, and their media-savvy commune (they have their own radio and even TV programs) could *almost* have flourished on either side—but not quite: A distinctive flavor of *poverty-by-choice* suffuses their modest, rambling Mexican headquarters, on the second floor of one of those small cement buildings that looks as if the purity of Modernism had trickled down and been reduced to its simplest possible avatar. But this same spirit of simplicity also sticks to them, individually and together, like a halo, or a protective invisible cloud, wherever they go (even when they must appear in privileged circles on the American side). One must hesitate to speak of "innocence," but there certainly is a quasi-monastic restraint in Bulbo's demeanor, and the sense of unlimited potential one tends to get from (individual and collective) endeavors that are generously expansive while also appearing to find within themselves their own energy and justification.

Francesco Pellizzi *is an anthropologist, writer, and the editor of RES. He is based in New York City and acted as an Interlocutor for* **Interventions***,* **inSite_05.**

1 G. Anders, "1. Considerazioni sull'anima nell'epoca della seconda rivoluzione industriale," *L'uomo é antiquato,* Milano, 2003 (1963), p. 106
2 I wish to thank Gini Alhadeff and Robert Hullot-Kentor for very helpful readings of this essay.
3 Paul Valéry, "Mauvaises Pensées et autres," in *Oeuvres Completes,* II, Paris 1960, p. 797
4 Alexandre Kojève, "Il Colonialismo nella Prospettiva Europea," in *Adelphiana,* 2, Milano 2003, pp. 69–86, passim.
5 One is often brought to think of "symbolic paradoxes" in relation to the various constitutive dimensions of **inSite_05**. My use of the notion is somewhat inspired by the way Wofgang Pauli could speak of the contradiction, in the terms of classical physics, between "frequency" and "energy," and of how it took a long time "to formulate a conceptual system adequate to this paradoxical fact, nonetheless devoid of logical contradictions [...] The 'abstract' mathematical functions of modern physics function in this case as symbols that rejoin the contrast." W. Pauli, "Moderni Esempi di 'Hintergrundsphysik'," in *Psiche e Natura,* Milano 2006, pp. 34–37
6 Giorgio Manganelli, "Cabala Urbanistica," in *L'Isola Pianeta e Altri Settentrioni,* Milano 2006, p. 138
7 Paul Valéry, op. cit., p. 878
8 Samuel Beckett, "Basta," in *Teste-Morte,* Milan 1969 (London 1958, Paris 1965–66), p. 54 (my translation).
9 Charles Malamoud, "Cosmologia prescrittiva: Osservazioni sul mondo e il non-mondo nell'India antica" in *La Danza delle Pietre,* Milano 2005, pp. 185–215

(de)Mapping
Tijuana/ Fiamma Montezemolo

Con lentitud, el mapa se ha librado de los itinerarios
que constituían la razón de su existencia [...] Y de esta manera,
se confronta –en el mismo plano– con otros sitios heterogéneos, algunos de ellos
heredados de esquemas tradicionales y otros más generados por la observación. Sin embargo,
lo más relevante en este caso es la anulación de dichos itinerarios [...]

Al escapar de las totalizaciones imaginarias producidas por el ojo,
lo cotidiano adquiere cierta extrañeza que no aflora, o cuya superficie constituye
el límite más elevado, que lo destaca a sí mismo frente a lo visible. [...] Estas prácticas
en el espacio se refieren a una forma específica de maniobras ("maneras de operar"), es decir, a "otra espacialidad"
que representa una experiencia "antropológica", poética y mítica de ese ámbito, así como a una movilidad oscura y ciega,
característica de la bulliciosa ciudad. Así, una metrópoli de carácter inmigratorio o metafórico
se introduce en el lúcido contexto de la urbe planeada y legible.
Michel de Certeau/ *La práctica de la vida cotidiana*

➔ Información del mapa traducida al español/ pp. 367–370

FECHA 30 de mayo 2006
PACIENTE Tijuana

ꗁLAB

BIO-CARTOGRAPHY OF TIJUANA'S CULTURAL-ARTISTIC SCENE: THE UTERUS AS LIMIT AND/OR POSSIBILITY

Fiamma Montezemolo

The nation (localism) stands forth as the enduring substratum through which individuals are guaranteed a life beyond the purely biological, finite life. This supposed organic power for giving birth is insinuated by the etymological link of the nation (what is local) with "nativity" and "birthing" [my emphasis].

Pheng Cheah[1]

Diagnosis

The Tijuana-uterus suffers from extreme *Topophilia*.[2] This involves the over-protection of the foetus-cultural life of the city, rendering separation from the womb/point of origin impossible. Separation anxiety makes it difficult for the subject to develop her own autonomous identity and her own explanatory cartography. Tijuana is continually described in maternal-patriotic terms: *Tijuana, mother of all frontiers, Here the homeland begins…*This amounts to the substitution of a nationalistic language for a language that is equally embedded in the myth of origins, but also connected to the local. Tijuana is characterized as a "singular" and "nurturing" place as well as an ideal urban model: *TJ is the happiest place in the world; TJ: Shantytowns as the new suburban ideal; TJ: the world capital of television*. Such definitions embody a strategic positioning that is in counterpoint to so-called cannibalistic globalization, and which if employed excessively is in danger of transforming the uterus into a closed box. The Tijuana-uterus becomes a limit rather than a potentiality. If the experience of the uterus is conceptualized as a transitory stage on the path towards life, rather than an end in itself then making the city can also be understood as an ongoing and evolving destiny, a work in progress.

In the case of the Tijuana-uterus the mother does not allow her progeny to separate from her. The offspring idealizes uniqueness (whether it be positive or negative) through hyper-definition: Tijuana is always *the most:* the most visited, the most passed through, the ugliest. Remaining in Tijuana and never leaving is explained in terms of myths constructed about the city's contextual specificity.

Patient Tijuana appears to be suffering from an "exaggeration" of the uterus. This is indicated by how she is described in terms of the myth of origins. As Simon Schama states: "We begin in the uterus, in a place that seems to have comfortable limits and in which we wiggle, knowing what we know. But then there is the place-space distinction, and space frightens all the more because it is more difficult to understand."[3]

The Tijuana-uterus has been transformed into an aesthetic object in order to be utilized by those who do not "belong" to it in the sense of being "originally from"—those who are referred to as *outsiders*. The curators, researchers, and cultural organizers who exalt the uniqueness of the region, in turn, reveal their own desire to be "discoverers" and preservers of the "new native's" creative genius, which is fostered in conditions of material deprivation. A place that has long been marginalized is now provisionally included—as long as it is potentially useful. It is mobilized for, and adjusted to, the ideologies of the moment: globalization-homogenization, the exoticization of the fashionable trend,[4] and the use and abuse of the concept of "authentic" Western civilization.[5] This *Tijuanese* myth may prove useful for the time being, but we can always anticipate a return to "origins," once the myth no longer concurs with the expectations of the *outsiders*.

Where once the "global" was too global now the "local" seems to suffer an excess of localism. Is it possible to stop seeing-using the so-called "third world" as a projection of the frustrations-needs of the so-called "first world" without relegating it to some Rousseaunian ideal or converting it into a homogeneous global entity? Is it possible to cease establishing difference through reference to "authentic" and "original" oppositional categories such as third world/first world, creative/practical, hidden/exposed, inside/outside? Is it possible to imagine a more lucid understanding of distance-proximity, related to Freud's notion of "the uncanny," rather than "the strange" as the synonym of the foreign and the unusual?

Perhaps the time has come for *other* cartographies, detached from mothers/god-mothers and their protections/projections.

1 Pheng Cheah, *Spectral Nationality*, Columbia University Press, 2003.
2 "Topophilia" describes the "affective bond between people and place or setting," and the values of human perception of spatiality (Tuan Yi-Fu, Topophilia: *A Study of Environmental Perceptions, Attitudes, and Values*, Columbia University Press, 1990, p. 4).
3 T. Dean and J. Millar, *Place*, Thames & Hudson, 2005.
4 Antonio Navalón, the Mexican business representative of the Spanish Prisa group, defined local space in order to position it in counterpoint—along with the space of the United States—to the space of "religious fundamentalism": "We are facing a total war among civilizations in which the elements that unite equal or similar civilizations should be more important than the cultural and legalistic fears that separate us. In this respect, the fact that Mexico and the other countries that produce emigrants belong to Western civilization, should bear greater weight than the effort to separate and pit the members of those same communities against one another through abstract fears. The common enemies on the Mexico-US border are those whose religious fundamentalism—pre-supposing the existence of social anarchy in the frontier—leads them to attempt to attack the methods and values common to free and democratic societies…" (Montezemolo-Sanroman, *Replicante*, 2005, p. 44).
5 "A new world. Tijuana is a new cultural Mecca. The city is recognized by a number of publications in the United States, Europe, and Mexico as a vibrant place of artistic innovation. Back in 1989, Néstor García Canclini was already describing Tijuana as 'one of the major post-modern laboratories,' placing it on an equal footing with New York. Since then, journalists, academics, and critics have celebrated the exciting diversity of Tijuana's artistic output." (Rachel Teagle, *Strange New World*, MCASD, 2006).

Fiamma Montezemolo *is an anthropologist and scholar currently working in Tijuana and San Diego.*
Design by Marcela Guadiana

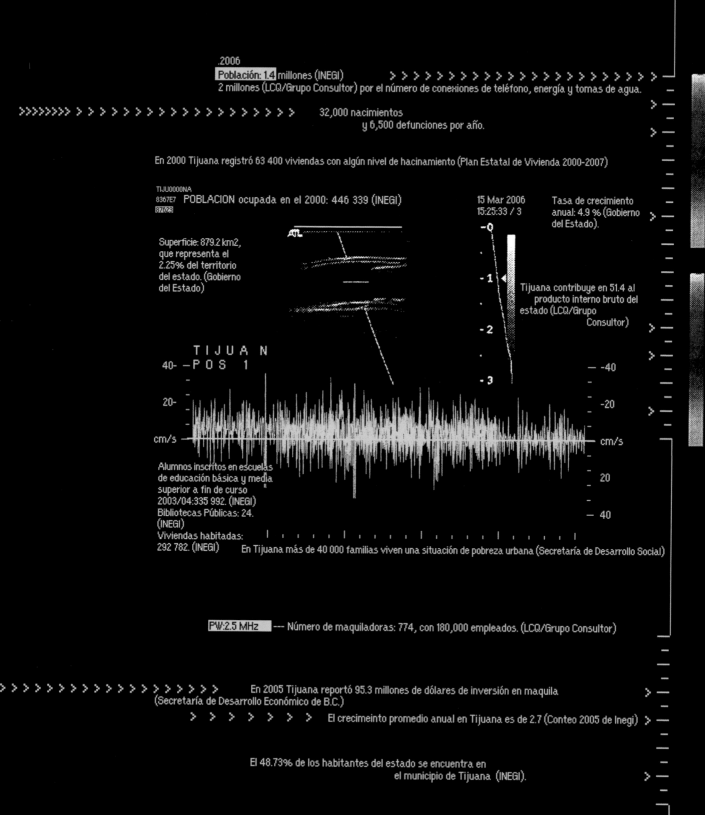

.2006
Población: 1.4 millones (INEGI) >
2 millones (LCQ/Grupo Consultor) por el número de conexiones de teléfono, energía y tomas de agua. >

>>>>>>> 32,000 nacimientos
y 6,500 defunciones por año.

En 2000 Tijuana registró 63 400 viviendas con algún nivel de hacinamiento (Plan Estatal de Vivienda 2000-2007)

TIJU0000NA
8367E7 POBLACION ocupada en el 2000: 446 339 (INEGI) 15 Mar 2006 Tasa de crecimiento
87623 15:25:33 / 3 anual: 4.9 % (Gobierno
 del Estado).
Superficie: 879.2 km2, —0
que representa el
2.25% del territorio Tijuana contribuye en 51.4 al
del estado. (Gobierno —1◄ producto interno bruto del
del Estado) estado (LCQ/Grupo
 Consultor)
 —2

T I J U A N
40- —P O S 1 —3
- — -40
20-
-
cm/s cm/s
Alumnos inscritos en escuelas
de educación básica y media 20
superior a fin de curso
2003/04:335 992. (INEGI)
Bibliotecas Públicas: 24. — 40
(INEGI)
Viviendas habitadas:
292 782. (INEGI) En Tijuana más de 40 000 familias viven una situación de pobreza urbana (Secretaría de Desarrollo Social)

PW:2.5 MHz --- Número de maquiladoras: 774, con 180,000 empleados. (LCQ/Grupo Consultor)

> En 2005 Tijuana reportó 95.3 millones de dólares de inversión en maquila
(Secretaría de Desarrollo Económico de B.C.)

> > > > > > > > El crecimeinto promedio anual en Tijuana es de 2.7 (Conteo 2005 de Inegi) >

El 48.73% de los habitantes del estado se encuentra en
el municipio de Tijuana (INEGI).

Es
la
quinta
cuidad
más
poblada
del
país.

La
tasa
de
desempleo
más
baja
del
país:
0.9 %

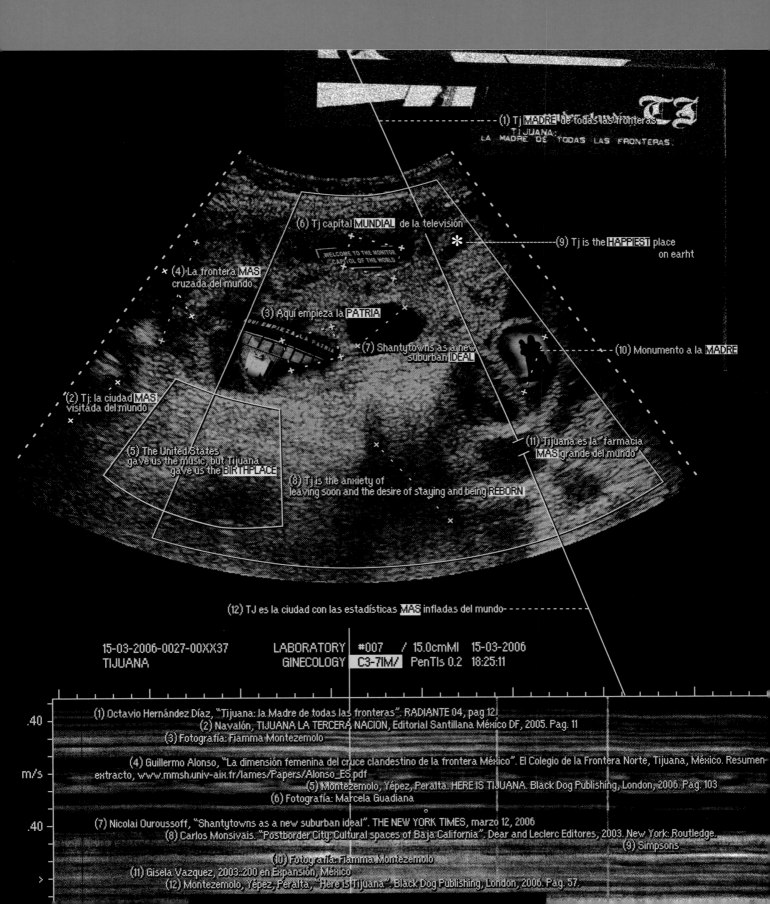

(1) Tj MADRE de todas las fronteras
TIJUANA:
LA MADRE DE TODAS LAS FRONTERAS.

(6) Tj capital MUNDIAL de la televisión

(9) Tj is the HAPPIEST place
on earht

(4) La frontera MAS
cruzada del mundo

WELCOME TO THE MONITOR
CAPITOL OF THE WORLD

(3) Aquí empieza la PATRIA

(7) Shantytowns as a new
suburban IDEAL

(10) Monumento a la MADRE

(2) Tj: la ciudad MAS
visitada del mundo

(5) The United States
gave us the music, but Tijuana
gave us the BIRTHPLACE

(11) Tijuana es la farmacia
MAS grande del mundo

(8) Tj is the anxiety of
leaving soon and the desire of staying and being REBORN

(12) TJ es la ciudad con las estadísticas MAS infladas del mundo

15-03-2006-0027-00XX37 LABORATORY #007 / 15.0cmMI 15-03-2006
TIJUANA GINECOLOGY C3-7IM/ PenTIs 0.2 18:25:11

(1) Octavio Hernández Díaz, "Tijuana: la Madre de todas las fronteras". RADIANTE 04, pag 12.
(2) Navalón, TIJUANA LA TERCERA NACION, Editorial Santillana México DF, 2005. Pag. 11
(3) Fotografía: Fiamma Montezemolo

(4) Guillermo Alonso, "La dimensión femenina del cruce clandestino de la frontera México". El Colegio de la Frontera Norte, Tijuana, México. Resumen-extracto, www.mmsh.univ-aix.fr/lames/Papers/Alonso_ES.pdf
(5) Montezemolo, Yépez, Peralta. HERE IS TIJUANA. Black Dog Publishing, London, 2006. Pág. 103
(6) Fotografía: Marcela Guadiana

(7) Nicolai Ouroussoff, "Shantytowns as a new suburban ideal". THE NEW YORK TIMES, marzo 12, 2006
(8) Carlos Monsivais. "Postborder City: Cultural spaces of Baja California". Dear and Leclerc Editores, 2003. New York: Routledge.
(9) Simpsons
(10) Fotografía: Fiamma Montezemolo
(11) Gisela Vazquez, 2003:200 en Expansión, México
(12) Montezemolo, Yépez, Peralta, "Here is Tijuana". Black Dog Publishing, London, 2006. Pag. 57.

.40

m/s

.40

>

The Garage Talks were conceived as open exchanges among the artists and curators of **Interventions** and publics interested in **inSite_05** projects. These dialogues took place between August and November 2005 at the Haudenschild Garage.

The aim of the Garage Talks was to focus on specific subjects to explore the intellectual challenges and political potential of **inSite_05**. Themes ranged from the difference between audience and public, the process of joint participation as a political construction, non-object based public art, curatorial dynamics and the control of urban space, among others. The texts that follow are edited excerpts of these talks. Above and beyond the digressions that naturally occur in an open forum, these selected fragments serve to enrich our interpretations of the projects and provide us with a more complex overview of the **Interventions**' process.

Garage Talk 1

August 28, 2005

In conversation with:
Omar Foglio/Bulbo, Måns Wrange, Paul Ramírez Jonas, Mark Bradford, Judi Werthein, Ruth Auerbach, Beverly Adams, and Javier Téllez

Moderated by: Joshua Decter

Joshua Decter Interlocutor/ Today, the artists will talk about the working processes that they employed in developing their projects for **inSite_05**, specifically within the framework of **Interventions**. On theoretical and pragmatic terms, questions of intervening in the public domain (however we define the public domain), and the conditions of process itself, have been central for the artists' working methods and project development. I would like to give each of them an opportunity to articulate a narrative based upon their respective processes of conceptualization: for instance, discussing how their projects changed during the course of the residencies, particularly as they transected through, and began to intervene within, the San Diego-Tijuana area. I would also like us to focus upon the processes of discussion and negotiation (even between the artists themselves) that took place over the past three years. In particular, how dynamics of exchange during this period might have contributed to the evolution of specific practices, and to consider the interrelationship between the complexities of the public domain and the dynamics of various types of process. It seems that **inSite_05** has been a transformative experience in terms of the meaning of process for artists, and from speaking with a number of the artists over the past few days, it appears that this context has required them to test the boundaries of their own artistic methodologies.

Omar Foglio/Bulbo Interventions artist/ *The Clothes Shop* is a project that doesn't just involve Bulbo. The people working in the workshop are really the ones making the decisions. Our role is really more that of a facilitator. So the process of what is going to happen is very open. It's up to the workshop participants. We're waiting for them to decide what's going to transpire. We are going to facilitate the creation of a mobile clothes shop that will be set up in four different places: two swap meets (one in San Diego and one in Tijuana), a clothes boutique here in San Diego, and a shopping mall in Tijuana.

Joshua Decter/ Aren't you using the media—radio and TV—to encourage people to come to the workshops? There's an attempt to make the workshops transparent to the public.

Omar Foglio/ The workshops are private, but you can follow the process through the webcast, which goes on each Saturday between 10:00 a.m.–2:00 p.m. Documentation of the workshops will also be available at the mobile shop. We are going to do a lot of promotion for the mobile shop and provide a lot of information about the process.

Joshua Decter/ The **Interventions** artists have in some way re-defined their function as agents of encounters and agents of negotiation. This is particularly evident in the case of Bulbo, where you have completely different individuals working together, who are coming from very different positions and class bases. I imagine that this generated some very unique situations.

Omar Foglio/ Working in Tijuana, I think that this process is something that is very natural for us. That said, *The Clothes Shop* is completely

different from anything we have done before. The experience has been very rewarding for us—there's been a lot of reciprocity in terms of our relationship with the participants. One of the participants is a woman in her fifties who is a designer. Her daughter called us and said that her mother has changed with this project and now she seems much more positive and happy. For us to hear things like that is really great. I can say that we have achieved the goal of the project. We were able to bring people together who did not know each other and who were very different, and we were able to create the conditions for them to work together. That is much more important than the actual "work" that was produced.

Måns Wrange Interventions artist/ When I was invited to participate in **inSite**, I was interested in the relationship between Tijuana and San Diego. I heard a lot of rumors about Tijuana in San Diego, and I wanted to see if there was someway to create a project about rumors. Most of the time, rumors attribute negative characteristics to people who are deemed "other." I was interested in the idea of replicating this by constructing and spreading a rumor, but also in inverting it. I worked with a team of people from Stockholm, San Diego, and Tijuana, and together we formed a strategy to spread the rumor. We targeted people with large social networks in San Diego and Tijuana to help us to spread the rumor. These people, who were termed "nodes," have been spreading the rumor and have also been given the task of recruiting three additional nodes to participate in the project. The nodes are largely people suggested by **inSite** so they have a personal relationship to the project. There is an element of trust. It wouldn't work if we tried to recruit people off the street; there has to be some sort of personal relationship.

Joshua Decter/ Can you tell us the rumor please Måns?

Måns Wrange/ If I told you it wouldn't be a rumor!

Paul Ramírez Jonas Interventions artist/ Måns is denying the audience. Måns is basically saying: "I will not tell you my piece." I've been thinking about this, replaying the infinite series of denials. The curatorial framework of **inSite** has forced us to consider that our "piece" is finally an audience; the exhibition has become an audience. I don't think I honestly want to be an artist today because you are not

the audience of my work. There is an audience out there for my work. I think the problematics of **inSite** is how to frame the projects. Are we going to frame it with the traditional frame of the exhibition?

Joshua Decter/ In some way you are suggesting that each of the projects in its own way constructs a particular audience.

Paul Ramírez Jonas/ Yes, there is a real distance between the audiences the projects are addressing and a traditional art-driven audience.

Joshua Decter/ Måns talked about trust. Your project is also dedicated to the creation of trust. Can you talk about trust in terms of how to not only reach an audience, but also different co-participants and collaborators (bearing in mind that collaborators are really an audience in and of themselves)?

Paul Ramírez Jonas/ I think if you set up a situation where you are successful within the white cube, then you are being successful in "making" the white cube. It was very interesting to see the *Farsites* exhibition opening during the opening weekend. It kind of didn't make sense. I don't know if that was the right approach. If we are going to have a project where you can't really see the pieces we have to reassess how we're going to frame it. I went to see Bulbo's project and I was thinking abut how many people were at the opening at the museum compared to how many people there were at *The Clothes Shop*. It was sort of like the project managed to escape, but audiences still found it easier to access the museum. We still haven't found a way to get that audience away from the museum, not from the museum to Bulbo, but to Bulbo, away from the museum. If only ten people saw the project, what does that mean?

Joshua Decter/ Yesterday I went to visit Mark Bradford's project *Maleteros*. By the time I got there all the carts had been redistributed in Tijuana, but the kind of interaction that Mark was having was quite phenomenal—I had never seen anything like it.

Mark Bradford Interventions artist/ I was trying to be faithful to what I considered the main component of the project: visibility and invisibility. I was interested in power in relation to **inSite**. Actually, for me, **inSite** is a kind of "government" organization in the same way as the US government and the Mexican government. For me the project was the opposite of government power, government projects. I am interested in things that negotiate through and around power. It is really in relation to power that the informal economy of the *maleteros* developed. For the past forty years, the *maleteros* have had to negotiate power. The project had to change because of conditions set either by the Mexican government, the US government, or **inSite**. So there had to be a lot of negotiations along the way, but the project survived nonetheless. From the beginning, I told the *maleteros* that **inSite** was the government with government money. That made sense to them. We had to work with that. I didn't necessarily have all the answers. I just tried to make the whole process as transparent as I could.

I formalized the sites where people always operated informally. So I was "officializing" the site. This could have been a problem because sometimes they wanted to be visible, and sometimes they wanted to be invisible and get on with doing their job under the radar of police and border patrol surveillance.

Judi Werthein Interventions artist/ My project is called *Brinco*. First of all, I am very happy to have had the opportunity to be part of this, and to have the chance to rethink my positions about many things. I decided to develop a project that would intervene on both sides of the border—Tijuana and San Diego. One of the first things that caught my attention was the issue of migration on the Tijuana side and the issue of consumerism and objects of desire on the San Diego side. I created a fictional company, which designed a sneaker specifically designed for undocumented migrants to cross the border. It has all the things that a migrant would need to cross. I did a lot of research with migrants. I spent a lot of time with them, talking to them about their experiences. I also followed a route out into the desert that undocumented migrants use to cross into the US. It was a very intense experience to be in contact with them and to be in the actual physical space where they cross. Through this process, all the ideas for the sneaker came together and I designed it. **inSite** then produced the sneaker in the same way that an American company like Nike or Reebok would. We used a maquiladora in China, mirroring the way that American companies exploit cheap labor over there. We're going to launch the product at 6:30 p.m. tonight and you will be able to purchase the sneaker as a utilitarian "piece" you can wear. The money made from the sales will go back to the migrants. So I invite you all to come later today to Blends—a sneaker store on 10th and Market.

Paul Ramírez Jonas/ I think that it is interesting to think of a certain generation of artists like myself, from the late eighties, early nineties, that really love the work of the seventies that tries to escape from the frame. They were trying to reconcile the exhibition format with works that are immaterial or echoes. In this sense I think that artists are way ahead of the institutions. From Chris Burden on you can see the multitude of solutions artists are trying out. None of them is perfect. In this type of work where you are relinquishing the frame of the institution it is almost more problematic. I think that if you look at different artists and their practices, then you can see the possibility for a solution.

Mark Bradford/ It's almost like there is a desperation that fetishises the solution; I think that the process gets overwhelmed. When I started the project there were a lot of questions. I don't know the solution, I don't know the solution where I end up, but the process in which I am engaged, this is the only thing I belong to. I really don't know what the solution will be, but I know the way of working where engagements are sort of contradictions of the problems. And their awkwardness is true because it sort of has a manifesto of engagement. At the same time you know the project will have a life beyond you. It's going to be in books. It's going to have this other solo life, which will go on and become this sort of symbol of your work. And I don't know how comfortable I am with that but at the same time I want the project to have a life.

Paul Ramírez Jonas/ If you look historically, the artists' process has kind of been opened up. In our studios we had the power not to be transparent. We were geniuses with masterpieces that come out of our studios. How did that happen? I don't know but I think it was quite successful and, if I may suggest, maybe the next thing that needs to be opened up and made transparent is curatorial practice.

Garage Talk 2
September 25, 2005

In conversation with:
Chris Ferreria, Hans Fjellestad, Maurycy
Gomulicki, Javier Téllez, and Itzel Martínez
del Cañizo
Moderated by: Joshua Decter

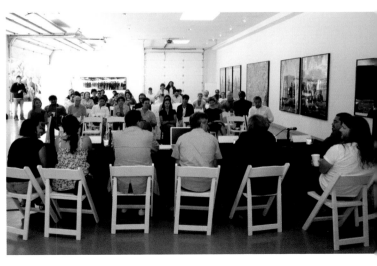

Michael Krichman Co-executive director, inSite_05/ As always I want to begin by thanking our hosts for today, Eloisa and Chris Haudenschild. Thank you very much for making these Garage Talks series possible, and many other events....

Joshua Decter Interlocutor/ Today, the focus of our second Garage Talk will be on issues of audience and publics. This is a topic of vital importance that, I believe, has been a concern of **inSite** since its inception in the early 1990s. The projects developed by all of the artists gathered here today, in one way or another, invoke the question of audience and public. For example, Javier Téllez's and Maurycy Gomulicki's projects reflect upon the question of "event-driven" strategies, in relation to the problematics of spectacle. I would like us to consider distinctions between the event and the spectacle (as distinct modes/languages of practice), and to focus upon what constitutes audience, public interaction, and networks of communication that may, or may not be, generated by these situations. Some questions that I would like the panelists to consider: What are the multiple audiences for **inSite**, and how are audiences created/constructed over the four-month span of the exhibition, perhaps in response to the durational unfolding of distinct artist's projects throughout this period? If this framework is operating to possibly generate new definitions of "public art," obliterating certain conventions and producing new knowledge, do we imagine that new audiences are also being generated—or new conditions of relation between publics, art, and producer? Or, are we somehow just preaching to the converted, and not necessarily constructing new moments of interaction? These are issues pertinent for **inSite**, and also reflect the preoccupation of organizers and artists in other global situations. I recall that during the first Garage Talk, Paul Ramírez Jonas compellingly refused to discuss his **Interventions** project because he claimed that the audience gathered that morning in August were actually not the appropriate receivers for his project. This was not a gratuitous gesture to refuse communication, but rather, I think, a smart tactical move that generated a very engaging and productive discussion on the complexities of audience.

Chris Ferreria Interventions artist/ My project is called *Some Kindly Monster*. Essentially it's a vehicle, which has been modified in divergent ways by two different groups that I invited to participate in the project. In a sense, I am borrowing from the practice of the "exquisite corpse," where you take a blank canvas and different artists contribute their creative talents to it and it unfolds into this weird, funky thing that somehow holds itself together as one body. I borrowed from the language of cars—the car-body becomes almost like a corpse that is somehow beautified, but still quite scary, almost like a monstrous body. At the same time there's something quite beautiful and sublime about it. The project also refers to the cultural practice in the Philippines of using a figurine, which is invested with spiritual and religious power, called the "Santo Ninyo." I wanted to overlap that cultural practice with the exquisite corpse idea and relate that to the car cultures that exist within Southern California. I invited two groups to participate in the project: "Team Hybrid," a Southern California Asian import car crew; I also invited one particular individual, José Ramón García, who is a retired mechanic and truck

driver. He has worked on customizing big trucks—18-wheelers—and modifying hot-rods as well as motorcycles. I wanted to somehow connect these two communities—two car cultures that wouldn't tend to intersect on a personal level. All these individuals are really quite unique in the sense that they brought with them specific narratives that are somehow inline with their particular communities but at the same time they also disrupted the stereotype of that community. Scott Dean was the point person for Team Hybrid. Normally you would think he would be Asian American, but he was a Caucasian. That disrupted that sense of who you would expect to see involved in an Asian import crew. José is a Boricua; he is a Puerto Rican. I thought that was interesting in terms of the Latino narrative of identity, which is very Mexico-US based. I think in response to the question about how collaborators become audiences and audiences become collaborators for myself this was an exercise in letting go of control of the project. I needed to figure out a way of being the mediator of the project. I needed to create a structure within which people could work collaboratively and invest themselves in the project. I see the audience more as the co-creators of the project itself.

Hans Fjellestad Curator of Ellipsis/ When you do this kind of event-based collective performance you generate a lot of adrenaline and enthusiasm. We were still celebrating six hours ago in Tijuana so please bear with me as my vocabulary slowly returns. The project last night was called *Ellipsis* and it referred to the double-center nature of the region, but more importantly to the relationship between audience and performer and the relationship between the space of the event, the history of the space, and the audience and the performer. It dealt with the various layers of interaction that are generated during this kind of complex temporal event. I am a filmmaker and a musician, and maybe that is why I was selected for this experiment. I say "experiment" because the initial idea was to create a spectacle with a different kind of logic than you would expect to see at, for example, the Super Bowl half-time

show or something like that, where the audience is simply reduced to a consumer, everything is reduced to consumerism. The idea that you would enter a space that is pretty much monopolized by sounds and images that the performers are producing with the goal that the audience would have some kind of meaningful input in that environment is challenging. I am not sure what the likelihood of success was, but the experiment was, I think, very interesting and I am very happy with the way it turned out. During the performance, we tried to design a space, both conceptually and technically, where any image, sound, or visual could be anywhere at any given time. Nothing that you saw on the screen that was generated by the digital artists or that you heard from Damon was prepackaged. None of it was automated or preproduced. Every image that was seen was the result of a decision made by one or more of the artists at the moment of the performance. That's not to say that there wasn't a structure and improvisation. In jazz we often look at open-form improvisation as a spontaneous structure. There's really no such thing as unstructured improvisation. There was a structure to this that was somewhere in between an open form, and maybe a graphic score that went from scene to scene to scene. Within the score there was all kinds of improvised material, but you had a certain kind of narrative. Primarily, I felt my job was to take the collective and the individual statements that were made by the artists I was working with and try to sculpt a narrative that made sense, that had a logic over the entire piece. We realized, of course, that the piece would need to make sense in small chunks. The nature of this kind of a party where there's no recital formality, where the audience is roving, and there is even a bar outside the space, is such that it was important to establish a way of engaging with the piece on different levels. We were trying to ensure there could be ten-minute chunks and then thirty-minute chunks and ninety-minute chunks of the whole that could make sense on their own. Another challenge was to avoid creating visual wallpaper, as you might see at a rave or an electronic music club. There you basically just get break-dancer loops and traffic and things like that, but it doesn't necessarily have any kind of direct relationship to the space itself, to what is happening in the space at the time.

Joshua Decter/ What I noticed was that there was such a division of human activity as you moved from the performance venue to other areas of the Caliente Racetrack. I am wondering what you think about these bifurcated or divided social spaces of engagement or disengagement between different communities, and the relationship between a specialized audience and people who were simply casually going there to bet. How did you go about "bridging" those communities?

Hans Fjellestad/ That is another aspect of the double-centered nature of the performance. Some of the material that Ivan brought into the space referenced Caliente's rumored relationship to drug culture and organized crime, but kind of turned it on its head by also suggesting the innocence of a family account. There were lots of different references to street dogs, relating to the greyhounds at the track. That was a kind of a thread throughout the entire piece. We weren't so concerned about guessing what the audience's experience might be because that didn't seem to be all that useful to us.

Joshua Decter/ I am not sure how much this has to do with your conceptualizing process, but the project was illustrative to me of this radical division socially and culturally between audiences. I am talking about audiences and public transiting literally, moving from one space to the other in very close proximity. We have a kind of avant-garde culture in one situation and a betting culture in another, and they are not even interfacing, they are not interacting. It's not a condition you generated in your piece, but it is so emblematic of these dichotomies and gaps in experience. Primarily, I was thinking that we are trying to propose certain ideas about collectivity, participation, and improvisation, but not necessarily trying to offer solutions to create those kinds of bridges.

Maurycy Gomulicki Interventions artist/ Even if **inSite** is not a "political" project, it is located in the intensely politicized context of the border. I have always tried to avoid politics as much as I can so I wasn't sure that I was going to fit into the project. Involving the community was also a very new thing for me. As I started to think about how I could approach the project I started thinking about "common spaces." I am very interested in fantasy and fetish objects as potential activators of reflections and fantasies. I am also interested in different spaces that are related to fantasy and the collective dreaming world. I decided that I would use fantasy as a bridging point because sharing a passion is something that makes us happy and makes us want to live more. I thought about our playground experiences—if we both love fishing we forget about race, we forget about nationality, and so on. The hobby of aerial modeling is very curious because most of the collectors expend a great deal of creative passion and energy collecting the objects of their desire or building models. They invest quite a lot of money on their hobby, which some of them don't have. You can spend half a year building a model plane and it can crash on the first flight. I think that that is very beautiful because it brings the fantasy even more to life. I am very surprised about how often fantasy becomes routine. I also wanted to try to remove people from their routines. That was the most challenging aspect of the project. In this project different things come together: there is the border and then there is the bridge, which is the shared passion for something. There is also the issue of space. For me the experience of space is very important. There is a kind of natural amphitheater in the Tijuana riverbed, which I feel has a great deal of poetic and dramatic potential. It could be a communal meeting space, but instead it is simply a space, which is abandoned, which is left for forgotten souls. I wanted to activate that space. As for working with the pilots, the first step was to gain their trust. In the case of the Mexican pilots there was a more heightened sense of distrust in the beginning, but once I approached them and they started to believe in the project they became 100 percent involved. In the case of the North American pilots it was easier to establish the first contact, but more difficult to stimulate a real working dynamic. This is the experimental part of the project. You realize how lived reality affects people. The fantasies of both the Mexican and American pilots had a childlike quality—the fantasy of the superhero and the wrestler, and so on. Mexican reality is much more chaotic, which means that one has to be inventive. You need to find creative solutions to resolve problems because often there are no ready-made answers. North

American reality is very highly developed. There are highly developed patterns and codes that you can appeal to when you need to resolve questions. Because of this, the ability to be spontaneously inventive is much slower. This difference is reflected in the planes. I was expecting to see much more spectacular planes from the North American pilots because they have more financial and technological resources. In fact they were much more shy about creating personalized planes. Mexican reality is like a membrane, which is constantly alive and mutating, so this ability to transform is part of the culture. I enjoyed working with all the pilots because they really gave their body and soul to the project. It was very moving to see the pilots changing over the course of their project, their minds opening, and their ideas changing. I think that everybody who is North American or knows the North American mentality knows that the decision to go into a very chaotic situation is extremely challenging. So I was also very impressed by that. When the unexpected happened yesterday and the river sluice was opened and sewage started flooding through the empty riverbed where we were holding the performance, all the pilots kept calm. They just picked up their planes and moved twenty meters and kept performing.

Joshua Decter/ What has been the relationship between the audience, the spectators, and this very elaborate process of negotiation with these individuals over more than a year? Were you thinking about how that might be communicated or the impossibility of communicating it? Or is it communicated in the artifacts, the planes themselves somehow?

Maurycy Gomulicki/ I believe the relationship is communicated somehow. I was talking with someone yesterday at the event about how art is not able to resolve things but art can comfort you with a sense of beauty. It can make you feel, make you think. I believe that was happening on the day of the event, both for the attending public and the participants. The public could see people from the two countries cohabiting that space. The symbolic potential of people from two nations being there was very striking. I always say that art is an opportunity, not a goal. I think both the audience and the pilots both experienced that. Throughout the process the pilots were interested in their role in an art project. It is not the same as a model airplane event. The artistic aspect of it was not just about the choreography of the planes, but something else. Obviously there are some aspects of the project that we weren't able to realize. For example, I wanted the US pilots to arrive via the US side of the border and the Mexicans pilots from the Mexican side and for each group to never actually cross the border except by means of their planes. But that was impossible for security reasons.

Joshua Decter/ Thank you. I think we can transit here into Javier talking about his project from the inaugural weekend. So Javier, please go ahead.

Javier Téllez interventions artist/ I'm fumbling with my English again. I wrote some notes this morning, and basically I have this anxiety about audiences, especially when they are homogeneous, like the one that we have today. We are here trying to locate meaning, trying to produce meaning out of bits and pieces. The artist as anthropologist, the aftermath of a fieldtrip, throwing his thesis in the air at the end. I am being ironical, obviously. The artist as a self-appointed delegate representing a community or a site that is often fictitious. The artist as a missionary or

evangelist of some system of beliefs. The artist as a therapist attempting to cure social sickness through individuals' transcendental experiences. Well, I want to claim today that I cannot add any more lies to the performance. To paraphrase, let's just say—as a famous statement of site-specificity made about the removal of a federal state plaza building—I would say today: to interpret is to destroy. Or perhaps I could instead talk about my experiences with the patients as Joshua suggested. I could talk about how the clamor of the patients and circus games are a more appropriate strategy to explore the relationship between the artist and institution. I guess when I say institution we all know that I'm talking about **inSite** and not about the hospital. My intervention in the traumatic site of the US-Mexico border involved hiring a man to fly over the inflictive sky of the frontier. Then the patients wanted to organize a circus in parallel with it. They used David Smith—the human cannonball—as a puppet. They wanted

to talk about another border—that border that affects them in a more direct way, the border that society has built for those who are considered to be affected with so-called pathologies. For them the border was only a metaphor for a world that they have faced in everyday life. The circus and the carnival were a reversal of this perfect order. The upside down of carnival that allows a human being to fly over the border fence. The world upside down where a patient wearing a tiger mask holds a plaque stating that patients are also humans. Social liberation gives the mentally ill and the clown an advantage: the disengagement from social norms. A population that is characterized by its invisibility in the public arena was able to be broadcast globally and to participate in an event that was the fourth most popular news story of the day. The circus is an art that is characterized by difficulty. The theater commonly uses fake props, such as a ball and chain made of cardboard. However, in the case of the circus the weights that the strong man lifts are rarely false. In our circus for **inSite_05** almost everything was fake: the tigers, lions, elephants, and even the lion tamer. It was a parody of circus. But the important elements of this upside down world were real: the patients, the border, and last, but not least, a US citizen named David Smith, risking his life like so many undocumented migrants as they try to cross the border everyday. It was this challenge that made circus what it is—the difficulty of addressing a site that in the real world is a matter of life and death. As the Cuban poet José Lezama Lima has said, "only what is difficult is stimulating," and that is the motto of this project.

Joshua Decter/ One of the issues that came up during the weekend was your relationship with the patients. I am interested in the process of how you worked with patients. Your relationship to David Smith was more of a client dynamic. You hired him to do this. But this was very different in terms of your collaboration with the patients. This raises a number of ethical questions in terms of whether you were utilizing, using, or even exploiting these patients.

Javier Téllez/ Obviously in the case of mental patients, there's a particular history of representation that my work is contesting. Even the confusion about what is the part of the circus is a sort of agenda. I am interested in how the patients could actually auto-gestate the

discourse or organically produce a discourse that would contest the historical discourse of representation of the mentally ill.

Joshua Decter/ Isn't it contested by communicating your working process with these individuals? Isn't the issue whether or not it is communicated to the audience? Isn't this where the ambiguity really lies?

Javier Téllez/ Well, I think the patients' involvement was pretty obvious. Of course partly it's a matter of language. The spectacle was organized in Spanish and the audience and the patients were Spanish speaking. I do feel that if you concentrated on the spectacle you could realize that this wasn't a piece that was orchestrated with them but generated by them. In terms of the placards, the sketches, the speeches, and the music—it was obvious that the patients devised the circus.

Joshua Decter/ Is this ethical question something that the patients and you talked about in terms of the public display of the event?

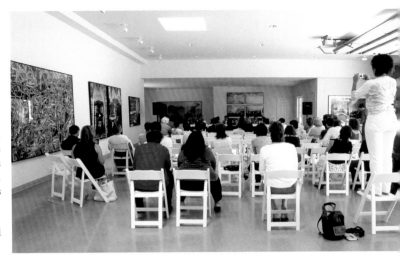

Javier Téllez/ One thing that is problematic in terms of ethics and the seriously mentally ill is deciding when to deny the capacity of citizens to decide on a certain representation. Being exhibited is making yourself public. We would have to ask ourselves what is the difference between a mental patient being exhibited and someone who is not a mental patient being exhibited. This is related to the question of being citizens in the state today. For me, it's more of a political act for the patients to be in public because they are usually invisible in the public arena.

Joshua Decter/ In a number of these event projects there tends to be a relinquishing of control in terms of media coverage, right? It's interesting to see how things reverberate outwards. They tend to become increasingly simplified. I want to say almost dumbed down. I am curious to see what residues are communicated through the mass media coverage of these kinds of events.

Javier Téllez/ In a way this is a bypass—which incidentally is the title of Osvaldo's [Sánchez] curatorial statement. The intervention goes beyond the event. It travels inside the circuits of distribution of the event. The circuits immediately neutralize the original intention of the event. However, it is very interesting that some of the patients, for instance, were interviewed after the human cannonball was launched. They interviewed David Smith; they interviewed the patients and myself. They gave a voice to these people. They had access to a public arena where they could talk about mental illness in Mexico and the health system. Even if that only lasts a second, it is important. Of course you cannot beat the media, the media is always going to win. The project is both a success and a failure. It's a success because David Smith flew, but it's a failure because he fell into the net. It is a metaphor.

Joshua Decter/ Thank you. Now I would like to hear from Itzel about her film. I would like to hear about your decision to give over the apparatus of representation to the subjects of your film by giving them cameras. I would like to know what you feel the decision to do that means in terms of collaborative practice and the language of documentary filmmaking.

Itzel Martínez del Cañizo Interventions artist/ In my video work, I'm principally interested in creating shared experiences while making visual

documents, even more so with this project because the main focus is the individuals who participated with me. I'm interested in using the camera as an active tool that generates communal experiences for the participants and viewers. The camera is a pretext and also a platform, and in some way it is also the element that brings the experience to life. Both in *Que suene la calle (Let the Streets of Tijuana be Heard)*, and in *Ciudad Recuperación (Recovery City)*, my main interest has been getting the people involved with the project to actually take it over, to make it completely theirs through the use of the video camera. In that sense, the creation of the audiovisual work has been as much their responsibility as mine. Because of this exchange between the participants and myself it is not necessarily a creation that is totally under my control. Both during the process of generating the work and the moment when the work is projected, the piece means very different things to the people who have created the work—the co-participants—and the people who view the work. The video work becomes the bridge between one reality and another, between one type of perception and another.

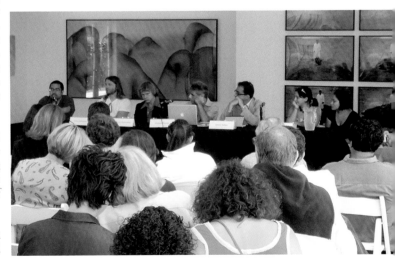

Garage Talk 3
October 23, 2005

In conversation with:
Osvaldo Sánchez, Carmen Cuenca, Donna
Conwell, Tania Ragasol, Beverly Adams,
Joshua Decter, Chris Ferreria, and Omar
Foglio
Moderated by: Sally Stein

Sally Stein Moderator/ Because it is Sunday and a dreary Sunday, I thought that I would start with a little bit of religion, but only a very little bit. Ever since the beginning of this **inSite**, just after New Orleans was hit by the hurricanes, I had an impulse to go back and pull out the old CD six-pack of Louis Armstrong. I was very struck by his rendition of the very old Dixieland dirge "Bye and Bye." I had never really heard the lyrics before and the refrain goes: "We will tell the stories of how we overcome and will understand them better bye and bye." It really struck a chord with me. There is a reason why I am using this as a prologue: I love the line, "…and I will understand them better bye and bye." I have no idea what that means. This is a funeral song, so I don't know if "we will understand them better bye and bye" simply means at the end of the storytelling we will get a better sense of them, or if it means that we too will understand things far better than we do now when we pass over—in other words, our understanding isn't perfect. I think that this is one of the things we learn from each **inSite**, by looking reflectively at what has happened, as it is taking place, and then as it is coming to its conclusion. What I want to posit as a question to everyone here at the panel today—which in a way is an impossible question—is: what have we learned during this process? I would like to hear your own retrospective thoughts about what you think was effective, and what you might have done differently, or what you might have emphasized differently.

Osvaldo Sánchez Artistic director, inSite_05, curator of Interventions/ [Laughing] Well, I have no major complaints. I feel pretty happy with what has happened, and the ways in which these complex interactions have unfolded over time. Even when I consider the numerous fights, nervous breakdowns, stress, and three years of perpetual anxiety, I am still very pleased to have been through such a rewarding experience, and to have remained focused on my personal commitment to art. This commitment is related to desire. Desire keeps us receptive to new experiences, and in this case open to knowledge-experiences that were not intended to only be artistic. You were talking about the storyteller, and those songs that talk about time and about life-processes. I think that many of the **Interventions** projects worked on that level, they dealt with knowledge as a process of being alive in the present; they instigated intense experiences of exchange in daily life. That interest in the other, that level of self-exposition, produces narratives; it produces micro-stories. That is what this project is all about. Of course there needs to be some sort of self-assessment. It is important to make changes in terms of **inSite**'s operation, organization, etc. We all leaned something, and we have been far from perfect. **inSite** should change for the next edition of the project—as it has before. It is important that it keeps moving and transforming in a thoughtful and intelligent way. Through these interactions, through these narratives that are so hard to track—so hard to frame as artworks—**inSite** has had an impact in the area in an almost imperceptible way. I feel that our commitment to exploring what "public" could potentially mean was a very compelling experiment, and a very urgent mission. It has been a very exciting learning process for everybody who has been part of this edition of **inSite**.

Carmen Cuenca Co-executive director, inSite_05/ Rethinking the format of **inSite_05** from the perspective of my experience of three previous **inSite**s was very interesting and important for me. **inSite_05** was the first occasion in which we collaborated as a full-time team based in the region—with the curators, directors, and production team under the same roof. It made a big difference. The artists' intense and committed approach to the construction of their projects and the detailed way in which the residencies were conceived demonstrate and reveal the impact that this change had. We went through a very deep intellectual process to organize and prepare every single component of **inSite_05**. This is very different from inSITE2000 or inSITE97, when we had teams of curators coming back and forth to the area—like artists in residency—who weren't really able to take on the responsibility of helping to construct each project and developing the process as a network. That is basically the biggest difference about this version of **inSite**—the fact it involved the self-conscious construction of a kind of organic sense of community. This intense process meant that this artistic experience was tremendously rewarding. The experience involved a lot of negotiation—inside our own organization, within our own board, and between Michael and me as co-executive directors. We had to remain flexible, and respect the position of the curator as a thinker as well as a project manager. The complex nature of this process is evident in each project, it is a part of what **inSite** has become.

Donna Conwell Co-curator, Interventions/ I think that it is important to assess what we have learned, what we have achieved during this process, but I also feel that to some extent we are lacking a position of critical distance at this time. Many projects are still ongoing; many dynamics are still unfolding. We are still very much involved in their continuing development. That said, there is also a sense in which Osvaldo, Tania, and I went through a moment of self-assessment before the public phase of **inSite_05**. As Osvaldo has said many times, what has been visible during the public phase of the project is rather like the tip of an iceberg; submerged beneath it are all manner of complex collaborative networks, relationships, and experiences. We have been witnesses and participants in these unfolding exchanges and temporary communities of affiliation for quite some time, and so to a cer-

tain extent there has been a kind of built-in and ongoing assessment of the projects throughout the process. I remember feeling a certain confidence about the projects before the public phase because as a team we all felt very excited about how the projects had unfolded over the months and the kind of feedback we had had from the co-participants. In a sense we didn't need to feel legitimized by the art world—however nice that has been—because we felt that the success of the project had already happened. The success of the project wasn't just centered on the exhibition moment and its reception.

Tania Ragasol Co-curator, Interventions/ I agree that it is really too early to have sufficient distance from the projects to really assess what we have learned during the whole process. Many of the projects are still ongoing. Next week some of the artists are coming back to the region to continue their work, handing off certain aspects, or "closing" a cycle. So we are still in the process and it is hard to really look back. To what point would we look back to anyway? Talking about stories—each project is a different story, each project involved different experiences. All of us—the curators as well as the artists—underwent an intense process of dialogue and negotiation with the co-participants and with the whole team. Each project was so different, each step in the process was so fragile, each narrative thread so individual and unique.

Sally Stein/ The reason I bring this topic up now, even though perhaps this is not the proper moment for retrospection, is because I often find that by the time a project comes to its conclusion the people involved forget to evaluate the experience. This line of questioning is not intended to commodify **inSite**, but to provide a platform from which to really think about the project as a developing process of conceptualization and negotiation.

Beverly Adams Interlocutor/ This process of evaluation seems to have been part of the model from the very beginning. Speaking as an interlocutor—and as someone who has spent the last two years trying to explain what that was [laughing]—it really is a privileged position to be able to come into a certain part of a process that is usually closed until the end. We had an opportunity to occupy a kind of middle ground and to negotiate between some of these intense relationships, trying to get a sense of what was unfolding from different perspectives, offering advice, and offering an ear. In the majority of cases, curatorial processes are very closed, even from the artists that are involved. In the case of **inSite_05** there was a kind of ongoing evaluation and discussion as the process was unfolding—it was built in.

Sally Stein/ It is sort of like having a group of psychoanalysts on call [laughing]. As interlocutors, did you find it frustrating to be both hands-on and hands-off?

Joshua Decter Interlocutor/ I don't know if I would categorize it as frustrating. Actually, given my past curatorial work, I think it was liberating on some level. We weren't brought in to select artists, which, for me, was very invigorating. As Beverly Adams indicated, from the embryonic moment of proposal development, we were invited to openly engage in conversations, discussions, and critique with the artists. I hadn't worked in this way before. This was a kind of revelation, and I think it provides a model that could be quite productive. This kind of transparency opened up a very arcane closed process. I think that there was some hesitation on all sides during our initial

meetings, but as we got to know one another better, and conversations and discussions began to occur off site, as well as through emails and other social situations, things became much more collaborative and that was quite unique as well.

Sally Stein/ I wonder if the artists could speak about how this experience might have changed their own practice.

Chris Ferreria Interventions artist/ It is safe to say that this has been a transformative experience for me. There is a marked difference in the way that I approach my projects now. Most of my collaborations prior to **inSite_05** have been with friends and fellow artists where we share a common understanding about what the goal is. It is a territory that is safe. What transpired with my particular project for **inSite_05** has ranged from being a very blissful utopian process to an extremely hellish distopic experience. I have come to realize that "successful" collaborations are as much about chemistry as they are about the talents of individuals who have come together to create something new. That is not to say that I won't be more cautious in the future about whom I collaborate with. I will be a lot smarter about it.

Omar Foglio Member of Bulbo, Interventions artist/ We are really happy with the whole experience. One of the things that made **inSite** so interesting for us was the curatorial statement, even if we had to read it a hundred times because we found it too academic. We don't come from an academic background. We weren't even part of the art world before **inSite_05**. This project has been an opportunity for us to push our work one step further and to do things we hadn't done before.

Sally Stein/ I am curious about what degree of interaction there was between the artists. I imagine there was an extent to which the projects bled through to one another.

Chris Ferreria/ I think there was definitely a mutual desire to have that level of interaction between the artists, but to a certain extent everyone was focused on his or her project with blinders on. For those who live permanently in Tijuana and/or San Diego it was easier to meet each other, hang out, discuss the projects, and step back for a moment from the actual experience of making the work. I don't think we took as much advantage of that as we could have—at least I don't feel that I did. In terms of the relationships between the projects, that would have been an interesting thing to explore, but I don't think that anyone wanted to take away from each other's thunder. We wanted each project to be able to shine at its particular moment—not to say that each project was a spectacle in itself, but at least to respect the territory that each artist had carved out for himself or herself.

Sally Stein/ In the curatorial statement there is something that I had to read ten times about avoiding using the city as a white cube—a desire to distance the project from the kind of interventions that use the city as a white cube. If that was **inSite_05**'s aim then why didn't we see more interaction between the various components of **inSite** and the projects themselves?

Osvaldo Sánchez/ Firstly, I would like to say that the statement was not intended as a text for publication or as a curatorial essay that would be illustrated by the project. It was a point of departure, a starting point for

a dialogue. I tried to draft a series of questions about what we mean by "public" and low-key artistic experiences that I felt were important to define in order to generate answers and/or more precise questions.

About the white cube—I come from the context of Mexico City and I am a bit resistant to the way in which most of the artistic engagements in this area have made recourse to representational discourses. These ideological discourses have been displayed in the city as images, objects and so on, and have used the city as a kind of white cube gallery space. Even though they may deal with social responsibility, political commitment, and community these—let's us call them "interventions"—are no longer capable of building community, of creating public experiences as vibrant and dynamic political networks. That is why I have resisted using the city as a white cube. I am resisting object-hood. It is also fashionable nowadays to think that public culture is just about urbanism; that to be engaged in representing the city and to play with the city's nostalgic utopian blueprints is the same as making public culture. I tried to avoid conceptualizing the city as a kind of maquette in which we would move objects infused with ideological discourses around.

Sally Stein/ I have a follow-up question: Can you explain a little more concretely how and why you were trying to disarticulate urbanism and public art, specifically within the context of San Diego-Tijuana, which is an urban conglomerate? Why were you trying to undo this?

Osvaldo Sánchez/ I was not trying to undo the geopolitical structure of the border, what I tried to disengage was the tendency of illustrating the border through political parodies, or by taking recourse in the symbolic power of the border territory as a way of self-exoticizing oneself. I wanted to get as far away as possible from the big picture of the border and try to be specific. I am convinced that we can only be effective, artistically and politically, if we intervene in a specific way. The idea of creating experiences immersed in daily flows motivated us to be ethically consistent and not to hide and obscure discourses.

Sally Stein/ That makes me think of Mark Bradford's project, *Maleteros*, which speaks to a system that connects two cities as one territory, but at the same time relies on "un-official" informal labor to move between San Diego and Tijuana because of other sorts of blockages.

Donna Conwell/ That is exactly right. Mark is tracing a system that is incomplete; there are gaps between its composite components. In essence the dynamic of the *maleteros* is broken up into three key groups: a semi-officially recognized group that carries baggage from the pedestrian entrance to US customs in Tijuana to the San Diego Trolley station; an informal group that transports goods and luggage from the entrance to the pedestrian corridor from the US to Mexico to the taxi rank in Tijuana. There is a third group, which is perhaps the most informal of all. They carry the belongings of people coming from downtown and beyond across a pedestrian bridge at the taxi rank that intersects with the pedestrian walkway to US customs. The three groups form an uneven circuit of service. It is uneven because the different groups have different degrees of legitimacy. The system breaks down because certain groups are fined for loitering or have their equipment stolen. In a way this mirrors the relationship between the two cities of San Diego and Tijuana—there are all these connections, networks, flows, but there are also all these disruptions, where things fail to link together, to intersect.

Omar Foglio/ Going back to the curatorial statement, I think that the ideas are so clear and powerful when you read it, but in reality it is extremely challenging to try to approach some of the ideas. Maybe one way to get closer to the essence of the statement is to get the **Interventions** artists to link up and to do something collaboratively, rather than framing the project as "this is his/her work" and "he/she is doing that." The statement is written down, but it up to us, the artists, to really create something out of that. I hope we don't just leave it as something written down.

Donna Conwell/ Tania and I were talking about this a little while ago. When we first read Osvaldo's statement it was really difficult for us to imagine how on earth things would take shape. To see how, over time, each project has taken that text as a point of departure and taken on a life of its own has been really fascinating. It has been an incredible learning experience to see the wide variety of strategies and collaborative methods that the artists have utilized, tested, and experimented with in their projects.

Joshua Decter/ As interlocutors we were sort of insiders and outsiders or outsiders and insiders, which gave us the ability to navigate between the curatorial team and the artists, between the directors and the curatorial team. It was interesting to see the pressures that were brought to bear and the resistances that emerged during the various meetings that took place with the artists. I thought that it was very productive and illuminating to see how out of those intellectual transactions creative things developed, emerged, and mutated on an ongoing basis. I don't think that it is my role to talk about how, for example, a number of projects shifted, and in some cases quite radically, in terms of their development over the past year and a half, but it was quite fascinating to see. I would like to know how this "exhibition" moment is conjugated over the course of a number of months. How are things conjugated in different ways? There are interwoven issues of visibility and invisibility, networks and infiltration, the ephemeral and dematerialization, and so on and so forth. Did you ever consider creating an interplay-interpenetration between those projects that have a kind of event moment and those that were kind of conjugated over a longer period of time? Was there an attempt to program an inter-relationship between duration and conjugation or was that almost unintentional?

>

Osvaldo Sánchez/ I have to admit that we were overwhelmed. The curatorial team was completely immersed in a million and one priorities, production duties, and technical tasks. That combined with the fact that everyone around us seemed terrified about the radical nature of the whole project meant that we weren't able to find the time to develop and implement a strategy that would link the production stage and the public phase. We would have liked to create more complex platforms of exposure and a scenario of inter-relations between the projects, but many of the projects had such a mutable nature that it would have required a lot of planning to respond to such an unstable process as it unfolded. That would have been a significant curatorial challenge. Of course there were other things that were requested, such as major audiences, or a festival/biennale format that we never intended to fit into. We weren't interested in being framed in that kind of way at all.

Joshua Decter/ Can the catalogue function retrospectively as a way of talking about the open narratives that Sally mentioned?

Osvaldo Sánchez/ I think specifically in the case of **inSite_05**, documentation has and will play a very important role, even at an ongoing level in terms of the inscription of the projects. At the very beginning, we suggested hiring someone to track that process—a curator whose role would involve compiling documentation and developing a way of tracking the process that would then feed into the final book about the projects. Unfortunately, we lost the curator who originally took on that responsibility, and subsequently we also lost that position within the team. So that initial goal was not accomplished in entirely the way we had expected and hoped. Some of the initial discussions we had with the artists were about diffusion and documentation. There were many disagreements between all of us about what could or should be expected as a "final document" in a project like this. Since we have tried to avoid the format of an exhibition as the primary level of exposure for the **Interventions** projects, I would like to avoid the format of the group show catalogue. I am much more concerned about how we can be loyal to all the different layers that each project had, to all the voices involved, and how we can communicate, in a beautiful, special, and simple way, what we all experienced together.

Woman in the audience/ It is interesting that there is always this tension between, as Joshua said, "this conjugation," the self-exposure, the event, and duration—and of the catalogue as another stop moment in the process. It seems as if there is no way for any of us to perceive the project as a whole, just as fragments of experience. I think the way that these experiences start layering is really interesting. None of us will have these kinds of experiences again. I am also an inSiter [A membership-based support group organized around **inSite_05**] by the way. I have been close to **inSite** for a long time and this is the edition that is the most complex and the hardest to get your arms around. It is also the most rewarding for that reason.

Chris Ferreria/ Two years ago when we first started the process of conceptualizing the project and entering into this terrain called **inSite**, I think that there was a level of intellectual nurture that was really interesting and important. But there is a certain kind of physical-

ity and nurturing that needs to be attended to beyond that, there needs to be the structure in place and the manpower to insure that it continues into the production phase. There were times when I think that everyone was exhausted—physically and mentally. There is a point when you think: "Why can't we just get this done?" At the same time, there is also a redeeming moment where you think: "It's okay, I'm going to get my second wind, my third wind, and get through this and the project will grow." I think it is important to think about how to extend this process of nurturing the artists and the projects further.

Donna Conwell/ We created a very ambitious project. None of us imagined that so many of the projects would become so complicated and intricate. We had a very small production team and this, combined with the fact that the projects were occurring simultaneously and were in constant evolution and mutation, which necessitated quick responses to unexpected situations, presented a real challenge. That said, not one project failed because of lack of support or because of budget limitations. It is true that on many occasions the artists had to get involved in problem solving, often in situations and contexts that they were unfamiliar with. We are really thankful to the artists for being prepared to help to resolve the complexities of their projects and for realizing that this was part of their role.

Carmen Cuenca/ The lack of manpower has been a problem during every edition of **inSite**, but it was even more complex this time. I have also felt frustrated, and struggled with the question of how we can perform better as an organization. We have been involved in a joint struggle to accomplish a project that we were all committed to. **inSite_05** incorporated a wide range of production demands, ranging from film production to building ephemeral architecture. It has been very challenging trying to determine what might be a suitable profile for an **inSite** team—what sort of person, or group of people, could organize the production of a sneaker in China, a complex film production in Tijuana, track a marketing campaign, nurture a voluntary choir inside a military community. The challenges that our production team and project managers faced were frightening. Exhaustion and failure were always a real possibility. Maybe that is one of the main reasons we are so committed to this project.

Betti-Sue Hertz Member of the audience, curator SDMA/ Being an independent non-profit organization that does not have an institutional affiliation, in the sense that it is not part of a university or a museum, gives **inSite** a certain amount of flexibility, but it can also mean a lack of institutional support as well. If you were attached to an institution you wouldn't have your independence of vision and you would be dependent on that relationship for all your resources. I also have a question about the idea of curatorial practice as a process of "training" artists. I think that, in part, this project involved taking a group of artists and re-training them, or re-tooling them, redefining some artists' practice in terms of criteria that were decided by the curatorial team. I am interested in that process. I know that from the artists' point of view there were some feelings about that process that have probably shifted and changed over time. I was wondering if you could talk about that because I think that it is key to both the challenges and successes of **inSite_05**.

Osvaldo Sánchez/ I don't entirely agree with your perspective. If we want to talk about, and somehow question, the learning

process that was involved in this project, I find it strange to frame the curatorial-artistic dialogue as a process of "training" the artists. The curatorial process was understood—at least from the curators' perspective—as a joint learning process. Our idea was to spend a period of time in a process of open discussion, dialoguing and challenging each other, doing our best to create a project that was not just about inviting artists to be part of a show. We tried to do something that could be different, new, and thought provoking for all of us, and at the same time could encompass a sense of personal and collective revelation and discovery. I have also worked in museums and I have certain misgivings about the dynamics of the contemporary art world today, and the anxiety to perform and act in a certain way. Often our ideas about our roles are related to modern paradigms about "the artist," "the curator," "the institution." This project was a good opportunity to question the goals of those roles and to recast them. It is a project that engaged all of us in a very special way. It has not been easy, but we were always honest about it, and we survived.

Ramona Piagentini Member of the audience, Bard College graduate/ Has there been any discussion about continuing some of these projects with the artists? Are there any artists' projects that may continue beyond November?

Carmen Cuenca/ As a processual project it is very difficult to say when **inSite** is finished. There is a moment when you have to physically dismantle components and/or disengage psychologically. Nevertheless, the life of some projects continues. There are certain interventions that are out of our control now. I think that the afterlife, for us, the organizers, is more focused on documenting the project.

Woman in the audience/ I am interested in the long-term effects of these pieces and how they affected the participants, for instance Javier Téllez's work with the psychiatric patients. How do we measure the success of this work?

Tania Ragasol/ I think that the way of measuring the success of each project is very different. I can give you the example of Maurycy Gomulicki's project, for instance, in which he collaborated with different groups of model airplane pilots. I found this to be one of the most rewarding projects in terms of the relationships that were generated between the co-participants, the artist, **inSite**, and everyone involved. The pilots really made the project their project. Maurycy and I just followed the path that they had carved out. The pilots have plans to keep flying together. The American pilots have invited the Mexican pilots to fly with them over here, and vice versa. The relationships that they established with one another are still going strong; they are still in contact. But I don't know how long we can we measure that. In terms of Téllez's project we could say that one way to measure the project's success is the extent to which the patients got involved in the project and made it their own. But again, up to what point you can measure something like "success," especially in the case of projects that involve long processes (I mean the process is really the project). There are a lot of different ways to measure something like that. As I said, every project has its own story and there are diverse points of entry for that story, different ways perceiving it.

Donna Conwell/ Should we say that one project is more successful than another because the kind of associations and connections it stimulated appear to have taken on a life of their own and are ongoing? Or is it enough for a project to have only instigated a temporary association, but one that could have a long-term impact for the participants involved? And, as Tania says, how do you measure something like that? Since the project was an experiment, it is often the gaps between what was imagined and what was possible that reveal new points of departure and the possibility to form new ideas.

Lucia Sanromán Member of the audience, curatorial assistant at SDMA/ My question is for Osvaldo. You have said that you tried to avoid exoticizing the border. Do you think that you have been successful?

Osvaldo Sánchez/ My preliminary approach to the project involved trying to avoid framing the border as a territorial icon. The symbolic intensity of the border has meant that it has been easy to exoticize it. In counterpoint to this, we wanted to explore the border in terms of its flows. We never imagined that so many projects would focus on the border as a matrix of social dynamics, as a zone infused with diverse and complex relationships. This is far removed from the view of the border as a binational construction that is promoted as a strange new world to the curious outsider. We chose to only commission one project specifically for the border area and that was the park that we constructed at Playas de Tijuana. The park is an interesting example because it is located in an area that has a number of very strong symbolic icons of the border: the white border demarcation obelisk, the chicken wire border fence, Friendship Park, a series of political murals inscribed on the fence. But I don't think that the park "uses" the border or stimulates a kind of exotic intervention there. The only project that used the border in symbolic terms was Javier Téllez's project, and in his case it involved a really complex use of the fence. During his work with psychiatric patients, Javier conceived a conceptual relationship between the functions of an institution like the Centro de Salud Mental de Baja California (Mental Health Center for the State of Baja California) and the border fence—so there was a kind of critical perspective. The event itself was not exotic, but radically bizarre, and critical (even in symbolic terms) of the idea of the spectacle. There were

important conceptual reasons why the project had to be performed in that space. We have tried our best to be honest and upfront about the issues that we are dealing with in the area. We have tried not to exoticize it, play with it, or use it in an opportunistic way. That said, you cannot control the way the media, the trend-builders and their ideologies that "promote new products for the cultural market," or even well-intentioned people who find these issues attractive, recast you. You have no control over how you are interpreted. In the case of Javier's project, for example, the work had a great deal of exposure throughout the international press and there is a sense in which you lose control over how people will frame and translate what you have done.

Joshua Decter/ On some level, there may be situations in which exoticizing the border is not entirely a bad thing—in terms of constructing broader audiences. In the case of the US-Mexico border, a little bit of exoticization might go a long way—not in terms of practices, but in terms of constructing a critical identity at some level. This is an ongoing issue.

Lucille Neeley Board member of inSite/ Even through **inSite_05** involved an incredibly complex network of practices, each project's overarching goals were clearly understood by everybody. It was painful to go through, and the people involved have been beating their brains out for many hours, and working incredibly hard. After all of this I think that a period of examination should be part of the process. There needs to be discussion, not only about how the artists were supported and not supported and about the end results, but I think it would be good idea to think about: who is the audience? Who is the public? What are we saying to the public? What do we want to say to the public? In what way do we want **inSite** to change and evolve? What did that three million dollars buy?

Woman in the audience/ I think that feedback is essential, but I think that the natural culmination for **inSite** would be to initiate those kinds of dialogues with other kinds of audiences—I mean if you are really going to make changes that resonate and not just converse with your colleagues.

Michael Krichman Co-executive director, inSite_05/ I would like to respond to something that Betti-Sue said. If you look at all of the projects that **inSite** has accomplished it is very difficult to think about what resources would need to be marshaled to produce such a project. If it had an institutional base, what would that institution look like? What would that production team look like? I think that it is extraordinary that **inSite** was able to accomplish all it has given the incredible variety of tasks that were at hand. It is also important to mention the extent to which this project would have been completely impossible without the network of collaborating institutions that in one way or another have been absolutely integral to the construction of **inSite_05**, 2000, 1997, etc. I would rather rely on that loose, unwieldy, frustrating network of resources for future **inSite**s, than construct some sort of mega structure where we would always make a movie and always build a park.

Sally Stein/ This has been one of the most exciting **inSite**s in terms of the range of interventions that move between gesture and architecture, that shift the ornamentation of social space. I take this opportunity to thank the curators, the artists, the directors, all the **inSite** staff, and the supporters of **inSite** because it falls on all of them to hold the project up collaboratively. Thank for coming today.

CVs
Interventions Artists

Allora & Calzadilla/ Jennifer Allora (Philadelphia, US, 1974) received a BA from the University of Richmond and earned an MA in Visual Studies from the Massachusetts Institute of Technology (MIT).

Guillermo Calzadilla (Havana, Cuba, 1971) graduated with a BFA from the Escuela de Artes Plásticas de San Juan in Puerto Rico.

Jennifer Allora and Guillermo Calzadilla have been collaborating since 1995. Their work has been included in group shows such as The Whitney Biennial 2006, Whitney Museum of American Art (New York, 2006); *Day for Night*, the 51 Biennale de Venezia (Venice, 2005); *Common Wealth*, Tate Modern (London, 2003); *How Latitudes Become Forms: Art in a Global Age*, the Walker Center (Minneapolis, 2003); and the III Bienal Iberoamericana (Lima, 2002). They have had recent solo shows at Palais de Tokyo (Paris, 2006); S.M.A.K. Stedelijk Museum voor Actuele Kunst (Gent, 2006); the Lisson Gallery (London, 2004); Galerie Chantal Crousel (Paris, 2004); and The Americas Society (New York, 2003). Allora and Calzadilla live and work in San Juan.

Barbosa & Ricalde/ Felipe Barbosa (Rio de Janeiro, Brazil, 1978) obtained a BFA from the Escola de Belas Artes at the Universidade Federal do Rio de Janeiro. He is currently completing an MA in Visual Studies.

Rosana Ricalde (Rio de Janeiro, Brazil, 1971) graduated with a BFA in from the Escola de Belas Artes at the Universidade Federal do Rio de Janeiro.

Barbosa and Ricalde's work has been included in group exhibitions such as *Perambulações*, Intercambio Brasil/Holanda, urban intervention (Rotterdam, 2005); *MAD-03*, Centro Cultural Conde Duque (Madrid, 2003); Prêmio Interferências Urbanas 4ª Edición/ 3ª Edición / 2ª Edición (Rio de Janeiro, 2002/2001/2000); and Prêmio TRANSURB Interferências Urbanas 1ª Edición (Rio de Janeiro, 2000). In 2003 Barbosa and Ricalde began to coordinate and edit the editorial project *IN CLASSIFICADOS*. Individually they have had numerous solo shows in Brazil and internationally. Barbosa and Ricalde currently live and work in Rio de Janeiro.

Mark Bradford/ (Los Angeles, US, 1961) obtained a BFA and MFA from the California Institute of the Arts. His work has been included in numerous group shows such as the Whitney Biennial 2006, Whitney Museum of American Art (New York, 2006); California Biennial, Orange County Museum of Art (Newport Beach, 2004); *Fade* (1990–2003), Luckman Gallery and University Fine Arts Gallery, California State University (Los Angeles, 2004); Craft and Folk Museum (Los Angeles, 2004); ARCO 2003 (Madrid, 2003); *Hair Stories*, Scottsdale Museum of Contemporary Art (Scottsdale, 2003); *Mirror Image*, UCLA Hammer Museum (Los Angeles, 2002); and *Freestyle*, Studio Museum in Harlem (New York, 2001). His solo and two-person exhibitions include *Bounce: Mark Bradford and Glenn Kaino*, REDCAT (Los Angeles, 2004); *Very Powerful Lords*, Whitney Museum of American Art (New York, US, 2003); and *Tainted*, Lombard-Freid Fine Arts (New York, 2003). Bradford currently lives and works in Los Angeles.

Bulbo/ (Tijuana, Mexico, 2002) is a media collective that incorporates television (Bulbo TV), printed media (Bulbo Press), Internet (Bulbo Web), and a music label (Disco Bulbo). Developed as an offshoot of Galatea Audio/Visual—a production company dedicated to the communication, production, and promotion of audio and visual arts in the San Diego-Tijuana area—Bulbo has participated in numerous film festivals such as San Diego Latino Film Festival (San Diego, 2004, 2003, 2002); Imperial Beach Film Festival (San Diego, 2003); and Este corto sí se ve (Mexico City, 2003). Bulbo's work has been featured in group exhibitions including, *Strange New World: Art and Design from Tijuana*, Museum of Contemporary Art San Diego (San Diego, 2006); *Tijuana Sessions*, ARCO 2005 (Madrid, 2005); *Tijuana Organic*, Cornerhouse (Manchester, 2006); and *LARVA*, Centro Cultural Tijuana (Tijuana, 2004). Bulbo's solo shows include *Historias que no venden*, Antiguo Colegio de San Ildefonso (Mexico City, 2006). Since April 2004, Bulbo TV has transmitted a weekly TV program in Mexico on Canal 22 and in nine US states. Bulbo currently live and work in Tijuana.

Teddy Cruz/ (Guatemala City, Guatemala, 1962) graduated with a BA in Architecture from California Polytechnic State University in San Luis Obispo and an MA in Design Studies from Harvard University's Graduate School of Design. In 2000 he founded estudio teddy cruz in San Diego. His architectural projects include *Manufactured Sites: Housing in Tijuana* (Tijuana, 2004); *Senior Housing with Childcare* (San Diego, 2002); *Housing Corridors on Imperial, Affordable Housing* (San Diego, 2002); and *Casa Familiar: Living Rooms at the Border* (San Diego, 2001). His work has been included in group shows such as *Strange New World: Art and Design from Tijuana*, Museum of Contemporary Art San Diego (San Diego, 2006); *Dark Places*, Santa Monica Museum of Art (Los Angeles, 2005); *Archilab: The Naked City*, (Orleans, 2004); and *Urban Diagnostics*, Centro Cultural Tijuana (Tijuana, 2002). Cruz is a recipient of the Rome Prize in Archi-

tecture and in 2005 he received the Stirling Prize—Memorial Lecture on the City by the Canadian Center of Architecture in Montreal and the London School of Economics and Political Science. Cruz currently lives and works in San Diego.

Christopher Ferreria/ (Adak, Alaska, 1975) received a BA in Studio Art from the University of California, Irvine and earned an MFA in Visual Art from the University of California, San Diego. His work has been featured in group exhibitions such as *Alimatuan: The Emerging Artist as American Filipino*, The Contemporary Museum (Honolulu, 2006); *Fresh*: *Southwestern College Faculty Exhibit*, Southwestern College Art Gallery (Chula Vista, 2003); *Schoolugyaru*, Studio 237, UCSD (San Diego, 2002); *Ghetto Fabulous*, Highways Performance & Visual Art Space (Santa Monica, 2001); *Hook't on Hip Hop*, Asian Arts Initiative (Philadelphia, 2001); and *When the Water's Warm Enough* (collaboration with the Renegades Art Collective), Deep River Gallery (Los Angeles, 1999). His solo shows include *Quiver*, VozAlta Project (San Diego, 2003); *To the Victor Goes the Spoiler*, Visual Arts Facility-Herbert Marcuse Gallery, UCSD (San Diego, 2002); and *Brothers Brown and Small*, Russell Gallery Space, UCSD (San Diego, 2000). Ferreria currently lives and works in San Diego.

Thomas Glassford/ (Laredo, US 1963) received a BFA from the University of Texas, Austin. His work has been included in numerous group shows such as *Polysemia*, Arcaute Arte Contempráneo (Monterrey, 2005); *Barrocos y Nebarrocos*, Domus Artium 2005 (Salamanca, 2005); *Erotic*, Centro Cultural Banco do Brasil (São Paulo, 2005); Centro Cultural Banco do Brasil (Río de Janeiro, 2005); and Centro Cultural Banco do Brasil (Brasila, 2005); *I'm he and you are he as are me as we are all together*, Central de Arte (Guadalajara, 2005); *Contiene Glutamato*, Galería OMR (Mexico City, 2005); *Zebra Crossing*, Haus der Kulturen der Welt (Berlin, 2002); *Mutations*, La video mexicaine actuelle, Palais des Arts de Toulouse (Toulouse, 2001); and *Erógena*, Museo de Arte Carrillo Gil (Mexico City, 2000). Glassford's solo shows include *Cadáver Exquisito*, Museo Universitario de Ciencias y Artes (Mexico City, 2006) *Aster*, Laboratorio Arte Alameda (Mexico City, 2003); and *Fuente*, Ex-Templo de San Agustín (Mexico City, 2002). He currently lives and works in Mexico City.

Maurycy Gomulicki/ (Warsaw, Poland, 1969) studied graphic art at the Academy of Fine Arts in Warsaw and continued his studies in Barcelona, Milan, and Mexico City. His work has been included in group shows such as *PINK NOT DEAD!*, Garash Gallery (Mexico City, 2006); and CCA Ujazdowski Castle (Warsaw, 2006); *Fuera del campo*, XI Muestra Internacional de Performance, XTeresa Arte Actual (Mexico City, 2003); *Snieguroczka*, Zacheta Gallery (Warsaw, 2002); and *Erógena*, Museo de Arte Carrillo Gil (Mexico City, 2000). Gomulicki's solo shows include *Energy Stills*, Sala de Arte Público Siqueiros (Mexico City, 2003); *Grietas*, MUCA Roma (Mexico City, 2002); *Tipologías sentimentales*, Mala Gallery (Warsaw, 1999); and *Nuevas aventuras de la huérfana Marysia o cumplimiento de los sueños*, Contemporary Art Center Ujazdowski Castle (Warsaw, 1997). He currently lives and works in Mexico City and Warsaw.

Gonzalo Lebrija/ (Guadalajara, Mexico, 1972) graduated with a BA in Communication Science at the Instituto Tecnológico de Estudios Superiores de Occidente in Guadalajara. He has participated in numerous group shows, including *Territory*, Artspeak (Vancouver, 2006); . . . *El Desollado*, National Art Museum of China (Beijing, 2006); *Business Class*, Museo de Arte Contemporáneo de la Universidad de Chile (Santiago, 2006); *Eco*, Museo de Arte Reina Sofía (Madrid, 2005); *So Far So Close*, The Americas Society (New York, 2004); *Oil*, Triangle Project Space (San Antonio, 2004); *Jet Set*, Museum of Installation (London, 2003); *Piel fría*, Museo de Arte Carrillo Gil (Mexico City, 2003); *Zebra Crossing*, Haus der Kulturen der Welt (Berlin, 2002); and *Axis Mexico: Common Objects and Cosmopolitan Actions*, San Diego Museum of Art (San Diego, 2002). His solo shows include exhibitions at Museo Carrillo Gil (Mexico City, 2006); Casa Taller J.C. Orozco (collaboration with Jose Dávila, Guadalajara, 2006); Museo experimental El Eco (collaboration with Jose Dávila, Mexico City, 2006); and Pynercontreras Gallery (London, 2005). Lebrija currently lives and works in Guadalajara.

João Louro/ (Lisbon, Portugal, 1963) studied architecture at the University of Lisbon and painting at Arco School of Visual Art. His work has been included in numerous group shows such as *The Experience of Art*, 51 Biennale di Venezia (Venice, 2005); *Into the Breach*, Smart Project Space (Amsterdam, 2003); *EAST* International, Norwich Gallery (Norwich, 2002); *UrbanLab*, Maia Biennial (Maia, 2001); XXV Bienal de Pontevedra (Galicia, 2000); and *Read My Lips...*, VI Biennale Internationale du Film d'Art, Centre Georges Pompidou (Paris, 1998). His

solo shows include *Play, Rec and Pause*, Christopher Grimes Gallery (Los Angeles, 2006), *Blind Runner*, Centro Cultural de Belém Lisbon (Lisbon, 2004), *Estudo sobre Origem das Línguas*, Cristina Guerra Contemporary Art (Lisbon, 2001); *La pensée et l'erreur*, Fundació Joan Miró (Barcelona, 2001); and *Run Away Car Crashed #1*, Centro Cultural de São Paulo (São Paulo, 1999). Louro currently lives and works in Lisbon.

Rubens Mano/ (São Paulo, Brazil, 1960) studied architecture and photography at the Faculdade de Arquitetura e Urbanismo de Santos, São Paulo and obtained an MA from the Escola de Comunicação e Artes, Universidade de São Paulo. His work has been included in numerous group shows such as *Espaço Aberto/Espaço Fechado*, Henry Moore Institute (Leeds, 2006); *Citizens*, Pitshanger Museum (London, 2005); Biennale of Sydney (Sydney, 2004); *GearInside*, streets of Rotterdam (Rotterdam, 2003); *Arte/Foto*, Centro Cultural Banco do Brasil (Brasilia, 2003); XXV Bienal de São Paulo (Sao Paulo, 2002); and *Panorama da Arte Brasileira*, Museo de Arte Moderno (Rio de Janeiro, 2001). Mano's solo shows include *Permeáveis*, Museu Victor Mierelles (Florianópolis, 2005); *Tudo entre nós*, Galeria Casa Triângulo (Sao Paulo, 2004): *Paisagem Incerta*, Bolsas Vitae (São Paulo, 2002); and *Básculas*, Galeria Casa Triângulo (São Paulo, 2000). He currently lives and works in São Paulo.

Josep-maria Martín/ (Ceuta, Spain, 1961) studied visual arts at the Escola Massana in Barcelona and graduated with a BFA from the École Supérieure des Beaux-Arts in Grenoble. His work has been included in numerous group shows such as *Laughing Out Loud*, Galería Adhoc (Vigo, 2006); *Stand By. Listos para actuar*, Laboratorio Arte Alameda (Mexico City, 2003); and the 9eme Biennale de l'image en mouvement, Centre pour l'Image Contemporaine (Geneva, 2001). His numerous public intervention projects and solo shows include *Maison des negociations*, Fri-art (Fribourg, 2004); *¿De parte de quién? Call Free*, Palau de la Virreina (Barcelona, 2003); *Ceramic Juice*, Espai d'Art Castellón (Castellón, 2002); *Nigerian Girls, Big Torino*, Biennale Internazionalle Arte Giovane (Turin, 2002); and *Milutown*, Project Room, ARCO 2001 (Madrid, 2001); Yokohama Museum of Art (Yokohama, 2000); and Echigo-Tsumari Art Triennial (Niigata, 2000). Martín currently lives and works in Barcelona.

Itzel Martínez/ (Tecamac, Mexico, 1978) studied communication science at the Universidad Autónoma de Baja California and has completed numerous workshops and courses related to research, communication, and visual arts. She is a member of Yonke Art, an independent production company based in Tijuana. Martínez's photography and installations have been included in numerous group shows such as *Tijuana Organic*, Cornerhouse (Manchester, 2005); *Tijuana la Tercera Nación*, ARCO (Madrid, 2005); *LARVA*, Centro Cultural Tijuana, (Tijuana, 2004); *BC-3 Nueva fotografía en Baja California*, Centro de la Imagen (Mexico City, 2003); and Centro Cultural Tijuana (Tijuana, 2003); *Spring Reverb*, Museum of Contemporary Art San Diego (San Diego, 2003); *Diagnósticos urbanos*, Centro Cultural Tijuana, (Tijuana, 2002); and *YONKE Frontier Life* (Tijuana, 2002), a multidisciplinary binational arts festival. She currently lives and works in Jalapa.

Aernout Mik/ (Groningen, Netherlands, 1962) studied at the Academie Minerva in Groningen and at Ateliers'63 in Haarlem. His work has been exhibited extensively in group shows such as Art Basel 2006 (Basel, 2006); 26th Bienal de São Paulo (São Paulo, 2004); and the International Video Art Festival, State Hermitage and State Russian Museum (St. Petersburg, 2003). Mik's solo shows include exhibitions at the UCLA Hammer Museum (Los Angeles, 2006); Galleria Massimo de Carlo (Milan, 2006); BAK–Basis voor actuele Kunst (Utrecht, 2006); MC Gallery (Los Angeles, 2005); the New Museum of Contemporary Art (New York, 2005); the Museum of Contemporary Art (Chicago, 2005); Argos (Brussels, 2005); the Centre pour l'Image Contemporaine (Geneva, 2004); Haus der Kunst (Munich, 2004); the Ludwig Museum (Cologne, 2004); The Project (New York, 2004); Caixa Forum (Barcelona, Spain, 2003); carlierIgebauer (Berlin, 2003); and Magasin 3 Stockholm Konsthall (Stockholm, 2003). Mik currently lives and works in Amsterdam.

Antoni Muntadas/ (Barcelona, Spain, 1942) obtained an MA from the Escuela Técnica Superior de Ingenieros Industriales in Barcelona and continued his studies at the Pratt Graphic Center in New York. His work has been included in numerous group shows such as *Dark Places*, Santa Monica Museum of Art (Santa Monica, 2006); *El arte sucede. Origen de las prácticas conceptuales en España, 1965-1980*, Museo Nacional Centro de Arte Reina Sofia (Madrid, 2005); *Desacuerdos. Sobre art, polítiques l'esfera pública al'Estat espanyol*, Museu d'Art Contemporani de Barcelona (Barcelona, 2005); *A Grain of Dust, A Drop of Water*, Gwangju Bien-

nale (Gwangju, 2004); *s(how)*, Institute of Contemporary Art (Philadelphia, 2003); *Nothing Special*, FACT (Liverpool, 2003); *Arte Cidade–Zona Leste* (Sao Paulo, 2002); *Televisions*, Kunsthalle (Vienna, 2001); 7a Bienal de La Habana (Havana, 2000); *Circa 68*, Fundaçao Serralves (Porto, 1999); and Documenta X (Kassel, 1997). Muntadas has had solo shows in spaces that include ISEA (San Jose, 2006); Württembergischer Kunstverein (Stuttgart, 2006); N.O. Gallery of Contemporary Art (Milan, 2006); Proyecto de arte público/Public Art Project (San Juan, 2005); 51 Biennale di Venezia (Venice, 2005); Laboratorio Arte Alameda (Mexico City, 2004); and Location One (New York, 2004). Muntadas currently lives and works in New York, Boston, and Barcelona.

Jose Parral/ (San Diego, US, 1972) studied landscape architecture at the University of California, Berkley and obtained an MA from the Architectural Association School of Architecture in London. He has worked for numerous landscape architecture firms such as Poirier Landscape Architects (San Diego), Pamela Burton & Company (Los Angeles), and Hood Designs (Oakland). Parral was recently awarded the Kate L. Brewster Rome Prize in Landscape Architecture 2006–2007. He has worked on various landscape projects, including The Getty Center Central Garden (Los Angeles); Cummins Child Development Center (Columbus); and the North Campus Wedge, University of California, San Diego (San Diego). His work has been included in group exhibitions such as *Otra/Another*, Galería de Arte del Instituto de Cultura de Baja California (Tijuana, 2003); *The Machinic Landscape Exhibition*, Universidad Nacional de la Plata (Buenos Aires, 2002); and *Projects Review*, Architectural Association School of Architecture (London, 2001). Parral currently lives and works in San Diego.

Paul Ramírez Jonas/ (Pomona, California, 1965, raised in Honduras) received his BA in Studio Art from Brown University in Providence and an MFA from Rhode Island School of Design. His work has been featured in group shows such as *Cultural Contamination*, Centro Cultural Español (Coral Gables, 2006); *Until Then Then*, Western Front Exhibitions (Vancouver, 2006); Shanghai Biennial (Shanghai, 2006); *The Plain of Heaven*, Creative Time (New York, 2005); *Collection Remixed: Self and Others*, Bronx Museum (New York, 2005); *Marking Time: Moving Images*, Miami Art Museum (Miami, 2005); *Cultural Territories International*, Galerie für Zeitgenössische Kunst Leipzig (Leipzig, 2003); *Special Projects*, P.S.1 (New York, 2001); *Media_City Seoul 2000*, Seoul Biennial (Seoul, 2000); *Speed*, Whitechapel Art Gallery (London, 1998); and *Volatile Colonies*, Johannesburg Biennale (Johannesburg, 1995). Ramírez Jonas' most recent solo shows have included exhibitions at Roger Björkholmen Galleri (Stockholm, 2006); the Cambridge Arts Council Gallery (Cambridge, 2005); Ikon Gallery (Birmingham, 2004); and Cornerhouse (Manchester, 2004). Ramírez Jonas currently lives and works in New York.

R_Tj-SD Workshop/ was founded in 2005. It consisted of a group of young architects and architecture students from Tijuana who worked collaboratively during 2005 to generate architectural and urban projects in the Tijuana-San Diego region and to conduct geographical research projects. Architect and urbanist Gustavo Lipkau (Caracas, 1972) instigated and coordinated the workshop. He currently lives and works in San Diego, Tijuana, and Mexico City. The workshop participants included Israel Kobisher Padilla (San Diego, 1983), an architecture student at the U.I.A. Noroeste who lives and works in Tijuana; Carlos Alfredo Augusto Paz Álvarez (Tijuana, 1983), an architecture student at the U.I.A. Noroeste who lives and works in Tijuana; Erick Miguel Pérez Martínez, (Mexico City, 1985), an architecture student at the U.I.A. Noroeste who lives and works in Tijuana; Roxana G. Quezada Arámbula (Tijuana, 1983), an architecture student at the U.I.A. Noroeste who lives and works in Tijuana; and Norma Angélica de la Torre Melgar, (Tijuana, 1984), an architecture student at the U.I.A. Noroeste who lives and works in Tijuana.

SIMPARCH/ Steven Badgett (Chicago, Illinois, US, 1962) graduated with a BFA from the University of Illinois.

Matt Lynch (Indianapolis, Indiana, US, 1969) obtained a BFA from Ball State University, and an MFA from Syracuse University.

Badgett and Lynch began to collaborate in 1996. Their work has been included in group shows such as the Whitney Biennial 2004, Whitney Museum of American Art (New York, 2004); *Speculative Chicago, A Compendium of Architectural Innovation*, Gallery 400, the University of Illinois (Chicago, 2003); Documenta XI (Kassel, 2002); and *An Investigation*

of *Trans-Architecture in the Western American Highwayscape*, Weber State University (Ogden, 1997). Badgett and Lynch's solo shows include *Clean Livin'*, Center for Land Use Interpretation (Wendover, 2003); *Spec–An Acoustic Collaboration Between SIMPARCH and Kevin Drumm*, The Renaissance Society at The University of Chicago (Chicago, 2001); and *Free Basin*, Hyde Park Arts Center (Chicago, 2000). Badgett currently lives and works in Chicago. Lynch currently lives and works in Cincinnati.

Javier Téllez/ (Valencia, Venezuela, 1969) studied at the Escuela Nacional de Bellas Artes Arturo Michelena in Valencia, the Taller de Cinematografía at the Universidad de Carabobo in Venezuela, the Escuela Nacional de Cine y Televisión in Caracas, and the Escuela Nacional de Escultura in Madrid. His work has been included in numerous group shows such as *On Reason and Emotion*, Biennale of Sydney (Sydney, 2004); *Emotion eins*, Frankfurter Kunstverein (Frankfurt, 2004); *Hieronymus Bosch*, Museum Boijmans Van Beuningen (Rotterdam, 2001); *Plateau of Humankind*, 49 Biennale di Venezia (Venice, 2001). Téllez's recent solo shows include *Javier Téllez. Un artista del hambre*, Museo de Arte Carrillo Gil (Mexico City, 2004); *Alpha 60 (The Mind-Body Problem)*, White Box (New York, 2002); *Bedlam*, Museo Tamayo Arte Contemporáneo (Mexico City, 2001); and *Bounced*, Serge Ziegler Galerie (Zurich, 2000). He currently lives and works in New York.

Althea Thauberger/ (Saskatoon, Canada, 1970) graduated with a BFA in Photography from the Concordia University in Montreal and an MFA in Visual Arts from the University of Victoria. Her work has been included in numerous group shows, including *The Peninsula*, Singapore History Museum (Singapore, 2006); *Mix*, Temple University Art Gallery (Philadelphia, 2005); *Emotional Realism: Althea Thauberger and Gillian Wearing*, Khyber Centre (Halifax, 2005); *Sobey Art Award Exhibition*, Museum of Contemporary Canadian Art (Toronto, 2005); *Baja to Vancouver*, CCA Wattis Institute for Contemporary Arts (San Francisco, 2005); Vancouver Art Gallery (Vancouver, 2004); Museum of Contemporary Art San Diego (San Diego, 2004); and Seattle Art Museum (Seattle, 2003); *Satan, Oscillate My Metallic Sonatas*, Contemporary Art Gallery (Vancouver, 2002). She has had numerous solo shows in spaces such as Künstlerhaus Bethanien (Berlin, 2006); Berkeley Art Museum (Berkeley, 2005); Presentation House Gallery (Vancouver, 2005); and White Columns (New York, 2004). Thauberger currently lives and works in Vancouver.

Judi Werthein/ (Buenos Aires, Argentina, 1967) graduated from the Universidad de Buenos Aires with an MA in Architecture. Her work has been included in group shows including the 2006 Bienal de Pontevedra (Galizia, 2006); *If a Cat Gives Birth to Kittens in an Oven, are They Kittens or Biscuits?*, Roebling Hall (Brooklyn, 2006); *On Mobility*, Contemporary Art Center (Vilnius, 2006); Studio Gallery (Budapest, 2006); and De Appel (Amsterdam, 2005); *Dark Places*, Santa Monica Museum of Art (Santa Monica, 2006); *S-Files*, Museo del Barrio (New York, 2003); *This Can Happen to You*, Apex Art (New York, 2003); and the 7a Bienal de La Habana (Havana, 2000). Her solo shows include *Dodecahedron*, Jessica Murray Projects (Brooklyn, 2004); *H*, Centro Cultural Borges (Buenos Aires, 2003); *Thoughts Come to Mind*, the Chinati Foundation (Marfa, 2003); *Manicurated*, Bronx Museum of the Arts (New York, 2002); and *Split Screen* (collaboration with Lucas Michael), Parlour Projects (New York, 2002). Werthein currently lives and works in Brooklyn.

Måns Wrange/ (Åhus, Sweden, 1961) studied philosophy at the University of Stockholm in Sweden. He continued his education at the Jan van Eyck Akademie van Beeldende Kunsten in Maastricht and at the Rijksakademie van Beeldende Kunsten in Amsterdam. Wrange's group exhibitions include: *Political Realities*, Heidelberger Kunstverein (Heidelberg, 2006); *Dark Places*, Santa Monica Museum of Art (Santa Monica, 2006); *HABITA—Baltic Biennale of Contemporary Art* (Szczecin, 2005); *Swedish Hearts*, Modern Museum (Stockholm, 2004), *Delayed-On Time*, Museum of Contemporary Art (Zagreb, 2004); *Momentum 04*, Biennial of Contemporary Art (Moss, 2004); *100 Artists See God* (touring exhibition in the US, 2004–2005), *Todos somos pecadores*, Museo de Arte Contemporáneo de Monterrey (Monterrey, 2003); and *Manifesta 4-European Biennial for Contemporary Art* (Frankfurt, 2002). He has had numerous solo shows at spaces such as Galleri Andréhn-Schiptjenko (Stockholm, 1999, 1996, 1992) and Lunds Konsthall (Lund, 2001). Wrange currently lives and works in Stockholm.

Traducciones

y versiones originales en español/ Ensayos y mapas

(DES)ORDEN FRONTERIZO/ SOBRE LAS POSIBILIDADES IMAGINARIAS DE LO INTER-MEDIO

Donna Conwell

La noción de motilidad abraca los diferentes estados que hay entre la movilidad y la inmovilidad. Motilidad [...] no significa inmovilidad ni movilidad, ni estabilidad ni inestabilidad, ni solidificación ni licuefacción. Describe aquellos momentos móviles en los que las personas y las cosas, en un sentido físico, virtual o en cuanto a su lugar de residencia, no están del todo en casa, pero tampoco están de viaje.

Jörg Bechmann[1]

El espacio/espacialidad es una dimensión de las relaciones y los imaginarios sociales; no se trata de una estructura objetiva, sino más bien de una experiencia social [...], se trata de una idea construida a partir de las prácticas sociales de las personas en su relación con el mundo.

Kirsten Simonsen y Jørgen Ole Bærenholdt[2]

En la historia, la frontera funciona como un tercer elemento... Es un lugar intermedio que está compuesto de interacciones y entrevistas; la frontera es una especie de vacío, un símbolo narrativo de los intercambios y los encuentros.

Michel de Certeau[3]

Los espacios fronterizos –ya sean los cruces fronterizos internacionales, los enclaves urbanos fortificados o los intersticios inestables que hay entre uno mismo y los demás– se encuentran en un estado de flujo permanente, cambiando, reconfigurándose y proliferando en un proceso constante de devenir que está imbuido en las "geometrías del poder".[4] (Re)producidos por los procesos socioeconómicos y las prácticas sociales cotidianas de grupos e individuos, los espacios fronterizos son los puntos en los que se intersecta una compleja serie de macro y micro relaciones, y en los que se lleva a cabo el ejercicio, el ocultamiento, el ordenamiento, y la administración del poder, así como la resistencia a él. Sin embargo, cabe preguntarse si estos procesos y estas prácticas sociales tan sólo construyen unidades e interfaces territoriales cercadas y discretas, o si también abren una línea de falla, una zona inter-media de transición que tiende un puente sobre las fronteras que hay entre los códigos binarios.

Aunque los espacios fronterizos se pueden aproximar a los no-lugares descritos por el antropólogo Marc Augé –lugares como el supermercado, la sala de espera y el centro comercial, espacios en los que, por un tiempo, uno pierde el sentido de lugar y es incapaz de entablar relaciones con los demás[5]–, también son espacios en los que convergen las diversas modalidades de la movilidad y la inmovilidad; el lugar y el no-lugar, el flujo y el reposo. Es precisamente esta ambigüedad del inter-medio, el hecho de que sea indeterminado, la que permite que los actores lo transformen en un espacio de insurgencia y trasgresión, en un espacio en el que es posible imaginar nuevas maneras de pertenecer al mundo y de operar en él.

Los proyectos de las **Intervenciones** de **inSite_05** implicaron un cambio conceptual –en vez de entender los espacios fronterizos como territorios físicos y absolutos, los artistas participantes trataron con ellos como espacios que, a la vez, constituyen y están constituidos por relaciones y prácticas sociales. Se plantearon las siguientes preguntas: Si los espacios fronterizos establecen las condiciones y los procesos que ordenan y producen la segregación espacial, ¿de qué manera podemos trazar las rupturas en ese ordenamiento? ¿Cómo podemos abrir las posibilidades creativas del inter-medio?

EL ORDEN DE LAS MOVILIDADES/ EL ESPACIO COMO TRAYECTORIA – EL ESPACIO COMO CIRCUITO

¿Por qué las culturas modernas invierten tanto esfuerzo en estructurar y ordenar la movilidad? ¿Por qué parecen estar tan obsesionadas con marcar caminos, trazar mapas, crear protocolos de transmisión de hipertextos y sellar pasaportes?

Jörg Bechmann[6]

Está usted hablando al Puerto de Entrada de San Ysidro
Hoy es 18 de julio de 2006
Estamos operando con un nivel de alerta amarillo
Son las 3:00 pm.
Hay 18 carriles vehiculares abiertos
El tiempo de espera por vehículo es de aproximadamente 60 minutos
La espera en SENTRI es de menos de 5 minutos
La espera peatonal es de 45 minutos

Puerto de Entrada de San Ysidro[7]

03.21.04/ 4:15 pm...
Hoy, Mark y yo caminamos alrededor del Puerto de Entrada de San Ysidro un par de veces; discutimos el proyecto, vimos los lugares y hablamos con los maleteros sobre el equipo que necesitan. Escogimos un mal momento y nos quedamos atorados en una cola muy larga con los que regresaban a Estados Unidos. ¿Por qué parece que siempre escojo esperar en la cola de inspección más lenta? Trato de tener los ojos bien abiertos para ver alguna señal; algo que me indique cuál será el carril más rápido, cual será la cola que tiene la aduana y el agente de control fronterizo más amables, pero parece que nunca acierto. La frustración se acumula –hay tanto que hacer en la oficina. Tengo que regresar. Mark me contó que ayer los agentes de la patrulla fronteriza lo habia hecho a un lado y lo había interrogado. Les pareció sospechoso porque había estado caminando por el puerto de entrada toda la mañana. Intentó explicarles que era un artista y que estaba haciendo un proyecto, pero no pensaba que le hubieran creído. Está preocupado de meterse en un problema serio. Creo que tendré que pedirle a Carmen alguna clase de carta oficial para él. Nos estamos volviendo todos más sospechosos conforme pasamos más y más tiempo en este sitio. Muy pronto vamos a necesitar algún tipo de identificación que explique porqué estamos dando vueltas alrededor de este sitio.

Las fronteras internacionales usan diferentes procesos de ordenamiento para administrar la movilidad. Cercan el flujo, y estructuran y dirigen el movimiento. Cualquier umbral presenta otro punto de no retorno. El movimiento siempre es unidireccional, y hay "administradores de flujos"[8] que se encargan de orquestarlo y controlarlo.

El Puerto de Entrada de San Ysidro-Tijuana entre México y los EUA es el cruce fronterizo más activo del mundo[9]. Alrededor de 150,000 residentes transfronterizos de California y 40,000 de México cruzan la frontera todos los días para ir al trabajo, a la escuela, al médico, de compras, por alguna actividad cultural, o para visitar a familia y amigos.[10] Entre semana el tiempo de espera promedio en la frontera es de 50 minutos, y en horas pico éste llega a ser de más de una hora, hasta de hora y media.[11]

¿Cómo está ordenada la movilidad en la frontera entre México y los EUA? Las diferentes movilidades que fluyen a través del Puerto de Entrada de San Ysidro son administradas por medio de la separación y se dividen en varias submovilidades:

Peatones/ ¿Aquí empieza la cola?

El tráfico peatonal que cruza de Tijuana a San Diego se filtra por un estrecho corredor situado a la derecha del tráfico vehicular. Al entrar al edifico de aduanas de los EUA, los peatones son separados en distintas filas y enviados a una serie de puertas de inspección. Cada una de ellas está dirigida por un agente de aduana y uno

fronterizo. La SENTRI (Red electrónica segura para la inspección rápida de los viajeros o Secure Electronic Network for Travelers Rapid Inspection) es un programa de inspección previa que, en la actualidad, permite que alrededor de 50,000 individuos eviten las largas colas al pasar por un carril rápido.[12] En el extremo izquierdo hay un "carril para bicicletas" por el que los pasajeros que viajan por este medio pueden evitar las colas más largas. Los peatones que llevan bolsas grandes también pueden usar este último carril.

Los peatones que entran a México desde los EUA son enviados a una zona de amortiguamiento que dirige el flujo ya sea hacia la parada de taxis, o hacia el centro y la Avenida Revolución con sus atracciones para turistas. Las puertas giratorias que están a cada uno de los lados del corredor funcionan como una válvula que impide la posibilidad de regresar una vez que uno ha pasado el umbral de la frontera.

Tráfico vehicular/ Acaban de cerrar mi carril. Por favor déjeme pasar. ¡DÉJEME PASAR!

El tráfico que cruza hacia el norte es canalizado por unos carriles que se estrechan en dirección a la frontera. Hay un máximo de 24 puertas de inspección primaria. Mientras los conductores intentan mantener su posición en la cola a empujones, se les cerca por todos lados, sin darles la posibilidad de detener su flujo unidireccional. En el extremo derecho hay una cola SENTRI rápida para automóviles.

Los vehículos que van hacia Tijuana desde San Diego llegan por la autopista Interstate 5. En las horas pico el tráfico puede llegar hasta el centro de San Diego. El tráfico de EUA a México recibe atención en 9 puertas y un área de inspección secundaria en la que caben cerca de 40 vehículos.

Transporte Público/ ¿A qué hora sale el último camión de regreso a San Diego?

Mexicoach es el servicio internacional de autobuses de cruce fronterizo más grande de los EUA. Básicamente se usa con fines turísticos y tiene su propio carril para cruzar la frontera. No lo comparte con ningún otro coche o autobús. También hay un autobús que va de Tijuana a San Diego y que coexiste con otros servicios, formales e informales. Estos autobuses cruzan la frontera por un carril especial. Los pasajeros se tienen que bajar del transporte y entrar al edificio de la aduana estadounidense por una puerta lateral. Una vez ahí, se unen a la "cola para bicicletas", que es más corta.

Los camiones que van a Tijuana desde San Ysidro también llegan por la I-5, al igual que el resto del tráfico vehicular. La última parada del trolebús de San Diego está justo fuera de la salida de la aduana de EUA y no cruza a Tijuana.

En todos los casos, la movilidad en el Puerto de Entrada de San Ysidro está administrada y ordenada en términos de trayectorias verticales de flujo bidireccional de norte a sur y de sur a norte. Pero, ¿estas rutas tan lineales corresponden a la realidad de quienes cruzan la frontera de manera cotidiana? Para la mayoría de los usuarios, la frontera entre México y EUA no es un punto en una trayectoria entre un lugar de salida y un destino, sino una zona inter-media que se recorre con frecuencia, un segmento en una ruta continua de ida y vuelta. Ya sea que aquel que cruza la frontera sea alguien que usa su tarjeta láser para ir a estudiar o a trabajar[13], un consumidor que va a un centro comercial en San Diego[14], o un turista que visita la Avenida Revolución o Corando, en la frontera se cruzan diversos tipos de movilidad y la mayoría de ellos fluye por rutas circulares, no lineales.

Dada la preeminencia de estos flujos circulares, ¿cuáles son los procesos y las prácticas sociales de que se han generado a nivel micro para facilitar la movilidad? ¿Cuáles son las tácticas que han evolucionado en respuesta a, o en diálogo con, la inscripción del espacio fronterizo en una trayectoria bilineal que conecta a estos dos territorios delimitados? En la frontera han surgido diversas empresas informales que alteran el discurso oficial del tráfico unidireccional. En 2000, cuando los tiempos de espera en la frontera se empezaron a volver cada vez más largos[15], un tijuanense emprendedor puso un negocio de renta de bicicletas. Los peatones que quieren cruzar a los EUA pueden rentar las bicicletas mientras esperan en Tijuana, y esto les permite evitar las largas colas fronterizas al tener acceso al "carril de bicicletas". Después, dejan las bicicletas en San Ysidro y alguien las regresa a Tijuana. Esto puede resultar en el curioso espectáculo de un hombre adulto que pasa por el "carril de bicicletas" empujando una bicicleta de niño como si fuera suya. Los maleteros son otro de los negocios informales que han surgido en respuesta a la realidad que viven aquellos que atraviesan la frontera todos los días. Los maleteros no sólo facilitan el flujo circular de aquellos que cruzan la frontera cargando productos de consumo, maletas y equipaje, sino que también pueden evitar las largas colas de la aduana de EUA, pues tienen acceso directo al "carril de bicicletas".[16]

Mark Bradford se unió a las actividades de los maleteros para llamar la atención hacia los flujos circulares que contradicen el ordenamiento bidireccional de la movilidad en la zona fronteriza. Aunque su proyecto se ha interpretado en términos de la relación que establece entre la esfera de la economía formal y la de la informal, *Maleteros* también pone de manifiesto las contradicciones que hay en las maneras en las que se administra y articula la movilidad en la frontera.[17] Al intentar y, hasta cierto punto, al fracasar en su intento de poner en marcha un circuito de movilidad sin rupturas entre los grupos de maleteros más organizados y los más informales que están instalados alrededor de la frontera, Bradford hizo patente lo desigual de las relaciones sociales y económicas que operan en el inter-medio. Los espacios para el flujo que se abrieron en el circuito fueron bloqueados por las profundas diferencias y las viejas rencillas que había entre los diversos grupos de maleteros, quienes buscaban mantener y proteger sus cotos de poder.

Varios de los proyectos de **inSite_05** rompían con esta lectura bidireccional de la movilidad en la frontera, substituyéndola por una que toma en cuenta una trayectoria circular en la que se intersectan diversas relaciones sociales y económicas. Aernout Mik y João Louro investigaron los circuitos de intercambio comercial y reciclaje que existen entre las ciudades de Tijuana y San Diego. Judi Werthein trabajó con la idea de que Tijuana San Diego es un nudo en una red "construida a partir de una constelación particular de relaciones sociales (a escala global y local), que se encuentran y se entretejen en un sitio particular."[18]

En un principio, Bradford tenía la intención de unir su interés por la movilidad con sus ideas acerca del "tiempo de la frontera" –una compleja intersección de diversas líneas de tiempo que se curvan y son experimentadas como una sola.[19] En particular, le interesaba explorar la relación entre el tiempo como *chronos* (un tiempo cronológico) y el tiempo como *kairos* (un tiempo marcado por acontecimientos) –la relación que había entre la experiencia del tiempo que transcurre mientras uno está cara a cara con un oficial de aduanas en inspección secundaria o el tráfico esperando a cruzar la frontera y el paso del tiempo. De este modo sus ideas se relacionaban con el argumento de Doreen Massey, quien afirma que la división entre espacio y tiempo es problemática pues resulta de una asociación fallida del cambio con lo temporal y lo estático con lo espacial. Ella ofrece una visión alternativa del "espacio-tiempo" en la que ambos son inseparables.[20] A Bradford le interesaba explorar las interacciones entre diversas espacialidades y temporalidades en la frontera. Aunque no incorporó el tema del "tiempo fronterizo" en su proyecto final, desde un principio estuvo interesado en concebir el espacio de la frontera como un inter-medio que une, a la vez que confronta, diversas categorías de oposición, entre las que se cuentan la movilidad y la inmovilidad, y el espacio y el tiempo.

Måns Wrange también estaba interesado en la noción del tiempo tal y como se experimenta en la frontera. Antes de trabajar en *El proyecto del buen rumor*, Wrange tenía la idea de emplear el principio de cómputo distribuido para aprovechar y usar, de manera colectiva, el tiempo que "pierden" aquellos que cruzan la frontera en sus largas esperas. Al darle forma a la experiencia colectiva de frustración y ambivalencia por la que pasan estas personas, y al ofrecerles una finalidad utilitaria y desalienante, Wrange buscaba intervenir en el orden "oficial" que determina la movilidad bidireccional en la frontera. Intentaba suplantar esta noción con la idea de una zona colectiva compartida, un nudo en la red, un inter-medio en el que fuera posible la creatividad en caso de que aquellos que cruzan la frontera se negasen a jugar su papel y alteraran la conducta y las respuestas establecidas.

Al comprometerse con el tema de la movilidad en el Puerto de Entrada de San Ysidro, varios de los artistas de **inSite_05** hicieron visible la manera en que las relaciones socioeconómicas se ocultan por medio de los procesos que ordenan la frontera, e intervinieron en ellos. Los artistas se preguntaron: Si los espacios fronterizos están construidos por medio de procesos socioeconómicos y prácticas cotidianas, ¿es posible imaginar otros usos y formas de operación a fin de obtener la posibilidad de activar diferentes tipos de espacio?

LA NACIÓN COMO ACTO EN EL INTER-MEDIO/ EL ESPACIO COMO RITUAL – EL ESPACIO COMO TEATRO

Las fronteras, en este sentido, son parte de las creencias y los mitos políticos acerca de la unidad del pueblo y, en ocasiones, de los mitos acerca de la unidad natural del territorio. Estas "comunidades imaginarias" están relacionadas con la forma más poderosa de vinculación ideológica en el mundo moderno: el nacionalismo.

Malcolm Anderson[21]

El estado no tiene una sustancia estable. Nuestra sociedad mundial esta poblada por diversos tipos de entidades móviles, un hecho que tiende a deslegitimar el concepto de

estado-nación como aquello que contiene estas entidades y que es su único exponente. Los sujetos, los ciudadanos, los habitantes, los bienes, el capital y los sitios de producción van y vienen. Lo que queda no es más que una forma temporal de auto-constitución que tiene que ser llenada, de manera constante, por flujos de entidades de todo tipo a fin de seguir estando presente.

Wolfgang Zierhofer[22]

04.10.05/ 2:56 pm…
Siempre que cruzo la frontera para volver a entrar a EUA me entra el pánico escénico, aunque sepa que todos mis papeles están en orden y que tengo mi visa de trabajo H1 emitida por la Embajada Estadounidense en Londres en el pasaporte. Me da miedo equivocarme, decir algo mal. Me da miedo que descubran que, de alguna manera, soy un impostor, que estoy fingiendo. Espero en la fila. Ensayo mis líneas. Me pone muy nerviosa. Hoy es todavía peor, cruzando con un camión lleno de artistas. Van a hacer tantas preguntas, va a haber tantas oportunidades de que me descubran, de que se den cuenta de que algo está mal, de que no tendrían que dejarnos pasar. Estamos en el limbo y llenos de ansiedad, esperando, esperando que nos otorguen nuestra autenticidad. Entonces podremos respirar tranquilamente de nuevo. Tan pronto como crucemos la línea fronteriza seremos libres, podremos relajarnos, reír y bromear de nuevo.

La práctica del control de pasaportes es un ritual, un acto rutinario por medio del cual se reproduce y se articula determinado orden social, político y territorial bajo el dominio de la forma institucional del estado-nación.[23] Las fronteras y los límites definen la identidad de los individuos en un sentido legal porque estructuran y limitan las condiciones en las que es posible tener una nacionalidad y ejercer los derechos que otorga la ciudadanía. A nivel colectivo, el estado-nación aparece como una comunidad natural, territorial y política más que como una organización histórica y contingente que ha sido naturalizada. El ritual de afirmación del estado-nación es un acto en el que participan aquellos que cruzan la frontera todos los días. Quienes hacen esto, actúan como auténticos "ciudadanos de una nación" o como "visitantes amistosos no-amenazantes" y forman parte de un intercambio ceremonial en el que las identidades se vuelven cuestionables, sospechosas y falsas. Todos son "impostores" en potencia.[24]

De manera similar a lo que ocurre en diversas fronteras en todo el mundo, el ritual del control de pasaportes en el Puerto de Entrada de San Ysidro de Tijuana a San Diego se da así:

Pasaporte por favor
¿Cuál es su nacionalidad? *Mexicana*
¿Por qué va a San Diego? *De compras*
¿Qué trae de Tijuana? *Nada*
Siguiente

Pasaporte por favor
¿Cuál es su nacionalidad? *Estadounidense*
¿Qué estaba haciendo en Tijuana? *De compras*
¿Qué trae de regreso de Tijuana? *Nada*
Siguiente

Pasaporte por favor
¿Cuál es su nacionalidad? *Estadounidense*
¿Dónde nació? *En Eslovenia*
¿Cuándo se convirtió en ciudadano norteamericano? *En 1996*
¿Cómo se convirtió en ciudadano norteamericano? *Estoy naturalizado*
¿Qué trae de regreso de Tijuana? *Nada*
¿Qué estaba haciendo en Tijuana? *De compras*
Siguiente

Este es un guión fijo. A fin de reducir la ambigüedad uno debe decir tan poco como sea posible y responder de manera codificada, con monosílabos. Desviarse del guión genera ambivalencia y eso puede hacer que se cuestione la legitimidad de quien cruza la frontera. Si, por ejemplo, en respuesta a la pregunta: "¿Qué va a hacer hoy en San Diego?" uno responde "voy al trabajo/a la escuela", hay un cambio en el guión y la autenticidad del que cruza la frontera se vuelve sospechosa. Este también es el caso si en respuesta a la pregunta: "¿Qué trae de regreso de Tijuana?" uno dice "antibióticos y anticonceptivos", o si a la pregunta: "¿Cómo se convirtió en ciudadano norteamericano?" uno responde "me casé". La respuesta correcta, "estoy naturalizado", inscribe a quien la dice en la articulación de un orden específico donde queda asumido que la nación es una comunidad natural, territorial y política, y no contingente e "imaginaria". Seguramente, dar otra respuesta haría que la afirmación de pertenencia a una nacionalidad fuera puesta en duda.

Al contrario de lo que ocurre con el guión elaborado con esmero que se repite en el control de pasaportes de EUA, la ausencia total de control de pasaportes en México sirve para acentuar la relación asimétrica que hay entre las ciudades de San Diego y Tijuana. Mientras que en un caso la entrada es celosamente controlada, en el otro ésta se promueve y se fomenta de manera activa.

La nación como acto es un rito ceremonial que aquellos que cruzan la frontera por el Puerto de Entrada de San Ysidro llevan a cabo todos los días, aún cuando, en muchas ocasiones, la noción de nación no esté relacionada con la manera en la que viven en comunidad, en la que los vínculos familiares, los compañeros de trabajo, las amistades, las lealtades y las alianzas atraviesan la línea fronteriza.[25] Los rituales de las reuniones familiares transfronterizas interrumpen los procesos sociales que refuerzan el orden territorial del estado-nación. Este ritual también es transgredido y hecho a un lado todos los días por los inmigrantes indocumentados que saben que no pasarán la prueba ceremonial y, en vez de eso, escogen otras rutas menos transitadas y con menos vigilancia para pasar al otro lado.

El proyecto *Hospitalidad* de Felipe Barbosa y Rosana Ricalde subvertía y alteraba la práctica del control de pasaportes al instigar un acto contrario a ésta. Al invitar a los peatones que cruzan el puente México hacia o desde la frontera entre EUA y México a que inscribieran su nombre de pila en el piso del puente, Barbosa y Ricalde sugerían una realidad alternativa de hospitalidad y amistad sin condiciones. En su micro-utopía sin documentos de identidad, no era necesaria ninguna prueba de residencia, ocupación o clase, y ni siquiera un apellido para pasar de un lado a otro. Preguntar por el nombre de alguien se volvía cuestión de un interés genuino y no una condición de entrada. Se aceptaba al otro como otro, con todas las diferencias sociales, culturales y morales que esto conlleva. Al no obligarlo a "actuar" su identidad, se le consideraba tal cual es.[26]

En su proyecto *Mi Casa, Su Casa*, Paul Ramírez Jonas empleó la metáfora de la llave para invertir la idea del estado-nación como una unidad territorial discreta. Una puerta también es una imagen de la frontera, tiene el mismo efecto de bloqueo y posibilidad. Al contrario que los pasaportes, que funcionan como "un certificado de ciudadanía, [que] sitúa al 'sujeto' [y] le ofrece las condiciones específicas para su movilidad global,"[27] Ramírez Jonas propuso un orden alternativo en el que generó una red de confianza y acceso por medio del intercambio de llaves en puntos claves de Tijuana y San Diego. Aún cuando una persona de Tijuana no pudiera cruzar la frontera entre México y EUA, ¿podría, en teoría, tener la llave de entrada de otra persona que vive en San Diego? En una escala micro, los individuos le daban acceso a sus espacios personales a otro individuo, rompiendo con el ordenamiento de admisión macro y creando un espacio comunitario, paralelo y alternativo, fundado en la confianza.

Con *Coro de Murphy Canyon*, Althea Thauberger construyó un contra-rito en relación a la nación como práctica ritual. Al decidir trabajar con la comunidad del ejército, Thauberger localizó su proyecto dentro del contexto de las ceremonias y los símbolos militares. El ejército encarna y refuerza la ideología imperante de nación como una "comunidad imaginaria" asociada a un territorio predeterminado que la colectividad debe mantener y que tiene que ser defendido por medio de pendones militares, banderas, uniformes, medallas de servicio, oraciones patrióticas y ceremonias con coreografía. Thauberger invirtió la puesta en escena "oficial" de la nacionalidad al escenificar un retrato más íntimo y personalizado de la vida en el ejército a través de las voces y las experiencias de los cónyuges de los militares. El sentimentalismo exacerbado de las letras de las canciones de los cónyuges, que muchas veces hablaban del estado indefinido de inquietud en el que se encontraban mientras esperaban noticias de su "héroe" o su regreso, tenía la capacidad de subvertir la manera en que están orquestados los actos oficiales en los que se afirma la idea de nación. Su pieza era una afirmación de los rituales de parentesco, de los lazos familiares y de la individualidad, que daba cuenta de la existencia de relaciones íntimas rotas y separadas por una frontera a miles de kilómetros de distancia. Al estimular un alto grado de identificación entre el público y los cantantes por medio de la fuerte carga sentimental y emotiva de las letras, Thauberger rompió las oposiciones binarias entre *ellos* y *nosotros* que han sido perpetuadas como tales en la conciencia nacional de los EUA. En un nivel micro, *Coro de Murphy Canyon* lograba alterar el modelo prevaleciente de las relaciones de los EUA con el otro.

Mientras que pareciera que, en los espacios fronterizos, la nación como acto refuerza su poder ideológico constantemente, el estado-nación es cada vez más puesto en duda por una sociedad de redes en la que los intercambios de la economía global están constituidos por los flujos de capital, personas e información entre un grupo de ciudades dominantes a nivel mundial, y no entre totalidades territoriales.[28] Si el estado-nación se ha debilitado, ¿qué tipos de documentos podrían llegar a reemplazar al pasaporte? ¿Qué tipos de comunidades y territorios emergerían si el pasaporte fuera reemplazado por conjuntos de tarjetas de crédito y credenciales de membresía o de tiendas?

El proyecto *Brinco* de Judi Werthein exploraba la manera en la que la expansión del capitalismo de consumo global ha llevado a que las identidades se entiendan como marcas, en términos de afiliaciones a entidades comerciales. Al revelar la manera en la que este proceso oculta las contradicciones implícitas en la "paradoja liberal",[29] Werthein intervino en el modo en el que el comportamiento del consumidor global ha construido nuevos ritos de pertenencia centrados en los artefactos de consumo. Del mismo modo en el que, en los espacios fronterizos, el perfil racial o étnico sirve para identificar y localizar a aquellos que tienen una identidad sospechosa por medio de ciertos rasgos y características claves que están codificados como "extranjeros", el capitalismo global concibe la identidad según un "perfil del comprador" a quien se identifica en términos de posición demográfica, conducta, etcétera, y que resulta igual de simplista que el de la nación.

Tal y como Judith Butler argumenta en su teoría de la performatividad, los actos performativos implican la reiteración constante de normas, que preceden, restringen y exceden a quien actúa. Al actuar de cierta forma el sujeto es constituido como tal.[30] Los artistas de **Intervenciones** sugirieron la posibilidad de crear "comunidades imaginarias" alternativas, por medio de la alteración de los actos que constituyen la nación. El día que Maurycy Gomulicki reunió a un grupo de mexicanos y norteamericanos que se dedican a pilotear aviones de juguete en un lote baldío a orillas del río en Tijuana y dijo: "Creo que el futuro pertenece a las tribus", afirmó que el intermedio es una línea de falla en la que podemos imaginar nuevos modelos de pertenencia. Su contra-acto poético demostró que es posible concebir otras comunidades que no obedezcan ni a la idea de nación, ni a un mismo patrón de consumo, sino a las metas en común, a la comunidad de intereses y a una auténtica preocupación por el prójimo.

EL ORDEN DE LAS INMOVILIDADES/ EL ESPACIO COMO MURO – EL ESPACIO COMO OTRO

La frontera se vuelve un síntoma que encarna la expulsión del otro de lo mismo. La frontera exterior es la ilusión que crea el negar la diferencia que hay en el interior, en lo entre integral, en el intersticio. La frontera del estado se erige como la marca simbólica del rechazo o, cuando menos, del control y de la vigilancia del otro, y del desplazamiento sintomático de un antagonismo radical al interior.

Patrick French[31]

[…] Las geografías imaginarias doblan la distancia y la vuelven diferencia por medio de una serie de espacializaciones. Multiplican las divisiones y las circunscripciones que separan "lo mismo" de "lo otro" y, a la vez, construyen y calibran una distancia entre ambos al designar, en nuestra mente, un espacio conocido que es el "nuestro" y un espacio desconocido que está más allá del "nuestro" y que es el "suyo".

Derek Gregory[32]

09.10.04/ 2:30 pm…
La temida Inspección Secundaria –el lugar a donde mandan a las entidades dudosas cuando no han pasado la prueba de autenticidad en el control de pasaportes. Hoy nos pasamos cuatro horas ahí porque resulta que Rubens Mano es brasileño y, por lo visto, los brasileños, así como los que tienen otras nacionalidades selectas, están señalados como posibles sospechosos y hay que investigarlos más a fondo. Regresamos tarde a San Diego. Michael quería que yo presentara las pláticas de los artistas por la noche. Me dijo que mi acento británico haría que lo que dijera sonara inteligente. ¿Qué tiene el acento británico que le parece tan entrañable y atractivo a los estadounidenses? A veces me da la impresión de que me ven como algo exótico. Por otra parte, sé que algunas de las personas de la región se están preguntando qué hago aquí, una mujer inglesa. ¿Qué derecho tengo a decir lo que sea de la frontera?

Los procesos que ordenan los espacios fronterizos generan ambivalencia. Son zonas en las que, por un momento, las entidades quedan suspendidas en el limbo, móviles e inmóviles, conocidas y desconocidas. Son espacios que producen "al extranjero". Ni amigo, ni enemigo, el extranjero es un personaje que al tender puentes entre los límites desafía las categorías aceptadas y, por lo tanto, produce ansiedad.[33] Sin embargo, la condición del extranjero como alguien que está en el inter-medio y en transición sólo es temporal. Los procesos socioeconómicos que producen los espacios fronterizos (el legado de los principios de orden de la modernidad) dictan que hay que fijar las identidades ambivalentes; hay que separarlas, ordenarlas y ponerlas en el lugar que les corresponde. En el Puerto de Entrada de San Ysidro, como en otros puertos de entrada, este proceso de filtrado se lleva a cabo en la inspección secundaria. Después de una inspección primaria, los agentes aduanales tienen que

decidir si hay que recomendar que el solicitante pase a un punto de inspección secundaria para una revisión más a fondo. Ahí es donde se llevan a cabo las búsquedas más intensas en los vehículos, se realiza un escrutinio minucioso de los documentos, se hacen las preguntas más comprometedoras y se solicitan más evidencias de autenticidad. Es desde ahí donde es posible expulsar al elemento heterogéneo hacia el que se ha desplazado el antagonismo social a fin de mantener la ilusión de un estado-nación coherente y homogéneo.

De manera asimétrica, para Tijuana, el puerto de entrada opera como la puerta por la que se expulsa al otro cuando éste es deportado de EUA a México. A su vez, México rara vez expulsa al otro. Es como una casa con la puerta delantera siempre abierta. El muro funciona en un sólo sentido.[34] Cuando México expulsa al otro, esto ocurre al sur, en la frontera con Guatemala. Ahí se reflejan los mismos procesos de filtrado y orden que hay en el control fronterizo y aduanal entre México y EUA.

Sin embargo, el acto de expulsar al otro deslegitima las relaciones y el deslizamiento que hay entre *nosotros y ellos*. Con ello es posible clasificar la identidad ambivalente del extranjero y ponerla en el lugar que le corresponde –el terrorista en Guantánamo, el buscador de asilo en el campo, el paciente psiquiátrico en el sanatorio, la obra de arte en su marco institucional–, pero ese acto no puede borrar el hecho de que una categoría no puede existir sin la otra; que una es producida en relación a la otra. Las fracturas entre ellos y nosotros suelen reflejar fracturas que hay dentro de nosotros.

Al relacionar la figura del paciente psiquiátrico con la del emigrante indocumentado, Javier Téllez demuestra la manera en la que las "geografías imaginarias […] conjuran, a la vez que rechazan, a lo extraño, lo no natural y lo monstruoso."[35] El "inmigrante ilegal", que es percibido como una amenaza para la salud de la nación, debe estar separado de los "auténticos ciudadanos", así como el "cuerdo" debe estar separado del "loco", pues hay que evitar la contaminación a toda costa. Al disparar a un ciudadano norteamericano desde un cañón situado en México sobre el muro que lo divide de los EUA, Téllez abre la línea de falla de la zona fronteriza para demostrar lo absurdo de la expulsión del otro. Al intentar transformar la zona fronteriza en una especie de carnaval renacentista en el que "se suspenden, por un momento, todas las distinciones jerárquicas, las fronteras entre los hombres […] y las prohibiciones de la vida cotidiana,"[36] Téllez generó un espacio en el que las personas que en la vida cotidiana están separadas por barreras jerárquicas impenetrables pudieran entrar en contacto de manera libre y familiar. Este contacto con el otro abre la posibilidad de reconocer al otro en nosotros. Téllez transforma el inter-medio en una zona en la que podemos imaginar otros modos de operar en el mundo que celebren lo indeterminado, la heterogeneidad y las relaciones y correspondencias entre las cosas.

El hecho de que los espacios fronterizos se produzcan por medio de un proceso de ordenamiento y expulsión del otro resulta cada vez más insensato en un mundo tan interconectado como el nuestro. Cada uno de nosotros es parte de una red de relaciones que, a su vez, está imbuida en las relaciones de poder que cubren la tierra, en "una jerarquía en la que una élite móvil transciende las fronteras espaciales, mientras que una clase no privilegiada cada vez más numerosa permanece inmóvil en los asentamientos irregulares de las grandes urbes o padece la movilidad forzada de los refugiados internacionales".[37] El impacto que el proyecto *Brinco* de Judi Werthein tuvo en el público, especializado en arte o no, provino del hecho de que le daba forma a las complejas dinámicas socioeconómicas que nos unen, y que nos permiten invertir, subvertir y transgredir el orden establecido de las cosas en tanto que actores. Sin embargo, este proyecto ¿nos transformó de consumidores en conspiradores o simplemente reflejó el arraigo de nuestro comportamiento como consumidores, la manera en la que expresamos nuestra filiación a las causas "globales" por medio de patrones de consumo sin realmente cuestionar el hecho de que quizá el problema sea el proyecto consumista global?

Sin embargo, la otredad en términos espaciales también implica la construcción narrativa del territorio y la construcción de fronteras cognitivas e imaginarias que se perciben como propias. Las narrativas de separación y diferencia que suelen estar relacionadas con los estereotipos y los prejuicios se construyen y se reproducen de manera colectiva. Aún cuando aproximadamente el 90% de los habitantes de San Diego ha visitado Tijuana, estos lo hacen con mucha menos frecuencia de lo que los tijuanenses visitan San Diego[38] y, en gran medida, esto se debe al mal concepto en el que tienen a Tijuana.[39] Esa frontera es, en cierto sentido, mucho más perniciosa y mucho más difícil de erradicar que la otra. Cuando Maurycy Gomulicki y Tania Ragasol intentaron convencer a un grupo de pilotos de aviones de juguete de que cruzaran la frontera para practicar con un grupo de pilotos mexicanos, se encontraron, en un principio, con una gran resistencia. Esta resistencia indica el tipo de fronteras cognitivas que construyen la diferencia. El "acto de la inmovilidad", la práctica de no cruzar las fronteras como un resultado de las múltiples fronteras que hay en la mente de las personas, persiste aún cuando no hay fronteras físicas.[40]

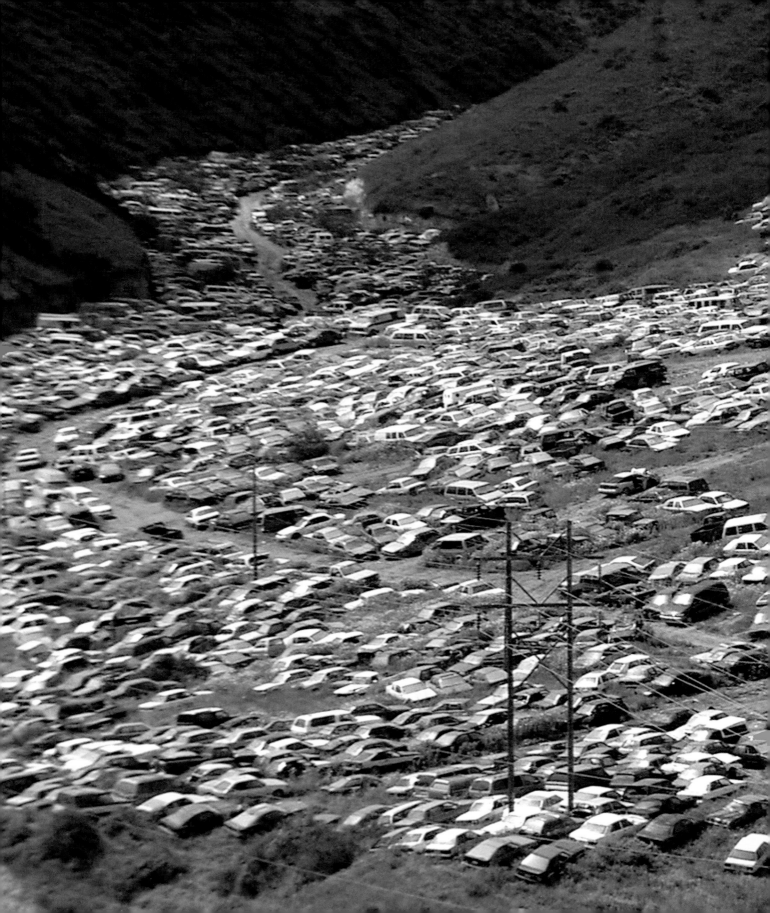

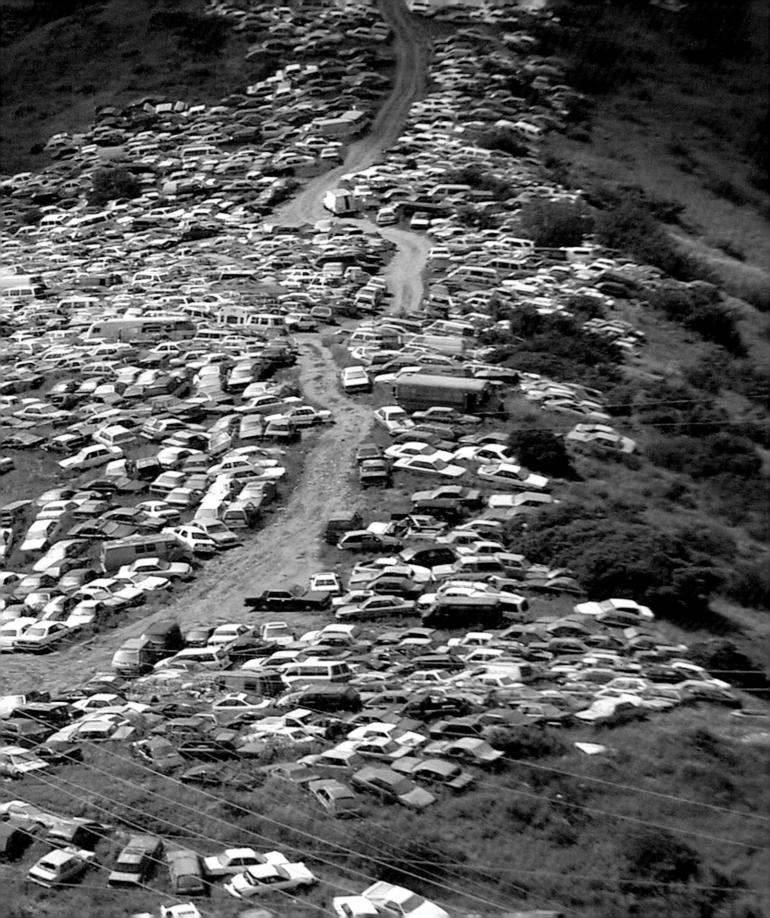

Måns Wrange reconoció que el poder de la información y de los medios se ejerce en acto y es móvil e ilimitado. Wrange intentó intervenir las narrativas internalizadas de la "otredad" que construyen la territorialidad, al generar un virus oral que subvertía y alteraba los discursos establecidos sobre la diferencia.

Itzel Martínez del Cañizo trabajó con los pacientes de un centro de rehabilitación para drogadictos a fin de crear nuevas narrativas de inclusión. Martínez del Cañizo colaboró con individuos para quienes la frontera entre México y EUA es equivalente a la que hay entre la Tierra y Marte, individuos a quienes sus compatriotas tijuanenses han satanizado como "narcos" porque no tienen los papeles para cruzar la frontera. Martínez del Cañizo intervino en la manera en la que las narrativas de la otredad producen fronteras dentro de los parámetros de una ciudad compartida. Los escenarios alternos de pertenencia que construyeron los pacientes subrayaban el hecho de que hay un "tercer mundo" en cada "primer mundo" y un "primer mundo" en cada "tercero".

Al transformar el espacio de la frontera en un inter-medio donde las nociones de otredad y diferencia resultan problemáticas, y la división entre nosotros y ellos se ha disuelto, los artistas de **inSite_05** fueron capaces de desestabilizar las posiciones de identidad fijas y plantear en su lugar la idea de las identidades como procesos; como algo que cambia constantemente a partir de sus colisiones y encuentros con el otro.

Sin las fronteras no puede existir nada o, al menos, no podemos saber de ello. En la frontera algo termina y algo empieza, o puede empezar. Una diferencia, entonces, existe cuando nos volvemos conscientes de la frontera. La frontera crea orden. [...] En un mundo donde todo se ha vuelto inter-medio [...] hay, de hecho, ciertos puntos de fuga más allá de los cuales reina el silencio. Es en la zona que está más allá de estos puntos de fuga donde la micro política, la macro política y las posibilidades de cambio tienen su dominio.

Ole Bouman[41]

Las posibilidades de la imaginación pueden surgir en las brechas que hay entre las oposiciones binarias, en los puntos de intersección precisos en los que movilidad puede querer decir inmovilidad, donde flujo puede querer decir reposo, donde el orden puede ser desorden y donde el yo y el otro se mezclan para convertirse en colaboradores y conspiradores. Es ahí, en el inter-medio, en la línea de falla de los espacios fronterizos, donde podemos ver las posibilidades de cambio. Como afirma Ole Bouman: "Sin las fronteras no puede existir nada o, al menos, no podemos saber de ello," pero las posibilidades imaginarias tienen su dominio en los frágiles espacios embrionarios que se crean en los intersticios que hay entre nuestras fronteras. Son espacios que no están plenamente conceptualizados, localizados y definidos, y por lo tanto tienen la libertad de seguirse transformando.

Donna Conwell *es curadora. Vive y trabaja en Tijuana San Diego. Fue co-curadora de* **Intervenciones**, **inSite_05**

Traducción: Pilar Villela

1 BECHMANN, Jörg, "Ambivalent Spaces of Restlessness: Ordering (im)mobilities at Airports" en, *Space Odysseys: Spatiality and Social Relations in the 21st Century*, Ed. Jørgen Ole Bærenholdt y Kirsten Simonsen, Ashgate, Aldershot, 2004, p. 39

2 SIMONSEN, Kirsten y BÆRENHOLDT, Jørgen Ole, "Introduction" en, *Space Odysseys*, pp.1-2

3 DE CERTEAU, Michel, *The Practice of Everyday Life*, University of California Press, 1984, p. 127

4 MASSEY, Doreen, "A Global Sense of Place", *Marxism Today*, junio, pp. 24-29

5 AUGÉ, Marc, *Non-Places: Introduction to an Anthropology of Supermodernity*, Londres, Verso, 1995.

6 BECHMANN, Jörg, "Ambivalent Spaces of Restlessness: Ordering (im)mobilities at Airports" en, *Space Odysseys*, p. 27 (Las itálicas son mías).

7 Información telefónica sobre el Puerto de Entrada de San Ysidro.

8 BECHMANN, Jörg, "Ambivalent Spaces of Restlessness: Ordering (im)mobilities at Airports" en, *Space Odysseys*, p. 39. Bechmann habla acerca de los "administradores de flujos" en relación a la manera en la que se ordena la movilidad en los aeropuertos.

9 Hay dos puntos de cruce fronterizo en la región: uno en San Ysidro y otro en Otay Mesa. Me he concentrado en el Puerto de Entrada de San Ysidro pues es el paso más importante entre San Diego y Tijuana.

10 *Blurred Borders: Trans-Boundary Impacts & Solutions in the San Diego-Tijuana Border Region*, Ed. Naoko Kada y Richard Kiy, International Community Foundation, 2004, p. 13

11 Basado en la página de información sobre retrasos en la frontera, disponible en www.uscustoms.gov.

12 Los residentes que pueden probar su ciudadanía, residencia y solvencia financiera, y que

pueden pagar una cuota, pueden obtener una tarjeta de pase rápido que les permite evitar las largas colas de la frontera. Sin embargo, la mayoría de las personas que cruzan la frontera no tienen un pase SENTRI y los tiempos de espera para aquellos que cuentan con la tarjeta de cruce rápido se están volviendo cada vez más largos debido al aumento en la demanda del servicio. (LINDQUIST, Diane, "Fast Lanes at the Border are Slowing Down" en, *The San Diego Union Tribune*, 26 de abril, 2005).

13 Las visas láser, también conocidas como BCC (Border Crossing Card), se le otorgan a los mexicanos que visitan los Estados Unidos y son capaces de probar que tienen vínculos importantes con México que los harán regresar después de una corta estancia en los EUA. Se les autoriza cruzar por un periodo de 72 horas, pero no cuentan con un permiso de trabajo legal.

14 En el 2002, los residentes de Baja California gastaron alrededor de $1,600 millones de dólares en bienes y servicios en el Condado de San Diego (MORRIS, "Moving Towards Smart Borders" en, San Diego Dialogue/Forum Fronterizo, junio, 2003). Un estudio similar realizado por el Banco de México calcula que, durante ese mismo año, el gasto total de los tijuanenses en los comercios minoristas de San Diego fue de $950 millones de dólares (Banco de México, 2002).

15 Después de los atentados de Nueva York hubo un incremento en la seguridad de la frontera entre México y EUA, lo que dio como resultado un aumento en los tiempos de espera.

16 El hecho de que el grupo particular de maleteros que se encarga de llevar el equipaje de Tijuana a San Diego a través del edificio de aduanas de los EUA esté reconocido "oficialmente" y regularizado a nivel local (incluso si su existencia está prohibida a nivel federal), indica que tanto aquellos que cruzan la frontera, como los "administradores de flujos" –cuyo trabajo es facilitar la movilidad a través del puerto de entrada– confrontan el discurso oficial de la movilidad unidireccional y negocian con él.

17 Resulta interesante que, en su proyecto, Bradford llegó a pensar en hacer una gráfica de flujos que señalara los diversos umbrales de movilidad unidireccional en la frontera. Más adelante esta información sería yuxtapuesta con la del movimiento circular de los maleteros.

18 MASSEY, Doreen, "A Global Sense of Place" en, *Marxism Today*, p. 28 (Las itálicas son mías). Resulta interesante que todos los proyectos disminuyeron el papel de México en el proyecto consumista, enmarcando al sur como una víctima del consumismo y la globalización, y evitando profundizar en el papel que éste juega en la perpetuación de ese sistema.

19 Mark Bradford, Propuesta para proyecto, 2004. (Por supuesto, la experiencia de múltiples temporalidades no se limita a los espacios fronterizos, pero Bradford argumentó que esa experiencia se vuelve más intensa en ese tipo de espacios. En parte, esto se debe a que la movilidad y la inmovilidad coexisten en ellos).

20 MASSEY, Doreen, "Politics and space/time" en, *New Left Review*, 196, pp. 65-84.

21 ANDERSON, Malcolm, "The Political Science of Frontiers" en *Borders and Border Regions in Europe and North America*, Ed. Paul Ganster, Alan Sweedler, James Scott, Wolf Dieter-Eberwein, San Diego State University Press, 1997, p. 29 (No obstante, el concepto de nación como una "comunidad imaginaria", corresponde a Benedict Anderson).

22 ZIERHOFER, Wolfgang, "'Your Passport Please!' On Territoriality and the Fate of the Nation State" en, *Space Odysseys*, p. 114

23 Ibid. p. 101

24 SENGUPTA, Shuddahbrata, "Nothing to Declare" en, *Dialogue 1: Liminal Zones, Coursing Flows,* **Conversations,** inSite_05, 2004, p. 16. En su ponencia Shuddahbrata habla de la idea del impostor.

25 40 % de los tijuanenses dice tener familiares en San Diego (*Blurred Borders: Trans-Boundary Impacts & Solutions in the San Diego-Tijuana Border Region*, p. 10)

26 Maurycy Gomulicki también usó la metáfora del puente en su proyecto *Puente Aéreo*, refiriéndose al proceso de volver a imaginar el espacio fronterizo como un conducto a través del cual se llevan a cabo conexiones y relaciones; en vez de considerarlo como un espacio de segregación tal y como es expresado por la metáfora del muro.

27 ZIERHOFER, Wolfgang, "'Your Passport Please!' On Territoriality and the Fate of the Nation State" en, *Space Odysseys*, p. 105 (Las itálicas son mías)

28 TAYLOR, Peter Taylor "World Cities and Territorial States: The Rise and Fall of their Mutuality" en, *World Cities in a World-system*, Ed. P.L. Knox and P.J Taylor, Cambridge University Press, 1995, pp. 48-62

29 La "paradoja liberal" se refiere a la idea de que la globalización y el mercado libre han intensificado las disfunciones económicas y sociales imponiendo la migración forzada.

30 BUTLER, Judith, *Bodies that Matter. On the discursive Limits of Sex*, Routledge, 1993, p. 2

31 FRENCH, Patrick, "Passage Barré: Port Bou, September 26, 1940" en, *Territories: Islands, Camps and Other States of Utopia*, KW-Institute for Contemporary Art, 2003, p. 232

32 GREGORY, Derek, "Connective Dissonance: Imaginative Geographies and the Colonial Present" en, *Space Odysseys*, p. 203

33 BAUMAN, Zygmunt, *Thinking Sociologically*, Blackwell, 2001, p.155

34 ILLICH, Fran, www.electronicbookreview.com/thread/technocapitalism/hacktivist

35 GREGORY, Derek, "Connective Dissonance: Imaginative Geographies and the Colonial Present", p. 204

36 BAKHTIN, Mikhail, *Problems of Dostoevsky's Poetics*, University of Minnesota Press, 1984, p. 15

37 JENSEN, Ole B. y RICHARDSON Tim, "Framing Mobility and Identity: Constructing Transnational Spatial Policy Discourses" en, *Space Odysseys*, p. 834. (El autor hace referencia a Zygmunt Bauman, *Globalization: The Human Consequences*, Polity Press, 1998).

[38] Blurred Borders: Trans-Boundary Impacts & Solutions in the San Diego-Tijuana Border Region, p.151

[39] San Diego Focus Group, El proyecto del buen rumor, Måns Wrange y Encuesta KPBS/CERC en enero de 2004 de Competitive Edge Research.

[40] STRÜVER, Anke, "'Space Oddity': A Thought Experiment on European Cross-Border

Mobility" en, Space Odysseys (Strüver examina la no-práctica del cruce de fronteras en la Unión Europea a pesar de las fronteras, en tanto que impiden la integración, han sido eliminadas).

[41] BOUMAN, Ole, "Don't save art, spend it!" en, Manifesta 3: Borderline syndrome-Energies of defense, European Biennial of Contemporary Art, 2000, pp. 15-16

UNA MIRADA A TIJUANA SAN DIEGO EN TRES POSTALES

Tania Ragasol

Hace unos meses miraba desde *La esquina/ Jardines de Playas de Tijuana* a una pareja besarse a través de un hueco en la valla metálica que separa a San Diego de Tijuana. Él se encontraba en el lado estadounidense y ella en el mexicano. Aprovechaban ese intervalo para encontrarse sin tener que cruzar por algún punto de entrada/salida oficial; pero el intercambio fluía de un lado al otro de cualquier modo. Uno se preguntaba: ¿Cómo habrán concertado la cita?: ¿"Nos vemos en el agujero de la barda"?, ¿"Nos vemos en la barda"? "La barda" entonces no era necesariamente un obstáculo, sino también un espacio, un sitio para el encuentro. Sin embargo, la pregunta que persiste es: ¿Se hubieran besado del mismo modo si no hubiese existido el obstáculo de por medio?

POSTAL 1: TERRITORIO, A VUELO DE PÁJARO

Una metrópolis transfronteriza, por definición, es un lugar en el que la circulación de personas, bienes y servicios a través de la frontera debe ser facilitada para que los límites no entorpezcan el circuito económico de la región. Se debe permitir a la región cumplir con su destino y convertirse en una ciudad/región que opere en la economía global.

Laurence A. Herzog[1]

En su libro *La imagen de la ciudad*, Kevin Lynch describe cinco elementos físicos identificables que actúan sobre la imaginabilidad colectiva de una metrópolis: sendas, bordes, barrios, nodos y mojones. Estos elementos refieren tanto a zonas específicas de una metrópolis, como a la ciudad toda. Debido a la especifidad de su análisis, Lynch en su texto decide pasar por alto "otras influencias que actúan sobre la imaginabilidad"[2] de la ciudad, que pueden ser relacionadas con las dinámicas sociales y económicas de una zona. Me pregunto si más que constituir instrumentos de estudio por separado, no serán precisamente esas "otras influencias", las que delinean sendas, bordes, barrios, nodos y mojones.

Podríamos deducir que estos elementos referidos por Lynch son los que predeterminan la existencia y la ubicación de lo que se conoce como *setback*: esa zona de separación y aislamiento intencional entre ciudades, barrios y casas. El *setback* y estos elementos –más allá de delinearse mutuamente– influyen sobre la cotidianidad social y económica de la zona fronteriza, al tiempo que toman forma debido a los requerimientos del propio contexto.

El primer *setback* identificable en la región es el que separa a San Diego de Tijuana y de Los Ángeles: Al norte, Camp Pendelton; al sur, el Tijuana Estuary y otras reservas naturales (y "el bordo"); al oeste, el Océano Pacífico y al este, las montañas y el desierto del sur de California. Esta asepsia en el asentamieto urbano se reproduce a escala en muchos de los vecindarios sandieguenses. Cuadras enteras están divididas por callejones, y las casas y los edificios no están construidos pared con pared, sino que "respiran" hacia sus cuatro costados, quedando así notoriamente separados unos de otros. De algún modo, estos elementos físicos urbanos garantizan la existencia de otros bordes, tanto a nivel metropolitano como a nivel personal en el habitante de San Diego. Esa zona de "acolchonamiento" contrasta con la imagen de numerosas casitas "comiéndose" a cerros y montañas en Tijuana. Esa imagen de densidad no sólo transparenta el crecimiento informal de los barrios periféricos. Basta pasearse por la privilegiada colonia Chapultepec de Tijuana para observar la convivencia puerta-a-puerta de las casas. Pareciera que de ese lado de la barda no se previene de manera calculada y evidente el contacto con el vecino. No se siente aquella cosa aséptica, aquél miedo al roce.

Cuando uno llega a Tijuana en avión, de sur a norte, estas aseveraciones cobran un nítido dramatismo. Desde el aire se observa cómo "la barda" ineludible separa a ambas ciudades; Tijuana parece mirar al norte, con sus casas abarrotadas contra el muro divisorio, mientras que San Diego se ensimisma (en todo caso mirando al mar) intentando inútilmente ignorar a Tijuana. Sin embargo, es otra imagen la que define de modo contundente las contradicciones de la zona: Desde la altura, la orografía se aprecia como una misma; las mismas montañas, el mismo mar, el mismo desierto:

un mismo territorio. Una sola región, Tijuana San Diego, atravesada por una barda y conectada por un eje vial. El flujo de tráfico se nota evidente hacia uno y otro lado, especialmente hacia el norte, con la fila de coches detenida en la Garita de San Ysidro. La carretera Interestatal 5 –que atraviesa la costa oeste de los Estados Unidos de sur a norte hasta llegar a Canadá– y el tijuanense Paseo de los Héroes conforman una línea continua, misma que intersecta –justo en la Garita de San Ysidro– con la valla metálica fronteriza en su camino este a oeste hacia la mar. A esa distancia, las vías vehiculares y la valla fronteriza se aprecian como los dos ejes, el cardo y el decúmano, de una zona de flujos e intercambios. Los rasgos físicos urbanos de la zona se leen de otro modo entonces: Tanto la valla como la conjunción Interestatal 5/Paseo de los Héroes parecen obedecer al funcionamiento de intercambios en la región, a la vez que intervienen esas mismas mecánicas de vida.

La idea de un único territorio compartido, atravesado por una línea divisoria arbitraria, subyace en el proyecto *Mi Casa, Su Casa*, de Paul Ramírez Jonas. En un momento inicial de su propuesta Ramírez Jonas proponía la elaboración y la distribución simbólica de "la llave de la ciudad" para Tijuana San Diego, es decir, una misma llave para la región; atestiguando este devenir como una única zona de reciprocidad y permutaciones. Una zona donde la llave ordinaria son pasaportes y visas, los cuales ayudan a filtrar y a poner condiciones de entrada y salida a quien quiere atravesar "la línea".

Pero existen también otras corrientes fronterizas que ignoran barreras y que se llevan a cabo con otro tipo de acuerdos y condiciones –y con menos filtros, parecería. En su video *Ósmosis y exceso* Aernout Mik analiza el circuito económico de la región, y cómo la dinámica de intercambio regional ha modificado y hasta cierto punto modelado de manera desigual el paisaje urbano compartido. Ya en el título del proyecto se alude al fenómeno físico que consiste en el paso recíproco de dos líquidos de distinta densidad a través de una membrana interpuesta entre ellos, haciendo una metáfora acerca de la influencia mutua que las economías de Tijuana y San Diego tienen una sobre la otra a través de la barda fronteriza. *Al esbozar un retrato de Tijuana y de cómo esta ciudad ha sido definida por sus flujos transitorios y por su relación de interdependencia asimétrica con su vecino del norte, Mik sugiere que la narrativa social y económica de una metrópoli está integrada por las configuraciones y transformaciones que se registran en su topología local.* [Donna Conwell][3]

En su ensayo "Resisting the City"[4] Mark Wigley afirma: *Siempre se nos ha tenido que decir cuando estamos en una ciudad. Siempre hay un letrero en la carretera, o una voz en el tren o el avión, que te avisa cuando estás en tal o cual ciudad, y otro letrero para avisarte cuando has salido de ella. ¿Por qué nos tienen que avisar? Porque la ciudad no es un objeto físico. Es un complejo paquete con distintos tipos de límites. Los letreros generalmente aparecen en una zona indeterminada, un territorio vago que es solo comprensible como "las afueras" de un sitio cuando un letrero aparece de pronto. El letrero podría ser fácilmente movido. No hay nada en el entorno físico que confirme lo que éste dice.* Esta apreciación es aplicable a Tijuana San Diego. Los letreros, la barda divisoria, las garitas de San Ysidro y Otay, e incluso el tráfico detenido en la intersección de la autopista Interestatal 5 y el Paseo de los Héroes anuncian que hay un límite entre un país y otro. Sin embargo, la geografía –el entorno físico– y sus flujos no lo confirman. La cotidianidad social y económica de la región –tanto a nivel personal como profesional– no parece confirmar ese límite impuesto, y sin embargo se acopla a él y se mueve a su alrededor, a veces ignorándolo y otras aceptando existir debido a él. Regiones geográficas, económicas, sociales y ecológicas compartidas suelen ser ignoradas y negadas –con demarcaciones constituidas por obstáculos artificiales– por ciudades, gobiernos y límites políticos, aunque sus dinámicas de existencia contradigan estos ordenamientos.

POSTAL 2: EXISTENCIA NOMÁDICA Y FLUJO FRONTERIZO

Estoy haciendo fila, haciendo fila, estoy haciendo fila para salir del país. Es algo natural, cosa de todos los días. A mi izquierda, una familia en una vagoneta nissan; a mi derecha, un gringo de lentes oscuros en un mitsubishi deportivo. Por el retrovisor veo a una muchacha en un volkswagen. Adelante, un toyota. Vamos a salir del país y es algo natural, cosa de todos los días.

Luis Humberto Crosthwaite[5]

Sin duda, una gran parte de la población urbana lleva hoy una existencia nómadica.

Andreas Ruby[6]

De las primeras "estrategias de vida" que uno debe de adoptar al vivir en Tijuana San Diego es adquirir un automóvil. Existen diversos medios de transporte público a ambos lados de la frontera: En San Diego los autobuses, el tren, los taxis y el *trolley* –cuya línea azul lleva desde Old Town en el centro de la ciudad hasta la garita de San Ysidro, y viceversa; y en Tijuana los taxis amarillos de cuota, los anaranjados con taxímetro (ahora rojos), los diversos taxis de ruta y las calafias[7]. De todas las opciones, la más cómoda y eficiente resulta ser el coche propio, tanto para circular dentro de cada una de las ciudades como para hacerlo entre ellas. Ahí uno puede hacer la cola para el cruce sentado, escuchar música al volumen que quiera mientras observa el atardecer y comer lo que se le antoje sin restricción alguna y sin tener que convivir con el chofer o con otros tantos pasajeros.

Para quienes circulamos en coche constantemente entre ambas ciudades, una de las vías de comunicación más emblemáticas del ritual del cruce es la carretera Interestatal 5, que dependiendo de la dirección desde la cual se la vea comienza o termina justo en la Garita fronteriza de San Ysidro. De algún modo la I-5 encarna el símbolo de la posibilidad de conexión entre las dos ciudades y de los flujos continuos en la región, y en el caso concreto de los proyectos de las **Intervenciones** se vuelve una especie de metáfora de las "idas y vueltas" de sus procesos de desarrollo. En el recorrido de la carretera se puede dar el tiempo y el espacio para que ocurran determinadas situaciones inherentes a los proyectos de **inSite**: tomar decisiones, enterarse de permisos concedidos o denegados, tener juntas sobre ruedas, discutir ideas con los artistas, sugerir y acordar posibles estrategias. De manera más general, en ese lapso uno puede comprender cómo funciona la región mientras escucha la radio. Se puede uno enterar de que las estaciones de radio de ambas ciudades venden publicidad a empresas de ambas ciudades que anuncian sus productos de manera indistinta para los potenciales consumidores de un lado y del otro de la barda; de que se puede comprar un colchón en San Diego y se lo llevan a uno sin costo alguno hasta su hogar en Tijuana; de que un taxi tijuanense lo puede recoger a uno en su hogar sandieguense y llevarlo hasta el aeropuerto en Tijuana; y de que hay estaciones mexicanas que transmiten del lado americano con programaciones habladas completamente en español y viceversa. A veces, sumergido en las dinámicas cotidianas del cruce, uno de pronto hasta puede olvidar que está en otra ciudad/país, pues recibe la señal de la radio sin interrupción en un trayecto, digamos, de Del Mar, CA hasta Rosarito, BC.

Si bien a ambos lados de la barda se comparte una "cultura del coche", la experiencia real automovilística se vive de maneras distintas en una ciudad y otra. En Tijuana pueden pasarse largas horas del día en el tráfico de la ciudad durante las horas pico, y sobretodo durante la espera en la línea para cruzar a San Diego, mientras que en San Diego ese tiempo se gasta generalmente en largas distancias recorridas en los *freeways* para llegar de un barrio a otro, o de una ciudad a otra. Es bien sabido que desde la industrialización del automóvil las ciudades americanas se comenzaron a diseñar para éste, dando por resultado que Estados Unidos es el país con más coches *per cápita* y más *freeways*. Para darse una idea de esto basta ver el tamaño de los estacionamientos y lotes de venta de coches en San Diego, en correspondencia directa con el tamaño de los *yonkes*[8] de coches en Tijuana, comúnmente habitados por autos americanos heredados del lado mexicano y luego abandonados como chatarra. En Tijuana los coches generalmente son de segunda mano, heredados de San Diego; mientras que en esta última los coches se cambian casi cada dos años.

En una cultura que gira en torno al automóvil, el hacer autos a la medida puede entenderse como una representación compleja de estatus. La pertenencia de grupo, la identidad cultural y la expresión individual o de grupo. [Donna Conwell][9] El icono del coche como articulador de identidad y símbolo de pertenencia es abordado por Christopher Ferreria en *Un cierto monstruo amable*, al convocar a dos grupos distintos de *car customizers* a participar en la transformación colaborativa de un camión repartidor. El proceso de colaboración implicó la colisión de diferentes estrategias transformativas y de adhesión cultural, logrando un híbrido en el que confluía la diversidad de la cultura automovilística local. La circulación del "coche monstruo" por muy diversas zonas de San Diego develaba las fronteras urbanas y sociales al interior de la misma ciudad. Fronteras que suelen ser navegadas, negociadas y atravesadas por aquellos que transitan sus calles diariamente sin siquiera salir del país.

Quizá la figura que más claramente encarna los flujos que alimentan y dan forma al tejido social de la zona sea la del *commuter*.[10] En esta región transfronteriza, el *commuter* generalmente cruza de Tijuana a San Diego por las mañanas y regresa por las tardes, aunque existen casos contrarios de gente que vive en San Diego y trabaja en Tijuana o tiene asuntos que atender cotidianamente de ese lado. En ambos casos, el proceso de tránsito implica horas de espera y trámite día tras día. Ese proceso en sí mismo puede constituir un elemento de identificación para aquellos que lo viven como parte de su cotidianidad, como *Visible* de Rubens Mano sugería al insertar

una señal en el cauce del commuter. Si bien tiene resonancia con las estrategias de los biólogos que "marcan" a sus objetos de estudio para poder estudiarlos, más allá de simplemente identificar una corriente fronteriza el proyecto buscaba generar una red de enlace entre los portadores de un señal-pin con la palabra visible. Mano sugería que es en ese commuting en donde se genera un nuevo territorio de conexión e identidad, interviniendo en la manera en que ese "ir y venir" te convierte en diferente. Como menciona Andreas Ruby en su texto *Transgressing Urbanism: Los nómadas* **commuter**, debido al largo viaje al trabajo y de regreso de éste, pasan varias horas cada día en el tráfico, que se convierte en una especie de hogar mientras sus actuales hogares funcionan en su mayoría como dormitorios, como es el caso de algunas tribus nómadas en África.[11]

Los límites entre las divisiones políticas de la región no parecen ser bloqueos insalvables para sus flujos; aún cuando ciertos intercambios pueden verse entorpecidos por la presencia de obstáculos que buscan regular la constitución de identidades. Paradójicamente, a veces es debido a dicha presencia de "estorbos" que los flujos funcionan de ciertas maneras definidas, más eficientes.

POSTAL 3: LA PRIMERA Y LA MEJOR

Hasta ahora definida como la cualidad de un lugar, la urbanidad se está transformando en una condición atmosférica ya no necesariamente limitada a un lugar o espacio. Esta urbanidad transurbana definitivamente va más allá del territorio del urbanismo. Ya no puede ser planeada, pues ocurre solamente si la ejecutamos.

Andreas Ruby[12]

Quizá uno de los elementos que de manera más efectiva actúa sobre la imaginabilidad de las ciudades sea su lema. En Tijuana y San Diego, sus lemas parecen ser particularmente elocuentes. Si en Tijuana nos informan que "Aquí empieza la patria", San Diego es "America's Finest City" (La mejor ciudad de Estados Unidos). Los tijuanenses se enorgullecen de ser "la esquina noroeste de Latinoamérica" mientras que los sandieguenses se jactan de tener la ciudad más limpia, ordenada y con mejor clima de su país.

El hecho de ser el principio de la patria convierte a Tijuana en la puerta de entrada a México desde el noroeste, lo que a su vez conlleva honra y cierto celo del tijuanense por su ciudad. Cuando se entra a la ciudad en coche desde San Diego y se continúa avanzando por la Avenida Paseo de los Héroes se llega a la Zona Río que, con "la bola" del Centro Cultural Tijuana a la cabeza, de alguna manera da la bienvenida al visitante. Considerado como el monumento cultural más emblemático de la ciudad, el edificio esférico del Cine Omnimax en la plaza del CECUT se encuentra representado en postales, libros y folletos de promoción turística. Quizá de algún modo estas circunstancias expliquen la desconfianza inicial del público tijuanense surgida al conocerse el proyecto del *infoSite*, cuya construcción debía de ocupar las escaleras norponiente del edificio. No obstante, los trabajos de construcción se llevaron a cabo sin contratiempos, contando con los permisos aprobados o en trámite. Tanto este "beneficio de la duda" concedido al proyecto como la "flexibilidad administrativa" del gobierno de la ciudad, contrastan con el proceso que se debió de seguir del lado estadounidense para la obtención de permisos y un sitio para poder construir el *infoSite* de San Diego. Tras un largo proceso de negociación con distintas instancias gubernamentales, la autorización para ubicar el *infoSite* en alguna zona de flujo peatonal en el centro de la ciudad fue denegada debido precisamente a que podía constituir un obstáculo al flujo. Aunque finalmente éste pudo ser construido frente al San Diego Museum of Art en Balboa Park, se debió pasar por tortuosos filtros institucionales para su aprobación.

La dificultad para la construcción de una estructura arquitectónica efímera en San Diego –en contraste con la posibilidad de lograr un proyecto de la misma índole en Tijuana– responde a la absoluta regulación de la vida pública para que la ciudad sea la "finest". Algo a lo que uno debe de entrenarse cuando se vive en San Diego es a leer continuamente las señalizaciones en la calle, no solamente cuando se maneja sino cuando se camina por la ciudad, por sus parques o sus playas. Es importante poner atención en los letreros dos informan de lo que uno no puede hacer en sitios "públicos": No tirar basura, No salirse de los caminos marcados, No quedarse a dormir, No beber alchohol (en ciertas áreas específicas y a ciertas horas específicas), No pasear perros sin correa (hay parques y playas específicas para perros), No llevar recipientes de vidrio, No fumar, No cruzar la calle aunque no vengan coches (a menos que el semáforo para peatones lo autorice). En muchos de los sitios para estacionarse uno no puede permanecer más de dos horas seguidas. Los límites de velocidad son estrictos al igual que los horarios de apertura de bares y restaurantes, y se debe estar al pendiente de ir en el carril correcto siempre ("Carril derecho vuelta obligatoria"); de saber qué días y a qué horas se puede uno estacionar o no delante de su propia casa (dependiendo de los horarios de limpieza de la calle y de recolección de basura). No es que otras ciudades no existan normas semejantes, sino que aquí la gente es devota por seguirlas, las multas

por no cumplirlas son altas y el rechazo social es evidente para quien no comulga con lo establecido, o se atreva a desafiar su lógica. Quizá esta obsesión por regular el espacio público, y hacer de éste un arriesgado territorio de responsabilidad, anule los impulsos espontáneos de encuentro con lo distinto y de cuestionamiento de lo establecido. Quizá esos impulsos sean los estímulos imprescindibles para experimentar lo público como algo vivo y no artificial, latente en nuestros actos.

¿Serán estas normas las que de alguna manera dictan y perpetúan el *setback* entre casas, barrios y ciudadanos? Curiosamente, en los *infoSites* de una ciudad y otra de alguna manera se sentían los ecos de las distintas maneras de ser y relacionarse con el entorno y con el otro. Mientras que el *infoSite* de Tijuana se adhería al símbolo urbano más emblemático de la ciudad para beneficiarse de su ubicación y su flujo de visitantes, el de San Diego –aunque también ubicado en un importante nodo de la ciudad– "respiraba" a sus cuatro costados, pudiendo ser rodeado por el visitante como inspeccionándolo antes de atreverse a entrar.

La normatividad y los largos procesos de negociación en la obtención de permisos para intervenir o actuar en espacios públicos y privados de San Diego resultan tan opresivos que revelan –a la vez que generan– miedos de la sociedad ante supuestas situaciones potencialmente "peligrosas" y aversiones hacia "lo distinto". El miedo gubernamental y ciudadano de San Diego se hizo patente cuando los dueños o las instancias administrativas de los edificios elegidos por Allora y Calzadilla para su proyecto *Signos mirando el cielo* manifestaron su negativa de colaboración. En uno de los casos la negativa obedecía al temor de que la instalación de un letrero luminoso en el techo del edificio pudiera convertirlo automáticamente en blanco terrorista. Esta clase de circunstancia determinó que la pieza finalmente fuese reconcebida como video, eludiendo la fisicidad de su instalación. Una situación semejante aconteció a nivel corporativo cuando para el proyecto de Mark Bradford se le solicitó al gerente de un restaurante Mc Donalds en el cruce fronterizo de San Ysidro, del lado estadounidense, el uso de su fachada para desplegar un mapa con el itinerario de los maleteros. La respuesta en esta ocasión fue muy similar, aludiendo a un posible ataque terrorista. Por supuesto, existen otras clases de miedo institucional. El temor subyacente a la negativa de colaboración con Javier Téllez para su proyecto *One flew over the void (Bala perdida)* por parte de instituciones siquiátricas en San Diego resultó ser el de una posible demanda legal al hospital o sus médicos por parte de los familiares de los internos.

De cualquier manera, a nivel personal la paranoia generalizada puede ser sorteada y vencida. Como parte de las negociaciones y la invitación a pilotos de modelos aéreos para participar en *Puente aéreo* de Maurycy Gomulicki, hubo que explicar que el vuelo conjunto se realizaría en Tijuana, llevándose a cabo algunas de las reuniones de planeación en San Diego. Esto implicaba necesariamente el cruce de unos y otros a la ciudad del vecino. La posibilidad de cruce de los pilotos tijuanenses al lado americano tenía más que ver con manejo de tiempo y con que se contara con el visado necesario, pero el cruce de los sandieguenses al lado mexicano era otra cuestión. Acostumbrados a la convivencia regulada en su ciudad, el cruce a Tijuana representaba el encuentro con el caos, y ésto les inspiraba desconfianza. Hubo varios pilotos estadounidenses que argumentaron esta precisa razón para no participar en el proyecto. A aquellos que aceptaron colaborar, **inSite** y el artista les aseguraron que se encargarían de proveer las condiciones para que tanto el desplazamiento como la estancia en Tijuana fueran no sólo seguros sino placenteros. Pero quienes realmente cambiaron la preconcepción de los pilotos estadounidenses acerca de Tijuana fueron sus colaboradores tijuanenses. Orgullosos de su ciudad y de su cultura, invitaron en más de una ocasión a "los americanos" a volar en su campo, siendo correspondidos con invitaciones a "los mexicanos" para volar en los campos de vuelo de San Diego. La experiencia de vuelo en uno y otro lado son completamente distintas: En San Diego el *hobby* se considera una actividad casi profesional después de la profesión y se lleva a cabo con una seriedad y sobriedad

inquebrantables; se prohíbe beber y fumar en el campo y rara vez se ve a niños o familiares acompañando a los pilotos, a excepción de los días de competencia. En Tijuana, en cambio, el *hobby* constituye un momento de relajación y diversión, convirtiéndose muchas veces en comidas con carne asada, cerveza, con familia y niños en el campo. La visita de ambos equipos al campo de vuelo de sus vecinos fue parte importante en la constitución de un solo equipo de trabajo, con respeto hacia la manera de hacer del otro, a la vez que se filtraban modos de operar. Para celebrar el desenlace del proyecto, tras el evento de vuelo, los pilotos mexicanos organizaron una reunión en un restaurante de Tijuana e invitaron a todos los colaboradores. El convivio se dio entre mutuos agradecimientos y elogios; hacia sus países, sus ciudades y sus maneras de trabajar. Una y otra vez, los pilotos recordaron el proceso de mutuo intercambio, y cómo éste había abierto en cada uno la opción vital de seguir dispuestos a ver y a experimentar lo qué hay "del otro lado".

Mark Wigley propone en su ensayo "Resisting the city" que *la ciudad no es un objeto o un fenómeno, sino una decisión*[13]. Si es así, entonces, ¿las fronteras que obstruyen la convivencia son urbanas, o humanas? ¿Cómo actúan los obstáculos físicos y las divisiones políticas sobre la creación de barreras sicológicas y emocionales? ¿Cómo se predeterminan mutuamente los elementos físicos identificables urbanos y las dinámicas sociales y económicas? Quizá los proyectos de **Intervenciones** más que "dar la vuelta" a estas barreras físicas sortearon y actuaron sobre barreras sicológicas y emocionales, insertándose e interviniendo en las dinámicas de convivencia e intercambio propias de la zona.

Tania Ragasol *es curadora. Vive y trabaja en Tijuana San Diego. Fue co-curadora de* **Intervenciones** inSite_05.

Versión original

1 HERZOG, Laurence A., "The Transfrontier Metropolis, A New Kind of International City", *Harvard Design Magazine*, Winter/Spring 1997, No. 1. p. 4
2 LYNCH, Kevin, *La imagen de la ciudad*, Ed. Gustavo Gili, Barcelona, 1998, p. 61
3 CONWELL, Donna, "Aernout Mik" en, *inSite/ Art Practices in the Public Domain, San Diego-Tijuana*, Guía impresa de la fase pública de **inSite_05**, San Diego Tijuana, 2005.
4 WIGLEY, Mark, "Resisting the City" en, *Transurbanism*, V2_Publishing/NAi Publishers, Rotterdam, 2002, p. 103
5 CROSTHWAITE, Luis Humberto, "La fila" en, *Instrucciones para cruzar la frontera. Relatos, México*, Ed. Joaquín Mortiz, S.A. de C.V., 2002, p. 15
6 RUBY, Andreas, "Transgressing Urbanism" en, *Transurbanism*, Rotterdam: V2_Publishing/NAi Publishers, 2002, p. 26
7 Nombre popular que se le da a los microbuses de transporte público en Tijuana. Su origen está en los antiguos Autotransportes Calafia de Gregorio Barreto.
8 Lotes de coches abandonados de segunda mano que generalmente llegan de los Estados Unidos y son después abandonados.
9 CONWELL, Donna, "Christopher Ferreria" en, *inSite/ Art Practices in the Public Domain, San Diego Tijuana*, Guía impresa de la fase pública de **inSite_05**, San Diego Tijuana, 2005.
10 Los *commuters* son personas que viajan diariamente al trabajo o la escuela, regresando por la noche a sus ciudades dormitorio. En el caso de una zona fronteriza, y específicamente el de esta que nos ocupa, el viaje del commuter implica en muchas ocasiones el cruce de un país a otro.
11 RUBY, Andreas, Op.Cit., p. 28
12 Íbid.
13 WIGLEY, Mark, Op.Cit., p. 113

SEÑUELOS
Osvaldo Sánchez

1.

Practicar una disciplina es diferente de imitar "un modelo" Peter M. Senge[1]

Además, las feroces espacio-temporalidades de la vida diaria contemporánea –impulsada por tecnologías que enfatizan las reducciones veloces y rápidas en la fricción de la distancia y los tiempos cambiantes– impiden que exista un tiempo de imaginar o construir alternativas distintas de las que se nos imponen de manera insensata, conforme nos apresuramos a cumplir con nuestros roles profesionales respectivos en nombre del progreso tecnológico y la acumulación de capital sin fin.

David Harvey[2]

[…] Venimos lentamente de una forma simple de cohabitación –ya sea evolutiva o revolucionaria– a una mucho más plena, donde más y más elementos son tomados en cuenta. Existe el progreso, pero éste va de una mera yuxtaposición a una forma entrelazada de cohabitación: ¿cuántos elementos contemporáneos podemos levantar lado a lado, a fin de generar una serie de simultaneidades?

Bruno Latour[3]

Lo urbano, lo público y lo fronterizo no habrán de encontrar por un buen tiempo un momento publicitario más radiante en el arte contemporáneo. Si **inSite** se hubiera aplicado a consagrarse como espectáculo global, hoy sería su hora de la estrella. Esa ventaja glamorosa, aunque circunstancial, no es gratuita. La escena del arte no puede vanagloriarse de muchos otros proyectos que hayan operado tantos años, en las arenas movedizas de *lo urbano, lo público y lo fronterizo*. Esto, en un punto de colisión geopolítica donde las prácticas locales de tránsito, hábitat y territorialidad replican,

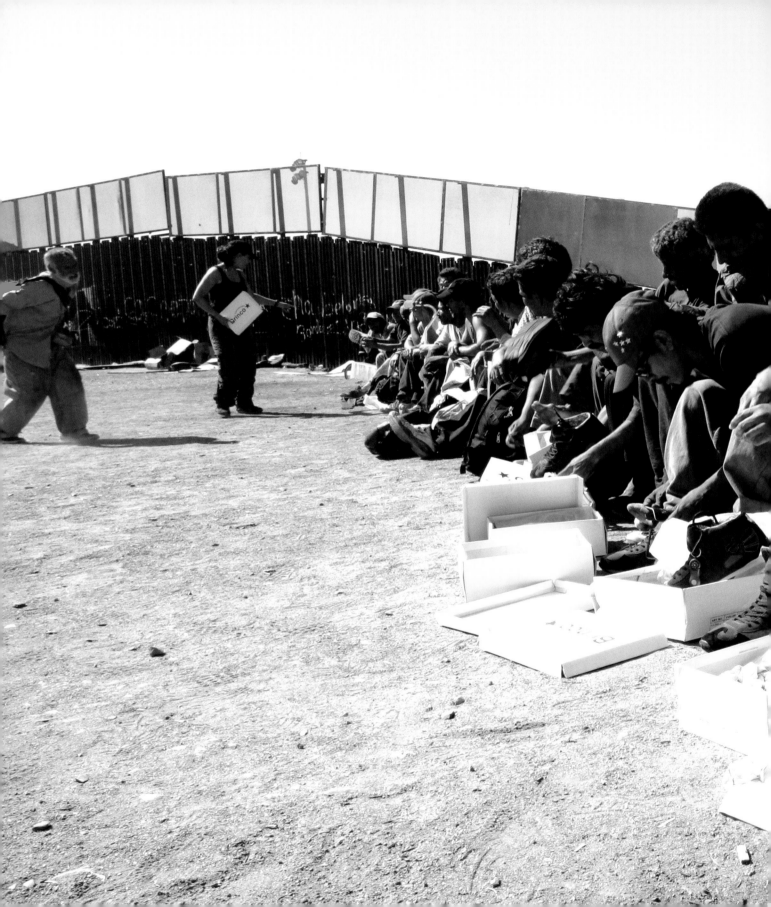

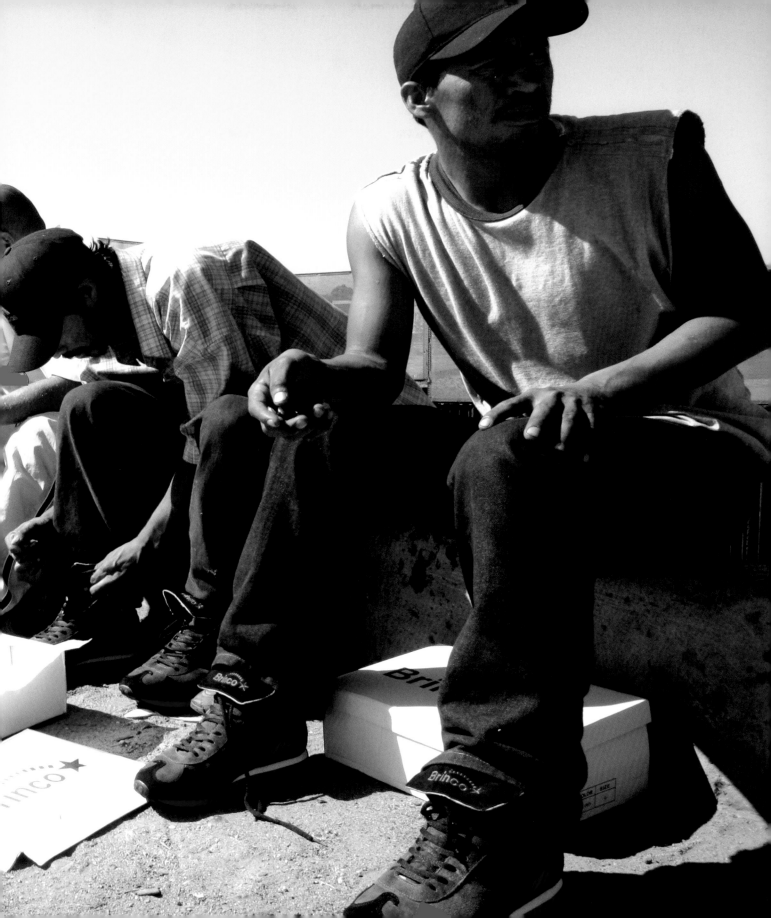

sin camuflaje alguno, las entropías del mercado laboral y de bienes global. Además, si consideramos el prestigio ya hoy institucionalizado de las estéticas relacionales[4], así como la creciente demanda de parodias de globalidad, una revisión mínima de **inSite** de 1992 al 2001 evidenciaría una gestión precedente asombrosa, en uno de los primeros feudos del *outsourcing*[5]. A estos atributos "de moda" agreguemos que hoy sería difícil encontrar un laboratorio urbano *offshore* más generoso que Tijuana San Diego; en un momento en el que el urbanismo y la arquitectura han consagrado a la ciudad –con sus elegantes utopías modernas incluidas– como la mercancía socializada de la cultura pública.

Posicionar a **inSite_05** frente a tales expectativas "ideales" de la actualidad artística requería de una distancia difícil de preservar sólo desde la curaduría. Obviamente *lo urbano*, *lo público* y *lo fronterizo* podían proveer de un marco teórico justo ahora en debate, al que sólo habría que agregar una lista previsible de artistas internacionales seducidos por la vivacidad escenográfica de lo urbano y de las fronteras. Pero, mi ya desajustada curiosidad intelectual oscilaba en torno al cuestionamiento político de lo público, y a las estrategias artísticas de intervención en el marco de la vida cotidiana. Incluso tensando la histórica orientación de **inSite** como evento de arte internacional, la gestión curatorial consideraba –a contracorriente– intervenciones de bajo perfil, y una desestimación consciente del formato de exhibición y de sus públicos de arte como destinatarios masivos y principales de los proyectos.

De estos tópicos originarios de **inSite**, *lo urbano* y *lo público* parecían suficientemente retorizados por las prácticas artísticas más establecidas; y quizá por ello mismo pertinentes para cuestionar las inercias mentales agazapadas tras la estilización de los repertorios urbanos, y tras las ficciones redentoras de las estéticas relacionales[6]. *Lo fronterizo*, aunque igualmente *trendy*, parecía más problemático. Para quien proviene del contexto cultural mexicano –donde por años las polaridades fronterizas han amenazado un volumen terrorífico de producción artística domesticada en la representación y en clichés de pertenencia institucional–, la frontera en sí, como demarcación territorial y macropolítica, como símbolo de un desacomodo histórico entre los mapas locales y los itinerarios globales, era un acercamiento a evitar a toda costa. No obstante, estaba claro que operar al interior de estos flujos fronterizos podía conducirnos, en un principio, a entender aquellas tácticas que facilitan la permeabilidad –no sólo de los bordes. Y nos obligaría además a enfrentar esa disposición a la permeabilidad y al flujo como un ejercicio de saber, que a su vez suponía un énfasis en lo procesual y en la fragilidad de aquellas alianzas y certidumbres forjadas durante la producción de una experiencia –¿artística?– extraordinaria.

De ahí que el *statement* curatorial[7] enfatizara lo público a partir de una perspectiva metodológica: la obra como producción de una experiencia de dominio público, mediante una lógica procesual de compromiso/ inmersión/ incubación/ iluminación de corte heurístico[8]. Ese *statement* inicial presumía un segundo campo de reflexión: *lo urbano*, en tanto palimpsesto capaz de revelar nuevas topologías conectivas en la región. *Lo urbano* visto no como representaciones socio-espaciales de *lifestyles*, sino como la simultaneidad de itinerarios cuasi-invisibles; como aquellos sucesos en flujo que transparentan estrategias de inscripción identitaria siempre circunstancial.

Pero las pautas curatoriales para **inSite_05** no procedieron inicialmente de mi adhesión a un cuerpo teórico, sino que fueron destiladas como inquietudes, desde el fuerte impacto que como espectador –paradójicamente, más que como co-curador de esa edición[9]– tuvieron en mí dos piezas de inSITE 2000-01: *Las reglas del juego* de Gustavo Artigas y *Blind/Hide* de Mark Dion.

Las reglas del juego, de Artigas, fue una obra memorable. Cuatro equipos de adolescentes, dos de Tijuana y dos de San Diego, se entrenan y conciben los detalles de un desconcertante espectáculo: jugar un partido de básquetbol y un partido de fútbol rápido, al mismo tiempo, en el mismo lugar, comentados en dos idiomas distintos, haciendo de los límites de fricción y de las dinámicas de flujo una visualización crítica de las probabilidades de coexistencia fronteriza. Este proyecto exponía sin reservas la autoconstrucción en vivo de *lo público*, mediante una experiencia liberadora –la obra en sí– entre individuos heterogéneos en circunstancias inesperadas. Para el público asistente, así como para los coparticipantes –jugadores aficionados de secundaria–, fluir en el *performance* del partido permitiría entender, desde otra perspectiva, y con gozo, la condición compleja de la zona. Una ficción paródica, aparentemente absurda, cuyos factores de certeza intentaban retar/sanar a las inercias entrópicas con que se autorregula la frontera.

Blind/Hide, de Dion, constaba de una caseta de observación de pájaros en medio del estuario del Río Tijuana del lado estadounidense, que apenas refería a la presencia cercana de una pista de entrenamiento para pilotos de helicópteros. Aún con su densidad metafórica –entre la reserva ecológica y el despliegue militar, entre observar pájaros y vigilar, entre las maniobras beligerantes y obsesivas de los helicópteros y las rutinas apenas perceptibles de las aves migratorias– *Blind/Hide* aludía a una

dimensión de la experiencia de lo público y a una escala de exposición visual que me resultaban inquietantes. La obra reclamaba un perímetro de intimidad, una motivación serena y curiosa, una (in)visibilidad que usa lo cotidiano como velo, y una experiencia de contacto sin promesas evidentes de diversión. Es decir, instaba a ser develada –vista, entrevista– como "obra", sin recurrir a ninguno de los indicadores de presencia o a los procedimientos de participación y retribución que califican a lo que hoy prevalece como *arte*, o como *arte público*.

Estas inquietes abrían la posibilidad de ensayar la edición de **inSite_05** enfocándonos en la producción del tejido público {como gestación protopolítica} mediante experiencias cotidianas de revelación {como construcción de sentido}, desde el arte. Ello implicaba acordar claramente un abandono del objeto artístico en tanto producto final, una renuncia a la representación como "discurso de compromiso" y un enfoque máximo en aquellos factores y sujetos relacionados con el proceso de producción de la experiencia. Esto no sólo en función de los requerimientos de la exhibición en la escena globalizada del arte contemporáneo, o de su presentación local como arte público.

Viéndolo en términos de una retribución más estratégica, el marco temporal de **inSite** –considerando cuán demandante era su programa de sucesivas residencias a lo largo de dos años–, quizá podía significar una pausa (y un desapego) ante la ansiedad y la instrumentalización bulímica imperantes en la producción artística contemporánea. Ese programa intensivo de residencias, la no-objetualidad, una erosiva coparticipación, y un contexto duro –de fácil explotación referencial pero de difícil inserción– podían permitir, al menos aquí, otros modelos de involucramiento y de acción desde el arte. Quizá una inmersión real en la densidad de este contexto ayudara a no coquetear avalando con nuestra energía las compulsiones globales de consumo, especulación y acumulación; quizá fuera posible con **inSite** negarnos a cortejar la manera en que nuestros compromisos profesionales y el estatus social que nos es proporcionado, son regulados y también combustionados por las dinámicas del mercado. Quizá no necesariamente todos los modelos de exhibición tendrían que estar orientados a hacerle a estas dinámicas las relaciones públicas.

2.

Esta intervención se traduciría, a nivel de la vida cotidiana, en una mejor repartición de sus componentes y de sus instantes en los "momentos", de manera que se intensifique la entrega vital de la cotidianidad; su capacidad de comunicación, de información, y también sobre todo de disfrute de la vida natural y social. La Teoría de los momentos [...] tendería así a convertirse, al seno de lo cotidiano, en una nueva forma de goce particular unido a la totalidad...

<div align="right">Henri Lefebvre[11]</div>

Los urbanistas del siglo XX deberán construir aventuras. El acto situacionista más simple consistirá en abolir aquellos souvenirs del empleo del tiempo en nuestra época; una época que, hasta el día de hoy, ha estado muy por debajo de sus posibilidades.

<div align="right">Internacional Situacionista[12]</div>

La esencia de una geografía cultural es precisamente ese análisis de la ambigüedad o, en términos más políticos, de la lucha entre varios significados. Diseñar un dominio público puede convertirse entonces en una cuestión de estimulación de manifestaciones informales de diversidad, y en la elusión de aquellas intervenciones que intentan hacer imposibles tales manifestaciones [informales].

<div align="right">Maarten Hajer & Arnold Reijndorp[13]</div>

La idea de *dominio público* nos permitía distanciarnos de cualquier asociación con lo que ha sido instituido de manera grosera en los Estados Unidos como *arte público*[14]. También al reapropiarnos conscientemente del término *dominio público*[15] nos obligábamos a revertir el significado que le ha sido impuesto desde los marcos legales de usufructo de un territorio –con la regulación subsecuente de las prácticas posibles. Nos interesaba hacer énfasis en la naturaleza vivencial, heterogénea y erosiva de lo público; y en la condición experiencial y siempre por renegociar de todo dominio (*dominus*: gobierno del señor). Al menos el término *dominio público* obviaba cualquier dimensión ornamental de lo urbano, y nos adentraba en la dimensión política real de todo territorio en tanto práctica manifiesta de poder.

Sin embargo, no se trataba de una representación de las políticas de espacio. No queríamos apoderar cómodas autorías ideológicas desde tecnificados discursos catastrales. No se trataba de atestiguar cómo los repertorios urbanos traducen –desde la organización del espacio y/o la construcción de lugares– modelos entrópicos de "cohesión". No buscábamos ilustrar las ficciones de progreso, las secreciones informales, las simulaciones de accesos, los acervos de nostalgia y de (auto)exotismo. Un

acercamiento a y desde Tijuana, implicaba eludir a conciencia el *glamour* duro de las "malformaciones congénitas" de la modernidad, y su pos, y contestar el modo en que estas "malformaciones" se convierten en materia prima simbólica (incluso como crítica) para las nuevas dinámicas globales. Ese "capital" local, que designa al urbanismo de lo informal requería a nuestro ver un enfoque diferente. Los impulsos exotizantes latentes, de un lado y del otro del borde, en torno a las facultades "regenerativas" y a la adopción estratégica de esos modelos de lo informal o lo emergente nos alertaban sobre la urgencia de cuestionarlos como citas o como repertorios reciclables. No podíamos asumir tal informalidad como si sólo estuviese referida a asentamientos urbanos dramáticamente densificados (legal o ilegalmente), a servicios, a demarcaciones y a usos de espacios. Más que proveer de acervos tipológicos, o de pautas de organización espacial, o de reacomodos de usos socializados de territorio y de hábitat; un análisis de lo informal en esta región debía facilitar una comprensión más profunda de ciertas tácticas locales de resistencia –también económica– al vórtice entrópico de este borde. Tácticas que operan a tiempo completo bajo la forma de reconversiones y simultaneidades; entre tráfico y trueque, entre traducción y dislexia, entre extrañamiento y pertenencia.

[…] la infinidad de combinaciones genéticas posibles, la infinidad de variaciones de la identidad humana se vuelve discernible en cuanto un campo abierto de acción.
Peter Weibel[16]

La interdependencia existente entre los modelos de pertenencia al grupo y las experiencias que ensayan y sancionan la vitalidad articuladora de esos modelos, era el cruce propuesto como investigación, lo que asumiríamos como dominio público. Entender el dominio público como experiencia, y no como espacialidad, exigía de cada proyecto iniciativas situacionales muy precisas, "momentos" de una gran delicadeza. La demanda emocional y la tensión a administrar en la implementación de estas sucesivas experiencias, era algo que no asomaba entre las frases seguras de aquel *statement* curatorial inicial:

> Dominio público *es la acción constitutiva de lo público, desde una red de interconexión manifiesta entre sujetos libres, en una situación de contacto-erosión-enfrentamiento-alianza. El dominio público es una práctica de sanación del Civilitas; es el ejercicio de desenajenar, de revivificar, los códigos de convivencia entre individuos con patrones de comportamiento, procedencia, estatuto, ideología, moral, mayoritariamente disímiles. Es un modo de hacer políticamente sustentable las bases del contrato social. Dominio público es preparar y hacer efectiva la negociación de ser nombrado, visto, abordado, por Otro. Es la certidumbre de una movilidad social ejercida en el espacio ético de la diferencia.*[17]

Implementar las **Intervenciones** como una producción de dominio público significaba vivirlas como una construcción de sentido en sí misma; entrar al interior de la articulación de esta red intersubjetiva cuya propia estructura, circunstancial, secretaría la conciencia de su vitalidad política y pública.

Lo público –como lo urbano– tampoco sería (re)presentado. El compromiso de **inSite_05** con lo público no consistía en exhibir masas de consumidores culturales en foros abiertos –como históricamente se ha justificado su estatuto cívico–, sino en convocar a grupos heterogéneos –y no tanto a comunidades institucionalizadas– a través de una (co)laboración específica, dedicada, y a mediano plazo. Más allá de los momentos exhibitorios en los que cada proyecto empalmaría con la escena del arte (con sus públicos de opinión y sus ávidos profesionales) insistimos en la idea de que lo público, en tanto articulación política originaria, radicaba en el proceso de comunión que sostiene a la experiencia toda y no en su consumo o posicionamiento como imagen/espectáculo. Producir estas "situaciones culturales", no-ordinarias, podría revelar, con suerte, la materia prima de lo público. Lo que quizá posibilitara reconfigurar, también en lo personal, el territorio y el capital de lo político.

Comunidades y vecindarios son sitios clave dentro de los cuales ocurren las exploraciones, tanto en el plazo del aprendizaje y la construcción de nuevos imaginarios de vida social como en el de sus realizaciones tangibles a través de prácticas materiales y sociales.
D. Harvey[18]

3.

El conocimiento es contextual. La realidad es relacional. […] La complejidad podría ser el objetivo de la evolución.
Mihaly Csikszentmihalyi[19]

Déjame brillar, hasta que me convierta al ser.
Goethe

A diferencia de ediciones previas, **inSite_05** no intentó emplazar las intervenciones en una dimensión perceptual-espacial (la visualización de la mancha urbana y sus conectores), agregando nuevos monumentos. Las intervenciones esta vez estarían enfocadas en la dimensión situacional del espacio público (el guión quebrado de sus protagonistas en flujo). Para infiltrar esa dimensión situacional, la curaduría proponía operar desde un paradigma heurístico. La heurística –fuera entendida como arte del descubrimiento o como una teoría general de modelos– se implementaría aquí como lógica de articulación sensible de una red manifiesta. Aún teniendo en mente a la *dérive*[20] como un entendimiento heurístico del espacio urbano, los proyectos evadirían citar a los situacionistas mediante la –ya muy común– objetualización lúdica y el rediseño de mapas de itinerarios urbanos. Las experiencias estimularían vivencias desalienantes al interior de los itinerarios ya existentes, sin intentar representarlos o estetizarlos. Una disposición a la heurística permitiría además convenir en cómo la garantía de saber no estaba en el resultado final de la experiencia, sino en los espasmos de su desenvolvimiento, y obligaba a deducir la posibilidad de certeza {¿lo que retamos como *lo posible* **versus** lo que conocemos como *lo real*?} desde la movilidad errática y la emergencia del proceso, y desde cómo los coparticipantes actúan o no en sincronía al interior de estas simultaneidades.

Las intervenciones artísticas deberían de entenderse literalmente como experiencias de revelación. Intervenir significaría crear una situación inédita capaz de revelar un saber tácito –un factor de certeza vivido como pertenencia {¿éxtasis?}. Ese saber tácito se manifestaría como la visualización de la totalidad de la red social, y encarnaría el potencial de autoengendramiento de lo público desde la inscripción simultánea de lo individual. Tales experimentos de asociación, creados desde el arte –como situaciones en las que también se actúa, o se parodia, la redistribución emergente del poder– inducirían a pensar sobre la condición heurística de toda constitución política y, por ende, de toda producción de dominio público.

En las experiencias de crecimiento simbólico, el individuo crea/descubre importantes significados a partir de esa experiencia; significados que no estarían representados objetivamente, o no serían inherentes al contexto o a la estructura lógica de los hechos mismos.
W.B. Frick[21]

Hay ciertos escritores, pintores, músicos a cuyos ojos un cierto ejercicio de estructura (y no sólo en su pensamiento) representa una experiencia peculiar; ellos, analistas y creadores, deben ser colocados bajo la apreciación común de lo que puede llamarse hombre estructural, definido no sólo por sus ideas o sus lenguajes sino por su tipo de imaginación –por la forma en que mentalmente experimenta la estructura.
Roland Barthes[22]

El paradigma heurístico exhibe una lógica de óptima verificación en el contexto de Tijuana San Diego. Las condicionantes fronterizas no hacen sino entrenar y legitimar esta disposición heurística a articulaciones de rápida operatividad. Las construcciones identitarias en la zona –generalmente sobresignificadas– catalizan, se niegan y se reajustan en ese *in-between* que es la fricción (primordialmente económica) del borde, mediante continuas experiencias individuales de *switch-eo*, de *commuting*, de encarnación táctica de máscaras culturales. Son estos modelos heurísticos, conscientes o no, los que proveen de un saber sobre comportamiento y operación al interior de los flujos –siempre amenazados de colapsar por las entropías de un sistema sobrearticulado.[23]

Era desde esa constatación en lo local desde donde debía de contextualizarse el por qué y el cómo de las coparticipaciones.[24] Pero además las coparticipaciones obligaban a una "reingeniería" del manejo artístico y a una reconsideración contextuada de las economías globales del arte y de sus órdenes simbólicos. Implicaba renunciar a la inversión autoral entendida como fiscalización intelectual y técnica de un resultado; en favor de un entendimiento de la efectividad artística como una especial habilidad humana para inducir y revelar la "visión" de una experiencia, no necesariamente perceptual. Intervenir desde aquí también significaba otros retos igual de desacostumbrados: la pérdida de control –y también de foco– sobre el resultado, conllevaba considerar la alternativa del fracaso como un desenlace posible en esta dinámica compleja de final abierto. Pero lo más difícil quizá no era cómo manejar las tensiones inherentes al roce de entidades heterogéneas que pretenden ser asimiladas en una red. Lo difícil era cómo atemperar las complejas relaciones entre: la intencionalidad individual de los coparticipantes –su autoconciencia como agentes en el proceso de revelación– y las coacciones manipulativas de un "proyecto de arte" cuya misión y objetivo ulterior eran posiblemente ajenos al grupo. Para artistas y curadores –tanto como para directivos y patronos de **inSite**– exigía una distancia de su propia adhesión al sistema establecido del arte, y una desobediencia ante la historia de **inSite**

como evento internacional de arte contemporáneo. Implicaba ahora reconsiderar los retos artísticos e intelectuales de estos proyectos, más en función del desciframiento de las pautas de la red {al interior del proceso de la experiencia}, y aceptar que las poéticas posibles {las obras} serían inseparables de las perspectivas reveladas.

4.

Una emancipación para la vida, bajo otro nombre.
<div align="right">D. Kahn[25]</div>

Tales dinámicas de compromiso no tienen nada que ver con las formas convencionales de opinión o con la división sujeto/objeto implícita en acciones ordinarias planeadas. Tienen que ver, en cambio, con claves perceptuales y kinéticas que aluden a 'caminos' familiares, fabricados a través de ámbitos locales, y que además implican tanto una modificación del entorno como de ciertos hábitos del cuerpo humano.
<div align="right">Laurent Trévénot[26]</div>

Toda mi generación seguro recuerda perfectamente esa escena de *Stalker*[27] lanzando los anillos envueltos en gasa –como señuelos de prueba– sobre el terreno minado de un borde cuyos trillos de recorrido se retrazaban todo el tiempo. Ya no sólo para cualquiera que haya vivido bajo una dictadura es familiar esa imagen: una frontera devastada, fuertemente militarizada; ese aire de muerte en el *in-between*, y aquel hombre –una especie de **pollero**[28]– intentando cruzar a otros hombres a través de un paisaje continuamente deslocalizado, y hacerlos llegar. Hombres asustados y resueltos, oscurecidos por extrañas concatenaciones entre su deseo personal y ese lugar extranjero –esa zona prohibida, donde uno quizá devendría otro, desde su posibilidad. Para muchos hoy, estas escenas del filme de Tarkovski no son ya más una metáfora críptica.

Hubo un momento en este proyecto en que regresé a *Stalker*, a esa escena del borde. Cuando para mi sorpresa vi cómo muchas propuestas operaban ese mismo señuelo. Otros anillos con gasas, lanzados en silencio para abrir pequeños itinerarios en busca de la zona, de ese lugar (más bien en el camino hacia) donde uno quizá devendría otro, desde su posibilidad. Pero estos señuelos en los proyectos de **inSite_05** no servían para cruzar esta frontera específica, no eran las garitas entre Tijuana y San Ysidro el *in-between*; ni Estados Unidos era *la zona*. Sí existía la certidumbre de que vivir en esta región fronteriza, aquí y ahora, debería de funcionar como preparación (y también como justificación) para intentar otros cruces –otros itinerarios a través de trillos que igual se retrazaban todo el tiempo.

La convocatoria y el inicio de las alianzas de coparticipación fue el momento más crítico de casi todas las propuestas. ¿Cómo hacer tácito que la zona era más bien una red? ¿Cómo comunicar que sólo logrando esa red –voluntaria, de alta creatividad y de final abierto– sería posible la visión y resignificación de esa otra red que es la pertenencia –desde un cuerpo trascendente, desde un tejido público? No se trataba de la *mise-en-scène* de una parodia {de comunión utópica} sino de implementar una experiencia real {de ninguna utilidad manifiesta}. Y hacerlo a conciencia {quizá como un juego social} al interior de una zona de inestabilidad {un sistema complejo}. Ese proceso {no necesariamente lúdico} quizá revelaría {más allá de su impostación como "pieza de arte"} una visión política de la estructura maleable de la totalidad de la red.

Aunque ese super-objetivo fuera el nodo del texto curatorial, no estoy seguro de que algún tópico de ese *statement* inicial refiriese siquiera de manera tangencial a estrategias concretas que lo hicieran posible. Cierto que el *statement* hablaba de "no intentar expandir el campo de representación de lo real sino proveer nuevas experiencias de lo real"; de "alentar cierto grado de (in)visibilidad para el develamiento de aquellas enajenaciones que prescriben las experiencias de lo cotidiano"; de "infiltrar la efervescencia embriológica de lo informal/fronterizo"; y de que "los verdaderos significados de los proyectos provendrían de sus procesos de erosión, del resultado de aquellas colisiones fortuitas que fuésemos capaces de no evadir". Pero nada preveía qué requerimientos –técnicos y metodológicos– serían necesarios para alcanzar una dimensión tácita en el proceso –dimensión imprescindible para toda colaboración compleja. Además, no era obvio que cumplimentar cualquier itinerario, como grupo, de por sí conllevaría el posicionamiento crítico de "la propia vida de uno [del artista y de los coparticipantes], como un *ready-made*" [Georges Maciunas, Carta a Tomas Schmidt, 1964][29].

¿Cómo liberar a la vida de estas dinámicas que la sofocan? Si la dinámica en cuestión se refiere al funcionamiento del deseo y se corresponde con la política subjetiva de la religión capitalista, entonces no hay forma de separarlos a menos que sea interviniendo en esa dimensión. Para conseguirlo debemos colocarnos en una zona híbri-

da donde los poderes para curar, crear y resistir entren todos en juego y las fronteras entre arte, política y terapia se vuelvan indiscernibles.
<div align="right">Suely Rolnik[30]</div>

Cuando la misma acción tiene efectos dramáticamente diferentes en el corto y largo plazo, hay complejidad dinámica. Cuando una acción tiene una serie de consecuencias locales y una serie muy diferente de consecuencias en otra parte del sistema, hay complejidad dinámica. Cuando las intervenciones obvias producen consecuencias no obvias, hay complejidad dinámica.
<div align="right">Peter M. Senge[31]</div>

Lo más demandante de estos procesos en **inSite_05** procedía de cómo manejar por tiempo completo la distribución de responsabilidades y de roles al interior de una red heterogénea. De cómo aplicar o improvisar eficientemente ciertas aptitudes comunicativas, en tiempo real y en situaciones cambiantes. Pero además se requería discernir dónde y a qué nivel de exposición los contenidos de la experiencia podían lograr un impacto crítico o liberador, también en audiencias expandidas, sin traicionar al proceso. Había que hacer visible ese nuevo territorio común {la red en proceso}, e incitar desde ahí al reajuste de esos órdenes de evaluación que Trévenot llama *los regímenes pragmáticos de compromiso*[32].

Por todo ello, la implementación de estos procesos exigía sobre todo de un conocimiento de dinámicas sociales y de un manejo de sistemas de complejidad realmente informado. Al menos, era un hecho que exigía un bagaje (también ético) distinto al usual necesario para la (re)presentación mistificada de cualquier discurso (posconceptual). Definitivamente la curaduría tampoco estaba preparada para acompañar con un saber previo a estas prácticas de proceso. Tal vez no fue del todo equivocado que la interlocución curatorial, por limitación, terminara siendo ejercida más como una comprobación sistemática de la perspectiva sobre el desenvolvimiento de la experiencia que como un tutelaje pragmático en torno a las estrategias posibles.

En un principio parecía que las dificultades para la conducción de la experiencia procedían sobre todo de la especifidad de los grupos de colaboración –maleteros, pilotos de modelos aéreos, veteranos de guerra, amas de casa, *commuters*, pacientes siquiátricos, esposas de militares, *etc*. Pronto se hizo obvio que lo difícil era operar, óptimamente, al interior del territorio de sentido donde la experiencia se comprobaba como un acto real. Ese saber operar dentro, no era algo que estaba a la mano. Lograr que la mayoría de los proyectos realizacen a tope su potencial crítico de intervención, hubiera requerido de una visión estratégica previa, más profunda, (desde la curaduría) sobre la naturaleza interdisciplinaria de estas prácticas y la especificidad de los saberes a aplicar (tanto por artistas como por curadores) en el devenir de sus pautas. Ciertos proyectos que secretaban o se posicionaban a través de redes económicas, quizá hubieran requerido asesorías más precisas sobre operación microempresarial. Otros proyectos más relacionados con redes de mercadeo o informativas o comunitarias, de seguro hubieran necesitado de más tiempo de entrenamiento y de intercambio entre sus coparticipantes para hacer más efectiva e informada la acción al seno de los canales de poder interferidos.

Por encima de estas limitaciones de concepción y operación de las **Intervenciones** de **inSite_05**, otras dificultades más pragmáticas también limitaron el arraigo y el impacto de no pocos proyectos. Una administración deficiente por parte de **inSite** de los recursos humanos necesarios para implementar intervenciones de proceso de este nivel de complejidad, restringió y desatendió de manera peligrosa la dinámica interna de muchas de las experiencias. También el marco temporal restrictivo de **inSite** como evento, violentó ritmos y aceleró o aligeró catalizaciones que hubieran requerido tiempos más propios.

Ciertamente inaugurar redes no implica de por sí construir comunidades. Pero que cada proyecto de **Intervenciones** funcionase como un integrador entre mutualidades recién ensayadas fue de por sí un logro enorme.

5.

Si no existe una puerta, ¿cómo pasarías?
<div align="right">Koun Yamada[33]</div>

Aunque para muchos resultara incomprensible, no era una paradoja voluntaria inscribir este proyecto de arte público desde el ejercicio de una invisibilidad. Una buena parte del *statement* inicial instaba a ejercer el poder crítico de ciertos velamientos. (In)visibilidad podía significar "un mínimo de imagen con un máximo de sentido", y también un mínimo de exhibición con un máximo de producción. Un mínimo de audiencia con un máximo de público. Un mínimo de interferencia con un máximo de masa crítica. Un mínimo de futuro con un máximo de presente. (In)visibilidad

significaba accionar otras estrategias de acceso y de identificación, más allá de los arquetipos de cohesión y de gratificación multitudinaria del espectáculo, en todas sus modalidades "democráticas" de mistificación de lo público.

Sin embargo, no todos los artistas y no todos en **inSite_05** estaban cómodos con inscripciones de bajo perfil. Varios tópicos curatoriales relacionados con la visibilidad del proyecto y su impacto como imagen –¿pública?– crearon sistemáticos momentos de tensión a lo largo de dos años: la idea de enfocarnos en pequeños públicos coproductores y no en grandes audiencias de consumo cultural, el hecho de no hacer *tours* por las intervenciones, el hecho de que casi no había "piezas", la cantidad de proyectos móviles o perceptualmente evanescentes, la casi nula ambición exhibitoria... En general, **inSite_05** trasluce las contradicciones del tipo de proyecto que se posiciona desde un formato de gran evento. Es fácil constatar cómo no pocos elementos, e incluso componentes, del programa general de **inSite_05**, contradicen las estrategias de intervención de sus proyectos artísticos. No obstante, aún con discursos de inauguración; con "fines de semanas de dos eventos"; aún con *tours* más o menos organizados para "ver" proyectos cuasi-invisibles, aquel día de "inauguración" no había manera de disimular que los proyectos, como tal, estaban en otra parte y que lo que quizá podía ser testimoniado como "visto" –como un producto o un documento, estético y final– apenas si se refería a la masa crítica, fugaz, que los mantenía por un instante a flote. Pero al menos, para quienes querían "ver" "piezas", ahí estaba la exposición *Sitios distantes*[34].

Pero la (in)visibilidad de las **Intervenciones** no derivaba lógicamente sólo de la ausencia de objetualidad. La (in)visibilidad aquí procedió en parte de los perímetros restringidos –por específicos– de acción, de despliegue y de significado de cada proyecto. En el sentido de que la mayoría de los proyectos ocurrieron al interior de territorios intrincados, no apropiados previamente –pero delimitados ahora como nuevas espacialidades/temporalidades conquistadas a través de eso que Appadurai llama producción de localidad[35]. Esta producción de localidad, entendida como la revelación de una consciencia relacional más compleja, en la mayoría de los proyectos sucedía como flujos deslocalizados o como breves eventos portátiles. Operar al interior de estas movilidades, o de estos corredores *in-between*, quizá también obligara a un "aligeramiento" estructural de las intervenciones.

¿Acaso este manejo sutil de los grados o velos de (in)visibilidad, traducía algún malestar, alguna disensión, alguna fatiga? ¿Obedeció a un reajuste ético de las escalas de pertenencia, y a una redimensión, menos enajenada, de los marcos de construcción de sentido?

Accionar en un bajo perfil posiciona escalas que hablan de nuevos órdenes más circunscritos y más verificables de inscripción identitaria –fuera de las normas de adhesión identitaria institucional. Y sobre todo, estas escalas más cotidianas designan otras fuentes de reconocimiento de estatus y de legitimación, y posibilitan otras experiencias de apertura personal y de crecimiento.

La (in)visibilidad también en algunos casos se comportó como una substracción táctica de cualquier indicador de presencia; como un obstáculo intencional capaz de evitar el tipo de iconización que hace incluso de los modelos de intervención, y hasta de sus documentos, un fetiche.

A causa de la mutabilidad extrema de las prácticas y los modelos encarnados al interior de su proceso, no pocas intervenciones de **inSite_05** parecieran haber contradicho sus nexos de pertenencia y compromiso, una vez que desbordaban su umbral de (in)visibilidad. Un aspecto polémico, aún *a posteriori*, ha sido cómo muchas de las piezas de **Intervenciones** concebidas como de bajo perfil aprovecharon su propia naturaleza de *iceberg*, al posicionar su enorme masa crítica sumergida –en la experiencia de colaboración–, sacándola de golpe a flote, en forma de evento. Cuando el proceso en sí, la experiencia toda, se condensa y convierte en accidente. Accidente totalmente asumido y hasta planeado, como una confrontación deliberada –y también abierta– entre el tejido tácitamente público de la colaboración y el escenario mistificado de lo público.

Una pieza como *One Flew Over the Void (Bala perdida)* [Uno voló sobre el vacío (Lost Bullet)] de Javier Téllez, fue acomodada por muchos como una imagen-espectáculo, y "colectivizada" en su consumo –desde los medios de comunicación globales, donde hizo noticia, o desde las expectativas de un público de arte convocado por **inSite**. Quizá fuera nuestro adocenamiento como espectadores, lo que facilitara este malentendido, mismo que además funcionó como diagnóstico. ¿Cómo es posible que nuestra adhesión ya internalizada a la sincronía global de todo megaespectáculo pueda bloquear lecturas más sutiles sobre aquellos tejidos públicos substraídos a lo social, que son revelados en el acto de su sobre-exposición?

Pero entender las narrativas evanescentes, sumergidas o reapropiadas, que desataron estas intervenciones, ha sido una lección difícil. Lo complicado no ha sido tanto ejercer el desapego ante la esfumación de la evidencia como aceptar y seguir la de-

liberada trasmutación de sus reliquias. Para Tania Ragasol, para Donna Conwell y para mí, el modo en que cada proyecto logró trascender esa básica intencionalidad artística que eufemísticamente se llamó *fase pública* de **inSite_05**, ha significado una introspección profesional convulsiva y además solitaria. No se trata de saber si algunos proyectos han ayudado a los artistas en su negociación con el mercado. Más bien, muchas veces, entre nosotros, nos preguntamos dónde quedó realmente la experiencia, en qué se hubo de convertir en tanto "pieza", a qué lugar esta experiencia nos ha llevado a nosotros, y adónde ha llevado a los artistas, a los coparticipantes, después de estos dos años y medio. Lo sorprendente –estando aún aquí– ha sido constatar el modo en que esas pequeñas acciones, esos intercambios extensos pero relativamente fugaces, aparentemente injustificados, han despertado –también en uno– latencias sobre otras posibilidades comprometidas de creación y de contacto; una convicción –quien sabe si profesionalmente conveniente– sobre otros modelos políticos de inscripción.

Más allá de los discursos de arte generados por el proceso de las intervenciones, existe entre nosotros la certidumbre de que muchas de ellas catalizaron finalmente como acciones públicas bajo una forma inaprehensible de narrativa. Una vez trascendido el punto de soltar el proceso –de abandonar todo rastreo de los indicios y las visiones de la experiencia, de ya no más identificar su (des)memoria "como obra de arte"–, esas intervenciones han seguido reapareciendo deslocalizadas como reapropiaciones (públicas) de lo posible. Más de un proyecto se ha consolidado en los imaginarios públicos locales como fábula, como reconstrucciones orales de un acto extraordinario y efímero desde fragmentos de memorias imperfectas, en números exponenciales. Quizá este tipo de intervenciones sedimente en lo público apenas como textos abiertos, donde autor y héroe son uno. Quizá su acción diminuta sea retar lo real desde el evanescente poder de los señuelos.

Osvaldo Sánchez *es curador y crítico. Vive y trabaja en San Diego-Tijuana y la Ciudad de México. Fue director artístico para* **inSite_05** *y co-curador de* **Intervenciones**.

Versión original

[1] SENGE, Peter M., *The Fifth Discipline*, Ed. Doubleday. NY, 1994, p. 11

[2] HARVEY, David, *Spaces of Capital*, Ed. Routledge, NY, 2001, p. 201

[3] LATOUR, Bruno, "Realpolitik to Dingpolitik", *Making Things Public*, Ed. ZKM/ MIT Press. London, 2005 p. 40

[4] El término ha sido glosado por el propio autor, Nicolas Bourriaud, en su libro *Relational Aesthetics*. Estética (relacional): Teoría estética que consiste en juzgar las obras de arte sobre la base de las relaciones interhumanas que éstas representan, producen o propician. Ver BOURRIAUD, Nicolas, Ed. Les presses du réel, París, 1998.

[5] *Outsorucing*: Término económico que refiere a la exportación de líneas de producción en busca de mercados laborales más baratos. Tijuana fue una de las primeras regiones del tercer mundo donde las llamadas maquiladoras, o ensambladoras corporativas, se establecieron, abaratando costos mediante bajos pagos y derechos laborales mínimos, centrándose en el proceso de ensamblaje final de un sinnúmero de productos industriales y de manufactura. En los últimos cinco años, muchas empresas establecidas en la zona han sido progresivamente trasladadas a otros mercados laborales emergentes como China e India.

[6] Desde las discusiones de propuestas, una de las perspectivas más cuestionadas desde la curaduría fue la tendencia a entender las intervenciones como gestos de autor (re)presentados en lo social. Las intervenciones en **inSite_05** buscaron alejarse de esas tautologías (postconceptuales) de *lo público* hoy exitosas en el escenario del arte contemporáneo –capitalizadas como *mèrde d'artiste* y después socializadas como representaciones críticas o incluso como un amuleto "relacional" de un nuevo confín geográfico, capaz de simular la energía salvaje de aquello que aún no ha sido convertido en marca.

[7] Ese *statement* curatorial pretendía ser el marco teórico para **inSite_05**, pero finalmente operó sólo para las **Intervenciones**, así como para los proyectos de *Archivo móvil_tranfronterizo* y *Elipsis*. Una versión en síntesis del statement curatorial inicial puede ser consultada en Internet, en el sitio www.inSite05.org (Otra versión impresa ha sido publicada en versión editada en: *Atopia Journal*, Brown University, No.4.33, octubre, 2005).

[8] Heurístico: Del griego, *heuristikein*, que significa descubrir o encontrar. También se usa para significar "una estrategia para la solución de un problema, cuyo objetivo es más obtener cierta utilidad que declarar una certidumbre. El investigador heurístico parte de la visión realista de que los problemas de la vida real son muy complejos, interactivos y dependientes de quien los percibe, para someterlos a un análisis comprehensivo y darles soluciones exactas." Véase: HEINEMAN, Martha. "The Heuristic Paradigm", *New Foundations for Scientific Social and Behavioral Research*, Ed. Loyola University of Chicago, 1995. pp. 207-208

[9] El equipo curatorial de inSITE 2000-01, a diferencia del equipo de **inSite_05**, funcionó como un equipo de selección y consultoría de los proyectos. Los curadores no fueron parte del proceso de producción de las obras ni de las residencias consecutivas de los artistas en el

área. El equipo de esa edición estuvo conformado por: Ivo Mesquita, Susan Buck-Morss, Sally Yard (quien sí reside en la zona) y el autor.

[11] LEFEBVRE, Henri, "La Somme et la Reste" Citado en: "Teoría de Momentos y Construcción de Situaciones", *Internationale Situationniste*, No.4, Ed. Librairie Arthéme Fayard. Paris, 1997.

[12] Editorial. En: *Internationale Situationniste*, No.3. Op. Cit.

[13] HAJER, Maarten & REIJNDORP, Arnold, *In Search of Public Domain*, Ed. NAi, Rotterdam, 2001, pp. 36-37

[14] *Todavía incluso en la escena profesional del arte contemporáneo se oye hablar de arte público refiriendo a objetos o a actos localizados en el espacio abierto. La rebasada concepción de arte público como artefacto estético urbano –apoyada en la escultura de gran escala– sigue en práctica, regida no sólo por la idea de ciudad como megaestructura única sino sobre todo por la insistencia en sublimar mediante el uso de símbolos monumentales las posibles fricciones sociales en el áspero y desvirtuado plan urbano. Estos grandes falos estéticos, emblemas de algún tipo de poder, enmascarados como arte público, han servido a su modo para denominar plazas, "vitalizar" parques, "embellecer" entornos naturales, jerarquizar cruces viales o tematizar nuevas urbanizaciones, y siguen haciendo de esta política de "estetización" de la disfuncionalidad urbana una epopeya gubernamental, aparentemente cívica, de bizarra creatividad, y de grandes dividendos. Como sabemos este arte público ha sido y sigue siendo investidura y telón de políticas demagógicas, de evasiones tributarias, de destrucción del patrimonio público, de desvío de recursos y de tráfico de influencias... Tras su máscara de progreso, este arte público sigue siendo legible como termómetro político. En más de un caso, evidencia no sólo la supeditación disimulada de la gestión gubernamental al interés corporativo, sino la ausencia reiterada de políticas coherentes en materia de reanimación urbana y de conservación patrimonial. Cualquier revisión de un equis programa gubernamental de arte público testimonia el modo en que tales ejercicios demagógicos burlan el consenso ciudadano, el debate abierto a la opinión, milita contra la politización-competencia legal profesional y una fiscalización rigurosa en tanto gasto público. El Estado y sus instancias –federales, distritales y municipales– han sido históricamente, por cualquiera de los motivos anteriores, el estímulo más persistente a esta idea de arte público, asumido como producción simbólica institucional. (En: "Bypass", **inSite_05** Statement curatorial de Osvaldo Sánchez)

[15] Dominio público (definido en Wikipedia como): Algo que está al alcance de todo el mundo y no sujeto a protección de derechos de autor. Dominio público suele referirse al *software*, pero también puede referirse en términos más generales a cualquier trabajo de propiedad intelectual.

[16] WEIBEL, Peter, "Art and Democracy", *Making Things Public*, Ed. ZMK. Rotterdam, 2005

[17] SÁNCHEZ, Osvaldo, *Bypass*, **inSite_05** Statement curatorial. Op.Cit.

[18] HARVEY, David. Op. Cit. p. 202

[19] CSIKSZENTMIHALYI, Mihaly, *Fluir (Flow)*, Ed. Kairos. Barcelona, 1990, pp. 115-131

[20] *Dérive*. Concepto francés que significa pasear sin rumbo; a veces traducido como vagar, probablemente por las calles de la ciudad; paseo que obedece al capricho del momento. Para el situacionista: un modo de conducta experimental ligado a las condiciones de la sociedad urbana: una técnica de paso momentáneo a través de diversos ambientes. También se usa para designar un periodo específico de derivación continua. "El concepto de *dérive* está indispensablemente ligado al reconocimiento de los efectos sicogeográficos, y a la confirmación de un comportamiento lúdico-constructivo, lo que lo opone totalmente a las nociones clásicas de viaje y de paseo." DEBORD, G, "Teorie de la Dérive", *Internationale Situationniste*, No.2. Op. Cit.

[21] FRICK, W.B., "The Symbolic Growth Experience, A Chronicle of Heuristic Inquire and Quest for Synthesis", *Journal of Humanistic Psycology*. 30. p. 68

[22] BARTHES, Roland, "The Structuralist Activity", *An Essay*, Ed. Doubleday, NY, 1972.

[23] No es casual que aquel primer *statement* curatorial se discutiera bajo el título de *Bypass*, como una metáfora de la urgencia por implementar ciertas estrategias alternas en una estructura comunicante de flujos densificados que enfrenta crecientes obstrucciones.

[24] Muchas de las prácticas artísticas de intervención de contexto hoy, dirigidas a producir una experiencia extraordinaria –no importa a qué grado de impostación estética–, aplican procedimientos propios de la heurística, aunque generalmente de modo inconsciente. Sea para intervenir en la (in)estabilidad de un aparato (cultural); o para actuar sobre el nivel de (in)visibilidad de los códigos de aprehensión (patrones identitarios) o para protagonizar el momento emergente de una autoorganización (conciencia de grupo).

[25] KAHN, Douglas, "The Latest: Fluxus and Music," *In the Spirit of Fluxus*, Ed. Walker Art Center, Minneapolis, 1996.

[26] TREVÉNOT, Laurent, "Which Road to Follow? The Moral Complexity of an 'Equipped' Humanity", *Complexities*, Duke University Press, 2002, p. 71

[27] *Stalker* se filmó en 1979, bajo la dirección de Andrei Tarkovsky. Los guionistas, Arkadi Strugatsky y Boris Strugatsky, basaron el filme en su novela *The Roadside Picnic*. Cerca de una ciudad gris y sin nombre está La Zona, un lugar extraño custodiado por alambre de púas y soldados. Pese a las terminantes objeciones de su esposa, un hombre se levanta en mitad de la noche: él es un merodeador, parte de unos pocos que tienen poderes mentales (y que se arriesgan a ser encarcelados) para guiar a las personas de La Zona a El Cuarto, un lugar donde las secretas esperanzas de la gente se vuelven realidad. Esa noche, lleva a dos personas a La Zona: un escritor popular en decadencia, cínico e inseguro de su genio; y un científico callado más preocupado por su mochila que por el viaje. Ya en la Zona desierta, la aproximación a El Cuarto resulta ser indirecta. A medida que se acercan, las reglas parecen cambiar y el merodeador enfrenta una crisis. (Tomado de Aislinn Race y Roopesh Sitharan. En: "Conversación con Osvaldo Sánchez", *Curating Now'05*, California College of the Arts, San Francisco, 2005.)

[28] Pollero/ Coyote: Personas que se dedican a traficar indocumentados. Usualmente pollero designa a quien los cruza y los hace llegar a los Estados Unidos desde la frontera con México, y el coyote es quien hace el negocio, cobrando el precio y disponiendo la maniobra del cruce.

[29] De mencionar un vínculo histórico que informa este tipo de proyectos procesuales, centrados en una acción en el marco cotidiano, y más enfocados en la socialización de la experiencia que en su canonización estética, señalaría además de las teorías de los Situacionistas, a Fluxus. Especialmente las piezas de Fluxus que fueron concebidas y accionadas como actos poético-conceptuales que instigaban una insubordinación del orden cotidiano de sentido, poniendo en tensión la relación entre el individuo (el artista) y el grupo (el auditorio) con el fin de hacer perceptible un saber sobre la experiencia de lo público. Fluxus posicionó la acción artística como un gesto (*sense of game*) contra los modelos cotidianos instituidos como capital (social). Y la acción, en tanto obra, era aprehendida como el presente de condensación de una alianza temporal entre desconocidos. Habría muchas razones en estos proyectos de **inSite_05** para regresar a una lectura de Fluxus: las ideas de Cage sobre la experiencia pura en el presente y la despersonalizacion del artista; y especialmente la noción de evento que George Brecht introdujera hacia 1959, entendido éste como una experiencia total de conocimiento, que puede emerger de una situación, aprehendida multisensorialmente, "el máximo de sentido con el mínimo de imagen". Para una perspectiva de Fluxus más centrada en el peso cognitivo de la experiencia, ver el ensayo: "Between Water and Stone: Fluxus performance: A Metaphysics of Acts." STYLES, Kristine, *In the Spirit of Fluxus*, Ed. Walker Art Center, 1993.

[30] ROLNIK. Suely. "Life for sale", *Farsites*, Ed. **inSite_05**, San Diego Tijuana, 2005, pp.140-159

[31] SENGE, Peter M., *The Fifth Discipline*, Ed. Doubleday, NY, 1994, p. 71

[32] TRÉVENOT, Laurent. Op.Cit. p. 76

[33] YAMADA, Koun, *The Gateless Gate*, Ed. Wisdom, Boston, 2004.

[34] *Farsites: Urban Crisis and Domestic Symptoms in Recent Contemporary Art* fue una exposición curada por Adriano Pedrosa a invitación de los directores ejecutivos para el programa de **inSite_05**, en el Centro Cultural Tijuana y en el San Diego Museum of Art. Ver *Farsites*, Ed. **inSite_05**, San Diego Tijuana, 2005.

[35] APPADURAI, Arjun, "The Production of Locality", *Modernity at Large*, Ed. University of Minesota, 1996. p. 187. Por lo tanto, el vecindario parece paradójico, porque a la vez constituye un contexto y requiere de uno. En cuanto etnopaisajes, los vecindarios implican, inevitablemente, una conciencia relacional con otros vecindarios, pero actúan al mismo tiempo como vecindarios autónomos de interpretación, valor y material específico. Por lo tanto, la localidad vista como un logro relacional vista no es lo mismo que la localidad vista desde un valor práctico, como la producción cotidiana de espacios y su colonización. La producción de localidad es hasta cierto punto inevitable contexto-generativa. Lo que define qué tanto lo es, depende de las relaciones entre los contextos que los vecindarios crean y los contextos que encuentran.

AGENCIAMIENTOS TRANSITORIOS Y COMPROMISO SITUACIONAL: ¿EL ARTISTA COMO INTERLOCUTOR PÚBLICO?

Joshua Decter

Encontrar una ciudad,
Encontrar una ciudad en la que pueda vivir Talking Heads[1]

Nos preocupa entender cómo es que las ciudades y las sociedades cambian según los proyectos colectivos y los conflictos sociales que se generan a través de la historia. Nuestras preguntas van dirigidas a la cuestión de cómo y por qué los creadores se enfrentan a aquellos que dominan.

Manuel Castells[2]

Parecería que en las pláticas en las que participo siempre se hace la pregunta: ¿A dónde pertenezco? Es como un lamento constante que se refiere a las dislocaciones que los sujetos desplazados sienten por las historias interrumpidas y por las identidades nacionales cambiantes y provisionales.

Irit Rogoff[3]

Entonces, ¿por dónde empezar?

Quizá con algunas de las muchas preguntas que generó **Intervenciones**…

¿Habría que empezar, por ejemplo, por la disolución teórica, material de las fronteras y los órdenes?

¿O por la cuestión apremiante de cómo podemos empezar a darle seguimiento a las repercusiones y las reverberaciones que los actos creativos tienen en la trama de las ciudades y en la imaginación de los ciudadanos?

O, antes que eso, ¿por cómo es posible reclamar la viabilidad material, simbólica, ideológica, política o libidinal del arte en relación a las circunstancias de la vida cotidiana? ¿Habría que volver a pensar en los diversos modelos de prácticas que responden a lo social?

¿O por la desaparición de la materialidad en la red de flujos de los encuentros sociales? ¿O por la redistribución de la producción cultural en los flujos transurbanos por medio de procesos de colaboración, negociación, infiltración e intervención?

Las iniciativas curatoriales y los proyectos de arte que se realizan para una ciudad en particular (ya sea que obtengan su financiamiento de los gobiernos locales, de agencias privadas o corporativas, o de ciertas combinaciones entre diversas fuentes de apoyos financieros y políticos) ¿funcionan para inducir a los ciudadanos a que imaginen su relación con los territorios urbanos en los que viven?

Una alternativa sería empezar por plantearse de nuevo las preguntas relacionadas con los lectores, el público, la colaboración y la participación. Por ejemplo, ¿quiénes son los lectores de este texto? ¿Quién recibe este discurso? En tanto que la lectura siempre es un acto de colaboración con el autor, ¿quién participa en la construcción de su significado? ¿Quién formará parte de este encuentro discursivo, de esta conversación imaginaria?

Asimismo, ¿cuáles eran los públicos de **Intervenciones** de **inSite_05**? ¿Cómo colaboraron, en tanto que receptores, en la formación de posibles significados? ¿Lo hicieron quizá como espectadores que fueron parte del proceso de encontrar los eventos fugaces construidos por los artistas y los arquitectos participantes, en estas situaciones que se dieron en un lapso de cuatro fines de semana, entre el fin del verano y el del otoño del 2005?

Es posible que los profesionales, los curadores, los organizadores, los intelectuales y todos aquellos que han intervenido en estas cuestiones entiendan que somos, a la vez, privilegiados y marginales, relevantes e irrelevantes (inmateriales), que estamos protegidos y que somos vulnerables; que, ante la presión de comportarnos de manera demasiado amable, cuando intentamos ser coherentes –aunque sea por un momento– estamos hablando con nosotros tanto como hablamos con los demás. ¿O es más bien que tenemos una fe inamovible en el hecho de que ciertas prácticas artísticas ponen en marcha momentos inesperados de transformación en algún punto de la línea de los encuentros sociales comunicativos y que, en potencia, estos sirven para ampliar nuestras interacciones discursivas y nuestros públicos?

¿Qué lugar es este? Edward Soja[4]

De nuevo, ¿por dónde empezar? En Playas, fuera de Tijuana, en un día caliente de agosto, donde los cuerpos se derriten bajo el sol, ves como un cañón dispara a un hombre bala gringo por encima de la cerca de metal - ruinosa y amenazante-, que separa la arena mexicana de la arena estadounidense. Mientras lo hace, se cruza con un grupo de pacientes psiquiátricos que actúan su versión de una manifestación política. ¿Por aquí quizá? ¿Por el proyecto *One Flew over the Void (Bala perdida)* de Javier Téllez donde el espectáculo se disuelve en el acontecimiento, y el acontecimiento en algo más efímero, en el producto de un proceso que crea, por un momento, un espacio de impunidad creativa y de investigación ética (en cuanto a la naturaleza de la colaboración de Téllez con los pacientes) que sólo se hace posible por medio de una compleja red de permisos y negociaciones con las instituciones? En esa tarde inaugural bañada de sol, todos volamos sobre la frontera ¿Pero todos aterrizamos en la seguridad de una red de espectadores?

Así que, ¿empezamos por estas paradojas fecundas en cuanto a las situaciones y en cuanto al arte?

¿O por cuestiones más básicas como son la historia del arte de sitio específico, el compromiso del arte con el espacio público y los territorios sociales urbanos, las complejidades de la investigación y la colaboración artística, o las visicitudes conceptuales de las obras orientadas al proceso?

¿O, en vez de eso, empezamos por el momento de una transacción, en la que al intercambiar una copia de la llave de tu casa por la llave de un desconocido, haces a un lado el recelo por un momento, lo suficiente para permitir la posibilidad de que otra persona transgreda tu enclave sin permiso? Hacerlo para volver a imaginar, como

Paul Ramírez Jonas hubiese querido que lo hiciéramos, ciertas cuestiones relacionadas con la confianza y la comunidad por medio de su proyecto: *Mi Casa, Su Casa*. Aun más, para ver hasta que punto, cuanto más aseguramos las fronteras que supuestamente nos separan de los demás –ya sea en términos de las fronteras nacionales o de las comunidades amuralladas–, mayores son la desconfianza, el temor y la sospecha que generan un ciclo –en potencia– infinito. Para aquellos que intercambiaron la llave de su domicilio por la llave de la casa de otra persona, este acto simbólico de confianza suspendió el ciclo de miedo y desconfianza por un momento, y logró una especie de ruptura postutópica, en la que los controles normativos se hacían a un lado, aunque fuera para regresar a la mañana siguiente.

¿O regresamos al proceso mismo de **inSite_05**, a ese lugar de intercambio continuo entre la imaginación de los artistas y los arquitectos, de los locales y los visitantes; a una interpenetración entre lo conocido y lo desconocido, una mescolanza de amigos y de extraños en dos años de investigación, desarrollo, producción, articulación, presentación, desaparición y disolución?

¿O, con lo que hay en la tele hoy por la noche? ¿Una telenovela? ¿*Desperate Housewives*? ¿*American Idol*? ¿Lo que estás viendo es una transmisión donde la gente reflexiona sobre su propio miedo? A la media noche, la cuestión del miedo vuelve a emerger por medio de una transmisión televisiva. Son una serie de entrevistas en las que se ven acercamientos de ciudadanos que pertenecen tanto al entorno de San Diego como al de Tijuana. Se trata de una reflexión sobre un problema que pega fuerte en el corazón de la situación fronteriza/postfronteriza, y que aquí aparece traducida al discurso de los medios masivos. Con *On Translation: Fear/Miedo*, Muntadas propone una interrupción de los flujos normativos de una industria comercial en la que se mezclan la información y el entretenimiento, alertando a los televidentes (que son, por definición, un público impredecible, diverso y homogéneo que suele ser visto, para bien o para mal, como un conjunto de consumidores pasivos), sobre lo que pueden estar sublimando antes de irse quedando dormidos, soñar con aquello a lo que más temen… con esos que están en ese supuesto otro lado, más allá de la frontera, en otras palabras, con nosotros.

De hecho, ahora existe, a lo largo de la ciudad territorial, una nébula mediática cuya realidad va mucho más allá de las fronteras, de los guetos, de los límites de las aglomeraciones metropolitanas.

Paul Virilio[5]

¿Hemos alcanzado una nueva fase en el desarrollo del arte y de los proyectos arquitectónicos en la que éstos operan a niveles liminales como si se tratara de la producción de sombras críticas, de rumores, de mitologías urbanas definidas, de resistencias silenciosas?

Transmites un rumor sobre esta ciudad, o sobre la otra. No reconoces la partícula de información como un rumor, pero aún así participas en la circulación y en la diseminación de ese rumor. *El proyecto del buen rumor* de Måns Wrange consistió en insertar dos rumores en las corrientes transnacionales de comunicación y no-comunicación acerca de Tijuana y San Diego, y es posible entenderlo como una manera de producir desbordamientos y *lapsus* lingüísticos poco comunes, transgresiones de las representaciones estereotipadas (retóricas) de la vida urbana, donde se entendía al lenguaje mismo, como un elemento constitutivo del espacio público, como un agente viral benévolo que es capaz de infiltrar las redes de intercambio social.

¿O por volver a pensar en las conexiones mutuas que es posible establecer entre los métodos de investigación, de desarrollo y de implementación; entre los procesos, la producción, los acontecimientos, los productos y los anti-productos, ya sean críticos o comerciales?

Mientras ves los contenidos de una tienda de moda en el centro de San Diego encuentras unos tenis con un diseño poco común. Durante el proceso de descifrar su iconografía, te das cuenta de que hay un mapa de la frontera entre San Diego y Tijuana impreso en el zapato. *Brinco* de Judi Werthein es un tenis diseñado como un sistema de navegación práctico para aquellos que cruzan la frontera, y también como un índice de las relaciones globalizadas de producción y mano de obra –las mismas que, en última instancia, están relacionadas con las complejidades sociales, políticas y subjetivas de la emigración y la inmigración–, y obtiene su poder simbólico al ser un objeto de diseño crítico camuflado con un producto normativo de la sociedad de consumo… ¿O es a la inversa? En otro lugar, ahora en Tijuana, sólo a escasos metros de la frontera cerca del lecho del río seco, esos mismos zapatos se distribuyen entre los emigrantes que intentan cruzar, de manera ilegal, a territorio californiano, quizá por vez primera, quizá para reunirse

con sus familias. ¿Qué pensaron los emigrantes de estos tenis? Al usar estos artefactos utilitarios-críticos-metafóricos ¿los emigrantes saldrán fortalecidos o se convertirán en los actores de una transmisión de significados y valores que está más allá de su ámbito de entendimiento? Es más, y si ocurren ambas cosas, estas contradicciones y esta complejidad ¿no son de por sí provocativas y provocadoras?

Una delicada alteración a los flujos establecidos de los sistemas económicos informales, los mismos que ya tienen –de por sí– una relación fecunda con las estructuras oficiales…

Quizás estás justo del otro lado de la frontera viniendo de San Ysidro, en donde empieza la zona de Tijuana; pasas por ese territorio y observas el flujo de cuerpos, bienes, transacciones, y diversos sistemas económicos. Quizás, en esa franja poblada por pequeños establecimientos de comerciantes que le ofrecen productos y servicios a los peatones que cruzan la frontera, te encuentras algún otro tipo de "tienda". Con *Maleteros*, Mark Bradford negoció una serie de relaciones nuevas con las personas que funcionan como maleteros en esta zona de economías informales. Al modificar un lugar para la distribución de carritos de supermercado nuevos, y al diseñar un sistema de mapas que indicaba los múltiples nodos, así como las diversas trayectorias del tráfico económico que generan los maleteros (que son, en efecto, los portadores de la zona fronteriza), y otras cifras –oficiales y no oficiales–, Bradford reinscribió, de manera discreta, un conjunto de relaciones que resulta complejo y que, en muchas ocasiones, es invisible.

…¿generar una trama híbrida de transacciones económicas e interacciones sociales?

O a lo mejor estás en un centro comercial de Tijuana, en una cálida tarde de sábado, escogiendo un diseño para una camisa nueva, y esperando mientras te lo imprimen en serigrafía en una tienda de ropa provisional al aire libre. ¿Se trata de un negocio, de un proyecto cultural o de algo más? Quizá te hayas hecho esta pregunta mientras te encontrabas el mismo tipo de ropa en el contexto de una tienda de ropa en La Jolla… ¿Quién produjo estos diseños? Esta es *La tienda de ropa*, un proyecto del co-lectivo Bulbo de Tijuana, que se ha comprometido en la organización de proyectos, eventos, programas de radio y programas de televisión (entre otras actividades) que responden a las dinámica de la(s) cultura(s) joven(es) de Tijuana. Para su proyecto de Intervenciones, Bulbo desarrolló un complejo proceso de colaboración con individuos que provenían de diversos estratos económicos y sociales en Tijuana, y trabajaron con ellos generando los diseños para una nueva línea de ropa que se llegaron registrando, destilando y traduciendo las observaciones que hacían de ciertos lugares de la ciudad. En cierto sentido, Bulbo, un colectivo cultural "localizado", se convirtió en algo temporalmente "des-localizado" por medio de su reinscripción dentro del marco institucional de **inSite_05**, y aún así las tácticas de diversos niveles los regresaron, de cierta manera, a las comunidades locales.

Un cierto mounstro amable de Chris Ferreira le dio cuerpo, de una manera muy energética, a la codificación de los lenguajes de representación cultural que se mueven, literal y simbólicamente, a través de diversas fronteras colindantes. Este camión de helados decorado y lleno de trucos, con dejos de *low-rider* y el estruendo de un DJ funcionaba, al activar las filiaciones y las no-filiaciones, como un signo móvil de lo híbrido de las condiciones raciales, culturales y estéticas.

Aquí, volviendo a este sitio textual, este ensayo sugiere de vez en cuando, un camino subjetivo que pasa por las fascinantes complejidades de **inSite_05**. Por lo tanto, parece obligatorio ser transparente en cuanto a la trayectoria de mi compromiso con **Intervenciones**. En el verano de 2003, en un encuentro en Nueva York, Osvaldo Sánchez, el director artístico de **inSite_05**, entró en contacto conmigo por vez primera para que fuera uno de los interlocutores (un término propuesto por el) en la sección **Intervenciones** del proyecto. Me presentó el marco básico de su metodología en relación con las versiones anteriores de **inSite**. Me interesé de inmediato y, sin embargo, no acabé de entender por qué había entrado en contacto conmigo, con un neoyorquino, para que me involucrara en los compromisos artísticos (post)fronterizos en el entorno de Tijuana San Diego.

La trama de relaciones sociales, ideológicas, psicológicas, culturales y de clase en las que he estado inmerso provienen del contexto urbano de la ciudad de Nueva York. Estas relaciones se contradicen entre sí, y no pueden ser ordenadas con facilidad, en tanto que Nueva York es una ciudad-espacio que se ha vuelto una hipóstasis de la extrusión homogénea de los deseos del capitalismo tardío, quizá la encarnación de otra fase de la decadencia iluminada que algunos piensan que podría ser un signo premonitorio de la caída de esto que se conoce como Imperio. Unos meses después, Sánchez y yo nos encontramos en la Ciudad de México para continuar la discusión, y aunque seguía sin parecerme claro en qué se iban a convertir las **Intervenciones**, me abrí al proceso.

Precisa o imprecisamente, ¿en qué iba a consistir mi relación con los otros cuatro interlocutores –Beverly Adams, Ruth Auerbach, Kellie Jones y Francesco Pellizi– además de las que tuviera con Sánchez, con los artistas y arquitectos participantes, con las curadoras asociadas –Tania Ragasol y Donna Conwell–, con los directores ejecutivos –Michael Kirchman y Carmen Cuenca– y con los demás? Antes, yo no hubiera asociado la noción de interlocutor con el proceso de una exposición: mi modo de operación solía consistir en desarrollar el concepto de una exposición y organizarla, básicamente como un agente independiente, en donde yo privilegiaba lo original (imaginario) de mi marco curatorial como una forma de distinguirme de la manada. Mi ambivalencia en cuanto a los equipos curatoriales o a los comités se debía a la ansiedad que me producía la idea de que mi "autoría" fuera consumida por los protocolos burocráticos, y por lo dudoso que me parece que sea posible producir algo con cierta calidad o relevancia por medio de la toma de decisiones colectiva (pues esto implica que hay que llegar a acuerdos, y estos pueden resultar debilitadores). De manera refrescante, en **Intervenciones**, no se le pidió a los interlocutores que funcionaran como equipo curatorial, puesto que Sánchez ya había seleccionado a los artistas, y ya le había asignado los participantes a sus curadoras asociadas. Más bien nuestro modo de operación consistió en ofrecer una respuesta crítica durante el desarrollo de los proyectos de los artistas y los arquitectos que participaron en Intervenciones desde finales del 2004 hasta principios del 2005. Como interlocutores, mientras nos dedicábamos a navegar con sutileza por territorios psicológicos, ideológicos, lingüísticos y culturales, estábamos a la vez dentro y fuera, éramos cómplices pero no responsables. Recuerdo que la primera mesa redonda con algunos de los artistas de **Intervenciones** estuvo caracterizada por una mezcla de escepticismo, confusión, curiosidad y buena voluntad. En esa primera etapa, todos estábamos algo desorientados y los artistas no estaban muy entusiasmados con la idea de que sus propuestas fueran a ser analizadas por un grupo de desconocidos. Aún así, a un nivel básico, la ambigüedad de nuestras circunstancias nos emancipaba, puesto que todos participábamos en un nuevo tipo de proceso más transparente que lo usual. No obstante, es importante no exagerar qué tan significativos fueron los interlocutores, puesto que nuestro contacto inicial con los artistas estuvo limitado y quizá sólo fue cuajando a medida que se desarrolló el proceso, cuando los niveles de confianza se volvieron más sólidos.

Según un diccionario, la palabra interlocutor tiene dos definiciones:

Alguien que participa en una conversación o una discusión/ Uno de los actores en un tipo de espectáculo en el que aparecían hombres blancos con la cara pintada de negro. Este personaje se paraba en el centro del escenario y actuaba como presentador que hacía bromas a los actores*.

*N. del T.: Puesto que las definiciones que utiliza el autor provienen de las acepciones en inglés, estas simplemente se han traducido sin atender a los significados del término en español.

El diccionario Oxford ofrece un enfoque más detallado:

Interlocutor, derivado del sustantivo Interlocución, el origen latino es: *interloqui* 'interrumpir (con el habla)'.

De Wikipedia, la enciclopedia gratuita:

En el uso coloquial, un interlocutor es simplemente aquel que interviene en una conversación.

El término también tiene varios otros usos especializados: En política describe a alguien que explica, de manera informal, el punto de vista de un gobierno y que también puede transmitirle mensajes. A diferencia del vocero, el interlocutor no suele tener un puesto formal, ni tiene la autoridad para hablar por él, e incluso cuando lo hace, todo lo que dice queda como su opinión personal, y no es una versión oficial. Como un actor con la cara pintada de negro al igual que los demás actores, el interlocutor tenía un porte un tanto aristocrático, el de un aristócrata de pacotilla. Este también es el nombre que, en la ley escocesa, se le da a la orden formal de la corte.

Para funcionar como interlocutor en **inSite_05** hacía falta que uno se convirtiera en una especie de territorio de intermediación, poroso y fronterizo: era necesario negociar tanto con las ideas propias y contradictorias respecto a que tan viable es el intercambio del arte, siempre tenue, con el espacio social y la política; como con las dudas, las esperanzas, el escepticismo y el idealismo de los demás participantes. No hacía falta fungir de árbitro, sino como un generador de retroalimentación crítica, como un traductor ocasional de significados posibles. Las sesiones con los interlocutores, en las que no participaron todos los artistas (por cuestiones de logística relacionadas con sus calendarios de residencia), generaron algunos momentos de interacción discursiva que resultaron muy interesantes y, en ocasiones, polémicos, dando lugar a un modelo sugerente para el desarrollo conceptual de una exposición.

En esta coyuntura, resulta necesario citar algunas de las ideas clave que Sánchez ofrece en *Bypass* –un texto que se puede considerar el marco interno del proyecto

Intervenciones– y que fue distribuido en un momento clave en el proceso de la exposición. Estos extractos del texto no se usan aquí como un rasero para medir las ideas curatoriales, ni como el criterio con el que juzgar que tan adecuadas o eficaces fueron las respuestas (o las resistencias) de los artistas con respecto a él, sino como un índice que representa la fortaleza con la que estaba articulado el marco curatorial:

Bypass *intenta visualizar la ciudad como un tejido social cuya supervivencia depende de sus flujos. Como resultado, intenta estimular nuevas experiencias del dominio público e implementar nuevos modelos de ciudadanía. (…) La esencia artística de* **inSite_05** *residirá, básicamente, en volver a tratar con qué tan adecuadas y qué tan pertinentes son ciertas estrategias cautivadoras, heurísticas y simbólicas que históricamente se han abordado desde el arte, y que aún constituyen lo que entendemos como artístico. Estas estrategias incluyen, entre otras cosas, las representaciones estéticas; la experimentación ambiental; la diseminación de archivos de información; las parodias de los eventos políticos y los espectáculos de masas; los modelos de filiación y consenso de una comunidad, y el registro tanto de los acontecimientos cotidianos, como de la resistencia cultural. (…) Incluso bajo el riesgo de romper la identificación a priori que hay entre* **inSite** *y la idea de un evento en el que se muestran talentos legítimos, el principal reto de* **inSite_05** *es facultar a cada proyecto para que induzca a la desobediencia, para que clone y des-institucionalice estas estrategias artísticas, a fin de re-escribirlas como experiencias creativas innovadoras que quiten el aliento y que resulten significativas en un sentido antropológico. Sólo así podemos contribuir en la creación de nuevos canales para los flujos culturales que ahora convergen por vía de los miles de afluentes que constituyen el tejido social urbano. (…) Cuando hablamos de invisibilidad, nos referimos a aquello que escapa a la corporativización de los valores culturales simbólicos y, a fin de cuentas, a lo que hoy reconocemos como 'público'. Lo invisible es aquello que no está inserto en los tiempos y los espacios institucionalizados por el mercado, por los rituales públicos del Estado, y por la industria del entretenimiento. (…) En años recientes cada vez más artistas han establecido sus compromisos –en general, por medio de procesos– desde la invisibilidad propia de los acontecimientos cotidianos, desde dominios que no se reconocen como públicos, o desde y para grupos que no se distinguen con facilidad. Lo han hecho de forma procesual y han inscrito lo público como una intervención en lo temporal, en la evolución de los procesos constitutivos de identidad y flujo –y no como una intervención en una dimensión espacial. Su objetivo no es extender el campo de la representación de lo real, sino ofrecer nuevas formas de experimentarlo.*[6]

Y ahora, volviendo a la representación de lo real por medio de la palabra escrita, lo que es, de por sí, una des-representación, he de decir que me hicieron falta varios viajes a la zona conurbada de Tijuana San Diego para estar cómodo con la idea de comprometerme con el proceso de **inSite_05**. En 2003, estuve a cargo de la réplica en la sesión "Zonas liminales, flujos en curso" de **Conversaciones** (en la que participaron Jordan Crandall, David Harvey y Ute Meta Bauer), en el Salk Institute de La Jolla. Durante este viaje, algunos de nosotros fuimos a uno de los recorridos pedagógicos del autobús antituristico de Teddy Cruz, que salían de San Diego y atravesaban los territorios intersticiales y desurbanos de diversas zonas de Tijuana. Este recorrido (que construyó parcialmente basándose en recuerdos estables y frágiles, que se materializan y se disuelven, lo que quizá los relaciona con la noción de una condición postfronteriza) estaba diseñado para familiarizar a aquellos de nosotros que carecíamos de información, o que estábamos mal informados, acerca de las condiciones arquitectónicas, urbanas y sociales de la zona.

Creemos que lo cosmopolita y lo híbrido son elementos constitutivos de la condición postfronteriza. Si entendemos la sociedad como un tejido temporal y espacial sobre el que se bordan los procesos de la vida humana, entonces es posible concebir que lo cosmopolita y lo híbrido expanden ese tejido hacia dimensiones que, hasta ahora, resultaban imprevisibles.

Michael Dear y Gustavo Leclerc[7]

En el camión, frente a un público (cautivo, sí, pero curioso) que incluía a algunos de los artistas participantes, a uno o dos patrocinadores, a algunos intelectuales, a los organizadores de **inSite** y a otras personas, Cruz tomó el micrófono y nos ofreció una Tijuana decodificada por medio de una amplia investigación, a la vez que nos transmitía el compromiso ético y político que tiene con la idea de generar una relación arquitectónica alternativa que se comprometa con este territorio urbano pleno de retos y complejidades. El camión se detuvo en algún punto de Tijuana y nos pidieron que nos bajáramos. Nuestra mirada se dirigió a lo que nos parecía, o al menos a mi me lo pareció, una especie de favela, una ciudad perdida densamente organizada, una ciudad construida con aquellos materiales que el paisaje urbano había desechado y que aquí habían sido reciclados. Era una especie de barriada instantánea en ruinas, una agrupación de arquitecturas informales que constituían un hábitat urbano producido por medio de tácticas de supervivencia que no parecía tener

reglas, ni ser del todo sustentable. Como es predecible, me sentí inquieto, no sólo por las condiciones de vida de los habitantes, sino también porque como cómplice en la observación de lo que parecía un entorno tercermundista, experimenté, a la vez, las punzadas residuales de la culpa liberal (¿gringa?), y la confusión que me producía no saber qué se suponía que tenía que hacer con esa experiencia (¿contra?)-antropológica. ¿Sacar una foto? ¿Este podía ser uno de los lugares para llevar a cabo una de las intervenciones de **inSite_05**? ¿Podía ser la plataforma para realizar un trabajo basado en la comunidad y diseñado para mejorar las condiciones en el sitio? Aunque me sentí inspirado por el discurso y el compromiso de Cruz, también me sentí escéptico en cuanto a mi presencia en esta situación (lo que quizá obedecía a la típica precaución en defensa propia característica del neoyorquino).

Así que me dediqué a usar esta experiencia para empezar el proceso de hacerme inmune a la insidiosa enfermedad de la desmoralización, o incluso del cinismo, que aflige a aquellos de nosotros que hemos empezado a perder la capacidad de operar más allá del límite de nuestros intereses en el contexto del mundo del arte; a aquellos que hemos empezado a perder la capacidad de imaginar que las prácticas artísticas, la organización curatorial, y el trabajo cultural relacionado con ella, a veces pueden tener la capacidad de interrumpir los patrones normativos del tráfico humano cotidiano. ¿En qué medida nuestro principal lugar de residencia determina la proyección, práctica e imaginaria, de lo que consideramos posible… en relación, por ejemplo, a lo que pueden hacer las prácticas artísticas que responden al contexto? Resulta irónico que en la mega-metrópolis de Nueva York es muy fácil estar aislado del mundo, aún cuando existe la creencia persistente de que Nueva York es el mundo, y no sólo en el sentido histórico y pintoresco de la mezcla cosmopolita de múltiples poblaciones de inmigrantes, o con el postulado de que, de manera inevitable, cualquier cosa con cierta relevancia para la cultura fluye o transita por el filtro urbano de Nueva York.

En las ciudades estadounidenses, que son tan diferentes como Nueva York y San Diego, el "espacio público" se concibe como una especie de dominio prefabricado (una situación que se ha vuelto más relevante desde los atentados de Nueva York): es un lugar regulado en exceso que está bajo una vigilancia constante para garantizar su seguridad; es el sitio en el que eventualmente tendría que aparecer eso que puede ser descrito como "arte público". En la actualidad, obtener un permiso permanente o temporal para utilizar un segmento del espacio público –ya sea que lo solicite una organización dedicada al arte público o una exposición que utiliza la ciudad como plataforma para la producción de proyectos artísticos– implica de antemano un proceso engañoso que requiere de una cautela y una deferencia extremas en las negociaciones con las instancias del gobierno local, los líderes políticos y los patrocinadores, ya sean particulares o corporativos. Sin lugar a dudas, el "espacio público" en los EUA está definido por normas que lo identifican como un lugar exterior (como una acera, o la fachada de un edificio) o interior por el que transitan numerosos peatones, que es posible preparar para que reciba trabajos que ya existen, que se pueden modificar, o que han sido comisionados para él… supuestamente obras de arte "público". En términos generales, la megaciudad se convierte en una plataforma en la que se colocan obras en ciertas locaciones urbanas específicas, obras que muchas veces funcionan como significantes representativos del paisaje urbano y en relación con él. El encuentro con las obras que forman parte del entramado de la ciudad es lo que crea un significado que es generado para los ciudadanos (aquellos que componen los múltiples "públicos"), y que es transmitido con relación a ellos. Por lo general, los encuentros que estos habitantes tienen de la urbe, estos públicos de espectadores/peatones promedio, pueden tener con estas construcciones que se realizan para ellos, tienen un carácter pasivo, aunque de vez en vez surgen oportunidades para que haya una relación más "interactiva" o con un mayor grado de "participación". En estos momentos de encuentro, el público se convierte en "audiencia", aunque sea temporalmente, pero ¿hay algo que active de manera sustantiva a este público en tanto que audiencia? O para el caso, ¿a dónde se fueron los espacios en los que se llevaban a cabo los actos de impunidad social? ¿Estas diferentes formas de arte público, o incluso, estas prácticas que responden a la sociedad (construidas, como lo están, por una red de permisos obligatorios) constituyen un espacio imaginario de impunidad para el ciudadano… aunque sea en forma precaria? Y ¿qué pasa en la zona de Tijuana, donde la cuestión del espacio y de los públicos resulta más complicada, donde hay menos normatividad y esta corresponde a cierta interpretación peculiar de las economías formales e informales, de los hábitats, y de las diversas legalidades e identidades? ¿Esto presenta una oportunidad para la intervención? ¿Para reclamar espacios de impunidad ya sea con permiso o sin él? ¿O esto no es más que la retórica confundida de una nueva forma de pensamiento utópico?

…Una insurrección total ante las influencias habituales.
…La construcción de una arquitectura y un urbanismo que, algún día, estarán al alcance de todos.

Guy Debord[8]

355

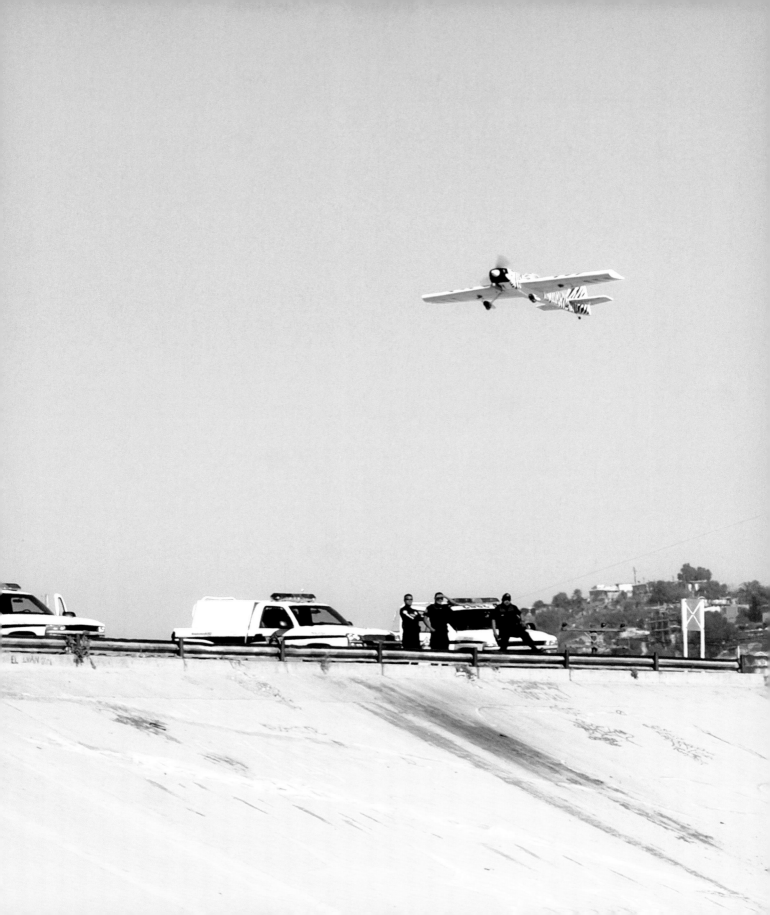

inSite ha funcionado, a lo largo de su historia, como un nexo a través del cual artistas y arquitectos han tenido la oportunidad de investigar y realizar tanto estrategias poco usuales, como tácticas para comprometerse y formas de colaborar con la comunidad, de participar en ella, infiltrarla y, en el caso de inSite_05, de intervenirla. De hecho, es posible identificar a inSite como la única exposición de los EUA –o más precisamente como un evento binacional y transfronterizo entre México y los EUA– que sigue insistiendo en trabajar con la idea de prácticas sociales, orientadas al contexto y a la colaboración. Y, como consecuencia lógica, en comprometerse con investigar, de nueva cuenta, qué es lo que constituye el nexo entre lo público y el "arte público". La evolución de inSite resulta paradigmática para todo aquel que esté interesado en estas cuestiones, en el debate continuo en relación a la producción artística y su vínculo con el espacio público o, para decirlo de manera más convencional, en las dificultades contemporáneas e históricas del "arte público" o de "contexto específico", con un compromiso social (que también podría llamarse una práctica que "responde al contexto"). Sería posible sugerir, de manera fundada, que de hecho, inSite fue un proceso que empezó con la primera edición de inSite, en 1992, y que ha continuado en todas las versiones subsecuentes. No es mi intención exagerar la perspectiva histórica, o hacer de menos lo que inSite_05 tiene de particular. Más bien se trata de volver a hacer énfasis –para el lector menos informado– en el juego sutil de ideas, métodos, políticas, identidades, compromisos, luchas y logros, que es posible identificar a lo largo de una trayectoria que ya lleva muchos años. No quiero, ni es mi función, reconstruir aquí esta historia. Más bien, mi propuesta es considerar que el marco curatorial que inSite_05 estableció para la sección de Intervenciones, resulta refrescante debido a su transparencia e invita a la reflexión en relación a las versiones anteriores (la más reciente es inSITE2001-2002, en la que Sánchez formaba parte del equipo curatorial). El texto curatorial de inSite_05 es una revisión rigurosa de la relación de inSite con la cuestión del arte público, la región fronteriza de Tijuana San Diego, la especificidad de sitio, la producción cultural basada en la comunidad y el arte comprometido y político.

Si bien las ediciones anteriores de inSite han estado organizadas en torno a la zona fronteriza de Tijuana San Diego, no fue sino hasta Intervenciones que la frontera –al menos en términos teóricos y curatoriales– se convirtió en una presencia figurativa cada vez más fuerte, en un terreno de investigación cada vez más desmaterializado en términos prácticos y teóricos. Para invocar una de las nociones centrales articuladas por Sánchez, el énfasis ha sido desplazado al concebir las zonas conurbadas de las áreas metropolitanas de Tijuana y San Diego como zonas liminales por las que los flujos y contra flujos pasan continuamente. Si bien, hasta cierto punto, las ediciones anteriores de inSite habían dependido de los procesos de investigación y desarrollo de los proyectos de los artistas, los arquitectos y los otros productores culturales, así como de los efectos que éstos tenían sobre inSite como una organización encargada de comisionar proyectos basados en la comunidad y orientados al contexto, la forma de organización elegida por Sánchez puso de manifiesto que su intención era ampliar las posibilidades que genera el proceso como metodología artística y curatorial; incluso, en cierto sentido, las del proceso del proceso, en términos tanto prácticos como teóricos. Además, en un sentido que excede a todo lo anterior, intentaba hacer que aquellos que participaron en Intervenciones concibieran la noción de lo público como proceso.

…el derecho a la ciudad no se refiere simplemente a tener acceso a lo que esta contiene. El derecho a la ciudad es el derecho a cambiar la ciudad, a transformarla. Este derecho tiene que ser inherente.

Cuando los grupos sociales reclaman un espacio en público, cuando crean espacio público, ellos mismos se vuelven públicos.

David Harvey[9]

Los artistas y los arquitectos que participaron en Intervenciones intentaron concebir y realizar formas sin precedente para investigar estos territorios complejos sin producir un fetiche que representara la frontera como el límite literal que separa y une a ambos estados-nación. No obstante, esto no implica sugerir la eliminación de la presencia de la frontera como aquello que demarca un territorio, ni su total ausencia en los conceptos (y, después, en los proyectos) de los artistas y arquitectos participantes. ¿Como podría desaparecer de la vista ya fuera en términos teóricos o prácticos? Incluso aquellos participantes que usaron el territorio de la zona fronteriza para generar una situación específica –como fue el caso de la bala humana de Téllez o la demostración de los clubes de aviones teledirigidos de Gomulicki– lograron evitar la recodificación de la frontera en términos de representación. ¿Cómo lo hicieron? Por una parte, y de manera bastante directa, al negarse a llenar la zona de basura, aunque fuera temporalmente, y no instalar objetos que pudieran pasar, ni si quiera por un momento, por esculturas de arte público. Los ejemplos que me vienen a la mente son los carritos de supermercado que Bradford colocó en la zona de San Ysidro como parte del sistema de maleteros, la diseminación de buenos rumores recíprocos

de Wrange acerca Tijuana y San Diego por medio de una red formada por grupos de individuos previamente seleccionados (nodos), y la manera en la que Werthein distribuyó esos productos culturales que se podían llevar puestos, tenían una función estética-utilitaria, y estaban diseñados como una forma de agitación.

En relación al marco curatorial de Sánchez (y, en particular, en cuanto sus cavilaciones acerca de las condiciones de invisibilidad y las nociones de lo público), una de las experiencias más asombrosas que tuve, y que me hizo pensar más, es la que está relacionada con el artista Rubens Mano de São Paulo, uno de los participantes de Intervenciones. Vi a Mano una sola vez, en una comida, la primera vez que fui a San Diego en 2003, como uno de los encargados de las réplicas de Conversaciones. Él estaba empezando la investigación para su proyecto *Visible* y en esa ocasión intercambiamos algunas fórmulas de cortesía. Después de ese encuentro, tanto Mano como su proyecto *Visible*, básicamente se volvieron invisibles para muchos de los que buscábamos localizarlo como un fenómeno materializado… localizarlo más allá del rumor y de las insinuaciones. Sin duda, la invisibilidad a veces logra generar cierto grado de mística e intriga. Ya sea como estrategia o de manera involuntaria, el proyecto de Mano puede funcionar como un emblema de las intrigantes contradicciones de Intervenciones: una intervención artística en los territorios liminales de la región transurbana de Tijuana San Diego que virtualmente desapareció de la vista. Y, en cierto sentido, este proyecto puede haber sido concebido y diseñado para desaparecer de la vista de aquellos públicos que buscan un arte que obedece a cierta normatividad… para ofrecer un tipo de resistencia a la visibilidad que, como metáfora, también funcionaba como una separación de la visibilidad institucional y que, al menos, era un emblema de la ansiedad que produce la filiación a una institución y la identificación con ella. ¿Esto fue una desaparición planeada y estratégica en la esfera social liminal o una retirada táctica de la presencia?

¿Hemos entrado al terreno de la obra de arte en la época de su aparición y desaparición, a una época en la que la obra está entre la visibilidad y la invisibilidad, en la que ésta sale a la superficie y se sumerge en los momentos tácticos en los que se compromete… y en los que deja de comprometerse? ¿Cuándo podemos considerar que un proyecto consiste en una estrategia de desaparición calculada o en una obsolescencia programada? Sí, es posible que la escena que invoco sea contradictoria, que en ella nuestro deseo de que el arte y la arquitectura tengan una vocación social y se comprometan quede frustrado debido a nuestras propias limitaciones en cuanto a aquello que constituye el compromiso y la intervención. Y, en realidad, ¿qué queremos que logre el arte? ¿Diseñar una experiencia pública o una interacción social basta para diferenciarlo? ¿Se trata de probar que tan viables son los artistas y sus obras como aquellos que activan nuevas relaciones (simbólicas, materiales, semióticas, espirituales, ideológicas) entre la "gente" y su contexto? ¿O, estamos intentando llevar a cabo una especie de regreso teórico y estratégico a un debate que se ha extendido por más de un siglo y que quizá tuvo su articulación más fecunda en los teóricos de la escuela de Frankfurt; es decir, a pensar lo político en relación con lo estético, lo estético en relación a lo político, la política de lo estético, y la estetización de la política… debates que, finalmente, se referían a los conceptos y a las estrategias de un compromiso con las condiciones sociales, ideológicas y económicas tanto en el nivel macro como en el micro?

Las formas de operar que prefirieron los artistas y los arquitectos de Intervenciones fueron: escenificar acontecimientos efímeros, promover una colaboración momentánea con los ciudadanos a un nivel 'personal' y 'político', insertar una unidad lingüística en el flujo de la comunicación, inscribir una participación en un subsistema preexistente de comercio y supervivencia, o producir mercancías con funciones duales y múltiples identidades (dependiendo del contexto de uso). Esto último fue lo que hizo *Brinco*, el proyecto sin precedentes de Werthein, en el que unos tenis diseñados para el cruce de la frontera fue distribuido en diferentes puntos socioeconómicos de Tijuana (por ejemplo, en la Casa del Migrante, que está en el punto en el que el muro fronterizo se cruza con el Río Tijuana, y en una tienda de zapatos de diseño en el centro de San Diego). *Brinco* alcanzó un ápice de visibilidad y distribución simbólica cuando apareció en los medios de comunicación comerciales y generó debates ideológicos en canales de noticias como CNN y Fox News justo en el momento en que se intensificaban las divisiones políticas respecto a la inmigración por la frontera entre EUA y México –un caso raro en el que el arte logró que un público más amplio llevara a cabo una reflexión crítica acerca de una compleja situación humana, política y económica.

Me acuerdo mucho de algo que dijo Måns Wrange en la primera de las Charlas de garaje (que eran discusiones públicas con algunos de los artistas de Intervenciones) en la que estuve como moderador en el fin de semana de la inauguración, a finales de agosto del 2005. Wrange, en un momento de frustración y desconcierto, hizo referencia a la ubicuidad del espacio público: en particular, decía que el territorio del espacio del "cubo blanco" de la galería o el museo es un espacio tan público como la calle, porque en ellos siempre hay un flujo constante de cuerpos, una interfase entre las definiciones (de lo interior y lo exterior, lo privado y lo público, etc.). Wrange se

refería al carácter intersticial que tienen los espacios sociales, incluso cuando están dentro de los entornos regulados de las megaciudades. De hecho, *El proyecto del buen rumor*, el proyecto de Wrange para **Intervenciones**, hace alusión a esta condición, en la medida en que utiliza ciertas nociones tomadas de la teoría de los rumores con la intención de generar grupos de enfoque, tanto en Tijuana como en San Diego, que dan origen a un rumor positivo acerca de cada una de las ciudades. Al parecer, estos dos rumores estuvieron circulando por estos territorios (y quizá más allá de ellos) casi por un año, y durante ese tiempo sólo los "nodos" participantes sabían cuáles eran los rumores, mientras que todos los demás quizá sólo los habíamos asimilado a un nivel liminal... el punto de contacto invisible entre los actos de habla, la interacción social y la detonación del significado en los momentos intersticiales. Para hacer la representación visual de este proyecto que era a la vez muy complejo y sumamente accesible, Wrange seleccionó un lugar público: se trataba de un documental promocional en video (producido al estilo de un reporte corporativo o un documento de ciencias sociales), que se exhibía discretamente al costado de un hotel en el centro de San Diego, se trataba de un gesto en el que el marco del proyecto aparecía de manera didáctica en la calle, el territorio urbano que suele estar asociado con el espacio público al que corresponde el arte público. Sin embargo, resulta evidente que, de hecho, el proyecto de Wrange exige una noción y una experiencia muy distintas de lo que es el espacio "público" en el que es posible conjugar un "arte público": en esta instancia éste era conjugado por la comunicación social, como una forma de contaminación viral, vinculada a la manera tan acertada en la que Wrange aplicó (y puso a prueba) la teoría del rumor. Aquí es donde está el arte, más allá de la investigación, la concepción, la organización y la realización: en esos momentos intersticiales de contacto, dentro de lo liminal y más allá de la apariencia, en la búsqueda de otra clase de economía posterior a la de la representación que, de alguna manera, es la que es posible enunciar por medio de los flujos sociales. Con todo, sigo en las tinieblas y no sé, de hecho, cuáles eran los rumores. Todavía no han revelado esa información y, después de haberme sentido frustrado, ha venido la resignación. Me he resignado a la idea de que no tenemos que saberlo todo, ni que entenderlo todo. Basta con sonreír e imaginar cuáles serían los rumores.

Volviendo a la cuestión del (los) público(s), la recepción, la comunicación y la traducción, y a otro momento en la primera sesión de las Charlas de garaje del fin de semana en el que se inauguró **inSite_05**, el metacomentario incisivo que hizo Paul Ramírez Jonas acerca de su papel en esa presentación no consistió en explicarle su proyecto al público, sino en articular, de manera convincente, que hablar de eso no era apropiado, pues su trabajo no iba dirigido a ellos. De hecho, yo habría entendido mejor la negación estratégica de Ramírez Jonas si la hubiese oído unos meses después, cuando finalmente tuve la oportunidad de estar en una de las presentaciones finales de su proyecto *Mi Casa, Su Casa* y que él había estado haciendo en diferentes lugares de la zona de Tijuana y San Diego (incluyendo una cárcel para mujeres en Tijuana). La versión que se llevó a cabo en una universidad de San Diego. Ramírez Jonas presentó una secuencia de imágenes, habló de varios asuntos relacionados con el desarrollo conceptual de su proyecto y después invitó al público que estaba presente esa noche (tal y como lo había estado haciendo en cada una de sus presentaciones de *Mi Casa, Su Casa*) a que pensara en darle una copia de una llave que abriera la puerta de su casa, que él haría un duplicado ahí mismo y después se lo daría a algún otro miembro del público a cambio de una llave que abriera la puerta de su casa, y así sucesivamente. Si uno participaba en el intercambio real y simbólico de llaves (como yo lo hice), recibía un recuerdo del artista, un regalo que conmemoraba este acto de confianza y este contrato inusual. Se trataba de un artefacto diseñado por él mismo: una llave que por un lado tenía grabada la imagen de dos manos, una sobre la otra, y por el otro, la de dos manos con unas llaves lo que sugería la clase de vínculo de confianza que se había establecido, en ese momento, entre dos individuos y que implicaba compartir los instrumentos que facilitaban la transición mutua por (y la invasión mutua de) los portales de privacidad en la ciudad, en los suburbios y más allá. Para mí, *Mi Casa, Su Casa* se trata, sobre todo de la confianza, de la comunidad, de la seguridad, del dominio privado, de las condiciones reguladas del espacio social público (*versus* la propiedad privada o el tener la propiedad de un espacio) y de cómo puede ser posible una intervención activa que haga que los individuos y, por extensión, las comunidades vuelvan a pensar acerca del temor que le tienen a la persona que vive al lado, el otro lado de la ciudad, en otro enclave económico o, incluso, del otro lado de la frontera.

Mi argumento es que los proyectos de Wrange, Ramírez Jonas, Werthein, Bradford y Mano parten de la premisa del individuo como una frontera que constituye un aspecto de lo público, del territorio público: el cuerpo, el sujeto, como un territorio intersticial que marca una distancia entre otros cuerpos, sujetos y subjetividades en el terreno de la interfase "pública"... la que, a su vez, también puede ser una experiencia privatizada. La frontera del *tu* como un lugar en el que se llega a compromisos, como una zona de negociación que facilita el movimiento por otros lugares, cuerpos, alientos, olores, políticas, ideas, emociones, capacidades, representaciones, silencios, desapariciones, regulaciones, impunidades. Cómo es posible que tus fron-

teras corporales, ideológicas, lingüísticas y demás, se tallen contra las fronteras de otras personas en los lugares de interpenetración social, en las zonas de convivencia y comunicación, ya sean públicas o privadas, que existen en los entornos urbanos y en los ámbitos relacionados con ellos.

Volviendo a Playas, una colaboración entre el arte y la arquitectura vuelve a activar una zona cerca de la playa fronteriza que había caído en desuso y estaba relativamente abandonada, dándole a diversas comunidades regionales y locales la oportunidad de experimentar este territorio como un parque-jardín recreativo. Thomas Glassford y Jose Parral colaboraron en *La esquina/ Jardines Playas de Tijuana* donde usaron la flora indígena y trabajaron con gente de la zona, facilitando con ello un nuevo tipo de acceso a este territorio. El diseño está enmarcado en relación al contexto existente y, por lo tanto, reenmarca este lugar, se trata de una intervención que fue pensada y llevada a cabo para generar una situación sostenible, tanto en el sentido ambiental como en lo que se refiere a los usos públicos. Si bien las transformaciones y las mutaciones por las que pasará el proyecto aún no están claras, esperemos que funcione como un modelo significativo de cómo crear sitios de uso público en una forma que responda a las demarcaciones geográficas particulares, así como a sus agendas políticas y sociales.

En términos más generales, **Intervenciones** nos hace volver a pensar en qué tan viable es el arte –sea lo que sea que el arte es hoy– para penetrar en el tejido social de la vida de manera más profunda, con más resonancia de lo que lo había hecho en cualquier momento anterior, quizá en la medida en que desaparece o se evapora en los flujos regulados y no regulados de los sistemas locales, regionales y transnacionales. Como un rumor, una leyenda urbana o un mito, una posibilidad susurrada, o un cuento tradicional:

¿Supiste del proyecto del artista, probablemente meses después de que se acabara la exposición, por las redes de distribución de los medios masivos? ¿Navegó por las corrientes de nuestro inconsciente social de manera que ni siquiera fuimos conscientes de que estaba entre nosotros... y aún así logró disparar ciertas mutaciones en nuestros patrones?

Imagina estacionar tu coche de alquiler en el estacionamiento subterráneo de un edificio en el centro de San Diego, y darte cuenta de que, justo por arriba del nivel de los ojos, se están proyectado unas imágenes en las que se ven unas suaves colinas cubiertas de autos en desuso, y unos trabajadores que están desenterrando el piso de una farmacia mexicana (y esa farmacia es una escenografía recreada en los Estudios Fox Baja, algo que simula a la de verdad, y que incluso es mejor que la de verdad por que es posible manipularla para hacer arte). Como un autocinema inesperado (que es, en sí mismo, una forma de cine casi obsoleta en los EUA), el mundo del estacionamiento bajo tierra de *Ósmosis y exceso* de Aeornut Mik se transforma de manera subrepticia en un lugar que existe dentro de una narrativa ficticia y que da lugar a una reflexión acerca de la manera subterránea en la que se interpenetran los momentos particulares que han sido capturados en paisajes postagrarios, disurbanos... y que son, a la vez, reales y construidos. Se trata de un regreso cinematográfico de lo reprimido, en el que se proponen flujos simbólicos de relaciones inesperadas entre aspectos topográficos y culturales de los entornos imaginarios y reales de Tijuana y San Diego, y que cualquier ciudadano o turista puede encontrar si, mientras va al centro comercial o a un juego de béisbol en el centro de San Diego, pone un poco de atención a lo que le rodea.

Otro lugar de San Diego: The Airport Lounge, un bar dirigido a los jóvenes de la ciudad, al que las personas que trabajaron en **inSite_05** iban de vez en cuando. En la zona del patio exterior, donde era inevitable volver los ojos y los oídos hacia el cielo cada tantos minutos debido a que está justo abajo del lugar donde terminan las rutas de los aviones que aterrizan en el aeropuerto de San Diego, se proyecta un video que documenta *Signos mirando el cielo* de Allora y Calzadilla. El lugar en el que se presenta el documento resultaba ingenioso, puesto que el proyecto consistía en escribir una serie de frases (que los artistas habían reunido durante su investigación con las personas que viven o trabajan en los edificios que quedan en la rutas de vuelo del aeropuerto), en las azoteas de estos edificios, y que sólo son visibles para los pasajeros de los aviones que llegan a la ciudad. Pero ¿la proyección del documento en The Airport Lounge es la evidencia de que se hicieron estos ajustes a la topografía urbana con los mensajes de los trabajadores y los residentes de la ciudad para los viajeros aéreos? ¿O el video sólo funciona como un disparador conceptual que da lugar a la alucinación de un posible proyecto en un espacio público... más allá del espacio público del bar? ¿O todo el asunto es una elaborada simulación de un proyecto no realizado?

Pasas al lecho seco del Río Tijuana, en una suave tarde de septiembre, en la que ves los movimientos aéreos de los aviones teledirigidos en una coreografía que ha sido diseñada por dos clubes de vuelo, uno de Tijuana y uno de San Diego. Los aviones

se entrecruzan sobre la línea de demarcación, literal e imaginaria, que está pintada sobre el lecho seco y artificial del río mientras los agentes fronterizos de ambos países los miran, unas veces entretenidos quizá, y otras entre perplejos y ansiosos. Los aviones pueden haber asumido el papel de agentes transgresores, pero se obtuvo un permiso que era uno de los requisitos para llevar a cabo el evento *Puente aéreo*, mismo que fue cuidadosamente orquestado por Maurycy Gomulicki. El artista había identificado, localizado y convencido a los miembros de estos dos clubes de vuelo para que empezaran a reunirse y hablaran de su pasatiempo, pensaran en posibles enfoques de diseño de aviones, e hicieran una estrategia para llevar a cabo el evento. De cómo el artista "penetró" en el mundo de estos pilotos y el proceso de colaboración que llevó a cabo con tanto esfuerzo, el residuo más significativo sigue siendo el puente que construyó entre los dos clubes. Aún cabe preguntarse sobre qué tan valioso es el significado que tuvo este evento más allá de un espectáculo fugaz y un momento de entretenimiento, pues quizá también sea un momento que puso en evidencia que en efecto, ahí ocurrió algo suficientemente excepcional.

Ahora llegas a otro puente, o a otro mecanismo de puente, el del Puente México, que pasa sobre el Río Tijuana, y es un lugar sobre el que hay puestos de artesanos y de otros negocios relacionados que atienden tanto a los locales como a los turistas. Algunos de ellos bordan su nombre ahí mismo y el equipo de Felipe Barbosa y Rosana Ricalde adoptó/adaptó este elemento básico del paisaje urbano como una fuente de inspiración para su proyecto *Hospitalidad*, al trasladar esta actividad, de manera muy literal, a la superficie del Puente México. Como el puente ya tiene una función simbólica como lugar de bienvenida, de transición hacia Tijuana, los artistas le dieron a los peatones la oportunidad de hacer que alguien pintara sus nombres sobre él y, después de un tiempo, este proceso generó una especie de mosaico lingüístico, una colección de nombres-trazos y de sujetos que habían cruzado por este territorio. Sigue sin saberse, al menos yo no lo sé, si inscribieron mi nombre ahí, y no es importante. Lo relevante es el proceso mismo en tanto que es un ejemplo de cómo las transacciones sociales básicas de los individuos que se mueven por esta estructura de transición dentro de la ciudad pueden llegar a establecer un nivel de convivencia accesible, lo que funcionó de manera muy puntual para darle cierta inflexión a este nodo urbano.

En otra tarde agradable de San Diego, estas sentado entre el público que ocupa un edificio localizado dentro de una base militar en la zona, viendo a un coro formado por las esposas de los hombres que están de servicio en Irak o con las tropas desplegadas en otras partes del mundo, mientras el coro presenta un programa de canciones compuestas por sus integrantes. Son canciones que están dedicadas a sus esposos; canciones que celebran la fe, la maternidad y el compromiso marital; canciones que señalan una perspectiva ideológica que no necesariamente es consistente con la propia. Los resultados de *Coro de Murphy Canyon* de Althea Thauberger fueron inesperados, e incluso: en tanto que era una empresa de colaboración orientada a hacer una presentación final, tanto la premisa conceptual como el proceso eran, sin duda, ambiciosos; sin embargo, me quedé preguntándome si la artista se había equivocado al no involucrarse más, incluso como una especie de agitadora sutil, en la escritura de estas canciones. Reconozco que Thauberger quería separarse de una estrategia que pudiera parecer la típica propaganda en el sentido ideológico; y que en vez de eso prefirió un tipo de invisibilidad autoral en la que sólo facilitaba y orquestaba los deseos "creativos" de los demás de manera relativamente neutral, quizá pensó que esa experiencia sería suficiente como para dar lugar a una transformación. Sin embargo, aunque al final de esta presentación sentí alguna empatía con la situación de vida de estas mujeres, y entiendo lo difícil de su postura en relación al reglamento del ejército, me pareció que había una falta total, incluso de algo sutilmente inscrito, de un cuestionamiento acerca de sus propias suposiciones, así como de su enervante sistema de creencias.

En Balboa Park, en San Diego, en la parte más íntima de la biblioteca del Veterans Museum, te encuentras con un contexto alterado. Varios monitores presentaban entrevistas en video con algunos ex-combatientes, los monitores estaban cerca de una estructura iluminada sobre la que se veía un inventario abstracto de las diferentes condecoraciones que se otorgan por haber estado en combate. Quizá esta era una especie de escultura social multimedia, que funcionaba como un dispositivo que le daba otro marco a la selección de libros que ocupan los anaqueles de la biblioteca. *Héroes of guerra* de Gonzalo Lebrija intentaba reactivar un lugar de conmemoración por medio de una colaboración activa con los hombres que fueron parte activa de la historia militar de los EUA, inscribiendo sus recuerdos subjetivos (historias orales) en un lugar que corresponde a la memoria histórica y de archivo. A mi parecer, este era un proceso de negociación difícil para Lebrija, debido a lo difícil de trabajar y comunicarse con individuos que pueden haber tenido una noción diferente de lo que es hacer arte (quizá Thauberger, con su proyecto, encontró dificultades de comunicación similares). Para mí, el "producto final" del proceso de Lebrija era, de hecho, una declaración de solidaridad con la experiencia y reflejaba la dignidad con la que el artista construyó las relaciones con sus colaboradores.

En lo que toca a la cuestión de la colaboración, ya sea en términos políticos, ideológicos o éticos, puede resultar instructivo considerar la manera en la que Téllez trabajó con los pacientes psiquiátricos para llevar a cabo la manifestación política, en parte ficticia y en parte real, que ocurrió como parte del evento *One Flew Over the Void (Bala perdida)*; el proceso de colaboración de Thauberger con las esposas de los militares; el diálogo de Lebrija con los militares jubilados, o los nodos de Wrange, en relación con la manera en la que Itzel Martínez del Cañizo enfocó el proceso y el lenguaje del documental en *Que suene la calle*. En su video, del Cañizo creó un marco en el que tanto los medios técnicos de documentación (las cámaras de video) y la escritura de la narrativa en el guión, estaban en manos del sujeto representado: mujeres adolescentes que están en tratamientos contra la narcodependencia, que viven en los márgenes de la sociedad de Tijuana, y que reflexionan acerca de todo lo que tuvieron que hacer para sobrevivir aún cuando participaban en actividades autodestructivas. Este video revela el interés que la artista tiene por refutar ciertos métodos tradicionales en la producción de documentales (en lo que quizá también sea un reconocimiento o una visión deconstructiva del documental que ha existido ya por varias décadas), mientras que también busca crear un marco en el que estas ciudadanas marginales puedan ser capaces de convertirse, hasta cierto punto, en agentes activos más allá de la catarsis terapéutica. En otras palabras, busca facilitar una experiencia que quizá, a en contra de todas las expectativas, de hecho logre generar alguna una diferencia productiva en su existencia cotidiana: es decir, una práctica cultural de participación como instrumento de intervención benévola.

Quizás, este intento por generar, o por facilitar, algún grado de instrumentalidad estética encaminada a detonar un proceso en el que se amplifican los niveles en los que el sujeto se puede transformar en un agente político, sea lo que finalmente conecta a muchos de los proyectos de **Intervenciones**.

Así que, ¿cómo concluir o cómo volver a empezar? ¿Con más preguntas?

¿Será que, al participar en **Intervenciones** buscábamos redimir, hasta cierto punto, la supuesta irrelevancia social del arte; redimir la ansiedad que produce el hecho de que cuando el arte parece aproximarse a lo real estableciendo un vínculo íntimo y "relacional" con ello, también se aleja de la coherencia?

O, buscábamos plantear algunas preguntas más amplias y paradigmáticas, tales como: ¿Qué significa para los artistas de hoy 'intervenir' en público, en el espacio público, en relación con públicos diferenciados? ¿Qué es lo público? ¿Y por qué un "público" diverso, más allá de los contingentes de intelectuales y productores culturales relativamente insulares que han participado en en el entorno de **inSite**, tendría que estar interesado por un proyecto de exposición como **Intervenciones**? ¿Por qué estas cuestiones son importantes hoy para nosotros, cuando no nos costaría nada dedicarnos, en cambio, a mantener un buen estilo de vida y a buscar oportunidades de inversión? Finalmente ¿quiénes somos para hacer estas declaraciones, grandes o pequeñas, acerca de la posible reconexión del arte con las narrativas económicas, ideológicas y culturales, con los flujos sociales, y con la vida y muerte de nuestras ciudades? ¿Qué queremos de esos públicos que quizás prefieren rechazar estas declaraciones o, simplemente, ignorarlas?

Tal y como Kevin Lynch señaló alguna vez, un espacio es realmente público sólo en la medida en que en efecto es abierto, accesible y le da la bienvenida a los miembros de la comunidad a la que sirve. También tiene que permitir que aquellos que lo usan puedan reunirse y actuar en él. Asimismo, tiene que haber algún tipo de control público sobre el uso que se le da y las transformaciones por las que pasa en el transcurso del tiempo.

William J. Mitchell[10]

Nos hemos dedicado a pensar estos asuntos, que no son pura retórica, con la curiosidad de poner a prueba si es posible reconstituir la función cívica del arte.

No hay necesidad de ponerse de acuerdo en cuanto a una definición de lo público, del espacio público, de lo social, del compromiso o de la lucha. Basta ser honestos en cuanto a nuestros objetivos, deseos, limitaciones, necesidades prácticas, y en cuanto a todas las complejidades y contradicciones que hemos encontrado por la línea de mayor resistencia. Por supuesto, si uno cree que es necesario ejercer presión sobre los hábitos mentales, sobre las convenciones que hay respecto a las ideas y a la acción, debe esperar que haya resistencia o incluso, alegrarse de que la haya.

Aun así, y pase lo que pase, mientras buscamos las conexiones que nos relacionen con la imaginación de otros grupos más amplios, tenemos que ser realistas en cuanto a saber qué y quiénes son nuestros diversos públicos, nuestras audiencias.

Quizás habría que volver a movilizar nuestras actividades artísticas, culturales e intelectuales como una fuerza de reconexión, pero no necesariamente de reconciliación, con receptores, públicos y audiencias que tengan diferentes ideologías. Una nueva ética del compromiso puede parecer reaccionaria, en particular si todavía se apega a la noción de que los artistas tienen la capacidad, incluso la responsabilidad, de poner en crisis las cuestiones éticas. Pero ¿que otra alternativa hay?

A lo largo de mi participación en **Intervenciones**, una de mis preocupaciones en general, ha sido hacerme la irritante pregunta de cómo conectar los puntos –para decirlo de alguna manera– que hay entre estas intervenciones artísticas y arquitectónicas, la gama presente de discursos teóricos que constituye el marco intelectual de la condición de frontera y postfrontera, y las diversas audiencias y asociaciones que pueden constituir algo llamado *público*. Me parece que esta relación es impredecible, que es difícil trazar un mapa para orientarse en ella, que controlarla es imposible y que anticiparla resulta peligroso. Aún así, ¿cómo podemos hablar de manera más eficaz cruzando las fronteras discursivas en relación con la manera en la que, por decirlo de alguna forma, **inSite** altera su propia actuación para diferentes públicos? ¿Qué pasa con los diferentes públicos y asociaciones, cuál es su relación con estos tipos de discursos y prácticas? ¿Cómo encontrar maneras eficaces de traducir ciertos tipos de proyectos complejos para los habitantes de una ciudad determinada, o para los turistas culturales que llegan en avión y sólo se quedan unos cuantos días? Sin duda, esta pregunta no es una novedad, y si no se hace con frecuencia es quizá debido a la frustración que produce la incapacidad de discernir el efecto que tienen las intervenciones artísticas/culturales. ¿Debemos intentar perfeccionar este conjunto de habilidades para entender mejor las consecuencias de nuestras actividades, de nuestros compromisos y para poder hacerlo de manera más realista? ¿Estas cuestiones también son "pragmáticas"? ¿**Intervenciones** funcionó como una herramienta en este proceso, como una plataforma para empezar a plantear estas preguntas?

Yo propondría que **inSite** en general, e **Intervenciones** en particular, tuvieron la capacidad de convertirse en agentes activos en la medida en que plantearon la cuestión de cómo el compromiso aún es posible en la cultura artística de hoy, y de cómo reinventar continuamente la idea de una actividad política eficaz. Finalmente, **Intervenciones** fue un proyecto de exposición que generó más preguntas que respuestas, y que se reveló, en el mejor de los sentidos posibles, como una contradicción viva. Al generar una densa red de relaciones mutuas, hizo que se volviera a tratar la cuestión del compromiso de los trabajadores de la cultura (y con esto me refiero a los artistas, curadores, arquitectos, intelectuales, organizadores, activistas, etc.) con una reflexión acerca de las prácticas artísticas contemporáneas como una forma de actividad efectiva en lo que toca a establecer redes en/con/a través de los sistemas sociales y políticos. En vez de limitarse a hablar de las cuestiones y las complejidades que están relacionadas con la manera en que se sigue definiendo el controvertido dominio del "arte público"; de la función que tienen los artistas como productores de plataformas y situaciones que ponen a prueba las nuevas relaciones que puede haber entre la obra de arte y el receptor (o, entre la obra de arte y el receptor en tanto que participan y colaboran en el proceso de la creación de significados), y de la dinámica que siguen las prácticas artísticas al desmaterializarse y rematerializarse en los ámbitos de la vida social, **Intervenciones** logró hacer que todos los que estuvimos involucrados en el proyecto participáramos en estas cuestiones.

Finalmente, todos estos discursos elaborados y estas buenas intenciones; así como las reflexiones éticas, los dilemas morales, las elecciones estratégicas y tácticas, y los compromisos ideológicos y políticos –reales y aparentes– tienen que ponerse a prueba en los términos de nuestras actividades en el terreno social de la ciudad, en las calles, en los encuentros cotidianos, en otros momentos de interfase urbana…

incluso con aquellos que quizá no comparten nuestros valores, ideologías, aspiraciones o, incluso, nuestras contradicciones. En tanto que productores culturales, ¿nos corresponde estar en los frentes de las luchas sociales o poner a prueba los límites del espacio público y de la capacidad de acción real de las prácticas artísticas, a dondequiera que sea que esto nos lleve? Me he hecho estas preguntas una y otra vez, en especial después de que asistí, en el otoño de 2005, a la distribución de los tenis *Brinco* de Werthein en el Río Tijuana en la Casa del Migrante. ¿Qué hacía yo en esa situación? ¿Funcionaba como el agente de una intervención benévola o participaba en una acto cuyas consecuencias eran desconocidas?

¿Qué sigue? ¿Cuál será la forma de las cosas por venir? ¿Es posible que los territorios israelíes y palestinos –que ya son unos de los más poblados del mundo– sigan siendo lo que ya son: fronteras sin fronteras? ¿El viscoso Estado-Jardín de los nacionalismos de ayer podría finalmente convertirse en la sólida Ciudad-Estado de la globalización de mañana, y pasar por una implosión en vez de por una explosión?

Zvi Efrat[11]

He incluido este pasaje como una manera de sugerir que los temas, las prácticas artísticas, los compromisos culturales y las preguntas que se generaron durante **Intervenciones** tienen puntos de conexión y convergencia, ya sea de manera directa o indirecta, con otras situaciones geopolíticas –que incluyen a los lugares en los que hay fronteras y postfronteras, y van más allá de ellos. **inSite**, en tanto que es una idea y una organización en proceso de evolución, demuestra que es posible reunir –de manera creativa y responsable– a artistas, arquitectos, curadores, intelectuales y demás, para volver a imaginar las nociones de lo público y de lo urbano a través de las conexiones mutuas que van entre los fenómenos locales, regionales, nacionales y globales. Más allá de esto, **inSite** también ha demostrado que tiene la capacidad de generar una red de individuos aún más amplia (una comunidad distribuida). Estos individuos hacen preguntas difíciles, buscan nuevas formas de injerencia social y cultural, y se comprometen, como interlocutores, con aquellos que podrían constituir a los nuevos públicos.

Joshua Decter *es curador y crítico de arte, actualmente trabaja en el postgrado del Centro de Estudios Curatoriales del Bard College. Vive en Nueva York. Decter fue uno de los interlocutores de* **Intervenciones** en **inSite_05**.

Traducción: Pilar Villela

1 Talking Heads, "Cities", 1979.
2 CASTELLS, Manuel, *The City and the Grassroots: A Cross-Cultural Theory of Urban Social Movements*, 1984.
3 ROGOFF, Irit, *Infirma: Geography's Visual Culture*, 2000.
4 SOJA, Edward, *Postmodern Geographies: The Reassertion of Space in Critical Social Theory*, 1989.
5 VIRILIO, Paul, *The Fire Tomorrow*, 1985.
6 SÁNCHEZ, Osvaldo, *Bypass*, texto curatorial de **inSite_05**.
7 DEAR, Michael y LECLERC, Gustavo, *Postborder City: Cultural Spaces of Bajalta California*, 2003.
8 DEBORD, Guy, *Introduction to a Critique of Urban Geography*, 1955.
9 HARVEY, David, *Dialogue 1: Liminal Zones/ Coursing Flows*, **Conversations**, **inSite_05**, 2004, p. 47
10 MITCHELL, William J., *City of Bits*, MIT Press, 1995.
11 EFRAT, Zvi, *borderlinedisorder*, 2005.

FRONTERAS ADENTRO

Francesco Pellizzi*

[…] nada es más plausible para quien está libre de teorías que el ser observado por objetos. […] Por lo general, o al menos en principio, concibe la "visibilidad" como una relación absolutamente recíproca: todo lo que ve también lo contempla a él, […] el hecho de considerarse a sí mismo "observado" por el mundo forma parte de su poco prejuiciosa concepción de éste.

Günther Anders[1]

En la choza ceremonial de doña Apolonia, "sacerdotisa de los hongos", ubicada en la sierra mazateca de Oaxaca, no había divisiones o separaciones –todos los celebrantes estaban reunidos como si se encontraran dentro de un círculo mágico alrededor del pequeño altar, para emprender conjuntamente el largo viaje nocturno que produce la ingestión del es-

píritu. En el refectorio del ex-convento de Santa Apolonia, en Florencia, un gran fresco de Andrea del Castagno que representa La última cena *ocupa el muro completo del fondo, decorado con elaborados paneles que imitan al mármol y dividido en forma horizontal por la imagen de la larga mesa del comedor. Sentadas en sus mesas colectivas, las religiosas habrían tenido a la vista la fila de apóstoles, con Cristo al centro, a excepción de uno de ellos, Judas Iscariote. El traidor se halla solo frente a Cristo, de espaldas a la habitación y al espectador, participando así de un ámbito liminal y ambiguo, entre el espacio-tiempo trascendente de la primera Eucaristía y el almuerzo mundano de las monjas. Iscariote es bien parecido, erguido y enérgico, además de que aparenta mantener con Cristo, quien se encuentra frente a él, una* sacra conversazione *que resulta indescifrable para el resto de los apóstoles, quienes parecen encontrarse inmersos en un sueño colectivo. Judas representa a nuestro mundo, enfrentándose al otro mundo de Cristo; pero también da la impresión de ser el único que en verdad observa la gran división que existe entre esos dos mundos, no sólo como seguidor sino como trágico antagonista que se encuentra de igual forma sujeto a su destino de sacrificador. Andrea del Castagno tal vez no era gnóstico, sin embargo (y*

THOSE
WONDERFUL
DAYS

IT TAKES
COURAGE

I WILL
ORGANIZE

THE O
I WILL
SERV

G IN
HOME

THEY ARE
JUST JOBS

I ONLY
REGRET

SEASONS
OF
ANGER

WE
AWAIT
YOUR
RETURN

SECRET
WARS

I HAVE
TO QUIT

TWO BIG IDEAS

quizás inspirado por el Evangelio de San Juan), nos muestra una imagen de división en la que la traición es un elemento constitutivo de la Revelación: Judas es un apóstol y, a la vez, no lo es; acepta la divinidad de Cristo al tiempo que no lo hace, y es un instrumento esencial de Salvación y no lo es. De este modo, al abolir el conocimiento satánico de la caída que separó al hombre de Dios (requiriendo, así, de un pacto), la conciencia de Judas los vuelve a unir en el fuego de la Destrucción. Nosotros, por lo menos en occidente, seguimos siendo sus herederos como parte del mundo cristiano, en el que el problema del poder, recién vinculado con la trascendencia de lo sagrado y con el culto a una autoridad terrenal, es defendido de inmediato y jamás evadido. No obstante, en Chilchotla, con la "católica" doña Apolonia, aún no se percibía (en la década de los años setenta) la existencia del algún otro poder con el que pudiera contarse, salvo aquel que se relacionaba con la comunión interna.

Se espera que un *interlocutor* intercale sus palabras en las pausas e interrupciones que se registran en los discursos de otros; sin embargo, no considero a inSite_05 como un ensamblaje al que deba escudriñarse a través de las fisuras de su entramado híbrido. Al reflexionar sobre su largo proceso de desarrollo y acerca de los acontecimientos que resultaron de ello, lo que recuerdo no son tanto sus discontinuidades deliberadas –a pesar de diversos momentos de sobresaltos transculturales y encuentros inesperados– sino la sensación de una extensa red de innumerables caminos y conexiones, como si se tratara de un nuevo y artificial sistema nervioso, ficticio y orgánico, que se hubiera extendido hasta la esquina urbana/suburbana del suroeste de los Estados Unidos o hasta la que se localiza en el noroeste de México. Se trató, pues, de un esfuerzo ambicioso, delicado y complejo que buscaba escapar de todas las trampas nacionalistas (y transnacionalistas), globalizadoras (y antigobalizadoras), así como localistas (y metro-corporativas) de las ubicuas metástasis de las "bienales", y desplazar de manera atrevida una actuación audaz a lo largo de dos filamentos tenues pero resistentes: el de la *frontera* (que también es un precipicio y una barranca) y el de los tiempos (que constituye, asimismo, la usurpación de acontecimientos mediáticos y el desgaste del olvido). Sin embargo, el dominante registro fue de múltiples y variadas colisiones, cuyos caleidoscópicos estallidos (e incluso, en cierta manera, *folclóricos*: la forma-como-máscara) revelaron des-plazamientos económicos, demográficos y políticos dentro de un vasto tejido urbano; mismos que, por lo general, permanecen ocultos tras las recientes y bien transgredidas formas de *pertenencia*, ya sea a un sitio, un vecindario, una comunidad, un lenguaje, una etnia, un medio, etcétera. inSite_05 encontró un terreno improbable y movedizo, similar al que puede hallarse entre dichas definiciones, sin alentar evasiones autosatisfactorias ni compromisos políticos ideológicos. Esto se llevó a cabo mediante la compleja estrategia de no intentar golpear, penetrar o remover obstáculos (muros), sino, más bien, de encontrar caminos alternos y novedosos –tal y como lo hace nuestro propio sistema nervioso cuando se ve obstruido o dañado. En retrospectiva, pienso en inSite_05 como esa mente casi palpable que, de manera gradual, extendió el alcance de su pensamiento durante más de dos años a toda la región de Tijuana San Diego, y cuyos efectos se mantendrán en la zona por mucho tiempo: Los asentamientos urbanos/suburbanos carecen de muros externos, sin embargo, la barrera que los divide es una membrana contra la que inSite_05, invirtiendo la imagen que Paul Valéry da acerca de la relación entre profundidad e infinidad, buscaba revelar lo visible e invisible, los filamentos conscientes y espontáneos de la oculta –o tal vez posible– vida pública:

"El pensamiento profundo" es aquel que tiene la misma potencia del sonido de un gong en un vestíbulo abovedado. Vuelve perceptibles los espacios en donde las cosas que uno no ve, y que quizá ni siquiera existan, son así la intensidad de tal resonancia los hace convincentes. Si el vestíbulo no fuera finito, el sonido del gong se perdería sin reflexión alguna: no existe por lo tanto profundidad alguna que pueda relacionarse con cualquier "infinidad".[2]

Encontrar los límites definitorios en tal entidad geográfica y sociopolítica, y hacerlos vibrar, ha sido uno de los objetivos y logros del proyecto.

Geográficamente, la ubicación regional de inSite y su funcionamiento pueden también ser vistos como si contaran con una estructura cruciforme: por un lado, existe el eje "horizontal" de un río (aunque gran parte de su cauce carece de agua y está bloqueado por el movimiento opuesto del oleaje) que funciona como barrera, y, por el otro, está el movimiento "vertical" que se registra en las carreteras, así como el de los inmigrantes y turistas –que guarda una similitud con la periodicidad del oleaje y las mareas. Múltiples ires y venires se oponen a la tranquilidad abstracta de la línea fronteriza. Seguramente, alguien debió percatarse de que los nombres usados del lado estadounidense a menudo son más "mexicanos" (es decir, "católicos") que los utilizados en la parte mexicana: Tijuana puede derivar su patronímico de la lengua yumán, en la que el término tiwan significa "cercano al mar". El lema de dicha ciudad reza "Aquí empieza la patria", lo cual implicaría que se registró un movimiento

hacia el sur considerablemente opuesto al flujo de inmigrantes que predomina, aun cuando la traducción oficial para los turistas que se hace de este lema es "Entrada a México" (divisa que asimismo trae implícito ese movimiento hacia el sur). De nueva cuenta y haciendo referencia a los turistas que tienen como destino el sur y que están acostumbrados a realizar visitas frecuentes, semejantes al movimiento de un péndulo, también se le denomina "La ciudad más visitada del mundo", y el cruce de su frontera es el más concurrido del orbe. No obstante, también es asimétrico, pues aunque no existe un verdadero obstáculo entre San Diego/San Ysidro y Tijuana, barreras de todo tipo limitan el movimiento hacia la dirección contraria. Incluso *dentro* de la zona centro de la región de San Diego una gigantesca construcción horizontal, que va de norte a sur y corre paralela a la línea costera, separa el puerto del centro de la ciudad como si se tratara de un colosal muro de cristal. Para tan sólo poder mirar el océano –lo que resulta casi inalcanzable (a diferencia de lo que ocurre en Tijuana)– hay que tomar un elevador o subir unas escaleras y así llegar a la terraza de observación que se ubica en el lado opuesto. Las carreteras y las autopistas que conectan, también de "norte a sur", las diversas zonas (uno duda en llamarlas vecindarios) de la región de San Diego, asimismo parecen funcionar como barreras, al igual que muchas arterias dentro de la extensión urbana.

Existen más elementos en cualquier frontera, y en particular en ésta, que el flujo desigual y las discriminaciones nacionales y étnicas. La lógica de la frontera equivale a un cuestionamiento de tales diferencias tanto como su reafirmación y su observancia. Las identidades de la región fronteriza siempre fluyen entre el debilitamiento y la intensificación, la negación y la jactancia; vaivenes que pueden observarse, en ocasiones, incluso en el intervalo de unas cuantas horas, mientras la gente avanza y retrocede entre idiomas y escenarios, fidelidades y extrañamientos. Así, fronteras desiguales que actúan más como válvulas que como filtros, separan a entidades inconmensurables. Uno no puede hacer caso omiso de las raíces semicoloniales del estado urbano/suburbano existente en el sur de California, territorio que fue en parte colonial (en relación con España) y en otra doblemente colonial (en relación con la Nueva España y con la anexión a los Estados Unidos ocurrida en 1848). Alexandre Kojève nos recordó que la verdadera relación colonial/imperialista es aquella en la que una entidad estatal/nacional obtiene de otra entidad (étnica, regional y/o nacional) más recursos de los que provee a cambio –algo que no fue invariablemente el caso en asentamientos históricos bajo dominación extranjera. Sin embargo, y en forma paradójica, también declara que el modelo de "capitalismo distributivo", como el que originalmente promovió la empresa Henry Ford & Co., fue el único que cumplió las verdaderas predicciones históricas de Marx (por el contrario, el modelo soviético, al ser centralista y estar limitado por el Estado, no era por lo tanto realmente marxista).[3] Existe una potencial presión-contradicción entre estos diagnósticos, al igual que la que hay entre un modelo de crecimiento interno y distributivo (a pesar del colosal aumento de las desigualdades, del que hoy en día somos testigos) y otro externo, laboral y de explotación de recursos. No obstante y en cualquier caso, la situación fronteriza de los Estados Unidos y México, en particular la del sur de California, sostiene un antagonismo permanente entre ambas configuraciones, al tiempo que oculta y preserva sus patrones básicos y dinámicos de interacción. inSite_05 decidió considerar las causas subyacentes a tal situación por medio de una serie de aproximaciones y descubrimientos: Al observarlas y enfocarlas, tanto desde dentro –en una especie de perspectiva microscópica local– como de manera telescópica –desde sitios tan lejanos como Escandinavia, América del Sur, la ciudad de Nueva York y Canadá–, y articulando una yuxtaposición de intervenciones generadas regionalmente e inspiradas desde el extranjero en lo que podría denominarse conciencia des-plazada de sus contradicciones y su complejidad intrínseca. Tal y como Robert Hullot-Kentor me ha comentado, "el conocimiento de algo desde dentro constituye el concepto enfático de la experiencia", e inSite_05 ha excavado en esta estratigrafía oculta, sacando a la luz los textos subyacentes que re-presentan algunas de las antiguas y nuevas mitologías urbanas de la aglomeración babélica de las fronteras.

Sin embargo, todos los trabajos de inSite_05 son, necesariamente, también *intervenciones en lo temporal*, y el tiempo es rito: Esto, a su vez, representa una aceptación consciente del *flujo* –privado o público, individual o colectivo. Sin el rito, uno no puede experimentar reacciones químicas ni crear trabajos ni juegos de especie alguna, ya que todo ejercicio del *poder de juego* implica una inversión energético-ritual. No obstante, el tiempo es invisible, por lo que el rito constituye, asimismo, la *visibilidad* del tiempo. Aun así, siempre debe recordarse que el rito no es, en sí mismo, un espectáculo (y todavía menos una "diversión") –se trata de la experiencia *localizada* de lo temporal (pero también de lo arquetípico y lo *sobrenatural*). En este sentido, el rito inevitablemente tiene que ver con la muerte, es decir, visualiza el límite. Sin embargo, existen diversas "muertes", entre ellas, la relacionada con los "ancestros", la que nos acecha o también la que llevamos en la memoria, al igual que aquella que *oscurece* el futuro. Entre esta visibilidad e invisibilidad transitoria del rito, se ubica un nudo simbólico fundamental (en el sentido antes mencionado), el cual ya ha sido desatado por inSite_05. En la modernidad tardía de nuestro mundo, estas dos for-

mas de lo transitorio siempre se encuentran en colisión, entre otras razones porque se vinculan de manera opuesta con el *genius loci*, y en el sur de California esta doble relación se vuelve aún más compleja a causa de la Gran División. Los ancestros están allí pero, al mismo tiempo, no lo están, por lo que resulta problemático e intrínsecamente inestable saber en qué tiempo vital y ritual se insertan las obras transitorias (*Passagenwerke*) de los artistas que participan en **inSite_05**, sus propios recorridos rituales (*parcours*) a lo largo de un mundo de mercancías y hacia lo des-conocido, y de *regreso* (lo que constituye una condición de la obra ritual). Porque este "territorio desconocido" de la frontera es un Purgatorio: el de nuestro cuasi-sacrificable y reconocible mundo urbano. Ante la imposibilidad moderna de invertir este universo dividido por la cosmo-lógica circularidad de lo ritual, **inSite_05** establece redes tales como la del paramesiánico *buen rumor*, creada por el artista sueco Måns Wrange con un anti-rito *virtual*: el indicio siempre cuestionable, siempre incierto, de las buenas noticias –tan imposible como *real* es la evidencia de su intención. Un intento anti-ritual similar y además *casi* invisible puede inferirse de la "comunidad transversal" creada por Rubens Mano (originario de São Paulo) al interior del flujo de los viajeros de transeúntes. Mano hizo que muchos de ellos portaran una señal visible (y reconocible) con el fin de manifestar su voluntad de pertenecer, durante un lapso específico, a este grupo efímero de transeúntes, adoptando así una "tercera" identidad ficticia –ni de "aquí" ni de "allá"– como capítulo innominado de **inSite**. Quizá estos "adeptos" generarán otros más, y se reconocerán los unos a los otros en una especie de pseudo cadena de culto que posiblemente se extienda a lo ancho y largo de la región, como sucedió con la red del *buen rumor*; reflejando así en cierta forma lo que Carmen Cuenca me describió una noche –mientras cruzábamos la frontera desde Tijuana– como la extraña capacidad que tienen los funcionarios fronterizos estadounidenses para adivinar "quién es quién" entre todos los que cruzan en coche la línea divisoria desde el otro lado.

En el actual y aparente callejón sin salida que significa la importancia de la creación de objetos en el contexto de un enloquecido mercado del arte-como-mercancía –posible señal, como sucedió tan a menudo en el pasado, de una inminente crisis financiera mundial–, **inSite_05** ha buscado desintegrar la *objetualidad* fetichista de la frontera Tijuana San Diego. El proyecto ha extendido por encima y a través de ella una red indescifrablemente perceptible de relaciones paralelas, con la intención de que con el tiempo expandirán su efectividad a nuevos espacios asociativos. "A-políticamente" por el momento, pero aun así en contra de la actual masa de tendencias políticas, todas las obras de **inSite_05** demuestran la naturaleza paradójicamente *vacía* y *sobre-caracterizada* del "corredor" en las que toman forma: La dis-topía, de hecho *a-topía*, urbana tardo-industrial y post-industrial marcada de manera singular por el aura negativa y la vibración de la barrera que lleva en su interior. De hecho, la frontera no es un lugar, sino un *no-lugar* con una fuerte carga de *no-realidad*. No obstante, y de nuevo en forma paradójica, su único e intenso contexto relacional se da en los espacios humanos que se conectan intermitentemente con este límite prohibido (y por lo tanto "sagrado"), que también constituye, no debemos olvidarlo, un instrumento potencial de "sacrificio", pues si se intenta ingresar por la fuerza –como lo hizo Remo durante la fundación de Roma– se pierde la vida. La muerte siempre ronda lo sagrado, hipóstasis de la separación de los dominios interno y externo; pero, en este caso, ¿qué es lo "interno" y qué "lo externo"? Esta es una de las paradojas simbólicas clave que aborda **inSite_05**.[4]

Un texano originario de Laredo (Thomas Glassford, actualmente residente en la Ciudad de México), quien ha vivido la experiencia de haber crecido en la Gran División, y un sandieguense de ascendencia mexicana (Jose Parral), se atrevieron a enfrentarse al vacío que separa y conecta las dos concentraciones urbanas, profundamente extranjeras, situadas a orillas del Océano Pacífico. Juntos crearon un jardín desértico público cercano a la playa de Tijuana, alrededor de una pequeña construcción helicoidal cuya vista da hacia el mar y hacia la reciente pero ya muy maltratada barda fronteriza que la delimita del lado estadounidense. La función inhibitoria de la valla se ve casi encubierta a causa del barniz sublime de su extraña apariencia y del matiz que le da la sal proveniente de la brisa marina. Al centro de este muro, una ventana perfectamente recortada permite observar las patrullas fronterizas y las potentes luces que provienen del lado norte de la frontera, e incluso ser testigo –como me ocurrió– de encuentros amorosos entre parejas procedentes de ambos lados de la línea divisoria. Esta es, ciertamente, una *esquina* (*La esquina*) del mundo noroccidental (en el suroeste): al alejarse de ella, uno no se encuentra en los trópicos, sino, más bien, rodeado de barrios bajos, maquiladoras y trampas para turistas; o encarando, del otro lado, la imagen mágica de un espejo que refleja el trecho de yermo desierto que parece casi artificial –como aquellos que se utilizaban para aislar y controlar algunas bestias peligrosas en los grandes zoológicos urbanos– que en de hecho la esquina suroeste de los Estados Unidos. Así, *La esquina*, creada por **inSite_05**, no constituye tan sólo un espacio comunal recreativo deliberado entre localidades con tensiones geopolíticas, sino un apoderamiento poético del gran vacío que se abre y, a la vez, se ve colmado de

súbito por la gran barda –y por lo tanto alegóricamente semejante a los jardines escultóricos fantásticos pseudo-iniciatorios del Renacimiento tardío, como Bomarzo u otros más tempranos realizados mediante una alquimia imaginaria, como el que encontramos en la *Hypnoerotomachia Poliphili*. Aquí, el turista se convierte en inmigrante y viceversa; pero mientras sueña con intercambiar papeles, algo inesperado puede ocurrir –la cuasi- tangible insinuación de otros viajes…

Sólo se puede *soñar* con saltar La Barda; sin embargo, una argentina (Judi Werthein, quien reside en Brooklyn, Nueva York) concibió –de forma imaginativa y concreta– un par de zapatos deportivos que vinculan por un lado ese deseo desesperado de inmigrar, con el consumo conspicuo –igualmente desesperado– de vestimentas para hacer ejercicio, por el otro. Regalo furtivo cuasi-legal a la par de una subcontratación hecha a la medida *demasiado* legal. Sus tenis *Brinco*, regalo para los futuros inmigrantes clandestinos, podrían serle devueltos con posterioridad, y, a cambio de ellos, dichos inmigrantes recibirían su doble del precio con el que tales artículos eran puestos a la venta en una lujosa tienda de San Diego. Sin embargo, ningún par fue devuelto: su magia resultó más poderosa que el valor del dinero. Esta obra, en tanto proporciona una especie de caja de herramientas para el traspaso internacional –que consta de un mapa, una brújula, la imagen de un santo protector y otros objetos–, no es un manifiesto de propaganda sociopolítica (como fue hipócritamente interpretada por muchos políticos y reporteros que se sintieron ofendidos por ella). Más bien evoca requerimientos extremos y logros truncados, re-uniendo la esperanza y las desolaciones desérticas, las mercancías útiles (entre ellas, un "objeto artístico" *portátil*), y el diseño práctico para las masas. De ahora en adelante resultará imposible observar lo que en la frontera y sus alrededores solía llamarse *zapatos tenis* sin medir la extensión de su alcance y la *eficacia* –real y simbólica– *de su uso*, al comparárseles con los *Brinco* presentados en **inSite_05**.

Muchos de los trabajos llevados a cabo en **inSite_05** permiten que lo *simbólico* guarde relación con lo *real en exceso*, en formas análogas a las dos descritas con anterioridad. Lo simbólico en ellas consiste en la capacidad de mantener dos valores (o más), a menudo opuestos, como pruebas simultáneas, con el fin de expresar –las más de las veces, por medio de elementos heterogéneos– contenidos in-mencionables. Estas creaciones y estos actos simbólicos no existen *per se*, en aislamiento; sin embargo, siempre están llenos de un potencial *no-razonable* y contra-dictorio, contrastando identificaciones emocionales y especulativas; oscilando entre posibilidades que, aun cuando mantienen su incompatibilidad, conservan en cada una de las obras su equilibrada intensidad ontológica. El pensamiento simbólico, en este caso al igual que siempre, postula de manera tangible la posibilidad de lo imposible, pero también, y con la misma fuerza, la intolerabilidad actual de lo posible. La inversión poética y urbana de **inSite_05** es como un reconocimiento multifacético a lo que en alguna ocasión el escritor italiano Giorgio Manganelli denominó *lenguaje arquetípico secreto*, inscrito en el tejido de todas las ciudades:

Desde tiempos inmemoriales, las ciudades han sido siempre máquinas de símbolos, esbozos mágicos trazados en el pavimento del mundo, lugares que, en una textura de calles, colinas, edificios civiles y religiosos, narraron una historia sagrada.[5]

inSite_05 no se intimida al afrontar esta sacralidad oculta, por lo menos en su mayor parte *invisible*, del entorno urbano fronterizo, inyectando en sus texturas existentes novedosas figuraciones *ad-hoc* cuyos destinos emotivos e intelectuales están dirigidos, para decirlo, a *re-activarlas*. De este modo, en el profundamente reservado e incluso conflictivo ámbito del cruce de fronteras, promocionó la "hospitalaria" intervención realizada por una joven pareja brasileña, Felipe Barbosa y Rosana Ricalde. Ellos procedieron a cubrir el piso de un puente peatonal o viaducto clave ubicado en el área fronteriza de la ciudad de Tijuana con los nombres de los incontables visitantes, inscribiéndolos en un arco iris de diversos colores, similares a las etiquetas de identificación y a las pulseras que se vendían en los puestos callejeros aledaños (pero evocando, asimismo, las bandas de las condecoraciones militares). En este caso, el acto de darse un nombre a uno mismo en una especie de grafitismo colectivo concertado y coordinado, muestra la anonimia y la no permanencia del turismo –o tal vez debamos decir la *permanencia* de su no permanencia– y la naturaleza intrínsecamente transitoria de la frontera. Al mismo tiempo, el proyecto llama la atención debido a que dos meses después de haber sido pintado los coloridos nombres inscritos en el puente, ya se han borrado a causa del desgaste ocasionado por los paseantes. De manera análoga, Paul Ramírez Jonas (un sudcaliforniano que creció en Honduras y ahora radica en la ciudad de Nueva York, en donde todo siempre debe guardarse bajo llave) transformó el poderoso signo de la llave de una casa en un símbolo de apertura potencial e intercambio. *Mi Casa, Su Casa* ahonda en el territorio de la pureza y el peligro, pero también en sentido opuesto a esos juegos suburbanos, decadentes y "desesperados", en los que las llaves y las esposas son intercambiadas por una noche. En estas y otras obras de **inSite_05**, el nudo simbólico consiste,

asimismo, en la conjunción de elementos "muy relacionados entre sí" y "desconocidos entre ellos". Dichos elementos delinean en cada instancia los confines de una nueva a-topicalidad, en una suerte de no-aprendizaje de la rigidez de los dominios privados/públicos existentes, con el fin de re-crearlos (por ejemplo, re-aprenderlos), y de re-conectarlos para desarticularlos (o revelarlos).

Una *parodia* es una canción alterna o un poema agregado que desplaza el contenido original, para luego crear un sentido intersticial que reposa por completo en la relación existente entre lo nuevo y lo viejo, que en cierta forma se sitúa *en ninguna parte*. Sin embargo, la parodia, como texto paralelo, puede dejar al descubierto la pomposidad y la fría seriedad de otro texto; también puede haber parodias, algunas de ellas muy refrescantes, de las sublimes y profundas creaciones del espíritu. Como tales, la parodia puede ser uno de los caminos que rodean la inercia de conjuntos de relaciones existentes, usos de categorizaciones físicas y discriminaciones sociales. En tanto el humor recorre **inSite_05** como si se tratara de una corriente eléctrica sutil y siempre presente, haciendo que los nervios transculturales se contraigan (sin que exista la más insignificante insinuación de una travesura unidimensional), la parodia fue una *chanson ajoutée* siempre presente, otorgándole a cada tarea largamente preparada y a cada acontecimiento fugaz, la tonalidad y el colorido de la ligereza: un tono festivo muy serio, claro está, como el que a menudo exhiben los niños cuando juegan. En **inSite_05**, cada una de las obras debe leerse de acuerdo con su valor nominal, casi de manera literal por decirlo de algún modo, pero también en concordancia con una realidad que en múltiples ocasiones resulta difícil de creer cuando uno de verdad la observa –como lo hacen los artistas que participan en la **Intervenciones** presentadas en **inSite_05**– con la firme e "intensa mirada de la imaginación" y sin "carecer de una profunda distracción".[6]

Años atrás, Chris Burden parodió algunos de los conocimientos y obsesiones generados alrededor de la frontera, lanzando pequeños aviones de papel rellenos de mariguana (¿quizá otro nombre que se le da a la "Tía Juana"?), lanzados desde el lado estadounidense de regreso hacia México. Con ello buscaba destacar y rebatir el prevaleciente *flujo* de desequilibrado estado mental de paranoia, y con ello también revelar la futilidad de la colosal máquina controladora que sostiene al mercado de las drogas y sus *costos*. Recientemente, en la ciudad de Nueva York, un grupo de estudiantes de Cooper Union (encabezados por Jana Leo, "arquitecta-filósofa" española) lanzó cientos de aviones de papel para que se deslizaran desde el último piso del vestíbulo central de las nuevas galerías del Museo de Arte Moderno alrededor del *Broken Obelisc* [Obelisco roto] de Barnett Newman –ante la sorpresa de los guardias, devotos de arte y turistas que visitan el museo los viernes, cuando la entrada es gratuita. En **inSite_05** un polaco que radica en la Ciudad de México (Maurycy Gomulicki) reunió a dos asociaciones que se dedican al aeromodelismo a control remoto, y que ignoraban la existencia la una de la otra, a fin de presentar un "espectáculo aéreo" dentro del lecho seco del río que corre a lo largo de la frontera y que separa sus respectivas comunidades. O quizá deberíamos decir que estos dos clubes de artesanos apasionados, de técnicos no especializados, de *bricoleurs*, sólo se percataron de que pertenecían a una "comunidad" durante el proceso en el que descubrieron el reflejo de su imagen por medio del lenguaje, las tradiciones, la religión, las convicciones políticas (o la carencia de éstas), etcétera. Un antropólogo (por entrenamiento, como yo) no puede equivocarse al pensar en el elevado número de sociedades arcaicas –e incluso en algunos aspectos de nuestras sociedades modernas– en las que lo social (*socious*) se define, a menudo de manera espacial y visual, precisamente por la adopción de dicotomías fundamentales y *simetrías* igualmente constitutivas del cuerpo social (*body-public*). En este caso, la intervención de **inSite_05** de hecho ha *representado* el sustrato público del desacuerdo fronterizo, al mostrarlo en primera instancia como una exhibición no competitiva –y como un *espectáculo*: se presentó ante un público conformado por aficionados de ambos lados de su alienación intrínseca, lo cual también hizo que la exhibición trascendiera en celebración con miras a una relación y un contacto futuros. Tal vez así es como puede continuar desarrollándose la acrobacia (incluso en ausencia de lo divino) que a menudo implican la repetición y la refracción de acontecimientos únicos: sin borrar las conclusiones ocultas y las hechicerías de la división, y al contrario darles voz, orquestarlas, darlas a conocer –incluso *acrobáticamente*, como ocurrió en este caso.

De forma análoga, así es como un sudamericano que radica actualmente en la ciudad de Nueva York (Javier Téllez) presentó una singular acrobacia al aire libre, con la entusiasta e hipersensible participación de alguna "gente tocada" de Tijuana (la expresión proviene de la pintora Claudia Pérez Pavón, de la ciudad de México) –invitados sensibles y frágiles procedentes de una institución mental quienes se desempeñaban como co-organizadores, a la vez que como público privilegiado y como los actores al mando de la procesión musical y la escenificación del evento. Éste consistió en propulsar al "vacío" –como Téllez lo denominó– que se localiza en el extremo occidental de la frontera más vigilada del mundo (misma que, como en alguna ocasión Joseph Beuys sostuvo, mira hacia el "Este"), al famoso artista

circense David Smith "The Human Cannonball" (bala de cañón humana) –desde el lado mexicano hasta el lado estadounidense. Este acontecimiento fue tanto una *puesta en escena* simbólica de la trans-lación de un cuerpo (en el sentido etimológico de trans-portación y trans-ferencia) por encima del vacío-de-significado de la frontera, como la actual intensificación o la reciente comprensión total de significado que se registra al interior del encierro psiquiátrico. Pero también fue una "bala perdida", es decir, un-vuelo-de-ida-sin-retorno que refleja lo que ocurre con los inmigrantes que se ven imposibilitados para siempre para regresar al lado de sus familias y a recuperar sus raíces (y también quizá, aunque de manera más remota, refleja los trayectos sin retorno que emprenden los desesperados suicidas que se inmolan con explosivos). De nueva cuenta, lo *privado* y lo *público* fueron intercambiados y subvertidos. Esto mismo lo realizó, aunque en forma más meditativa, un artista de Guadalajara (Gonzalo Lebrija), quien de manera silenciosa se introdujo al Veterans Museum (Museo de Veteranos) y su biblioteca, ubicados en Balboa Park (el tranquilo centro *histórico* de San Diego, una de las bases navales más grandes del mundo). En las cámaras ocultas del museo –su sagrario interno– insertó las memorias semi-olvidadas y semi-suprimidas de ex-prisioneros de guerra. Éstas eran narraciones que los encargados del recinto jamás habían considerado que valiera la pena contar –quizá ni siquiera recolectar– hasta entonces, o incluso que sería aceptable y significativo hacer esas memorias públicas y compartirlas. En este caso, al igual que en otros proyectos de **inSite_05**, se puso en marcha un proceso práctico y consciente que muy posiblemente se perpetuará y repercutirá más allá de los límites del espacio-tiempo del "acontecimiento artístico". Casi con certeza, esto sucederá en el caso de las esposas desesperadas de soldados en servicio de guerra con las que una artista de Saskatoon, Canadá (Althea Thauberger) creó, orquestó y puso en escena composiciones corales de dolor y de tristeza provenientes de mundos privados dispares e incluso discordantes.

Una vez más en Tijuana, un colectivo de jóvenes denominado Bulbo –que de manera local produce programas, publicaciones y eventos utilizando diversos medios– decidió darse a la tarea de dirigir sus esfuerzos hacia el significado de la moda de hoy, tan manipulada y explotada por intereses comerciales, incluso, o quizás aún más, en la pobreza que caracteriza el entorno urbano fronterizo. Pero, se preguntaron, ¿qué ocurriría si *diseñar y confeccionar* nueva ropa se volviera en verdad una actividad *pública*, en la que la gente pudiera unírseles en todos los aspectos y las fases del proceso? ¿Qué clase de prendas de vestir o de desvestir podrían surgir de semejante experimento?, ¿qué tipo de objetos se producirían, cómo se usarían y de qué manera se pondrían en circulación? ¿Acaso los cuerpos que deberán cubrir se convertirían en una suerte de faros dentro del extenso cuerpo social, llevando la moda hecha en casa (sin embargo, pública) a los espacios abiertos de interacción pública? En otras palabras, ¿acaso las nuevas vestimentas se convertirán en un *descubrimiento* (apenas sospechado) de los potenciales de cohesión ocultos bajo los ropajes de la división y la convención? **inSite_05** estaba dirigido a generar interrogantes *operacionales*, y esta particular *factura* –o *hechicería*– fue llevada a cabo en Tijuana por los integrantes de Bulbo bajo la apacible tutela de un viejo y sabio pensionista. El colectivo se mueve con facilidad en ambos lados de la frontera y sabe lo que hay que saber acerca de ambas regiones. Su comunidad de medios de difusión (tienen sus propios programas de televisión y radio) podía haber florecido en cualquiera de los dos lados –y sin embargo, no: Un distintivo sabor *pobreza-por-elección* impregna sus modestas oficinas mexicanas, en el segundo piso de uno de esos edificios de cemento que se ven como si la pureza del modernismo se hubiera deslavado y hubiera sido reducida a su más simple avatar. Ellos muestran este mismo espíritu de simplicidad, ya sea cada uno en lo particular o de manera colectiva, como si se tratara de un halo o de una nube protectora invisible, en dondequiera que se encuentren (incluso cuando se presentan en círculos privilegiados del lado estadounidense). Uno debería dudar en calificar de "inocencia" esta postura, pero evidentemente existe una cierta cohibición cuasi-monástica en el comportamiento de los integrantes de Bulbo, y el sentido de potencial ilimitado que uno tiende a obtener de los esfuerzos individuales o colectivos que son generosamente expansivos, también parece encontrar en ellos mismos su propia energía y justificación.

En estos días oímos hablar mucho sobre la "re-contextualización", como si se tratara de una panacea en contra de los supuestos males que la *globalización* trae consigo. Sin embargo, lo auténtico nunca ha requerido ser re-contextualizado, ya que está definido y modelado por su propia y singular *localización* (*locality*), en lo interno y lo externo (*within and without*). Lo auténtico es simplemente aquello que, en cualquier lugar y a cualquier hora es real, y como tal, *necesario* –de la misma forma como lo es el agua potable. Lo anterior pudo haber sido insinuado por un colectivo estadounidense (SIMPARCH) en colaboración con la Fundación Esperanza de México: ¿Acaso puede purificarse de manera simbólica la carencia crítica de salud y esperanza que predomina en las duras condiciones del tránsito fronterizo mediante un flujo destilado por medio de luz solar? En semejante contexto de vida-y-muerte, la *transparencia* quizá pueda señalar el camino hacia una humanidad menos anticuada:

Para poder de tiempo en tiempo disfrutar del cielo, utilizaba un pequeño espejo redondo. Tras empañarlo con su aliento y frotarlo contra su pantorrilla, buscaba las constelaciones. ¡Las tengo!, exclamaba, refiriéndose a la Lira o el Cisne. Y a menudo agregaba que el cielo nada tenía.[7]

En los textos védicos que constituyen una de las raíces indoeuropeas de nuestra tradición occidental, aparece la palabra *loka*, que se utiliza para denotar "el mundo" como algo opuesto al dominio de lo privado y del "hogar". Dicho término también se refiere al ámbito de la vida "tal y como es", en oposición al dominio normativo de "cómo debería ser" (*dharma*). En estrecha analogía con la extensión semántica de la palabra francesa *monde*, asimismo se refiere a "la gente común" en oposición a los "especialistas" (por ejemplo, en la antigua India, los expertos en rituales y en gramática). Me parece que esta antigua noción resulta relevante para lo que **inSite_05** significa. Más aún si uno recuerda las connotaciones sensorias originales del término védico que hacían referencia a un espacio abierto o un "claro" delimitado por el bosque circundante (de la misma forma en que algunos de sus consanguíneos germánicos y latinos tempranos, y otros posteriores se referían a ello) y, por lo tanto, también a un lugar de elevada visibilidad y "brillantez".[8] En el paisaje híbrido de los confinados y no confinados claustros neocoloniales (¿o guetos?) del sur de California, **inSite_05** ha creado una constelación de *claros* o espacios de intenso resplandor público, no mediante el modelaje de objetos o la construcción de monumentos, sino por medio de la movilización de fuerzas cohesivas que se encuentran ocultas en las aperturas y las fisuras de sus bosques sociales y sus símbolos.

* Quiero agradecer a Gini Alhadeff y a Robert Hullot-Kentor por las útiles lecturas realizadas a este ensayo.
Traducción: Gabriel Bernal

1 ANDERS, G., *L'uomo é antiquato: 1. Considerazioni sull'anima nell'epoca della seconda rivoluzione industriale*, Milán, 2003. Primera edición, 1963, p. 106
2 VALÉRY, Paul, "Mauvaises Pensées et autres", en *Oeuvres Complètes*, II, París, 1960, p. 797
3 KOJÈVE, Alexandre, "Il Colonialismo nella Prospettiva Europea", en *Adelphiana*, núm 2, passim, Milán, 2003, pp. 69–86
4 Uno a menudo reflexiona sobre las "paradojas simbólicas" en relación con las múltiples dimensiones constitutivas de **inSite_05**. El uso que hago de este concepto de alguna manera se inspira en la forma en que Wolfgang Pauli hablaba de la contradicción entre *frecuencia* y *energía*, en términos de física clásica, y de cómo tomó tiempo formular un sistema conceptual que se adecuara a este hecho paradójico, no obstante carente de contradicciones lógicas [...] Las funciones matemáticas "abstractas" de la física moderna operan en este caso como símbolos que se reincorporan al contraste. PAULI, W., "Moderni Esempi di Hintergrundsphysik", en *Psiche e Natura*, Milán, 2006, pp. 34 y 37
5 MANGANELLI, Giorgio, "Cabala Urbanistica", en *L'Isola Pianeta e Altri Settentrioni*, Milán, 2006, p. 138
6 VALÉRY, Paul, op.cit., p. 878
7 BECKETT, Samuel, "Basta", en *Testo-Morte*, Milán, 1969. (Londres, 1958, París, 1965-1966), p. 54 [traducción al inglés del autor]
8 MALAMOUD, Charles, "Cosmologia prescrittiva: Osservazioni sul mondo e il non-mondo nell'India antica", en *La Danza delle Pietre*, Milán, 2005, pp. 185–215

MAPAS/ (des)Mapeando San Diego

LA LLANURA COSTERA Y LA ECORREGIÓN DE CHAPARRAL DE CALIFORNIA se extienden desde el noreste de Baja California en México hacia el norte a lo largo del Pacífico, para internarse al sur de California en los Estados Unidos. La ecorregión está circundada al este por el desierto de Colorado y Sonora, y continúa al sur hasta Punta Baja (México) e incluye las Islas Canal (EE.UU.), así como las islas mexicanas de Cedros y Guadalupe. El terreno se conforma por terrazas costeras, llanos y pastizales, constituyendo de este modo una de las cinco ecorregiones de clima mediterráneo en el mundo.

World Wildlife Fund © 2001

Diversas ciudades como Los Ángeles, San Diego, Phoenix, Tucson y Tijuana poseen acueductos cuyas aguas regresan al Río Colorado.

en Wikipedia.org/wiki/Colorado_River_(U:S.) – 40k – En caché – Páginas similares

El curso natural del Colorado fluye hacia el Golfo de California, pero su gran utilización como agua de riego para el Imperial Valley ha desecado el caudal bajo del río en México, de tal modo que ya no llega al mar en forma consistente.

La región de San Diego obtiene actualmente cerca del 80 al 90% de su suministro de agua importándola del norte de California y el Río Colorado. La demanda del líquido

en el área de servicio de la Water Authority se considera en dos categorías básicas: municipal e industrial (M&I) y agrícola. El empleo actual de M&I representa cerca del 80 al 85% del consumo del agua regional, y el de la agricultura –utilizada en su mayor parte en el regadío de huertos y cultivos– es suficiente para el resto del 15 al 20% de dicha demanda, que para el año de 2030 se pretende alcance los 829.030 acres-pie (AP). Esto significa de modo aproximado un aumento del 29% de los 642.152 AP respecto a la demanda que se presentó en el año fiscal de 2005.

www.eere.energy.gov/buildings/appliance standards/pdfs/ca petition comments/29 sdcwa.pdf

El acueducto binacional de Tijuana avanza, pero la tubería puede no estar lista a tiempo

Tijuana. El tema del agua ha estado en las noticias de días recientes, dado que los niveles de lluvia en Baja California cayeron a su menor grado en más de un decenio, y la presa Rodríguez de la ciudad está a un cuarto de su lleno total. Pero esta sequía sólo acentúa un desafío mucho mayor: el de satisfacer las crecientes demandas de agua que en pocos años habrá en Tijuana, la ciudad más grande del estado. Un acueducto binacional, construido en colaboración con el condado de San Diego, sería la solución; sin embargo, las autoridades de Baja California temen que aun cuando se apruebe este controversial proyecto de más de mil millones de dólares, la tubería no podría ser terminada a tiempo para subsanar la inminente escasez de agua.

Septiembre, 2002. U.S. Water News Online

MAPAS/ (des)Mapeando Tijuana

Biocartografía de la escena artístico-cultural de Tijuana: Útero como límite y/o posibilidad

Fiamma Montezemolo (COLEF)

La nación (localismo) se presenta como el sustrato perdurable a través del cual se garantiza a los individuos una vida más allá de la vida finita puramente biológica. Éste supuesto poder orgánico de originar es insinuado por el enlace etimológico de la nación (de lo local) con "natividad" y "natalidad" (mi énfasis).

Pheng Cheah
Spectral Nationality, Columbia University Press, N.Y., 2003.

Diagnosis:

El útero/Tijuana padece una autotopofilia extrema, lo que implica una hiperprotección del feto/vida cultural que imposibilita lograr la necesaria separación de la matriz. Esto dificulta el desarrollo de una identidad autónoma y de una cartografía propia.

El lenguaje maternal-patriótico con el que a menudo se define a la ciudad: *Tijuana, madre de todas las fronteras*, *Aquí empieza la patria...* es la sustitución del lenguaje nacionalista por un lenguaje igualmente originario vinculado al concepto de *lo local*. Tijuana se nos presenta como madre "única" y feliz, y al mismo tiempo modelo ideal –TJ es el lugar más feliz de la Tierra; TJ: Barrios de chabolas como nuevo ideal suburbano, TJ capital mundial de la televisión. Estas definiciones encarnan una situacionalidad estratégica –opuesta al así dicho *globalismo canibálico*–, misma que, llevada a un extremo, presenta el riesgo de transformar al útero en una caja cerrada. El útero/Tijuana se vuelve límite en vez de potencialidad. De lugar de paso, en el sentido de un útero que no es meta sino momento transitorio hacia la vida, la ciudad se vuelve un destino-vocación del cual no parece posible prescindir. La madre no deja ir a su prole y la prole la idealiza a través de su unicidad (positiva o negativa, no importa) y de una hiperdefinición continua. Tijuana es siempre la *más*: la más visitada, la más cruzada, la más fea. Se justifica el deseo de quedarse en ella, de no dejarla nunca, "gracias" al mito de su especificidad.

La paciente Tijuana parece sufrir de una "exageración" del útero, debido al énfasis referencial de su pertenencia originaria. Simon Schama: *Empezamos en el útero, en*

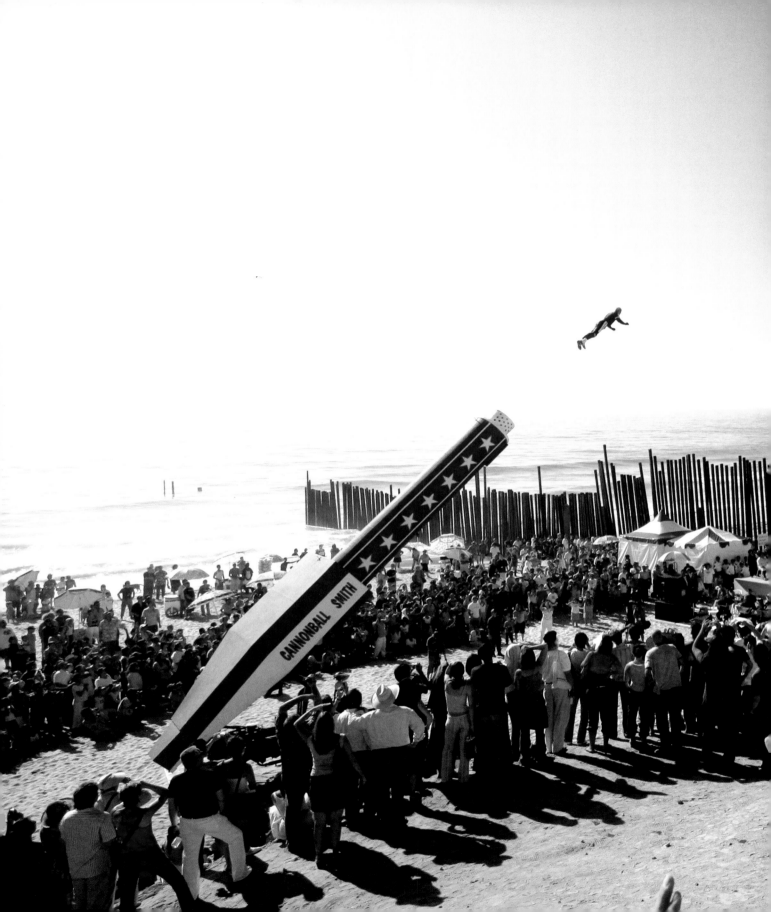

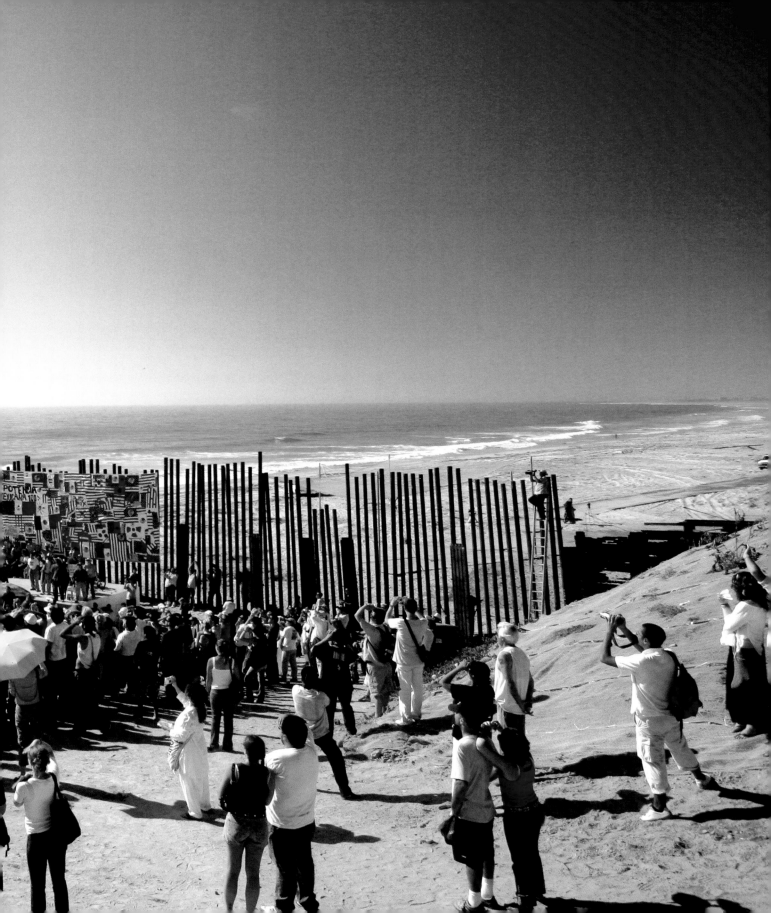

un lugar que parece tener límites confortables y en el cual nos meneamos, sabiendo lo que sabemos. Pero existe entonces la distinción espacio-lugar, y el espacio da mucho más miedo pues es más difícil de entender. (en Dean, T.-Millar, J., In Place, Thames & Hudson, 2005, N.Y.).

Estetizada, la Tijuana-útero es funcional también para aquellos que no le "pertenecen" en sentido "originario" –los así llamados *de afuera*: los curadores, investigadores y organizadores culturales, quienes exaltan la unicidad local para justificar a su vez su propio rol de descubridores, salvadores de ese "nuevo nativo" con genio creativo en condición material limitada. Un local antes marginado, pero ahora generosamente y provisionalmente incluido mientras resulte teóricamente útil, para oponerlo o acoplarlo a la ideología del momento: la globalización-homogenización, el exotismo *fashion*[1], hasta el uso y abuso del concepto de *real civilización occidental*[2]. Mito tijuanense útil hoy y ahora, pero con la reserva de un posible regreso inmediato a su "origen" una vez que ya no sea adecuado a la exigencia proyectiva de los *de afuera*.

Antes el global era demasiado globalizado, ahora el local padece de un localismo exagerado.

¿Es posible acabar de ver/utilizar al llamado *Tercer Mundo* como proyección de las frustraciones/necesidades del llamado *Primer Mundo* sin relegarlo a un ideal roussoniano o convertirlo en un homogéneo globalizado? ¿Es posible acabar de establecer diferencias con base en dualismos "auténticos" y "originarios" como *Tercer Mundo-Primer Mundo*, creativo-práctico, escondido-descubierto, adentro-afuera? ¿Es posible elegir un juego de distancia-proximidad que sea más cercano al concepto de *uncanny* freudiano, en lugar de *raro*, como sinónimo de *extranjero*, o de *no común*?

Quizá llegó el tiempo de cartografías *otras*, desvinculadas de madres/madrinas y sus protecciones/proyecciones.

[1] Un nuevo mundo. Tijuana es una nueva mecca cultural. La ciudad es reconocida por numerosas publicaciones en los Estados Unidos, Europa y México como un vibrante sitio de innovación en las artes. Ya desde 1989, Néstor García Canclini describía a Tijuana como "uno de los mayores laboratorios de la posmodernidad", colocándola a la par de la ciudad de Nueva York. Desde entonces periodistas, académicos y críticos han celebrado la excitante diversidad de la producción artística de Tijuana. (*Strange New World*, Rachel Teagle, MCASD, 2006, San Diego).

[2] El empresario representante en México del grupo español Prisa, Antonio Navalón, así definió el espacio local para contraponerlo junto con el espacio estadounidense al espacio del "fundamentalismo religioso": *Estamos ante una guerra total de civilizaciones en la que deben ser más importantes los elementos que unen a las civilizaciones, iguales o parecidas, que los miedos culturales y legales que nos separan. En este sentido tiene mucho más valor el hecho de la pertenencia de México y otros países emisores de emigrantes a la civilización occidental, que el intento de separar y afrentar por miedos abstractos a los miembros de las mismas comunidades. Los enemigos comunes de la frontera de México y Estados Unidos son todos aquellos que desde el fundamentalismo religioso, a partir de una asumida anarquía social del espacio fronterizo, pretenden atacar los métodos y valores de vida que son comunes a las sociedades libres y democráticas.* (En Montezemolo-Sanroman, *Replicante*, D.F., 2005, p. 44).

Estadísticas incluidas en el mapa

(5) Los Estados Unidos nos dieron la música pero Tijuana nos dio el lugar de nacimiento (Montezemolo, Yépez, Peralta. AQUI ES TIJUANA, Black Dog Publishing, London, 2006, p. 103)/ (7) La favela como nuevo IDEAL suburbano (Nicolai Ouroussoff, "Shantytowns as a new suburban ideal", THE NEW YORK TIMES, marzo 12, 2006)/ (8) TJ es la ansiedad de irse pronto y el deseo de quedarse y RENACER (Carlos Monsiváis, "Postborder City: Cultural spaces of Baja California", Dear y Leclerc Editores, New York: Routledge, 2003)/ (9) TJ es el lugar más FELIZ de la Tierra (Simpsons)/

CON TUTTO

Eloisa Haudenschild/ Presidente de la mesa directiva, **inSite_05**

Lo más gratificante de **inSite** es el impacto que tiene en la vida de tantas personas. Ese impacto está referido sólo indirectamente a las piezas de arte producidas para cada edición; yo más bien diría que tiene que ver con la presencia sostenida y comprometida en el área de tantos artistas, curadores, e intelectuales por un lapso expandido de más de dos años. La calidad de esa gente, sus mentes, sus temperamentos. La fuerza de **inSite** emana de esa erosión, de esas amistades y alianzas que no son meramente profesionales, y que cambian tu manera de ver, tus apreciaciones, tus compromisos. Es esa fuerza de inspiración, cada vez más sólida, aún después de no pocas ediciones, lo que me sigue asombrando.

Es difícil hablar en nombre de una mesa directiva. Uno termina escribiendo formalidades, frases hechas. Pero desde mi lugar aquí, debo agradecer que, en lo personal, **inSite** siempre haya correspondido y haya retado mi necesidad de cambio, mi curiosidad, mi sorpresa. Desde mi involucramiento inicial en 1993, lo que más me interesó de **inSite** fue su estructura cambiante. Esa capacidad para abrir nuevos intersticios, entre lo que entendemos por arte y todas aquellas experiencias personales que una obra de arte acumula tras de sí, tras su presencia. Incluso, entre un **inSite** y el que sigue está ese otro intersticio, esa pausa aparente de repensar un proyecto, de poder decir *tabula rasa*, y abrirse a nuevas ideas, a nuevos retos, a nuevos artistas. Esa capacidad de moverse, de cambiar, ha sido una gran lección.

inSite ha tenido un impacto educativo muy fuerte a niveles tanto personales como insitucionales. Cambios que a veces son imperceptibles pero igualmente relevantes.

Digamos con la mesa directiva, por ejemplo. Nos ha enseñado no sólo a entender el arte en un contexto amplificado, sino incluso a hacer una colección, y sobre todo a consolidar y a entender desde otra perspectiva que nuestro compromiso como coleccionistas y como filántropos, es en primera instancia hacia la comunidad artística y hacia las libertades públicas. Este aprendizaje ha sido parte de esa aventura, al seno de una organización que siempre está abierta a otras cosas, y que arriesga no para construir una posición.

Todos sabemos que al interior de una mesa directiva siempre hay modelos distintos de participación, motivaciones muy variadas, que en el fondo siempre son compromisos muy personales. Un proyecto como **inSite** reúne, y por sí sólo explica, un perfil muy especial de su mesa directiva. Muchos son miembros que llevan apo-

yando la vocación crítica y alternativa de este proyecto por más de una década. No es una mesa directiva donde uno esté por figurar, por *glamour*, por algún tipo de conveniencia. El perfil de nuestra mesa directiva yo diría que no es nada común, y es también nuestro orgullo. No somos empresarios administrando cultura.

Hoy nuestro reto sigue siendo hacer de **inSite** parte de la vida cultural cotidiana del área. Y eso es un reto enorme. Desde 1994, cuando **inSite** arrancó creando la mayor red de alianzas culturales transfronterizas que nunca haya existido en la región, eso fue una marca en la historia del área. A otros niveles, **inSite** ha impactado no sólo la agenda sino también la geografía cultural de muchas instituciones a ambos lados de la frontera. A veces esa influencia se comporta de manera reactiva; lo ves en el modo en el que algunas instituciones responden con paternalismo o con desmemoria ante el papel de **inSite** desde 1992 en esta área fronteriza. Otras muchas instituciones culturales líderes en Tijuana y San Diego son socias invaluables de **inSite** y han compartido esfuerzos y experiencias de crecimiento inolvidables. Especialmente el Centro Cultural Tijuana, el San Diego Museum of Art, el Athenaeum Music Arts & Library de La Jolla y el Instituto de Cultura de Baja California, así como un sinúmero de otras organizaciones pequeñas, comunales y no gubernamentales.

A esta altura, siento que todos los involucrados seguimos estando muy satisfechos con esta edición de **inSite_05**. Su complejidad, su multiplicidad de capas de lectura y de acción, y la sutileza de sus niveles de visibilidad, lejos de intimidarnos han sido un estímulo también para toda la mesa directiva. Por suerte somos una mesa directiva que siempre ha estado ahí para apoyar las propuestas de los curadores y de los artistas, y mover a **inSite** adonde ellos han querido moverlo.

Como cada edición, durante **inSite_05** fue muy gratificante comprobar como ha crecido el nivel de confianza, local, regional e incluso internacional, ante esta labor. **inSite_05** se consolidó también gracias el apoyo de otras instituciones filantrópicas de gran prestigio que han avalado generosamente lo que hacemos. Recuerdo cuando en 1994 empezamos con las residencias, lo extraño y a veces gratuito que aquello resultaba para muchos. Desde entonces siempre hemos estado muy atentos a las nuevas situaciones que cada **inSite** crea, desde sus artistas y desde sus curadores. Es que ahí está su relevancia. Porque cada situación exige de cada uno de nosotros nuevos roles.

Por todas estas razones, por la generosidad de muchas de estas alianzas, de un sinnúmero de coparticipantes y de patronos que han compartido estos esfuerzos y estas alegrías, es que estamos aquí para, una vez más, lanzarnos *con tutto*.

Projects/	Artists/	Curators/
_ Archive Project/ **Mobile_Transborder Archive**		Ute Meta Bauer
_ Online Project/ **Tijuana Calling**	Ricardo Domínguez/	Mark Tribe
	Coco Fusco	
	Anne-Marie Schleiner/	
	Luis Hernández	
	Fran Ilich	
	Ángel Nevarez/	
	Alex Rivera	
	Ricardo Miranda Zúñiga	
_ Live Visual and Sound Image Event/ **Ellipsis**	Damon Holzborn	Hans Fjellestad
	Liisa Lounila	
	Magaly Ponce	
	Iván Díaz Robledo	

➔ Traducciones/ p. 410

Scenarios examines practices involved with the public domain that transcend urban spatial locations and sites of action that require the convening of an audience. Focusing on time-based considerations and the removal of the physical object as a support, these three projects deal with less established practices that have nonetheless become key to the construction of the public sphere as a space of discourse.

Scenarios refers to processes that parody common models for consuming, distributing, exhibiting, and storing cultural information. For the past few years, languages and formats ordinarily used to transmit information, such as the Internet, the spectacle, and the index, have allowed art to create new, more radical inscriptions of "the public."

The public impact of the projects featured in **Scenarios** lies in the fact that they afford us new means of relating to art through the fragile complexity of the shared experiences they provoke, the information networks they stimulate, the efficacy of their connectivity, and the morphing capacity of the articulations they generate. **Scenarios** raises questions about the predominance of temporalities determined by the circularity, speed, and expandability of networks that define new zones of transgression and contamination as different modes of knowledge that define today's social imaginary. o.s.

Scenarios/

The idea of commissioning an archive project stemmed from an interest in investigating existing networks that are used for the dissemination and storage of information/knowledge. The aim of the project was to question and reveal the institutional policies that govern the access to, and end uses of, collective memory. Rather than merely absorbing existing memory networks, the Archive Project—curated by Ute Meta Bauer in conjunction with Elke Zobl—sought to bring them into collision through a process of mutual recognition involving institutions, individuals, social organizations, and academic archives in San Diego and Tijuana. The Archive Project explored how the complex social fabric of the region is perpetually constructed through the civic and political functions of archiving and its public discourses. The *Mobile_Transborder Archive* manifested itself as an action that transcended the border fence. It provided an open-ended perspective about archival knowledge as a pubic practice that should not only be understood as edited memory. o.s.

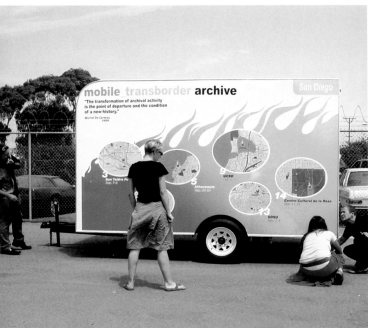

Mobile Transborder_Archive

Curator/ Ute Meta Bauer/ **Assistant Curator/** Elke Zobl
Project Assistant/ Haydeé Jiménez

The border as a whole is not a thing, a line or wall.
It's a system of social relations.
Mike Davis, 2005

MOBILE_TRANSBORDER ARCHIVE
Ute Meta Bauer/ Curator

Borders construct a dense, complex scenario and multiple zones of transition, contradictions, inter-sections, embedding the visibility of border crossings, as well as the development of cultural and transnational identities and diversities.

The project reviews the concept of the archive and its mechanisms of representation. It engages various public spheres in a discourse regarding who and what constitutes an archive by which premises. This leads to the questioning and critical reflection of archives as such. A dense fabric, like the San Diego-Tijuana border region, is particularly suitable for such an exploration.

The *Mobile_Transborder Archive* operated as a mobile unit moving between organizations, institutions, archives, and university and public libraries in San Diego and Tijuana. The intention was to draw connections between individual researchers and activists, cultural and community centers, and grassroots initiatives that focus on specific border issues in San Diego-Tijuana and the California-Baja California region, employing a transdisciplinary approach. Texts, books, photographs, films, videos, oral histories and online resources, addressing both the specific region and archives as such, were accessible in the transborder mobile unit.

While on tour, the *Mobile_Transborder Archive* opened up a space for events, discussions, and film screenings addressing diverse audiences. >

→ Otras traducciones/ p. 410

> In conjunction with the mobile unit, materials from private and public collections of the area were presented at exhibitions at the Athenaeum Music & Arts Library in La Jolla, one of the oldest cultural institutions in San Diego and one of only sixteen remaining membership libraries in the US, and the Centro Cultural Tijuana, the largest cultural institution in Tijuana. The materials on display were selected from a rich spectrum of possible topics and materials generated by this border region. Topics like labor, environmental issues, migration and human rights, questions of identity and women's rights, and youth culture offer a good point of departure for such an undertaking.

The project sought to draw connections between various archives and collections and to make their existence and longtime research known to a wider, cross-border audience from the area and to international visitors of **inSite_05**. As a case study, the *Mobile_Transborder Archive* could be transferred to other border zones in order to make the structural similarities and specific differences of border regions visible and accessible for further debates on the mechanisms of archival representation.

During her research residencies in the area Ute Meta Bauer interviewed numerous academics and researchers, including Nora Bringas, Mike Davis, Paul Ganster, and Norma Iglesias, among others> Durante sus estancias de investigación en el área, Ute Meta Bauer entrevistó a numerosos académicos e investigadores, como Nora Bringas, Mike Davis, Paul Ganster y Norma Iglesias, entre otros

Ute Meta Bauer is a curator currently serving as director of the Visual Arts Program in the Department of Architecture at MIT. She is based between Cambridge, Massachusetts, and Berlin and was the curator of *Mobile_Transborder Archive*, a project commissioned for the **Scenarios** component of **inSite_05**.
Elke Zobl is a writer and researcher currently based in Salzburg. She served as the adjunct curator of *Mobile_Transborder Archive*, a project commissioned for the **Scenarios** component of **inSite_05**.

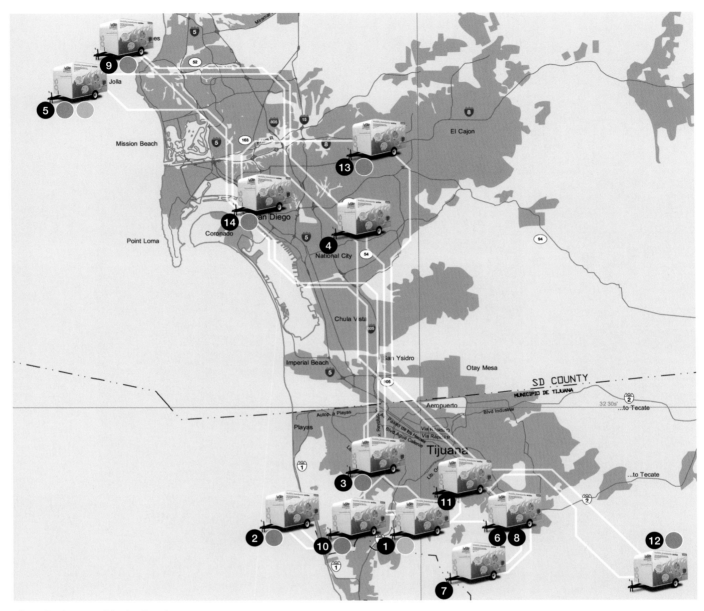

Symbology> Simbología

● Location> Sitio 🚚 *Mobile Archive* visit> Visita del *Archivo móvil* ● Video screenings> Proyecciones de video ● Exhibits> Exhibiciones

Activities Schedule> Calendario de actividades

No.	Activ.	Location> Sitio	Date> Fecha	Time> Hora	Videos/ Events> Eventos
1	🚚	**TJ/** CECUT, Av. Paseo de los Héroes, (664) 684-0095 **www.cecut.gob.mx**	Aug> Ago 27–28	11 a.m.–5 p.m.	
2	🚚 ●	**TJ/** Univ. Iberoamericana, Biblioteca Loyola. Archivo de José Saldaña, Av. Centro Universitario 2501, Playas de Tijuana, (664) 630-1577 **www.loyola.tij.uia.mx**	Aug> Ago 31 Sep 1–2	12 p.m.–5 p.m. 12 p.m.–5 p.m.	Sep. 1, 5:00–6:30 p.m. (Auditorium) *Frontera entre India y Paquistán, Una temporada afuera>* Border Between India and Pakistan, A Season Outside by> por Amar Kanwar/ *Frontera Sur Sampler.*

No.	Activ.	Location> Sitio	Date> Fecha	Time> Hora	Videos/ Events> Eventos
3		SD/ San Diego Public Library - San Ysidro Branch, 101 W San Ysidro Blvd., (619) 424-0475 www.sandiego.gov/public-library	Sep 7 Sep 8–9	3–8 p.m. 12–5 p.m.	Fanzine-Workshop> Fanzine-Taller Sep. 7, 6 p.m. Presented by> Presentado por: Roberto Partida, *Bulbo Press* (Tijuana) and> y *Grrrl Zines A-Go-Go* (San Diego). Screening of> Proyección de *Letras al margen* (Bulbo TV).
4		SD/ Malcolm X Library & Performing Arts Center, 5148 Market Street, (619) 527-340 www.sandiego.gov/public-library	Sep 15–17	12–5 p.m.	Sep. 16, 3 p.m.–5:30 p.m. Public Library Downtown (820 E St., (619) 236-5800). *Escuela: a documentary* by> por Hannah Weyer and> y *Going the Distance* by> por The Media Arts Center San Diego's Teen Producers Project. Presented by> Presentado por: Robert Bodle and> y Teen Producers.
5		SD/ Athenaeum Music & Arts Library, La Jolla, 1008 Wall Street, (858) 454-5872 www.ljathenaeum.org	Sep 23 Sep 24	6–9 p.m. 12–5 p.m.	Reception of the exhibition> Recepción de la exhibición, Sep. 23, 6:30–8:30 p.m. Filmscreening> Proyección, Sep. 24, 6:30–8:00 p.m. Videos and presentation by> Videos y presentación por: Bulbo TV and> y Media Arts Center San Diego's Teen Producers Project.
6		TJ/ Centro Madre Asunta para Mujeres Migrantes. (Closed to the public> Cerrado al público)	Sep 30	12–5 p.m.	
7		TJ/ Centro de Información para Trabajadoras y Trabajadores (CITTAC), (664) 622-4269, (619) 216-0095 www.cittac.org	Oct 1	12–5 p.m.	2 p.m. Tijuana Maquiladora Workers' Network Meeting> Reunión de la Red de Trabajadoras y Trabajadores de la Maquila en Tijuana. [organized by> organizado por: CITTAC].
8		TJ/ Centro Madre Asunta para Mujeres Migrantes. (Closed to the public> Cerrado al público)	Oct 2	12–5 p.m.	
9		SD/ University of California, San Diego library walk, 9500 Gilman Drive, La Jolla, co-sponsored by> co-patrocinado por: the Visual Arts Department www.ucsd.edu	Oct 5–6	11 a.m.–4 p.m.	Oct. 6, 6 p.m.–7:30 p.m. (Visual Arts Facility). *Performing the border* by> por Ursula Biemann and> y *Frontera entre India y Paquistán, Una temporada afuera> Border Between India and Pakistan, A Season Outside* by> por Amar Kanwar. Presented by> Presentado por: Mike Davis and> y Norma Iglesias.
10		TJ/ Casa de la Cultura en Tijuana en Altamira. Archivo Histórico de Tijuana, Av. París y Lisboa 5, (664) 687-2604	Oct 13–15	12–5 p.m.	Oct. 14, 6 p.m. Videos and presentation by> Videos y presentación por: Bulbo TV and> y Media Arts Center San Diego's Teen Producers Project.
11		TJ/ Instituto de Cultura Baja California, Av. Centenario 10151, Zona Rio	Oct 20–22	11 a.m.–4 p.m.	
12		TJ/ Maclovio Rojas, Aguas Calientes Community Center, Unión de Posesionarios del Poblado Maclovio Rojas Márquez, Asociación Civil. Edificio Aguas Calientes, carretera libre Tijuana-Tecate Km 29.5, Delegación La Presa, (664) 698-1939	Oct 29–30	3–8 p.m.	Oct. 29, 6 p.m. (Poblado Viejo community center). Videos and presentation by> Videos y presentación por: Bulbo TV and> y Media Arts Center San Diego's Teen Producers Project.
13		SD/ San Diego State University, Open Air Theatre Walkway, 5500 Campanile Drive, (619) 594-6791, co-sponsored by> co-patrocinado por: the Center for Latin American Studies www.sdsu.edu	Nov 2–4	11 a.m.–4 p.m.	Nov. 3, 5 p.m.–6:30 p.m. (SDSU Little Theatre). *Border visions = Visiones fronterizas* (2002) by> por Evangeline Griego and> y *Perra vida* by> por Bulbo TV. Presented by> Presentado por: Paul Ganster and> y Amelia Simpson.
14		SD/ Centro Cultural de la Raza, 2125 Park Blvd., (619) 235-6135 www.centroraza.com	Nov 11–13	12–4 p.m.	Nov. 13, 1 p.m. *Everyone their Grain of Sand* by> por Beth Bird. Presented by> Presentado por: Beth Bird, Fred Lonidier.

Exhibits> Exhibiciones

No.	Activ.	Location> Sitio	Dates/Hours> Fechas/Horarios
1		Questions of environmental issues> Cuestiones de temas ambientales • Migration and human rights> Migración y derechos humanos • Identity, gender issues, and women's rights> Identidad, género y derechos de las mujeres TJ/ CECUT, Av. Paseo de los Héroes, (664) 684-0095 www.cecut.gob.mx	Aug> Ago 27–Nov 13 Mon–Sun> Lun–Dom 9 a.m.–7 p.m.
5		Questions of labor in relation to globalization> Cuestiones laborales relacionadas con la globalización • Youth and counter cultures> La juventud y las contraculturas SD/ Athenaeum Music & Arts Library, La Jolla, 1008 Wall Street, (858) 454-5872 www.ljathenaeum.org	Sep 24–Nov 13 Tues–Sat> Mar–Sab 10 a.m.–5:30 p.m. Wed> Mier 10 a.m.–8:30 p.m.

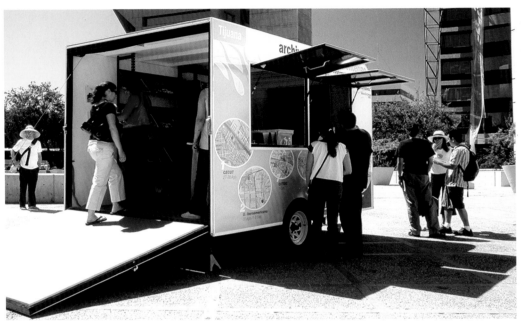

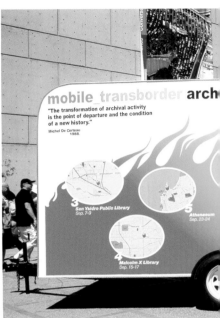

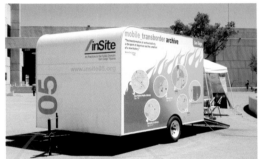

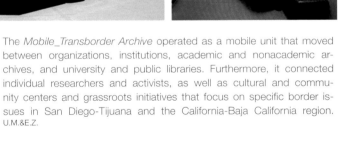

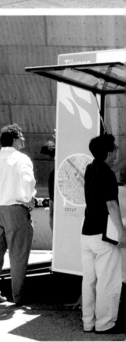

The *Mobile_Transborder Archive* operated as a mobile unit that moved between organizations, institutions, academic and nonacademic archives, and university and public libraries. Furthermore, it connected individual researchers and activists, as well as cultural and community centers and grassroots initiatives that focus on specific border issues in San Diego-Tijuana and the California-Baja California region. U.M.&E.Z.

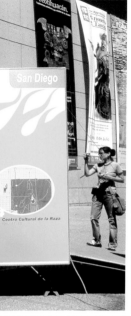

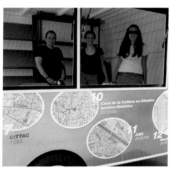

- What is an archive and how are the histories of archives determined?
- How are archives related to memory and the production of history and knowledge and their hegemonic power?
- What is archived by whom and for whom?
- Who is speaking and who is addressed?
- Who "owns" what material and who has access to the archive?
- What is archived on each side of the border?

- ¿Qué es un archivo y cómo son determinadas las historias de los archivos?
- ¿Cómo se relacionan los archivos con la memoria, con la producción de historia y de conocimiento, y con sus poderes hegemónicos?
- ¿Qué es archivado, por quién y para quién?
- ¿Quién es quien habla y a quién se está dirigiendo?
- ¿Quién detenta el material de archivo y quién tiene acceso a él?
- ¿Qué se archiva a cada lado de la frontera, en lados distintos de un mismo borde?

Transborder Archive Exhibit/
Centro Cultural Tijuana, Tijuana

• CUESTIONES SOBRE TEMAS AMBIENTALES
• CUESTIONES SOBRE MIGRACIÓN Y DERECHOS HUMANOS
• CUESTIONES SOBRE IDENTIDAD, GÉNERO
Y DERECHOS DE LAS MUJERES
• TOPICS ABOUT ENVIRONMENTAL ISSUES
• TOPICS ABOUT MIGRATION AND HUMAN RIGHTS
• TOPICS ABOUT IDENTITY, GENDER ISSUES
AND WOMEN'S RIGHTS

The *Mobile_Transborder Archive* sought to link numerous private and public archive collections throughout the area. It brought together a diverse array of materials selected from a rich spectrum of possible topics generated by the border region. Topics like labor, environmental issues, migration and human rights, questions of identity and women's rights, and youth culture provided an interesting point of departure.

As the *Mobile_Transborder Archive*'s mobile station traversed San Diego-Tijuana, temporarily stopping at diverse locations throughout the area, archive material that had hitherto been stored in personal collections or in libraries and institutions was temporarily brought out into the open for individuals to access and engage with. The *Mobile_Transborder Archive* also included an exhibit that was jointly held at the Athenaeum Music & Arts Library and the Centro Cultural Tijuana and brought varied archival material together and into dialogue.

Transborder Archive Exhibit/
Athenaeum Music & Arts Library, La Jolla

• CUESTIONES LABORALES RELACIONADAS
CON LA GLOBALIZACIÓN
• CUESTIONES SOBRE LA JUVENTUD
Y LAS CONTRACULTURAS
• TOPICS ABOUT LABOR IN RELATION TO GLOBALIZATION
• TOPICS ABOUT YOUTH AND COUNTER CULTURES

El *Archivo móvil_transfronterizo* se propuso conectar numerosas instituciones privadas y públicas, así como individuos, de la región que trabajan archivos sobre el área. El proyecto reunió un rico espectro sobre tópicos de interés para el área, como políticas laborales, medio ambiente, migración, derechos humanos y problemas de género e identidad y derecho de las mujeres; así como cultura juvenil. Estos temas constituyeron un punto de partida muy útil para cuestionar las funciones del archivo.

El *Archivo móvil_transfronterizo* contó con una unidad móvil que atravesó el área Tijuana San Diego, haciendo paradas temporales en diversas locaciones, a fin de hacer accesible material de archivo perteneciente a entidades privadas, a individuos y a insituciones públicas; para la consulta abierta de los usuarios ocasionales. Además de aquellos materiales disponibles en la unidad móvil, se exhibieron materiales provenientes de colecciones públicas y privadas de la zona, tanto en el Athenaeum Music & Arts Library, de La Jolla (del 24 de septiembre al 13 de noviembre), como en el Centro Cultural Tijuana (del 27 de agosto al 13 de noviembre).

 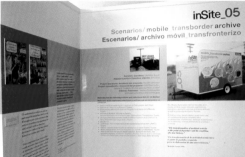

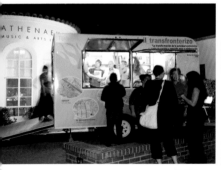

Intending to challenge the Internet's capacities for connectivity, expansiveness, and sustainability, and to utilize it as a platform for the construction of public domain, we decided to invite a curator to commission a group of artists to create projects online.

The curatorial framework for **inSite_05** sought to stimulate experiences that would constitute "public" as a live (political) action, and not the other way around. In other words, we were not aiming to characterize "public" as an audience that incarnates political discourse. This in and of itself did not pose a challenge, and could not be regarded as a particularly effective strategy of social change. We were convinced that the vitality of the public domain lay in the capacity/will of its members/players to transform their daily experiences of friction-alliance-dissent into a sense of belonging. An online project commissioned under these premises should have avoided framing the Internet as a platform for the representation of authored ideological discourses, and instead utilize it to provide unaccustomed ways of building new models of association. It was from that starting point that **inSite_05** took on the cultural challenge of the project. O.S.

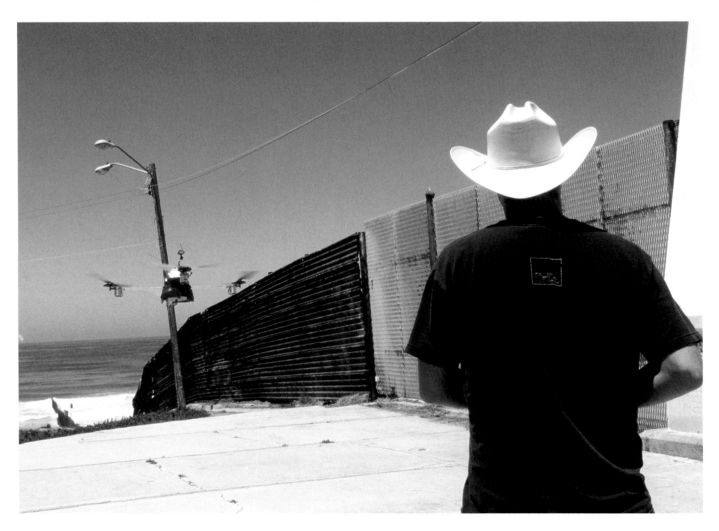

Online Project/ **Tijuana Calling***

Artists/ Ricardo Domínguez & Coco Fusco • Anne-Marie Schleiner & Luis Hernández • Fran Ilich •
Ángel Nevarez & Alex Rivera • Ricardo Miranda Zúñiga/ **Curator/** Mark Tribe

Llamando Tijuana es una muestra en línea de cinco proyectos por encargo que utilizan la Internet para explorar diversos rasgos característicos de la región fronteriza de Tijuana San Diego, entre los que se incluyen el turismo cultural, la odontología de la frontera, los narco-túneles transfronterizos, los murmullos generados por la acechanza de los "vigilantes" y el entusiasmo periodístico que rodea a la delincuencia fronteriza. A semejanza de las **Intervenciones de inSite_05**, estos proyectos surgieron de un largo proceso de estudio e investigación, y aun cuando los cinco existen en línea, adoptan un amplio espectro de estrategias artísticas, mismas que van desde juegos hasta literatura táctica. Como extensión del portal de **inSite_05**, *Llamando Tijuana* los documenta y se vincula a ellos, aunque éstos —en sí mismos— ocurren en diversos sitios de la red. Mark Tribe/ Texto curatorial

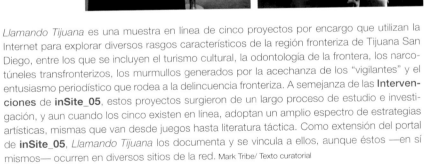

http://www.insite05.org

Click on *Tijuana Calling* at the bottom of the main page> Haga click en *Llamando Tijuana* al pie de la página principal

* The title of this curatorial project is taken from the lyrics of *Tijuana for Dummies*, a track by Hiperboreal on *Tijuana Sessions, Vol. 1* by the Nortec Collective> El título de este proyecto procede de la letra de *Tijuana for Dummies*, una canción de Hiperboreal en *Tijuana Sessions, Vol. 1* del Colectivo Nortec

→ Otras traducciones/ pp. 410–411

TIJUANA CALLING
Mark Tribe/ Curator

Tijuana Calling is an online exhibition of five commissioned projects that makes use of the Internet to explore various features of the San Diego-Tijuana border region, including cultural tourism, the symptomatic economy of border dentistry, transborder narco-tunnels, vigilante surveillance drones, and the journalistic hype surrounding border crime. Like **inSite_05**'s **Interventions** these projects grew out of a lengthy process of research and investigation. Although all five projects exist online, they adopt a wide range of artistic strategies, from game play to tactical literature. As part the **inSite_05** website, *Tijuana Calling* documents and links to these projects, but the projects themselves exist elsewhere on the Internet.

Artists first began experimenting with the Internet in the mid-1990s, when the first Web browsers became available to the public. Net artists, as they called themselves, saw the Web not as a way to publish their portfolios online but as a space for art making. Although Net art may be over as an art movement, artists continue to work online in ever greater numbers. For these artists, the Internet is a medium and a platform, a set of tools, and a distribution channel through which they can gain direct access to a global art audience, without the assistance of art world institutions. Equally important, it can enable artists to reach audiences that rarely set foot in galleries, museums, or performance spaces.

One of my main goals in organizing *Tijuana Calling* was to support projects that have the potential to reach beyond the art world and into an online equivalent of what has been called the public sphere. If the public sphere is a place where politics happens, then I looked for projects that transform this sphere, if only temporarily, into a place where art happens.

Mark Tribe *is an artist and a curator currently serving as assistant professor of Modern Culture and Media at Brown University. He is based in New York. Tribe served as curator of* Tijuana Calling*, a project commissioned for the* **Scenarios** *component of* **inSite_05***.*

Corridos/ An oral form of communication, deeply rooted in Mexican culture, perfected during the revolution (1910), when the media was co-opted by the government, as an open source, peer–to–peer, efficient way of disseminating news from afar, mainly great battles and heroic gestures. In recent decades, this form has been retaken to sing about famous narco (drug) traffickers and big trafficking operations. Narco-corrido songs tell the sometimes sad, cynical, and romantized adventures of narco traffickers who take great risks to deliver drugs across the Mexican-US border, over a polka or waltz beat in the background. In keeping with the folklore of illegality of the Norteño frontier, in older narco-corridos, words for drugs and weapons were codified—heroin is a *chiva* (goat), marijuana is *gallo* (rooster), cocaine is *perico* (parrot), unlike the more obvious and crude terminology of more recent corridos. Corridos are usually commissioned to Norteño musicians by the traffickers themselves, who like to hear songs about their exploits, beginning at 500 USD and going up. A.S.&L.H./ Extract from their website

Corridos/
Anne-Marie Schleiner & Luis Hernández

http://ungravity.org/corridos

Tj Cybercholos/ (a project of tactical literature>
un proyecto de literatura táctica)/ Fran Ilich

http://delete.tv/loscybercholos

Dentimundo/ El Progreso, Ojinaga, Juarez, Nogales, Mexicali, and Tijuana are all Mexican towns or cities that sit on the edge of the United States. These are border sites that have established a direct symbiotic relationship with the US economy by providing a variety of services to US citizenry and attracting US dollars. One may easily imagine the multitude of bars, food establishments, and the sale of cheap goods that can be found along many borders, but firmly embedded within the entertainment and consumer economy is a hi-tech, knowledge-intensive medical service that subsidizes the United States' health care system. Dentist clinics are as prominent as three-for-a-dollar tacos, margarita specials, and Mexican ponchos.

According to a dentist in Ojinaga (forty miles south of Marfa, Texas), 90 percent of his clients are US citizens. Dr. Ubaldo Eliaz Paez moved from Chihuahua, a metropolitan city in Mexico, to establish a clinic in a tiny border town. This clinic prospers due to US mouths and dollars. Tijuana alone houses approximately 3,500 dentists and is popularly considered a dentist capital of the world. Dr. Felipe Alvarez Olloqui is from Mexicali. He studied in Mexico City and then set up his practice in Tijuana where he and his wife treat patients from as far as Texas, Las Vegas, San Francisco, and Los Angeles. Seventy to 80 percent of his patients are US citizens. Throughout the border there is a parallel flow of migrants seeking prosperity, some economic and lifelong in the United States, others for dental hygiene in Mexico.

What deficits in the US health system are causing this outflow to Mexico? How do the dentists on each side of the border view one another? Where do US citizens prefer to have their teeth cleaned and why? These are just a few of the questions that come to mind when considering the immense quantity of Mexican dentists along the Mexico-United States border.

Dentimundo.com is a multimedia documentary of this micro-economy between the US and Mexico that investigates border dentistry while also presenting users with a directory of dentist clinics along the border.
R.M.Z./ Introduction to website

DENTIMUNDO
Dentistas en la Frontera / Dentists on the Border
Mexico / U.S.A.

translation
traducción

They come from the entire United States to Mexico looking for high quality, inexpensive dental service.

Dentimundo/
Dentists on the Border Mexico/USA/ Dentistas en la Frontera
Ricardo Miranda Zúñiga with> con Kurt Olmstead & Brooke Singer
http://www.dentimundo.com

Turista fronterizo/

Ricardo Domínguez & Coco Fusco

http://www.turistafronterizo.net

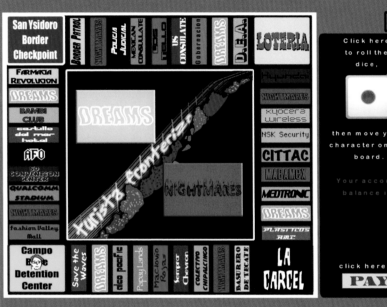

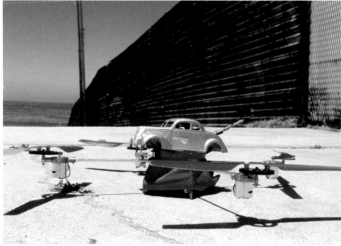

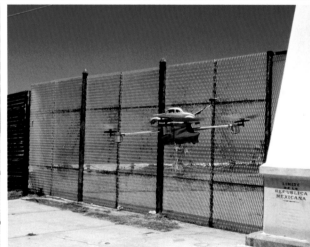

Friday October 21> viernes 21 de octubre

5:00 – 7:00 p.m. Scenarios: *Tijuana Calling*, a presentation of online projects. Hosted by CRCA at the Calit2 auditorium, University of California, San Diego> Escenarios: *Llamando Tijuana*, presentación de proyectos en red. Presentado por CRCA en el auditorio Calit2, University of California, San Diego.

Online
Presentations

Saturday October 22> sábado 22 de octubre

4:00 p.m., Scenarios: *Tijuana Calling*, a presentation of online projects. Tijuana > Escenarios: *Llamando Tijuana*, presentación de proyectos en red. Tijuana. In collaboration with> En colaboración con: Instituto de Cultura de Baja California, Tijuana.

LowDrone/
Ángel Nevarez & Alex Rivera
http://www.lowdrone.com

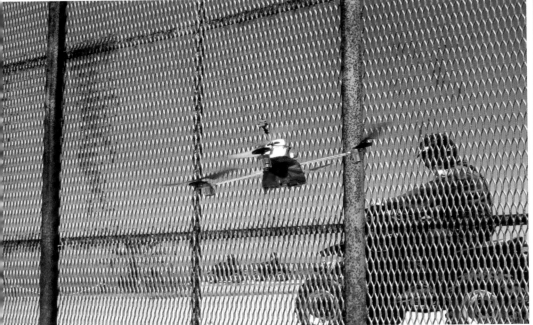

The dense network of sensorial indices—visual and auditory—that pollute, anesthetize, and redefine social space today has not only provided new practices of knowledge, but has also introduced us to more complex visual and literary narratives during the last decade. The decision to commission *Ellipsis* responded to an interest in experimenting with temporary models of social adhesion. We sought to provoke situations involving distinct modalities of time, evolving languages, and identities in flux that could be brought into collision in the intersection between the "spectacle" and the "gathering."

The specificity of the Caliente Racetrack (the ex-Hipódromo, Tijuana's former racetrack and current gambling center) located within a highly politically charged and visually intense context became the backdrop to this "event." *Ellipsis* raised questions about the use of sound and image to create a random/improvised model of interaction that would also stimulate critical awareness and/or challenge prevailing models of group belonging. o.s.

Every image is surrounded by an atmosphere of world.

Sartre

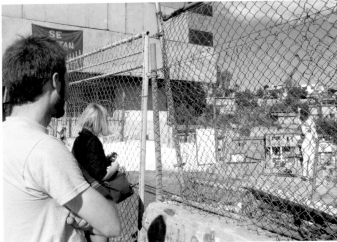

ELLIPSIS
Hans Fjellestad/ Curator

There are as many worlds as there are images, and each visual and sound image is a passage between. It is this movement that defines an image over time and destabilizes notions of physical and institutional space. Improvised processes and open-form structures are at the heart of this movement where real-time analysis, intuition, instinct, and action are situated within a specific cultural context that combines to construct an emergent public space.

Ellipsis approaches its image-producing technology not as a tool but as a constructed environment where the participants interact. In this way, our technology is considered additive in nature rather than subtractive or competitive. The medium is not merely the conduit for discourse. It possesses a discrete identity of its own, a personality that may offer up some resistance, echoing organic systems that behave unpredictably, that kick and scream, and will not go gently under the artist's control. In short: an environment that is alive. >

→ Otras traducciones/ pp. 411–412

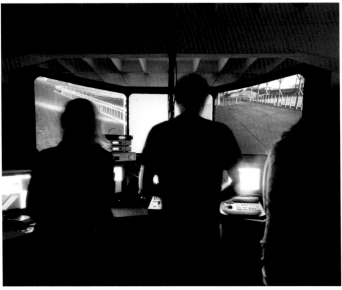

We are made of compacted water,
earth, light and air…
The eye binds light, it is itself bound light…
This binding is a reproductive synthesis,
a Habitus. James Flint (by way of Gilles Deleuze)

> This new synthesis, which might appropriate Pierre Bourdieu's concept of habitus, is defined and populated by a fluid world of details that hints at both the limitlessness of potential choices and the lack of possibilities in reality, the push and pull of capital within a complex social system. This concept of habitus recognizes that there are limitless options for action that an individual would never hit upon, and therefore those options do not really exist as possibilities. In common social situations, a person relies upon an established store of knowledge, scripts and patterns, which present that person with a very specific picture of the world and how to behave within it.

So it becomes difficult to imagine a useful dialogic space within the context of a spectacular performance event. Spectacle can seem the opposite of dialog; defining itself according to its own methodology and subsequently monopolizing the space it inhabits, it forces the spectator into a passive, slavish posture. Even with direct input from the spectator ("Cast your vote!") the spectacle simply reconstitutes itself, cannibalizing the input, feeding back into the system, only to spit it out as the same product repackaged.

Visual, aural, human, machine, artist, performer, spectator: it is essential that no single component dominate the space if we are to challenge, or possibly even transcend, familiar modes of cultural transaction within the spectacle.

Performance art works generally share the same consumerism logic as more openly commercial producers such as MTV or CNN. That is, consumption (or "investigation") itself is the goal. Propaganda, information, entertainment, art: sites of struggle for domination. A reification of pre-existing value systems that privilege appearance over essence, mediated experience over direct experience, the spectacle valorizes the means of production as an end unto itself, an investigation inside of a prearranged

tain amount of unpredictability, or risk, must be programmed into the system so that improvisation is utilized, even necessary, to maneuver within it. This not only makes it more difficult for the dominant social hierarchy to reassert itself, but also promotes a kind of creative tension, a survival instinct, that might uncover unexpected and meaningful narratives. A question of life or death, which Deleuze describes as a distance "proportionate to the extent to which the characters know that all hangs on very small differences in behavior. Thus one moves from the 'behavior' to the 'situation' in such a way that, from the one to the other, there was the possibility of a 'creative interpretation of reality.'"

The artist participants came together to interpret this new "reality" through a custom cinematic and sonic language comprising individual and collaborative image "statements." This vocabulary pool, or lexicon, was made available to the collective, and the resulting "statements" were combined to construct an argument that might justify (or not) the existence of the image worlds generated by the spectacle, with each performer taking responsibility for his or her contribution to this evolving argument.

During a series of residencies in San Diego and Tijuana, participating artists Iván Díaz, Liisa Lounila, Damon Holzborn, and Magaly Ponce collected materials and composed a score that functioned as both a conceptual and a methodological framework for a ninety-minute performance work. The score was not fixed in any traditional sense, but left open-ended with certain reference points for the artists to adapt to over time. In this way, recital formality was replaced by the collective sculpting of a shared narrative, the formation and building of a community. Consider the process, the production as a whole, as one narrative arch, a cohesive experience rather than a cellular accumulation of fractured signifiers.

Careful thought was given to the venue itself, the Agua Caliente Greyhound Racetrack in Tijuana, a cultural focal point since the days of >

and preapproved social laboratory as both the methodology and the goal. This situation can easily be misrecognized as something rooted in atemporal or natural truth, value, or necessity—characteristics that are then attributed back to the dominant structures of interpretation and evaluation within the institution, thus perpetuating the cycle and reasserting its centralized information network.

To create a more interesting and meaningful public space, it is useful to break away from these behaviors as much as is possible by proposing a distributed information system that allows for a less passive stance on the part of all participants—performer, audience, environment. A cer-

> Prohibition. As Tijuana-based artist and *Ellipsis* participant Iván Díaz noted: "Considering the symbolic weight of the Caliente Racetrack, images of Tijuana's dark, legendary past inevitably come to my mind. So do the political associations that can change the fate of a city that experiences both the advantages and the disadvantages of its immersion in the dynamics of global exchange." Díaz often utilized socially charged iconographic imagery to explore "games involving the oppressor and the oppressed" and viewed this project, in part, as "a political experiment that seeks inclusive practices in a context where different interests exist, derived from different cultural backgrounds, negotiated to final decisions applied to a space."

Helsinki video artist Liisa Lounila became interested in displacing the temporality inherent in the repetitive patterns of dog racing itself, but also commenting on "how much passion such an identically repeated activity seems to raise in people watching it, having their money and hopes tied to these dogs running the same circle over and over again." Lounila stretched out frame-by-frame visual moments to expose in-between patterns. She composited haunting, real-time images of spectator participants with images of the same locations captured on other days, and juxtaposed these with loops of the racing greyhounds, emphasizing the beauty and futility of certain repetitive human social behaviors.

New York sound artist Damon Holzborn sculpts dense layers of sound, working with programmatic and abstract materials that are unfolded and processed in real time. The soundtrack for *Ellipsis* was projected and spatialized through a surround sound system that enabled Holzborn to move his independent sound channels around the performance space. In addition to speakers, microphones were placed in strategic locations to give the space several pairs of ears, which fed spontaneous input into the system. Similar to Lounila's visual time-displacement techniques, Holzborn explains that he "can extract long durations out of small musical moments, pulling at a sound to discover unexpected textures inside of it. The sounds would harmonize with the space and the visuals, and then be in conflict, and then become insulated and detached, with a mobility of meaning as flexible as the sounds themselves. And always buried in the mix are clues and connections to the original, organic process of collecting source sounds and field recordings linked conceptually and uniquely to this project."

Chilean-born video artist Magaly Ponce extended her thematic material by using advanced GPS technology to track a street dog ranging outside in the city, taking on a decidedly larger set of socio-political considerations: "Digital media, like racing tracks, emulate our mnemonic processes by tracking, compiling, storing, and utilizing data. Data used to monitor consumer behavior creates an abstract imprint of life, expanding our visualization of the world. Data patterns allow the reading of the masses and facilitate the formation and transformation of control systems that predict social trajectories. The more efficient the tracking is, the more predictable our participation will become. The need for efficiency on the track defines the breeding and training of the racing dog whose form is optimized for its function. Here, time actually is money and speed the obsession that realizes this goal. In contrast, the arbitrary trajectories of the street dog, a genetic mutation optimized for survival, not for speed, is the embodiment of chaos. The dog's unique appearance belies packaging, becoming an anti-consumerist symbol. Their unpredictable behavior sabotages notions of an idyllic life and threatens tourism and human health.

Street dogs paradoxically reflect the most visceral and basic aspects of reality."

Hans Fjellestad *is a musician and filmmaker currently based in Los Angeles. He was curator of* Ellipsis, *a project commissioned for the* **Scenarios** *component of* **inSite_05**.

Clearly, the racetrack provided its own framework for these various image statements. Upon entering the space, one may become aware of a kind of subtextual "musical score" or "screenplay" already in place—a meta-score that contains bits of information, social transactions, epistemologies, and meanings already orbiting the geographical site of our spectacle. This meta-score is a constantly evolving map incarnated within a specific slice of time/space that each artist was keen to tap into and explore on both a personal level as well as through a push and pull of collective negotiations. *Ellipsis*, as a large-scale collaborative experiment, was cast as interpreter, facilitator, and actor—intervening and participating within the larger collective narrative. Perhaps something like a performance art equivalent of Heisenberg's "uncertainty principle" in the sense that it is impossible to precisely define the position or momentum of any single event in our meta-score at the same time, so that our narrative's trajectory, or meaning, is more precisely defined in hindsight and according to the observer's point of reference.

The San Diego-Tijuana borderlands constitute a complex region of interactions with multiple sociological loci. Movement and flow define the image of the transborder corridor. This elliptical, double-centered urban space, like no other location, surrenders itself to this dance of indices with athletic mobility and convertibility of opposed distant situations. *Ellipsis* sought to inhabit this in-between world, linking temporal optical/sound images and space to create a temporary circuit, and produce a creative tension that gave the event momentary life.

Photo Project for Ellipsis/ Alfredo De Stéfano

Traducciones
al español/ Escenarios/ Por proyecto

Este proyecto analiza el concepto de archivo y sus mecanismos de representación, e implica la participación de diversas esferas públicas en la elaboración de un discurso respecto a quién crea un archivo, de qué elementos está conformado y sobre cuáles premisas se establece. Lo anterior conduce a realizar un examen crítico acerca de la noción de archivo como tal, y un entramado tan compacto como el de la región fronteriza de Tijuana San Diego resulta particularmente adecuado para llevar a cabo una reflexión de este tipo.

El *Archivo móvil_transfronterizo* opera como una unidad itinerante que se desplaza entre organizaciones, instituciones, archivos, y bibliotecas universitarias y públicas, ubicadas en San Diego y Tijuana. Por medio de un acercamiento transdisciplinario, dicho proyecto busca enlazar a investigadores y activistas, centros culturales y comunitarios, así como a aquellas iniciativas que tienen arraigo y que se enfocan en temas fronterizos específicos de las regiones de Tijuana San Diego y Baja California California. El *móvil_transfronterizo* permitirá el acceso a textos, libros, fotografías, películas, videos, historias orales e información en línea referentes a esta región específica y a los archivos en sí. A lo largo de sus desplazamientos, el *Archivo móvil_transfronterizo* ofrecerá un espacio para celebrar una serie de eventos, debates y exhibiciones fílmicas, todo ello dirigido a públicos diversos.

En conjunto con la unidad móvil se exhibirán materiales provenientes de colecciones públicas y privadas de la zona, tanto en el Athenaeum Music & Arts Library, de La Jolla —una de las instituciones culturales más antiguas de San Diego y también una de las 16 bibliotecas de Estados Unidos que aún conservan su nómina de asociados—, como en el Centro Cultural Tijuana, la mayor institución cultural de dicha ciudad. La selección de materiales expuestos se realizó a partir de una amplia gama de posibles temas y documentos generados en esta región fronteriza, donde las cuestiones laborales, ambientales, de migración y derechos humanos, de género y derechos de las mujeres, así como de cultura para la juventud ofrecen un buen punto de partida para llevar a cabo tal empresa.

Este proyecto tiene el propósito de vincular diversos archivos y colecciones y dar a conocer tanto su existencia como la labor desarrollada durante años de investigación entre un público más amplio a ambos lados de la frontera y también entre los visitantes extranjeros que asistan a **inSite_05**. Como estudio de caso, el *Archivo móvil_transfronterizo* podría trasladarse a otras zonas de la línea divisoria binacional, con objeto de hacer visibles las similitudes estructurales y las diferencias específicas de regiones semejantes y de permitir futuros debates sobre los mecanismos de la representación archivística.

Ute Meta Bauer *es curadora y actualmente directora del Visual Arts Program en el Departamento de Arquitectura de MIT. Bauer vive entre Cambridge, Massachusetts y Berlín./* **Elke Zobl** *es una investigadora actualmente radicada en Salzburgo. Bauer junto a Zobl curó* Archivo Móvil_Transfronterizo.

El *Archivo móvil_transfronterizo* operó a partir de una unidad móvil en circulación entre organizaciones, instituciones, archivos académicos y no académicos, y entre bibliotecas públicas y universitarias. Además, el archivo conectó a investigadores y activistas, así como a centros comunitarios y espacios culturales, diseminando iniciativas enfocadas en tópicos específicos del área de Tijuana y San Diego, pero también de la región de Baja California y California.

U.M.&E.Z.

Escenarios/

Proyecto de archivo/ *Archivo móvil_transfronterizo*/ Curadora: Ute Meta Bauer
Proyecto en red/ *Llamando Tijuana*/ Curador: Mark Tribe
Evento de imágenes visuales y sonoras en vivo/ *Elipsis*/ Curador: Hans Fjellestad

Escenarios reúne prácticas de dominio público que rebasan la localización espacial urbana y la concertación de públicos en torno a un sitio intervenido. Con un énfasis en las condicionantes de temporalidad y en la desobjetualización de sus soportes, estos tres proyectos agrupan prácticas menos establecidas que hoy son clave en la construcción de lo público, como un espacio de discurso en vivo.

Escenarios también refiere a procesos que parodian modelos cotidianos de consumo, circulación, exhibición y almacenaje de información cultural. Es sintomático que lenguajes y formatos de uso informático ordinario —como la Internet, el espectáculo y el índex— hayan estado nutriendo, desde el arte, nuevas inscripciones, más radicales, de *lo público*. **Escenarios** explicita un terreno emergente de prácticas culturales alternas, con nuevas jerarquías y exigencias. La vitalidad conceptual de estos proyectos depende de otros factores ajenos a las exigencias tradicionales para con el objeto artístico, tales como: la sofisticación lúdica de la experiencia compartida, la especificidad de la información que se oferta, la eficacia de la conectividad y la capacidad de *morphing* de las articulaciones a las que voluntariamente el participante se enlaza. **Escenarios** devela preguntas acerca del predominio de otras temporalidades, fijadas por la circularidad, velocidad y expansibilidad de las redes; un territorio de transgresión y contaminación desde otras prácticas de saber hoy definitorias del imaginario social.

Osvaldo Sánchez

Archivo móvil_transfronterizo

El proyecto de archivo surgió como la posibilidad de investigar en el área las redes existentes de circulación y almacenaje de información. La idea era cuestionar y transparentar las políticas institucionales que pautan los accesos y usos ulteriores de la memoria colectiva. Este proyecto de archivo, comisionado a Ute Meta Bauer en colaboración con Elke Zobl, más que absorber estas redes de memoria buscó confrontarlas a través de un reconocimiento mutuo entre instituciones e individuos, entre organizaciones sociales y archivos académicos, en Tijuana y en San Diego. Su objetivo era exponer el complejo entramado abierto, en perpetua construcción, que constituyen los discursos y las funciones cívicas, políticas, del archivo en la región. El *Archivo móvil_transfronterizo* se manifestó como una acción por encima de la barda, como una pregunta extendida en torno a ese otro tejido público que entendemos y ejercemos como saber, no sólo bajo la forma editada de memoria.

Osvaldo Sánchez

La frontera como un todo no es un objeto, una línea divisoria o un muro. Es un sistema de relaciones sociales. Mike Davis

Las fronteras dan forma a un escenario complejo y compacto, así como a múltiples zonas de transición, de contradicciones e intersecciones que incorporan la visibilidad de los cruces fronterizos, al igual que el desarrollo de identidades y diversidades culturales y transnacionales.

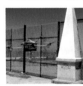

Llamando Tijuana

La invitación a un curador para comisionar a un grupo de artistas a desarrollar proyectos en línea proponía retar las capacidades de conectividad, expansividad y sustentabilidad de la Internet con el fin de implementar nuevas estrategias constitutivas del tejido público. **inSite_05**, desde su perspectiva curatorial, buscaba estimular experiencias constitutivas de *lo público*, como acción política —y nunca lo contrario. Es decir, el proyecto no buscaba personificar *lo público* como una audiencia que encarna discursos políticos. No creíamos que esto constituyera de por sí un reto, ni que siguiera siendo una estrategia articuladora socialmente eficaz. En el entendido de que la vitalidad de todo dominio público radica en la capacidad/voluntad de sus miembros/agentes para hacer de sus experiencias cotidianas de fricción-alianza-disensión una construcción de pertenencia. Y desde esa convicción —de evadir toda institucionalización y representación de lo político—, fue que pensamos en el poder de ciertas estrategias artísticas —también desde la operatividad de la red— para proveer vías desacostumbradas para la construcción de otros modelos de asociación. Era desde ahí que **inSite_05** asumió su reto cultural. La idea inicial de comisionar estos proyectos en línea precisamente buscaba esquivar la idea del espacio de la Internet como una superficie de representación y consumo de discursos ideológicos autorales.

Osvaldo Sánchez

Los artistas empezaron a experimentar con la Internet a mediados de los años 90, cuando los primeros navegadores comenzaron a estar al alcance del público. Los artistas de la red, como se llamaron a sí mismos, vieron la *web* no como un modo de publicar sus portafolios en línea, sino como un espacio para hacer arte. Aunque es probable que el Net Art haya dejado de existir como movimiento artístico, los artistas siguen trabajando en línea en números cada vez mayores. Para estos artistas, la Internet es un medio y una plataforma, una serie de herramientas y un canal de distribución a través del cual pueden tener acceso directo a un público global, sin la intermediación de las instituciones del mundo del arte. Igualmente importante es el hecho de que el arte ciberespacial puede permitir a los artistas llegar a públicos que rara vez ponen un pie en las galerías, los museos o los espacios de *performance*.

Uno de mis principales objetivos al organizar *Llamando Tijuana* fue promover proyectos que tuvieran el potencial suficiente para trascender el mundo del arte y llegar al equivalente en línea de lo que ahora se conoce como esfera pública. Si la esfera pública es un lugar donde la política ocurre yo estoy buscando proyectos que transformen esta esfera, aunque sólo sea temporalmente, en un lugar donde el arte suceda.

Mark Tribe/ Texto Curatorial

Corrido: Forma oral de comunicación profundamente enraizada en la cultura mexicana. Perfeccionado durante la Revolución, cuando los medios de comunicación estaban cooptados por el gobierno como un eficiente recurso de código abierto y de diseminación rizomática para contar noticias de lugares lejanos, especialmente de grandes batallas y gestas heroicas. En décadas recientes, esta forma ha sido retomada para cantar acerca de narcotraficantes famosos y grandes operaciones de contrabando. Los *narcocorridos* cuentan las a veces tristes, cínicas o romantizadas aventuras de narcotraficantes que toman grandes riesgos para contrabandear drogas a través de la frontera norte de México, con base rítmica de polka o vals y floriituras de acordeón. Siendo portadoras del folclor de la ilegalidad en la frontera, los *narcocorridos* más antiguos usaban muchas claves, sobre todo para designar las drogas y las maneras de decir las cosas de un modo no abierto. Últimamente el lenguaje comúnmente usado es mucho más directo y obvio. Estas canciones son normalmente comisionadas a los artistas norteños por los narcotraficantes mismos, a quienes les gusta oírse en tan populares canciones. Para que te hagan un *narcocorrido* puedes pagar 500 dólares o más, dependiendo.

A.S.&L.H./ Texto de su sitio *web*

El Progreso, Ojinaga, Juárez, Nogales, Mexicali y Tijuana son pueblos o ciudades mexicanos que se encuentran en el límite de los Estados Unidos. Son sitios fronterizos que han establecido una relación simbiótica con la economía de los Estados Unidos al proveer una variedad de servicios a la ciudadanía de aquel país y atraer dólares norteamericanos. Uno puede imaginar fácilmente la multitud de bares, establecimientos de comida y de venta de bienes baratos que pueden encontrarse a lo largo de muchas fronteras, pero firmemente arraigado en la economía del entretenimiento y el consumo hay un servicio médico de alta tecnología e investigación que subsidia el sistema de seguridad social de los Estados Unidos. Las clínicas odontológicas son tan prominentes como los tacos de "tres por un dólar", las margaritas especiales y los jorongos mexicanos.

De acuerdo con un dentista de Ojinaga (40 millas al sur de Marfa, Texas), 90 por ciento de sus clientes está conformado por ciudadanos de los Estados Unidos. El doctor Ubaldo Elias Páez se mudó de Chihuahua, una metrópoli mexicana, para establecer una clínica en un pueblito de la frontera. La prosperidad de esta clínica se debe a las bocas de los estadounidenses y a los dólares. Nada más Tijuana aloja a aproximadamente 3,500 dentistas y es conocida popularmente como una de las capitales odontológicas del mundo. El doctor Felipe Álvarez Olloqui es de Mexicali. Estudió en la ciudad de México y luego se estableció en Tijuana, donde él y su esposa atienden a pacientes de lugares tan retirados como Texas, Las Vegas, San Francisco y Los Ángeles. De un 70 a un 80 por ciento de sus pacientes está conformado por ciudadanos norteamericanos. A lo largo de la frontera hay un flujo paralelo de migrantes en busca de prosperidad: bienestar económico o mejores condiciones de vida a largo plazo hacia los Estados Unidos; otros, por higiene dental hacia México.

¿Qué déficit del sistema de salud de los EU está provocando este flujo hacia México? ¿Cómo se ven entre sí los dentistas de cada lado de la frontera? ¿Dónde prefieren los ciudadanos de EU limpiar sus dientes y por qué? Estas son apenas unas cuantas preguntas que vienen a cuento cuando se considera la gran cantidad de dentistas mexicanos que se encuentran a lo largo de la frontera México-Estados Unidos.

Dentimundo.com es un documental multimedia sobre esta microeconomía entre EU y México que investiga la odontología de la frontera, al mismo tiempo que le ofrece a los usuarios un directorio de clínicas odontológicas que se encuentran en la zona.

R.M.Z./ Introducción al sitio *web*

Elipsis

La densa red de indicadores sensoriales —visuales y auditivos— que polucionan, anestesian y también (re)definen hoy el espacio social, no sólo ha provisto de nuevas prácticas de conocimiento, sino que también ha complejizado las narrativas de la última década. Comisionar un proyecto como *Elipsis*, respondía al interés por experimentar modelos más laxos de adhesión circunstancial, dentro de situaciones inducidas de flujo de lenguajes, imaginarios, tiempos, y personas; y desde patrones ambiguos de convivencia *lounge* y "espectáculo". La especificidad del sitio elegido (el ex-Hipódromo, actual centro de apuestas Caliente) y el cargado peso político del contexto regional, en una ciudad de gran intensidad expresiva visual y con una fuerte escena popular de producción sonora, eran condiciones a tener en cuenta. *Elipsis* buscaba preguntas interesantes en torno a cómo intervenir con imágenes sonoras y visuales, desde un modelo aleatorio de roce; e incentivar desde sus simultaneidades discursivas alguna reflexión sobre otros modelos de pertenencia y cohesión.

Osvaldo Sánchez

Elipsis
Hans Fjellestad

Cada imagen está rodeada por una atmósfera de otros mundos. Sartre

Hay tantos mundos como imágenes, y cada imagen visual y sonora constituye un pasaje intermedio. Este movimiento define una imagen en el tiempo y desestabiliza nociones de espacio físico e institucional. Procesos improvisados y estructuras de forma abierta están en el centro de este movimiento, donde el análisis de tiempo real, la intuición, el instinto y la acción están situados dentro de un contexto cultural específico que se combina para construir un espacio público emergente.

Para *Elipsis* su tecnología de producción de imágenes no es una herramienta, sino un ambiente construido donde los participantes interactúan. De esta forma, nuestra tecnología se considera aditiva por naturaleza, en lugar de substractiva o competitiva. El medio no es solamente el conducto para el discurso. Posee una identidad discreta de suyo propio, una personalidad que puede ofrecer cierta resistencia, haciendo eco de sistemas orgánicos que se comportan de manera impredecible, que patean y que gritan, y no actuarán de manera sumisa a las órdenes del artista. En resumen: un ambiente vivo.

Estamos hechos de agua, de tierra, de aire y de luz, compactados[...] Los ojos atan la luz, son de hecho ataduras de luz[...]
Y esa atadura es una síntesis reproductiva, un Habitus[...]
James Flint (por medio de Gilles Deleuze)

Esta nueva síntesis, que podría apropiarse del concepto de Pierre Bordieu de *hábito*, está definida y poblada por un mundo fluido de detalles que apunta a un ilimitado potencial de opciones y a una falta de posibilidades en la realidad; el estira y afloja del capital dentro de un complejo sistema social. Este concepto de *hábito* reconoce que hay opciones ilimitadas para la acción que un individuo nunca encontrará, y por lo tanto esas opciones no existen realmente como posibilidades. En situaciones sociales comunes, una persona depende de una reserva establecida de conocimiento, guiones y patrones que enfrentan a esa persona a una imagen muy específica del mundo, y al dilema de cómo comportarse dentro de él.

Así se vuelve difícil imaginar un espacio dialógico útil en el contexto de un performance espectacular. El espectáculo puede parecer lo opuesto al diálogo; definido a sí mismo de acuerdo con su propia metodología y, en consecuencia, monopolizando el espacio que habita, éste obliga al espectador a asumir una posición pasiva, esclavizada. Aunque sea el espectador el que realice el gasto directo ("¡Emita su voto!"), el espectáculo se reconstituye a sí mismo, canibalizando el gasto, que retroalimenta al sistema tan sólo para que éste lo escupa en el momento en que el mismo producto se reempaca.

Visual, aural, humano, máquina, artista, performer, espectador: es esencial que un solo componente no domine el espacio si es que vamos a poner en tela de juicio, o inclusive a trascender, los modos familiares de transacción cultural dentro del espectáculo.

El arte del *performance* comparte en general la misma lógica de consumismo con productores más abiertamente comerciales, como MTV o CNN. Esto es, el consumo (o la "investigación") es la meta. Propaganda, información, entretenimiento, arte: arenas de lucha por la dominación. Una reificación de los sistemas de valor preexistentes que privilegian la apariencia sobre la esencia, la experiencia mediática sobre la experiencia directa. El espectáculo valora los medios de producción como un fin en sí mismo, una investigación dentro de un laboratorio social preordenado y preaprobado en cuanto metodología y objetivo. Esta situación puede fácilmente malinterpretarse como algo arraigado en una verdad, un valor

o características de necesidad atemporales o naturales que se atribuyen de nuevo a las estructuras dominantes de interpretación o evaluación dentro de la institución, perpetuando así el ciclo y reafirmando su red de información centralizada.

Para crear un espacio público más interesante y significativo, es útil romper con estas conductas tanto como sea posible, proponiendo un sistema de información que permita una estancia menos pasiva de parte de todos los participantes —ejecutante, público, entorno. Cierta cantidad de incertidumbre, o riesgo, debe programarse en el sistema, de modo que la improvisación se utilice, en caso de ser necesaria, para maniobrar con ella. Esto no sólo hace más difícil para la jerarquía social dominante reafirmarse a sí misma, sino que también promueve una suerte de tensión creativa, un instinto de supervivencia que puede desvelar narrativas inesperadas y significativas. Una cuestión de vida o muerte, que Deleuze define en términos de una distancia *proporcional a la medida en que los actores sepan que todo depende de diferencias muy pequeñas de comportamiento. Por lo tanto, uno se mueve del "comportamiento" a la "situación", de modo que, en el tránsito de lo uno a lo otro, se da la posibilidad de una "interpretación creativa de la realidad".*

Los artistas participantes se reunieron para interpretar esta nueva "realidad" por medio de un lenguaje cinemático y sonoro compuesto por "pronunciamientos" en imágenes individuales y colectivas. Este vocabulario base, o léxico, se puso al alcance de la colectividad, y los "pronunciamientos" resultantes se combinaron para construir un argumento que justificara (o no) la existencia de los mundos de imágenes generados por el espectáculo, con cada *performer* asumiendo la responsabilidad de su contribución a la evolución del argumento.

Durante una serie de residencias en Tijuana San Diego, los artistas participantes —Iván Díaz, Liisa Lounila, Damon Holzborn y Magaly Ponce— recabaron materiales y compusieron una partitura que funcionó como un marco conceptual y metodológico para la presentación de una obra de 90 minutos. La partitura no obedecía a ningún sentido tradicional, quedaba más bien abierta con ciertos puntos de referencia para que los artistas los adaptaran a su antojo. De esta forma, la formalidad del recital fue reemplazada por la escultura colectiva de una narrativa compartida, la formación y la edificación de una comunidad. Consideren el proceso, la producción como un todo, como un arco narrativo, una experiencia cohesiva más que una acumulación celular de significantes fracturados.

Se pensó cuidadosamente en el lugar, el galgódromo de Agua Caliente, en Tijuana, un punto cultural focal desde los días de la Prohibición. Como artista residente en Tijuana y participante de Elipsis, Iván Díaz anotó: *Considerando el peso simbólico de la pista de Agua Caliente, imágenes del pasado oscuro y legendario de Tijuana inevitablemente me vinieron a la mente. Lo mismo sucedió con las asociaciones políticas que pueden cambiar el destino de una ciudad que experimenta las ventajas y las desventajas de su inmersión en las dinámicas del intercambio global.* Díaz recurrió a una imaginería cargada de contenido social para explorar los *"juegos que involucran al opresor y al oprimido",* y entendió este proyecto, en parte, *como un experimento político que busca prácticas inclusivas en un contexto donde existan diferentes intereses, derivados de diferentes áreas culturales y acordados en discusiones finales con incidencia en el espacio.*

La video artista de Helsinki Liisa Lounila se interesó por desplazar la temporalidad inherente a los patrones repetitivos de la crianza de los perros, pero también reparando en *cuánta pasión parece despertar una actividad repetida idénticamente en la gente que la observa y que ha comprometido su dinero y sus esperanzas con estos perros, que recorren el mismo círculo una y otra vez.* Lounila extendió cuadro por cuadro momentos visuales para exponer patrones intermedios. Compuso imágenes perturbadoras en tiempo real de espectadores participantes, a partir de imágenes de las mismas locaciones tomadas en otros días, y yuxtapuso este material con giros de la carrera de los galgos, enfatizando la belleza y la futilidad de ciertos comportamientos sociales humanos repetitivos.

El artista sonoro de Nueva York Damon Holzborn esculpe densas capas de sonido, trabajando con materiales programáticos y abstractos que se despliegan y procesan en tiempo real. La banda sonora para *Elipsis* se proyectó y espacializó por medio de un sistema de sonido ambiente que le permitió a Holzborn mover sus canales independientes de sonido alrededor del espacio del *performance.* Además de las bocinas, los micrófonos fueron colocados en lugares estratégicos para darle al espacio varios pares de oídos, lo cual proveyó al sistema de entradas espontáneas. De modo similar a las técnicas visuales de desplazamiento temporal empleadas por Lounila, Holzborn explica que puede *extraer largas duraciones de pequeños momentos musicales, tirando de un sonido para descubrir texturas inesperadas dentro de él. Los sonidos serán armónicos con el espacio y los elementos visuales, luego entrarán en conflicto y luego se volverán aislados e independientes, con una movilidad de significado tan flexible como los sonidos mismos. Siempre enterradas en la mezcla hay claves y conexiones con el proceso original orgánico de recabar sonidos fuente y grabaciones de campo vinculadas en forma particular y conceptual con este proyecto.*

La video artista chilena Magaly Ponce amplió su material temático usando tecnología avanzada GPS para seguir el rastro de un perro callejero que deambulaba por las afueras de la ciudad, tomando en cuenta una serie definitivamente más amplia de consideraciones sociopolíticas: *Medios digitales, como las pistas de carreras, emulan nuestros procesos mnemónicos de búsqueda, compilación, almacenamiento y utilización de datos. Los datos empleados para monitorear el*

comportamiento de los consumidores crea una huella abstracta de vida, que expande nuestra visualización del mundo. Los patrones de datos permiten la lectura de las masas y facilitan la formación y la transformación de sistemas de control que predicen trayectorias sociales. Mientras más eficiente sea el seguimiento, más predecible se volverá nuestra participación. La necesidad de eficiencia en la pista define la crianza y el entrenamiento de los perros de carreras cuya forma se vuelve óptima en razón de su función. Aquí, el tiempo es dinero, y la velocidad la obsesión que permite realizar esta meta. En contraste, las trayectorias arbitrarias del perro callejero, una mutación genética diseñada para la supervivencia, no para la velocidad, son la encarnación del caos. La apariencia única del perro contradice el empaque, lo cual lo convierte en un símbolo del anticonsumidor. Su comportamiento impredecible sabotea las nociones de una vida idílica y amenaza el turismo y la salud humana. Los perros callejeros reflejan paradójicamente los aspectos más viscerales y básicos de la realidad.

Claramente, la pista de carreras constituye un marco en sí mismo para estos pronunciamientos de imagen diversos. Al entrar en el lugar, uno percibe una suerte de "partitura musical" subtextual o de "libreto" que ya ha tomado su lugar —una metapartitura que contiene pedazos de información, transacciones sociales, epistemologías y significados que orbitan el sitio geográfico de nuestro espectáculo. Esta metapartitura es un mapa en constante evolución dentro de una porción específica de tiempo/espacio que cada artista ha perforado a su gusto a fin de explorarla a un nivel personal y a través del estira y afloja propio de las negociaciones colectivas. *Elipsis,* en cuanto experimento de colaboración a gran escala, cumple con las funciones de un intérprete, un facilitador, un actor-interventor y un participante dentro de una narración colectiva más grande. Esto quizá se trate de un arte performativo equivalente al *principio de incertidumbre* de Heisenberg. Esto en el sentido de que es imposible definir con precisión la posición o el momento en que ocurre cualquier hecho individual en nuestra metapartitura al mismo tiempo, de modo que la trayectoria de nuestra narración, o significado, estará definida con mayor precisión en retrospectiva y de acuerdo con el punto de referencia del observador.

La frontera Tijuana San Diego constituye una región compleja de interacciones con múltiples epicentros sociológicos. Movimiento y flujo definen la imagen del corredor transfronterizo. Este espacio urbano elíptico, de doble centro, como ninguna otra localidad, se rodea de esta danza de indicios con movilidad atlética y convertibilidad de situaciones distantes opuestas. *Elipsis* busca habitar este mundo intermedio, uniendo imágenes ópticas/sonoras temporales con el espacio para crear un circuito temporal y producir una tensión creativa que le dé al evento vida momentánea.

Hans Fjellestad *es músico y cineasta. Vive en Los Ángeles. Curador de Elipsis, un proyecto comisionado para el componente de* **Escenarios** *de* **inSite_05**.

Traducción: Gabriel Bernal Granados

CVs
Ellipsis/ Artists

City, 2004); VI Salón Internacional de Arte Digital (Havana, 2004); Feria del Libro de Coyoacán (Mexico City, 2004); and The 32nd Montreal International Festival of New Cinema and New Media (FCMM). Ilich's work has also been shown in diverse international venues such as Centro Cultural de España (Buenos Aires, 2004); Museo de Arte Moderno de Buenos Aires (Buenos Aires, 2004); ItauCultural (Sao Paulo, 2004); and Museo Rufino Tamayo (Mexico City, 2004). He has participated in conferences and seminars in cities around the world, including Sevilla, Paris, Mexico City, São Paulo, and San Diego. Ilich currently lives and works in Mexico City.

Ricardo Domínguez/ (Las Vegas, US, 1959) received his BA in theater studies from the University of Southern Utah, an MFA in acting from the Asolo Conservatory in Sarasota, Florida, and an MA in performance theory from Florida State University. He is co-founder of The Electronic Disturbance Theater (EDT), a former member of the Critical Art Ensemble, and is currently senior editor of *The Thing*, an online journal. Domínguez has held performances and presentations in diverse venues, including the Museo de Arte Reina Sofia (Madrid, 2004); the Tate Modern (London, 2003); the Centre de Cultura Contemporania de Barcelona (Barcelona, 2002); and the Finnish Contemporary Art Center Kiasma (Helsinki, 2001). He has also participated in diverse arts festivals and biennials such as the 29th International Krakow Theater Festival (Krakow, 2004); In-Transit Performance Festival (Berlin, 2003); International Theater Festival (Lublin, 2002), and the Whitney Biennial (New York, 2000). Domínguez currently lives and works in San Diego.

Ricardo Miranda Zúñiga/ (San Francisco, US, 1971) obtained a BA in practice of art and English literature from the University of California, Berkeley and an MFA from the Carnegie Mellon University. His work has been included in numerous exhibitions such as *sonambiente*, Akademie der Kunst am Pariser Platz and tesla im Podewils'schen Palais (Berlin, 2006); *Russia: Signifigant Other*, The National Center of Contemporary Art (St. Petersburg, 2006); *FALLOUT: What's Left*, Momenta Art (Brooklyn, 2005); *Counter Culture*, New Museum of Contemporary Art (New York, 2004); *artport gatpage*, web initiative of the Whitney Museum (New York, 2003); *L Factor*, Exit Art (New York, 2003); *Alt Digital*, The American Museum of the Moving Image (New York, 2003); *AIM 23*, The Bronx Museum (New York, 2003); backup_festival (Weimar, 2003); InteractivA'03, Museo de Arte Contemporáneo de Yucatán (Yucatan, 2003); *Version>03 Digital Convergence*, The Chicago Museum of Contemporary Art (Chicago, 2003); and *Race in Digital Space*, Lucas Complex, University of Southern California (Los Angeles, 2002). Miranda currently lives and works in Brooklyn.

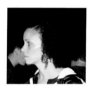

Coco Fusco/ (New York, US, 1960) is an associate professor at Columbia University's School of the Arts. Her video and performance work have recently been featured in the Shanghai Biennial (Shanghai, 2004); Transmediale Festival of Electronic Arts (Berlin, 2003); The Time Based Arts Festival at the Portland Institute for Contemporary Art (Portland, 2003); and The International Center of Photography's 1st Triennial (New York, 2003). Fusco's work has also been shown at such venues as the Museum of Modern Art (New York, 2005); the Itau Cultural Center (São Paulo, 2004); the Museo de Arte Contemporáneo de Barcelona (Barcelona, 2002); and The Boijmans Van Beuningen Museum (Rotterdam, 2001). She currently lives and works in New York.

Ángel Nevarez/ (Mexico City, Mexico, 1970) studied biology at the University of California, San Diego and in 2001-2002 was a studio fellow of the Whitney Museum Independent Study Program. A multidisciplinary artist and musician, he also collaborates with Valerie Tevere as neuroTransmitter. Their work fuses conceptual practices with transmission, sound production, and mobile broadcast system design. neuroTransmitter has created visual works, performed, and broadcasted live on local bandwidths in public spaces and galleries throughout New York City, Sao Paulo, Rio de Janeiro; St. Petersburg, New Plymouth, Munich, Weimar, Stralsund, Helsinki, Aarhus, and Madrid. Alongside his collaborative work, Nevarez has maintained an individual art practice and has shown his work at the 8th Biennial Festival, LA Freeways (Los Angeles, 2002); Sarah Lawrence College (New York, 2002); The Bronx Museum of the Arts (New York, US, 2000); and the Lecture Lounge, PS1 Clocktower Gallery (New York, 2001). Nevarez currently lives and works in New York.

Luis Hernández Galván/ (Mexico City, Mexico, 1977) holds a degree in engineering and architecture from the Escuela Superior de Arquitectura in Mexico City. He co-founded Heterarquia, an organization dedicated to architectural experimentation and low-tech, developing proposals for an interactive pavilion, which obtained second prize in the Third Arquine Competition, and a low-cost shelter for the homeless. Hernández' work has been shown in numerous exhibitions, including Festival Internaticonal de Linguagem Electronica (São Paulo); Microwave International Media Festival (Hong Kong); The New Museum (New York); Museo Reina Sofia (Madrid); Centre de Cultura Contemporánia de Barcelona (Barcelona); and 8th Salon de Arte Digital de la Habana (Havana). He was commissioned by rhizome.org to produce *Oversaturation*, a video game dealing with limited space. He has produced extensive illustrations for Disco Movil Voyager, as well as designs for Orbe® T-shirts and OUT posters. He currently lives and works in Boulder and Mexico City

Anne-Marie Schleiner/ received her BA in studio art from the University of California, Santa Cruz and an MFA in computers in fine art from San Jose State University. She is currently an assistant professor of fine art at the University of Colorado in Boulder. Her work has been exhibited at diverse venues, including the Centro de la Imagen (Mexico City, 2004); The New Museum (New York, 2004); The Whitney Biennale (New York, 2004); and the American Museum of the Moving Image (New York, 2002). Schleiner founded and manages opensorcery.net, a website focused on game hacks and open source digital art forms, and has been actively involved in the anti-war game performance art initiatives *Velvet-Strike* and *OUT*. She designed the games *Anime Noir* and *Heaven711* and has curated numerous online exhibitions of game mods and add-ons, including *Snow Blossom House*, Sonar Festival (Barcelona, 2001) and *Mutation.fem*, an online exhibition hosted by *Alien Intelligence*, Kiasma Museum (Helsinki, 2000). Schleiner currently lives and works in Boulder.

Alex Rivera/ (New York, US, 1973) received his BA from Hampshire College in Amherst. His work has been broadcasted on PBS and has been screened at the Guggenheim Museum (New York, 2001, 2000); the Telluride Film Festival (Telluride, 1999); the New Museum of Contemporary Art (New York, US, 1997); the San Francisco Exploratorium (San Francisco, 1997); the Lincoln Center (New York, 1996); The Museum of Modern Art (New York, 1996); and the Nuyorican Poets Café (New York, 1995). Working with eleven other filmmakers, Rivera founded SubCine.com, a distributor entirely focused on selling Latino film and video to the educational market in 2000. He also worked with La associación Tepeyac, the largest association of Mexican immigrants in New York, to found a video school. Rivera is a Sundance Fellow, Rockefeller Fellow, and a recipient of a Silver Hugo. He currently lives and works in New York City.

Fran Ilich/ (Tijuana, Mexico) received his BA in Latin American studies from the Alliant International University. His projects have been presented at numerous arts festivals, including the Feria Internacional del Libro Infantil y Juvenil (Mexico City, 2004); the Feria del Libro del Zócalo (Mexico

Damon Holzborn/ (Sunnyvale, CA, 1970) holds a degree in music from the University of California, San Diego, where he studied improvisation with George Lewis, guitar with Celin Romero, and composition with Frederic Rzewski, Brian Ferneyhough, Will Ogden, and Rand Steiger. As an improviser and composer who works primarily with electronics, he is a founding member of the Trummerflora Collective and is currently pursuing his doctoral degree in composition at Columbia University. Holzborn has presented his work in the US, Mexico, Europe, and Japan, performing as a solo artist and with several ensembles, including Donkey and Quibble. He has performed and/or recorded with Muhal Ricard Abrams, George Lewis, Miya Masaoka, Lê Quan Ninh, Eugene Chadbourne, DJ Marcus B, and the Nortec Collective, among others. Holzborn also regularly creates music for dance, often collaborating with the innovative dance collective Lower Left, producing both custom compositions and improvised performances. He currently lives and works in Brooklyn.

Liisa Lounila/ (Helsinki, Finland, 1976) studied at the Academy of Fine Art in Helsinki, Helsinki University, and Slade School of Fine Art in London. She received her MFA from the Academy of Fine Arts in Helsinki. Her work has been included in numerous group shows such as *The Youth of Today*, Schirn Kunsthalle (Frankfurt, 2006); *First We Take Museums*, Kiasma Museum for Contemporary Art (Helsinki, 2005); *Video Hits*, Queensland Art Gallery (Brisbane, 2004); *I Don't Know What to Do with Myself*, Galleria Marella Arte (Milan, 2004); *Gokann*, IV Triennial of Finnish Art (Kyoto, 2003); *Poetic Justice*, 8th Istanbul Biennial (Istanbul, 2003); *Devil-May-Care*, 50 Biennale di Venezia (Venice, 2003); *Transparente*, Museu nazionale delle arti de XXI secolo (Rome, 2003); *Evil North*, Universite der Kunst (Berlin, 2002); and *Greyscale/CMYK*, Tramway (Glasgow, 2002). Lounila has had solo shows in venues that include the Wilkinson Gallery (London, 2004); Galeria Anhava (Helsinki, 2003); and the Gallery of the Academy of Fine Art (Helsinki, 2002). She currently lives and works in Helsinki.

Magaly Ponce/ (María Elena, Chile, 1970) received a BA in graphic design from the Universidad de Valparaiso and an MFA from Syracuse University. She is currently assistant professor at Bridgewater State College in Massachusetts. Ponce's work has been shown in numerous exhibitions, including *Recent Developments*, Fort Gondo Compound for the Arts (St. Louis, 2003); *Concurring Cities and a Cicada*, Lucy and Stanley Lopata Sculpture Garden at the Sheldon Art Galleries (St. Louis, 2003); *Human Condition/Global Position: 4 Contemporary Chilean Artists*, Sheldon Art Galleries (St. Louis, 2003); *Follow the Highway*, Saint Louis University Museum (St. Louis, 2003); and *Betraying Amnesia: Latin America Video Portraiture*, Festival Latin America Fest. (Los Angeles, 2002); Rochester Institute of Technology (Rochester, 2002); and Otis College of Art and Design (Los Angeles, 2002). She has been awarded numerous prestigious grants such as the Andes Foundation, the Fullbright Grant, and the Rockefeller-Mac Arthur-Lampadia. Ponce lives and works in Providence.

Iván Díaz Robledo/ (Mexico City, Mexico, 1977) graduated with a degree in communications from the Universidad Autónoma de Baja California. A filmmaker and video artist, he is currently director of YONKEarte, an independent organization dedicated to the production of audio-visual projects and community and interdisciplinary arts. Ex member of the Nortec Collective, Diaz's work has being included in several video and art festivals, including *Video Zone 2*, 2nd International Video Art Biennale (Tel Aviv, 2004); 7th d.u.m.b.o art under the bridge festival (Brooklyn, 2003); Guadalupe Film Festival (San Antonio, 2003); and *Mexartes*, Casa de las Culturas (Berlin, 2002). His work has been shown in diverse exhibitions such as *LARVA*, Centro Estatal de las Artes de Monterrey (Nuevo León, 2004); Centro Cultural Tijuana (Tijuana, 2004); and 3rd Annual Spring Reverb, Museum of Contemporary Art San Diego (San Diego, 2004). Díaz lives and works in Tijuana.

Hans Jørgen Fjellestad/ (San Diego, US, 1968) received his BA in music from the University of California, San Diego. Fjellestad performs and records regularly, both as a solo artist and in collaboration with various experimental music ensembles, and has an extensive discography. He has directed and produced numerous films, including the feature documentaries *Moog* (2004) and *Frontier Life* (2002). He has presented his work in the United States and internationally at festivals that include the Rotterdam International Film Festival (Rotterdam, 2005); Festival Beyond Innocence (Osaka, 2005); Madrid International Film Festival (Madrid, 2005); Adelaide International Film Festival (Adelaide, 2005); Mexico City International Film Festival (Mexico City, 2005); Karlovy Vary International Film Festival (Karlovy Vary, 2004); Sound Unseen Film & Music Festival (Minneapolis, 2003); d.u.m.b.o art under the bridge festival, d.u.m.b.o. art center (Brooklyn, 2003); Northwest Film Forum (Seattle, 2003); Calgary International Film Festival (Calgary, 2002); and the Yokohama Jazz Festival (Yokohama, 2002). Fjellestad currently lives and works in Los Angeles.

inSite_05

Staff> Equipo de trabajo

Executive Directors> Directores ejecutivos/ Michael Krichman & Carmen Cuenca

Artistic Director> Director artístico/ Osvaldo Sánchez

Curatorial on Site> Curadores en residencia/ Tania Ragasol • Donna Conwell • Osvaldo Sánchez

Moriah Ulinskas • Marcela Quiroz • Nick Hutchinson/ Documentation and Web Coordinators> Documentación y coordinación del sitio web
Nathalie Woyzbun • Ivette Herman • Yvette Román • Paola Arreola • Paola González Rubio • Ximena Amescua/ Interns> Servicio social

Administration> Administración/ Maryann Moore/ Director of Administration> Director administrativo
Joy Decena/ Office Manager and Administrator> Jefe de oficina y administración
Sarah Haughton/ Office Manager> Jefe de oficina

Production> Producción/ Daniel Martínez/ General Production Manager> Director general de producción
Márgara de León/ Production Manager in Tijuana> Jefe de producción en Tijuana
Joy Decena/ Production Researcher> Investigación de producción
Esmeralda Ceballos/ Production Coordinator in Tijuana> Coordinador de producción en Tijuana
Zlatan Vukosavljevic/ Production Coordinator in San Diego> Coordinador de producción en San Diego
Michael Golino/ Pre-production Manager in San Diego> Jefe de preproducción en San Diego

Communications> Comunicaciones/ Barbara Metz/ Director of Public Relations> Director de relaciones públicas
Papus Von Saenger/ Public Relations Coordinator> Coordinador de relaciones públicas
Selene Preciado/ Institutional Liaisons Assistant> Asistente de coordinación institucional
José Manuel Cruz Vázquez/ Designer-at-Large> Diseñador jefe
Sirak Peralta/ Graphic Designer> Diseñador gráfico

During the unfolding process numerous individuals collaborated on specific **inSite_05** projects. Please see project credits and acknowledgements for more details. p. 432> Durante el proceso de **inSite_05** numerosos individuos colaboraron en proyectos específicos. Por favor consulte los créditos y agradecimientos por proyecto, p. 432

Board of Directors> Mesa directiva

President of the Board> Presidenta de la mesa directiva/ Eloisa Haudenschild

Executive Directors> Directores ejecutivos/ Michael Krichman & Carmen Cuenca

Board of Directors> Mesa directiva/ Barbara Borden • Cathe Burnham • Luis Cabrera • Dolores Cuenca • Mario Espinosa • Gerardo Estrada • Rosella Fimbres • Peter Goulds • Aimée Labarrère de Servitje • Eugenio López Alonso • Karen Mercaldo • Lucille Neeley • Randy Robbins • Hans Schoepflin • Bernd Scherer • Teresa Vicencio • Víctor Vilaplana • Yolanda Walther-Meade

LOOKING BACKWARD AND FORWARD: A PRELIMINARY HISTORICAL CONVERSATION ABOUT inSite

Sally Stein

*Someday, hopefully not too far in the future, someone may be ambitious enough to examine a multitude of perspectives on how **inSite** arose and developed. Ideally such a project would involve dozens of interviews with directors, board members, curators, artists, and critics, maybe even a few politicians. The results inevitably would alternate between some measure of harmony and at least as much dissonance, for what else could one expect for a chronicle of such an unprecedented cultural collaboration between institutions and countries, one that developed fairly self-consciously by stages on the dialogic basis of learning from trial, error, and success?*

*But for starters, Osvaldo Sánchez (artistic director for **inSite_05**) invited me, a longtime camp follower of **inSite**, to come from Los Angeles to interview the two executive directors, Michael Krichman and Carmen Cuenca. In keeping with their packed schedules, the day I showed up at the downtown San Diego offices at the end of March 2006—the same week as the spontaneous spread of regional protests against current anti-immigrant policies—both Carmen and Michael had so many appointments on both sides of the border that there was no time when the three of us could sit down together. So what follows represents a weaving together of separate interviews conducted over the space of two days and then heroically transcribed from tapes by **inSite**'s staff.*

Sally Stein/ I've been attending **inSite** events since 1992, yet after nearly fifteen years I realize that I have no idea how this quite unique cross-border matrix of art and cultural events developed. As preface to that, I'd like to begin by hearing something about where you were in your own professional lives at the moment when you became involved in **inSite**.

Michael Krichman/ I returned to San Diego in 1985 where I had not lived for sixteen years. Although I started working in the environmental department of a local law firm, I soon recognized that I had a stronger interest in contemporary art. On a volunteer basis I had been involved with the Museum of Contemporary Art, and in the process I became good friends with Mark Quint. About the time that the Berlin Wall came down, Mark and I decided to go to Eastern Europe to see what was there in terms of art and artists. I left my law firm in 1990, taking a leave of absence from which I have never returned, and Mark and I started what ultimately became Quint Krichman Projects. After spending considerable time in Poland, we returned with the notion of setting up a residency program that we hoped would produce art that

we could sell to make the program self-supporting. We rented a house and studio space, and facilitated artists in their making of new work. Quint Krichman Projects worked through 1993. In early 1992, Mark became involved with Installation Gallery, an artist-run space that began operating in the early 1980s. By the early 1990s, the organization was pretty much on its last legs. The president of Installation Gallery at that time, Randy Robbins, who is still on our board, put together an advisory group including Mark Quint, Sally Yard, and Ernie Silva, among many others. I was not part of it. The group's task was to figure out what to do with Installation Gallery, and the ideas ranged from "let's raise $100 million dollars and open a new museum" to "let's close this thing—it's dead."

I think that Mark was the one who came up with not only the initial idea for **inSite**, but also the name, which came to him in the shower one day. In many cases what organizations become has a lot to do with how they begin, so it's worth recalling that **inSite** really began as a very modest idea in response to Mark and Ernie's sense of what was problematic about San Diego: you had this landscape of cultural institutions, universities and junior colleges, assorted museums, etc., but without any cultural center. The most prominent contemporary arts institution in the city, the Museum of Contemporary Art, was quite small, and the larger San Diego Museum of Art was not a terribly exciting place at the time. The obvious challenge was how to galvanize the energy of then-current artistic practice—installation, site-specific work, etc.—that a lot of smaller institutions were championing. Mark's original idea was to see what would result if every visual arts non-profit in the area agreed to sponsor related kinds of new work, all of which would be on view at the same time in the month of October. That, in a nutshell, was the basis for IN/SITE'92. The resulting publication was a modest brochure, belying the extraordinary regional coordination effected by Mark and Ernie. That their efforts succeeded probably also reflects how weak the local cultural situation was; imagine the jockeying that would arise among major institutions if you tried to do that in Los Angeles. But in San Diego everybody went along with the idea. The entire budget for IN/SITE'92 was, I believe, something like $3,500, and that grand total included a few small payments to facilitate various projects.

I was really on the fringes of **inSite** at the time. Mexico was also on the fringes. A few artists did some work in Mexico. Most notably, Kim McConnell and Jean Lowe did a piece at the Casa de la Cultura. That was the extent of Mexico's participation. Nevertheless, IN/SITE'92 was an interesting exercise on many different levels, and it garnered enormous public attention from a surprising number of local arts writers. Back then, San Diego had two daily papers—the *Union* and the *Tribune*—each of which had its own arts critic; in addition there was a San Diego edition of the *Los Angeles Times* with Leah Ollman writing art reviews. As a result the first **inSite** generated a disproportionate amount of ink.

It was only after that debut that I really got involved. Installation Gallery had significant problems. It had only a few brave members of its board of directors left, no money, and no base of support. A few years earlier the City of San Diego had cut off funding to Installation Gallery after it served as fiscal agent for a controversial project by David Avalos, Elizabeth Sisco, and Louis Hock. Compared to some of the things **inSite** has produced since then, their project seems mild, but in 1987 it provoked so much controversy that Installation Gallery was all but blacklisted by the San Diego Commission for Arts and Culture and the California Arts Commission. To make matters worse, for a number of years Installation Gallery had failed to

file financial reports as required by the National Endowment for the Arts and the IRS.

While fending off the IRS and helping resolve legal issues, I also became part of the small group trying to figure out what might be interesting to do with this nearly defunct organization. At one point, we almost concluded that Installation Gallery, with all its baggage, wasn't worth keeping. I think the only reason we decided to stick with it was for funding purposes: to apply for grants you had to be part of an organization that had been in existence for at least three years.

So we had this shell of a non-profit, and we began thinking that it would be most interesting to extend **inSite** across the entire San Diego-Tijuana region. It's hard to imagine that we could have been any more ignorant about the cultural scene in Mexico, or how it functioned. What was the Centro Cultural Tijuana? We all thought that it was a museum. For further evidence of our naiveté, consider the fact that for the brochure published for IN/SITE'92, the graphic designer thought that "Tijuana" would look better with an accent over the "i"—and nobody previewing the copy objected!

As we began planning for another coordinated project, I became president of **inSite**'s board. At the time, MCA was a major participant as well, and Lynda Forsha eventually left her position as curator there and came to work as director of inSITE'94.

Brochure IN/SITE'92

Catalogue Cover inSITE'94

A defining moment in the planning process was when we first approached the then-director of the Centro Cultural Tijuana, Pedro Ochoa. I went to Tijuana with La Jolla gallerist José Tasende and Jorge Hinojosa (an activist living in Tijuana who was a crucial link for Tijuana installations). We introduced our general plan and our hope that institutions in Mexico would contribute to making this a bi-national cultural project. "Sounds great," Pedro said, "but it is too big for me alone. We have to talk to the head of the Instituto Nacional de Bellas Artes, Gerardo Estrada." On that basis, Lynda, who was at that point the liaison to the project from MCA, José, and I flew down for a meeting in Mexico City. After waiting a day and a half, we met with Gerardo for four minutes to present our idea of multiple institutions commissioning site-specific and installation works in the fall of 1994. Gerardo immediately responded, "Great, let's do it!" With that proclamation, the short meeting ended and we were ushered out by another door.

Who knows how well he grasped our brief proposal or what he thought he was committing to? To be sure, Gerardo was very smart and had his own activist history. During the uprisings in Mexico City in 1968 he had delivered the students' demands to the government. More recently Gerardo had served as the director of Programa Cultura de las Fron-

teras in the northern Mexico border regions, and had also started a radio station devoted to new Norteño bands. However, he had far less familiarity with contemporary visual art. Nevertheless, much of our subsequent development pivoted on Gerardo's remarkably positive response, which he followed up with a mandate of institutional support at the Mexican federal level. Whatever he thought he was committing to, following that meeting we restructured our board of directors, and Gerardo assigned Walther Boelsterly, who was deeply involved with **inSite** through 2000, to serve as his liaison and keep track of the plans as they developed.

If anything, our expanding points of contact made the structure for inSITE'94 even more complex, involving something like thirty-eight institutions ranging from the Instituto Nacional de Bellas Artes (INBA), working through the Centro Cultural Tijuana, the Museum of Contemporary Art, the San Diego Museum of Art, the Centro Cultural de la Raza, Mesa College Art Gallery, etc.—each institution sponsoring at least one art work. As a check against complete decentralization, we set up a semi-autonomous curatorial review panel, which of course produced new tensions as the small organizations such as Centro Cultural de la Raza compared their resources to large organizations such as the Museum of Contemporary Art, suspicious that the whole thing was a plot to usurp artistic practice related to the border.

At least those local frictions were familiar and thus predictable; we were in unknown territory when we set out to work bi-nationally. There was very little understanding across the border of how institutions operated. In San Diego, we barely comprehended the thorny power issues associated with culture in Mexico. Indeed, inside Mexico those fissures had only just erupted in partisan splits between INBA, controlled by the PRI (Partido Revolucionario Institucional) at the federal government level (wielding more money and more expertise), and institutions that represented Tijuana and Baja, which were PAN (Partido de Acción Nacional), the first opposition government in Mexico. At every level, including of course publicity, there was considerable partisan maneuvering between these institutional sponsors. And of course, there was lots of suspicion of anything from north of the border.

Sally Stein/ Before continuing I would like to hear from Carmen about what she was doing prior to inSITE'94.

Carmen Cuenca/ After completing an art history degree at Universidad Iberoamericana and having worked for nine years at the San Carlos Museum in Mexico City in the department of exhibitions and documentation, I decided for family reasons to move to Tijuana with my two daughters in 1989. Up to this moment, Tijuana was for me only a point of reference in relation to San Diego, where my family used to come for holidays. So, moving to Tijuana involved creating a totally new life. It is important to keep in mind that Tijuana was in a state of unprecedented transition in 1989: both the city and the state were breaking with the entrenched power of the PRI following the first gubernatorial election of a PAN politician, the former mayor of Ensenada, Ernesto Ruffo Appel. Having previously served as a courier for the transport of an exhibition from Mexico City to the Centro Cultural Tijuana (CECUT), my first plan was to think of CECUT as my point of reference. But between March 1989 when I first arrived and September, I also decided to take over a commercial gallery located at Las Torres in Tijuana. I went to

the director of CECUT to introduce myself as an art historian with a background in museum studies, and he invited me to collaborate with them. Thus between 1989 and 1994 I ran the gallery while also working in various capacities at CECUT.

I first heard about **inSite** in 1992 when Mark Quint made contact with me on the basis of my gallery's commitment to contemporary art alongside my work at the Centro Cultural Tijuana. I got more involved in 1993 when planning for inSITE'94 was starting. After Michael Krichman had a meeting with CECUT director Pedro Ochoa, Ochoa asked me in so many words, "There's a crazy gringo telling me that we should do an exhibition of installation and site-specific art. What the hell is that?" At that point, he appointed me as CECUT's contact for the project, and I became part of the team working on inSITE'94 from the Centro Cultural Tijuana.

Michael Krichman was the key representative from San Diego working to forge connections across the border. I had to explain to him that we didn't have curators in Tijuana at that time, or directors of institutions, in the way they are understood in the US. Clarifying the differences was crucial because the basic model for inSITE'94 was an umbrella of participating institutions expected to select and also financially support their own artists. That model wouldn't translate easily for collaboration by Mexico; in Tijuana we had no art museums, no university galleries, and likewise nobody whose job definition was exactly that of a curator or museum director—nobody with comparable cultural authority to, say, Sally Yard, who was part of the curatorial group for inSITE'94. Nevertheless, given my background in museum work and my established ties to Mexico City and INBA, it seemed logical that I would assume the responsibility for representing the region in this novel collaboration. But I quickly aimed to involve multiple institutions by organizing a Baja California committee.

Sally Stein/ Who was on the committee you organized in 1993 for inSITE'94?

Carmen Cuenca/ The Centro Cultural Tijuana was the only federal/PRI-backed institution in Baja California, making it all the more important to incorporate different voices and perspectives of representatives from the local cities if one wanted to achieve any sense of real participation. Therefore, in addition to the director of CECUT, I also made a point of involving officials from the Casa de la Cultura de Altamira, representing the city of Tijuana; the Instituto de Cultura Baja California; and the Colegio de la Frontera Norte. This committee tried to operate like a curatorial jury, starting with an open call for project ideas by visual artists from Ensenada, Mexicali, Tijuana, and Tecate. At that time we didn't know who would be able or interested in undertaking site-specific or installation work. Nobody local was doing that at all. As for the wide reach, we initially embraced this project, in part, for its potential as a political collaboration by public institutions that lacked the funding or experience for such an innovative artistic activity. Our committee narrowed down the proposals to a group of twenty-two, and I then took that selection to be considered further by a group of curators from additional institutions such as the Stuart Collection at the University of California, San Diego, MCA, the San Diego Museum of Art, and the Museum of Natural History. That process resulted in the final selection

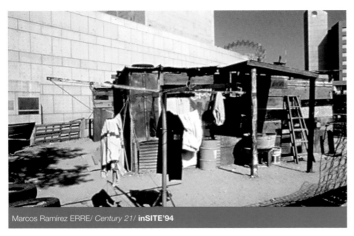

Marcos Ramirez ERRE/ *Century 21*/ **inSITE'94**

of nine artists from the Baja region, including the unexpected emergence of one complete unknown, Marcos Ramírez ERRE. His *Century 21*, the shanty house he built on CECUT's plaza, had great impact for **inSite** as well as for Tijuana's art scene and for his own career.

Michael Krichman/ That was one of the early gambles that really paid off. Marcos Ramírez showed up with a shoebox to present his proposed model for *Century 21*. We went with it, even though nobody could really envision what would result. So inSITE'94, turned out to be a kind of free-for-all, with some very interesting projects like *Century 21*, and some that were not so interesting. However, while those of us in San Diego were just feeling our way, it's worth noting that we had no monopoly on blindness to the emerging Mexican art scene. I recall that as part of her search for Mexican artists who would be commissioned by Installation Gallery itself, Lynda Forsha contacted Robert Litman, who then was the director of the Centro Cultural Arte Contemporáneo Televisa in Mexico City. In response to her query, Litman wrote back that there was only one artist worth thinking about at all in this context—Silvia Gruner. He didn't even mention Gabriel Orozco. Silvia herself gave us the best advice, which may be how we heard about a group of artists working out of a house on Temístocles Street in Mexico City. I went there and met Eduardo Abaroa, Daniela Rosell, Sofia Táboas, Abraham Cruzvillegas, Diego Gutiérrez, and Pablo Vargas Lugo, among others. On my return I convinced Kathleen Stoughton, gallery curator at Mesa College, to give each of these artists an airline ticket and $1,000 to make a new work at the Casa de la Cultura in Tijuana. Up to this point, official Mexico had never supported these artists at all.

We also started making contact with a group of art historians in Mexico City who were already emerging as a key new cultural force, but were still pretty much below the official radar. I'm speaking of Olivier Debroise, Cuauhtémoc Medina, and the group at Curare. I first heard of Olivier, not in Mexico, but rather in New York, when, prior to inSITE'94, I went to talk with Tomás Ybarra-Frausto at the Rockefeller Foundation. After telling him about our plans, he rightly wondered, "Do you have any idea what you

are doing, where you are, or what system you are operating in?" But he wasn't outright dismissive and he certainly provided one invaluable lead in suggesting that we really had to meet this guy named Olivier Debroise, a key figure in Curare, an independent group of scholars and critics that had applied for and been awarded a Rockefeller grant. By the time inSITE'94 came around, he was actively interested in seeing what had developed, and then we commissioned him and his close associate Cuauhtémoc Medina to write for the catalog.

Sally Stein/ The process itself sounds like pure improvisation.

Carmen Cuenca/ Exactly! Along with much disorganization, there was this lively improvisation. The challenges of **inSite** were considerable, given our resources and near-total lack of expertise from fundraising to overseeing the travel and activities of artists, to learning how to work with the media, and, most crucially, to work with two very different systems of cultural production and the politics surrounding each. In lots of ways it was a crazy time. Half a year before the opening, in March 1994, PRI presidential candidate Luis Donaldo Colosio was assassinated while campaigning in Tijuana, and the resulting spotlight on corruption, violence, drugs, etc., hardly helped the city's image.

Sally Stein/ Did that make Tijuana the "Dallas" of Mexico?

Carmen/ At many different levels that event precipitated enormous crisis and turmoil. For one thing, following the assassination, Pedro Ochoa assumed a new political position, leaving CECUT without a director. Thus it fell to me to become the primary contact person between **inSite**, CECUT, and INBA in the crucial months before **inSite** opened. At that time I was also offered a new job as cultural attaché to the Mexican Consul in San Diego. That government position really helped me to obtain all the different permissions for the artists whose projects would be realized in Tijuana. I worked closely with Walther Boelsterly, who was in charge of the construction of most of the projects overseen by INBA. In the context of Tijuana, which at the time was still a small city—in the last dozen years it has grown by 300 percent—with limited cultural resources and hardly any cultural professionals, it was enormously satisfying to see it all come together as planned at CECUT. Of course some of the media attention

Catalogue Cover **inSITE'97**

was less focused on the art than on the continuing crisis in Mexico, both political and economic. The other controversial element was the 1994 NAFTA treaty that forced governments and economies to confront each other and the bigger process of globalization. The art of inSITE'94 was overshadowed by these huge uncertainties, but much of the art also resonated with some of those issues. In 1995 I became full-time co-director of inSITE'97.

Restructuring inSite for 1997

Sally Stein/ Notwithstanding the success and impact you had in 1994, you didn't follow the biennial model and repeat **inSite** two years later, and by the time of inSITE'97 major changes had been made in the basic structure of the overall operation. How did you decide on those changes?

Carmen Cuenca/ Actually, when inSITE'94 ended, one of the first proposals from the Mexican side was the idea of a biennial. Some of our biggest Mexican supporters were anxious not to wait too long before doing it again. Of great significance was that at that time, despite Mexico's transition from one six-year presidency to another, many of the same cultural officials retained their government positions. That provided a foundation for going forward, because instead of having to start introducing the idea all over again to a new set of players, well-placed figures like Gerardo Estrada and his team (which included key players like Walther Boelsterly, Antonio Vallejo, and Claudia Walls) were already committed to the project.

Michael Krichman/ Going into inSITE'97 was really a different matter in that we aimed for a much clearer idea of how we could distinguish the project and make it most meaningful for this region. First of all, when the initial excitement passed, Sally Yard, Carmen, and I initiated extended talks with participating institutions to see if they wanted to pursue further collaboration, and if so in what way. The small ones reported that it had been too taxing given their limited resources. They were right. There was a tremendous disparity between what MCA could do on its own, commissioning a major a piece by Nancy Rubins for their building, and what the Athenaeum Music & Arts Library could manage, let alone the Casa de la Cultura in Tijuana. What came out of that analysis was the realization that if **inSite** were to work again with such a diverse range of institutions, each one would need to feel that it was benefiting from the collaboration rather than being overloaded.

A defining moment was when we proposed our plan for inSITE'97 to the Museum of Contemporary Art, which had been a leading player in 1994. MCA was in the middle of expanding their La Jolla facility, and decided that for this, and I'm sure for other reasons, they would be unable to participate in another **inSite** until at least 1998. The museum had been an important partner in IN/SITE'92 and inSITE'94, but, because of their stature, it would have been difficult to introduce a centralized curatorial structure for **inSite** that did not include or pivot around MCA's curatorial staff. In many ways their decision not to participate in 1997 paved the way for a total restructuring of **inSite**. Installation Gallery and INBA agreed to work on **inSite** as equal institutional partners, with me serving as the US Director, and Carmen as the Mexico Director. Once that was in place, we worked with Sally Yard to imagine the dream curatorial team for inSITE'97: Sally Yard, Olivier Debroise, Ivo Mesquita, and Jessica Bradley.

Carmen Cuenca/ With Sally from the US, Olivier based in Mexico, Ivo from Brasil, and Jessica from Canada, the team of curators drew on perspectives and knowledge of artists from all over the hemisphere. And starting with a dialogue across the Americas, we could then focus on the particulars of this corner of the Americas that is specific to **inSite**'s immediate local geography.

The curators were invited to begin work in the context of their own residencies, and very soon the residencies became key for the whole project. With the change in **inSite** from an umbrella to an independent bi-national organization—with a consolidated administration, staff, and budget—we could really make residencies a basic priority, first for the curators, and then for the artists whom they selected to participate.

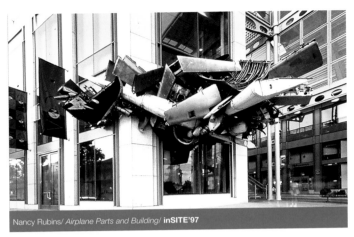

Nancy Rubins/ *Airplane Parts and Building*/ **inSITE'97**

It became our job to organize those residencies and to make sure the budget could support their extended work in the region.

Michael Krichman/ Going into inSITE'97 with this new structure raised a host of new challenges. In partnering with INBA, we soon realized that we needed to spell out contractually some basic issues, the most important being that we were going to have a curatorial group, which would need to have creative autonomy. This was not an easy principle to establish with INBA, especially given our choice of utterly independent curators. Olivier, for example, had not worked inside an official institution at least since Curare had started, and he adamantly insisted that he not be hired by INBA. Notwithstanding the tension, we were able to maintain our position, in part because the politics of the cultural scene were changing in Mexico in ways that dovetailed with our own stance. The period between 1995 and 2000 was, in my opinion, a new age for both museums and contemporary art in Mexico. For the first time the Mexican elite departed from the patronage tradition and began making museum appointments on the basis of merit. It's hardly coincidence that in those same years you had this very interesting group of younger artists in Mexico developing international reputations (with and without government support), being invited to do different things abroad, and thus also challenging the traditional system of patronage that previously affected the arts nearly as much as politics.

Carmen Cuenca/ In retrospect, the biggest mistake from the Mexican perspective was that in starting anew we made a deal that in all matters there would be parity; however, the plan of funding on a fifty-fifty basis was impossible to achieve on the Mexican side once the budget grew to be something over one million dollars. It forced us to be bolder in our fundraising efforts, seeking out grants from the few Mexican foundations. Nevertheless, the cash contribution from the US side was far greater in the end, so that we tried to justify parity by carefully calculating in-kind support from the Mexican side. But ultimately we learned the lesson that in terms of financing for **inSite**, "fifty-fifty" bi-national agreements were unrealistic. Yet in other respects, the principle of parity between the two countries that informed our rethinking of **inSite** at that time made a big difference. This was the period when we developed more organized educational programs as part of the entire process with Néstor García Canclini and Manuel Valenzuela of the Colegio de la Frontera Norte—ex-

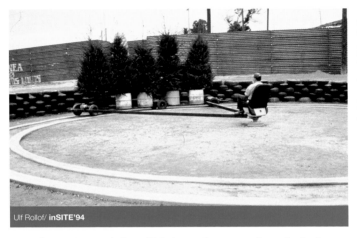

Ulf Rollof/ **inSITE'94**

tremely prominent scholars of Mexican culture—coming to both observe what we were doing and also to engage in dialogue with the artists.

Michael Krichman/ There also arose quite a few other informal educational activities, thanks largely to the interests of the inSITE97 curatorial group. Almost as a precondition of their participation, Olivier and Ivo insisted that if we did nothing else we had to develop a structure of workshops for artists in Tijuana. There were no art programs at the university level in Tijuana. At their urging, we commissioned Felipe Ehrenberg to come for two months to conduct workshops with younger artists, including visits by Olivier, Ivo, Jessica, and Sally. Most of these meetings addressed the most basic issues of how to present your work to a curator—practical yet invaluable information.

Carmen Cuenca/ Of great significance, too, was that we adhered to our stated decision that all participating artists for inSITE'97 would be treated equally in terms of honorarium, and pretty much also in terms of budget, no matter their age, or stature, or where they came from—something that never happened in inSITE'94.

Michael Krichman/ This was the time when we were revising our entire process and likewise our ideas about effective cultural practice. Indeed, the other source for our momentum was the new kinds of projects we were excited to see developing at the core of **inSite**. I have learned, since working on inSITE'94, that certain projects from one **inSite** end up providing clues or leads to what you aim to do next. In this respect the inSITE'94 projects by Silvia Gruner and Ulf Rollof were extremely influential. It's not a question of making an absolute judgment that those works were "better." Nancy Rubins' work at MCA was a beautiful example of what she produces for a variety of sites, with no particular relation to the immediate environment. By contrast, the works by Rollof and Gruner stood out and really resonated with us for a long time because they were not presented as conclusive artistic statements, but seemed to be as much about the process of research which shaped an experience in the form of a question, or questions, rather than the illustration of an answer.

It was work along those openly exploratory lines that we aimed to cultivate, and with the curators we formulated not only the residency plan but also the idea of bringing the artists together for an initial trip to reconnoi-

ter the region while participating in a series of introductory discussions. We scheduled a period of a week or ten days when the artists stayed in San Diego and then went to Tijuana, with meetings occurring around these tours so that the artists could show their work to one another and share initial thoughts about what they were encountering.

It was also while organizing inSITE'97 that we, again in crucial dialogue with the curators, began broadening our notion of the range of practices that made sense to support: getting away from, or beyond, the traditional notions of site and entertaining possibilities of event-based practice, a type of performance but as a contextual intervention. Andrea Fraser's piece at the 1997 opening immediately comes to mind as a stunning example.

Sally Stein/ Was it a struggle to bring the combined board along in this new direction?

Michael Krichman/ It was frequently a hard sell in Mexico. Imagine convincing the government of Mexico to put money into a project that they saw as a total sham supporting Francis Alÿs, for example, who had convinced us to fund his trip around the world with nothing more than a postcard to show for it in the end.

Carmen Cuenca/ Francis Alÿs' work, which was an action, not an object at all, was the project most difficult for the Mexican members of the board. It didn't help that he was neither from the US nor from Mexico, and there was a big fight about paying for airplane tickets for this Belgian artist based in Mexico City to travel around the world for twenty-eight days as a way of traveling between Tijuana and San Diego without crossing the border. Another important issue that sparked controversy was the idea of paying artists an honorarium whether the work was object-based or non-object based. In defending the curators' selection, the first and continuing question I faced was, "Why are we paying them?" From their perspective, it should be considered honor enough for an artist to be included. They really had trouble accepting the idea of the artist's work as *work*, which, as such, warrants payment.

Michael Krichman/ With INBA, yes . . . there were numerous fights. But it was never about content in the way you might imagine it. It was

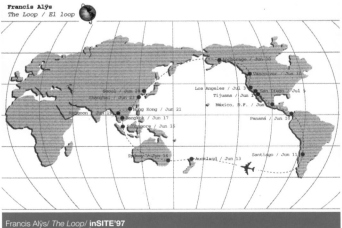

Francis Alÿs/ *The Loop*/ **inSITE'97**

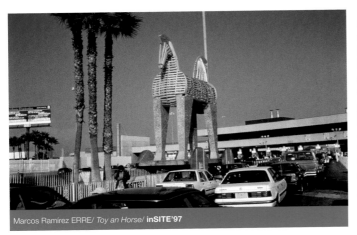

Marcos Ramirez ERRE/ *Toy an Horse*/ **inSITE'97**

more about artistic practice on the order of "Come on, Francis Alÿs isn't an artist . . . the kind of thing he's doing isn't serious art." There were never controversies about political messages or anything like that. Never! I wish I could give you a good story about some sponsor wanting to censor something on that basis, but I can't. And maybe for that reason you could judge **inSite**'s claim to be a force of criticality as a failure. The really big obstacle has been less political per se than logistical in terms of obtaining permissions for various projects on both sides or right at the border. Starting out, it's never clear-cut where we stand. My background in law has come in handy because I did a lot of work with administrative agencies; however, with each project we almost always find ourselves in the land of unfettered administrative discretion. On the one hand, there is no imperative to say yes to us. On the other hand, we have managed to proceed with various projects. Throughout the process we have continually anticipated that the phone would ring and someone would tell us that permission had been denied or revoked . . . but it's never happened. *Toy an Horse* at the border by Marcos Ramírez ERRE in inSITE'97 was really a perfect example.

Carmen Cuenca/ For 1997, we decided to invite Marcos Ramírez ERRE again; well, really the curators decided and we welcomed the decision. It was felt by all that Marcos deserved this second invitation because his work for inSITE'94 was this utter surprise by a complete unknown who had neither formal background nor ongoing institutional support. Along with Allan Sekula's photographic series *Dead Letter Office* of the 1996 Republican Convention in San Diego, and the *Ayate Car* of Betsabeé Romero, *Toy an Horse* by ERRE was one of the works in inSITE'97 that not only attracted the press, but also really intrigued them and thus provoked a larger discussion.

Michael Krichman/ The genesis of that horse says a great deal about the dialogue that usually characterizes **inSite**'s process. In his original proposal, Marcos wanted to have a horse that rolled back and forth between the two countries. For that to have happened, the horse would have had to be very small to get through the gates, and the curators weren't so excited with the concept. Then Marcos came back with the idea of a huge horse planted right over the traffic lanes. To that I responded, "This is never going to happen! How the heck are we going to ever figure out how many jurisdictions we've got going on in that spot?" But the artist and curators persisted with the plan. And we couldn't have been luckier in terms of the politics of the border at that time. Outside of **inSite**, there were

two people who together helped make it happen. There was Alan Bersin, whom Clinton had appointed to be not just US attorney for the region but also the "Border Czar." Alan's wife and I were childhood friends. We introduced Alan to another friend, Luis Herrera Lasso, the Mexican consul in San Diego with whom Carmen then worked. They got along very well and began working jointly on various border problems—not just political issues but also logistical solutions to traffic by creating fast lines for border commuters. So when ERRE developed his concept, I called Alan and briefed him on the project and admitted that there was no way we could do it unless both he and Luis cleared the way with approvals, which they did—helping us to gain the approval of over thirty state, federal, and municipal agencies on both sides of the border that had some jurisdiction over the site.

inSITE2000-2001

Sally Stein/ On thinking over what you've recounted so far, I'm struck by the fact that the residency concept, which began being integral to inSITE'97, was already something you, Michael, had tried with Mark Quint a few years before **inSite** even began. Of course then it was conceived in practical terms, without much necessary reference to the area, but there's an echo or reiteration here of wanting to mix things up in San Diego by bringing in outside players.

But to return to the chronology, if the residency principle was already established in inSITE'97, at which time you already had established a team of four curators, and this teamwork at the curatorial level continued for 2000, what do you see as the major changes that took place between inSITE'97 and inSITE2000-2001? I would have thought that the coordination would have become easier after the reorganized **inSite** had such great impact in 1997.

Michael Krichman/ There was some overlap between the two, especially at the curatorial level. Two of the curators for inSITE'97, Sally and Ivo, continued for 2000, with Susan Buck-Morris and Osvaldo Sánchez joining them.

inSite had operated according to a relatively non-traditional format, but through 1997 it still had some points of comparison with *Sculpture Projects* in Münster or *Places with a Past* (the exhibition of installation art

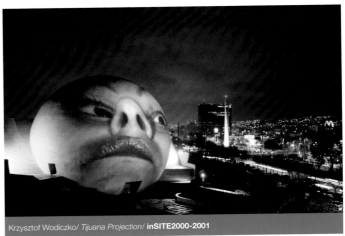

Krzysztof Wodiczko/ *Tijuana Projection*/ **inSITE2000-2001**

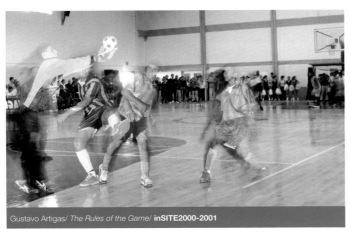
Gustavo Artigas/ *The Rules of the Game*/ **inSITE2000-2001**

organized in conjunction with the Spoleto Festival in Charleston, South Carolina). For inSITE2000-2001, those points of reference seemed no longer apt. We only recognized that shift well into the preparatory stage, and suddenly we, not just Carmen and I, but others too on the board, became worried about the public presentation of this thing. At the time, we kept assuring others that we weren't worried about the exhibition format and all that business, which of course meant that we were really worried because an exhibition was precisely what we were geared up to do. At that juncture, it was a fairly serious revelation that we weren't going to have all of the projects done at the same time because people were really involved with processes and it wasn't all coming together simultaneously. Judith Barry wasn't going to be finished with her "narrow cast" network video installation; with Iñigo Manglano-Ovalle, we couldn't get the bull ring until the last minute so we had no idea whether he would be able to deliver on his "search for aliens" idea by transforming that space with a radio telescope and sound amplifiers. Indeed in response to our evident if muted concerns, the artists wondered, "Why are you guys so worried all of a sudden about September 23," or whatever the date was.

Sally Stein/ You actually pushed it back so that it opened uncharacteristically late, in mid-October of 2000 and then continued through early spring 2001.

Michael Krichman/ Well, we had to make some adjustments once we recognized that this was happening at a different rhythm. And even then there were lots of works that our printed announcement could only describe quite vaguely as planning to appear months later. Still, it was hard to let go of the format we had developed for public presentation. Aside from the question of our own mindset, it was too late to simply throw out the model completely. That's always difficult, and in this case it was a model that had satisfied funders, members of our board, the art public in town, while making you a cool guy for organizing a really neat art-expedition-cum-bus-trip.

All of a sudden we had to acknowledge that this would not please those who had come to expect an art world experience, a go-around-and-see–stuff-and-have-it-all-

Catalogue Cover **inSITE2000-2001**

organized experience. Although we tried, there was simply no way to avoid disappointing a lot of people who were expecting a tour of sited works in the context of a singular big event. The press response to inSITE2000-2001 was no better. What I now see as interesting is that the press—the art press to some extent, and certainly the local press—was inclined to brand inSITE2000-2001 as elitist because it was not playing out as a well-organized festival. In fact, I think it was exactly the opposite—the best projects had a substantial life of their own in the communities where they operated, but were not meeting the expectations of the art world. Looking back, I'm impressed by so much of the work that was done for inSITE2000-2001; however, organizationally, it was a very painful experience.

Carmen Cuenca/ Throughout the process, I had to contend with a lot of negative reactions from the Mexican side. It didn't start in 2000; we already experienced it in 1997, regarding the travel project by Francis Alÿs. But that kind of response was very strong around 2000. They found it hard to understand the art and equally hard to accept why we would invite artists from all over the world, or at least from so many different places. They were hoping that **inSite** would be more locally based and focused on supporting artists from the region. Adhering to that premise, they would constantly ask, "Why not spend money instead only for our own artists instead of doing this for, or with, international artists?" And outside of the board, one would hear similar resentment from local artists: "Why am I not participating?" So the Mexican side of the board faced a lot of pressure.

Michael Krichman/ On all sides, there was a fair amount of wound-licking at the end of inSITE2000-2001. We took a long time with the catalogue, an important way of framing the experience, and we commissioned one of the inSITE2000-2001 curators, Osvaldo Sánchez, to act as editor. It was through the extended process of preparing the catalogue that we began to initiate discussions about what would make sense as a next step. What would it look like? What would be a real contribution? Is there a real reason to do it again? What's left on the table to work with? To pursue?

inSite_05 and Beyond

Sally Stein/ Now that **inSite_05** has ended, how would you characterize the major changes affecting **inSite**'s operations since 2000?

Michael Krichman/ We might as well start with the most obvious political ones. By the end of 2000 more conservative parties were in power in both countries. During the first half of 2001 it looked like presidents Fox and Bush might reach some new agreements on immigration, although that vanished from the horizon following 9/11. More immediately, the national change in power from PRI to PAN had enormous implications for us in Mexico. We had been unusually fortunate in having Gerardo Estrada and his team retain their positions over the last two PRI administrations. After being able to count on their memory, trust, and support of our ongoing work, all of a sudden everybody that we had been dealing with for more than six years was gone. On the US side, after 9/11 and the ensuing "war on terror," we, like everyone

else, had no idea how things would be curtailed, censored, self-censored. At the most practical level, we figured that there would be difficulty in obtaining permissions. Sometimes we encountered fewer obstacles than we expected. Amazingly, we succeeded in obtaining permissions to shoot a human cannonball across the border as part of a larger project by Javier Téllez. The brilliance of the piece is a bit like ERRE's horse, including a sort of spectacle so out of the ordinary that officials did not see it as jeopardizing their everyday systems of control.

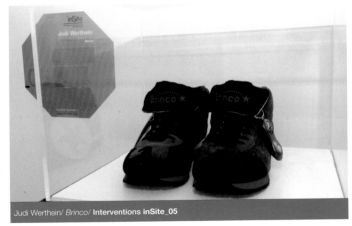

Judi Werthein/ *Brinco*/ **Interventions inSite_05**

Sally Stein/ It must have been equally politically complex, in the case of Carmen's work in Tijuana, arranging all the permissions for the development of the park by Thomas Glassford and Jose Parral just south of the border fence at Playas de Tijuana.

Carmen Cuenca/ That work of beachfront urban renewal represents **inSite**'s first permanent intervention. It's taken many years but I've learned how to be a good player in the political waters, finding ways to establish common points of interest in order to achieve what needs to be done in order for the projects to be fully realized.

Michael Krichman/ After inSITE2000-2001 we also rethought the participation of local artists. There's always been a balancing act of artists from outside and from the area, which leaves us repeatedly questioning whether the balance struck is fair. While that is never resolved, this time the curators insisted on treating local artists in the same way as artists from outside the area by ensuring that they too undertook artists' residencies. We've tended to assume that artists based in this area can be flexible in accommodating us, but in a lot of ways they have the least amount of time because they're here doing what they otherwise do.

Carmen Cuenca/ Itzel Martínez de Cañizo's video pieces for **Interventions**, *Que suene la calle* and *Ciudad Recuperación,* attest to how much **inSite** has grown and with it the artistic work in the region. Such a strong controlled statement in her films really caused me to reflect on what has developed over the past ten years in the city, generally, and in the arts.

Sally Stein/ You've alluded to "homeland security," and I must say that I'm really surprised that sector, or else the immigration authorities, didn't intervene around Judi Werthein's work on *Brinco*. Given the considerable press it received, I kept wondering whether the only reason the feds never started hollering was that it coincided with the Katrina hurricane disaster when officials in Washington were too busy defending themselves against charges of racism and incompetence to mount an attack on this work as aiding and abetting illegal migration?

Michael Krichman/ With so much media attention, I am sure they ultimately heard about this project and were not happy about it. We had not asked them for permission to distribute tennis shoes in Tijuana that might be used by undocumented immigrants. There was no jurisdictional issue since the distribution took place in Mexico, and there was no direct connection between the shoes and the non-profits involved. I followed the project closely, and not only for the obvious legal reasons. When an artist with little knowledge of the region's artistic as well as political history comes from outside and quickly seizes upon the topic of immigration, I've learned to advise rather empathically, "you need to first learn about all the artistic practice that has taken place in, around, and about the border,

starting well before **inSite**." Of course, mindful of the controversy around the 1993 *Art Rebate* by Avalos, Sisco and Hock, I wanted to avoid having any public money involved in funding Judy's project, because that issue would only muddy the ramifications of what she really wanted to get at. But more importantly, I didn't want it to be naive. I wanted to make sure that we as an organization, and that Judi as an artist, were really clear about the terms of engagement. One key element of the project was Judi's determination to have the sneakers manufactured in China and prominently labeled as such. As capital follows labor around the world, the local industrial jobs inevitably vanish. Her piece raised issues for both sides of the border, challenging Tijuana's specious boosterism of its thriving economy and the fallacies underlying the current debate about immigration. Wodiczko and others have dealt brilliantly with these issues for many years, yet Judi addressed it in a different medium and register. In the end it was neither repetitive nor pretentious.

Sally Stein/ I've been conducting these conversations in the San Diego office of **inSite** where there's lots of activity in various corners, but my eyes keep being diverted to one area where there's a sizable collection of storage boxes. What's in them?

Carmen Cuenca/ It's our history. We have been trying to organize it into an archive. There is a lot of history packed into those boxes. Each set of files for a project contains a story, actually many stories. Here are the artifacts, the evidence on paper, of what one needed to do before something—each project—happened. When not so long ago we moved to this office, we decided to organize the records systematically, including two or three boxes relating to Installation Gallery from the years before **inSite**, which I rescued from storage.

Sally Stein/ Have you thought about depositing them in a library?

Carmen Cuenca/ We have not decided yet. Personally, I would love to develop an archive center of information. If we keep it here as part of our office operation, outsiders can come to study it and so can we. These are important records that will help us to remember how we developed things in the past, even as we keep changing

Sally Stein *is a writer and curator currently serving as associate professor of Art History at the University of California, Irvine. She is based in Los Angeles.*

Entrevista

UNA MIRADA RETROSPECTIVA Y HACIA ADELANTE: CONVERSACIÓN PRELIMINAR E HISTÓRICA SOBRE inSite
Sally Stein

Ojalá y algún día no muy lejano, alguien sea lo bastante ambicioso como para examinar las innumerables perspectivas sobre la manera en que surgió inSite *y cómo se desarrolló. En forma ideal, semejante proyecto debería incluir docenas de entrevistas a los directores, integrantes del consejo directivo, curadores, artistas y críticos y, quizás incluso, a algunos políticos. Los efectos que se producirían, de manera inevitable oscilarían entre cierto tipo de armonía y, por decir lo menos, el mismo volumen de disonancia, pues ¿qué más podría esperarse de una crónica referente a la colaboración cultural sin precedente entre instituciones y países, que aquella que se desarrolló por etapas y de forma cabalmente consciente, sobre la base dialogística de aprender de los juicios, los errores y los éxitos?*

Para comenzar, Osvaldo Sánchez, director artístico de inSite_05, *me invitó —a mí que he sido una seguidora de* inSite *desde tiempo atrás— a viajar desde Los Ángeles con el fin de entrevistar a los dos directores ejecutivos, Michael Krichman y Carmen Cuenca. Ciñéndome a su apretada agenda, el día que me presenté en las oficinas, ubicadas en el centro de San Diego, a finales de marzo de este año, la misma semana en que las protestas regionales en contra de las actuales políticas de inmigración comenzaron a extenderse de manera espontánea, tanto Carmen como Michael tenían tal cantidad de citas en ambos lados de la frontera que no logramos empatar los tiempos para sentarnos a conversar los tres juntos. Por ello, el siguiente texto representa un entramado de entrevistas grabadas y realizadas por separado a lo largo de dos días, mismas que con posterioridad fueron transcritas heroicamente por el equipo de* inSite.

Sally Stein/ Desde 1992 he acudido a los eventos presentados por **inSite**; sin embargo, tras cerca de 15 años me doy cuenta de que desconozco cómo se ha desarrollado esta singular matriz de acontecimientos artísticos y culturales en este cruce de fronteras. Como preámbulo a todo ello quiero comenzar por conocer a qué se dedicaban en su vida profesional cuando decidieron incorporarse a **inSite**.

Michael Krichman/ Regresé a San Diego en 1985, ciudad en la que no había radicado en 16 años. Aunque comencé a trabajar en el departamento de asuntos ambientales de una firma local de abogados, pronto me percaté de que me interesaba más el arte contemporáneo. De manera voluntaria había estado colaborando con el Museo de Arte Contemporáneo y, mientras lo hacía, trabé amistad con Mark Quint. En la época en que el muro de Berlín fue derribado, Mark y yo decidimos viajar a Europa del Este a fin de averiguar qué estaba sucediendo allá en lo relativo al arte y los artistas. En 1990, solicité una licencia en mi trabajo y abandoné la firma; fue en ese entonces cuando Mark y yo iniciamos lo que se convertiría en la empresa Quint Krichman Projects. Después de pasar una larga temporada en Polonia, regresamos con la idea de crear un programa de residencias que esperábamos produjera obras artísticas vendibles, para así convertirlo en autofinanciable. Rentamos una casa,

además de un espacio que utilizaríamos como estudio, allanándoles de esta forma el camino a los artistas para que tuvieran la posibilidad de crear nuevas obras. Quint Krichman Projects funcionó hasta 1993. Desde principios de 1992, Mark empezó a trabajar con Installation Gallery, espacio dirigido por personas involucradas con el arte que comenzó a operar en los inicios de la década de los ochenta, pero, para principios del siguiente decenio, esta organización estaba casi agonizando. Randy Robbins, presidente de dicho espacio en esa época y quien aún forma parte de nuestro consejo directivo, creó un grupo de asesores, entre ellos, Mark Quint, Sally Yard y Ernie Silva, por sólo mencionar algunos, del cual yo no me formé parte. Su tarea consistía en decidir qué hacer con la galería, y de ahí surgieron ideas tan disímbolas que iban desde "reunamos 100 millones de dólares y abramos un nuevo museo" hasta "cerremos la galería, que ya pasó a mejor vida".

Creo que a Mark se le ocurrió no sólo la idea inicial de crear **inSite**, sino también el nombre del organismo, el cual le vino a la mente cuando tomaba una ducha. En múltiples casos, mucho tiene que ver cómo se inicia una organización para saber en qué se convertirá, por lo cual vale la pena recordar que **inSite** comenzó en realidad como una idea modesta en respuesta a lo que Mark y Ernie veían como los problemas fundamentales que experimentaba San Diego: se contaba con un panorama de instituciones culturales, universidades y escuelas universitarias, múltiples museos, etc., pero se carecía de un centro cultural. La institución más prominente de arte contemporáneo de la ciudad, el Museo de Arte Contemporáneo, era muy pequeña, y el Museo de Arte de San Diego, aunque de mayores dimensiones, no resultaba uno de los sitios más excitantes en aquellos años. El desafío más evidente que se planteaba consistía en cómo estimular la energía de la entonces práctica artística común, la instalación y la obra específica de sitio, defendidas por gran número de instituciones pequeñas. La idea original de Mark era observar qué se obtendría si cada organización de artes visuales no lucrativa de la zona aceptaba patrocinar nuevas obras relacionadas entre sí, las cuales se exhibirían al mismo tiempo en el mes de octubre. En pocas palabras, esa constituyó la base para la creación de IN/SITE'92, y la publicación resultante fue un folleto modesto, que contradecía la extraordinaria coordinación regional llevada a cabo por Mark y Ernie. El que sus esfuerzos hayan tenido éxito, quizá también refleja cuan débil era la situación cultural local; imagina las maniobras que se producirían entre las principales instituciones, si intentaras realizar esto mismo en Los Ángeles; sin embargo, en San Diego, a todo mundo le pareció una buena idea. El presupuesto total que se tuvo para llevar a cabo IN/SITE'92 creo que fue cercano a los 3,500 dólares, y ese gran total incluía algunos pequeños pagos para facilitar la puesta en marcha de diversos proyectos.

En ese entonces, yo me encontraba al margen de **inSite**, y México estaba en la misma situación, ya que pocos artistas realizaban algunos trabajos en aquella ciudad, en especial Kim McConnell y Jean Lowe, quienes crearon una pieza en la Casa de la Cultura, y hasta ahí llegaba la participación artística de este país. Sin embargo, IN/SITE'92 resultó ser un ejercicio interesante en varios niveles, y acaparó enorme atención pública, gracias al sorprendente número de escritores locales dedicados al arte. En esos años, San Diego contaba con dos periódicos, el *Union* y el *Tribune*, y cada uno de ellos tenía su propio crítico de arte; además, existía también la edición sandieguina del diario *Los Angeles Times*, en el que Leah Ollman publicaba sus reseñas. Como resultado de lo anterior, la primera muestra de **inSite** produjo una cantidad excesiva de tinta.

Fue luego de ese debut cuando realmente me incorporé al proyecto. Installation Gallery afrontaba serios problemas, pues en su consejo directivo sólo permanecían algunos de los miembros más osados; además carecía de recursos y no tenía base alguna de apoyo. Pocos años antes, la ciudad de San Diego le había retirado el financiamiento, luego de que dicho espacio se había desempeñado como agente fiscal de un proyecto muy controvertido, creado por David Ávalos, Elizabeth Cisco y Louis Hock. En comparación con muchas de las obras producidas por **inSite** desde aquel entonces, el mencionado proyecto resulta ahora sumamente moderado, pero en 1987 provocó tal controversia que la galería fue puesta en la lista negra de las comisiones de Arte y Cultura de San Diego y de Arte de California. Para empeorar las cosas, durante varios años dicha galería no había presentado los informes financieros, tal y como lo exigía el National Endowment for the Arts y el Internal Revenue Service (IRS por sus siglas en inglés).

Mientras apelaba ante el IRS y resolvía algunos asuntos legales, comencé también a formar parte del pequeño grupo que trataba de decidir lo que podría hacerse con esa organización casi difunta. En un momento dado, casi llegamos a la conclusión de que no valía la pena conservar la galería, con todo su bagaje, y creo que la única razón para mantenerla a flote fue con el propósito de conseguir financiamiento, ya que para solicitar subsidios era preciso formar parte de un organismo que hubiera. Contábamos, pues, con esta organización sin fines de lucro que apenas se iniciaba, y empezamos a considerar que resultaría muy interesante extender **inSite** a toda la región de Tijuana San Diego. Resulta difícil

imaginar que pudiéramos haber sido tan ignorantes respecto a la escena cultural de México y a su funcionamiento. ¿Qué era el Centro Cultural Tijuana (CECUT)? Todos pensábamos que se trataba de un museo, y para dar mayor prueba de nuestra ingenuidad, está el hecho de que en el folleto que editamos para IN/SITE'92, el diseñador gráfico pensó que la palabra Tijuana se vería mejor si se acentuaba la "i", y ¡ninguno de quienes revisaron las planas hizo algún señalamiento en contra!

Cuando empezamos a planear otro proyecto conjunto fui nombrado presidente del consejo directivo de **inSite**. En ese entonces, el Museo de Arte Contemporáneo era uno de los principales copartícipes del proyecto, y Lynda Forsha eventualmente dejó su puesto de curadora en dicha institución para hacerse cargo de la dirección de inSITE'94.

Un momento definitorio en el proceso de planeación surgió cuando nos acercamos por vez primera a Pedro Ochoa, director en aquel entonces del CECUT, y viajé a esa ciudad en compañía de José Tasende, galerista de La Jolla, y de Jorge Hinojosa, activista radicado en Tijuana, quien resultó ser un enlace fundamental para poder llevar a cabo las instalaciones. Presentamos nuestro plan general y pusimos sobre la mesa nuestro deseo de que las instituciones de México contribuyeran en hacer de éste un proyecto cultural binacional. "Suena estupendo", dijo Pedro, "pero dicho proyecto es demasiado extenso para manejarlo yo solo; tenemos que hablar con el director del Instituto Nacional de Bellas Artes (INBA), Gerardo Estrada". Sobre esa base, Lynda, quien en esa época se desempeñaba como enlace del proyecto por parte del Museo de Arte Contemporáneo, José y yo volamos a la Ciudad de México para asistir a una reunión. Después de esperar día y medio, nos encontramos con Gerardo y en cuatro minutos le presentamos nuestra idea de realizar las instalaciones en el otoño de 1994 con la participación de múltiples instituciones que solicitarían la creación por encargo de obras específicas de sitio. Estrada de inmediato dijo: "Grandioso, ¡hagámoslo!" Con esta respuesta concluyó la brevísima reunión y nos hicieron salir por una puerta distinta a la que entramos.

Quién sabe qué tanto comprendió Gerardo nuestra breve propuesta o qué pensó acerca del compromiso que estaba adquiriendo. Sin duda, Estrada es un hombre inteligente y tiene su propia historia como activista; en efecto, durante el movimiento estudiantil de 1968 en la Ciudad de México, él fue el encargado de presentar ante las autoridades gubernamentales las demandas estudiantiles. Años después desempeñó el cargo de director del Programa Cultural de las Fronteras, que se ocupaba de las zonas ubicadas en la línea divisoria del norte de la República Mexicana, y creó una estación radiofónica dedicada a transmitir música de los nuevos grupos norteños; sin embargo, en aquel entonces no estaba muy familiarizado con las artes visuales contemporáneas. No obstante, gran parte de nuestro desarrollo subsecuente giró en torno a la respuesta admirablemente positiva de Gerardo, quien continuó respaldando el proyecto, mediante un mandato federal de apoyo institucional. Sea lo que fuere lo que haya pensado acerca del compromiso que estaba adquiriendo con nosotros, luego de la reunión antes referida reestructuramos nuestro consejo directivo, y Gerardo designó a Walther Boelsterly, quien estuvo muy involucrado en el desarrollo de **inSite** durante todo el año 2000, para que fungiera como su enlace, además de mantenerse al pendiente del desenvolvimiento de los planes.

Nuestros crecientes puntos de contacto hicieron que la estructura creada para inSITE'94 se volviera aún más compleja, involucrando a cerca de 38 instituciones, entre las cuales se encontraban el INBA, representado por el Centro Cultural Tijuana, el Museum of Contemporary Art, el San Diego Museum of Art, el Centro Cultural de la Raza, la galería de arte del Mesa College, por mencionar unas cuantas, y cada una de ellas patrocinaba al menos una obra de arte. Como un control y con el propósito de evitar una descentralización total, creamos un panel semiautónomo de revisión curatorial, que por supuesto produjo nuevas tensiones, a medida que las organizaciones pequeñas, como el Centro Cultural de la Raza, comparaban los recursos de que disponían con los de otros organismos de mayor importancia, como el Museo de Arte Contemporáneo, ya que desconfiaban del proyecto y pensaban que éste era una conspiración dirigida a apropiarse las prácticas artísticas relacionadas con la frontera. Al menos estas fricciones locales nos eran familiares y por la misma razón resultaban predecibles; pero cuando decidimos trabajar en forma binacional nos encontramos en territorio desconocido. Quienes estábamos del lado estadounidense, entendíamos poco acerca de la forma como operaban las instituciones mexicanas, pues en San Diego comprendíamos con dificultad los espinosos asuntos de poder asociados con la cultura en México. Por supuesto, al interior de dicho país apenas estaban surgiendo las fisuras y divisiones partidistas entre el INBA, controlado por el Partido Revolucionario Institucional (PRI) en el nivel gobierno federal (el cual manejaba mejor los recursos y tenía mayor experiencia), y las instituciones que representaban al Instituto, dependientes del Partido Acción Nacional (PAN), tanto en Tijuana como en toda la parte norte de la península, primera entidad mexicana gobernada por la oposición. En cada uno de los niveles de gobierno, incluso en el de la publicidad, se presentaba un número considerable de maniobras partidistas entre

los patrocinadores institucionales, y por supuesto existía una enorme desconfianza sobre cualquier asunto que se generara allende la frontera.

Sally Stein/ Antes de continuar, quisiera que Carmen me hablara sobre las actividades que realizaba antes de integrarse a inSITE'94.

Carmen Cuenca/ Tras obtener un grado en historia del arte por la Universidad Iberoamericana y trabajar durante nueve años en el Departamento de Exposiciones y Documentación del Museo de San Carlos en la Ciudad de México, en 1989 decidí, por razones familiares, irme a radicar a Tijuana con mis dos hijas. Hasta ese momento, esta ciudad era tan sólo un punto de referencia en relación con San Diego, lugar a donde mi familia solía viajar durante las vacaciones y, por lo tanto, trasladarme a Tijuana implicó crear una vida totalmente distinta a la que llevaba en el Distrito Federal. Resulta muy importante considerar que en 1989 Tijuana se encontraba en un estado de transición sin precedente, ya que tanto ésta al igual que la entidad rompieron con el arraigado poder del PRI, luego de la primera elección a gobernador de un político panista, Ernesto Ruffo Appel, ex-alcalde de Ensenada. Habiendo fungido con anterioridad como correo para el transporte de una muestra proveniente de la Ciudad de México y dirigida al Centro Cultural Tijuana, mi primer plan fue pensar en este Centro como punto de referencia. Pero entre marzo de 1989 —cuando llegué a Tijuana— y septiembre del mismo año, también decidí hacerme cargo de una galería ceremonial ubicada en Las Torres de Tijuana. Fui a ver al director del Centro y me presenté ante él como historiadora del arte, con antecedentes en estudios museográficos, y éste me invitó a colaborar con ellos. Así, entre 1989 y 1994 dirigí la galería, al tiempo que desempeñaba diversas tareas en el Centro Cultural Tijuana.

En 1992, escuché hablar por vez primera de **inSite**, cuando Mark Quint se puso en contacto conmigo, considerando el compromiso que adquirí con la galería respecto al arte contemporáneo y mi experiencia laboral en el Centro Cultural Tijuana. En 1993 me involucré más en dicho proyecto cuando apenas se iniciaba la planeación de inSITE'94. Con posterioridad, Michael Krichman se reunió con Pedro Ochoa, director del CECUT, quien en pocas palabras me planteó: "Hay un gringo loco diciendo que deberíamos montar una muestra de instalación y de arte específico de sitio. ¿Qué demonios es eso?" En ese momento me nombró como enlace del CECUT para el proyecto, y comencé a formar parte del equipo que laboraba en inSITE'94, trabajando desde el Centro Cultural Tijuana.

Michael Krichman era el representante más importante de San Diego y parte de su labor consistía en crear contactos del lado mexicano. Tuve que explicarle que en ese entonces no contábamos con curadores en Tijuana o con directores de instituciones artísticas, en la forma como se conocen en los Estados Unidos. Aclarar las diferencias resultaba fundamental, porque en el modelo básico que se seguiría para la realización de inSITE'94 debían intervenir múltiples instituciones que tendrían a su cargo la selección de los artistas, pero, además, debían otorgarles financiamiento para realizar su obra. No sería sencillo aplicar tal modelo en la colaboración que se intentaba iniciar con México, porque en Tijuana carecíamos de museos de arte, galerías universitarias, y también de persona alguna cuya definición laboral tuviera el perfil de curador o de director de museo, es decir, nadie con autoridad cultural comparable a la de Sally Yard, por mencionar un nombre, quien formaba parte del grupo curatorial que intervendría en inSITE'94. No obstante, dados mis antecedentes en el trabajo museográfico y los vínculos que había creado en la Ciudad de México y en el INBA, parecía lógico que asumiera la responsabilidad de representar a la región en este novel esfuerzo de colaboración. Sin embargo, con celeridad busqué incorporar al proyecto a numerosas instituciones y organicé un comité en Baja California.

Sally Stein/ ¿Quiénes formaban parte del comité que organizaste en 1993 para la realización de inSITE'94?

Carmen Cuenca/ El Centro Cultural Tijuana era la única institución federal apoyada por el PRI en Baja California, por lo que resultaba aún más importante incorporar voces y perspectivas distintas provenientes de representantes de las ciudades locales si lo que se buscaba era alcanzar un objetivo de participación real. Por lo tanto, además del director del CECUT, también incluí a algunos funcionarios de la Casa de la Cultura de Altamira, para representar a la ciudad de Tijuana; del Instituto de Cultura de Baja California y de El Colegio de la Frontera Norte. Dicho comité intentó operar como si se tratara de un jurado curatorial, comenzando por hacer un llamado abierto a fin de presentar ideas de proyectos realizados por artistas visuales de Ensenada, Mexicali, Tijuana y Tecate. Entonces no sabíamos a quién podría interesarle o quién estaría capacitado para llevar a cabo una instalación o una obra

específica de sitio, dado que en la región nadie desarrollaba este tipo de actividad. En lo que respecta a una búsqueda más amplia, inicialmente adoptamos este proyecto por su potencial como colaboración política por parte de las instituciones públicas que carecían de financiamiento o de la experiencia para llevar a cabo semejante actividad artística innovadora. Nuestro comité redujo el número de propuestas a 22, y luego sometí los trabajos seleccionados a la consideración de otro grupo de curadores pertenecientes a la Stuart Collection de la Universidad de California en San Diego, el Museum of Contemporary Art, el San Diego Museum of Art, y el Museum of Natural History, entre otros. Este proceso desembocó en la selección final de nueve artistas de la región de Baja California. Entre ellos surgió de manera inesperada un completo desconocido, Marcos Ramírez ERRE, cuya obra denominada *Century 21*, choza que construyó en la plaza del CECUT, tuvo un gran efecto para **inSite**, al igual que para la escena artística de Tijuana, y para su propia carrera.

Michael Krichman/ Esa fue una de las primeras apuestas que de verdad resultó redituable. Marcos Ramírez se presentó con una caja de zapatos en las manos para dar a conocer el modelo que proponía para *Century 21*. Todos lo aceptamos, aun cuando en realidad nadie podía imaginar qué resultaría de ello. Así, inSITE'94 acabó siendo una especie de ámbito libre-para-todos, con algunos proyectos muy interesantes como el mencionado *Century 21*, y otros no tanto. Sin embargo, mientras que quienes estábamos en San Diego andábamos con pies de plomo, cabe hacer notar que no teníamos monopolio alguno de la ceguera en lo que respecta a la emergente escena artística mexicana. Recuerdo que como parte de su búsqueda de artistas mexicanos a quienes la propia Installation Gallery les solicitaría obra por encargo, Lynda Forsha se puso en contacto con Robert Litman, quien en aquel entonces era director del Centro Cultural Arte Contemporáneo Televisa, en la Ciudad de México. En respuesta a su petición, Litman le escribió, asegurando que únicamente había un solo artista en el que pudiera pensarse para realizar obra en este contexto, Silvia Gruner; ni siquiera mencionó a Gabriel Orozco. La propia Silvia fue quien nos dio el mejor consejo, y quizá por ella nos enteramos de la existencia de un grupo de creadores, quienes trabajaban en la parte exterior de una casa ubicada en la calle Temístocles de la Ciudad de México. Me dirigí allí y conocí a Eduardo Abaroa, Daniela Rosell, Sofía Táboas, Abraham Cruzvillegas, Diego Gutiérrez y Pablo Vargas Lugo, entre otros. De regreso en San Diego convencí a Kathleen Stoughton, curadora de la galería del Mesa College, de que enviara a cada uno de ellos un boleto de avión y mil dólares para elaborar una nueva pieza en la Casa de la Cultura de Tijuana. Hasta ese momento, las autoridades oficiales de México jamás habían apoyado a estos artistas.

Asimismo, comenzamos a establecer contacto con un grupo de historiadores del arte en la Ciudad de México, quienes ya habían surgido como una nueva e importante fuerza cultural, pero aún se encontraban muy por debajo del radar oficial. Me refiero a Olivier Debroise, Cuauhtémoc Medina y el grupo que trabajaba en Curare. Oí hablar de Olivier, no en México, sino más bien en Nueva York, cuando me reuní con Tomás Ybarra-Frausto en la Fundación Rockefeller, antes de la puesta en marcha de inSITE'94. Después de darle a conocer nuestros planes, me preguntó claramente: "¿Acaso tienes idea de lo que estás haciendo, sabes en dónde estás parado o en qué sistema vas a operar?" Sin embargo, su comentario no fue desalentador y de hecho me proporcionó una valiosísima pista al sugerirme que de verdad teníamos que conocer a Olivier Debroise, figura central de Curare, grupo independiente de académicos y críticos que había solicitado un subsidio a la Fundación Rockefeller, mismo que le fue concedido. Para cuando inSITE'94 arrancó, Debroise mostró sumo interés en observar cómo se había desarrollado el proyecto, y luego le pedimos a él y a su colaborador cercano, Cuauhtémoc Medina, que escribieran un texto para el catálogo.

Sally Stein/ El proceso en sí suena como pura improvisación.

Carmen Cuenca/ ¡Así es! Además de una gran desorganización, existía una activa improvisación. Los desafíos que afrontaba **inSite** eran considerables, dado los recursos con los que contábamos y la casi total falta de experiencia, que iba desde conseguir financiamiento hasta ocuparnos de los viajes y actividades de los artistas, aprender cómo interactuar con los medios y, de manera más decisiva, cómo trabajar con dos sistemas de producción cultural diametralmente distintos y con la política que intervenía en cada uno de ellos. En muchas formas fueron tiempos de locura. Seis meses antes de la inauguración, en marzo de 1994, Luis Donaldo Colosio, candidato presidencial del PRI, fue asesinado en Tijuana mientras realizaba un acto de campaña, y a raíz de esto la luz de los reflectores se centró en mostrar la corrupción, la violencia y el tráfico de estupefacientes, situación que en poco ayudó a la imagen que se tenía de la ciudad.

Sally Stein/ ¿Ese acontecimiento hizo de Tijuana el "Dallas" de México?

Carmen Cuenca/ En diferentes niveles, dicho acontecimiento precipitó una enorme crisis y causó gran confusión. En primer lugar, luego del asesinato, Pedro Ochoa asumió un nuevo cargo político, dejando al CECUT sin director. Por lo tanto la responsabilidad de ser el principal contacto entre **inSite**, el Centro y el INBA recayó en mí, y ello ocurrió en los meses cruciales que antecedieron a la inauguración de **inSite**. En ese momento se me ofreció el puesto de agregada cultural del Cónsul de México en San Diego, cargo oficial que me ayudó muchísimo en lo que respecta a la obtención de los diversos permisos que debían tramitarse para los artistas, cuyos proyectos se realizarían en Tijuana. Trabajé muy de cerca con Walter Boelsterly, quien se ocupaba de vigilar la construcción de gran parte de los proyectos financiados por el INBA. En el contexto de Tijuana, que en aquel tiempo todavía era una ciudad pequeña —ya que a lo largo de los últimos 12 años ha crecido 300% más— con recursos culturales limitados y sin contar con casi ningún profesional de la cultura, resultó sumamente satisfactorio observar cómo todo se desarrolló de acuerdo con los planes llevados a cabo en el CECUT. Por supuesto, la atención de algunos medios se centraba más en la continua crisis política y económica de México que en las obras que se presentaban. El otro elemento controvertido fue el Tratado de Libre Comercio, suscrito en 1994, que obligó a los gobiernos y a sus economías a confrontarse, así como también a hacer frente al gran proceso de globalización. Las obras presentadas en inSITE'94 se vieron oscurecidas por estas enormes incertidumbres; sin embargo, muchas de ellas también guardaron cierta resonancia con estos temas. En 1995, asumí el cargo de codirectora de tiempo completo para el proyecto de inSITE'97.

La reestructuración de inSite para 1997

Sally Stein/ A pesar del éxito y los efectos obtenidos en 1994, no siguieron el modelo de bienal y llevaron a cabo un nuevo proyecto de **inSite** dos años más tarde, y para cuando presentaron inSITE'97 habían realizado cambios muy importantes en la totalidad de la estructura básica de la operación. ¿Cómo decidieron tales cambios?

Carmen Cuenca/ De hecho, cuando concluyó inSITE'94, una de las primeras propuestas que recibimos de nuestra contraparte mexicana fue la idea de realizar una bienal. Algunos de nuestros mayores patrocinadores estaban ansiosos por volver a participar en un acontecimiento semejante sin tener que esperar demasiado tiempo. Entonces este hecho resultaba de gran relevancia, pues, a pesar de la transición presidencial mexicana, que ocurre cada seis años, muchos de los funcionarios culturales de la administración anterior mantuvieron sus puestos en el gobierno, y ello proporcionó el fundamento para seguir avanzando con el proyecto, porque en vez de comenzar a presentar un esbozo acerca de este último a los nuevos funcionarios, personajes bien situados, como Gerardo Estrada y su equipo, entre ellos Walter Boelsterly, Antonio Vallejo y Claudia Walls, ya se encontraban comprometidos con él.

Michael Krichman/ La preparación de inSITE'97 fue un asunto completamente distinto, debido a que nuestro objetivo se dirigía a tener una idea mucho más clara sobre cómo podríamos hacer un proyecto más distintivo y sobre todo más significativo para la región. Antes que nada, luego de que la algarabía inicial concluyó, Sally Yard, Carmen y yo comenzamos a sostener largas pláticas con los representantes de las instituciones participantes, a fin de ver quién continuar colaborando con nosotros, y si tal fuera el caso, en qué forma lo harían. Las de menor tamaño nos informaron que su participación les había generado una carga impositiva demasiado elevada, tomando en consideración los recursos limitados con que contaban. Y estaban en lo correcto. Existía una enorme disparidad entre lo que el Museum of Contemporary Art podía realizar por cuenta propia, encargándole a Nancy Rubins la creación de una importante pieza para su edificio, y los recursos de que podía disponer la Athenaeum Music & Arts Library, ya no se diga la Casa de la Cultura de Tijuana. El resultado del análisis que llevamos a cabo fue que si **inSite** de nueva cuenta volviera a trabajar con un espectro tan diverso de instituciones, cada una de ellas debería sentir que se estaba beneficiando con la colaboración, en lugar de considerarla como una carga.

El momento definitorio se dio cuando le propusimos el proyecto de inSITE'97 al Museum of Contemporary Art, mismo que había desempeñado un papel de liderazgo en 1994. Dicha institución se encontraba realizando la remodelación de sus instalaciones en La Jolla, y por ello decidió, aunque estoy convencido de que también por otras razones, que no podría participar en ningún otro evento organizado por **inSite** sino, por lo menos, hasta 1998. El museo había sido un importante socio de los proyectos IN/SITE'92 e inSITE'94, pero, debido a su relevancia, hubiera resultado muy complejo crear una estructura curatorial centralizada para **inSite**, que no incluyera al equipo curatorial del propio Museum of Contemporary Art o girara a su alrededor. De muchas maneras, la decisión de no participar en el proyecto que

se preparaba para 1997 allanó el camino para la reestructuración total de **inSite**. La Installation Gallery y el INBA estuvieron de acuerdo en trabajar con **inSite** como socios institucionales igualitarios, quedando yo como director para los Estados Unidos y Carmen como la directora para México. Una vez que esto quedó establecido colaboramos con Sally Yard para decidir el equipo curatorial de ensueño que reuniríamos para la preparación de inSITE'97, y éste estuvo conformado por Sally Yard, Olivier Debroise, Ivo Mesquita y Jessica Bradley.

Carmen Cuenca/ Con Sally, de los Estados Unidos, Olivier, radicado en México, Ivo, de Brasil, y Jessica, de Canadá, el equipo de curadores analizó las perspectivas y la información existente sobre artistas provenientes de todo el hemisferio. Y, así, comenzando con un diálogo a lo largo de toda América, podríamos enfocarnos luego en las particularidades concretas de esta esquina del continente que es específica para la geografía local inmediata de **inSite**.

Se invitó a los curadores a que iniciaran sus trabajos desde sus propios lugares de residencia, y muy pronto dichos sitios se convirtieron en el centro de todo el proyecto. Con los cambios ocurridos en **inSite**, que pasó de ser un organismo en el que intervenían múltiples instituciones para transformarse en una organización binacional independiente, con una administración consolidada que contaba con su propio equipo y presupuesto, pudimos hacer de las residencias artísticas una prioridad básica; primero para los curadores y luego para los artistas seleccionados por ellos a fin de que participaran en el proyecto. Nuestro trabajo consistía, pues, en organizar dichas residencias y en asegurarnos de que el presupuesto con que contábamos pudiera respaldar la extensa labor que desarrollarían en la región.

Michael Krichman/ Participar en inSITE'97 con esta nueva estructura trajo consigo innumerables desafíos. Al asociarnos con el INBA, pronto nos dimos cuenta de que necesitábamos precisar en un contrato algunos puntos básicos, el más importante entre ellos era el hecho de tener un grupo curatorial con absoluta autonomía creativa. Establecer lo anterior con el Instituto no resultó ser tarea fácil, debido a que habíamos seleccionado a un grupo de curadores totalmente independientes. Olivier, por ejemplo, no había trabajado en dependencia pública alguna, por lo menos desde el inicio de Curare, e insistía en forma incontrovertible en no ser contratado por el INBA. A pesar de las tensiones que esto provocaba, pudimos mantener la posición que habíamos adoptado, en parte porque la política en la escena cultural de México estaba cambiando de manera tal que se acoplaba a ella. En mi opinión, el periodo transcurrido entre 1995 y el año 2000 significó una nueva era para los museos y el arte contemporáneo de ese país. Por vez primera, la élite mexicana abandonó la tradición de patrocinio y comenzó a seleccionar museos de acuerdo con sus méritos. Resulta difícilmente una coincidencia que en esos mismos años este grupo interesantísimo de jóvenes artistas mexicanos, que buscaban crearse una reputación internacional (con el apoyo gubernamental y sin él), fueran invitados a producir diferentes obras en el extranjero, desafiando así el sistema tradicional de patrocinio que de manera previa se aplicaba tanto para las artes como para la política.

Carmen Cuenca/ Si vemos todo este asunto en retrospectiva podemos considerar que el mayor error cometido, desde la perspectiva mexicana, fue que, al comenzar de nueva cuenta, hicimos un trato en el que existiera igualdad en todos los aspectos; sin embargo, del lado mexicano resultó imposible llevar a cabo el plan de financiamiento, sobre la base del 50% para cada una de las partes, luego de que el presupuesto creció hasta alcanzar una cifra cercana al millón de dólares. Esto nos obligó a ser más osados en los esfuerzos que realizábamos para conseguir fondos, y nos impulsó a buscar subsidios por parte de algunas fundaciones mexicanas. No obstante y a final de cuentas, las aportaciones en efectivo provenientes del lado estadounidense fueron mucho mayores, por lo que intentamos justificar tal igualdad, calculando con todo cuidado el apoyo en especie que se proporcionaría en el lado mexicano. Pero, finalmente, aprendimos la lección de que, en términos de financiamiento para **inSite**, los acuerdos binacionales en los que cada parte debía aportar el 50% resultaban poco realistas. Sin embargo, en otros aspectos, el principio de igualdad entre las dos naciones que animó nuestro replanteamiento de **inSite** marcó, en ese entonces, una gran diferencia. Durante este periodo, como parte de todo el proceso, comenzamos a desarrollar programas educativos con Néstor García Canclini y Manuel Valenzuela, de El Colegio de la Frontera Norte, académicos muy prominentes de la cultura mexicana, quienes nos visitaron y examinaron todo lo que llevábamos a cabo y entablaron un diálogo con los artistas.

Michael Krichman/ Asimismo surgió un número reducido de actividades educativas no formales, en gran medida gracias al interés mostrado por el grupo curatorial que intervenía en inSITE'97. Casi como precondición para participar en el proyecto, Olivier e Ivo insistieron en que debíamos crear en Tijuana una estructura de talleres para los artistas, aunque sólo hiciéramos eso. En el nivel universitario de dicha ciudad no existía programa alguno de estudios relacionado con el arte. Ante su insistencia, comisionamos a Felipe Ehrenberg para que se trasladara a tal metrópoli a fin de conducir algunos talleres para los jóvenes artistas, mismos que incluirían visitas por parte de Olivier, Ivo, Jessica y Sally. La mayor parte de estas reuniones estaban dirigidas a plantear cuestiones básicas, como, por ejemplo, la manera en que los creadores debían presentar sus obras a los curadores, información práctica, pero no por ello menos valiosa.

Carmen Cuenca/ Muy significativo resultó también que hayamos mantenido nuestra decisión de que todos los artistas participantes en inSITE'97 recibieran los mismos honorarios y contaran con el mismo presupuesto para desarrollar su obra, sin importar de dónde provenían, cuál era su edad o si ya eran reconocidos, situación que jamás se dio en inSITE'94.

Michael Krichman/ Lo anterior ocurrió cuando nos encontrábamos revisando todo el proceso, al igual que las ideas respecto a la eficacia de la práctica cultural. Por supuesto, la otra fuente de tales ideas provenía de los nuevos proyectos que nos entusiasmaba ver desarrollarse al interior de nuestra organización. Desde que trabajé en inSITE'94 he aprendido que ciertos proyectos de determinada muestra de **inSite** acaban por proporcionarnos algunas claves o guías de lo que buscamos realizar con posterioridad. En este aspecto, los proyectos presentados por Silvia Gruner y Ulf Rollof en inSITE'94 ejercieron gran influencia, y no se trata de emitir un juicio absoluto acerca de que dichas obras fueron las "mejores". La pieza creada por Nancy Rubin para el Museum of Contemporary Art constituye un hermoso ejemplo de los trabajos que realiza para gran multiplicidad de sitios, que guarda una relación específica con el entorno inmediato. En contrapartida, las piezas de Rollof y Gruner sobresalieron y realmente adquirieron resonancia dentro de nuestra organización durante un largo periodo, porque no fueron presentadas como si se tratara de manifestaciones artísticas concluyentes, sino más bien parecería que eran piezas relacionadas con el proceso de investigación conformado por una experiencia planteada en forma de cuestionamiento o preguntas, más que ilustrar una respuesta.

Buscábamos cultivar el trabajo que se generaba a lo largo de estas líneas exploratorias abiertas, y junto con los curadores formulamos no sólo el proyecto de residencias artísticas, sino también la idea de reunir a los creadores con el propósito de que realizaran un viaje de reconocimiento en la región, al tiempo que participaban en una serie de discusiones introductorias. Así, programamos para ellos una estadía de entre ocho y diez días en San Diego, para luego dirigirnos a Tijuana, y durante ese lapso celebramos reuniones con el fin de que los artistas pudieran mostrarse sus obras e intercambiaran algunas reflexiones iniciales acerca de lo que estaban percibiendo.

Mientras organizábamos el programa para inSITE'97, y siempre mediante un diálogo fundamental con los curadores, comenzamos a ampliar nuestro concepto relativo al espectro de prácticas artísticas que resultaba importante apoyar. Es decir, había que alejarse de las nociones tradicionales de sitio, planteando la posibilidad de organizar una práctica basada en el propio evento, un tipo de *performance* pero como intervención contextual o, tal vez, ir más allá. La pieza de Andrea Fraser que se presentó en 1997 durante la inauguración, me viene a la memoria, como un ejemplo sorprendente.

Sally Stein/ ¿Tuvieron que batallar mucho para hacer que este consejo mixto estuviera de acuerdo con la nueva dirección que buscaban dar al proyecto?

Michael Krichman/ Con frecuencia, teníamos dificultades para que México lo aceptara. Imagínate lo que era intentar convencer al gobierno de este país de que invirtiera en un proyecto que consideraba como una gran farsa, dándole apoyo a Francis Alÿs, por ejemplo, quien nos había persuadido a que le financiáramos su viaje alrededor del mundo, para que, una vez concluido éste, su obra se resumiera en una postal.

Carmen Cuenca/ La pieza de Francis Alÿs, que de hecho era una acción y no un objeto, fue la que resultó más difícil de aceptar por parte de los integrantes mexicanos del consejo directivo; además, el hecho de que Alÿs no fuera ciudadano estadounidense ni mexicano no ayudó en mucho, y se generó una gran discusión respecto a si se asumía el costo de los boletos de avión de este artista belga, radicado en México, para viajar alrededor del mundo durante 28 días, como una forma de pasar de Tijuana a San Diego sin cruzar la frontera. Otro tema importante que generó gran controversia fue la idea de pagar honorarios a los artistas, independientemente de que sus obras se basaran o no en la creación de un objeto. Al defender la selección de artistas hecha por los curadores, uno de los primeros cuestionamientos que se me planteó fue: "¿Y por qué les estamos pagando?" Desde la perspectiva de los integrantes del comité directivo, los creadores debían considerar un honor suficiente haber sido incluidos en el proyecto, y les costaba mucho trabajo aceptar la idea de que la obra de un artista implicaba trabajo, que, como tal, debía remunerarse.

Michael Krichman/ Con el INBA, sí… hubo múltiples discusiones, pero estas nunca se daban en relación con el contenido de las piezas, como uno hubiera podido imaginarse, sino, más bien, giraban alrededor de la práctica artística, en el tenor de "Por favor, Francis Alÿs no es un artista… el tipo de obras que está produciendo no pueden considerarse arte serio." Jamás hubo altercados relativos a mensajes políticos o algo por el estilo, ¡nunca! Me gustaría poder ofrecerte una anécdota acerca de algún patrocinador que haya intentado censurar algo sobre esa base, pero no existe ninguna. Y quizá debido a ello, podrías juzgar como un fracaso la pretensión de **inSite** de ser una fuerza crítica. El verdadero gran obstáculo ha sido más logístico que político *per se*, en términos de obtener los permisos para realizar diversos proyectos a ambos lados de la frontera o en la propia línea divisoria. Para empezar, nunca está bien definido en dónde estamos parados. Mis antecedentes en derecho me han servido de mucho, porque realicé múltiples trabajos con agencias administrativas; no obstante, con cada trabajo nos encontramos casi siempre en la necesidad de destrabar la reserva administrativa. Por una parte, no existe ninguna razón imperativa para decirnos que sí y, por la otra, hemos logrado poner en marcha diversos proyectos. A lo largo de todo el proceso anticipábamos de manera continua que el teléfono sonaría y que alguien nos diría que el permiso nos había sido denegado o, en su caso, revocado… pero hasta el momento esto no ha ocurrido. La pieza *Toy an Horse* de Marcos Ramírez ERRE, ubicada en la frontera, que fue presentada en inSITE'97, fue un perfecto ejemplo de ello.

Carmen Cuenca/ Para la versión de 1997, decidimos invitar a Marcos Ramírez ERRE de nueva cuenta; bueno, en realidad lo decidieron los curadores y nosotros aplaudimos la idea. Todos sentíamos que Marcos merecía esta nueva invitación, porque la obra que había presentado para inSITE'94 resultó una cabal sorpresa, puesto que había sido creada por un completo desconocido que carecía de capacitación formal, al igual que de apoyo institucional. Junto con las series fotográficas *Dead Letter Office*, relativas a la convención republicana de 1996 en San Diego, piezas de Allan Sekula, y el *Ayate Car* de Betsabé Romero, *Toy an Horse*, obra de ERRE, fue uno de los trabajos de inSITE'97 que no sólo atrajo a los representante de la prensa, sino que también realmente los intrigó, provocando así un debate aún mayor.

Michael Krichman/ El origen de ese caballo nos dice mucho acerca del diálogo que de manera usual caracteriza el proceso de **inSite**. En su propuesta original, Marcos quería crear un caballo que se deslizara hacia adelante y hacia atrás en ambos países; pero a fin de que esto pudiera ocurrir, las dimensiones del equino tendrían que haber sido muy pequeñas para que éste pudiera pasar a través de las puertas de acceso, y a los curadores no les entusiasmaba mucho ese concepto. Entonces a Marcos se le ocurrió la idea de crear un enorme caballo que se ubicaría en medio de los carriles vehiculares, a lo que respondí: "¡Eso jamás va a suceder! ¿Cómo diablos crees que vamos a averiguar a cuántas jurisdicciones afectaría si lo colocamos en ese sitio?" Pero el artista y los curadores insistieron en el proyecto, y en aquel entonces no pudimos haber tenido mejor suerte en términos políticos fronterizos. Dos personas externas al proyecto de **inSite** ayudaron a que ello ocurriera; por un lado Alan Bersin, a quien Clinton acababa de nombrar no sólo procurador regional de justicia sino también "Zar de la frontera", y por otro, la esposa de Alan y yo que éramos amigos de la infancia, presentamos a Alan con Luis Herrera Lasso, cónsul de México en San Diego, también amigo nuestro, y con quien Carmen había trabajado. Ambos entablaron una buena amistad y comenzaron a colaborar juntos en diversos problemas fronterizos, no sólo en asuntos de carácter político sino también tratando de encontrar soluciones logísticas al tránsito, mediante la creación de carriles rápidos para aquellas personas que realizaban el recorrido cotidiano de la casa al trabajo y viceversa. Por lo tanto, cuando ERRE desarrolló el concepto para su obra, llamé a Alan y le expliqué brevemente el asunto, reconociendo que la única forma de llevarlo a cabo era si él y Luis nos ayudaban a conseguir la aprobación de más de 30 agencias federales, estatales y municipales de ambos lados de la frontera que tuvieran cualquier tipo de jurisdicción sobre el sitio, cosa que ambos hicieron.

inSITE2000-2001

Sally Stein/ Al considerar el recuento que han hecho, me llama la atención el hecho de que el concepto de residencias que comenzaron a aplicar en forma integral en inSITE'97 era algo que tú, Michael, habías intentado llevar a cabo junto con Mark Quint algunos años antes de que comenzara el proyecto de **inSite** Por supuesto, en aquella época dicho concepto se concibió en términos prácticos sin hacer mayor referencia a la región; no obstante existe la reiteración de mezclar cosas en este proyecto al tratar de integrar a actores externos.

Pero regresando a la cronología, si la iniciativa de crear residencias artísticas ya se había establecido en inSITE'97 cuando formaste el equipo de cuatro curadores,

mismo que continuó con su labor hasta el año 2000, ¿cuáles piensas que fueron los mayores cambios registrados entre esta versión de **inSite** y la que se llevó a cabo en 2000-2001? Habría pensado que la coordinación hubiera resultado más sencilla después de que el reorganizado **inSite** causó semejante impacto en 1997.

Michael Krichman/ En efecto, hubo un traslape entre ambos, especialmente en el terreno curatorial. Dos de los curadores que intervinieron en inSITE'97, Sally e Ivo, continuaron hasta el 2000, junto con Susan Buck-Morris y Osvaldo Sánchez, quienes se les unieron.

inSite había funcionado de acuerdo con un formato poco tradicional, pero a lo largo de 1997 aún tenía algunos puntos de comparación con *Sculpture Projects* en Münster o *Places with a Past*, la muestra de instalación organizada conjuntamente con el Festival de Spoleto en Charleston, Carolina de Sur. Para la versión de inSITE2000-2001 tales puntos de referencia parecían no tener cabida, y sólo nos percatamos de ello en la fase preparatoria; de manera repentina no sólo Carmen y yo sino también otros miembros del consejo directivo empezamos a inquietarnos por la presentación pública de este evento. En esa época les asegurábamos a los demás que no nos preocupaba el formato de la exhibición, lo que por supuesto significaba que sí lo hacía, puesto que estábamos obligados a montar una exposición. En esa coyuntura nos percatamos de la imposibilidad de realizar todos los proyectos a un mismo tiempo, debido a que todo mundo se encontraba involucrado en los procesos correspondientes y nada llegaba a término en forma simultánea. Judith Barry no podría concluir su instalación de videos en red con su "limitado elenco" y en el caso de Íñigo Manglano-Ovalle no nos fue posible conseguir la plaza de toros sino hasta el último minuto, por lo que no teníamos idea de si él sería capaz de presentar su idea de la "búsqueda de extranjeros", transformando dicho espacio con un radiotelescopio y amplificadores de sonido. En respuesta a nuestra muda pero evidente inquietud, los artistas se preguntaban: "¿De dónde les surge tanta preocupación por lo que ocurrirá el 23 de septiembre?", o cualquiera que fuese la fecha de la inauguración.

Sally Stein/ De hecho, ustedes retrasaron la inauguración del evento hasta mediados de octubre del año 2000 y éste continuó hasta principios de la primavera del 2001.

Michael Krichman/ Bueno, tuvimos que hacer algunos ajustes cuando nos dimos cuenta de que el evento estaba adquiriendo un ritmo diferente, e incluso entonces había una serie de obras que nuestro folleto de presentación sólo podía describir vagamente ya que se planeaba exhibirlas meses después. Aun así resultaba difícil abandonar el formato que habíamos desarrollado para la presentación pública. Además de la cuestión de nuestro propio parecer, era demasiado tarde para desechar el modelo por completo, lo cual siempre resulta difícil, y en este caso se trataba de un modelo que había satisfecho a quienes otorgaban el financiamiento, a los integrantes de nuestro consejo directivo y a las personas de la ciudad interesadas en el arte, mientras uno aparecía como buen organizador de una expedición artística en autobús.

De súbito teníamos que reconocer que todo ello no sería del agrado de quienes esperaban que la exposición resultara una experiencia artística mundial, es decir una experiencia organizada para deambular, observar los trabajos y disfrutar el viaje. A pesar de que lo intentamos, no había manera de no decepcionar a un sinnúmero de personas que esperaban una visita guiada de obras *in situ*, en el contexto de un gran acontecimiento. La opinión de la prensa respecto a inSITE2000-2001 no fue mejor, pero lo que ahora me parece interesante es que los periódicos, en especial los dedicados al arte hasta cierto grado y, evidentemente, los diarios locales se inclinaban por calificar de elitista esta versión de **inSite**, porque en realidad no se presentaba como un festival bien organizado. De hecho creo que sucedió todo lo contrario, pues los mejores proyectos poseían vida propia en las comunidades en donde operaban, pero no cumplían con las expectativas del mundo del arte. Viéndolo en retrospectiva, me impresionaron en gran medida muchos de los trabajos realizados para inSITE2000-2001; sin embargo, por lo que respecta a la organización resultó ser una experiencia muy dolorosa.

Carmen Cuenca/ A lo largo de todo el proceso debí enfrentarme a una serie de reacciones negativas por parte del lado mexicano, las cuales no habían comenzado en el año 2000, sino que las habíamos experimentado en 1997 en lo referente al proyecto de viaje presentado por Francis Alÿs, pero este tipo de respuesta se presentó con mayor fuerza en el 2000, porque le parecía difícil comprender el arte, e igualmente difícil aceptar el hecho de que invitáramos a artistas de todo el mundo, o por lo menos de tantos lugares diferentes. Esperaban que **inSite** tuviera una base más local y que se enfocara en apoyar a los artistas de la región. Ante tal premisa

preguntaban insistentemente por qué no gastar los recursos sólo en nuestros propios creadores en lugar de hacerlo en los artistas internacionales. Fuera del consejo directivo podía uno observar un enfado similar, proveniente de los creadores locales, quienes se preguntaban por qué no podían participar en el evento. Y, así, el consejo directivo del lado mexicano afrontaba innumerables presiones.

Michael Krichman/ Al concluir inSITE2000-2001, quienes participábamos en este proyecto teníamos muchas heridas que sanar. Nos tomó un tiempo considerable elaborar el catálogo, que era una manera de destacar la experiencia, y comisionamos a Osvaldo Sánchez, uno de los curadores de esta versión de **inSite**, para encargarse de la edición. Fue durante el largo proceso de preparación del catálogo cuando iniciamos las discusiones acerca de cuál sería el mejor paso a seguir, en qué consistiría éste, qué constituiría una contribución verdadera, existiría alguna razón de peso para volver a intentarlo, qué quedaría pendiente de hacer y qué se perseguiría.

inSite_05 y más allá

Sally Stein/ Ahora que ha concluido **inSite_05**, cómo caracterizarían ustedes los cambios principales que afectaron el funcionamiento de **inSite** desde el año 2000.

Michael Krichman/ Bien podríamos comenzar con los cambios políticos más evidentes. Para finales del 2000, los partidos más conservadores se hallaban en el poder en ambos países, y durante la primera mitad del 2001, me da la impresión de que los presidentes Fox y Bush estaban a punto de lograr nuevos acuerdos migratorios, aun cuando esta perspectiva se desvaneció en el horizonte luego de los acontecimientos del 11 de septiembre. El cambio de poderes que pasó del PRI al PAN tuvo enormes implicaciones en México para nuestra organización. Habíamos tenido la gran fortuna de que Gerardo Estrada y su equipo conservaran sus puestos durante las dos últimas administraciones del PRI. Después de haber podido contar con su apoyo y su confianza en lo que respecta a nuestro proyecto, de pronto todos aquellos con quienes habíamos tratado por más de seis años se habían ido. Del lado estadounidense, tras el 11 de septiembre y la consecuente guerra contra el terrorismo, ninguno de nosotros, al igual que todos, tenía idea de qué tipo de limitaciones, censuras y autocensura se aplicaría. En el aspecto más práctico, consideramos que con toda certeza tendríamos dificultad para obtener los permisos, pero en ocasiones nos topamos con menos obstáculos de los esperados. Sorprendentemente logramos el permiso para lanzar una bala humana a través de la frontera, como parte de un proyecto más extenso presentado por Javier Téllez. La brillantez de la pieza se asemeja en algo al caballo creado por ERRE, incluyendo una suerte de espectáculo tan fuera de lo común, que los funcionarios no lo consideraron riesgoso para sus sistemas cotidianos de control.

Sally Stein/ En el caso del trabajo de Carmen en Tijuana debió ser igualmente complejo en términos políticos obtener todos los permisos para el desarrollo del parque de Thomas Glassford y Jose Parral, ubicado justo al sur de la barda fronteriza localizada en Playas de Tijuana.

Carmen Cuenca/ Esta obra de renovación urbana de la playa representó la primera intervención permanente realizada por **inSite**. Me ha tomado muchos años, pero he aprendido a saber moverme en aguas políticas, encontrando formas de establecer puntos de interés común, con objeto de llevar a cabo lo que debe hacerse para que los proyectos se realicen de manera cabal.

Michael Krichman/ Después de inSITE2000-2001 volvimos a replantearnos la participación de artistas locales. Siempre ha existido un equilibrio entre los participantes extranjeros y los regionales, lo cual nos hace cuestionarnos en forma reiterada si dicho equilibrio es justo. Dado que el problema es irresoluble, en esta ocasión los curadores insistieron en tratar a los artistas locales de la misma forma que a los creadores provenientes de otros sitios, asegurándose de que ellos también efectuaran residencias artísticas. Nuestra tendencia ha sido asumir que los artistas residentes en esta zona pueden ser flexibles en recibirnos, pero, en muchos casos, cuentan con menos tiempo para hacerlo, debido a que están dedicados a realizar aquello que siempre han hecho.

Carmen Cuenca/ Los trabajos de video elaborados por Itzel Martínez del Cañizo para **Intervenciones**, denominados *Que suene la calle* y *Ciudad Recuperación*, dan testimonio de lo mucho que ha crecido **inSite** y, por ende, el trabajo artístico que se desarrolla en la región. La poderosa manifestación de control que muestra en sus cin-

tas me obligó realmente a reflexionar acerca de todo lo que ha ocurrido en la ciudad a lo largo de los últimos diez años, tanto en lo general como en lo que respecta al arte.

Sally Stein/ Ambos han hablado sobre "seguridad interna", y debo señalar que en verdad me sorprende que tal sector o el de las autoridades migratorias no hayan intervenido en lo relativo a la obra de Judi Wertheim, denominada *Brinco*. Dados los numerosos artículos de prensa que generó, me sigo preguntando si la única razón para que las autoridades federales no comenzaran a vociferar fue que la presentación de dicha obra coincidió con el desastre ocasionado por el huracán Katrina, momento en que los funcionarios de Washington se encontraban muy ocupados en asumir su propia defensa en contra de los cargos de racismo e incompetencia que generó su actuación, como para montar un ataque en contra de dicha obra, por considerar que favorecía la inmigración ilegal.

Michael Krichman/ Con toda la atención que recibimos de los medios masivos, tengo la certeza de que sí se enteraron de dicho proyecto y no les gustó mucho. No les habíamos pedido permiso para distribuir los zapatos deportivos en Tijuana, que tal vez podrían ser utilizados por los posibles indocumentados, por lo que no había asunto jurisdiccional alguno que perseguir, dado que la distribución de dichos zapatos se realizó en México, y por tanto no existía ninguna conexión directa entre los tenis y las organizaciones sin fines de lucro involucradas. Seguí muy de cerca el proyecto, y no lo hice únicamente por razones legales; cuando un creador extranjero, con escaso conocimiento de la historia artística y política de la región hace suyo rápidamente el tema de la inmigración, he aprendido a aconsejarle de manera enfática: "En primer lugar, necesitas enterarte sobre la práctica artística que ha tenido lugar en la zona, alrededor de ella y en la frontera, misma que se inició mucho antes de que **inSite** tomara forma". Por supuesto, atento a la controversia surgida en 1993 por el trabajo *Art Rebate* de Ávalos, Cisco y Hock, buscaba evitar que hubiera financiamiento público apoyando el desarrollo del proyecto de Judi, porque ello sólo enturbiaría las ramificaciones de lo que en verdad quería alcanzar con su obra. Pero más importante aún, no quería que se nos tildara de ingenuos, y buscaba asegurarme de que nosotros, como organización, y Judi, como artista, tuviéramos muy claros cuáles eran los términos de nuestro compromiso. Un elemento fundamental del proyecto fue la determinación de Judi de que los zapatos deportivos se manufacturaran en China y que la etiqueta así lo señalara en forma prominente. En tanto que el capital controla la fuerza laboral en todo el mundo, los empleos ofrecidos por la industria local inevitablemente se desvanecen. Su trabajo tuvo consecuencias en ambos lados de la frontera, al desafiar el aparente impulso de Tijuana creado por su próspera economía y las falacias que subyacen en lo referente al actual debate sobre la inmigración. Desde hace varios años, Krzysztof Wodizko y algunos más han tratado de manera brillante estos temas, sin embargo, Judi lo planteó en un medio y con un registro distintos. Y al final no resultó reiterativo, ni tampoco pretencioso.

Sally Stein/ He mantenido estas conversaciones desde la oficina que **inSite** tiene en San Diego, y he podido observar la enorme actividad que se realiza en cada rincón de ella, pero hay un área específica a la que en cada momento se dirige mi mirada, un espacio conteniendo innumerables cajas. ¿Qué hay en ellas?

Carmen Cuenca/ En ellas está nuestra historia, la cual hemos intentado organizar en un archivo. Cada conjunto de expedientes que se abre para un proyecto específico contiene una o varias historias. Allí se encuentran las pruebas documentales de lo que es necesario realizar antes de que algo, cada proyecto, tome forma. Cuando nos mudamos a esta oficina decidimos organizar sistemáticamente toda la información, incluyendo las dos o tres cajas cuyo contenido tiene que ver con la Installation Gallery antes de que se creara **inSite**, mismas que rescaté del almacén.

Sally Stein/ ¿No han pensado en depositarlas en alguna biblioteca?

Carmen Cuenca/ Aún no hemos tomado una decisión al respecto. A mí me gustaría más bien crear un archivo de información documental, y si mantenemos aquí esas cajas como parte del funcionamiento de nuestras oficinas, es para que quienes nos visitan puedan consultar su contenido al igual que nosotros, ya que guardan información importante que nos ayudará a recordar de qué manera desarrollábamos los proyectos en el pasado, incluso mientras seguimos cambiando…

Sally Stein es escritora y curadora. Actualmente es profesora asociada de historia de arte en la University of California, Irvine. Vive y trabaja en Los Ángeles.
Traducción: Clairette Ranc

● **Acknowledgements/** Curatorial/
inSite_05's curatorial program was made possible thanks to the support, consultation, and advice of: Catriona Jeffries • Victoria Noorthoorn • Ivo Mesquita • Holly Block • Beverly Adams • Ruth Auerbach • Joshua Decter • Kellie Jones • Francesco Pellizzi • Ute Meta Bauer • José Ignacio Roca • Michelle Marxuach • Marisa Flórido Cesar • Eungie Joo • Laura Bucellato • Aimée & Roberto Servitje • Roberto Tejada • Bulbo • Moicir dos Anjos • Norma Iglesias • Patricia Sloane • George & Alice Moore • Yishai & Irene Jusidman • Kate Fowle • Boris Hirmas • Marketta Seppala • Abril Castro • Kitty Scott • Norma Bringas • Alejandro Sahagún • Grant Arnold • Daina Augaitis • Elise Barclay • Jessica Bronson • Juan Devis • Gary Dufour • Lauri Firstenberg • Bruce Grenville • Stephen Hanson • Carla Herrera-Prats • Songmi Huff • Bill Kelley • Jenny Liu • Marvella Muro • Rubén Ochoa • Yoshua Okón • Max Presneill • Alma Ruiz • Reid Shier • Monika Szewczyk • Kerry Tribe • Lynn Zelevansky • Cecilia Navarro • Erika Torri • Derrick R. Cartwright • Teresa Vicencio • Bern Scherer • Mauricio Maillé/
The Artistic Director Osvaldo Sánchez was awarded a curatorial grant from the American Foundation in 2002, which facilitated his travel research for **inSite_05**.

● **Signs Facing the Sky> Signos mirando el cielo/** Jennifer Allora & Guillermo Calzadilla/
Credits> Créditos: Co-participants> Co-participantes: People who live, work, or frequent buildings along the flight path into San Diego International Airport/ **Video production> Producción de video:** Footage: Ken Jacques • Josh Zimmermann • Editor: Carlos Díaz/ **inSite production> Producción inSite:** Daniel Martínez • Márgara de León • Joy Decena • Zlatan Vukosavljevic • Esmeralda Ceballos/ **Co-curator> Co-curadora:** Donna Conwell/ **Acknowledgements> Agradecimientos: Individuals> Individuales:** Beverly Schroeder • Randy Robbins • Paul Ganster • Ivor Shier • Mauricio Couturier/ **Organizations> Organizaciones:** CCDC • Corporate Helicopters of San Diego/ **Sponsors> Patrocinadores:** The Airport Lounge, San Diego • The United States Embassy in Mexico City

● **Hospitality> Hospitalidad/** Felipe Barbosa and Rosana Ricalde/
Credits> Créditos: Co-participants> Co-participantes: Art students from the Escuela de Arte de la Universidad Autónoma de Baja California & Universidad UNIVER (Student Coordinator: Melissa Muca) • Sign-makers: César Castro • Daniel López • Fernando Ramírez/ **inSite production> Producción inSite:** Daniel Martínez • Márgara de León • Joy Decena • Zlatan Vukosavljevic • Esmeralda Ceballos/ **Co-curator> Co-curadora:** Tania Ragasol/ **Acknowledgements> Agradecimientos: Individuals> Individuales:** Marisa Flórido Cesar • Bulbo • Evenor Medrano • Sergio Rommel • Diana Díaz Moreno • Alicia Macedo • Joaquín Herrero • Madre Gema Lisot • Francisco Javier Reynoso Nuño • Raúl Zárate • Rodolfo Figueroa • Daniel López • Daniel Gudiño • César Castro • David Atilano • Fernando Vázquez • Fernando Ramírez/ **Organizations> Organizaciones:** Grupo Beta • Instituto Nacional de Migración • Casa de la Madre Asunta, A.C. • Escuela de Arte de la Universidad Autónoma de Baja California • Casa del Migrante • Universidad UNIVER • Policía Turística/ **Sponsors> Patrocinadores:** Sherwin Williams

● **Maleteros/** Mark Bradford/
Credits> Créditos: Co-participants> Co-participantes: Maleteros: Octaviano A. García • Amparo Sillas Cirilo • Jesús Morillo Guardo • Fernando Martínez • Don Chewy • Israel Maldonado • Rubén Núñez Reyes • Ramón López • Aurelio • Manuel • El Rafa • Dolores Martínez • Armando • Pedro • Jorge/ (among others)/ **Architect of the project> Arquitecto asesor:** Monique Birault/ **inSite production> Producción inSite:** Daniel Martínez • Márgara de León • Joy Decena • Zlatan Vukosavljevic • Esmeralda Ceballos/ **Co-curator> Co-curadora:** Donna Conwell/ **Acknowledgements> Agradecimientos: Individuals> Individuales:** Teddy Cruz • Kianga Ford • Bulbo • Miguel Ángel Méndez • José Schroeder • Orlando V. Chambers • Miguel Aguirre • Luis Cabrera/ **Organizations> Organizaciones:** INDAABIN • Tijuana Duty Free • San Ysidro Port of Entry • Delegación Centro (Tijuana)/ **Sponsors> Patrocinadores:** The United States Embassy in Mexico City • Tijuana Duty Free

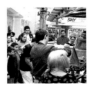

● **The Clothes Shop> La tienda de ropa/** Bulbo/ Adán Rodríguez Camacho • Ana Paola Rodríguez España • Araceli Blancarte Gastelum • Blanca O. España Montoya • Carla Pataky Durán • Cristina Velasco Lozano • David Figueroa Tagle • Dulce Roa Flores • José Luis Figueroa Lewis • Juan Carlos Ayvar Covarrubias • Juan E. Navarrete Pajarito • Lorena Fuentes Aymes • Miguel Ángel Álvarez Cisneros • Omar Foglio Almada • Sebastián Díaz Aguirre • Vanesa Capitaine Martínez/ **Credits> Créditos: Co-participants> Co-participantes:** Alejandro Ruiz Barraza • Cleotilde Elena Valdez Cruz • Gabriel del Portillo Sánchez • Jorge Santana Villaseñor • María Yvonne Quiñónez Saucedo • Olga Lourdes de la Vega Cervantes • Sandra Renata Gómez Delgado/ **Advisors> Asesores:** Lídice Figueroa Lewis • Olga Sánchez de la Vega/ **Co-curator> Co-curadora:** Tania Ragasol/ **Acknowledgements> Agradecimientos: Individuals> Individuales:** Marcos Martínez • Charles Glaubitz • Fidel Ledesma • Foy Jiménez • Gabriela Fuentes • Isabelle Wasserman • Jonás Benton • Olga Sánchez • Sandra Díaz • Alberto Hernández/ **Organizations> Organizaciones:** Tiendas La Parisina • Swap Meet Fundadores • Pomegranate • Plaza Mundo Divertido

infoSite/ San Diego/ Teddy Cruz/

Credits> Créditos: Construction> Constructor: Quijada Gutiérrez + Associates/ **inSite production> Producción inSite:** Daniel Martinez • Márgara de León • Joy Decena • Zlatan Vukosavljevic • Esmeralda Ceballos/ **Co-curator> Co-curadora:** Donna Conwell/ **Acknowledgements> Agradecimientos> Individuals> Individuales:** Victoria Hamilton • Michael Behan • Michael Ruiz • Beverly Schroeder • Kathleen Haseneaur • Garry Papers • Carolyn Wormser • Cynthia E. Kodama • Heath Fox • Derrick Cartwright • Don Mullen • Darlene Davies • Vicki Granowitz • Jeffrey Kirsch • Dan Mazzella • Nancy Rodríguez • Paul Ricci • Michael Singleton • Donald Steele • Michael Stepner • Joyce Summer • Jack Farris • Beth Murray • Gary Stromberg • David A. Lang • David Kinney • Mark Berlin • Ali Fattah • John Peterson • Richard Weyerhaeuser • Nancy Higgins • Debbie Petruzzelli • Jose Jaime Samper • Aaron Gutiérrez • Norma Medina/ **Organizations> Organizaciones:** Center City Development Corporation • City of San Diego • Balboa Park Committee • City of San Diego Park and Recreation Board • Balboa Park Cultural Partnership • San Diego Museum of Art • City of San Diego Development Services • Balboa Park Special Events (Developed Regional Parks Division) • The Timken Museum • Mingei International Museum • The Old Globe Theatres • House of Hospitality • San Diego Art Institute • Hospitality Ink • Balboa Park Visitors Center/ **Sponsors> Patrocinadores:** The San Diego Union Tribune • The United States Embassy in Mexico City

Some Kindly Monster> Un cierto monstruo amable/ Christopher Ferreria/

Credits> Créditos: Co-participants> Co-participantes: José Ramón Garcia • Raúl Espinoza • Team Hybrid • DJ Mane One (Mannie Putian) • ThaiMex (Paul Phruksukarn) • DJ Marlino (Marlino Bitanga)/ **inSite production> Producción inSite:** Daniel Martinez • Márgara de León • Joy Decena • Zlatan Vukosavljevic • Esmeralda Ceballos/ **Co-curator> Co-curadora:** Donna Conwell/ **Acknowledgements> Agradecimientos: Individuals> Individuales:** Dewey Young • Peggy Woolery • Tony and Scott of Interstate Brands Corporation • Rubén Ochoa • Patrick "Pato" Hebert • Rohanee Zapanta • Aya Seko • Kara Lynch • Brennan Hubble • Michael Schnorr • Vallo Riberto • Steve and Sherri Dean • Michelle Dean • Daniel Martinez • Marco Llanos/ **Organizations> Organizaciones:** Interstate Brands Corporation • La Curva Studios • Voz Alta Project/ **Sponsors> Patrocinadores:** Team Hybrid • United States Embassy in Mexico City

La esquina/ Jardines de Playas de Tijuana/ Thomas Glassford & Jose Parral/

Credits> Créditos: Production team> Equipo de producción>: Sergio Soto • Jesús Serrano • Guillermo Sariñana • Oscar Mendoza • Dolores Cuenca/ **inSite production> Producción inSite:** Daniel Martinez • Márgara de León • Joy Decena • Zlatan Vukosavljevic • Esmeralda Ceballos/ **Co-curator> Co-curadora:** Tania Ragasol/ **Acknowledgements> Agradecimientos: Individuals> Individuales:** Roberto Espinoza • Gabriel Boils • Javier Ramírez • Oscar Romo • Greg Abbott • Anne Marie Tipton • Laura Silvan • Karen Levy • Fernando Padrés • Rodolfo Anguiano • Manolo Escutia • Gabriela Guinea • Clay Phillips • Luis Miguel Auza • Annie Sartor • Mike McCoy • Tom Polkalski • Ron Saenz • Serge Dedina • José López Hurtado • Melquiades Reyes • J. Arturo Herrera Solís • Daniel Sánchez • Felipe Camberos • Osvaldo Cuadra • Julia Bendimez • Roberto Castillo • Alfonso López • José Manuel Valenzuela • Haydeé Jiménez • Ernesto J. Jiménez • Bruce Hanson • Joaquín Martinez Leal • Lina Ojeda • Ezequiel Ezcurra/ **Organizations> Organizaciones:** Tijuana River National Estuarine Research Reserve • International Boundary and Water Commission • Comisión Internacional de Límites y Aguas • Grupo Ecologista Gaviotas, A.C. • Proyecto Bio-regional de Educación Ambiental • Proyecto Fronterizo de Educación Ambiental • Delegación Playas de Tijuana • Instituto Nacional de Antropología e Historia en Baja California • Vecinos de Playas • Patronato de Recuperación de Áreas Verdes, A.C./ **Sponsors> Patrocinadores:** RECON Native Plants, Inc. • Fraccionamiento Real del Mar • Casas GEO Baja California • United State Embassy in Mexico City • XVIII Ayuntamiento de Tijuana • Gaviotas Grupo Ecologista A.C.

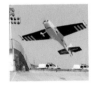

Aerial Bridge> Puente aéreo/ Maurycy Gomulicki/

Credits> Créditos: Co-participants> Co-participantes: Ray Fulks • Dickson López • Tim Attaway • Chuck Grim • Doug Rubin • Michael Blott • Alan Andere • Humberto Jocobi • Alejandro Guzmán • Gildardo de la Mora • Gerardo Ontiveros/ **inSite production> Producción inSite:** Daniel Martinez • Márgara de León • Joy Decena • Zlatan Vukosavljevic • Esmeralda Ceballos/ **Co-curator> Co-curadora:** Tania Ragasol/ **Acknowledgements> Agradecimientos: Individuals> Individuales:** Neuton Chávez • Alberto Caro Limón • Bruno Enríquez • Glenn McMclintic • David Pitcairn • Tim Attaway • Luis Ramos • Luis Miguel Auza • Alberto L. Rodríguez • Elda L. Elias Acosta • Esteban Yee • José Carlos Sánchez • Enrique García • Ramón Oropeza • Roberto Espinoza • Joaquín Herrero/ **Organizations> Organizaciones:** Silent Electric Flyers of San Diego • Chula Vista Model and Radio Control Club • Club de Aeromodelismo Real del Mar • Policía Turística • Delegación Centro (Tijuana) • Comisión Nacional del Agua • Comisión Estatal de Servicios Públicos de Tijuana • Comisión Internacional de Límites y Aguas

Heroes of War> Héroes de guerra/ Gonzalo Lebrija/

Credits> Créditos: Co-participants> Co-participantes: Mugs McKeown • Ronald Ritter • George Pappas • Tom Crosby • Ronald Miller • John McCann • Donovan R. Leavitt • Conrad Hoffner • Paul Gabriel Fusco • General Robert Cardenas/ **inSite production> Producción inSite:** Daniel Martinez • Márgara de León • Joy Decena • Zlatan Vukosavljevic • Esmeralda Ceballos/ **Co-curator> Co-curadora:** Tania Ragasol/ **Acknowledgements> Agradecimientos: Individuals> Individuales:** Dee Diaz • Gail Braverman • René Peralta • Pam Strong • Susan Shipp • Lauri Pappas • Abraham Shragge • Rod Meléndez • John A. Smith • Dolly Cramer • Verda Schmidt/ **Organizations> Organizaciones:** Veterans Home of California–Chula Vista/ **Sponsors> Patrocinadores:** Veterans Museum and Memorial Center

The Jewel / In God We Trust/ João Louro/

Credits> Créditos: Co-participants> Co-participantes: Students and teachers from 3rd and 4th grade of the Colegio Patria, Tijuana/ **inSite production> Producción:** Daniel Martinez • Márgara de León • Joy Decena • Zlatan Vukosavljevic • Esmeralda Ceballos/ **Co-curator> Co-curadora:** Tania Ragasol/ **Acknowledgements> Agradecimientos: Individuals> Individuales:** Eloisa Haudenschild • Cristina Guerra • Alberto Caro Limón • Luz Olivia Navarro • Guillermo Jiménez • Vicente Gómez • Saúl Sandoval Álvarez • Pedro Antonio Olivaz • Abimael Martinez • José Ángel Flores Zárate/ **Organizations> Organizaciones:** Colegio Patria • Yonke Tijuana • Yonke Salceda/ **Sponsors> Patrocinadores:** Ferrari and Maserati of San Diego

Visible/ Rubens Mano/

Credits> Créditos: Co-participants> Co-participantes: Bulbo • La Línea • Students from: Universidad Iberoamericana • Universidad Autónoma de Baja California-Escuela de Arte/ Escuela de Comunicación • El Colegio de la Frontera Norte/ **Co-curator> Co-curadora:** Tania Ragasol/ **Acknowledgements> Agradecimientos: Individuals> Individuales:** Abril Castro • Amaranta Caballero • Bulbo • Claudia Smith • Dani Lima • Fiamma Montezemolo • Gabriel Martinez • Gilberto Martínez Ayala • Izabel Burbridge • Javier Torres • Laura Mazella • Luciana Molisani • Luis Castro Niño • Marcela Quiroz Luna • Olivia Ruiz • Omar Pérez • Marcos Sámia • Max Lizárraga • Paula Croci • Raúl Ramírez Baena • Raquel Garbelotti • René Peralta • Selene Preciado • Stephen Berg • Luis Kendzierski • Evenor Medrano • Rosio Barajas • Patricia Martínez • Alicia Macedo • Claudia Algara/ **Organizations> Organizaciones:** Grupo Beta • Casa del Migrante • Universidad Iberoamericana • Universidad Autónoma de Baja California • El Colegio de la Frontera Norte

A Prototype for Good Migration> Un prototipo para la buena migración/ Josep-maria Martín/

Credits> Créditos: Co-participants> Co-participantes: Residents and staff of the Casa YMCA de Menores Migrantes-Tijuana/ **Architect for the project> Arquitecto del proyecto:** Sergio Soto/ **inSite Production> Producción inSite:** Daniel Martínez • Márgara de León • Joy Decena • Zlatan Vukosavljevic • Esmeralda Ceballos/ **Co-curator> Co-curadora:** Donna Conwell/ **Acknowledgements> Agradecimientos: Individuals> Individuales:** Oscar Escalada Hernández • Uriel González • Braulio Chávez • María Martínez • Rogelio Vergara • Marcela Merino • Gema Lisot • Gilberto Martínez Anaya • Luis Kendzierski • Guillermo Alonso Meneses • Olivia Ruiz • Francisco Javier Reynoso Nuño • Raúl Zárate • Evenor Medrano • Ramón Hernández • Marco Becerril • Roberto López Leyva • Anabella Acevedo • Kathi Anderson • Rosina Cazali Escobar • Víctor Clark Alfaro • Wayne Cornelius • Carol Girón • Julia Guzmán • Julio Hernández Cordón • Maricamen Hernández • David Heer • Jesús Montenegro • Guillermo Rangel • José Juan Velázquez • Christian Ramírez • Isabel Ruiz • Belia de Vico • Elana Zilberg • Jorge Santibáñez Romelló • Rodolfo Cruz Piñeiro • Manuel Ángel Castillo • Fabianne Venet • Patricia Eugenia Lavagnino Spinola • Gustavo Mohar • Noel Medina • Ramón Hernández Tepichin/ **Organizations> Organizaciones:** Casa YMCA de Menores Migrantes-Tijuana • COLEF • Centro de Investigaciones Regionales de Mesoamérica • Instituto Guatemalteco de Cultura • FLACSO • Guatemalan Consulate in Mexico • Grupo Beta • Contexto Galería • Fronteras Unidas Pro Salud • Casa de la Madre Asunta • Casa del Migrante • Instituto Nacional de Migración • Delegado Regional de Migración • Murofast • INEA • Centros de Integración Juvenil • Procuraduría de Derechos Humanos • Promo Juv **Sponsors> Patrocinadores:** Consulado General de México en San Diego

Ciudad Recuperación/ Itzel Martínez del Cañizo/

Credits> Créditos: Co-participants> Co-participantes: Gabriel Tovar • Cristian Contreras • Pablo Gerardo • Aurelio Contreras • Martín Navarro • Luis Alberto Sevilla • Gabriel del Real • Juan Martín García • Jorge Pérez • Alida Cervantes • Vicky Cuenca • Yolanda Walther-Meade • Yolanda S. Walther-Meade/ **Video production> Producción de video:** Yonke Art • Ingrid Hernández • Iván Díaz • Abraham Ávila • José Luis Martín/ **inSite production> Producción inSite:** Daniel Martínez • Márgara de León • Joy Decena • Zlatan Vukosavljevic • Esmeralda Ceballos/ **Co-curator> Co-curadora:** Tania Ragasol/ **Acknowledgements> Agradecimientos: Individuals> Individuales:** Michael W. Hager • Juan Carlos Arreguin • Daniel Macías • Antonio Alapisco • Mario González • Raymundo Reveles • Teresa Vicencio/ **Organizations> Organizaciones:** Centro de Rehabilitación ARAC-MERAC Tijuana y Tecate • Yonke Art/ **Sponsors> Patrocinadores:** XEWT Canal 12 • Cerveza Tijuana • Consejo Nacional para la Cultura y las Artes • Centro Cultural Tijuana

Osmosis and Excess> Ósmosis y exceso/ Aernout Mik/

Credits> Créditos: Film director> Director fílmico: Aernout Mik/ **Video production> Producción de video:** Benito Strangio • Elsje de Bruijn • Marjoleine Boonstra • Anca Munteanu Rimnic • Daniel Martínez • Márgara de León • Guillermo Parra • Sergio Berry • Edgar Luzanilla • Heriberto Luzanilla • Constancio Castillo Toledo • Pablo Maanon • Enrique Guzmán Medina • Paco García • Javier Vera • Esmeralda Ceballos • Andre Vázquez • Oscar Inzunsa • Montserrat León • Héctor Vázquez "Tito" • Sergio Brown • Octavio Castellanos • Jesús Efrain García/ **Co-curator> Co-curadora:** Donna Conwell/ **Acknowledgments> Agradecimientos: Individuals> Individuales:** Enrique Fajardo • Griselda Arellano • Hugo Abel Castro Bojórquez • Alcide Roberto Beltrones • Ernesto Santillana Santillana • Charly Arneson • Florisse Vázquez • Luz Olivia Navarro • Dinora Alarcón Angulo • Lupita Lona • Hilda López Núñez • Liliana Gómez • Eréndira Real • Capitán Sarquis • Luis Cabrera • Pedro Ochoa • José Márquez Padilla • Jan Galicot • Edgar Aarón Rodríguez • Berenice Aguilar • Salvador Verga Alejandre • Jaqueline Mandujano • Carlos Semental Ortiz • Francisco Retana • Vladimir Fafarrate • Alejandro Espinoza Martínez • Alonso Genaro López • Sharon MacComish Ripa • Mia Fernanda D'Unanue Bezada • Nadia Montes Odilón • Sergio Paul Martínez • Edwin Daniel López González • Alexander Dey Bueno • Armando René Quintal Sánchez • Andrés Carlos Madrueño Ortiz • José Esteban Ortiz Galván • Ixzayana Yarely • Márquez López • Uriel Ornaz • Erika Gabriela Mandivil • Fabián Corrales • Diana Carolina Segovia Panales • Alán Fernando Rodriguez Mercado • Diego Meráz López • Ana Cristina Ayala Quintero • Daniela Maung • Víctor Manuel Coronel Ramírez • Jorge Abel Meza López • Andrés Puentes de la Cruz • Kevin Luciano Sanmiguel • Carmen Alina Kyriakides • Manuel A. Corona Ávila • Mónica Samantha Corona Pérez • Iván José Partida Prieto • Naiem A. Aguirre Cota • Mijail Hibram Quintero Castañeda • Silvia Fernanda Peña García • Thania Berenice Hernández • Osmar Leopoldo Sanmiguel • Ana Bertha Hernández Alarcón • Norma De la Puente • Juan Barrera • David Bello • Sandra Bello • Alfonso Caraveo • Antonio Nava • Mary Sains • Julia M. Crespo • Garry Papers • Beverly Schroeder • Sergio Ortiz • Rosana Ricalde • Felipe Barbosa • Marco Antonio López Alcaráz • Florian Brann • Christina Chapman/ **Organizations> Organizaciones:** Delegado de la Mesa • Delegado de San Antonio de los Buenos • Chapman and Leonard • Secretario de Seguridad Pública • Colegio Patria • Unidad Aérea • Consulado General de México en San Diego • Tijuana Customs • The Medicine Company • CECUT • Seguridad Pública, Delegación La Mesa • Panteón Colinas del Descanso • Grúas Vladi • Ayuntamiento de Tijuana • Comisión de Filmaciones de B.C. • Secretaría de Turismo • Delegación San Antonio de los Buenos • CCDC • Óptica Sola de México • Parkade/ **Sponsors> Patrocinadores:** Fundación Televisa • XEWT Canal 12 • Farmacia Nacional • Fox Studios Baja

On Translation: Fear / Miedo/ Antoni Muntadas/

Credits> Créditos:Co-participants> Co-participantes: Norma Iglesias • Carmen Cuenca • Abril Castro • Fiamma Montezemolo • Mely de Reeve • Patricia Montoya • Nora Aidee Mejía • Rocío Lilián Mejía • Louis Hock • Teddy Cruz • José Luis Figueroa • Heriberto Yépez • José Manuel Valenzuela • René Peralta • Amy Corton • Jane Egüez • Petar Perisic • Austin Lynn • Rigoberto Nájera • David Figueroa • Carlos García • Karen Mercaldo • Pat Moore • Oscar Romo • Greg Abbott • Helmut Kiffmann • Samuel Guajardo • René Vargas • Nelson Rincones • José Zúñiga • Rohanee Zapanta • Bernard Casillan • Spencer Llanos • Fred Sobke • Carolyn Jones/ **Research assistant, DF> Assistante de investigacion, DF:** Vannesa Bohórquez/ **Research assistant, Televisa > Assistante de investigacion, Televisa:** Gustavo Fuentes/ **Video Production> Producción del video>:** Galatea audio/visual • Producción: Sebastián Díaz • Edición: Lorena Fuentes • Cámara: Carla Pataky • Sonido: Omar Foglio • Foto fija: Paola Rodríguez • Asistentes de Producción: Cristina Velasco • José Luis Figueroa/ **inSite production> Producción inSite:** Daniel Martínez • Márgara de León • Joy Decena • Zlatan Vukosavljevic • Esmeralda Ceballos/ **Co-curator> Co-curadora:** Tania Ragasol/ **Acknowledgements> Agradecimientos: Individuals> Individuales:** Alberto Caro Limón • Aníbal Yáñez-Chávez • Ernesto Santillana Santillana • Alfonso Ramírez Huidobro • Genaro Carrillo Elvira • Eduardo Zarquíz • Sean S. Isham • Gilberto Martínez • Padre Luis Kendzierski • Enrique Zambrano • Wendy Ware • Fernando Corona, Murcof • Ross Cisneros • Dan Van Roekel • Pablo Helguera • Mauricio Maillé • Diana Mogollón • Fernanda Monterde • Gerardo Jean • Enrique Martínez • Primitivo Cruz/ **Organizations> Organizaciones:** Secretaría de Seguridad Pública • Comandancia de Policía y Tránsito Municipal • Unidad Aérea Pegaso • U.S. Department of Homeland Security/ Customs and Border Protection/ U.S. Border Patrol Public Information Office • Casa del Migrante • Static discos • The Leaf Label • The Arts Center • Visual Arts Program, MIT/ **Sponsors> Patrocinadores>:** Fundación Televisa • XEWT Canal 12

Mi Casa, Su Casa/ Paul Ramírez Jonas/

Credits> Créditos: Co-participants> Co-participantes: Eloisa Haudenschild • Helena Stage • Oscar Romo • Nancy Rodriguez • Dr. César Amescua • Benjamín Reyes • Selena Preciado • Cecilia Navarro/ **Assistant> Asistente:** Francisco Bates/ **inSite production> Producción inSite:** Daniel Martínez • Márgara de León • Joy Decena • Zlatan Vukosavljevic • Esmeralda Ceballos/ **Co-curator> Co-curadora:** Tania Ragasol/

>

Acknowledgements> Agradecimientos: Individuals> Individuales: Eloisa Haudenschild • Erika Torri • Josefina Pataky • Adelaida del Real • Teddy Cruz • Jesús Héctor Grijalva • María Elena Rodríguez Ramos • Heather Martin • Tina Yapelli • Jo-Anne Berelowitz/ Organizations> Organizaciones: The Athenaeum Music & Arts Library • Centro Cultural de la Raza • Instituto de Cultura de Baja California • Tijuana River National Estuarine Research Reserve • Woodbury School of Architecture • El Lugar del Nopal • Fundación Esperanza de México, A.C. • Sistema Estatal Penitenciario • Programas de Readaptación y Reinserción Social • The School of Art, Design and Art History, SDSU

● infoSite/ Tijuana/ R_Tj-SD Workshop/
Team> Equipo: Gustavo Lipkau • Israel Kobisher Padilla • Carlos Alfredo Augusto Paz Álvarez • Erick Miguel Pérez Martínez • Roxana G. Quezada Arámbula • Norma Angélica de la Torre Melgar/ Credits> Créditos: Coordination> Coordinación: Gustavo Lipkau/ Institution> Institución: CECUT/ Construction> Construcción> Constructor: Quijada Gutiérrez + Associates/ Co-curator> Co-curadora: Tania Ragasol/ Acknowledgments> Agradecimientos: Aarón Gutiérrez • Octavio Quijano • Julia Cerrud • Teresa Vicencio • Abril Castro • Daniel Iñiguez • Gabriel Martínez • Marcela Quiroz/ Sponsors> Patrocinadores: Prodigy Infinitum • TELNOR • The San Diego Union Tribune • The Centro Cultural Tijuana • Consejo Nacional para la Cultura y las Artes • Fondo Nacional para la Cultura y las Artes

● Dirty Water Initiative> Iniciativa del agua sucia/ SIMPARCH/
Credits> Créditos: Participating communities> Comunidades participantes: Fundación Esperanza • La Morita • Ejido Lázaro Cárdenas • Chilpancingo/ inSite production> Producción inSite: Daniel Martínez • Márgara de León • Joy Decena • Zlatan Vukosavljevic • Esmeralda Ceballos/ Co-curator> Co-curadora: Tania Ragasol/ Acknowledgements> Agradecimientos: Individuals> Individuales: Jorge Carrillo • Teddy Cruz • Marcos Ramírez ERRE • Roberto Espinosa • Simón Orozco • Xiomara Delgado • Yesenia Guadamuz • Miguel Angel Méndez • Josefina Pataky • Graciela Lara • María Soledad Dávalos • Nicolasa Lucero • Olivia Lucero • Marcel Tam • Maraiah Hill • Eduardo Savala • Heidi Sánchez • Edmundo Romo • Jorge L. Gabayet • Cynthia Hooper/ Organizations> Organizaciones: Fundación Esperanza de México, A.C. • Ecoparque • Laboratorio Inapramex • Cristalum/ Sponsors> Patrocinadores: The United States Embassy in Mexico City

● One Flew Over the Void (Bala perdida)/ Javier Téllez
Credits> Créditos: Co-participants> Co-participantes: Mental Patients from Centro de Salud Mental del Estado de Baja California • David Smith/ Assistant> Asistente: Julián González/ inSite production> Producción inSite: Daniel Martínez • Márgara de León • Joy Decena • Zlatan Vukosavljevic • Esmeralda Ceballos/ Co-curator> Co-curadora: Tania Ragasol/ Acknowledgements> Agradecimientos: Individuals> Individuales: Luis Cabrera • Sam Boodman • Rodrigo Muñoz • Oscar Romo • Phil Rulard • Clay Phillips • Jorge Nava • María Consuelo Herrera • Luis Enrique Dorantes Martínez • Víctor Salvador Rico • Valdemar Rodriguez • Juan Antonio Estrada • Martha Fierro • Marisela Jacobo Heredia • Carmen Bojórquez • Ismael Castro García • Christian Fernández/ Organizations> Organizaciones: Centro de Salud Mental del Estado de Baja California • Tijuana River National Estuarine Research Reserve • Banda del Estado de Baja California • Centro Estatal de las Artes • La Tierra de la Iguana/ Sponsors> Patrocinadores: Instituto de Cultura de Baja California • Consulado General de México en San Diego

● Murphy Canyon Choir/ Althea Thauberger/
Credits> Créditos: Co-participants> Co-participantes: Heather Bankson • Diana Butler • Christina Carattini • Tracy Condren • Amy Heise • Jennifer Ramert • Amanda Skidmore • Liz Wolfe/ Choir director> Director coral: Terry Russell/ Composer-in-residence> Compositor: Scott Wallingford/ Accompanist> Pianista acompañante: David Castel de Oro/ inSite production> Producción inSite: Daniel Martínez • Márgara de León • Joy Decena • Zlatan Vukosavljevic • Esmeralda Ceballos/ Co-curator> Co-curadora: Donna Conwell/ Acknowledgements> Agradecimientos: Individuals> Individuales: Dan Hall • Donna Hilt • Shiela Sola • Shannon Smith • Scott Sutherland • Becky Kist • Dan Hall • Susan Burns • Sarah E. Burford • Linda Ragland • Mary Kirby • Charlene Giles • Heather Henderson • Regan Wright • Sherri Senter • Mike Hall • Jan King • Deanna Angel • Jill Biberardino • Beth Steinke • Jesse Aguirre • Cindy Farless/ Organizations> Organizaciones: Lincoln BP Management • ASYMCA • Fleet and Family Support Center • Military Outreach Ministries • San Diego USO • Marine and Family Services • New Parent Support Program • Jag Office • Navy Region Southwest (Public Affairs Office) • MWR (Moral Welfare and Recreational Services) • CNRSW Public Affairs • Healthy Start • Murphy Canyon Chapel • National Pediatrics Support Services • Operation Homefront

● Brinco/ Judi Werthein/
Credits> Créditos: Co-participants> Co-participantes: This work was produced in collaboration with migrants who cross the US Mexico border everyday. It was fabricated by maquiladora workers from HengJiaLi Shoes Inc (a shoe factory in Nighei, China)/ Fashion design consultant> Asesor de diseño moda: Lucio Castro/ Graphic design consultant> Asesor de diseño grafico: Alejandro Ros/ inSite production> Producción inSite: Daniel Martínez • Márgara de León • Joy Decena • Zlatan Vukosavljevic • Esmeralda Ceballos/ Co-curator> Co-curadora: Donna Conwell/ Acknowledgements> Agradecimientos: Individuals> Individuales: Mike K. Toe • Madre Gema Lisot • Padre Luis Kendzierski • Gilberto Martínez Anaya • Oscar Escalada Hernández • Uriel González • Evenor Madrano • Braulio Chavez • María Martinez • Eric Sun • Francis H. C. Crick • Chistof Koch • Omar Pimienta • Cacora • Roni Trigo • John Bebout • Dave Ahumada • José Gómez • Graham Boles • Ky Baker • Eli Bethea • Alex Pels • Madeleine Eayres • Liad Krispin • Jessica Murray • Alejandra Seeber • Ari Handel • Greg Horwitz/ Organizations> Organizaciones: HengJiaLi Shoes Inc • Blends-Beatnic-Carve • Casa YMCA • COLEF • La Casa del Migrante • Grupo Beta • Casa de la Madre Asunta • Adio Footwear/ Sponsors> Patrocinadores: XEWT Canal 12 • Ruth Benzacar Gallery • The United States Embassy in Mexico City

● The Good Rumor Project> El proyecto del buen rumor/ Måns Wrange/ OMBUD/
Credits> Créditos: Co-participants> Co-participantes: Enrique Herrera • Janet Colletti • Igor Isaksson • Don Sciglimpaglia • Manuel Chavarin • Dream Addictive Laboratory • Fiamma Montezemolo • William Jewson • Maria Karlsson • nodes/ inSite production> Producción inSite: Daniel Martínez • Márgara de León • Joy Decena • Zlatan Vukosavljevic • Esmeralda Ceballos/ Co-curator> Co-curadora: Donna Conwell/ Acknowledgements> Agradecimientos: Individuals> Individuales: Allen Guilmette • Rodolfo Cruz Piñeiro • Francisco Barraza • Redi Gomis • Luis Eduardo Cantú • Aarón Martinez • Jesús Madrigal • Manuel Quintana • Betty Juárez • Paty Blake • Jeromy Stallings • Cristina Astorga • Alicia Macedo • Fernando López Mateos • Lucille Neeley • Eloisa Haudenschild • Lola Cuenca • Karen Mercaldo • Randy Robbins • Cathe Burnham • Yolanda Walther-Meade • Hans Fjellestad • Damon Holzborn • Dustin Hassard • Chris Ferreria • Ivette Herman • Charles Reilly • Joy Espiritu • Pat Moore • Tiffany Lendrum • Beverly Schroeder/ Organizations> Organizaciones: Metro Publicidad • Plaza Research • Ninthlink • VC Asociados • Yonke Art • Galatea • Dream Addictive Laboratory • CCDC • L Street Gallery • JMI Realty • OMNI Hotel/ Sponsors> Patrocinadores: Metro Publicidad

● **Live Visual and Sound Image Event> Evento de imágenes visuales y sonoras en vivo/** Ellipsis> Elipsis/
Curator> Curador: Hans Fjellestad/ **Artists> Artistas:** Damon Holzborn • Liisa Lounila • Magaly Ponce • Iván Díaz Robledo **Credits> Créditos: inSite production> Producción inSite:** Daniel Martínez • Márgara de León • Joy Decena • Zlatan Vukosavljevic • Esmeralda Ceballos/ **Acknowledgements> Agradecimientos: Individuals> Individuales:** Carlos Valverde • Eduardo Hernández • Sergio Muro • Victor de la Fuente • Ángel García • Ethan Heilman • Alfonso Paredes • Manuel Gómez • Hector Hugo Torres • Edgard Zamudio • Uli Fielitz • Stefano Rampazzo • Lawrence J. Harman • Uma Shama • Marco Tapia • Manuel Lozano • Thorsten Dennerline • Roberto Ponce • Margaret Bellafiore/ **Organizations> Organizaciones:** Hipódromo de Agua Caliente • Generación Móvil • Nextel • Telcel • Sramp • Enviromental Studies • Bridgewater State College • Geo Graphics Lab • School of Mathematics and Computer Science • Perrera Dirección Municipal de Salud, Tijuana/ **Sponsors> Patrocinadores:** Fundación Televisa • Caliente • Fundación Cuervo • XEWT Canal 12 • Cerveza Tijuana

● **Online Project> Proyecto en red/** Tijuana Calling> Llamando Tijuana/
Curator> Curador: Mark Tribe/ **Artists> Artistas:** Ricardo Domínguez and Cuco Fusco • Fran Illich • Ricardo Miranda Zúñiga • Ángel Nevarez and Alex Rivera • Anne-Marie Schleiner and Luis Hernández/ **Acknowledgements> Agradecimientos: Individuals> Individuales:** Carol Hobson • Sheldon Brown • Ivan Orkeny • Miklos Szurdy • Ruben Ortiz Torres • Dr. Ramón Félix Landeros • Dr. Orlando Acosta • Dra. Cinthia Romo • Dr. Leon Dychter • Demetrio Cárdenas Garcia • Jesús Vázquez • Dr. Carlos Peralta • Dr. Ubaldo Eliaz Paez • Dr. Felipe Álvarez Olloqui • Márgara de León • Esmeralda Ceballos • Joseph Arnone • Josep Arnonoe • Ivan Orkeny • Miklos Szurdy • Kurt Olmstead • Brooke Singer • Alex Dragulescu • Christine Foerster/ **Organizations> Organizaciones:** Center for Research in Computing and the Arts, University of California, San Diego, Dragonfly Innovations/ **Sponsors> Patrocinadores:** Instituto de Cultura de Baja California • TELNOR • Prodigy Infinitum • Cerveza Tijuana • Department of Visual Arts, University of California, San Diego

● **Archive Project> Proyecto del archivo/** Mobile_Transborder Archive> Archivo móvil_transfronterizo/
Curator> Curadora: Ute Meta Bauer/ **Adjunct curator> Curadora adjunta:** Elke Zobl/ **Credits> Créditos: Project assistant> Asistente del proyecto:** Haydeé Jiménez/ **Project consultants> Consejeros del proyecto:** Beth Bird, Bulbo, Yvonne P. Doderer, Norma Iglesias, Fred Lonidier/ **Design> Diseño:** José Manuel Cruz/ **Design assistant> Asistente de diseño:** Andrea Iglesias/ **Interns> Pasantes:** Jessica Finsterwalder and José Luis de La Cruz Dominguez/ **inSite production> Producción inSite:** Daniel Martínez • Márgara de León • Joy Decena • Zlatan Vukosavljevic • Esmeralda Ceballos/ **CECUT:** Abril Castro, Equipo museográfico CECUT/ **Sponsors> Patrocinadores:** Goethe Institut Mexiko • Athenaeum Music and Arts Library • Centro Cultural Tijuana • Consejo Nacional para la Cultura y las Artes/ **For providing materials and for research advice we are deeply indebted to> Por proveer materiales y asesoría de investigación, agradecemos a:** Archivo Histórico de Tijuana/ José Gabriel Rivera Delgado • Athenaeum Music & Arts Library/ Erika Torri • Bulbo • Casa del Migrante en Tijuana/ Gilberto Martínez Anay and Luis Kindzierski • La Casa de la Cultura en Altamira/ Elsa Arnaiz, Silvia Jaimez • Centro Cultural de la Raza/ Viviana Enrique Acosta, Nancy Rodriguez • Casa de la Madre Asunta/ Hermana Lisot Chema • CITTAC/ Colectiva Feminista Binacional/ Carmen Valadez, Jaime Cota Aguilar • Connie Garcia • COLEF/ Humberto Berumen, Nora Bringas, Alfonso Caraveo, Fiamma Montezemolo, Silvia López, Guillermo Meneses, Rudolfo Cruz Rineiro, José Manuel Valenzuela, Rafael Vela, Laura Velasco, Nancy Utley • Environmental Health Coalition/ Jorge Osuna, Amelia Simpson, Joy Williams • Grupo Beta/ Evenor Medrano • Instituto de Cultura de Baja California/ Armando García Orso, Carmen Segura • La Línea • Maclovio Rojas • Media Arts Center San Diego/ Robert Bodle and teen producers • NaCO • The Midge Costanza Institute for the Study of Politics and Public Policy • Pressless/ Javier Guerra, Roberto Partida • SANDAG/ Ronald Saenz • San Diego Historical Society Research Library • San Diego-Imperial Counties Labor Council • San Diego Maquiladora Workers' Solidarity Network/ Enrique Dávalos • San Diego Public Library/ Richard Crawford, Marc Chery, Ralph Delauro, Dawn Porfirio-Milton • San Diego Women's History Museum and Educational Center/ Dawn Marsh Riggs, Eneri Rodríguez • SDSU/ Nannette Bell, Prisca Bermúdez, Cristina Favretto, Paul Ganster, James Gerber, Norma Iglesias, Harry Johnson, Marita Johnson, Cecilia Puerto, Kathleen Robles, Elizabeth Saenz-Ackermann, Patrick Sullivan • Spica*/ Gabriela Fuentes Aymes • Sociedad de Historia de Tijuana/ Gilberto Ríos, Mario Córdova Torres, Sergio Vázquez • UCSD/ Lynda Claassen, Steve Fagin, Fred Lonidier, Kim Schwenk, Visual Arts Department • Universidad Iberoamericana Tijuana/ Javier Torres Alcalá, Ariel Mascareño, José Saldaña, Marcus Pfund, David Ungerleider • USD Transborder Institute/ Stephen Elliott, Kyla Lackie, David Shirk, Paul Turounet • Voces de la Maquila/ Sylvia Calatayud Cataño • Women Make Movies/ David Bacon, Ursula Biemann, Beth Bird, Kaucyila Brooke, Abril Castro • Raúl Cárdenas • Mike Davis • Sergio de la Torre • Maria Teresa Fernandez • Hans Fjellestad • Evangeline Griego/ About Time Productions, Grrrl Zines A-Go-Go, Amar Kanwar, Annie Knight, Lula Lewis, Valeriano López Domínguez, Coral MacFarland Thuet, Virginia MacFarland, Juliana Maxim and Can Bisel, Helena Maleno, Alex Muñoz, Producciones Nicobis, Victor Rins, Raúl Rodríguez González, Héctor Sánchez, Angela Sanders, Adriana Trujillo, Hannah Weyer • Bern Scherer

05

/inSite

www.insite05.org

05

Prácticas artísticas en
el dominio público

Major and Distinguished Sponsors> Patrocinadores mayores y distinguidos/ The Andy Warhol Foundation for the Visual Arts • Artography, a program of the Ford Foundation • Fundación BBVA Bancomer • The Burnham Foundation • Casas GEO Baja California • The City of San Diego Commission for Arts and Culture • Consejo Nacional para la Cultura y las Artes (CONACULTA) • Fondo Nacional para la Cultura y las Artes (FONCA) • Goethe Institut Mexiko • The Bruce T. Halle Family Foundation • Eloisa and Chris Haudenschild • Instituto Nacional de Bellas Artes (INBA) • The James Irvine Foundation • Fundación Jumex • The Lee Foundation • The Lucille and Ronald Neeley Foundation • The National Endowment for the Arts • The Peter Norton Family Foundation • Panta Rhea Foundation • The San Diego Foundation • The San Diego Union-Tribune • Fundación Televisa • Union Bank of California • United States Embassy in Mexico City • Universidad Nacional Autónoma de México (UNAM)

Publication Sponsors> Patrocinadores de esta publicación/

◀CONACULTA·FONCA

haudenschild**Garage**

Fundación Televisa

LA COLECCIÓN JUMEX.

Paper generously provided through Anthony Siani, Bulkley Dunton Publishing Group
Cover: Utopia One X Silk 120# | Body: Utopia One X Silk 100#